Published by Akashic Books
©2024 Dennis Burmeister and Sascha Lange

ISBN: 978-1-63614-186-2
Library of Congress Control Number: 2024933628

First printing
Printed in China

Cover design by Dennis Burmeister
Front cover photo © Michael Herrmann
Front and back endpaper photos © Juliane Henke

The translation of this work was supported by a grant from the Goethe-Institut.

First published in Germany in 2023 by Aufbau Verlag GmbH & Co. KG, Berlin 2017 (published with Blumenbar; Blumenbar is a trademark of Aufbau Verlag GmbH & Co. KG).

Akashic Books
Brooklyn, New York
Instagram, X, Facebook: AkashicBooks
info@akashicbooks.com
www.akashicbooks.com

DEPECHE MODE LIVE

DENNIS BURMEISTER & SASCHA LANGE

TRANSLATED FROM GERMAN BY NOAH HARLEY

AKASHIC
BOOKS

BROOKLYN, NEW YORK

CONTENTS

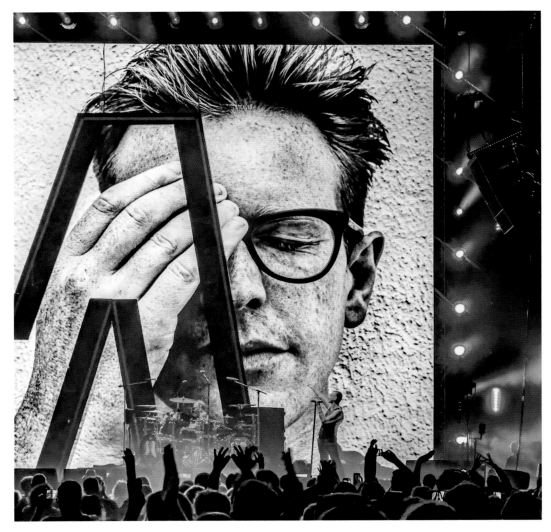

Andy "Fletch" Fletcher (1961 – 2022)

"It's our fans that give us the freedom to release music
we like rather than music that we have to make." —Andy Fletcher

. . . for Fletch.

PREFACE

Depeche Mode shows are a phenomenon unto themselves. For decades, generations of fans, dubbed the "Black Swarm" by the band, have poured enthusiastically into halls and stadiums, their numbers reaching well into the millions by now. They haven't released their hold on us, either. Over the past forty years we've taken in a tremendous amount of music from a vast range of artists; our record cabinets and Spotify playlists are bursting with great records from across the globe, and we've been to more concerts than we can count. Depeche Mode has always been something special, a sort of companion through all life's challenges, from our teenage years into the present day, like a part of the family. It's just about impossible for anybody—for the group or its fans, let alone the music press—to explain the emotional ties that connect so many people to Depeche Mode. Still, we've tried our best.

Eleven years ago, in *Depeche Mode: Monument,* we explored the band through the story of their studio albums, a showcase of their work that has since been translated into seven languages. Yet as exhaustive and labor-intensive as the book was, in the end it could only tell one part of the story.

In 2018 we turned our attention to a special chapter in the history of the band's fans in *Behind the Wall: Depeche Mode Fan Culture in the GDR,* showing how strongly the music and style of Depeche Mode brought youth culture from East and West Germany together in the eighties—and how in doing so, the band transcended the Iron Curtain. Yet even after a second book, the story wasn't over.

In *Depeche Mode: Live,* our third and final volume about this exceptional group, we've gone back to unearth more previously unpublished photos and unseen material from the live tours. Concert photos that nobody knew even existed; fan snapshots that capture the feeling of the live show with greater intensity than any glossy professional image could. We've also conducted a set of illuminating interviews with some of the key figures in the band's history. The result is a visually arresting book that shows Depeche Mode's evolution from tour to tour, from the eighties on. It is a book about a band whose concerts continue to move and inspire millions of people the world over to this day, in spite of life's trials and tribulations. Every fan has a tale about his or her first Depeche Mode show, their own personal memories of the numerous concerts that often followed.

We hope to stir these memories in readers, to let them relive the path that brought them from their first concert to today, and to throw a couple of memorable images, background stories, and anecdotes in to boot. As with our previous two books, we relied on the help of many to do so. We'd like to thank Sony Music Germany in particular for its support, as well as everyone who contributed photos, information, and other material.

Wishing you lots of fun with the rummaging, reading, and memories,
Dennis Burmeister & Sascha Lange

Broadmayne looking toward downtown Basildon in the 1970s

The Beginning

Once upon a time, just about every last British teenager dreamed of playing in a band. Sure, a couple still dreamed of becoming a professional footballer or prime minister, but that isn't who this book is about. We're talking about the English kids who kept their faces glued to the TV as soon as *Top of the Pops* came on, the kind who cranked the radio up whenever their favorite song came on, or spent weeks saving for the next vinyl.

When punk and new wave swept the UK in 1977, it took youth culture along with it; soon every childhood bedroom, no matter how small, every neighborhood, no matter how drab, was pulsing with the sounds of new, exciting, cool bands. It was a musical revolution, and teens were ready for it. It wasn't only in the larger cities either, but suburbs and smaller towns too.

The Basildon Bond

Basildon is a small city in Essex County, a little under thirty-five miles east of London. The city was first built after World War II as a new development for around 80,000 people, mostly from the working class.

It was in Basildon that Vincent "Vince" John Martin (b. July 3, 1960; he didn't change his last name to Clarke until 1981) and Andrew "Andy" Fletcher (b. July 8, 1961) first met through a Christian scout organization called the Boys' Brigade, before switching to the Methodist church's teen group. Vince had been interested in music from an early age, learning to play guitar in grade school.

Another classmate friend of Andy's, Martin Lee Gore (b. July 23, 1961), soon joined the Methodist youth group. Martin also

Christmas Eve 1980 at the Trinity Methodist Church in Basildon: Andy Fletcher, Andy's best friend Steve Burton, Mark Crick, Martin Gore with his girlfriend Anne Swindell, and Denise Jekyll.

played the guitar and had already started his first band, Norman & the Worms, in 1977. Vince was also active at the time in Nathan, a duo based out of the church group.

After practicing several times with close friends, Martin Gore and Phil Burdett (also from Basildon) played their first "real" concert as Norman & the Worms in 1978 at the St. Nicholas Comprehensive School in Basildon. There in the background, inconspicuous even in those days, is Andy Fletcher. "He was always around," Phil Burdett later recalled in an interview.

The teens' first musical influences were the leading lights of the 1970s—Pink Floyd, Simon & Garfunkel, David Bowie. Until, that is, punk changed everything. In their songs and style, the Sex Pistols and the Clash gave voice to the anger of an entire generation, ushering in a new cultural era. Soon other bands were setting their own trends: Joy Division, the Cure, Fad Gadget, and other new wave groups. DIY, or do-it-yourself, became the law of the land. The new generation of more affordable synthesizers just then coming onto the market made things easier still for anyone interested in getting started in music. No more need for crabby piano teachers to force you to play classical music for hours on end—you could make a go of it yourself.

In 1979, inspired by the Cure's first LP, *Three Imaginary Boys*, Vince and Andy started a new band called No Romance in China. Around the same time, their visits to church dropped off, replaced by meetups with Martin and other friends at Basildon's cultural center. The three graduated in summer 1979; Martin and Andy both took apprenticeships, Martin at a bank and Andy at an insurance office. Vince, meanwhile, elected to focus on music. He signed up for the dole, got by with part-time jobs, and saved up for a synthesizer.

Opposite page: one of Norman & the Worms's first shows was in spring 1978 in the living room of the Gore family home. Steve Burton recalled: "I think Martin's parents went out and we flipped the couch around and set the instruments up. Martin and Phil played and we just sat there with about ten mates in the front row and enjoyed it."

1980—A Band Is Born

"You have to play bass now. But on synth!"
—*Vince Clarke to Andy Fletcher, 1980*

In early 1980, Vince and Andy started another new band with the unwieldy name Composition of Sound. They started out on guitar and bass but were ultimately after the sound of the exciting new electronic bands, and for that they needed someone with a synthesizer. They landed on Martin, who had just bought one, even if it was intended for a group called French Look that Martin was playing in with his school friend Robert Allen.

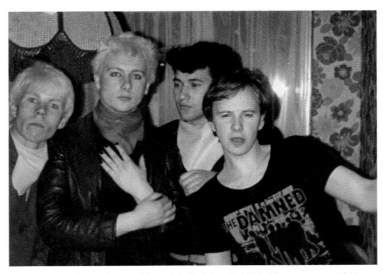

Vince Clarke, Robert Allen, and friends in Basildon, in 1980; Allen grew up with Vince, Andy, and Martin in Basildon, later achieving recognition under the name Robert Marlow. Before launching French Look with Martin, he and Vince played together for several weeks in a band called the Plan. Their guitarist, Perry Bamonte, later made music history with the Cure.

Vince, Andy, and Martin were soon practicing together; in time the drums gave way to a cheap drum machine, with Vince taking over the singing and guitar, Andy on bass, and Martin on synthesizer.

The group's initial repertoire consisted of covers and songs written by Vince. Composition of Sound's first "shows" came in March and April 1980 at the Woodlands School in Basildon, only several weeks after the band formed. The shows were closer to what might be called rehearsals or public practices; the three played in front of some kids at the school's youth club in the afternoon. As Andy recounted in 1982 to a journalist from BBC Radio Stoke, "When we first started, we did concerts around people's houses in Basildon. That's before Dave joined, and it was quite good. One of the gigs we'd played in front of seven people and ten teddy bears. And we dressed up in pajamas. It was just a good laugh."

All in all the band was initially just for fun. Only Vince, who had no professional plan B and wanted to make his money with music going forward, took things a little more seriously. On May 30, 1980, Composition of Sound finally had its first show in front

of a proper audience of peers at Paddocks Community Hall in Laindon, a neighborhood in Basildon. Vince's girlfriend at the time, Deb Danahay, organized the party, and the whole crew showed up. Vince had scraped enough together to buy his own synthesizer by then, and Fletch continued on bass. French Look, Martin's other project, shared the bill. Even if no one knew it at the time, the whole band was there that night; Dave Gahan was also at the party, though not onstage.

On May 30, 1980, Mr. David Gahan attended a birthday party thrown in Laindon for Vince Clarke's girlfriend, Deb Danahay. Perry Bamonte's younger brother Daryl later recalled that Dave had done the lights for the bands that night.

Composition of Sound had made its first splash. Less than one week later, on June 5, they landed a gig at a spot called Scamps in nearby Southend-on-Sea. They shared the stage with the School Bullies, a young punk band out of Basildon with guitarist Perry Bamonte, the brother of their classmate Daryl. Anybody who had said at the time that in ten years Perry would be playing guitar with The Cure would have been taken to be hopelessly insane. Daryl Bamonte described the show later to the German newspaper *Die Welt*: "My brother played a show with his band in Southend, and since he and Vince were good friends, he asked him if Composition of Sound wanted to play as an opener. And since I was there anyway, lugging equipment for my brother, I helped the lads set up." As it turned out, Daryl would accompany "the lads" as a roadie for the next fourteen years.

After these shows, it dawned on Vince, Andy, and Martin that they needed a real singer; Vince wasn't exactly comfortable in the role of front man. Practicing one afternoon at the Woodlands School, they happened to overhear David "Dave" Gahan (b. May 9, 1962) singing David Bowie's "Heroes" in a neighboring room. Excited, Vince quickly approached Gahan to ask if he wanted to join Composition of Sound. After a moment's hesitation, Dave agreed.

Just a few days later, on June 14, 1980, Dave found himself onstage with Vince, Andy, and Martin for a concert at St. Nicholas Comprehensive School in Basildon. Admission was 50p, with the French Look opening. Dave brought friends with him from his technical school—the show was a hit.

The band quickly gathered momentum. At the end of June, Composition of Sound played two consecutive nights at Top Alex, a pub in Southend-on-Sea, followed by a string of shows in August and September at Croc's Glamour Club in Rayleigh, just east of Basildon. At the time, Croc's was the hip spot in the area for all the new wave and punk kids, and the shows helped the group

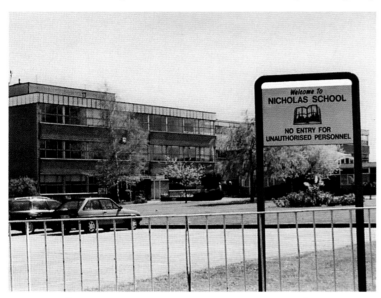

Dave Gahan first took the mic as the new singer for Composition of Sound on June 14, 1980. The band that eventually became Depeche Mode was born at a show in a dressing room at Basildon's St. Nicholas School.

draw greater attention. On August 30 they supported Soft Cell, another new act. Regular appearances at one of the hottest clubs in the area were crucial in helping the band to quickly build their following. Playing multiple shows at the same club within a short period wasn't uncommon at the time; pub and club owners were looking to keep regular guests entertained while also attracting a bigger audience, and more and more young people were lured in by the new electronic music. Bands would often put a break in the middle of their set so people could get another drink. At the time, Dave was still bringing a music stand onstage with him to read the lyrics to any new songs Vince had. They didn't own keyboard stands yet either, so once at the club they would set their synthesizers down on tables, beer crates, or whatever they found lying around.

In a bid to land more concerts, Composition of Sound visited a small studio in neighboring Barking in the summer and paid fifty pounds to record the tracks "Ice Machine," "Radio News," and "Photographic." The band copied the tracks onto cassette, and then used them to solicit other clubs for shows. They also made the rounds of London record labels—to no avail. Even so, the tape succeeded in bringing in new gigs.

Andy had in the meantime laid aside his bass guitar and bought himself a small Moog synthesizer. As Fletch later told *Die Welt*, "Up to then I had only played bass, I hadn't ever touched a keyboard. I had barely even played bass in fact. And here comes Vince and he says 'You have to play bass now. But on synth!' So I bought one."

Depeche Mode, the Bridge House, and Daniel Miller

As a band name, "Composition of Sound" was fairly clunky, failing to project even remotely the same cool that other popular electronic bands did, with names like the Human League and Ultravox. Until one day late in the summer of 1980, that is, when Dave came across a copy of the French fashion magazine *Dépêche Mode*, and a new name was found.

The band first announced itself as Depeche Mode on September 24 at London's Bridge House, a show for which they received a whole fifteen pounds for their troubles. While the Bridge House itself was a relatively small venue with a capacity of 560 people, it was popular at the time and each concert there helped bring the newly christened Depeche Mode greater recognition.

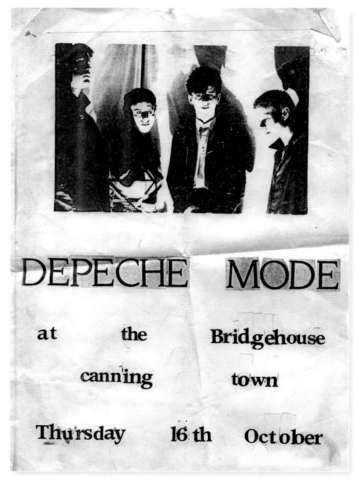

Poster for the show on October 16, 1980, at London's Bridge House.

A recording made of another Bridge House concert on October 30, 1980, soon began to circulate, later appearing on cassette tape and eventually vinyl.

Two weeks later, on November 12, Daniel Miller, founder of the small independent label Mute Records, saw the band open for one of Miller's own, Fad Gadget, a group considered an inside tip in the London scene at the time. Miller later recalled his impressions of Depeche Mode in the *Independent Echo:* "They had three little synths supported on beer crates, and the

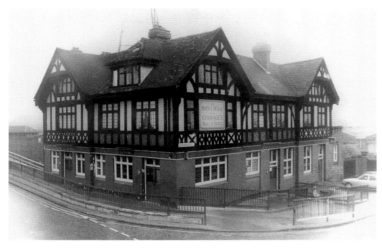

Starting in the mid-1970s, the Bridge House in Canning Town, East London, became one of the hottest live music clubs in Britain's cultural capital. Acts that went on to worldwide fame like Iron Maiden, U2, Dire Straits, and the Stray Cats all got their start at the Bridge House. A relatively small pub that could hold up to 560 punks, mods, pop fans, heavy metal heads, skinheads, and other misfits on the weekends, the Bridge House laid the groundwork for the later success of Depeche Mode and Daniel Miller's Mute Records.

DEPECHE MODE • *BRIDGEHOUSE* 12" PICTURE DISC • BOOTLEG

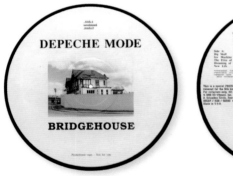

A Depeche Mode set recorded live at the Bridge House on October 30, 1980, and released in late 1988; today, the legendary Bridge House picture disc remains a sought-after rarity among fans and record collectors. It features unreleased songs like "Television Set," "Tomorrow's Dance," "Reason Man," and a cover of the Everly Brothers's classic "The Price of Love," making the mediocre recording quality somewhat beside the point. The discreet note that the record is a Mute Records release to mark the label's tenth anniversary is basically nonsense intended to allay the fears of serious record sellers that they were dealing with an illegal product.

lead singer had a light that he shone upward to make himself look gothic. But when they came onstage that night, I watched the first song and just thought: *What?! That's fucking incredible! What the hell's that? I'm sure it will go downhill from here.* But it didn't—it just got better and better."

It wasn't their first encounter; they had met several weeks before when Dave and Vince landed in the London office of Richard Scott, the owner of Rough Trade, on their search for a record label. Scott declined after listening to the demo with the band, though he brought it to the attention of Miller, who happened to be passing through the office. But at the time, Miller was too stressed out about Fad Gadget's first LP, and quickly vanished from the room in a bad mood. Now, following the show, Daniel Miller visited the lads backstage: "Hi, I'm Daniel from Mute. I really enjoyed it."

While the band obviously knew about the indie label and loved its records, the initial response was chilly; Dave and Vince hadn't forgotten how Miller had shrugged them off at Rough Trade. They did tell him, though, about another upcoming concert at the Bridge House. Two weeks later Miller showed up again, this time flanked by US artist Boyd Rice, who had released a single for his project NON with Mute in June, and Hildi Svengard, Miller's first employee. All three were taken with the show, and Rice and Svengard both advised Miller to work with Depeche Mode. Miller once again marched backstage, this time with something concrete in mind: "Do you fancy doing a single?"

Daniel Miller and Mute Records

Daniel Miller was born in London in 1951. Between 1968 and 1971, he studied film and television at the School of Art in Guildford. As punk took hold throughout 1977, he quickly recognized the opportunities that came with the new DIY philosophy, and bought himself a synthesizer.

A year later, Miller released his first single under the pseudonym the Normal on his own label, Mute. "T.V.O.D."/"Warm Leatherette" quickly went on to sell more than 30,000 copies and assume cult status in the electronic scene. This led artist after artist to Miller's door, seeking out a label for experimental electronic music. Soon Miller was in business.

A series of singles followed on Mute, including work by Fad Gadget and the first LP from the pioneering West German electro-punk act D.A.F. By the time Miller asked Depeche Mode if they wanted to make a single with him, he had a dozen 7"s and three LPs under his belt. Put out a single with Mute? Of course the answer was yes. Then, in December, Soft Cell's manager, Steve "Stevo" Pearce, asked the band if they would contribute a song to his *Some Bizzare* sampler.

They decided on "Photographic," which they recorded that same month with Miller at Tape One Studio in London.

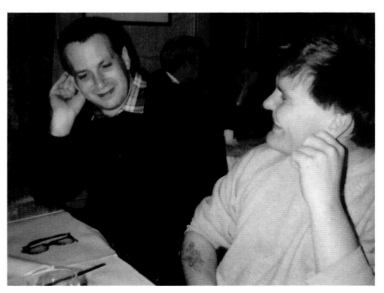

Daniel Miller—founder of Mute, the man responsible for discovering Depeche Mode, and a friend and father figure to the band—in conversation with Steve "Stevo" Pearce, founder of Some Bizzare Records.

As Steve Burton, a close friend of Andy Fletcher, later re-called, "On January 26, 1981, a Monday, 'Photographic' played for the first time on John Peel's show on BBC Radio One. I was so excited that I ran out right away to tell Andy about it. He lived just a couple doors down, but he wasn't there, he was practicing with the lads. I told his father John the news. We were both thrilled."

The *Some Bizzare* record came out on January 30, 1981. It was Depeche Mode's first official release.

Shows in 1981

Depeche Mode played its last show of 1980 on December 28 at the Bridge House. Not one week later they were back on-stage at Croc's in Rayleigh for a show on January 3, 1981. Using every opportunity to achieve greater recognition, they played London again on January 23 at a music pub called Hope & Anchor. The evening before, the club hosted the Hit-men, a little-known group with a keyboardist by the name of Alan Wilder. Their paths would cross again before 1981 was out.

Up to this point, the band's pull had been confined to London and surrounding environs. That changed with the release of the *Some Bizzare* sampler. Steve Pearce organized a tour in January called Some Bizzare Evenings, intended to showcase the groups on the sampler in a rotating lineup. Yet things came to an abrupt end after just two of the ten shows planned. Following Leeds on February 2 (nearly two hundred miles from London) and Sheffield on February 3, the London company providing the stage tech for the tour stopped working with Pearce due to "chaotic organization."

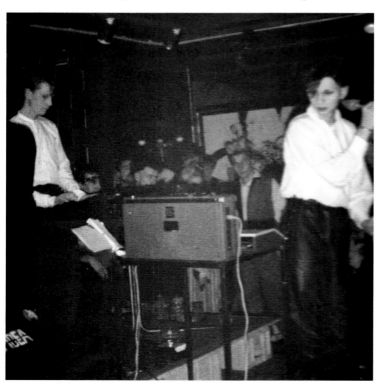

Depeche Mode playing at Scamps, a pub in Southend-on-Sea on England's south coast, on January 23, 1981.

Undeterred, Depeche Mode carried on through February and March. They played eight shows in London alone, among them a February 14 gig at the Rainbow organized by Visage singer Steve Strange and DJ Rusty Egan: the People's Palace St. Valentine's Ball. Ultravox headlined; Depeche Mode received a scant fifty pounds as one of the warm-up acts.

On February 20, 1981, the first Depeche Mode single, "Dream-ing of Me," came out on Mute, recorded together with the B-side "Ice Machine" at London's Blackwing Studios. As excited as every-one was about the band's first release, it was unclear what would happen next. Mute had only limited reach as a label, and its bud-get was too small to properly promote the single. Still, Daniel Miller's friend, a radio promoter named Neil Ferris, managed to get the single on the radio, where it peaked at number 57 on the UK singles chart. Mute had its first record on the charts! Miller's feeling about Depeche Mode's potential as a group now had some solid evidence to back it up.

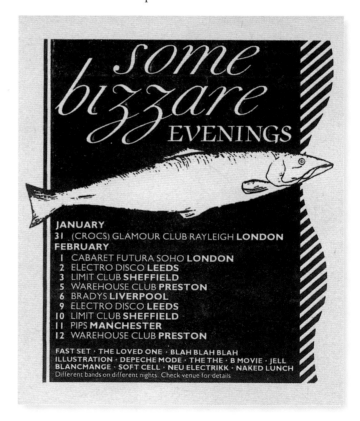

The band was just as thrilled with the success. Barely nine months after their first show in Basildon, they had a single that was being played on the radio—surreal! Miller obviously wanted to continue working together, but major labels offering record contracts with large advances also began to take an in-terest in the young group. Yet Depeche Mode hesitated. Sure, Miller couldn't afford a large advance, but on Mute they were more than just another band on a roster. Mute's partners, like Rod Buckle from the music publishing house Sonet, also advised them to stay with Miller.

In the end, they agreed to a deal for the UK rights, with the band and Mute splitting all costs and profits evenly.

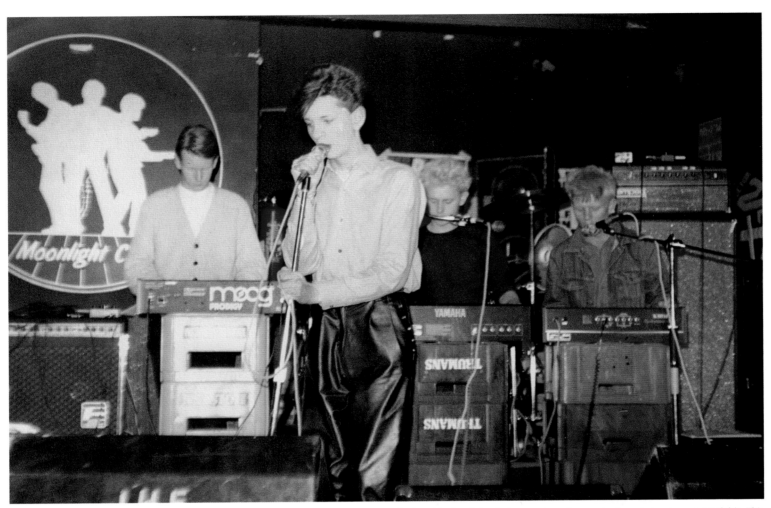

Depeche Mode live at the Moonlight Club in London on February 1, 1981. Sometimes the band had to bring in beer crates when no keyboard stands were available. This wasn't a rare occurrence, as photos just a week later from the Bridge House on February 9 attests (photo at right).

In the meantime, the calendar continued to fill up: Depeche Mode played nearly thirty shows between the beginning of the year and the end of April.

On April 26, 1981, the band shared the stage with Neue Deutsche Welle (German new wave) band Palais Schaumburg, among others. "I met Depeche Mode for the first time in 1981, right after they had put out their first single on Mute," Thomas Fehlmann recalled. "Daniel Miller had invited Palais Schaumburg, the band I was playing in at the time (with Holger Hiller and F.M. Einheit), to play at the London Lyceum for the Mute Night, Silent Night show. The headliner was Fad Gadget. We played first, then Boyd Rice was patched in by phone from America—I think that might have gone over people's heads, because it was just some static and clatter. Then Depeche Mode played, and after that Frank Tovey (of Fad Gadget). That was the day Kraftwerk had released *Computer World*. We all had a copy under our arms and were dying to finally put it on."

Two days later, at a show in Basildon, Depeche Mode received an unexpected visitor from New York. Seymour Stein, cofounder of Sire Records and the man who discovered the Ramones and later Madonna, had gotten word that his friend and colleague Daniel Miller just signed a new band.

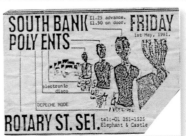

A ticket, button, and one of the band's first backstage passes, featuring Mark Crick's design for the single "Dreaming of Me." Crick was a school friend of Martin Gore's. After all the decades, it's unclear which show or tour leg the pass was used for.

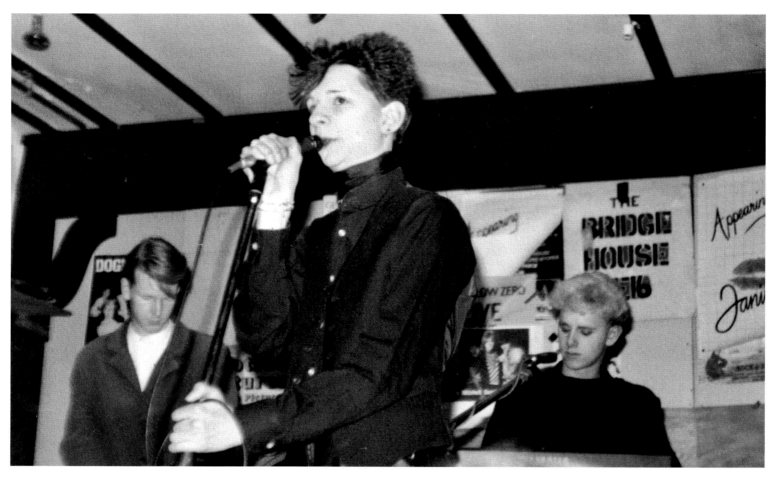

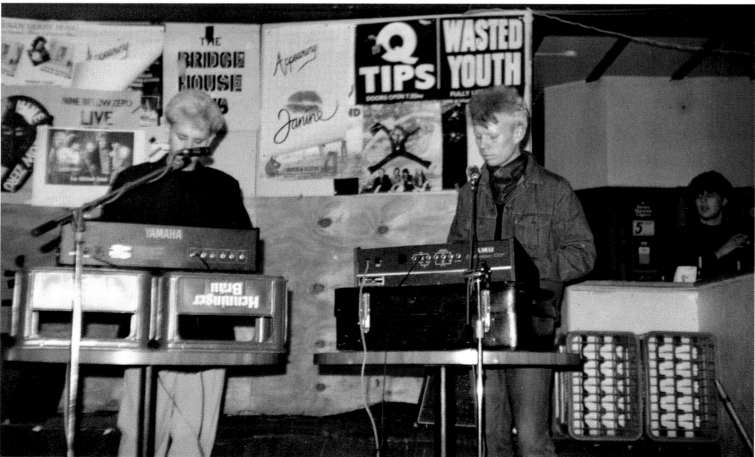

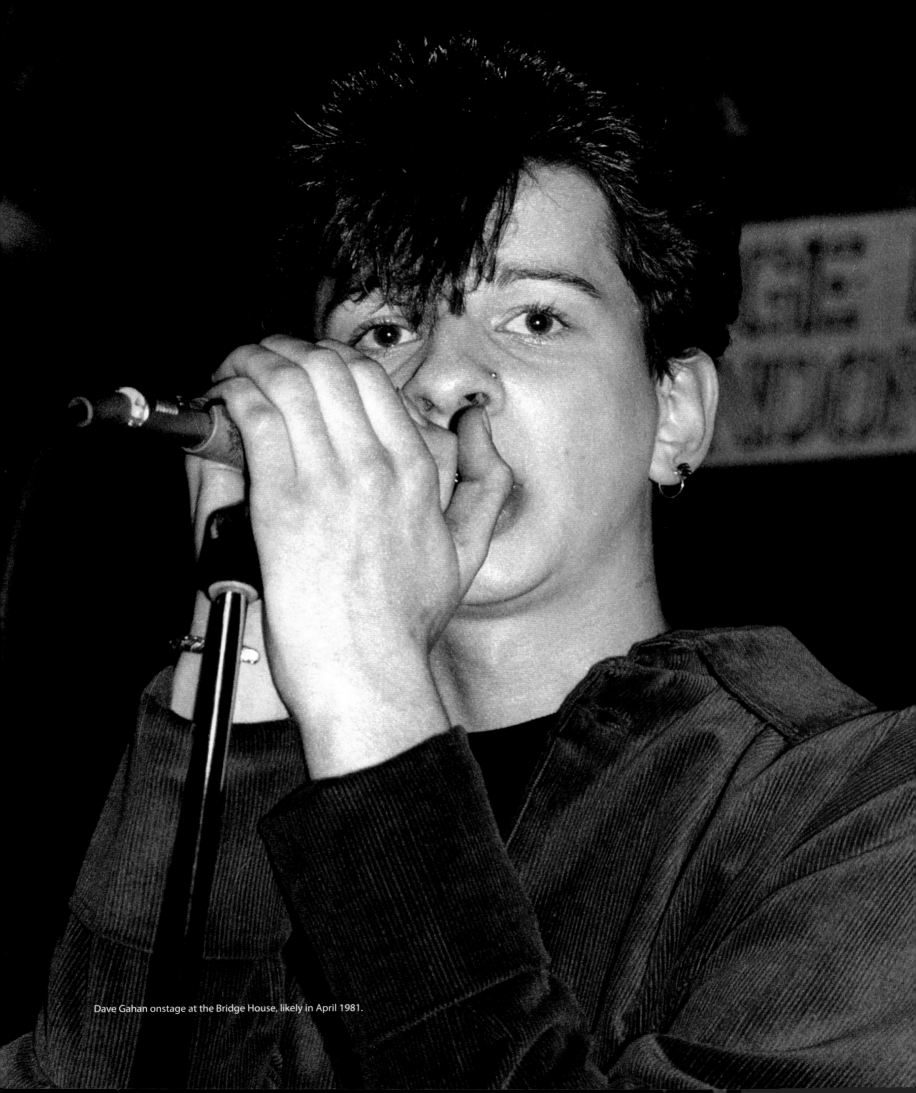

Dave Gahan onstage at the Bridge House, likely in April 1981.

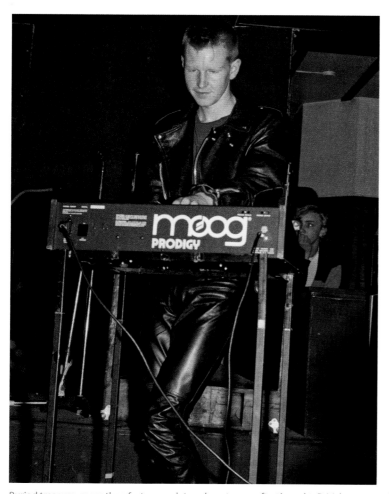

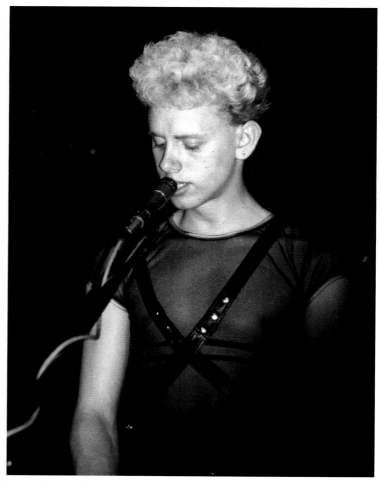

Buried treasure: more than forty years later, almost as an afterthought, British concert photographer Jonathan Crabb released these photos of Andy Fletcher and Martin Gore live at the Bridge House, probably from April 1981.

Acting on the spur of the moment, Stein had boarded the Concorde and flown to London to see the group play live. Depeche Mode could hardly believe that someone had flown in, especially from the US, to see them play. Captivated by the show, Stein immediately struck a deal with Mute for the US—insane!

Depeche Mode's first show outside of England came on May 9, 1981—Dave's nineteenth birthday—in the Welsh capital, Cardiff. "It took four or five tunes for the dancing to begin. But once it started there was no stopping them, especially with 'Dreaming of Me,'" wrote an enthusiastic critic for *Record Mirror*. That night the band also performed its second single, "New Life," which came out on June 13, 1981.

On June 2, the group opened for the Psychedelic Furs, a popular indie act at the time, at London's Hammersmith Palais. Tom Robinson, later known as a radio DJ on BBC 6, recounted his memories of the show: "Depeche Mode turned out to be four small, shy, skinny youths with three cheap bottom-of-the-range synths on makeshift stands and no backline at all. There was no sign of Vince's drum machine—instead, at the front of the stage, Dave Gahan had a radio cassette recorder that was wired into the PA system. As he announced each song, he would pull a cassette out of his shirt pocket, put it in the machine, and out would come a plinky DR-55 drum pattern at exactly the right speed. A fool-

proof low-tech solution to the tempo problem. Their sound was young, fresh, sexy, and quite unlike anything I'd seen or heard before. The Furs were as heavy, dull, and predictable as a Sherman tank, and after two numbers I slipped away. As to what happened next . . . 'New Life' went to number 11 that month on the un-

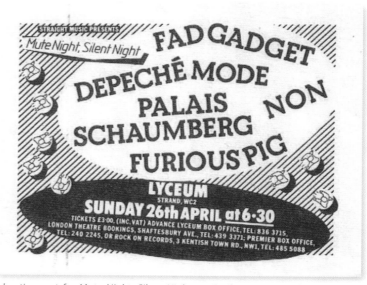

Advertisement for Mute Night, Silent Night on April 26, 1981, at the Lyceum in London.

known indie label Mute—while later in the year, for all the Furs's touring and promotional push, 'Pretty in Pink' failed to even dent the UK top 40."

The BBC began to pay attention to Depeche Mode, and invited them in for a live recording session. On June 11, the band went on BBC Radio 1's *Evening Show* with Richard Skinner, where they performed "Photographic," "Tora! Tora! Tora!," "Big Muff," and "Boys Say Go!" for broadcast six days later. The live versions may have differed at times from how they were eventually recorded, but the set still showed how tight the band's live sound already was.

Three days after the BBC 1 session, Depeche Mode returned to Blackwing Studios in London to record their first album, *Speak & Spell*. Daniel Miller produced it, spending hour after hour with Vince Clarke in the studio; only later did the other members come in to record their parts at Blackwing.

Top of the Pops and a Full Calendar

On June 24, the band realized a childhood dream: an invitation to *Top of the Pops*, the hottest music program on British television at the time. Just twenty years old themselves, now *they* would be the ones idolized by kids glued to their screens. The studio attendant didn't even want to let the young musicians on the premises at first, when they failed to drive up in a limousine like other artists. "The guards couldn't believe these four little boys were actually supposed to play there," Miller recalled. When the show aired the following day, all of Basildon was in front of their TV sets.

It may have been the band's first time on TV, but it wouldn't be their last that year; broadcaster London Weekend Television came by Blackwing Studios and filmed two songs live at Croc's the next day. The footage was broadcast at the end of August.

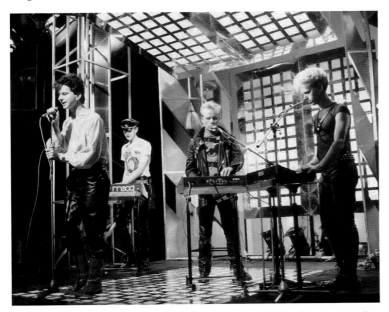

In June 1981, the childhood dreams of four boys from Basildon became a reality: with the whole town watching, the band went on *Top of the Pops* with their song "New Life."

The programmers for *Top of the Pops* seemed to have taken a liking to Depeche Mode, and invited them back to play their single "New Life" on July 16, then again on July 30. "New Life" reached number 11 on the UK singles chart.

On July 25, 1981, the band's first visit to the European continent coincided with their first outdoor show at the Hague's Zuiderpark, in the Netherlands. A live recording of the show opens with a percussive instrumental that recalls later songs "Any Second Now" and "Shout!" Next they played "Television Set," a song written by a friend of Vince's, Jason Knott. The song's authorship also explains the reason why it didn't ultimately make the record.

At the time, Depeche Mode's live performance was more forceful than their debut album *Speak & Spell*, with booming bass and sounds that didn't appear in the later studio versions. Hardly anybody in the Netherlands knew about Depeche Mode, and audience response was reserved. Yet the band didn't lose confidence—with appearances on *Top of the Pops*, their songs on the radio, and a growing collection of newspaper articles about them, they had begun to attract promoters and show organizers outside of London, and a first short tour was soon in the works.

At an online auction in 2006, a previously unknown soundboard recording of a show on June 27, 1981, at Croc's in Rayleigh switched owners. It is the earliest known live soundboard recording of a Depeche Mode concert.

On August 5, the band played two shows in Manchester. One of them, at Rafters, was attended by then-unknown Steven Patrick Morrissey, the eventual singer of the Smiths. Morrissey later wrote a scathing review of the concert for the *Record Mirror*: "Their sophisticated nonsense succeeds only in emphasizing just how hilariously unimaginative they really are."

Concerts in the north of the UK, Leeds, and Edinburgh followed, to different crowds than what the band was used to in London. As Andy told the teen magazine *Look In*, "Up north, it's such a struggle. They're different to southern audiences. They don't react because they don't know our stuff. They go wild at the end though." Dave Gahan added his own two cents: "I think it's just the way northern people are. They listen to it more, take it in more. But in London they just go mad from the start!"

Andy Fletcher live at London's Bridge House on July 29, 1981.

Signed ticket from a show at Fagins in Manchester on August 5, 1981.

On September 7, 1981, Depeche Mode released its third single, "Just Can't Get Enough," accompanied for the first time by a music video. The catchy song was the band's first hit, launching them into the UK top 10. Soon they were back on *Top of the Pops* to play the hit track, as their growing success began to at-

tract media attention from outside Great Britain as well: "Kraftwerk meets the Bay City Rollers!"

"The crowd: young, hip, and ready to dance," wrote one journalist from the West German magazine *ME Sounds* after attending a sold-out show on September 19 at London's the Venue. "Dancing on chairs, on tables, and the entire gallery, as though the end of the world drew nigh." Late that September, the band set off on its first continental tour.

Their first show in West Germany came on September 25 at Hamburg's Markthalle, where advance tickets went for twelve deutschmarks. West Berlin's *Spex*, still more of a fanzine than a proper magazine at the time, sent its reporter Ralf Behrendt to the show to give his assessment. Behrendt's response was positive; it wasn't just the four musicians who left a good impression, but label head Daniel Miller as well. "That evening he definitely looked after his protégés without ever seeming dictatorial. I've never known a producer or label manager to go on tour with his acts, help set up the sound equipment, take on promotional and organizational tasks, and sit at the mixing desk during the show, all while keeping himself discretely in the background."

An interview with Andy Fletcher revealed a bit more about the band's equipment setup to *Spex* readers: "We're able to carry our sound equipment in cars, because it's just three small synths, a tape recorder, four mikes, an eight-channel mixer, echo machine, one (!) amplifier, and two speakers. It's up and down in a second,

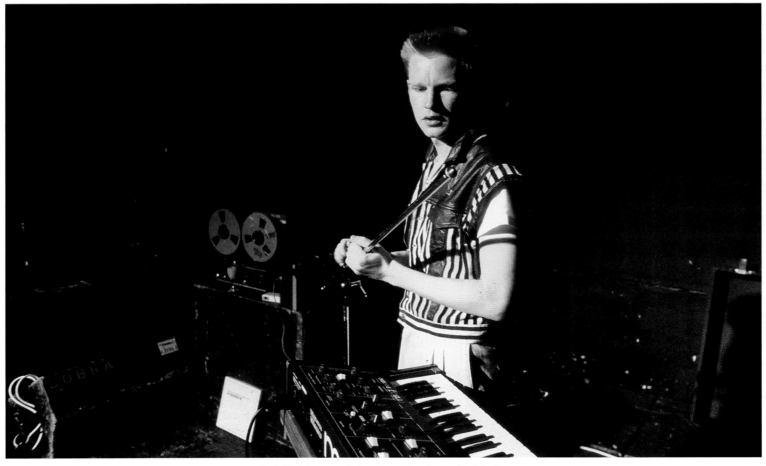

Andy Fletcher sound-checking at Hamburg's Markthalle.

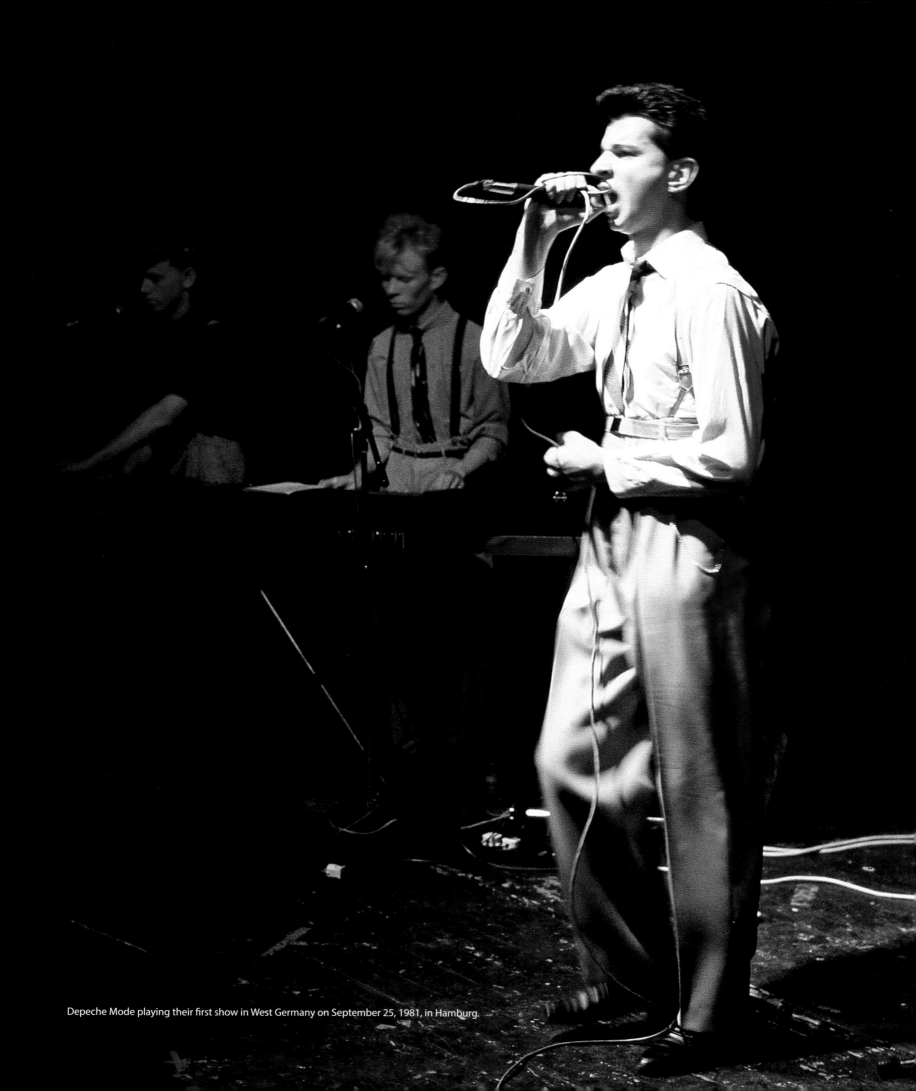

Depeche Mode playing their first show in West Germany on September 25, 1981, in Hamburg.

has a clean sound, and only costs 250 pounds per person split four ways." At the time, Andy was playing a Moog Source synthesizer, Vince a Roland JP 4 Polysynth, and Martin a Yamaha CS5. The drum sounds came from a professional TEAC tape machine. After Hamburg, the tour continued on to Amsterdam and Brussels.

Depeche Mode played its first show in France on September 29. Roadie Daryl Bamonte observed, "People were dancing, singing, holding each other in their arms. People who didn't even understand English were singing along, feeling the music. Mental! I was standing there and realized what tremendous potential the band might have."

Everything seemed to be going perfectly. Yet beneath the surface, the band's leader, Vince, was increasingly uneasy—all the hype, the relentless press inquiries, the impending tour for *Speak & Spell*. Following their Paris concert, Vince stayed on in the French capital with his girlfriend, Deb Danahay, wrestling with the thought of whether to leave the project.

Back in Basildon, Vince shared his decision with each band member individually. Dave, Martin, and Andy were all shocked; virtually on the eve of breaking through, their lead songwriter and front man was leaving them. Vince declared himself still

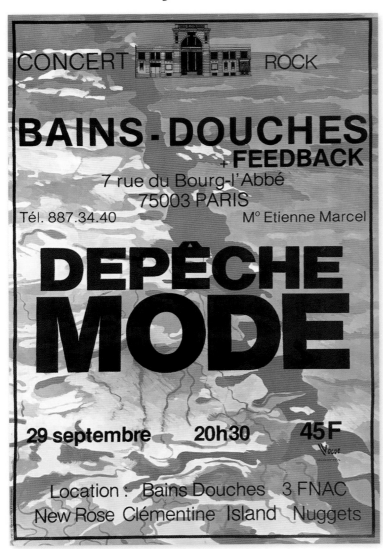

Poster from Depeche Mode's first show in France on September 29, 1981.

willing to do the upcoming UK tour, and the band agreed to officially announce his departure *after* the tour. Fans were clueless.

On October 23, the BBC invited Depeche Mode to a Soho studio, this time to film a half-hour performance in front of a live TV audience for the program *Something Else*. The show aired on November 6, 1981, on the early evening program—the perfect promotional slot for a new band with its debut album ready for release.

Speak & Spell Tour

In late October, Depeche Mode's long-awaited debut album finally arrived: *Speak & Spell*. With 60,000 presales in the UK alone, the record immediately rose to number 10 on the UK charts upon its release.

The futuristic cover image—a swan wrapped in cellophane—came from the London studio of British photographer Brian Griffin, who had previously worked with artists like the Clash, Iggy Pop, and Kate Bush. Griffin later explained that he hadn't had any concept for the album cover ahead of time, and that it came about almost by chance.

Two days after releasing the album, the band began its first proper headlining tour across Great Britain, playing fourteen shows that ended with London gigs at the Lyceum on November 15 and 16.

The *Speak & Spell* tour was organized by Dan Silver, whose Value Added Talent (V.A.T.) booking agency handled multiple tours for the band in the years to follow. "Those two nights at the Lyceum were awesome. And I remember pulling the promoter and the hall manager into the venue and pointing at the rear balcony and saying, 'Can you see how much that balcony is moving?' Since it was bouncing up and down because the kids were bouncing up and down at these two shows. Huge success."

The tour PA was provided by the company Showtec, with two technicians who soon became steady members of the group's entourage: J.D. Fanger at the mixing desk, and Andy Franks handling the stage monitors. The tour crew totaled fifteen people, including Dave's fiancée, Jo Fox, and Martin's girlfriend, Anne Swindell, who ran the merch stand together. In November, Depeche Mode made its first appearance on German-language TV with an invitation from Bavarian state television in Munich to perform their current single in-studio on the show *Pop Stop*. That same day, photos of the band appeared in *Bravo*, one of the era's most popular magazines for young people.

With news of Vince's departure from the band now public, his final show came on December 3, 1981, in Chichester, recorded live for the TV show *Off the Record*. The last time the four shared the stage was on December 22, for a *Top of the Pops* Christmas special. And with that, Vince Clarke and Depeche Mode were history.

Vince had offered to keep writing songs in the meantime, but the band preferred to stand on its own two feet. How would things go from there?

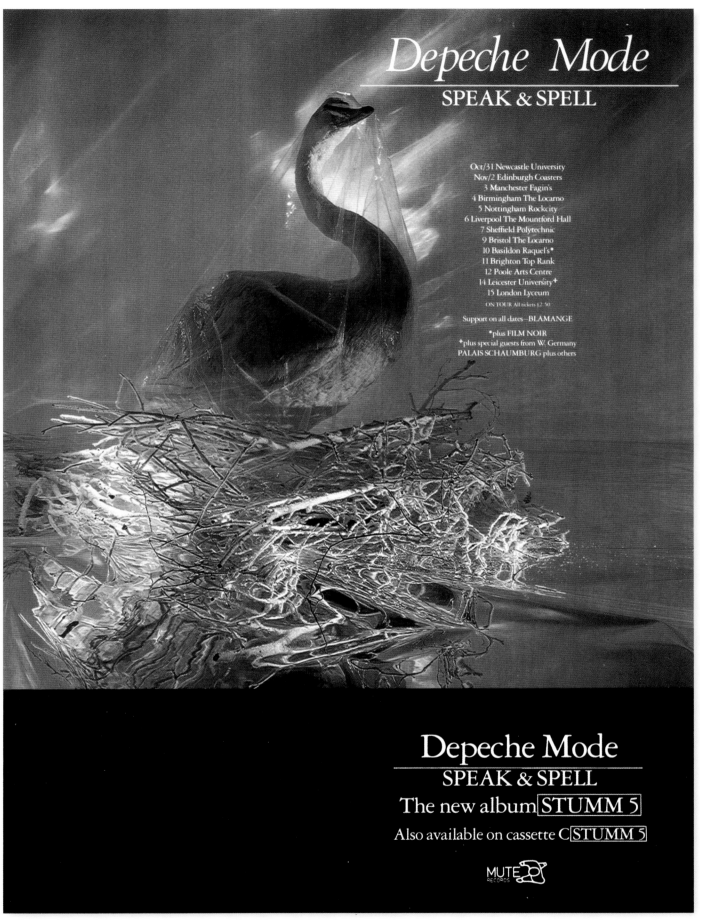

Announcement for Depeche Mode's first tour, 1981.

DEPECHE MODE BRITISH TOUR

P.A Company:

Lighting Company:

Agency:

29/10	Rehearsal	Windsor
31/10	University	Manchester
2/11	Coasters	Edinburgh
3/11	Fagin's	Manchester
4/11	The Locarno	Birmingham
5/11	Rockcity	Nottingham
6/11	The Mountford Hall	Liverpool
7/11	Polytechnic	Sheffield
9/11	The Locarno	Bristol
10/11	Raquel's	Basildon
11/11	Top Rank	Brighton
12/11	Arts Centre	Poole
14/11	University	Leicester
15/11	Lyceum	London
16/11	"	"

N.B. Any pho

by the

All tickets are priced at £2.50 and are available from venues

in advance

Except London

The first crew itinerary for the 1981 UK tour, also known as the *Speak & Spell* tour. Itineraries helped orient the team and artists while on tour, providing contact information for crew members, the addresses and telephone numbers for each venue and hotel, and later on information about things to do with any time off.

hotech

5 West Street,

ld Market,

ristol Tel: (0272) 213782

enith

3 Lots Road,

ondon SW10 Tel: (01) 351 1222/3/4

.B.A. International,

24 Hanover Square,

London W1 Tel: (01) 409 3070

ls made during tour must be settled

dual at the time of departure.

PERSONNEL LIST

Jon Botting..........Tour Manager/F.O.H. Engineer

Steve Hill..........Lighting Engineer

Daryl...............Backline Roadie

J.D.Fangor............P.A. Crew

Andy Franks..........P.A. Crew

Geof Simmons.........Truck Driver

DEPECHE MODE:

David Gahan..........Vocals

Andrew Fletcher.......Synth

Vincent Clarke.......Synth

Martin Gore..........Synth

BLANCMANGE:

Niel Arthur Guitar/singer

Steven Lunscombe keyboards.

MERCHANDISING:

Anne

Jo-anne

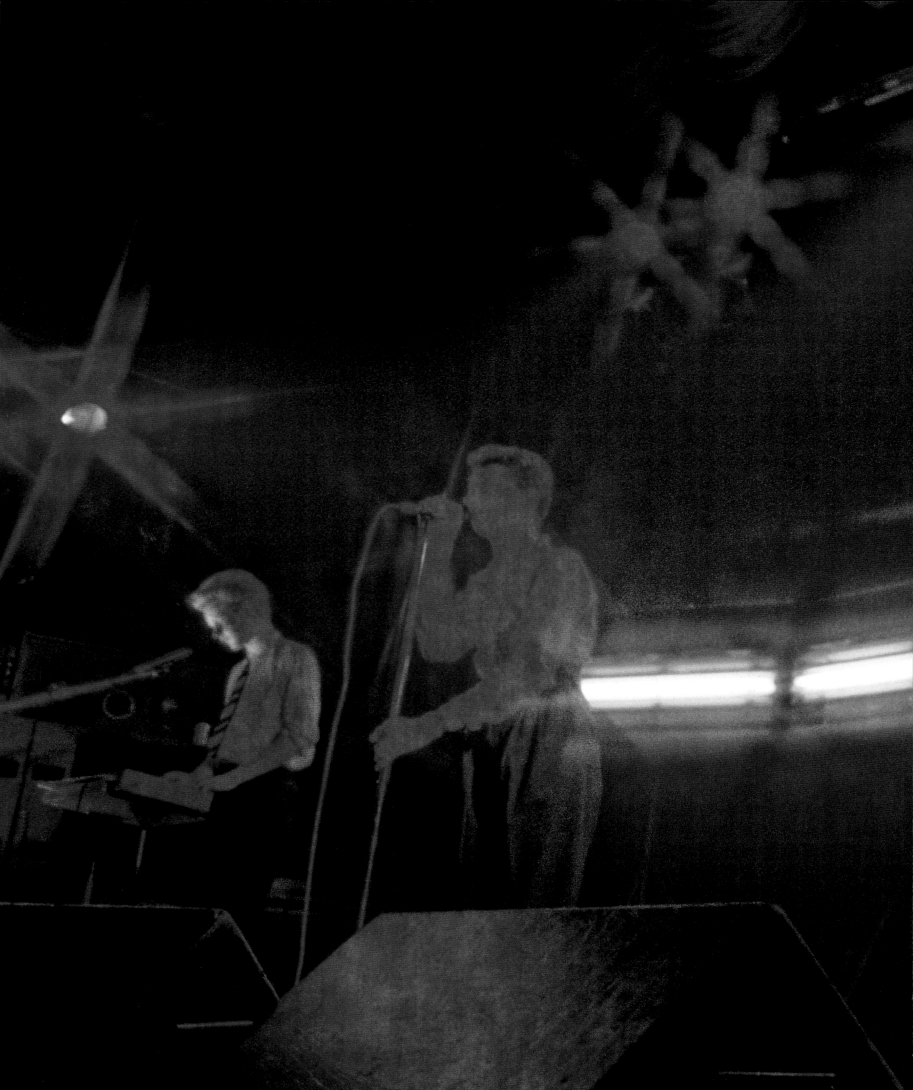

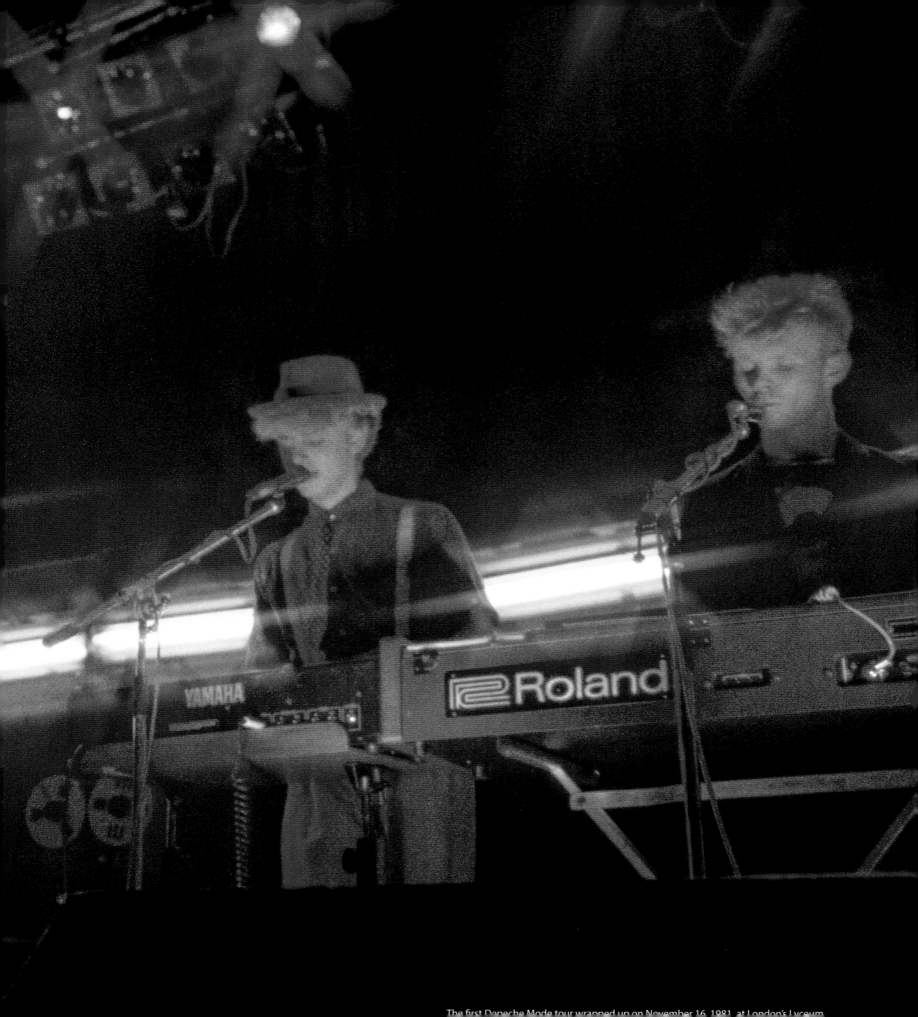

The first Depeche Mode tour wrapped up on November 16, 1981, at London's Lyceum

"See You" / A Broken Frame

By the time Vince Clarke revealed in October 1981 that he would split from Depeche Mode at the end of the year, Martin and Andy had already left their jobs. Dave also saw his professional future as resting with the band. Yet Vince had taken care of everything up to that point—would it even be possible to carry on without him?

Vince Clarke's last full show with Depeche Mode came on December 3, 1981, at the Festival Theatre in Chichester. He stood behind the keys one final time on December 22 for the *Top of the Pops* Christmas show. The original four from Basildon remained friendly despite Vince's departure from the band.

At the same time, with *Speak & Spell* at number 10 on the UK album charts, it felt obvious to everyone involved that Depeche Mode simply *had* to keep going. It was an opportunity Dave, Martin, and Andy couldn't let slip through their fingers. There was also the fact that Sire Records hoped to introduce the band in the US, as well as numerous outstanding show requests in the UK and across Western Europe. For the three remaining members, two questions had to be answered in the wake of Vince's departure: who would write the songs for Depeche Mode from now on, and how would the band perform them live? Martin quickly became a lead candidate for the songwriting. He had already contributed two songs for *Speak & Spell*, and still had a handful of compositions from earlier projects.

One of those was "See You," recorded with Daniel Miller in December 1981 at Blackwing Studios and released as a single in late January 1982. "See You" was an announcement that things would continue, even without Vince. When the track went all the way to number 6 on the UK singles chart not long after, it became clear that Depeche Mode wouldn't have anything to worry about where new songs were concerned. But what about upcoming shows—would they remain a trio, just with more playback off the tape machine? Dave, Martin, and Andy initially wanted to give it a try—though it was Miller who convinced them to introduce a fourth musician for live shows.

Alan Wilder

In December 1981, the band posted an anonymous advertisement in the music magazine *Melody Maker*: "Popular band seeks keyboard player. Must be under 21."

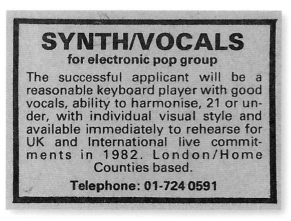

Ad in a December 1981 edition of *Melody Maker*.

What followed was a sort of audition by invite at Blackwing Studios. If it was only about outfits and haircuts, most applicants would have fit right in to the band, but hardly any were actually able to play the keyboard.

One such hopeful was Alan Wilder, born in London on June 1, 1959. Wilder was twenty-two at the time, but had fudged his age during preliminary talks so as not to be rejected outright. Yet unlike the others, Alan was a trained musician who already had some experience performing live; he was instantly able to play everything the band asked him to on the keys. "He could simply do it all," Gahan said, recalling his excitement at the audition.

The band had found its new stage musician. Alan was officially introduced as the fourth member of the group in the *Depeche Mode Information Service*, the group's newsletter. "We are pleased to announce that the fourth member of Depeche Mode has been found," the announcement read. "Although his position isn't yet permanent, he will be playing with Depeche Mode during their British and European tours."

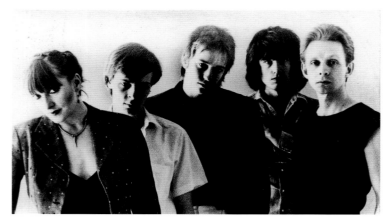

Alan Wilder had been involved in a number of other bands and projects before joining Depeche Mode in 1982, among them the Dragons, the Korgis, Real to Real, the Flatbackers, the Hitmen, and Dafne & the Tenderspots (photo from 1979).

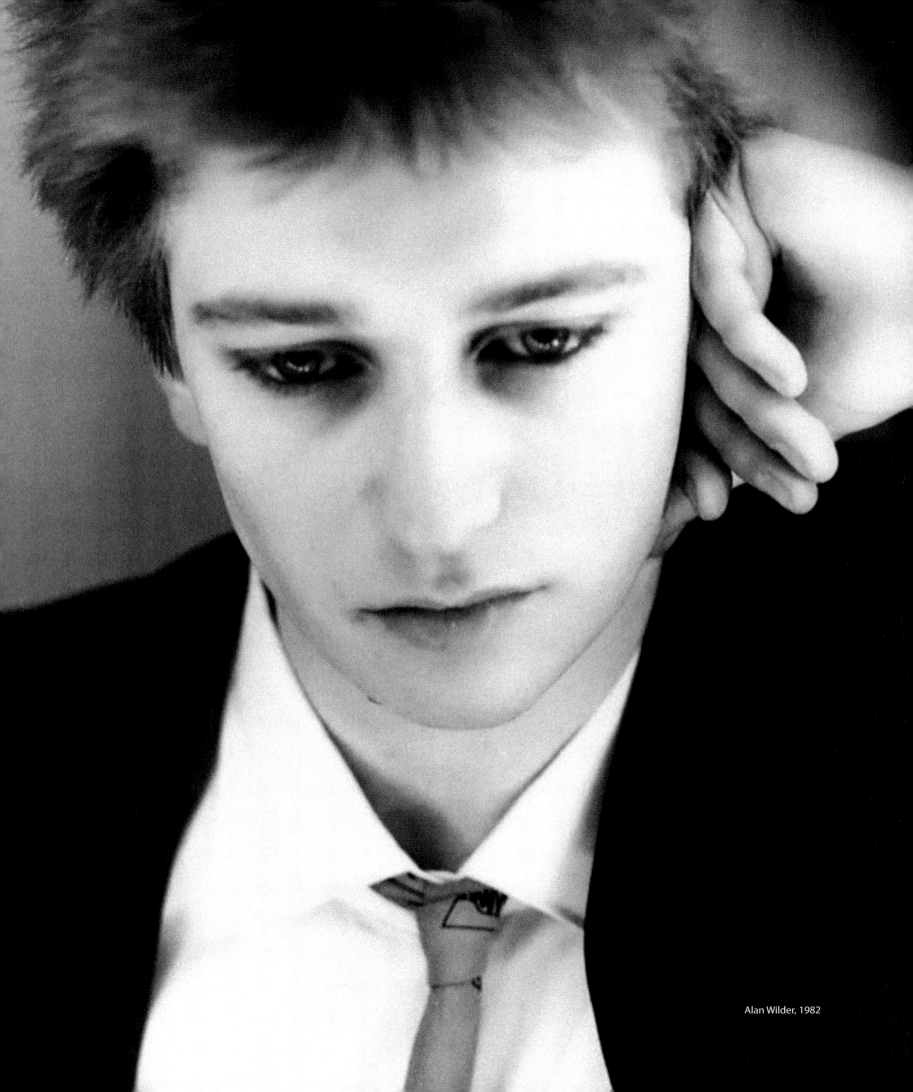

Alan Wilder, 1982

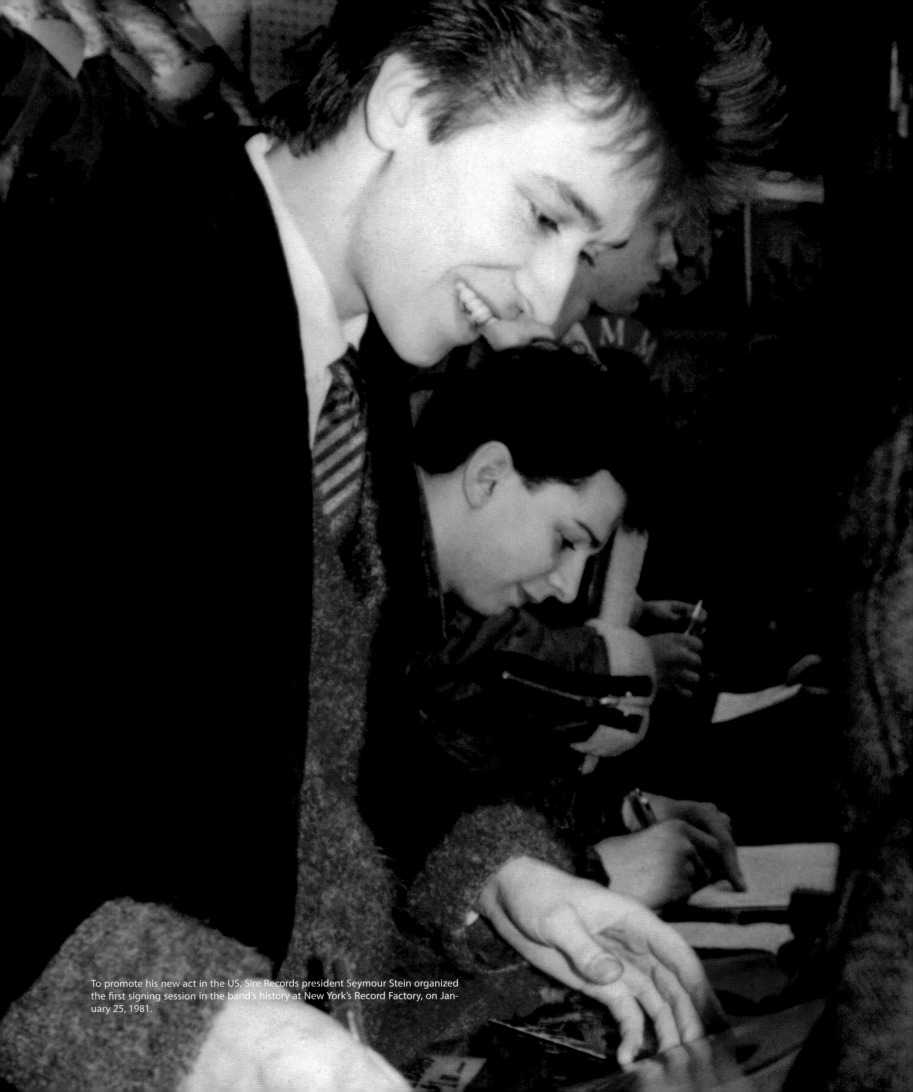

To promote his new act in the US, Sire Records president Seymour Stein organized the first signing session in the band's history at New York's Record Factory, on January 25, 1981.

Alan took the stage for the first time with his new band on January 20, 1982, at Croc's, the small but hip club that Depeche Mode had been playing regularly since the year before. It would be their last show at the club; they had grown too large for small pubs.

Depeche Mode live at Croc's on January 20, 1982.

Wilder later recounted his starting role in Depeche Mode: "Initially, they employed me as a sort of part-time member. Someone who could appear on the TV shows, who could go on tour, play the parts live, all this sort of thing. But they didn't really want to be seen as bringing in some musician to take over and take control, so I didn't partake in any of the studio sessions for another nine months after that."

Wilder wasn't thrilled with the arrangement, but after their former songwriter Vince had left, Martin, Dave, and Andy were keen to show that they could do it themselves, without Vince or a replacement. At the same time, Alan was more to the group than just a live performer. He appeared in the official music video for "See You" in January 1982, and every other video for the singles that were released that year. His starting pay for playing exclusively with Depeche Mode was a hundred pounds a week.

Alan was also there to accompany the band on its next adventure: a flight to New York for two shows at the Ritz on January 22 and 23. A teenager by the name of Richard Melville Hall (who in another ten years would become known worldwide as Moby) went to one of the shows, and had to lie about his own age just to get in. As he later told SiriusXM, "I remembered so clearly: the doorman said, 'Let me see your driver's license.' So I handed him my driver's license and he said: 'That says you're sixteen.' And I said: 'Yeah, it's two years old.' And he got confused and let me in." A *New York Times* journalist was also at one of the shows, although unlike Moby, he didn't find much to like about the young English group, writing that "Depeche Mode's melodies amount to little more than mournful chants, intoned by the lead singer, Dave Gahan, in a pseudo-funeral drone."

"See You" Tour, 1982

Back in London, Depeche Mode returned to BBC Studios on February 10, 1982, for a half-hour concert that was eventually broadcast on BBC 1 two months later.

In addition to "See You," the band debuted another new song by Martin for the performance: "The Meaning of Love." Dave introduced the band after their first song, pronouncing it "Depesh-ey Mode" as they had done in 1981. The BBC studio hosted another young act that night, Talk Talk, who were promoting their first single, "Mirror Man."

The very next day, Depeche Mode was back on *Top of the Pops* with their new single; it was Alan Wilder's first TV appearance with the band. Then, after running tech rehearsals at the Zig Zag Club in London, everyone piled into the tour bus on February 12 and they were off on the "See You" tour, for a total of fifteen dates through Great Britain. The Glasgow show on February 21 was recorded and broadcast by Radio Clyde.

DEPECHE MODE • *TOYS* 12" PICTURE DISC • BOOTLEG

The Glasgow show at Tiffany's circulated as a bootleg in various formats under different names; the limited *Toys* picture disc regularly fetches top prices among collectors, while a misprint of the record bearing an image of Robert Smith from the Cure is considered an absolute rarity.

On February 27, 1982, they returned to London to play a secret show under the pseudonym "Modepeche." The concert was a benefit for the Bridge House, a club to which the band owed a great deal for all its success since 1980, but had fallen on hard financial times. Sadly, the campaign wasn't able to save the venue, and the Bridge House had to close that year.

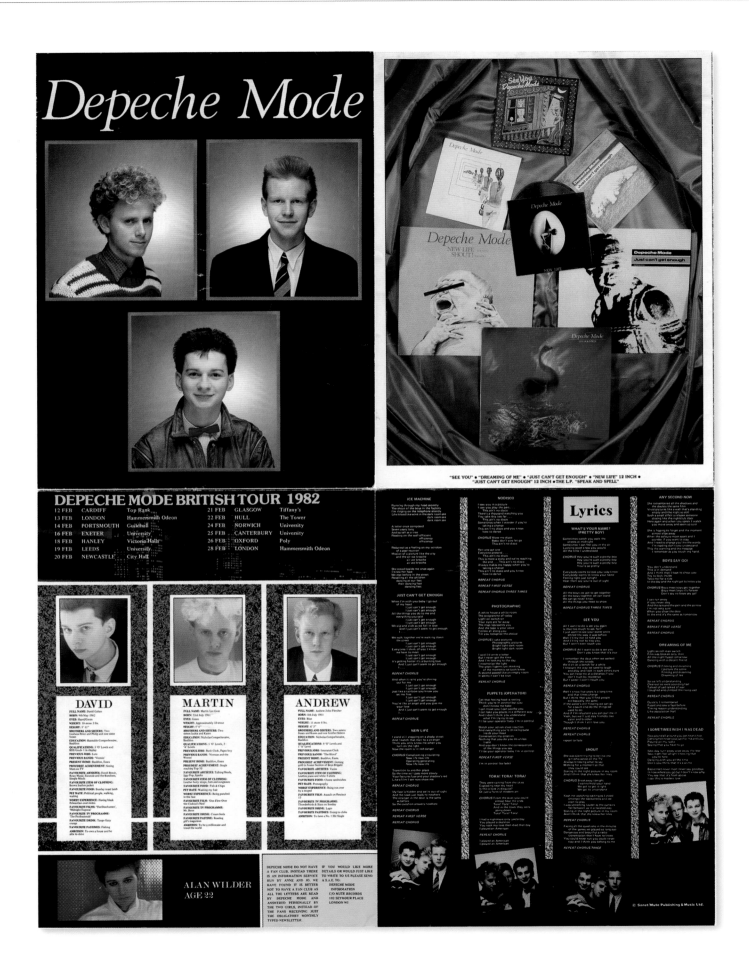

The only evidence of the new band member in the booklet for the 1982 "See You" tour was a brief caption: *Alan Wilder, Age 22.*

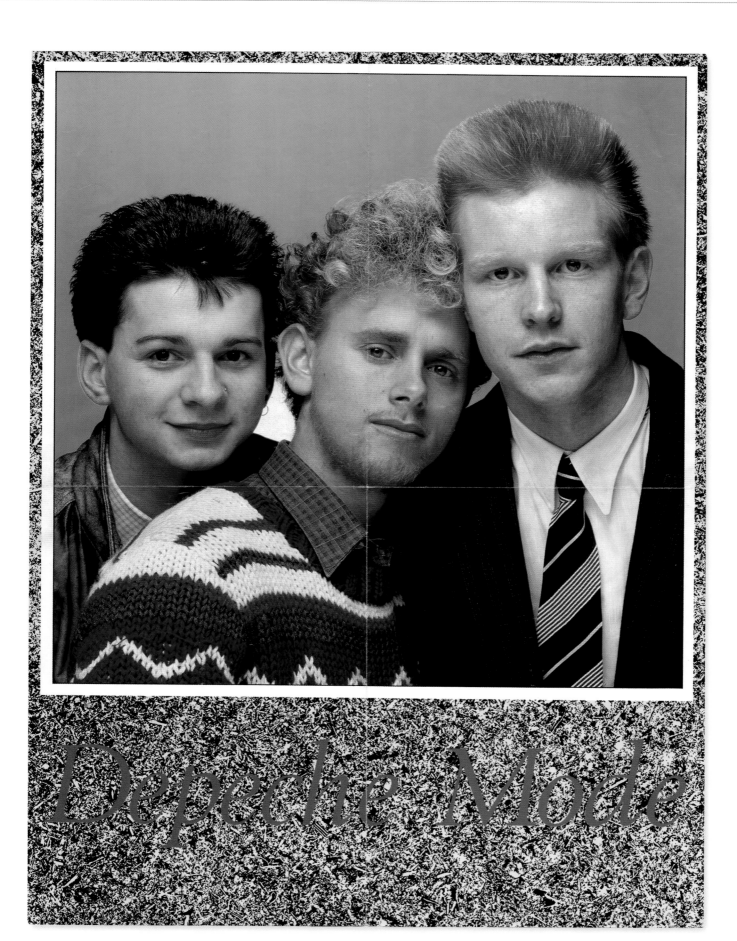

On February 13, the band played its first show at the Hammersmith Odeon in London. With a capacity of more than 3,500, the legendary concert hall was one of the top addresses in the English capital and showed the league that Depeche Mode had joined; nine years before, David Bowie had made the concert film *Ziggy Stardust and the Spiders from Mars* at the Hammersmith Odeon with D.A. Pennebaker. Depeche Mode would meet the renowned US filmmaker themselves in just a few years' time.

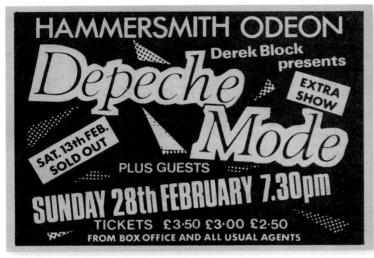

After their February 13 show sold out, Depeche Mode played an extra show at the Hammersmith Odeon on February 28.

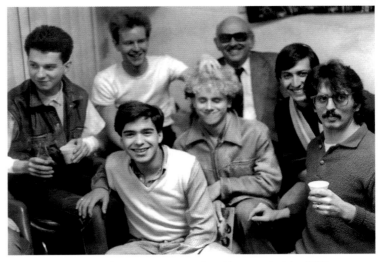

Guests on *Aplauso*, a program on Spanish state television RTVE.

In early March, the lads traveled to Spain for the first time, performing "Just Can't Get Enough" on March 4 on the TV show *Aplauso*. On March 5 and 6, they played two celebrated shows at Rock-Ola, a popular nightclub in the heart of Madrid.

The band made another two TV appearances before setting out on its European tour, playing "Just Can't Get Enough" on the West German TV program *Music Box* on March 8, followed by an appearance on *Top of the Pops* on March 11 to perform their new single, "See You."

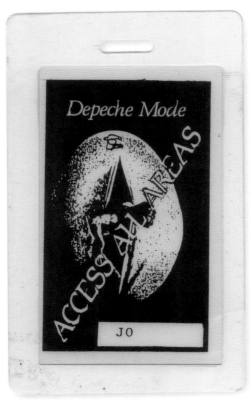

All-access pass for Jo Fox on the 1982 "See You" tour. Jo, Dave Gahan's girlfriend at the time (before she eventually married him), handled merch sales on tour. After so many years, obtaining personalized backstage passes from former crew members' private collections has become nearly impossible, which is part of the reason they command such high prices at auctions.

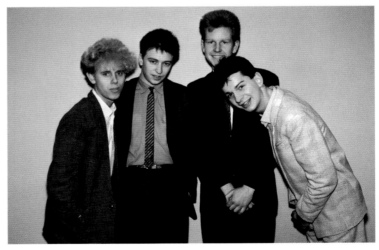

In March 1982, Depeche Mode made an appearance on *Music Box*, a West German TV show hosted by Désirée Nosbusch.

The European tour opened in Stockholm on March 20, 1982, followed by shows in Hamburg, Hanover, and West Berlin. The initial leg of the tour was dogged by problems—the technical failures during the Hamburg show became etched in Andy's memory: "The Roland, Moog, PPG, they were all causing trouble. We had to hire another Source and Danny programmed it in forty-five minutes before the gig started. And then when we went onstage, there was a big crash and we thought the PPG had blown up. It was the PA—even *that* had gone wrong."

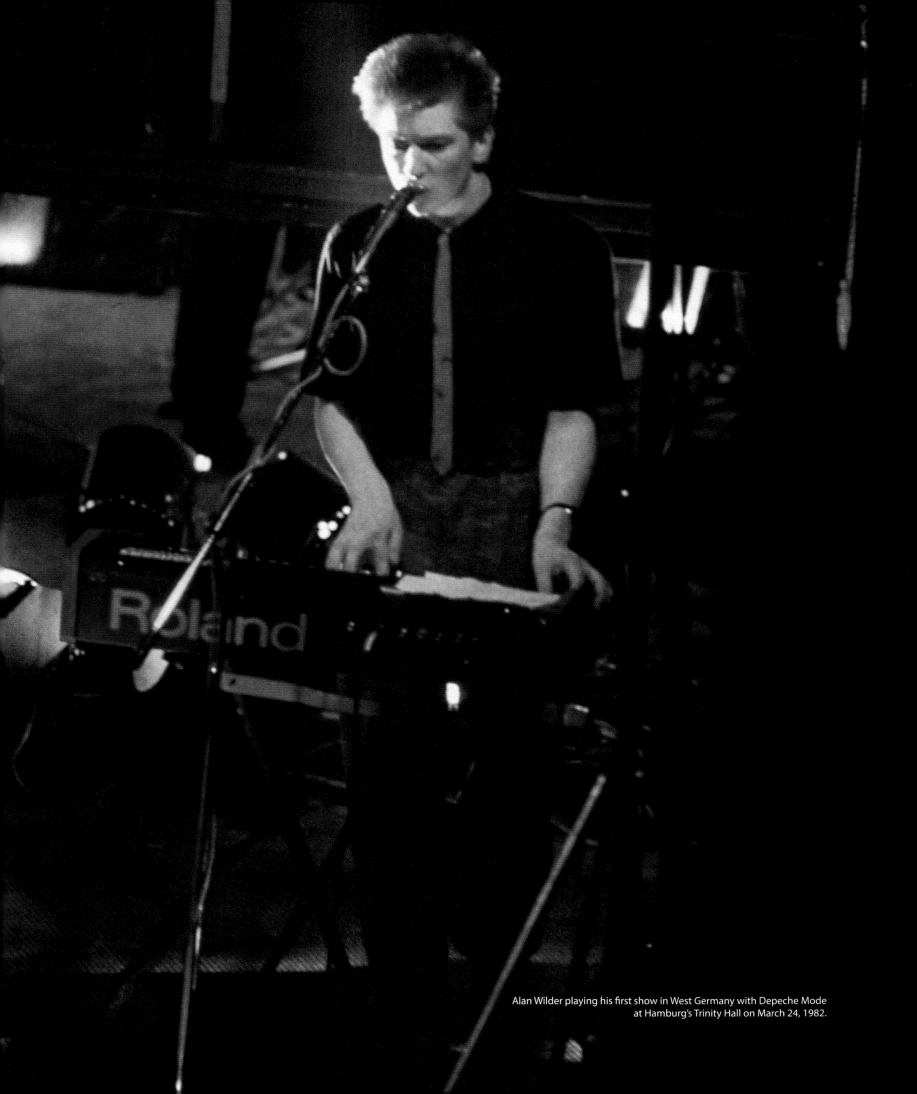

Alan Wilder playing his first show in West Germany with Depeche Mode
at Hamburg's Trinity Hall on March 24, 1982.

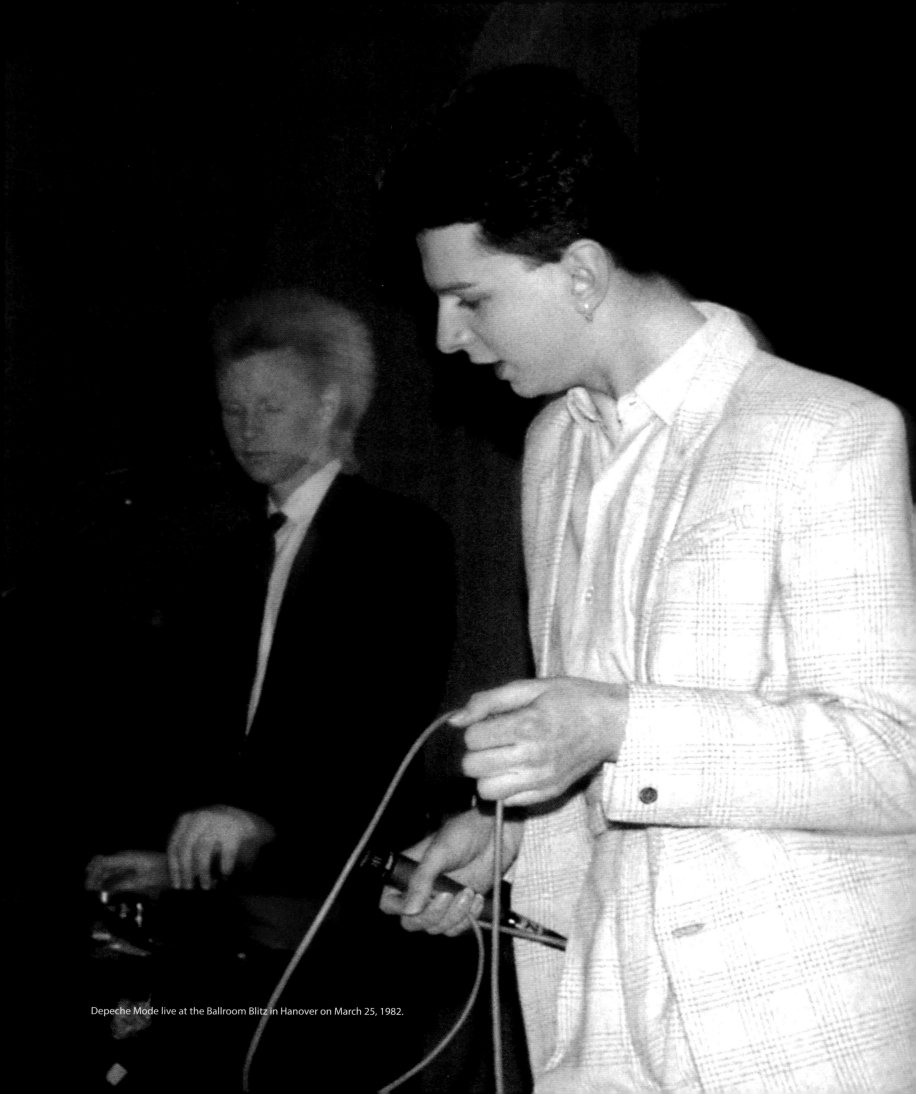

Depeche Mode live at the Ballroom Blitz in Hanover on March 25, 1982.

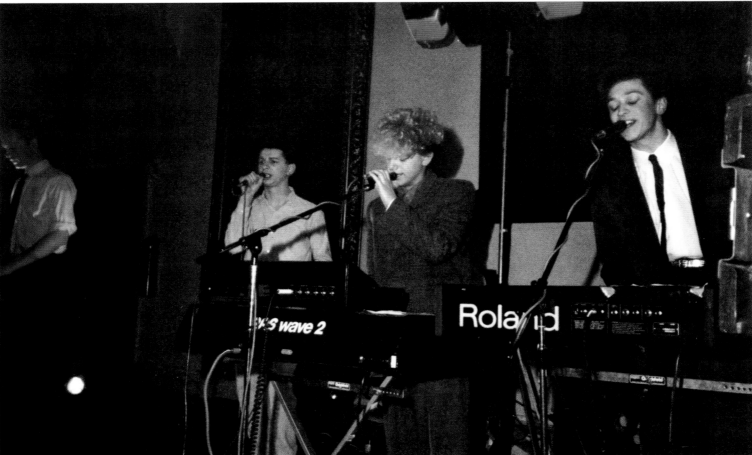

Ticket stub and flyer for the show on March 25, 1982, at Hanover's Ballroom Blitz.

The longer Depeche Mode toured and gigged in Europe, the more their fan base grew. In whatever city they played in, the band now also came into increasing contact with their fans, who were no longer simply going to a single show but had started following Depeche Mode over multiple concerts.

One fan from the early days was Maren Bode from Cologne, fifteen years old at the time. She had grown attached to the group after hearing "New Life" for the first time, buying every record and collecting photos and newspaper articles.

Maren first came to the band's attention after *Bravo* dedicated a two-page spread to the teen in their "Personal Fates" column. In the piece, Maren described her first Depeche Mode show, on March 25, 1982, in Hanover, as well as her encounter with the band afterward; she collected their autographs and sent them on their way with long letters and small gifts.

One day several weeks after the show, Maren received an unexpected letter from England. It was from Martin and was written in German, thanking her kindly for the letters and gifts, and sending autographed cards and singles from the band in return. Help-

ing with communication was the fact that Martin had concentrated in German in college and had stayed with a family in Schleswig-Holstein on a number of occasions.

A friendly exchange of letters unfolded in the months that followed, and Maren began to receive letters from Alan as well. In their missives, the musicians wrote about plans for touring and making new records, and gave passing insights into their personal lives. Martin had long understood the importance of communicating with fans like Maren, even stating in one letter that she was "better" than the record company in terms of the amount of promotion she was doing. As it was, more and more fans were forming groups, meeting up at shows or at the back entrances to concert halls and hotels, swapping photos and cassettes, contributing significantly to the band's growing popularity.

On March 28, Depeche Mode played in Rotterdam, a show that was broadcast in high quality more than twenty years later in April 2003 on the Dutch station VPRO's *Nighttrain* program.

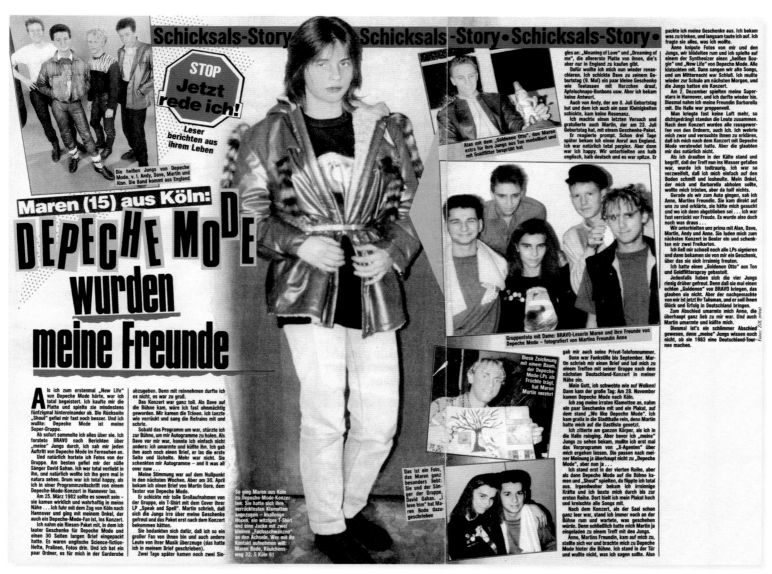

A firsthand account by Maren Bode from 1983 about her love of Depeche Mode that ran in *Bravo* magazine; we have fans like Maren to thank for many of the concert photos and private snapshots with the band from their early days in West Germany.

14 Shepeshall
Basildon
ESSEX
England
20.4.82

Hallo Maren! Hier schreibt Dir
Depeche Mode. Zuerst wahrschein...

Dir viel danken für
Geschenke und d...
langen Brief. Nie vor...

Martin von...
soll ich...
Deutsche...
drei Jahre...
in der...
leider h...
Deinen Brie...
dem es...
zu lese...
oder Sch...
Dir einen...
zu schr...
Andy oder...
sonst w...
geschrieb...

④

Im England sind die Konzerte sehr
einfach im Vergleich. Wir sind
nur zweimal nach Europa gefahren
um Konzerte zu spielen aber
fast jedes Konzert war eine
Sorge. Wegen Techischen Problemen
Der Grund dafür: Das Gerät
ist nicht für Reisen gebaut,
besonders Luftreisen! Hast Du
gesehen wie man die Flugzeuge
entladet! Es scheint von Deinem
Brief daß Du besser für uns
als unsere Plattenfirma bist.
Du gibst uns mehr Werbung,
noch wieder vielen dank!
wann Du die Schule schwänzt
um das Konzert in Hanover zu
sehen, hoffe ich daß Man Dich
nicht gescholten hat!
 Jetzt werde ich versuchen, Deine
Fragen zu antworten. David hat

Brüder u...
hat zwei
Bruder.
Bruder ab...
er ist n...
wei Sches...
gibt zw...
die rauch...
Andy. D...
aber nur
ann wirk...
wärne
Jahr
len we...
bißchen
Sa...
ehren
konzert...
Im...
zwei...
machen
Deine

Ich wollte a...
schicken...
Brief habe...
heißt...
gle...
ich glaube d...
in Deutsch...
hat. Die...
neueste...

Dein...

+ Dep...

Fragen zu antworten. W...
hat Geburtstag am erst...

③

aben ~~wir~~ *Farbewechsel* nicht so viel Spaß
zmacht. Ich habe auch eine bißchen
Zeit gefunden, elektronen spiele
nes meiner Hobbies in diesem Augenblick)
Spielen. Es gab ein Freibad
der Nähe von der Konzert Halle
nach dem Konzert
hwimmen gehen.
erfreulich aber
de hat es uns
wir diesen Tagen
t machen und
auglich sind. Auf
diese Woche fast
s beste Konzert
Europa (lauber England) gespielt
Meinung nach,

⑤

ine schwester.
estern und
glaube ich, hat
ch bin nicht
u!) Ich habe
on uns in der
egentlich nicht,
und Alan rauchen
selten.
nicht sagen
aß wir erst
der Nähe von
Ich werde
unseren
In einer
nach Amerika
spielen.
Juli nehmen
LP auf.
unsere gesagt)
gewesen
war.

⑥

Tournee. Ich hoffe
Geschenke gern
muß Jetzt Schluß
bin kein langer Brief.
und Auch.
'The Pash Maid'
Wirst Du
schlimmes Deutsche
st eine sehr lange
seit ich in

Bäuerin, die in
Feld steht und
den Korn mit
Die Farben sind se
Die Texte wird
luckt dieses Mal.
Du Weißt wah
schon daß wir
nd im November
spieler

②

p ist. Jetzt fertig.
eißt. A BROKEN FR
Freigabe ist am
mbers. Ich hoffe
sie mögen wirst.
heißen 1. Leave in
secret Garden 3. Mor
ng to fear. 5. SEE you
ite 7. The Meaning of
Photograph of you 9.
done that 10. The s
Rainfall. Nach mein
g, die Lieder sind se
gfaltig und nicht s
erwartet.

Two days later, the band played a sleepy town called Oberkorn in Luxembourg. The following morning, during breakfast at the hotel, Martin struck on the idea of naming the B-side of their next single after the town. (Years later, on May 28, 2022, two days after Andy Fletcher passed away, RTL Luxembourg played a short live video of three songs from the 1982 performance in his memory.)

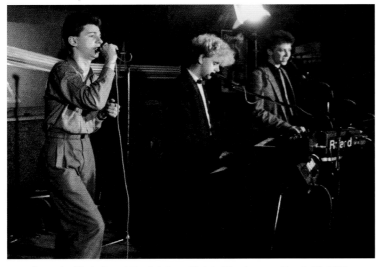

Depeche Mode live at the Rainbow Club in Oberkorn on March 30, 1982.

The band spent that April in Europe shuttling between TV appearances, photo shoots, and live shows. The tour even included stops on the two small British Channel Islands of Jersey and Guernsey, along the French coastline. On April 26, they released their new single, "The Meaning of Love," which Martin, Dave, and Andy had recorded without Alan.

The very next day, Depeche Mode made one of its most dubious and best-known TV appearances, on *Bananas*, a West German music and comedy show, performing "See You" against the backdrop of an old barn while cradling live chickens. The idea hadn't been the band's, obviously, but the producers'. Decades later, though, they could still remember the scene: "They gave us these chickens and I was singing a song and holding a chicken," Dave recalled while laughing on Swedish TV.

And even if Alan had nothing to do with it, his first tour with Depeche Mode continued to be plagued by bad luck. The *Depeche Mode Information Service* reported that "the band have just returned from their European concerts with a tale of woe! Apparently all three synthesizers broke down at one time or another. The tape machine just stopped in the middle of 'New Life' at four gigs and the coach broke down in a village in the wilds of Luxembourg. However, all of the venues were packed, and everyone seemed to enjoy themselves. Let's hope the American tour comes off a bit better."

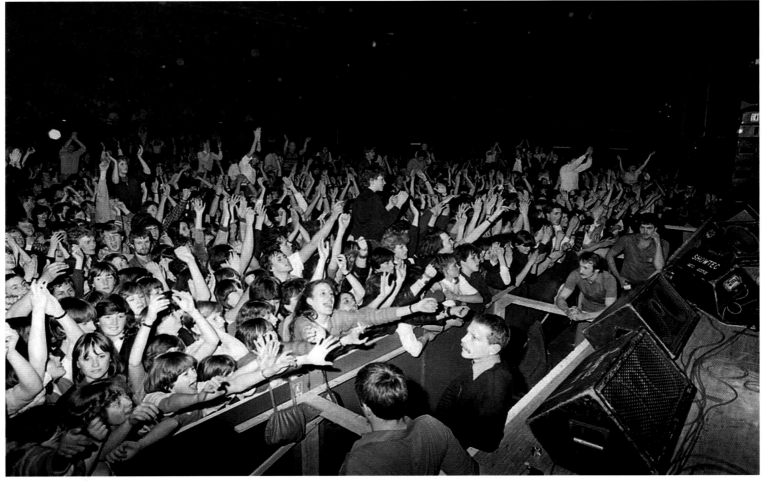

The return of Beatlemania: 2,000 mostly female fans were beside themselves at the show on April 10, 1982, in St. Helier, the capital on the island of Jersey.

That's right, America. Hoping to expose the group to a larger audience in North America, Sire Records had organized an eight-show tour through the US and Canada.

The band returned to New York on May 7, 1982, but the string of bad luck had followed them. Martin later described the experience to the Canadian magazine *Explain!*: "We had to do *Top of the Pops* and then they put us on the Concorde to get us to New York in time to play the show at the Ritz. The Concorde had problems and we were delayed. So we ended up getting there later than we would have done taking a normal plane. We arrived late in New York and then we had a really late sound check. And you didn't go on till really late—two in the morning at the Ritz in those days—so we were all totally jet-lagged, all of our equipment broke down, and it was an absolutely dreadful show. And I remember leaving the venue very depressed and some guy came up to us and said, 'What happened to you guys? You used to be good!'"

Andy shared his own memories of the US tour with *One Two Testing* magazine: "In Philadelphia we went off after the set and they were all shouting for more and suddenly the Source started up on its own going 'eep, urp, oop, oop' and making noises. The crowd thought it was the encore."

On May 15, Depeche Mode played a small club called Perkins

Poster for the show at San Francisco's Kabuki Night Club on May 14, 1982.

Place in Pasadena, California, not five minutes' drive from the Rose Bowl Stadium. The following day the band spent an hour signing autographs at a popular record shop called Vinyl Fetish in LA, a setting with a similarly familial feel to it. There would be no comparison to what the band would find there just six years later.

Poster for the show on May 9, 1982, in Toronto, Canada.

Fletch signing autographs in West Hollywood on May 16, 1982.

A Broken Frame Tour, 1982–1983

Back in Europe, there was no thought of a break. Just one week after the band's mini-tour of North America, Depeche Mode was on Westdeutsche Werbefernsehen's *WWF Club*, a popular West German weekly TV show, to play "The Meaning of Love." The performance went out on Westdeutscher Rundfunk's early evening program, with Jürgen von der Lippe, Marijke Amado, and Frank Laufenberg moderating.

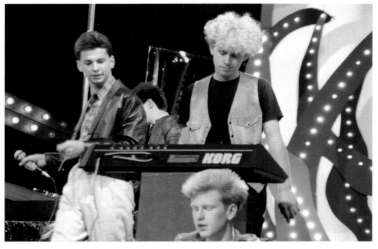

Depeche Mode playing on the *WWF Club* in Cologne, May 21, 1982.

Martin, Dave, and Andy now returned to Blackwing Studios in London to record a second LP, again with Daniel Miller as producer. Martin had several new songs in addition to the latest two singles, and the three wanted to prove themselves capable of putting together an entire album without Vince Clarke.

On August 16, the band released its new single, "Leave in Silence," the first result from their work in the studio, and performed it on *Top of the Pops*. While the song climbed no higher than 18 on the UK charts, it reached a surprising number 17 in Sweden, and 58 in West Germany. Meanwhile, the studio record-

ings were advancing smoothly, thanks in part to Daniel Miller and a new fleet of synthesizers.

At long last, the band's second full-length record, *A Broken Frame*, came out in stores in late September to great acclaim, rising to number 8 on the British album charts. On the whole, the record was darker than the debut album, with greater sophistication in the arrangements and sounds. Even if it may not rank as one of the band's best from today's perspective, Martin, Dave, and Andy had proved beyond a reasonable doubt that they were still able to make music without Vince.

Touring for *A Broken Frame* began on October 4, 1982, in Chippenham, England, before the band headed to Ireland for its first three shows in that country. Reporting on their Dublin performance, the *Record Mirror* noted, "The star of the show was definitely vocalist Dave Gahan, whose seemingly casual approach in the opening notes soon gave way to precise professionalism as he danced in front of a pair of spotlights throwing beams and shadows to all corners of the house from his animated silhouette."

At the time there were still no "trenches" or metal barriers between audience and band. Instead, onlookers stood directly at the edge of the stage, which also served for many as a place to set down their jackets or drinks. Concertgoers regularly made a game

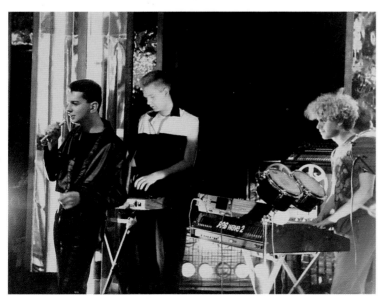

Depeche Mode returned to *Top of the Pops* on September 1, 1982.

Tour booklet for 1982's *A Broken Frame* tour.

DEPECHE MODE

A BROKEN FRAME

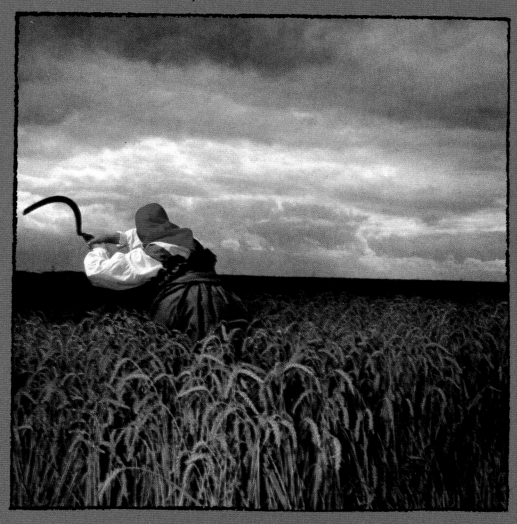

New Lp On Mute Records

Plus Scheduled Live Engagements At:

October 6th, Dublin Stadium. 7th, Cork City Hall. 8th, Gallway Leisureland. 10th, Southampton Gaumont. 11th, Leicester De Montford Hall. 12th, Brighton The Dome.
13th, Westcliffe Cliffs Pavillion. 15th, Bristol Colsten Hall. 16th, Birmingham Odeon. 17th, Birmingham Odeon. 19th, Glasgow Tiffanys. 20th, Edinburgh Playhouse.
21st, Newcastle City Hall. 22nd, Liverpool Empire. 24th, Hammersmith Odeon. 25th, Hammersmith Odeon. 27th, Manchester Apollo. 28th, Sheffield City Hall.
29th, St. Austell Coliseum. 1982.

Announcement for the UK leg of the *A Broken Frame* tour in 1982.

of climbing up and dancing beside Dave, before crew member Daryl Bamonte quickly ushered them offstage.

Coming into direct contact with the audience presented other kinds of difficulties as well. As Dave told *Record Mirror* about the start of the tour, "It was a bit hairy in Ireland—our coach driver got beaten up. We did three gigs, two of them were great, but at one of them the crowd were a bit backward. I think they thought they were watching a punk band or something. I can't stand it when people start spitting, it really spoils everything." The stint in Ireland was followed by sixteen largely sold-out shows in England and Scotland.

The band got more proof of how exhausting an audience could be at their Leicester show on October 11, 1982. "Last night," Dave explained, "there were three blokes who'd obviously been down the pub, bought a ticket, and come in just to aggravate me. I always get it first 'cause I'm at the front. So I just stopped the music and said to 'em: 'Why do you bother going to gigs? Get out, we don't need you.' They were really embarrassed, they couldn't move. The rest of the crowd loved it. It was a victory for us."

The press didn't always enjoy the shows, either. Simon Scott of *Melody Maker* wrote about the band's performance in Birmingham, "The remainder of the set was large chunks of their new album, a directionless mishmash of old Ultravox riffs und Gregorian-chant voices. This was the first of two sold-out nights at Birmingham, so they must be doing something right, and I must be missing what it is."

On October 24 and 25, Depeche Mode filled the Hammersmith Odeon for two consecutive nights. Mute Records paid for the second performance to be filmed, for later release as a concert video. The process dragged out, however, and in the end both band and label abandoned the plan. In 1983, recordings from the concert were included on the limited 12" singles for "Get the Balance Right!," "Everything Counts," and "Love in Itself," albeit out of order. Numerous bootlegs of the show also exist.

Alan and Depeche Mode

Alan had been playing as a guest musician in Depeche Mode for nine months by now, and was growing increasingly unsatisfied with his role. It wasn't enough simply to play concerts or serve as an extra in video clips for the singles; he also wanted to show what he was capable of in the studio and participate creatively. Finally, he confronted Dave, Martin, and Fletch with a choice: "Look, either let me join, or I'll just go somewhere else, 'cause I don't want to be a part-time session musician, really."

After consulting with label head Daniel Miller, the three came to a decision. "Alan Wilder is now a permanent member of Depeche Mode," the October issue of the *Depeche Mode Information Service* announced. "He will be joining Dave, Martin, and Andy in the recording studio from now on."

Depeche Mode was back to being a four-piece.

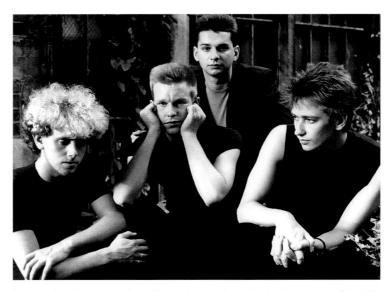

Depeche Mode in the garden of Blackwing Studios, taken in the summer of 1982 by none other than Mute label head Daniel Miller.

A backstage pass from the Karsten Jahnke Concert Agency for the band's West German dates on the *A Broken Frame* tour, beginning in November 1982.

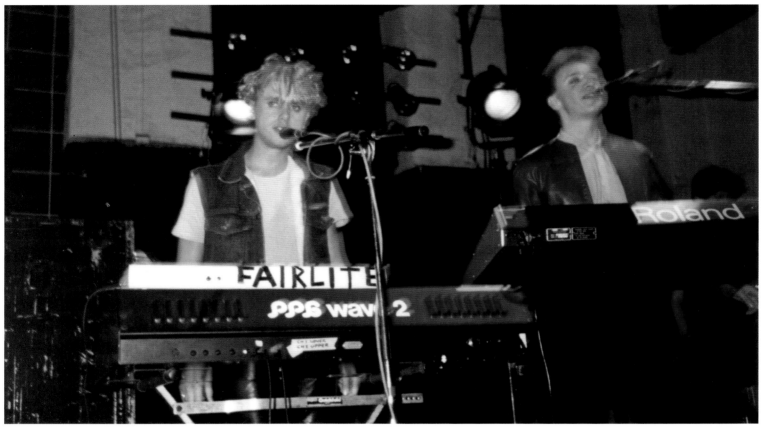

Martin and Alan sound-check at Zeche in Bochum on November 28, 1982.

Concerts in West Germany

The band spent November and the first half of December on tour, playing one to two shows in Sweden, Denmark, the Netherlands, and Belgium. They also played twelve concerts in West Germany and West Berlin, where they had already achieved some level of recognition, even if they were still a ways off from higher positions on the charts and venues were often smaller than in England.

On December 7, 1982, for example, they played a disco in Stuttgart. Another performance was planned for the following day at Lopo's Werkstatt in Darmstadt, until a disagreement between the club owners and band about where to position the stage led to the concert being called off entirely.

The tour also included venues like West Berlin's Metropol, Zeche in Bochum, and Munich's Alabamahalle, which regularly hosted popular indie acts and were becoming institutions in their own right. Martin later recalled a botched encounter with Kraftwerk on November 28 in Bochum: "We heard that Kraftwerk would come to the show. We were unbelievably excited, because they were our absolute idols. At the time we were using a PPG synthesizer. It wasn't actually built for traveling and broke during the first song. The performance turned really awful, because that was our most important keyboard. We didn't end up meeting Kraftwerk. Someone said later they had found it horrible and left before the end of the show."

The next day, a journalist from the trade publication *Musik-magazin* attended the band's show at the Stadthalle Cologne. He later took condescending glee in describing the audience: "They [the band] seem really lovable, far less grown up than all the gussied-up fourteen-year-olds out in front of the stage. This is most likely what prematurely awakens the maternal instinct in all those chubby girls sweating away while staring out in rapture. My God, so many fat girls, all in a heap . . . And then the stuffed animals, which the roadies move out of sight as quick as can be. One can really see the mixture of being touched and embarrassed in the four. Their record company lured a couple of journalists out of the jungle for Depeche Mode to complain to about how no one takes them seriously . . . and now? Fat girls with stuffed animals . . ."

On their way to West Berlin for a show on December 3, De-

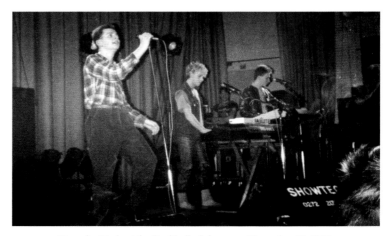

Depeche Mode at the Stadthalle Cologne on November 29, 1982.

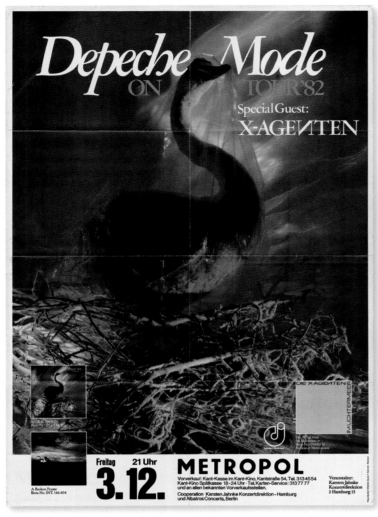

Poster for the show at the Metropol in West Berlin, December 3, 1982.

peche Mode made a first trek out of Hanover on the transit route leading through what was then still East Germany. At the time, nobody had the slightest inkling that in seven years the Iron Curtain would be history; in 1982, there were still passport checks and an inspection of the tour bus to put up with. The band played

its last show in West Germany of 1982 on December 10 at Studio M in Minden.

A short while after, the punk fanzine *Irre* published an enthusiastic review: "The total hysteria near the front of the stage conjures up memories from the history of the Beatles . . . The singer's excellent dancing interludes further lit up the mood. There wasn't a trace of coldness from the stage, as I had initially feared. The live versions spoke to me more than the studio recordings . . . anyone who likes synth-pop should see this band at least once."

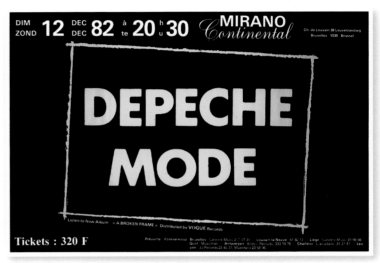

Poster for the show on December 12 in Brussels, Belgium.

In mid-December, Depeche Mode returned to England for more TV appearances. The day before Christmas Eve, they took the stage in Brixton for a show recorded by Channel 4. The support was Fad Gadget, an act that Depeche Mode had supported themselves two years earlier.

Pin for the *A Broken Frame* tour, 1982.

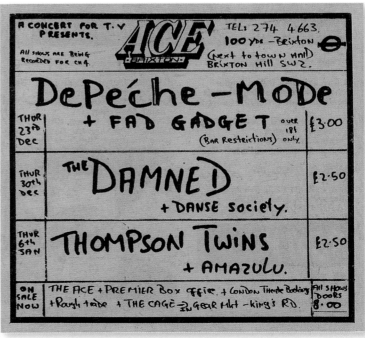

Advertisement for the final show of 1982 on December 23 in Brixton.

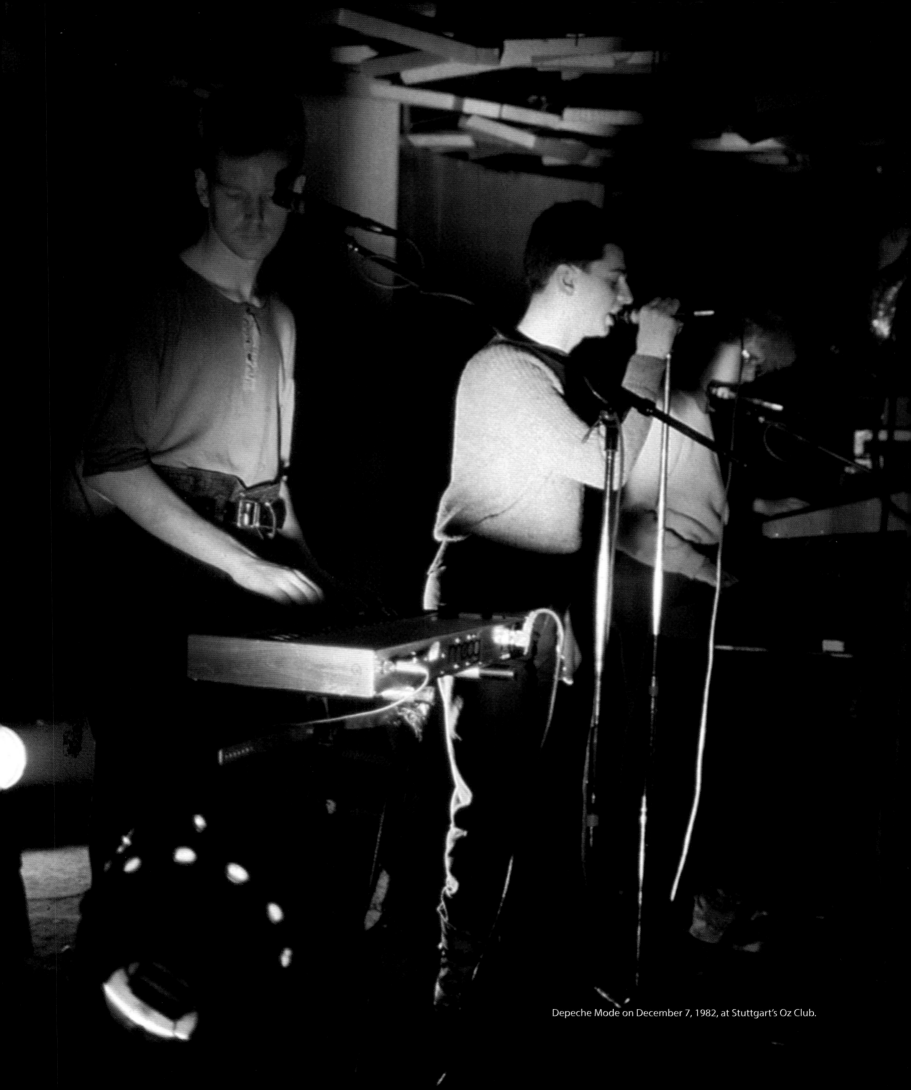
Depeche Mode on December 7, 1982, at Stuttgart's Oz Club.

The lads spent January 1983 in London, some of the time film-ing a video for the first single recorded with Alan in November 1982, "Get the Balance Right!" It was plain to hear the musical development from *A Broken Frame*; Alan's involvement in the re-cording sessions was paying dividends.

Following an exclusive concert at a music festival in Frankfurt in early February, North America was back on the itinerary. The band's show on March 24 in New York was the first of four con-certs throughout the US, followed by two more shows in Canada.

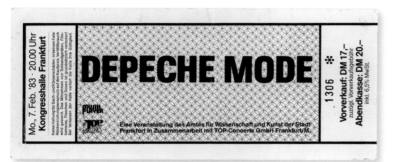

Ticket to the band's performance at the Frankfurt Music Fair on February 7, 1983.

On March 26, they supported the Psychedelic Furs in Chicago.

On March 28, Depeche Mode played in Vancouver, Canada. Journalist Rob Bailey reported on the show for the magazine *Geor-gia Straight*: "This was a very different band from any I had seen before, and I was puzzled by their stage setup. No drums, four key-boards in a row on stands, and most puzzlingly, a Tascam four-track tape machine on a table behind them. The tape started playing, and they trotted out in their effortlessly cool British finery, all sculpted hair and tight clothing, but quickly retreated back to the dressing room in less than a minute when a mix-up of lines to the console rendered performance impossible! A roadie rewound the tape, hit play, and they started the show over! Shit happens."

A journalist for the *Record Mirror*, meanwhile, didn't find much to like about the band's show on March 29 at the Kabuki Night Club in San Francisco: "Ultimately the Mode offer only a bit of cheek and youth. Their pop is pretty and danceable and frequently intelligent. Like most pop, it's too clean to be truly exciting live mu-sic. Whoever replaced rock and roll with pop forgot about that."

As it happened, the following evening at the Kabuki featured another young British band hoping to break through: the Thomp-son Twins.

After their US and Canadian shows, Depeche Mode was off to Asia for the first time. That next leg of touring featured two con-certs in Tokyo on April 2 and 3, a show in Hong Kong, and two gigs in Bangkok. For boys from Basildon, it all would have been unimaginable just two years before—now they were taking their girlfriends sightseeing in Thailand.

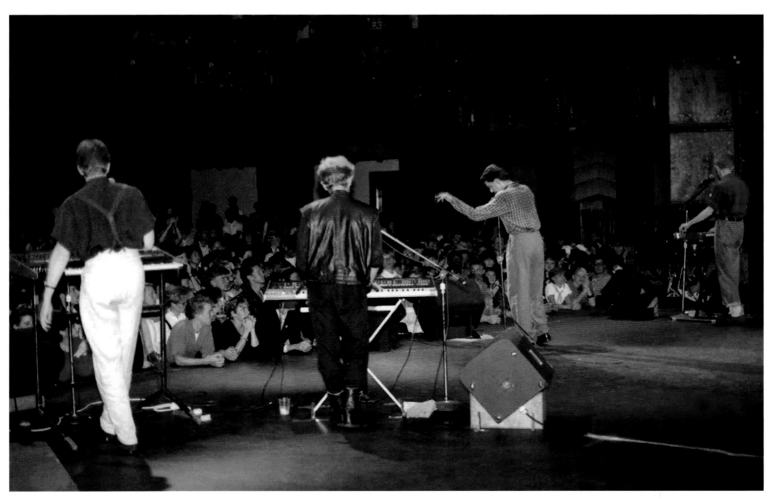

Depeche Mode live at the Beverly Theatre in Los Angeles on March 30, 1983.

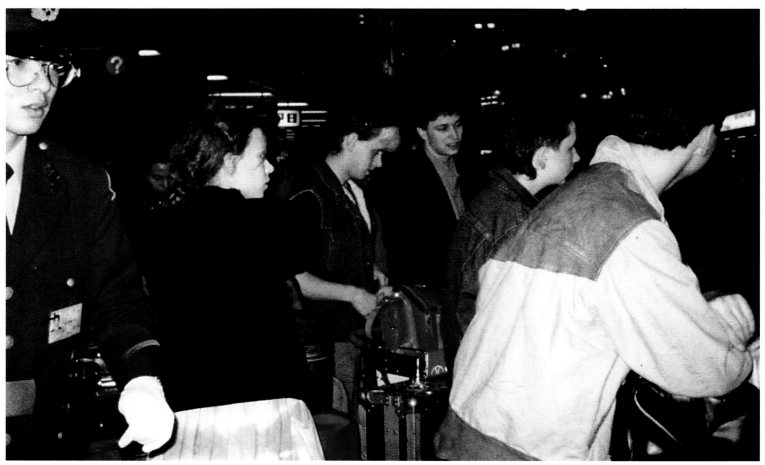

Depeche Mode arriving in Tokyo on April 1, 1983.

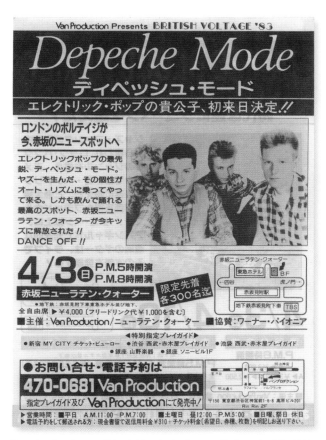

Flyer for the show at Tokyo's New Latin Quarter Club on April 3, 1983.

Back in Great Britain, the band turned down further show invitations, deciding to wait on more touring until their next album had been released. They made just one exception, playing their current set at an outdoor concert in Schüttorf, by the Dutch border in West Germany, on May 28. Meanwhile, the songs for their next album were already written . . .

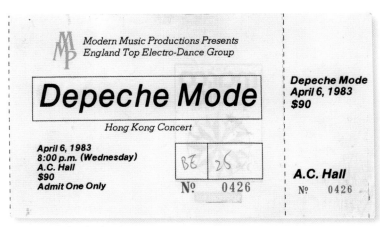

Ticket for the show on April 6, 1983, at A.C. Hall in Hong Kong.

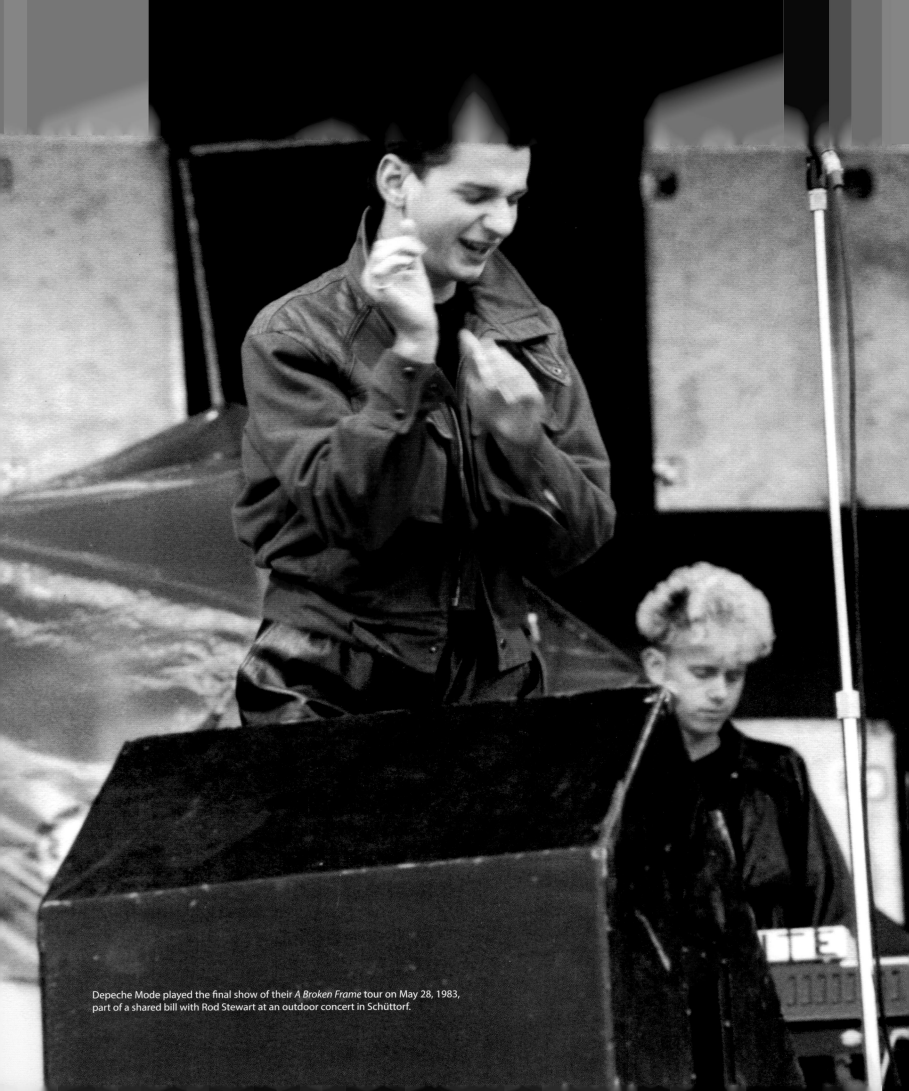

Depeche Mode played the final show of their *A Broken Frame* tour on May 28, 1983, part of a shared bill with Rod Stewart at an outdoor concert in Schüttorf.

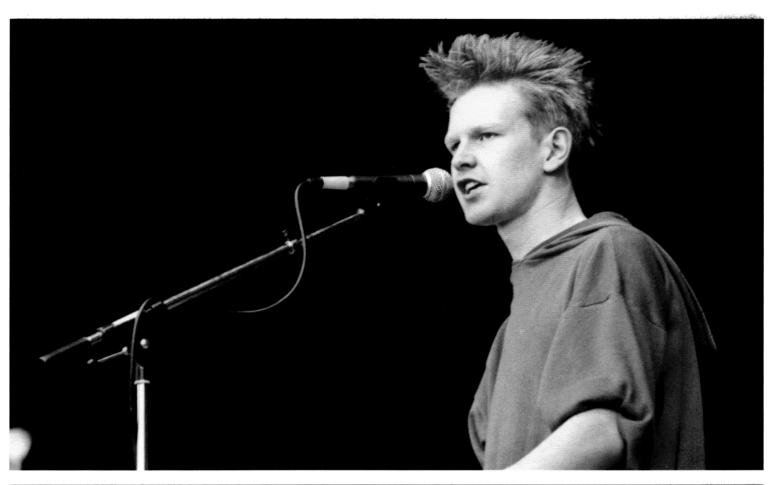

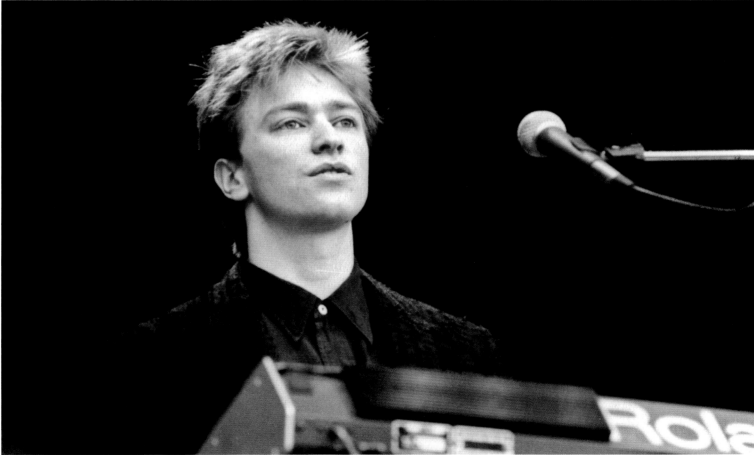

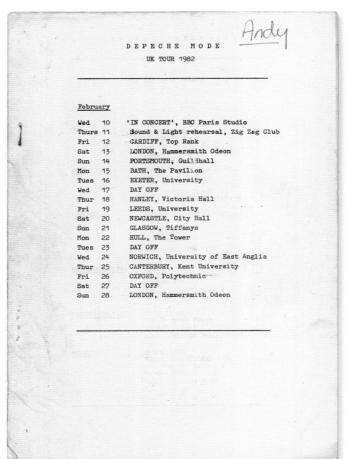

DEPECHE MODE
UK TOUR 1982

February

Wed	10	'IN CONCERT', BBC Paris Studio
Thurs	11	Sound & Light rehearsal, Zig Zag Club
Fri	12	CARDIFF, Top Rank
Sat	13	LONDON, Hammersmith Odeon
Sun	14	PORTSMOUTH, Guildhall
Mon	15	BATH, The Pavilion
Tues	16	EXETER, University
Wed	17	DAY OFF
Thur	18	HANLEY, Victoria Hall
Fri	19	LEEDS, University
Sat	20	NEWCASTLE, City Hall
Sun	21	GLASGOW, Tiffanys
Mon	22	HULL, The Tower
Tues	23	DAY OFF
Wed	24	NORWICH, University of East Anglia
Thur	25	CANTERBURY, Kent University
Fri	26	OXFORD, Polytechnic
Sat	27	DAY OFF
Sun	28	LONDON, Hammersmith Odeon

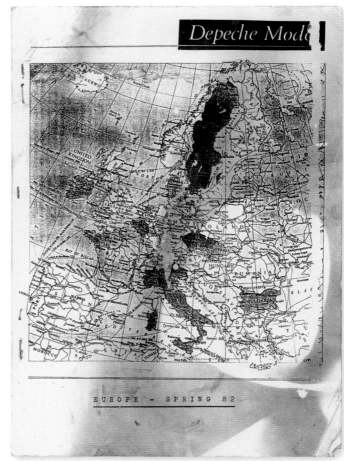

EUROPE - SPRING 82

CHANNEL ISLANDS / PARIS
APRIL 1982

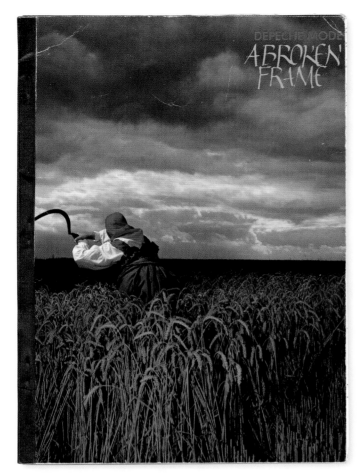

A complete collection of crew itineraries from the "See You" and *A Broken Frame* tours:

1 – "See You" tour | UK 02/10–02/28/1982

2 – "See You" tour | EU 03/18–04/03/1982

3 – "See You" tour | 04/10–04/17/1982

4 – *A Broken Frame* tour | 10/02–10/29/1982

5 – *A Broken Frame* tour | 11/28–12/10/1982 | Germany

6 – *A Broken Frame* tour | 11/22–12/15/1982

7 – *A Broken Frame* tour | 03/22–04/16/1983 | USA + East Asia

Construction Time Again

Working with Alan Wilder on "Get the Balance Right!" had revealed new potential within the band and increased its ambitions about making a really good third record. When they sat down with Daniel Miller in London in spring of 1983 to plan the next stint in the studio, everyone was highly motivated to take a decisive next step, both compositionally and sonically. In preparation, the band went in search of new sampling technology, Martin wrote songs, and Alan brought in a handful of demos. Daniel also arranged for a new sound engineer, Gareth Jones, a lively man brimming with good ideas.

Recording began in April with two months at the Garden Studio in London, which offered greater technical possibilities than Blackwing. For mixing, Gareth Jones suggested moving the operation to Hansa Studios in West Berlin, which had a fifty-six-channel mixer, a piece of equipment that was impossible to source in London at the time. For four weeks that summer, everyone moved to West Berlin, into a studio where idols like David Bowie had worked previously. The band was thrilled by the studio's working conditions as well as its location, from where they could look out directly onto the Berlin Wall and the Eastern Bloc. The small enclave of West Berlin also harbored a lively nightlife of the sort the band was unused to in London, and after work they dove in, meeting other musicians, from Einstürzende Neubauten to the Humpe sisters.

On July 11, "Everything Counts" came out. The first advance single from the new record, it quickly reached the top 10 in Great Britain and 23 in West Germany. The West German chart position took both band and label somewhat by surprise, since they

didn't have the same level of media presence there as they had in Great Britain.

The video for the single was directed by British filmmaker Clive Richardson. Edited together out of a series of clips of West Berlin and band members, the video was more compelling than previous ones. Multiple British TV shows had Depeche Mode on to promote the single, among them *Top of the Pops*.

Following three months of hard work in the studio, the band's new full-length effort, *Construction Time Again,* came out on August 22, 1983. The album was a hit; the songs and the sounds had a new quality to them that showcased the musicians' growth as a band. "It was our first collective effort, including Alan, that sounded as though the real Depeche Mode sound had begun to develop," Gahan later recounted.

Leaving behind the slightly coy, cheerful bubblegum pop of its first two records, Depeche Mode had come out with a record full of unusual and sophisticated sound samples, melancholic melodies, and socially engaged lyrics. "We were getting a bit older and more worldly. We'd even been to Asia. We were becoming more aware of the world as a whole," Martin recalled, describing the influences on the songs' lyrics. What was more, two out of the nine songs on the record came from Alan Wilder, demonstrating the level of seriousness with which the band now treated him. Fans were just as excited about the album, sending it into the top 10 in both Great Britain and West Germany.

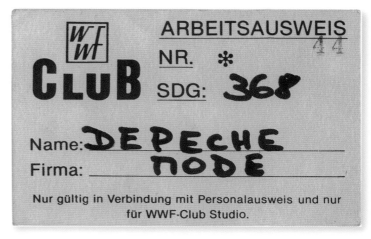

Work permit for the band to perform on the *WWF Club* at the International Radio Exhibition in West Berlin on September 2, 1983. At the time, the exhibition was considered the most important fair for manufacturers of home and consumer electronics.

Depeche Mode's recurring appearances on TV shows throughout this period proved helpful, especially in West Germany. On September 2, for example, well-rested and sporting healthy tans from vacation, the band went back on *WWF Club*, this time in West Berlin for the International Radio Exhibition. It didn't take long before *Construction Time Again* was selling better in West Germany than it was in Great Britain. By this time, Stuttgart's Intercord label knew for sure that it had made a good decision back in 1981 to strike up business with the little indie label Mute Records and Depeche Mode.

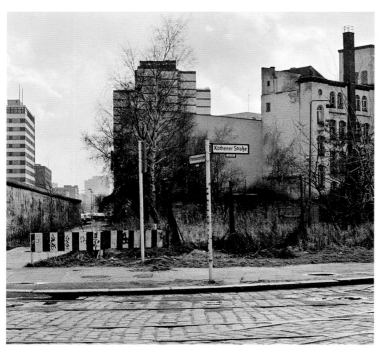

A dystopian work environment: located at 38 Köthener Strassee, Hansa Studios were situated right by the Berlin Wall and the death strip separating East from West Berlin.

Construction Time Again

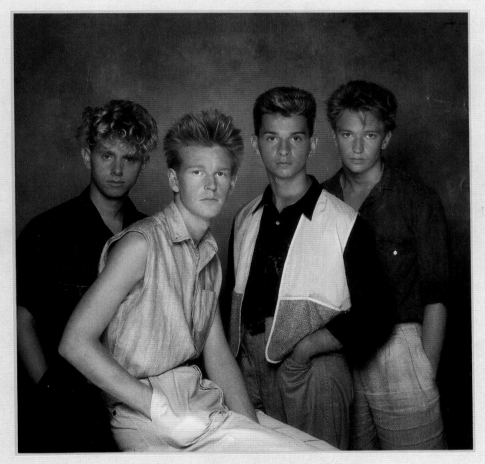

DEPECHE MODE

Tour booklet from the *Construction Time Again* tour, 1983.

Construction Time Again on Tour

The *Construction Time Again* tour opened on September 7, 1983, at the Regal Theatre in Hitchin, about an hour's drive north of London. Despite the established routine of touring, Martin, Dave, Fletch, Alan, and friend and mentor Daniel Miller were all excited to see how the songs from the new record would land with the public.

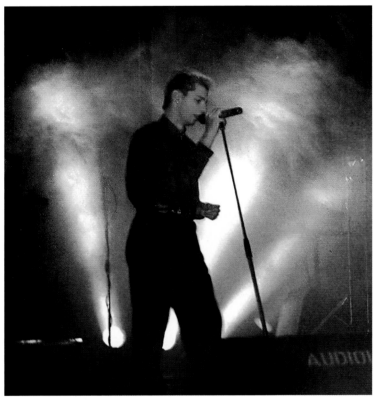

The tour got underway on September 7 at the Regal Theatre in Hitchin.

The first leg of the tour took the band through Great Britain for twenty-two shows, including their first performance in Belfast, Northern Ireland, and another in Dublin. Tickets ranged from four to six and a half pounds. One sign of the band's growing popularity arrived in the form of vendors selling cheap, unlicensed merchandise out of large sports bags outside the shows, always ready to flee to avoid getting caught.

It wasn't just the new record—the live act was also making strides. One enthusiastic review in *Melody Maker* followed shortly after their Belfast show on September 10, 1983: "Tonight the long lonely months of waiting for someone to go quite daft over were soon forgotten and there were many here who had the wisdom to appreciate the rare quality of what they had just seen. Namely, an inspired live performance by the best and most grossly underrated young pop band in Britain today."

After attending the Bristol show on September 12, a journalist from *Electronic Soundmaker & Computer Music* magazine wrote, "Depeche Mode can't hit the number 1 spot with the ease of Duran Duran, but there is more to them than pretty-boy pop stars singing corny love songs. Indeed, they seem to be developing a social conscience; in contrast to older material like 'Just Can't Get Enough,' songs like '2 Minute Warning' and 'Everything Counts' are giving the kids something to think about as well as dance to."

Accompanying the group on the road for the first time was Jane Spiers, a New Zealander with three years' experience as a light designer and one of the few women in the live crew. Spiers didn't just run the lights every evening from her desk; she was also responsible for setting up and dismantling the spotlights and crossbeams. "Oh yes, it's very hard work. Dirty hard work. There is no glamour to it," she explained in an interview. Still, her efforts injected all the more life and nuance into the live show.

While the band spent most nights in hotels before heading out in the morning for the next town or city, the crew slept on a separate nightliner bus in between venues. There wasn't enough time otherwise; the entire stage had to be broken down, loaded up, then set back up again the following morning in the next town—truly unglamorous activity.

Midway through the tour, on September 19, 1983, the third single off the new record came out: "Love in Itself."

Alongside conventional singles, Depeche Mode now also began experimenting with limited-edition singles with individual designs. The B-sides consisted of live recordings from the October 25, 1982, show at the Hammersmith Odeon. A total of twelve live tracks were released in this format—much to fans' delight.

Following the bitter experiences of the "See You" tour, in which one keyboard after another gave up the ghost, the band had invested in sturdier equipment this time around. In its December 1983 issue, British magazine *Electronics & Music Maker* published a review of the Cardiff show with all the technical details: "The stage was set with David Gahan flanked on each side by Alan Wilder who played a Jupiter 8 (with another as a spare!) and Andy Fletcher who had a OBXa. Martin Gore was center stage at the back and had at his disposal a newly acquired Yamaha DX7, which replaces the PPG because it's too unreliable. He also had an Emulator, a variety of flutes, and a twelve-string guitar. The band also had a Sundrum each, and these were used to great effect during the show. The backing tape was as powerful as ever and sounded particularly good. They now use an eight-track to accommodate the extra sequencers and keyboard parts, while their drum sound is now provided by a Drumolator, extra percussion being synthesized."

For the tour, Depeche Mode also relegated their TEAC A-3440 tape machine—which played the drum tracks and up to that point had featured quite prominently—to the backstage.

As the *Construction Time Again* tour progressed, Dave's growing self-confidence as a performer became especially visible. Even if his dancing had steadily increased over the past few years, before it had always been marked by a certain shyness; now he was whirling across the entire stage. He was well aware of how much rested not only on his singing, but his overall presence and activity during the concerts.

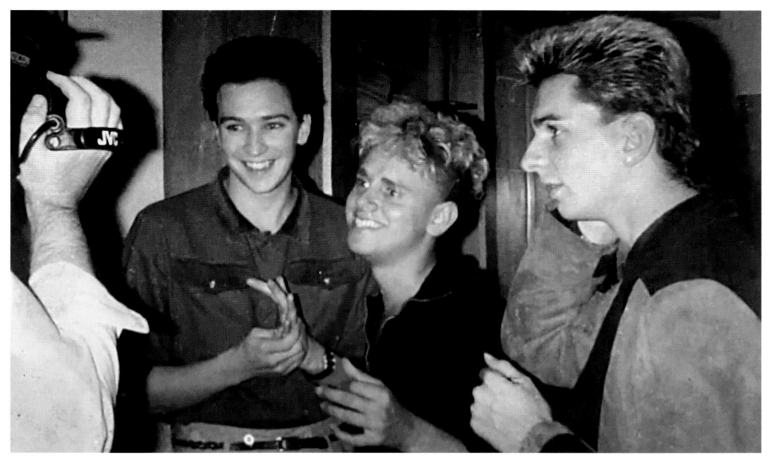

Backstage at Ulster Hall in Belfast on September 10, 1983.

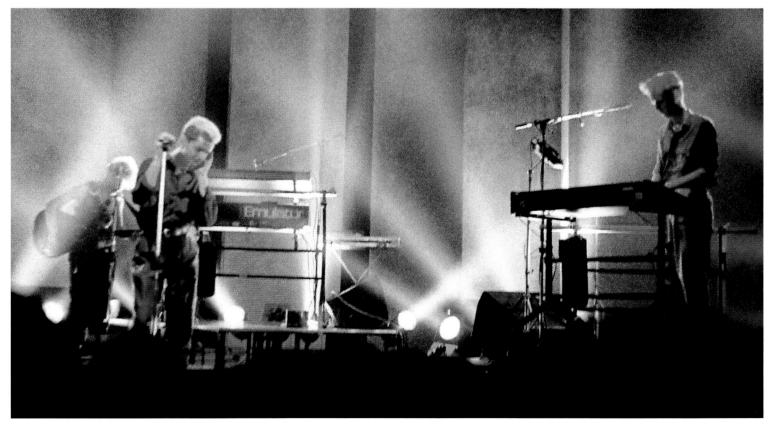

Depeche Mode live at Birmingham's Odeon Theatre on September 28, 1983; the stage design was more atmospheric and theatrical than on previous tours, turning the shows into a complete audiovisual experience.

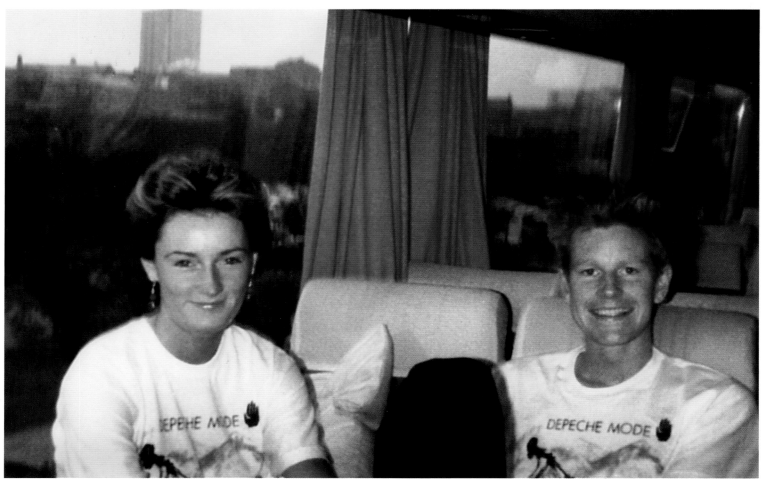

Andy Fletcher with then-girlfriend and future wife Graínne in the tour bus after the Birmingham show.

The tour's London stops gave a clear sign of how Depeche Mode's fan base had grown in the meantime—they played the Hammersmith Odeon three nights in a row, from October 6–8. *Record Mirror* wrote: "Perhaps Depeche Mode have found the secret of eternal youth. They're no less bouncy now than three years ago at the Bridge House, no less able to convey their obvious enjoyment while playing expensive synths than when they rested their Wasps on cardboard boxes. Their audience has grown up with them, and they've grown up with technology. They have it and know how to use it . . . Dep Mod don't distance themselves from their fans. There's no star trip, no contrived audience participation—the whole thing stood on the quality of the songs."

When asked about his initial takeaway directly after one of the London shows, Alan replied, "We're all a bit knackered, but it's been a very successful tour. The least amount of keyboard problems we've ever had. And all in all, a great success."

The BBC was there to record the October 8 show at the Hammersmith Odeon, for broadcast six weeks later on Radio 1. BBC Transcription Services also produced a limited vinyl of the recording, which it sent around the world to member BBC stations for broadcast and was never released for sale. It remains a coveted collector's item today.

Pass for the first segment of the *Construction Time Again* tour, 1983.

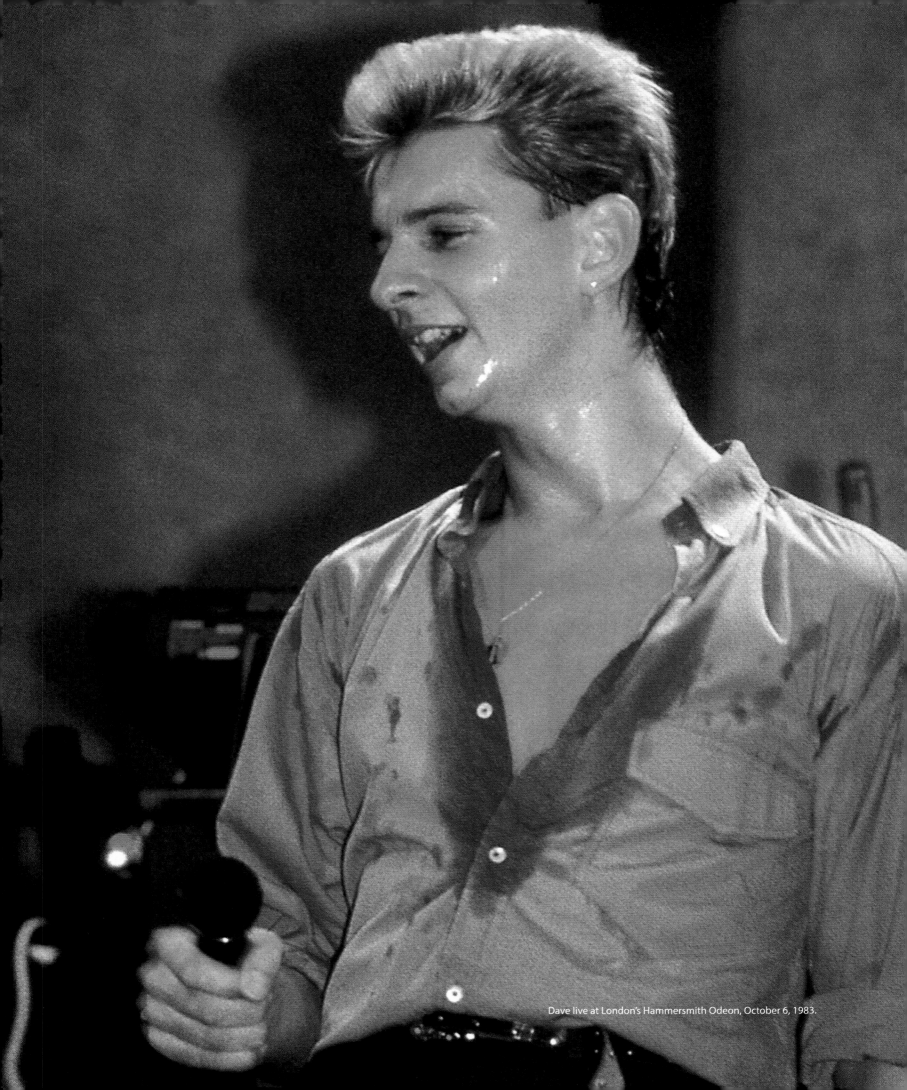

Dave live at London's Hammersmith Odeon, October 6, 1983.

On October 8, 1983, members of the Swiss Depeche Mode fan club called "New Life" set off for London to see the band play at the Hammersmith Odeon. Jon Botting, the band's tour manager and head of sound at the time, knew the group from before and took them backstage after the show. Dave, Fletch, and Daniel Miller were impressed by all the activities the fan club were organizing, and the following day an employee at Mute Records invited the Swiss guests for an impromptu visit to the label's offices, where they received another warm welcome from Martin, Alan, and Daniel. In addition to discussions about the band, the fan club, and its members, the group was also treated to a screening of the video for the latest Depeche Mode single, "Love in Itself."

The photos taken during the visit are the only known visual record of the Mute Records offices at Kensington Gardens Square in London.

A pile of presents courtesy of Martin, Alan, and Daniel Miller was awaiting members of the "New Life" fan club—Monika Lüssi, Gabi Ackermann, Bruno Klingler, Rene Gastl, and Sebastian Koch—on their visit to the Mute offices.

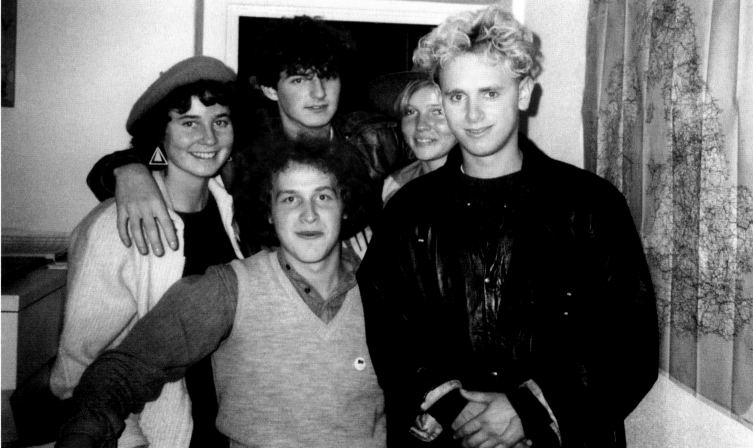

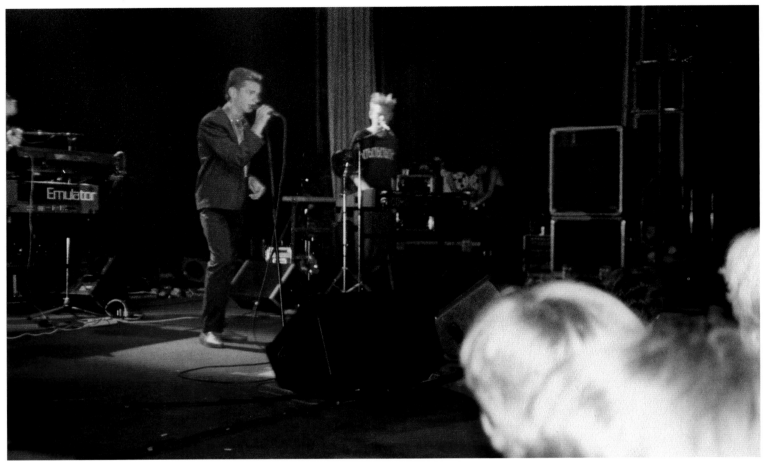

Depeche Mode live in Copenhagen on December 2, 1983.

Shows in Western Europe

On December 1, 1983, Depeche Mode opened the Western European leg of the tour with an electrifying concert in Stockholm. Enthusiasm for the group in the Swedish capital continued unabated: "In Sweden we were spoiled really, the audiences were so very, very warm," Dave raved in an interview about the Stockholm and Lund shows. The December 6 concert in Amsterdam was recorded live by the Dutch radio station VPRO FM, and eventually broadcast in 1984. The recording subsequently appeared over the years on numerous bootlegs.

DEPECHE MODE • *NEW LIFE* (AMSTERDAM 1983) • CD BOOTLEG

The *New Life* CD, released by Swingin' Pig Records, is an especially popular bootleg.

Ticket for the December 2 show in Copenhagen.

Martin Gore onstage in Amsterdam, December 6, 1983.

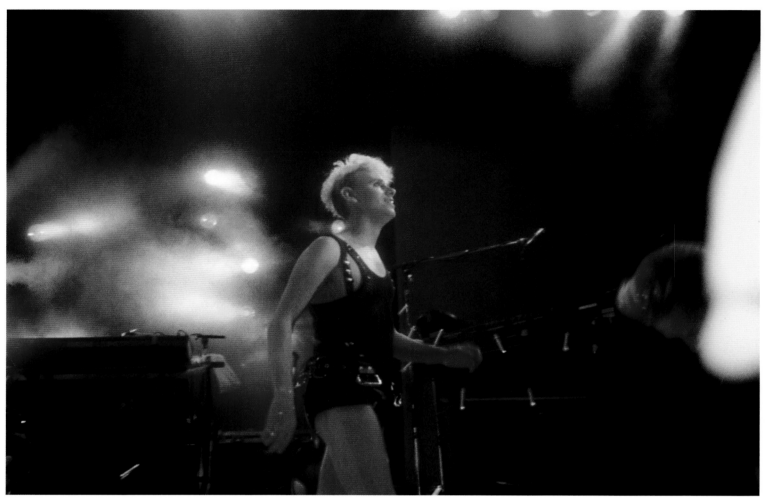

Depeche Mode plays West Berlin's Deutschlandhalle on December 8, 1983.

After Sweden, the band traveled to West Germany, where a growing community of fans quickly made its presence felt. With a total of fourteen shows, Depeche Mode played more dates in West Germany than anywhere else except back at home in the UK.

In West Berlin, ticket presales went so well that the December 8 show was moved from the Metropol to the Deutschlandhalle, for the band's largest concert to date to over 6,000 dancing fans.

The group was also noticing a shift: "Usually Berlin is very cold and people just stand, but everyone was joining in and it was good

Backstage pass from the Karsten Jahnke Concert Agency for the shows in West Germany.

Pin from the *Construction Time Again* tour, 1983.

fun," Dave recalled. For his part, Alan noticed that "in Germany, the fans are a lot more varied: there's young and there's more older people as well, and there's lots of different types of people . . . That's a slightly more varied audience here, whereas in England it's still quite a young audience." Tickets, meanwhile, cost nineteen deutschmarks, as much as a record in shops. The Mannheim and Bremen shows also had to be moved to larger spaces due to demand. The tour wrapped up with three sold-out shows at Hamburg's Musikhalle on December 21–23.

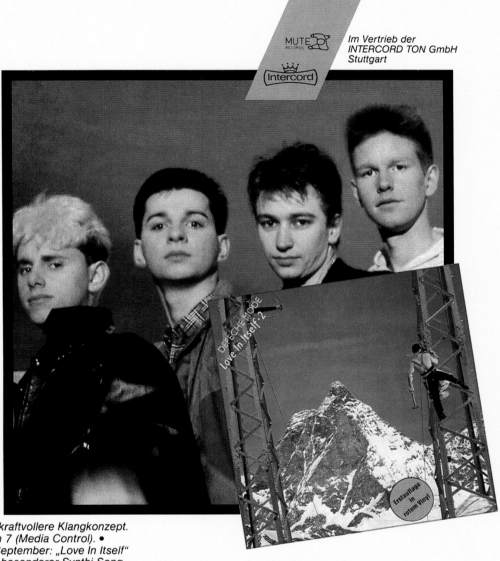

MUTE RECORDS

Im Vertrieb der
INTERCORD TON GmbH
Stuttgart

Intercord

Depeche Mode
*Berlin, im Juli '83:
Vier Synthi-Spezialisten
spielen ihr neues Album
ein. Auf 56 Spuren. •
London/Stuttgart,
Anfang September:
„Construction Time
Again" wird von der
Kritik als „Meisterwerk
des Synthi-Pop" um-
jubelt. • Baden-Baden,
Mitte September:
Die Fans bestätigen das kraftvollere Klangkonzept.
Mit einer starken Position 7 (Media Control). •
Stuttgart/London, Ende September: „Love In Itself"
wird ausgekoppelt. – Ein besonderer Synthi-Song
mit Seele. • Baden-Baden, im November:
Dienstags erscheinen die Charts …*

TV-Termine
*24.10. ZDF „Ronny's Pop-Show"
4.12. ARD „Rock aus dem Alabama"
14.12. ZDF „Tele-Illustrierte"*

Aus der aktuellen LP
Construction Time Again
LP INT 146.807 · MC INT 446.807

Die aktuelle Single
Love In Itself
*Single INT 111.814
Maxi Single INT 126.816
Super-Sound-Single-Cassette INT 426.816
Maxi Single (Limited Edition) INT 136.802*

Depeche Mode auf Tournee
8. Dez. Berlin	*16. Dez. Düsseldorf*
9. Dez. Mannheim	*17. Dez. Borken*
11. Dez. Würzburg	*19. Dez. Osnabrück*
12. Dez. Sindelfingen	*20. Dez. Bremen*
13. Dez. Neu Isenburg	*21. Dez. Hamburg*
15. Dez. Köln	*22. Dez. Hamburg*

The record company Intercord's ad for Depeche Mode shows in West Germany in December 1983.

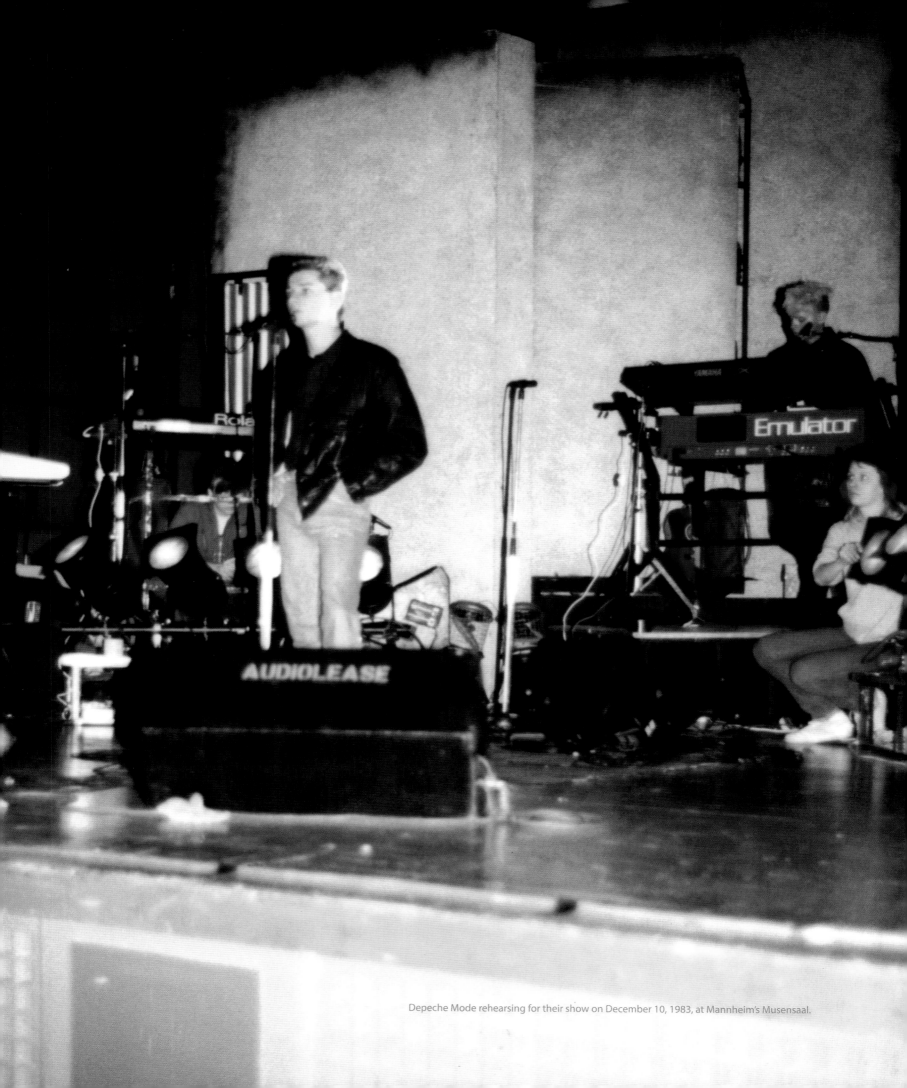

Depeche Mode rehearsing for their show on December 10, 1983, at Mannheim's Musensaal.

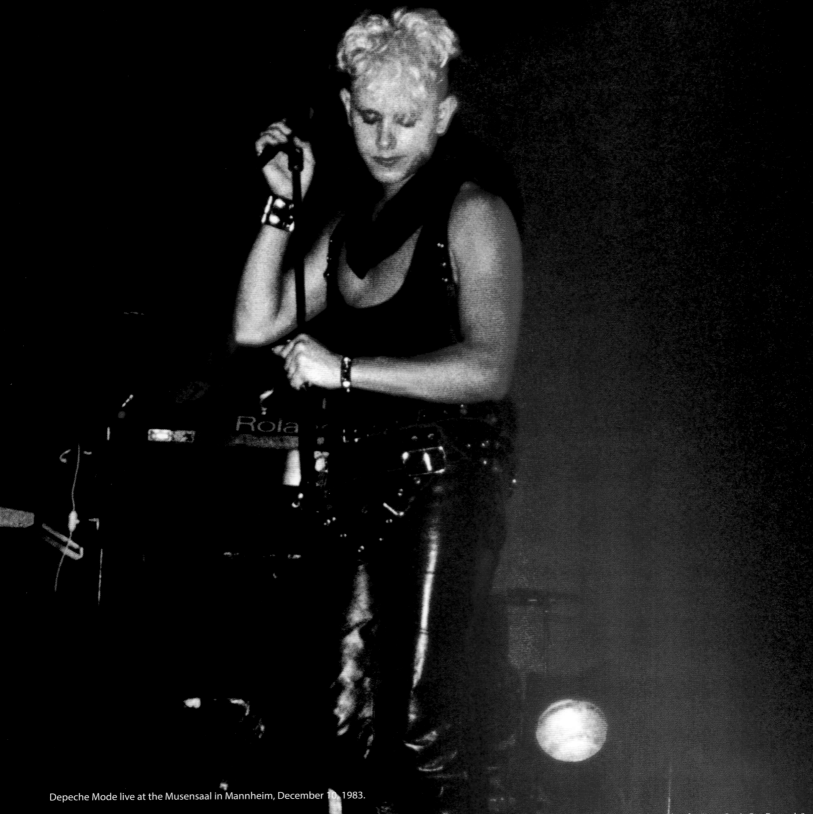

Depeche Mode live at the Musensaal in Mannheim, December 10, 1983.

Since the very beginning, Depeche Mode's members have experimented with one style after another, from the 1970s leather look, as in the video for "Just Can't Get Enough," to the swing era of the 1940s. In 1982, the band developed a curious, if passing, preference for knitted sweaters with striking patterns.

1983 wasn't just a year of shifting musical styles for the band. Martin in particular—inspired by the London and West Berlin nightclubs and his time spent with Blixa Bargeld from Einstürzende Neubauten—developed a distinctive style of dress with leather pants and even leather harnesses from the S-M scene. Teen magazines like West Germany's *Bravo* addressed the new outfit in a number of articles, with editors often finding it more interesting than the music itself.

The shows on the *Construction Time Again* tour were remarkable for another reason as well: this was the first time Martin stepped out from behind his synthesizers to take the lead, singing the song "Pipeline."

To this day, Martin on lead vocals remains a highlight at any Depeche Mode concert, and it all goes back to the 1983 tour.

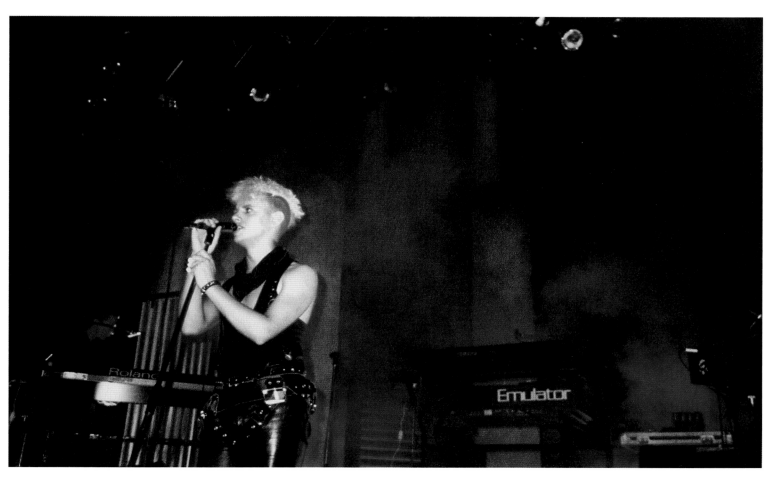

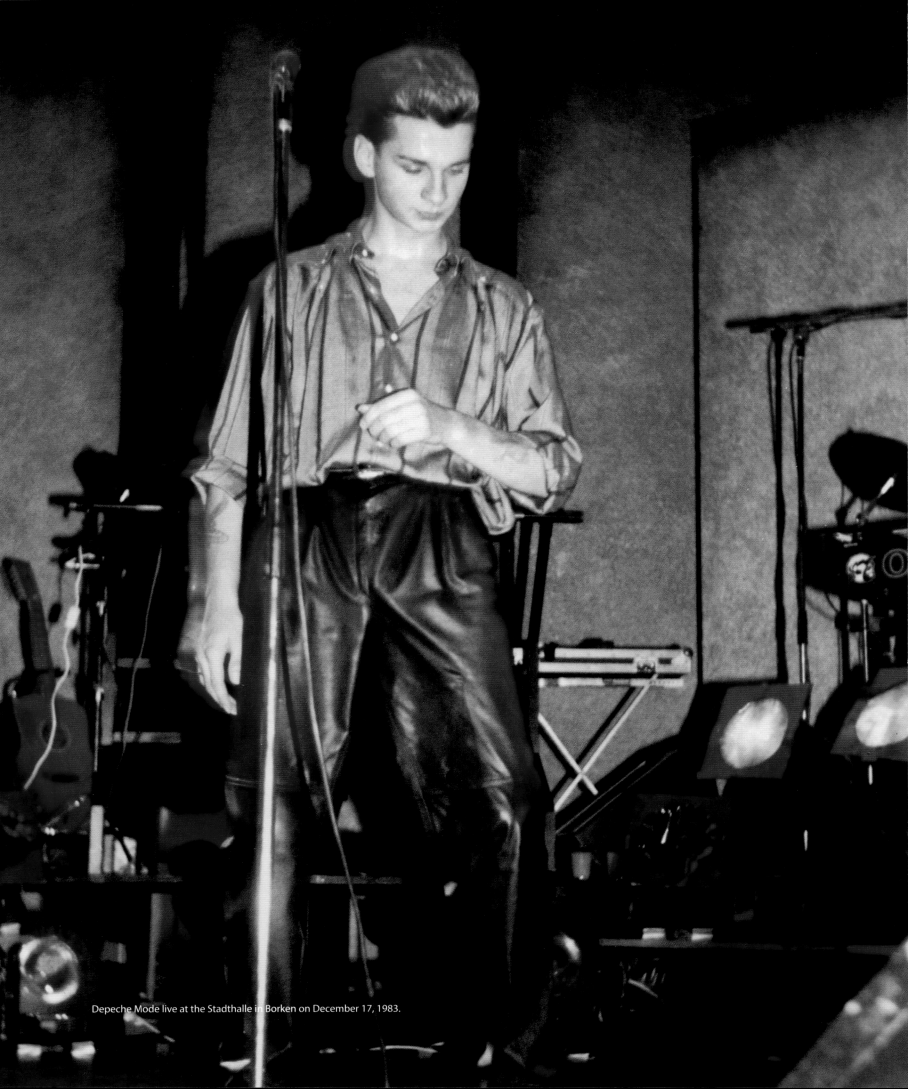

Depeche Mode live at the Stadthalle in Borken on December 17, 1983.

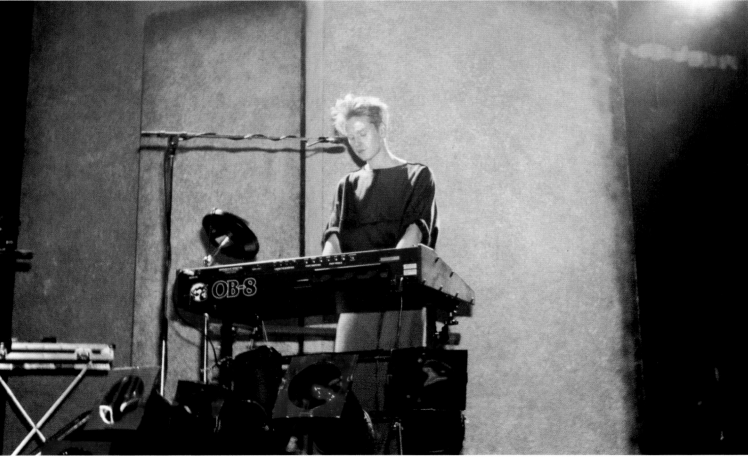

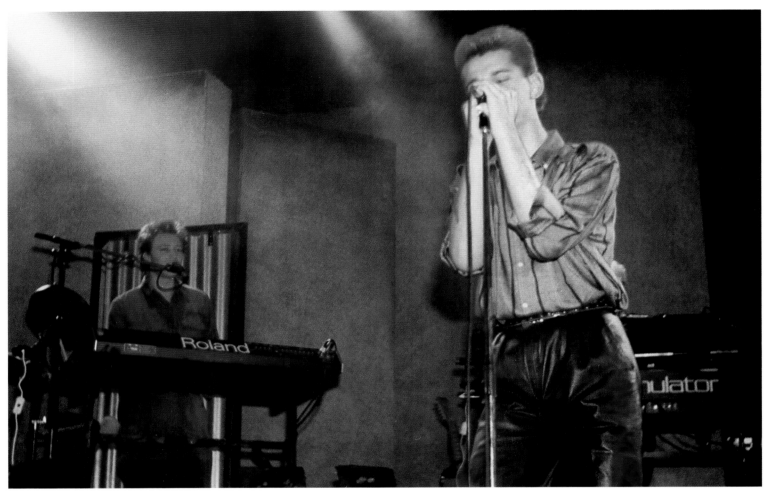

Depeche Mode at Hamburg's Musikhalle, December 22, 1983.

On February 3, 1984, the band was back in Birmingham, this time playing to more than 3,000 people. The show was recorded live by British TV as part of the documentary *Depeche Mode on the Road*. The film offered viewers an up-close look at life on the road for the young musicians, including clips from the tour bus and backstage.

No shows were planned for France, although early March brought two concerts in Italy and three in Spain. There were originally four dates in Spain on the calendar for February; that January, the Spanish division of RCA issued a special release of the track "Told You So," listing the tour dates on the cover. Yet the shows were postponed until March due to logistical issues, and the show in San Sebastián fell through entirely.

Plans to travel back to the US and Canada didn't come to fruition either; promoting the shows, especially in the US, would have required songs to be on daily radio rotation, and Depeche Mode was simply too "indie" for most commercial stations.

Other tentative plans to tour Greece, Israel, Hong Kong, and Japan in early 1984 likewise proved unfeasible. Martin had a new batch of songs at the ready that everyone was keen on recording, and besides, by March 1984 a new single that would drive home the band's musical development was already waiting in the wings.

Backstage passes for the Hamburg Christmas concert.

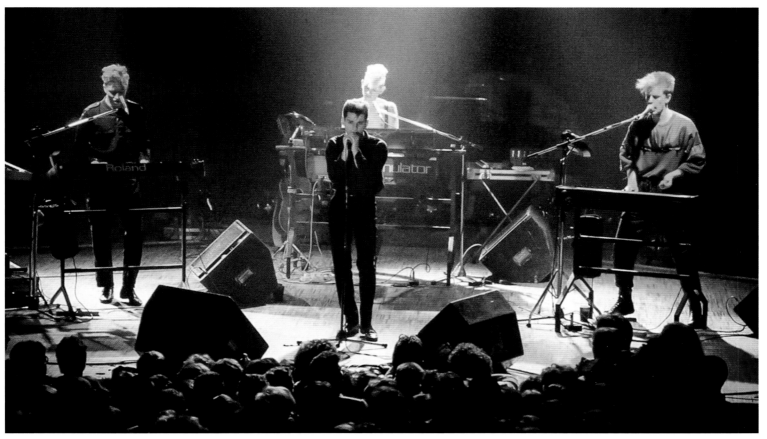

Depeche Mode takes the stage at Studio 54 in Barcelona, March 9, 1984.

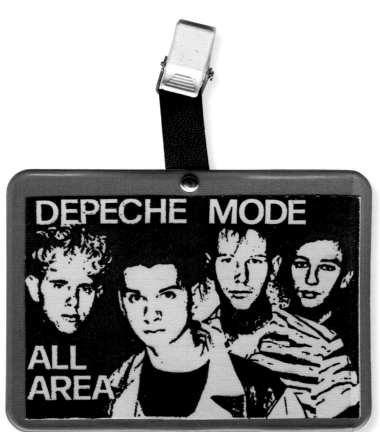

Backstage pass for shows in Italy, spring 1984.

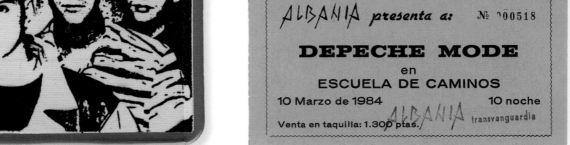

Flyer and ticket for a Madrid show on March 10, 1984.

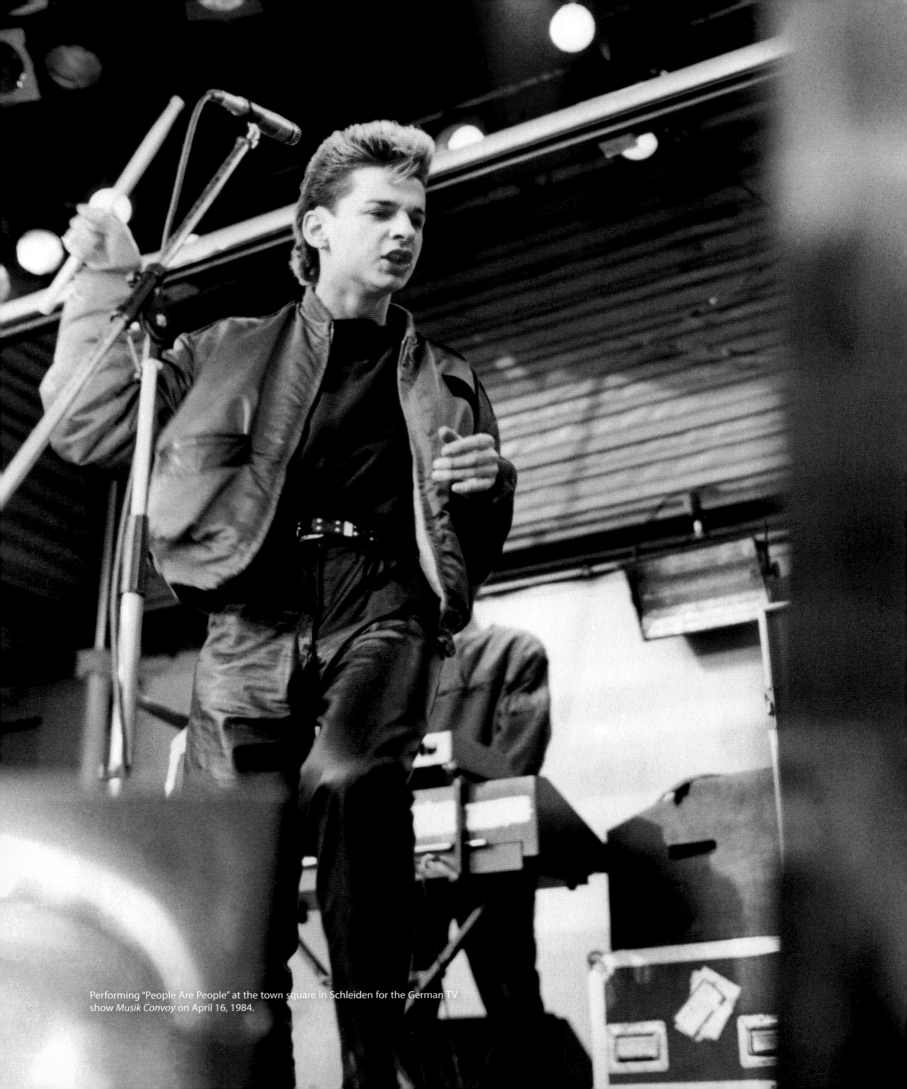

Performing "People Are People" at the town square in Schleiden for the German TV show *Musik Convoy* on April 16, 1984.

Some Great Reward

"People Are People"

Up to this point, Depeche Mode was still considered somewhat of an insider's tip; many teens had no idea of the band's existence. All that changed overnight in 1984. When the group recorded its new single, "People Are People," at Hansa Studios in West Berlin at the beginning of the year, everyone involved suspected the song might be a hit—the hook was built for radio, and the sounds continued to show an innovative streak.

It took less than two weeks for "People Are People" to reach number 4 on the British charts after its release on March 12, 1984.

Soon after appearing on British TV programs like *Top of the Pops* and *The Tube,* Depeche Mode was invited onto French and West German programs.

Depeche Mode recording for the program *Flashlights* at Munich's ZDF Studios in February 1984; "People Are People" had its TV broadcast premiere on the show on March 14, 1984.

Again tour even though the tour had officially ended three months before. "People Are People" also had its live debut in Ludwigshafen.

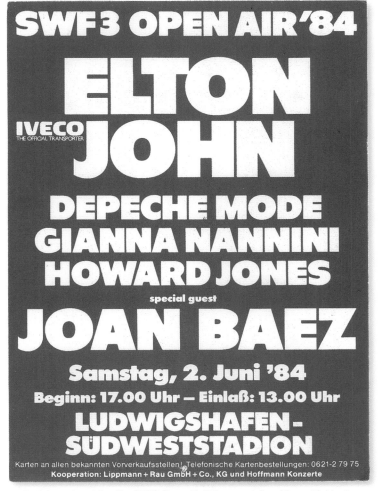

A sticker advertising the SWF3 Open Air '84 concert. Speaking with Martin at the event, British superstar Elton John revealed himself to be a fan of Depeche Mode's new single, "People Are People."

One such appearance came in mid-April in Schleiden, a sleepy town on the Dutch border. Performing for Westdeutscher Rundfunk's program *Musik Convoy,* the band played in the town square from the cargo bed of a tractor trailer. Even if the improvised stage and the provincial setting gave no clue, at the time, "People Are People" was on top of the West German single charts, where it stayed for three weeks. Whether it was radio or television, in the spring of 1984, *nobody* in Western Europe could get by without hearing "People Are People."

Back in London, Martin, Alan, Dave, and Andy continued work on their fourth full-length record at Music Works Studio, with Daniel Miller producing and Gareth Jones promoted to the role of coproducer. The band had intended to concentrate entirely on the new record over the coming months, but one request came in that they weren't able to turn down: on Saturday, June 2, they played an outdoor show at the Südweststadion in Ludwigshafen.

With a slightly abbreviated set list comprising mostly older songs, the show was classified as part of the *Construction Time*

Work on the new record continued throughout July at Hansa Studios in Berlin. Gareth Jones had moved to West Berlin in the meantime, while Martin Gore was sharing a small apartment in the city with his girlfriend, Christina. The other band members set up shop at the InterContinental Hotel, located directly between Tiergarten and the famous Kurfürstendamm.

On August 20, 1984, looking to build on the runaway success of "People Are People," Depeche Mode released another single off their upcoming album: "Master and Servant." The song peaked at number 9 in Great Britain and went to number 2 on the West German singles chart—the band was back in daily rotation! In the US, the single reached 87 on the *Billboard* Hot 100, with the B-side "(Set Me Free) Remotivate Me."

On September 24, Depeche Mode released its fourth full studio album, *Some Great Reward.* The record was a smash hit, rocketing to number 5 on the British charts and number 3 in West Germany.

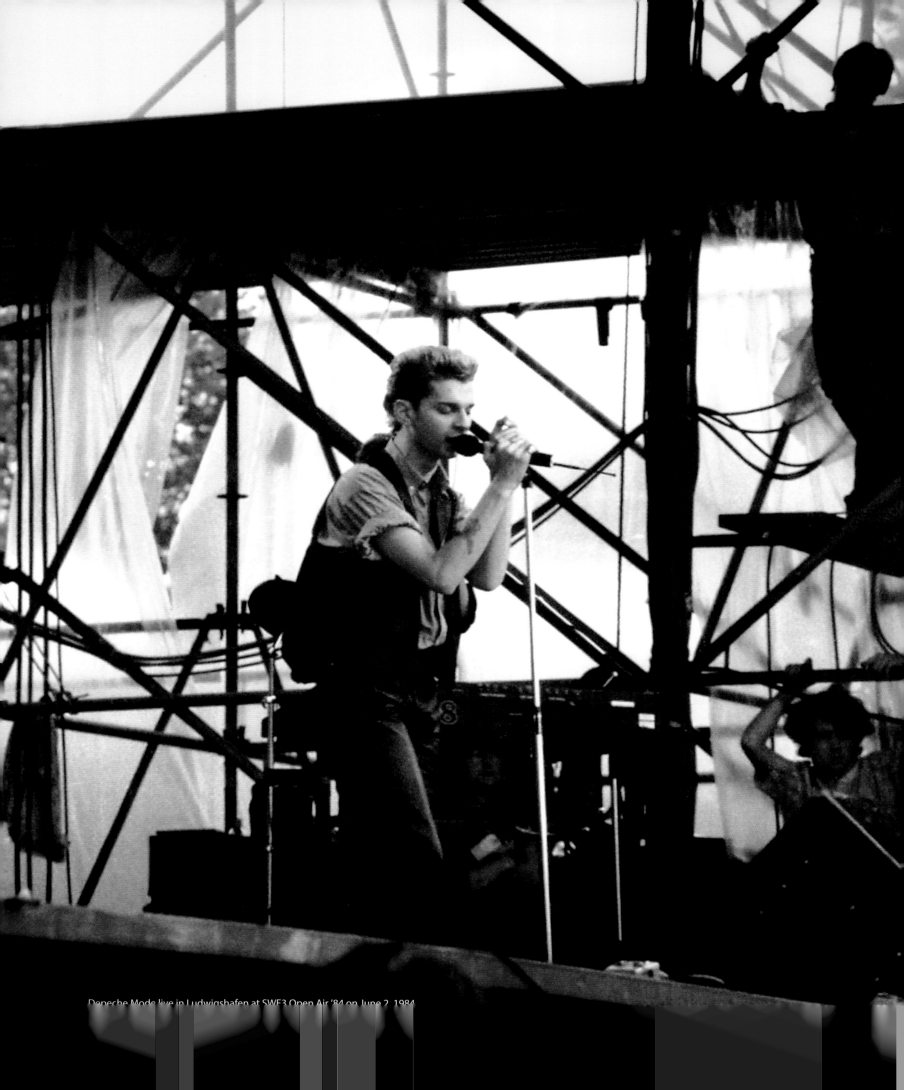

Depeche Mode live in Ludwigshafen at SWF3 Open Air '84 on June 2, 1984

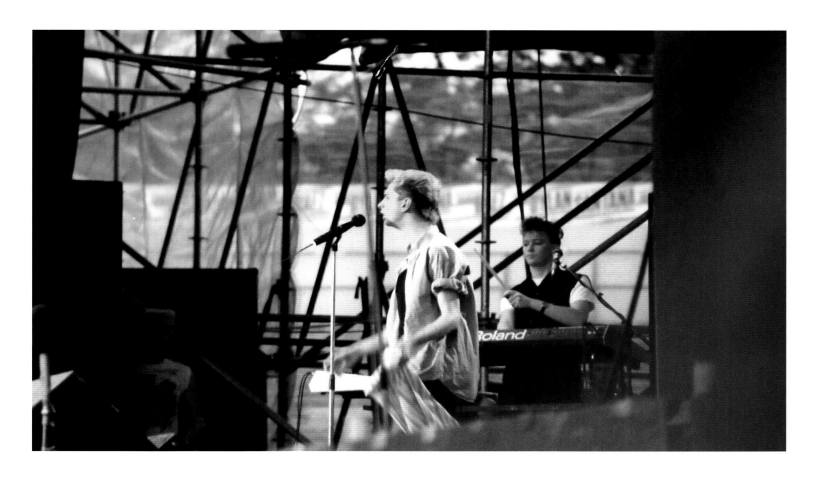

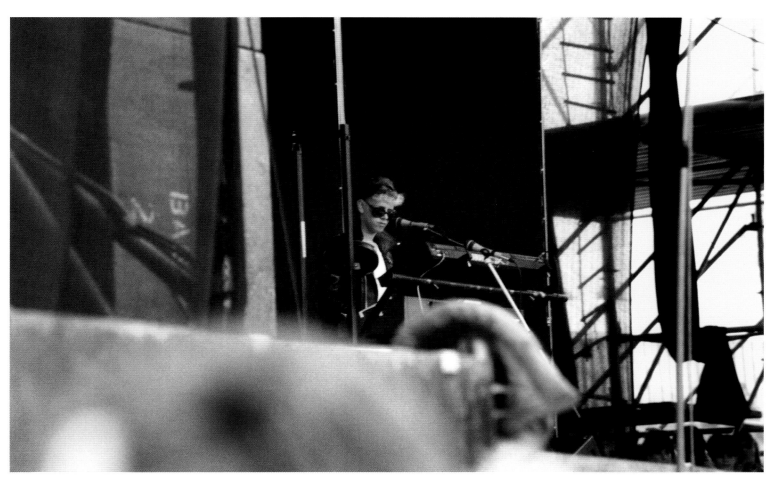

Some Great Reward Tour, 1984

By now, just about everyone in Western Europe knew "People Are People," but would a single be enough to draw them out to concert halls? The tour for *Some Great Reward* opened in St. Austell in England on September 27, the first of twenty-nine shows throughout Ireland and Great Britain.

Reporting from the band's September 29 show, the *Liverpool Echo* wrote, "Depeche Mode may not have soul, but they do have warmth, and a direct input into music that moves and sweeps you along on a driving frenzy of beat. Measured beat, maybe, but the lyrics are clever, and Gahan a superb front man. Behind him, Andy Fletcher, Martin Gore, and Alan Wilder mesh their machines together into a riot of rhythm, and the crowd goes crazy."

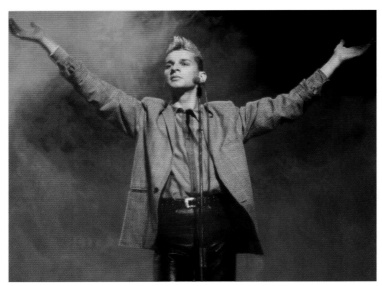

Dave on the stage of Liverpool's Empire Theatre, September 29, 1984.

The band played two consecutive nights in Birmingham on October 12 and 13, with clips of the audience later appearing in the music video for "Blasphemous Rumours." From November 1–4 they sold out London's Hammersmith Odeon; the November 2 show was again recorded by BBC Transcription Services and sent out to BBC stations worldwide.

Depeche Mode and their twenty-person crew had gotten to

DEPECHE MODE • *A QUICK ONE* (LONDON 1984) • CD BOOTLEG

A high-quality version of the BBC recording appeared on this unofficial CD.

know their audiences quite well by now, and made a point of ensuring they were treated respectfully and felt safe, including protocols that other concert promoters would come to adopt years later. The tech rider explicitly relayed to local promoters in Britain that "as this is a young mainly female audience, please ensure that you have very good cover in this area."

The band's production manager, Harald Bullerjahn from Hamburg, recalled, "With Depeche Mode we introduced security and admissions protocols at the concerts that hadn't existed at all at

Backstage pass for the UK leg of the *Some Great Reward* tour, 1984.

live shows before. They later became the industry standard. We had special entry gates set up and only used police barricades at the front of the stage, though we quickly replaced those with self-built barriers, and later the normal professional variety."

On October 29, with the band still on the UK leg of the tour, the double single "Blasphemous Rumours/Somebody" was released. The live versions on the B-side of the limited-edition single and the maxi-single were recorded at Liverpool's Empire Theatre on September 29, 1984.

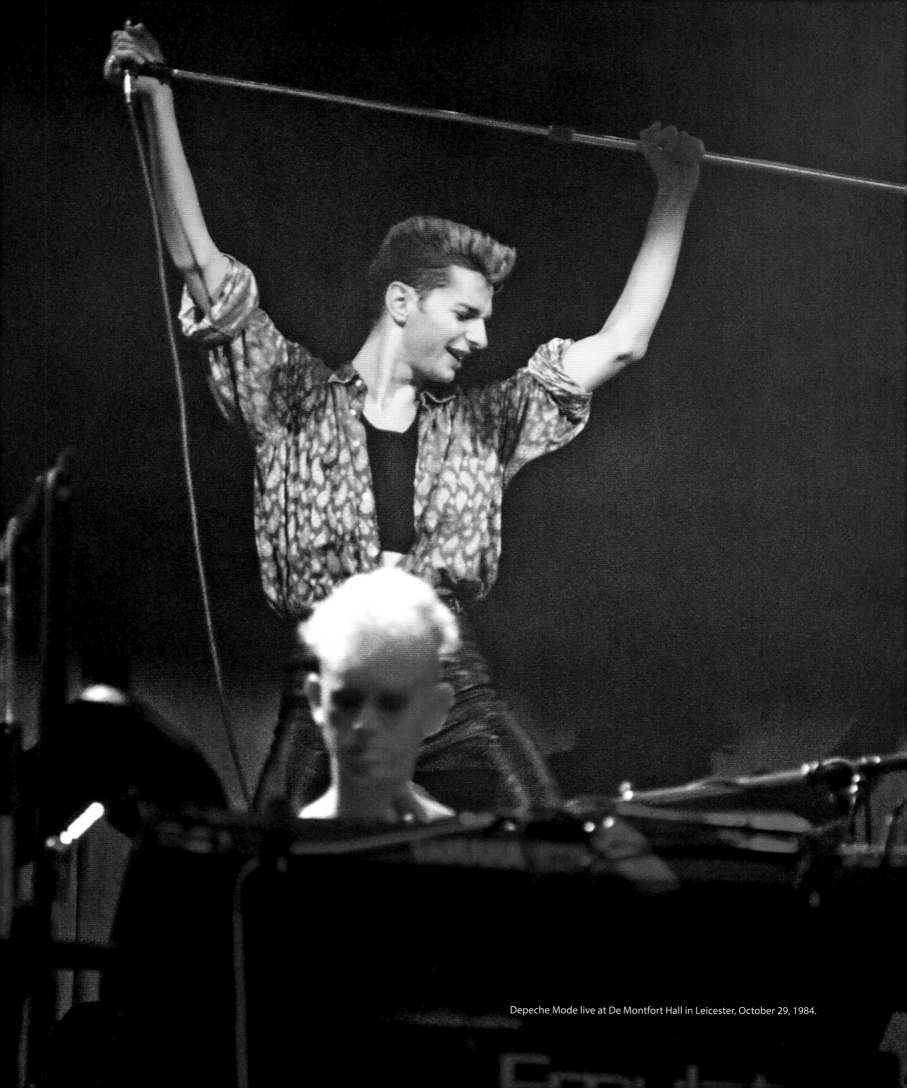

Depeche Mode live at De Montfort Hall in Leicester, October 29, 1984.

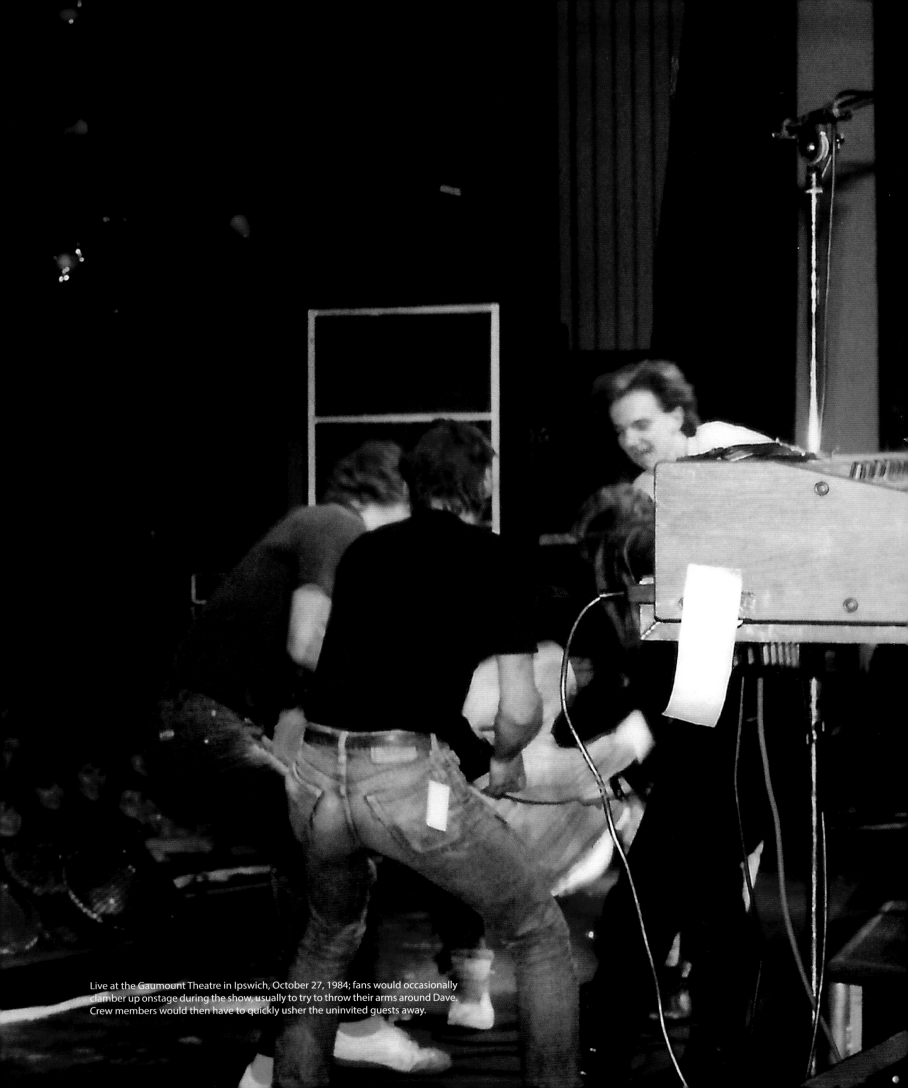

Live at the Gaumount Theatre in Ipswich, October 27, 1984; fans would occasionally clamber up onstage during the show, usually to try to throw their arms around Dave. Crew members would then have to quickly usher the uninvited guests away.

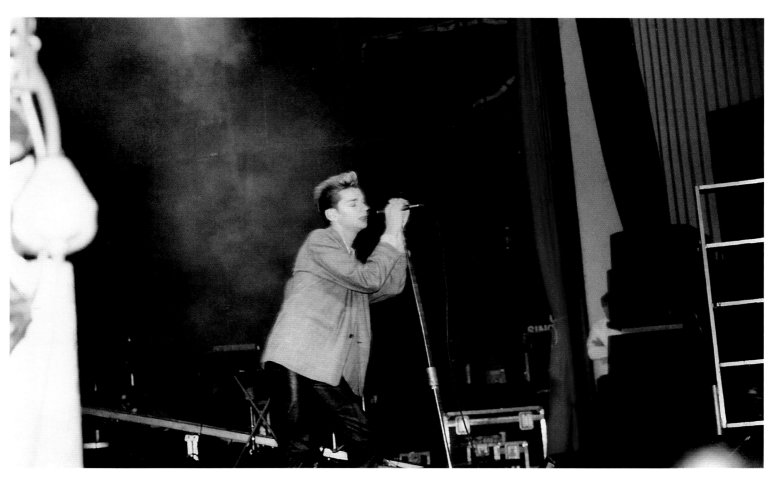

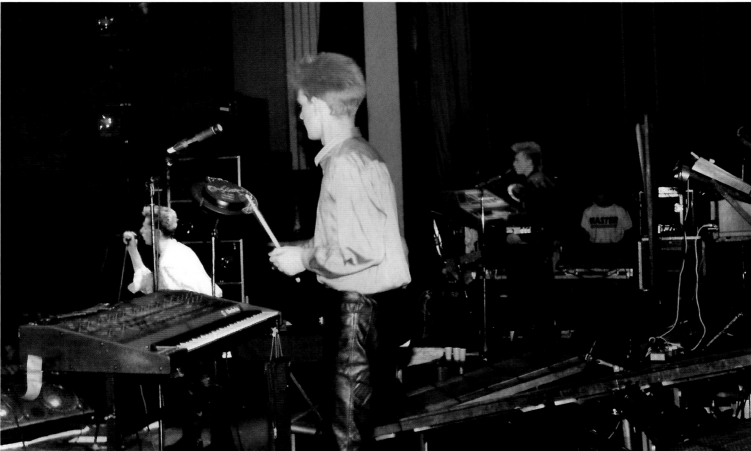

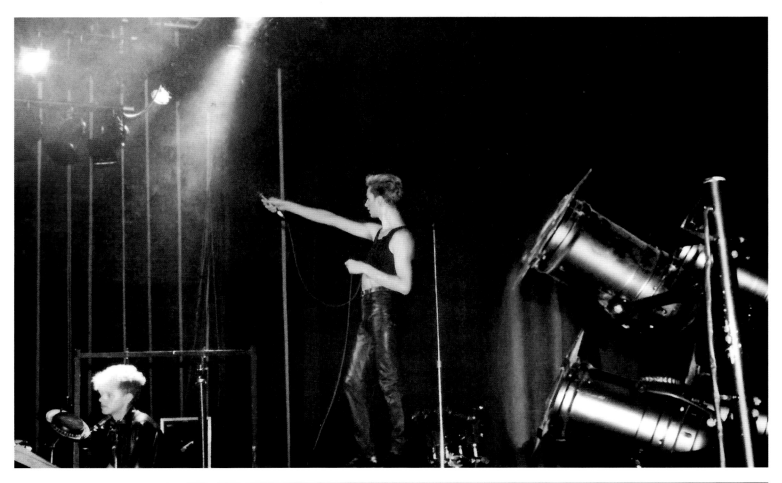

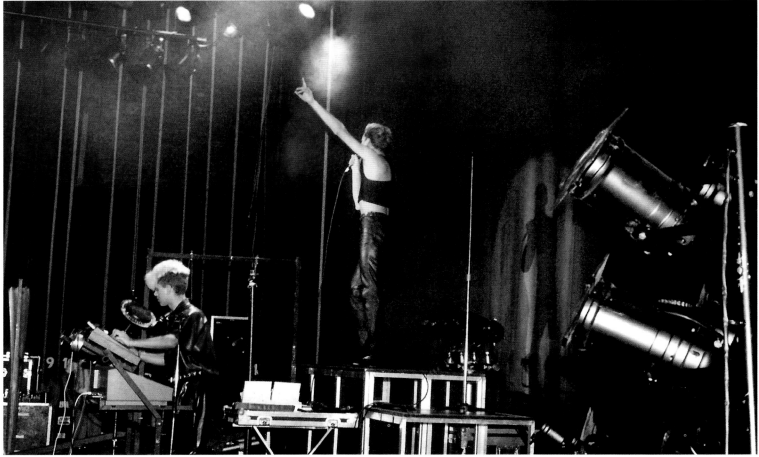

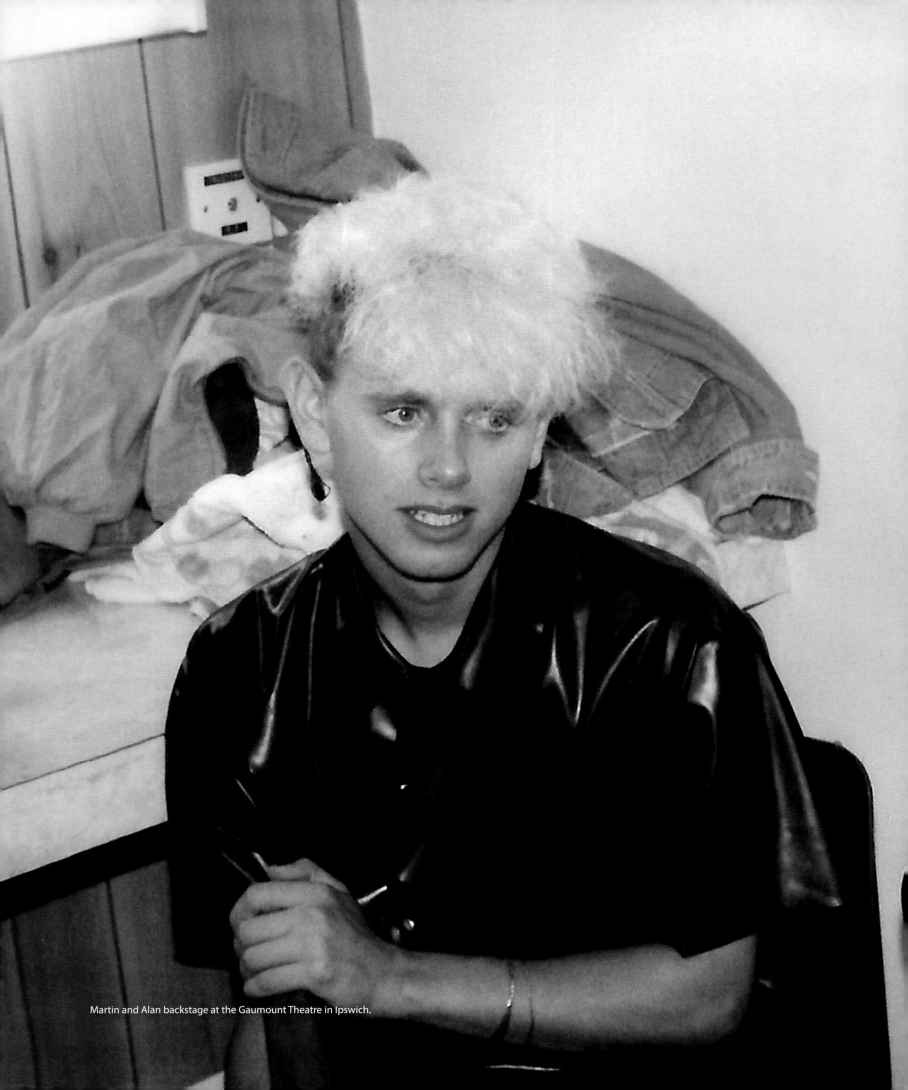

Martin and Alan backstage at the Gaumount Theatre in Ipswich.

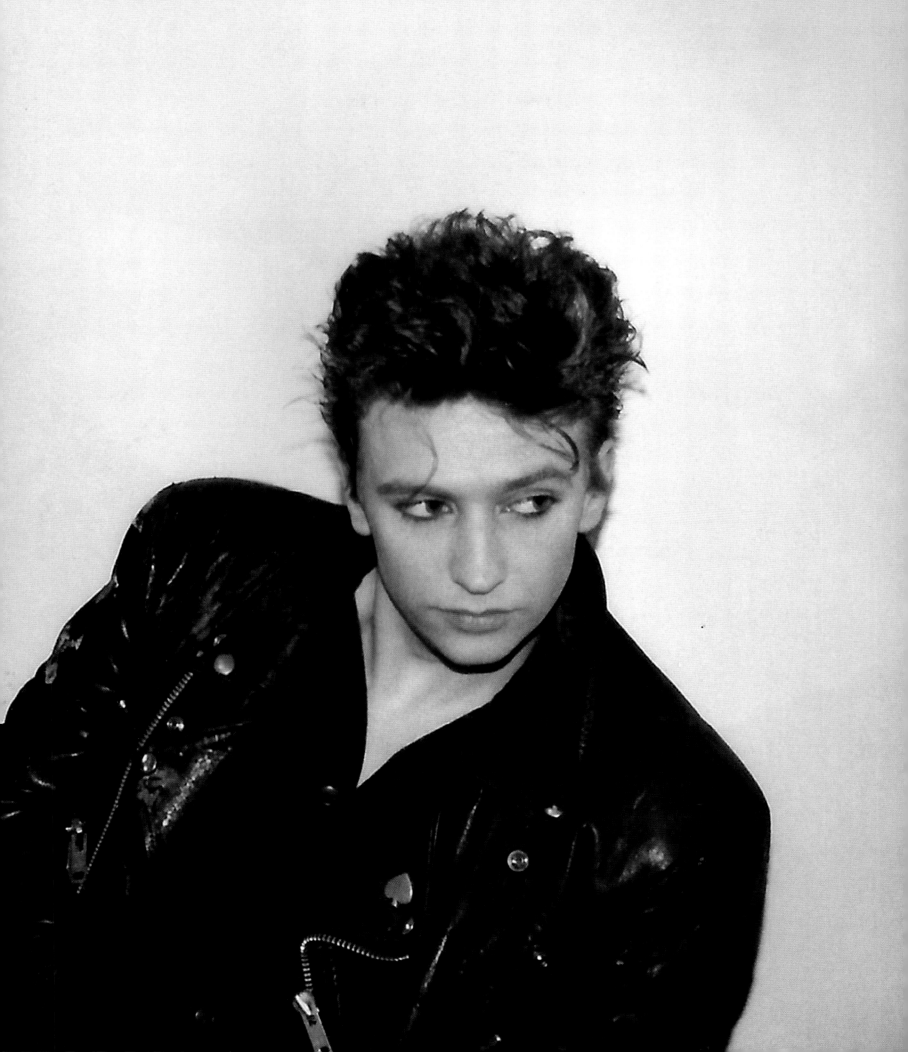

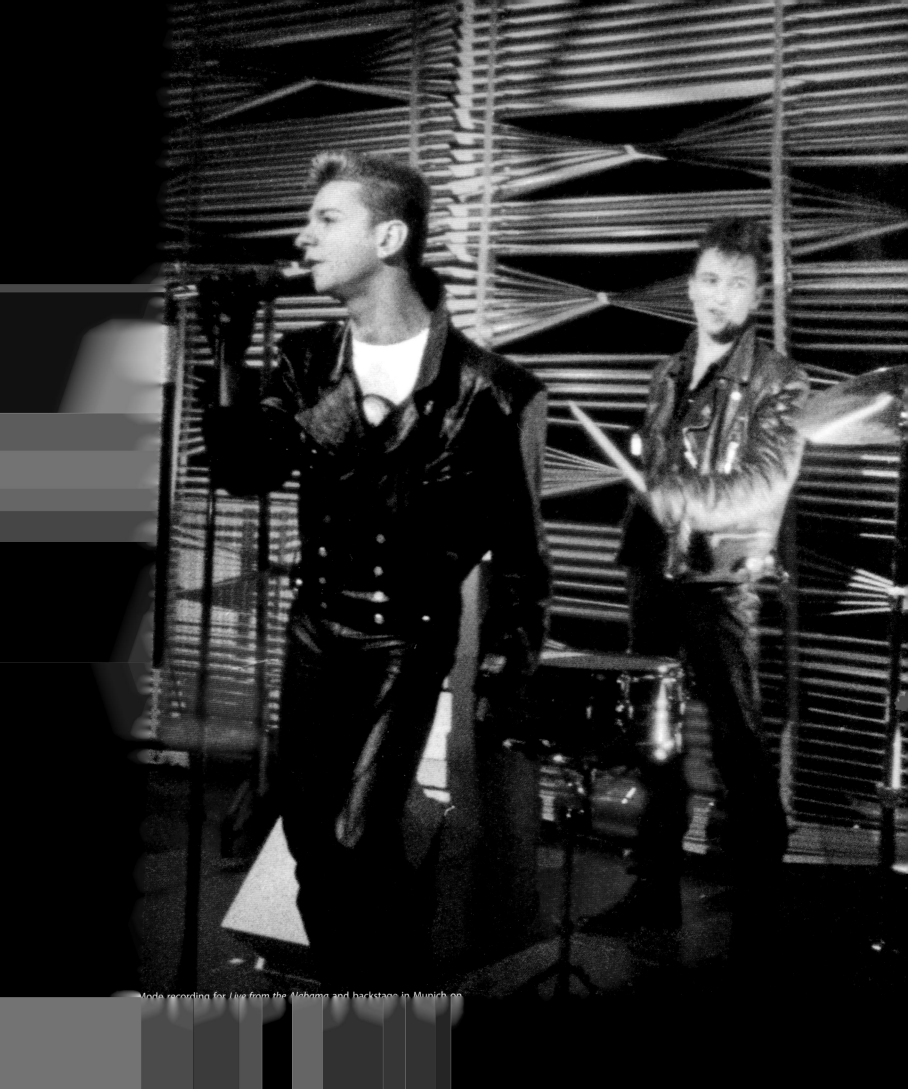

Mode recording for *Live from the Alabama* and backstage in Munich on

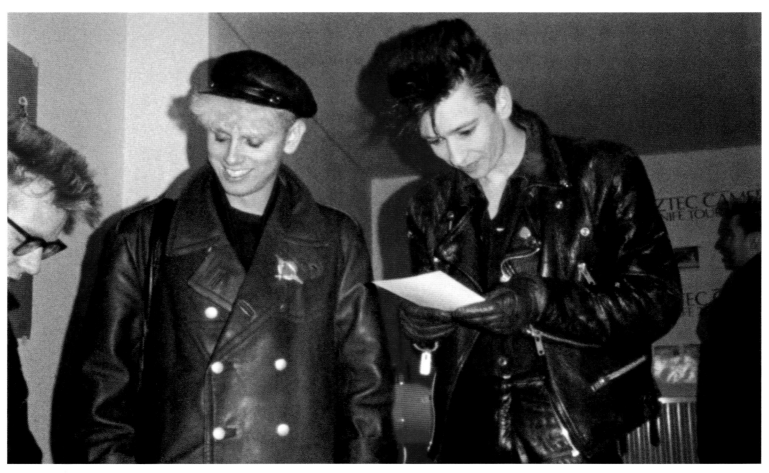

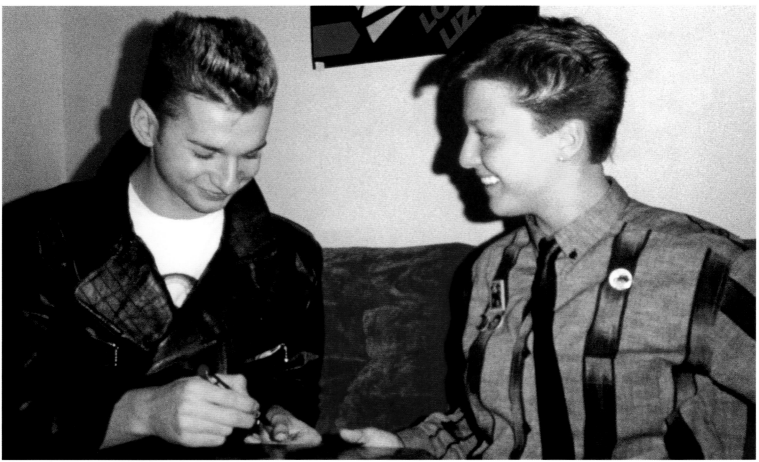

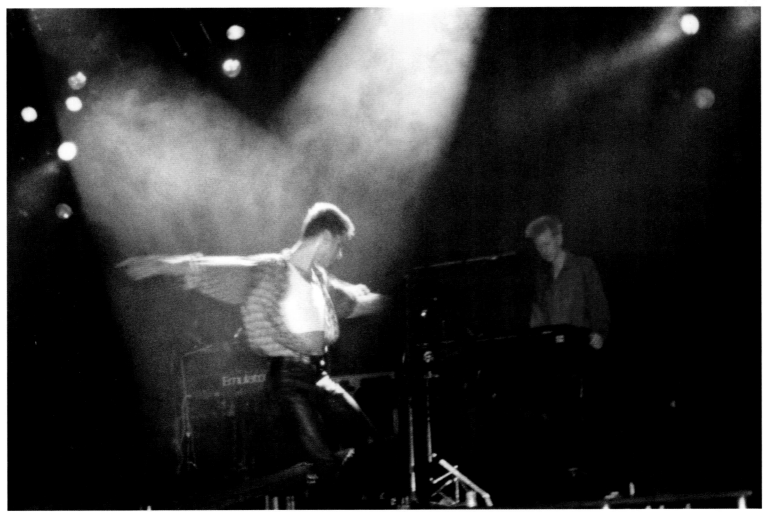

Depeche Mode opened their West German tour on November 20, 1984, at the Grugahalle in Essen.

Europe

After a short break, the European section of the tour opened in Copenhagen. The band played a total of three shows in Scandinavia; a fourth concert planned for Oslo was canceled.

On November 19, a day before their first stop in West Germany at Essen's Grugahalle, Depeche Mode was invited to play "Master and Servant" on *Live from the Alabama,* a new youth program on Bavarian state television that had started broadcasting in January 1984. Combining panel discussions of the day's controversies with national and international musical acts, the show had quickly established a solid following, and the band's appearance helped bring it broader recognition.

A performance of "Blasphemous Rumours" and "People Are People" followed on November 24, 1984, for *Thommy's Pop Show* at the Westfalenhalle in Dortmund. Hosted by the immensely popular Thomas Gottschalk, the show was the ZDF's most prominent foray into pop music at the time, and anyone who appeared on it could consider themselves among the year's top acts in West Germany. Peter Illmann took over as moderator after 1985.

Artist pass for shows in West Germany, 1984.

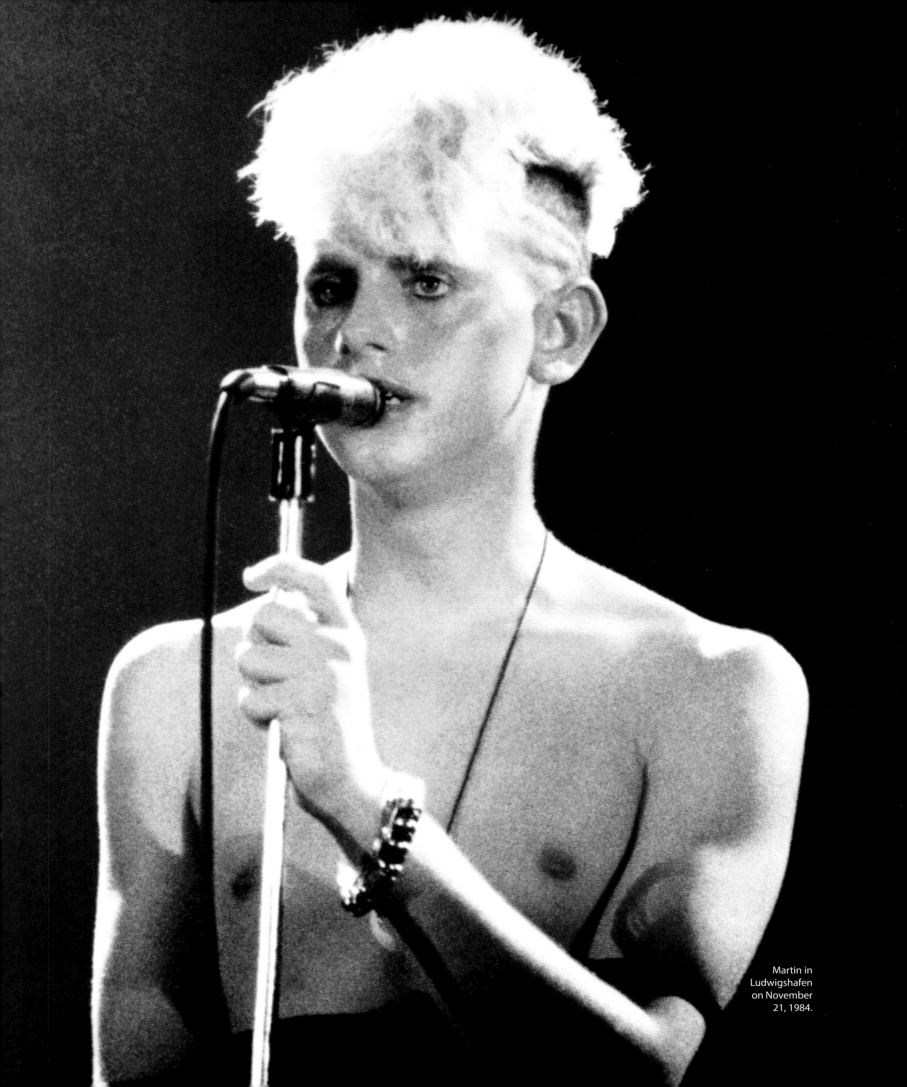

Martin in
Ludwigshafen
on November
21, 1984.

Three dates in Italy followed, from November 26–28. Technical difficulties cropped up right before the final show in Milan, when a number of synthesizers began to malfunction due to heat and condensation. Luckily, the problem was solved just five minutes before the show was set to start.

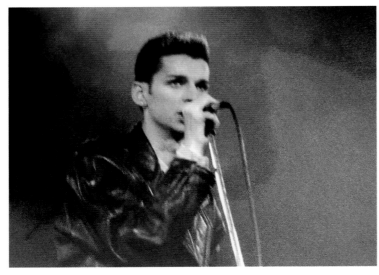

Dave at the mic at Milan's Teatro Tenda, November 28, 1984.

Crew itinerary from November 15–December 18, 1984.

DEPECHE MODE • *PERFORMANCE (BASEL 1984)* • 2LP BOOTLEG

The Depeche Mode concert on November 30, 1984, in Basel was recorded live by the Swiss radio station DRS3 for broadcast the following month. It later showed up in a variety of unauthorized formats, and today remains one of the most beloved bootleg recordings of the band.

Shortly after attending their December 1 show in Munich, *New Music Express (NME)* journalist Don Watson wrote a piece that still captures what the band stands for today: "Depeche Mode could sell out the world, and still be one of the least mega-bands on the planet. They may play football stadiums, but their sound will still be stamped indelibly with the mark of the youth club disco—which is, in itself, neither a good or bad thing, just a fact. Depeche are the original small-town boys. The question is, given that, what do they do? And the answer is, quite a lot . . . The show in Munich is punchy, polished but still unpredictable enough to rupture the melodic surface. Dave Gahan, once the most unassuming of front men, races around the stage jerking hips and engaging the audience in call-and-response routines. If this were Bono, I might throw up, yet in this context these gestures appear just what they are—a bizarre and rather amusing ritual."

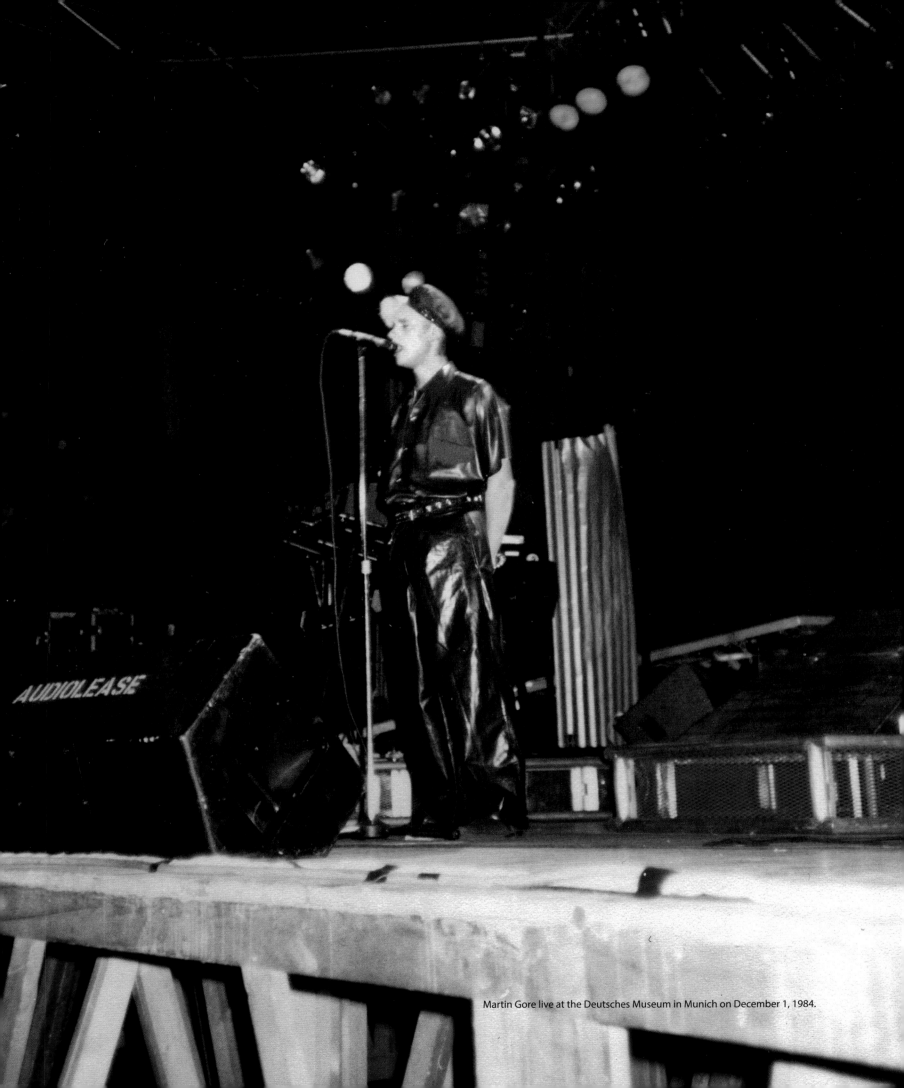

AUDIOLEASE

Martin Gore live at the Deutsches Museum in Munich on December 1, 1984.

European tour booklet for the *Some Great Reward* tour, 1984.

Pin from the *Some Great Reward* tour, 1984.

Watson also made a number of discoveries about *Bravo* in an interview with Andy Fletcher, including why Depeche Mode no longer had anything good to say about the West German youth magazine. "It's no good refusing to talk to them," Fletcher said, "they'll just go ahead and make it up anyway. The last time we refused an interview with them, they made up a story about Dave having to be carried offstage at the end of every performance, taken to a separate dressing room, and kept supplied with constant fluids. The time before that, they said we hated everyone under twenty, which made us very popular with their readership."

Even if Depeche Mode owed a good part of their popularity in West Germany and, indirectly, East Germany throughout the second half of the eighties to a growing presence in *Bravo* and other teen magazines like *Popcorn* and *PopRocky*, the band quickly (and understandably) grew tired of all the sensationalist reporting, and soon stopped giving interviews.

Throughout 1984, new young pop acts from Great Britain flooded the charts like never before; whether it was Bronski Beat, Duran Duran, or Frankie Goes to Hollywood, ABC, or Wham!, every week seemed to find a new hit single plastered all over radio and television.

Yet Depeche Mode had more to offer than radio-ready hits. They also had a first-rate live show, helping them attract still more new fans. They hadn't been prefabricated by a major label, and were showing that indie bands could perform both in the studio and onstage—and at a high level.

Trouble in West Germany

Meanwhile, the size of the halls that Depeche Mode played in West Germany—some venues held up to 10,000 people, and most sold out—were a sign of just how popular they had become in the country.

And yet, without intending to, the band had become a polarizing force. On the evening of December 4, 1984, a group of around thirty skinheads was found milling outside the Hanover show, targeting the new wave audience. Police presence was thankfully able to prevent any attacks, and the abuse was only verbal. A piece for radio station NDR 1 described the actual concert: "Every song, from 'Love in Itself' to 'Somebody,' ran with the precision of a shuttle flight. The slide sequences were tied into the light show, displaying images in the style of Soviet propaganda paintings whose revolutionary message Depeche Mode has been toying with since *Construction Time Again*. To me, the whole thing gave a

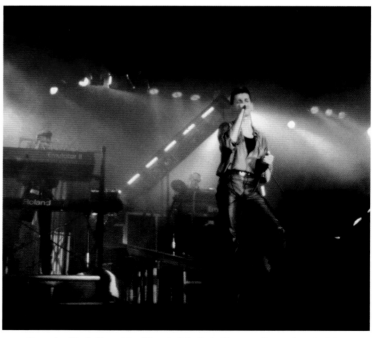

Depeche Mode live at the Eilenriedehalle in Hanover, December 4, 1984.

rather cold, emotionless, and perfectly calculated impression. That being said, the group's 5,000-odd fans were all going wild."

Before the band's Kiel show on December 8, rumors spread about a gang of bikers who had it out for Depeche Mode fans; police were present this time as well, and in the end the gang didn't materialize.

Three days later, Depeche Mode performed outside Stuttgart at the Sporthalle in Böblingen for 6,000 fans. During the encore, an audience member lit off a smoke grenade, leading to minor injuries among a handful of concertgoers. Unsurprisingly, the tabloids had a field day with the incident, exaggerating freely in their coverage. In reality, few at the show had heard anything at all about an "explosion." Only in the back of the hall did word of the incident spread, sparking a brief panic. Unaware that Depeche Mode crowds were otherwise peaceful, organizers for the following night's show at the Alte Oper in Frankfurt got cold feet and canceled on short notice. The concert agency responsible for West Germany, Karsten Jahnke Konzertagentur, scrambled and managed to arrange a secondary location in neighboring Offenbach, complete with shuttle buses, and the show went on.

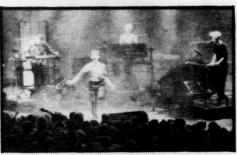

Depeche Mode: Explosion – 40 Verletzte bei Popkonzert

Panik bei Depeche Mode! 40 junge Fans wurden verletzt, sind zum Teil noch in der Klinik. Grund: Ein unbekannter „Irrer" zündete Dienstag abend beim Konzert der Popgruppe („See You") inmitten der 6000 Fans in der Böblinger Sporthalle eines „CS-Gasbombe". Das Super-Tränengas löse Tumulte aus: Türen krachten, Fenster splitterten: Gehirnerschütterungen, Quetschungen, Prellungen, verätzte Augen. Silvia (16), die ohnmächtig wurde: „Ich dachte, jetzt sterbe ich." Die Polizei: „Ein Wunder, daß es keine Toten gab."

Tabloids reported an "explosion" in Böblingen.

High spirits in the hotel after a show at Düsseldorf's Philips Halle to 6,000 fans on December 13, 1984.

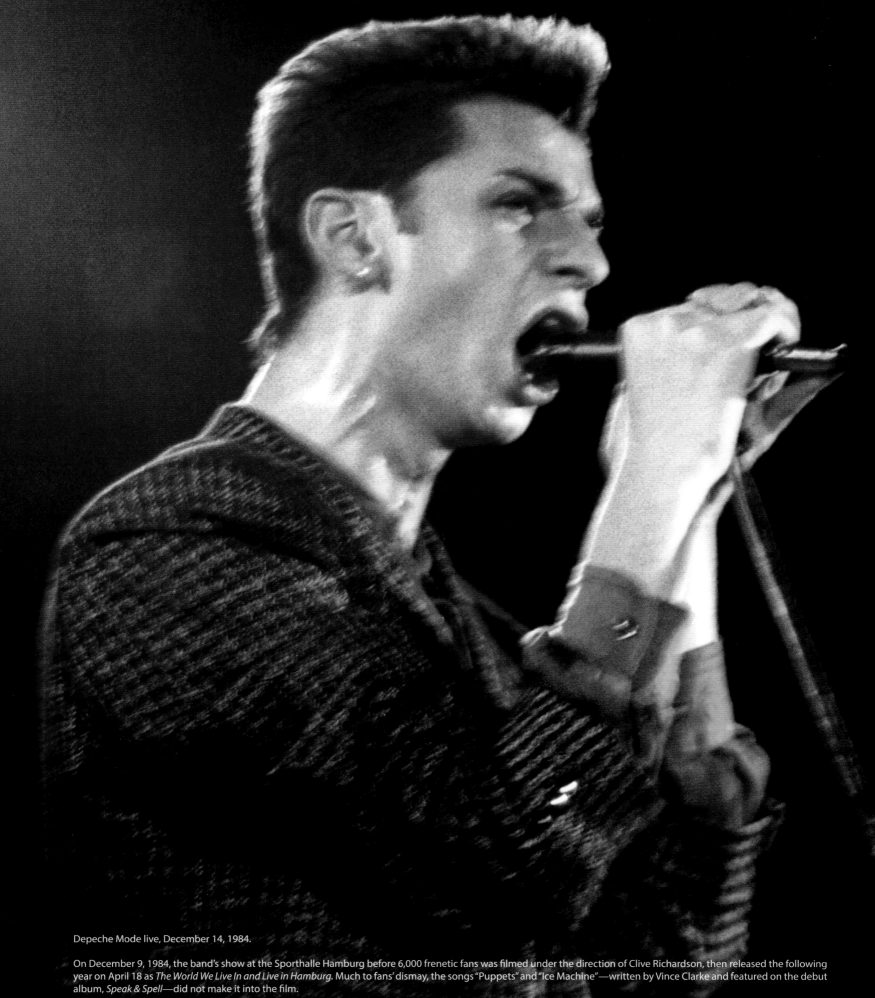

Depeche Mode live, December 14, 1984.

On December 9, 1984, the band's show at the Sporthalle Hamburg before 6,000 frenetic fans was filmed under the direction of Clive Richardson, then released the following year on April 18 as *The World We Live In and Live in Hamburg*. Much to fans' dismay, the songs "Puppets" and "Ice Machine"—written by Vince Clarke and featured on the debut album, *Speak & Spell*—did not make it into the film.

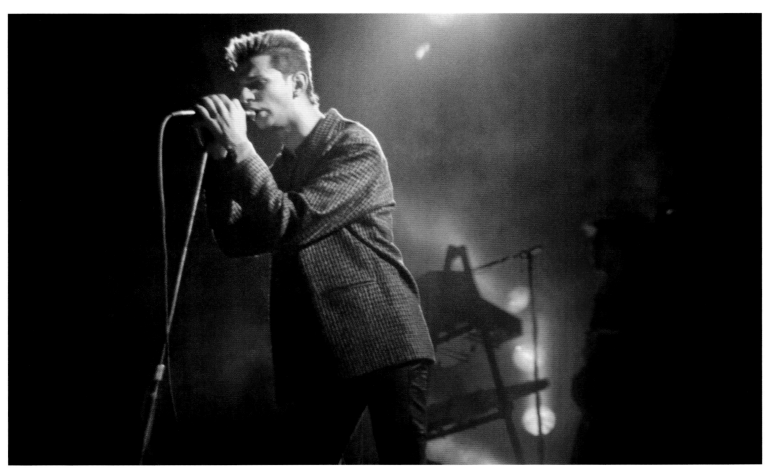

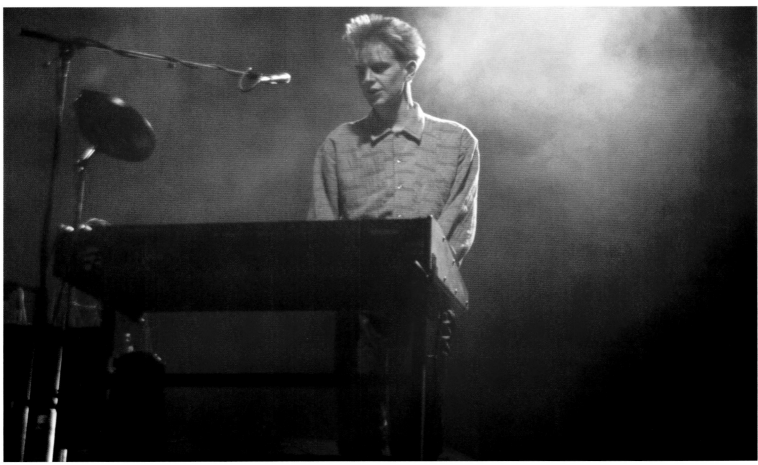

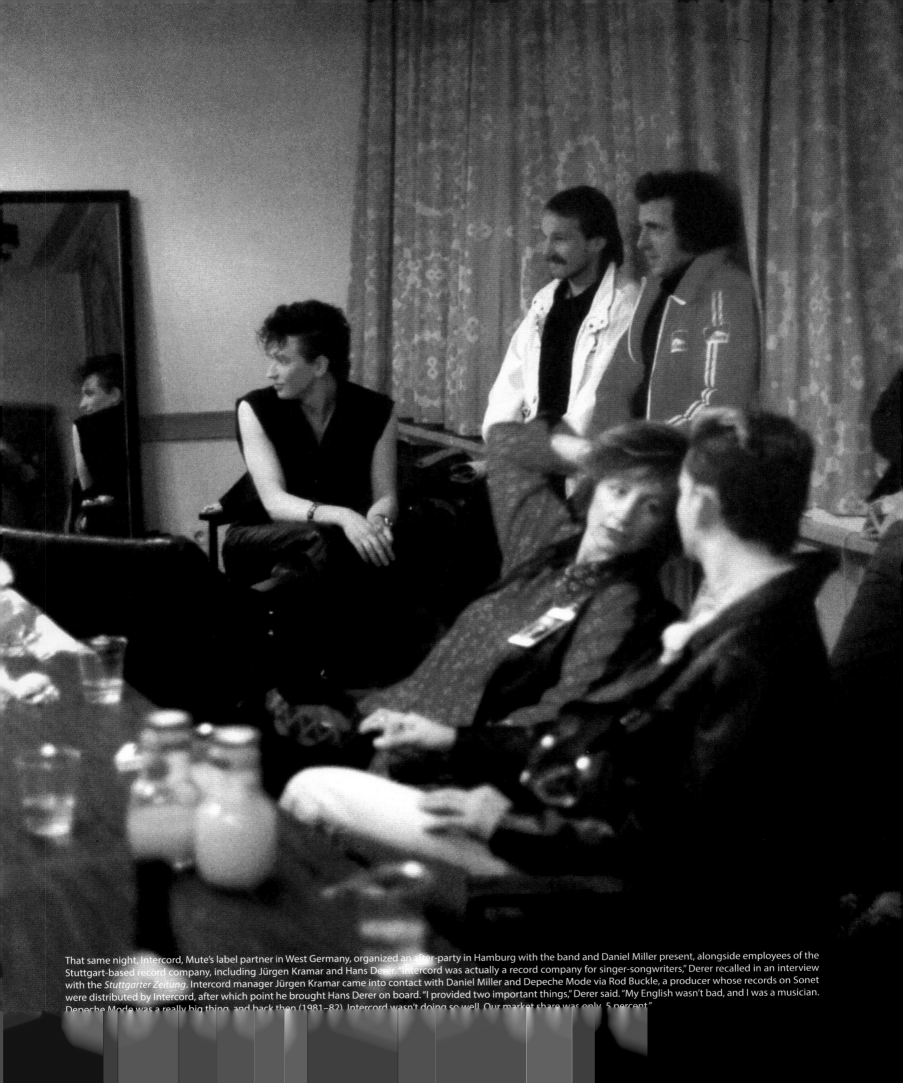

That same night, Intercord, Mute's label partner in West Germany, organized an after-party in Hamburg with the band and Daniel Miller present, alongside employees of the Stuttgart-based record company, including Jürgen Kramar and Hans Derer. "Intercord was actually a record company for singer-songwriters," Derer recalled in an interview with the *Stuttgarter Zeitung*. Intercord manager Jürgen Kramar came into contact with Daniel Miller and Depeche Mode via Rod Buckle, a producer whose records on Sonet were distributed by Intercord, after which point he brought Hans Derer on board. "I provided two important things," Derer said. "My English wasn't bad, and I was a musician. Depeche Mode was a really big thing, and back then (1981–82), Intercord wasn't doing so well. Our market share was only 5 percent."

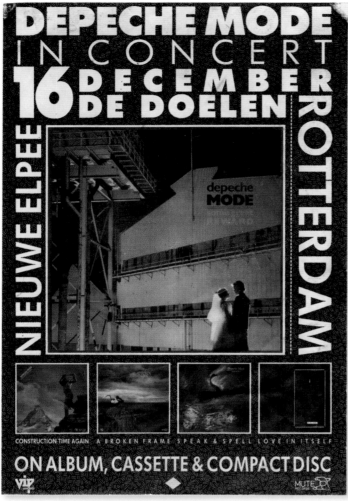

Ad for a concert in Rotterdam on December 16, 1984.

Depeche Mode hysteria had slowly taken hold of France as well; after a two-year hiatus, a concert in Paris on December 17 drew over 14,000 people. The show left the band and record label speechless; the last time they'd played there in 1982, it had been to just 500 people.

Backstage pass for the show in Paris on December 17, 1984.

1985 Touring

With a top 10 album, three hit singles, and a wildly successful Western European tour behind them, 1984 had been Depeche Mode's most successful year to date. And touring for *Some Great Reward* hadn't even finished . . .

With concerts planned abroad for the following spring, Depeche Mode and Daniel Miller decided to break up the labor-intensive rhythm of releasing a record every year and not to put one out in 1985. Still, to keep up their presence in the public eye, in early 1985 they returned to Hansa Studios to record a new single—"Shake the Disease."

In mid-March, the band headed off for the North American leg of their *Some Great Reward* tour, with a total of fifteen concerts planned in the US and Canada.

Booklet for the *Some Great Reward* tour in the US, 1985.

One of the dates included an interview with MTV, whose off-shoot in Western Europe wouldn't launch until 1987. In 1984, the same year that Depeche Mode began its worldwide ascent, selling out larger and larger concert halls, the MTV Video Music Awards also took place for the first time in New York on September 14, in what became a critical stage for bands and solo artists.

The *Los Angeles Times* acknowledged the band's popularity, reporting, "This English synthesizer-oriented group quickly sold out three Southland shows: the Hollywood Palladium on Satur-

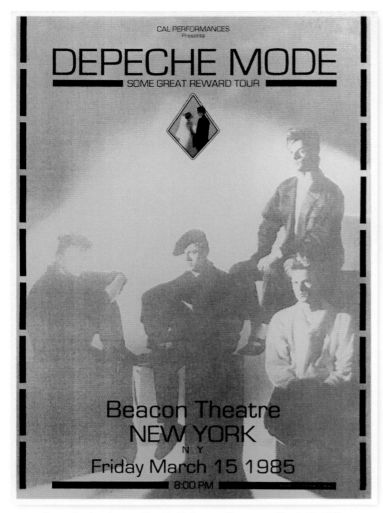

Poster for the show at New York's Beacon Theatre on March 15, 1985.

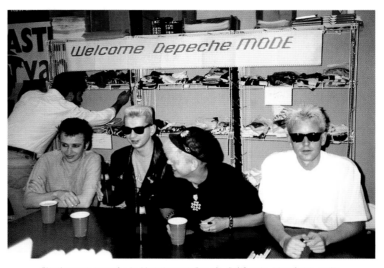

Signing autographs in Huntington Beach, California, March 31, 1985.

of them at different clubs in Tokyo. The band ran into old friends Einstürzende Neubauten from West Berlin backstage at the April 8 show in Tokyo's Nakano Sun Plaza.

Back in England, there was hardly time for R&R: a film of the band's December 9, 1984, show in Hamburg, *The World We Live In and Live in Hamburg,* came out in mid-April, followed just eleven days later by the new single, "Shake the Disease."

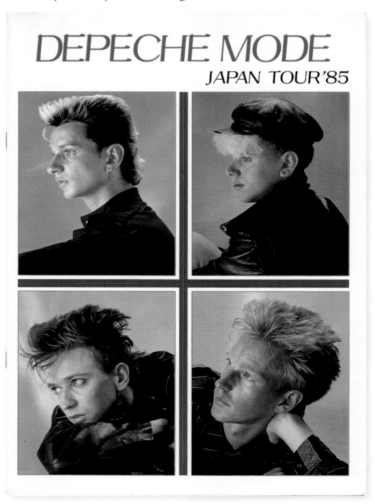

Booklet for the *Some Great Reward* tour leg in Japan, 1985.

day, Irvine Meadows Amphitheatre on Sunday, and the San Diego Sports Arena tonight . . . Not only did the Palladium date sell out in 'fast fashion' . . . but the place was packed with the sort of fans you'd expect to find at a U2 show. That means we're talking enthusiasm. When lead singer Dave Gahan raised his arm, the fans raised theirs—by the thousands. When he pointed the mic their way, they lustily sang. And when Gore . . . stepped forward to take a rare lead vocal, female screams shook the chandeliers."

The band won over an unexpected fan in Billy Gibbons, the head of the Texas rock group ZZ Top. Gibbons later told *Rolling Stone* magazine about his encounter with Depeche Mode after catching their show in Houston on March 26, 1985: "I went to see them one night, and it was a mind-bender. No guitars, no drums. It was all coming from the machines. But they had blues threads going through their stuff. I went backstage; I had to meet these guys. They were surprised—'What brings you here?' I said, 'Man, the heaviness.' We became friends."

Depeche Mode's US fan base was steadily expanding, especially in the greater Los Angeles area with the help of KROQ-FM and its announcer Richard Blade. The March 30 show at the Palladium in LA had sold out before the band even left London.

The North American leg of the tour ended on April 3 in Oakland. Four days later, they were off to Japan for four shows, three

Throughout May and June, Depeche Mode made multiple TV appearances, including one at the Montreux Rock Festival in Switzerland, alongside a host of other well-known acts, that was soon broadcast on multiple stations.

There was also good news from the US: after a successful tour where they had played to tens of thousands of new fans, record sales were now also climbing. On May 25, 1985, fourteen months after its release, "People Are People" reached number 18 on the *Billboard* charts. By now Depeche Mode were a global phenomenon, with their singles receiving airtime on many large radio stations. At the same time, pressure was also increasing on the band to continually have new songs ready for release, just to stay afloat in the fast-paced pop music industry. That June, they were back in the studio to produce a new single for release in September. The initial choice was "Fly on the Windscreen," but a decision was made to go with the poppier "It's Called a Heart" after concerns were raised about the word "death" appearing in the first line of the song.

It wasn't long after the studio session that the band was back in the tour bus for concerts and festivals throughout Europe, although this time they would truly span the continent, not just the western half.

The string of shows began with two outdoor concerts in Bel-

Artist pass for the summer 1985 festival season, printed with the "It's Called a Heart" design.

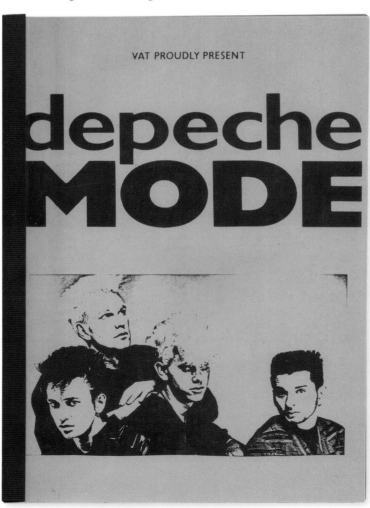

Crew itinerary for the month of July 1985.

gium on July 6 and 7, 1985, where the band played alongside the Ramones, R.E.M., and U2. Three dates in France followed, including one on July 13 in Brest at the Rockscene Festival that also featured the Clash and Leonard Cohen.

That same day, Live Aid, the largest outdoor concert in the history of rock music, was taking place simultaneously in London and Philadelphia. A continuation of the Band Aid project started by Bob Geldof and Midge Ure, Live Aid seemed to have every last act in the top tier of rock music at the time: Madonna, Queen, David Bowie, Paul McCartney, and others. The concert aired on numerous TV and radio stations, reaching some 1.5 billion people worldwide. Depeche Mode wasn't asked to play, nor would they likely have been all that tempted to share the stage with such a long list of superstars. A different kind of adventure stood on their itinerary . . .

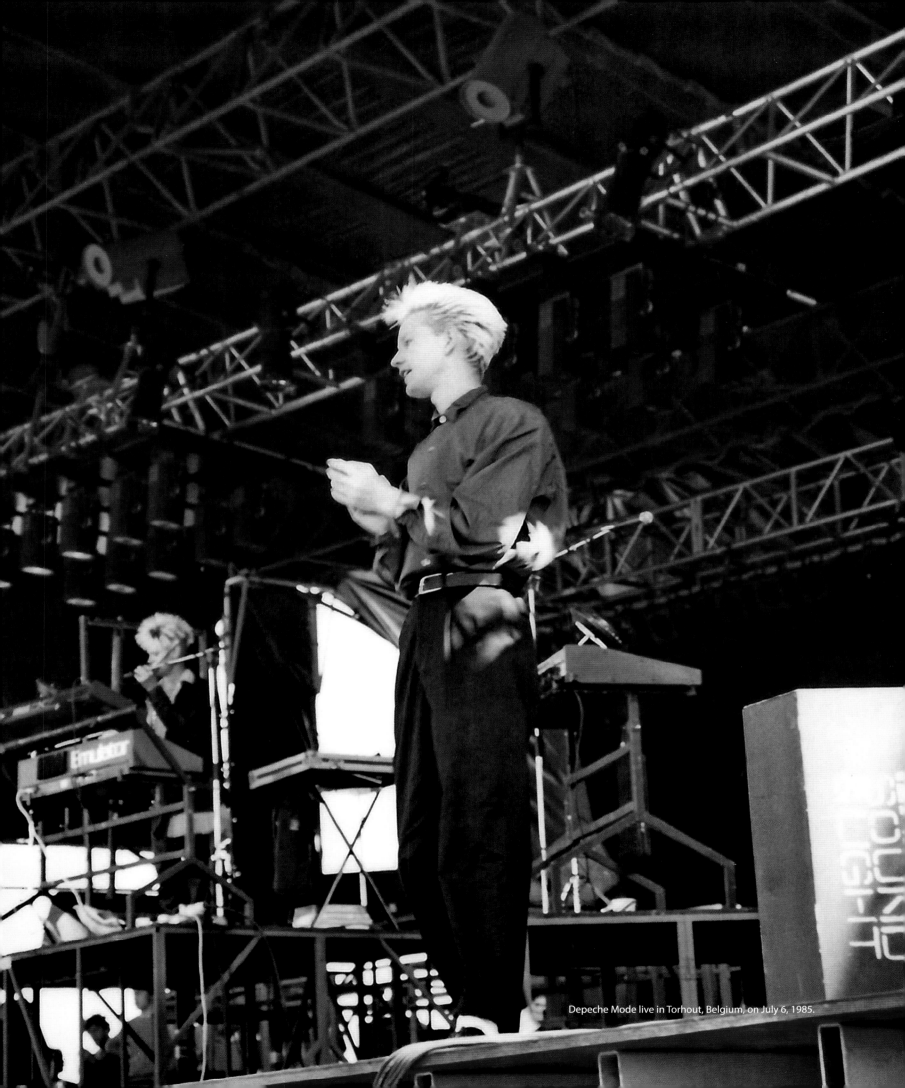

Depeche Mode live in Torhout, Belgium, on July 6, 1985.

Behind the Wall, Volume 1

On July 22, Depeche Mode traveled behind the Iron Curtain for the first time, to Budapest, Hungary, for an open-air concert in front of 17,000 fans the following day. The Budapest show and the tour finale in Warsaw on July 30 were the result of a tenacious campaign by Hungarian concert organizer Laszlo Hegedus to convince government authorities to allow the concerts. Hegedus had previously met the band and Daniel Miller in London, and had offered to make use of his contacts in the East.

Poster for the show in Budapest on July 23, 1985.

Alan Wilder's backstage pass from the concert in Budapest.

The next stop following Budapest was on July 26 at Rock in Athens '85, a two-day outdoor festival with Culture Club and the Stranglers, among other acts. The second day featured the Cure and Talk Talk. The festival was marred by clashes between anarchists and the police, when the former tried to enter the festival grounds without paying.

Four days later, the band played to 5,000 fans in Warsaw, Poland, in what was the very last performance of the *Some Great Reward* tour. Depeche Mode was one of the few Western groups at the time to actually travel to the Eastern Bloc and perform. While the two dates were an absolute loss financially speaking, the gesture to fans was priceless.

Fans stare in disbelief at Dave sitting at a street café in downtown Warsaw.

Speaking with the British Granada TV shortly after, Andy Fletcher recalled, "The crowd react the same. But obviously a little more crazy because they don't get really many bands."

All in all, the *Some Great Reward* tour spanned ten months and eighty-one shows—nearly twice the number of the previous tour.

Even so, by September the band was back together with TV appearances in West Germany, Italy, and the UK, to promote the September 16 release of their new single, "It's Called a Heart," followed in October by their first full-length compilation, *The Singles 81–85*. The release left many fans wondering whether it spelled the end. As it turned out, Martin Gore already had new demos recorded, and in early November the band returned to Westside Studios in London to begin work on the next album.

On November 9, Depeche Mode was invited back to Dortmund's Westfalenhalle for *Peter's Pop-Show*, where they preformed "Shake the Disease" and "It's Called a Heart."

Depeche Mode wasn't close to the end by a long shot. Quite the opposite, in fact: they were unstoppable.

Ticket for the final concert of the tour in Warsaw, July 30, 1985.

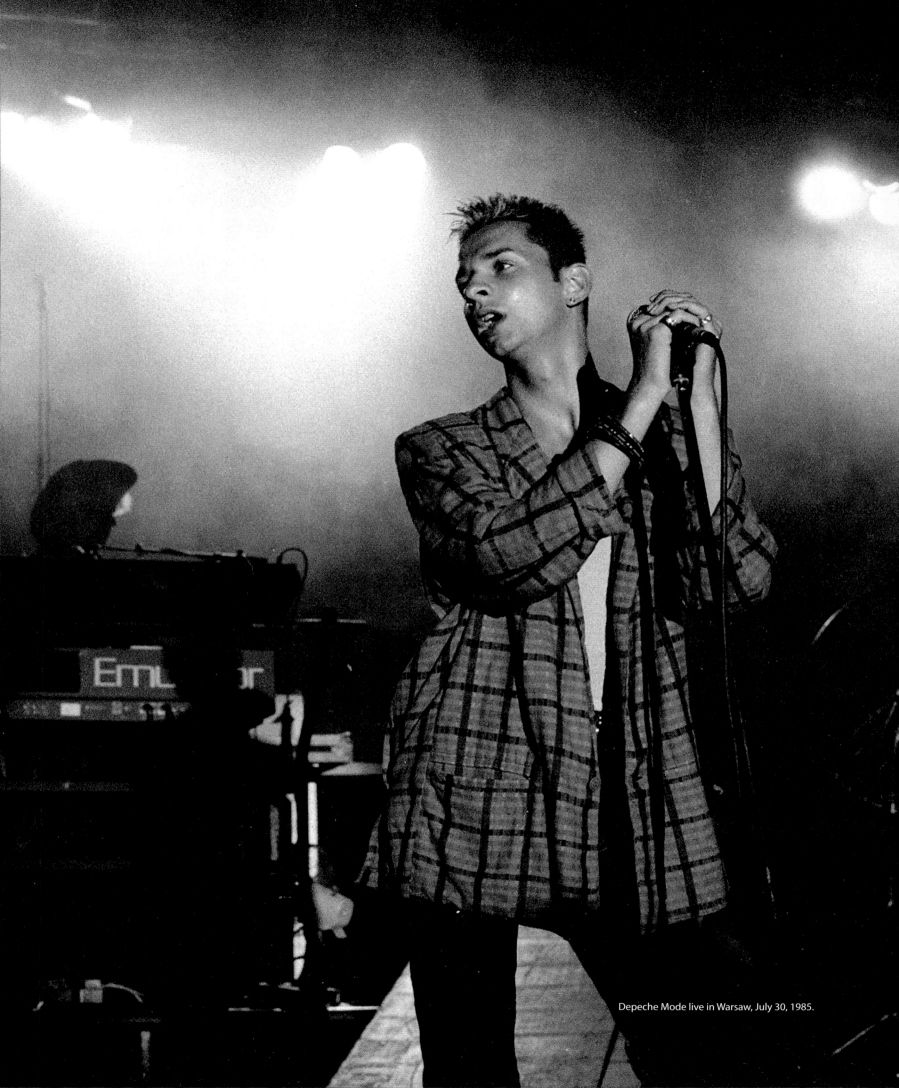

Depeche Mode live in Warsaw, July 30, 1985.

Interview with Karsten Jahnke and Gaby Meyer

For decades now, Karsten Jahnke has ranked as one of Germany's most prominent concert promoters. In 1981 he became the first promoter to bring Depeche Mode from England to West Germany. Gaby Meyer worked for Jahnke from 1980–2000, and was responsible for organizing many concerts.

When and how did your career in concert management begin?

Karsten Jahnke: I started my working career with an apprenticeship in the import and export business in 1956, and was later hired by a company in 1959. I worked there for over a decade, organizing concerts on the side, mostly in the jazz genre, with my boss's permission. One day he told me, "You should start your own business," and starting in 1970 I went into business as an independent concert organizer. I have Insterburg & Co. to thank for the fact that I even made it on the map as a concert promoter in the seventies. They were actually a kind of quirky comedy act, a bit like Helge Schneider. I worked with them for ten years, ten years straight with 150 shows a year, and every single show sold-out.

It's unthinkable from today's perspective: we never signed a contract. Instead we had an unbeatable business model: we split all the profits five ways, between four Insterburgs and myself. The main advantage was that we always had enough money available for other projects. In 1973, for example, I organized a tour with Peter Herbolzheimer's Rhythm Combination & Brass that lost about 250,000 deutschmarks, a tremendous sum. About 1.5 million euros today. It's quite a comfort to have the money when something like that happens, otherwise we would have had to file for bankruptcy.

How did the agency come across new bands from the UK in the early eighties?

Gaby Meyer: I came to the agency out of that music in late 1980, out of a connection with Dan Silver from England. *That guy has some crazy acts!* we thought. Fad Gadget, for example, was a marvelous artist. We put on a show with him here in Hamburg. Dan Silver was friends with Daniel Miller, the head of Mute Records. And that's how we came across the young Depeche Mode.

Jahnke: Punk and new wave in particular came through a few specialized agencies. I always had a soft spot for them. In the end, we turned what was a hobby into a career; we never "thought like a business." We wanted to put on music that we loved.

For our first Depeche Mode show, in September 1981 at the Markthalle in Hamburg, we printed in bold on the flyer that the show would only last forty-five minutes. That was because shortly

Legendary concert promoter Karsten Jahnke in the 1970s.

before, Fritz Rau, who's since become a legendary concert promoter, had lost a court case—for some inexplicable reason, people in Germany seem to think that a concert has to last longer than an hour for it to count. Fritz had put on a Shirley Bassey show, but she only sang for an hour, and Fritz was taken to court by one attendee who wanted his money back because the show had been too short. The judge ruled that in West Germany a concert had to last two hours—either that or you had to publicly announce the shorter amount of time.

Meyer: So we printed "Live Presentation: 45 minutes" on the flyer.

Jahnke: And Depeche Mode played exactly forty-four minutes, though they played another song as an encore after that.

What was it like running the Karsten Jahnke Concert Agency in the early eighties?

Jahnke: I had a technical manager from the very beginning, because I didn't have a clue about the technical aspects. Other people showed up after that; by 1981 we must have been between six and eight people.

One thing about us was that we really did only do tours with artists that we would have gone to see ourselves. And that was an advantage: If you lose money on a group that you find awful to begin with, you'll be quite put out. But if you take a loss on a group that you like, it's not so bad.

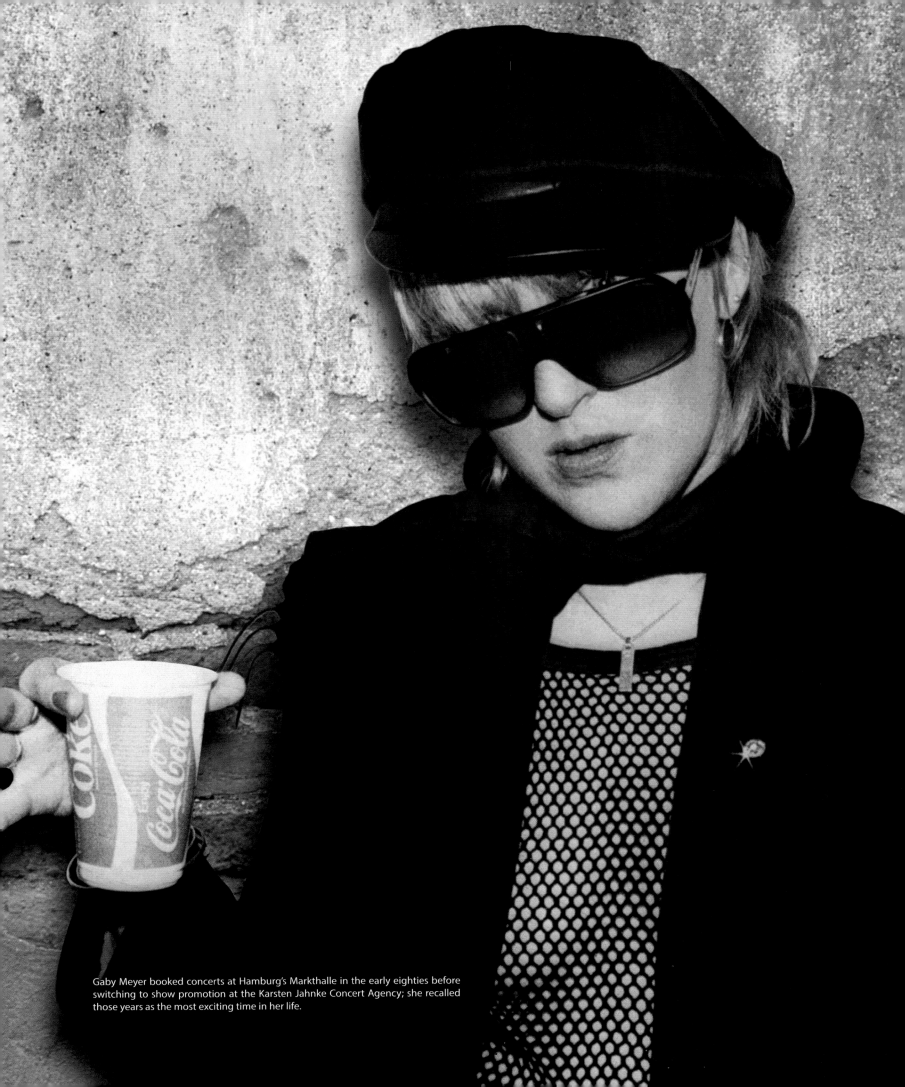

Gaby Meyer booked concerts at Hamburg's Markthalle in the early eighties before switching to show promotion at the Karsten Jahnke Concert Agency; she recalled those years as the most exciting time in her life.

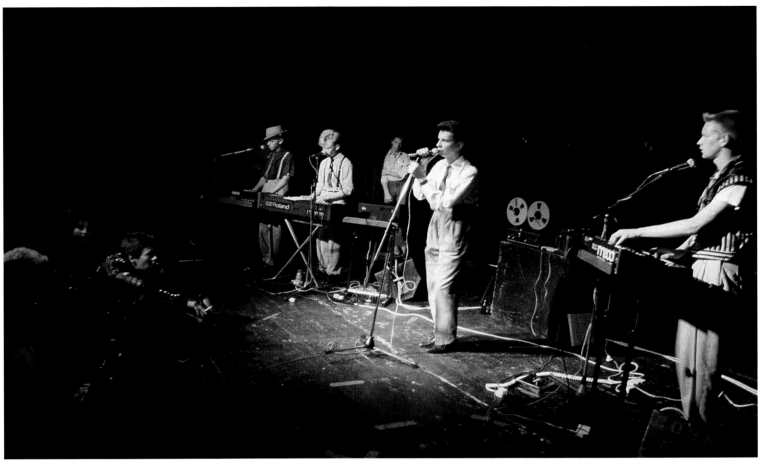

Depeche Mode's first show in Germany took place at the Markthalle in Hamburg on September 25, 1981. *Endlösung*, a north German punk fanzine, later wrote that the show was "an unusually stupid and superfluous concert."

Meyer: As a concert promoter, you're also helping to build the bands. In that way, it's an investment.

Jahnke: And we built up a number of bands . . .

Meyer: We worked with other synth bands in the early eighties, Blancmange and the Human League, for example. The singer from Human League unfortunately came across as quite arrogant. It wasn't like that with Depeche Mode, they were really friendly, calm, funny people, especially Fletch.

You first heard about Depeche Mode through Dan Silver?

Meyer: Yes. His company is called V.A.T., a great name: Value Added Talent. Those sessions were always fun.

Jahnke: Yeah, Dan Silver is a good guy. It's always nice when you also get along with people personally.

Meyer: We started planning new concerts with Depeche Mode pretty quickly after their first show in Hamburg, in March '82. We wanted to print the swan from *Speak & Spell* in silver on the tour posters, but the printer told us that nobody would be able to make out anything when the sun was out because of the reflec-

Kultur-Notizen

New Romantic heißt jene neue Musik-richtung, die in Londons feinem Jugend-club „The Blitz Bar und Restaurant" ge-boren wurde. Das erste Konzert dieser neuen britischen Welle auf hanseati-schem Terrain gibt die Gruppe Depeche Mode am 25. September in der Hambur-ger Markthalle. Musikalisch und optisch wird's ein recht synthetisches Erlebnis werden. Gekleidet in Phantasie-Unifor-men und Kostümen (zum Teil orientiert an viktorianischen Originalen), stützen die New Romantics sich auf elektroni-sche Klänge aus Rhythmus-Maschinen und Synthesizern. Für Hamburgs Blitz Kids wird es ein kurzes Vergnügen: De-peche Mode spielt nur 45 Minuten. Be-ginn: 21 Uhr.

Announcement for Depeche Mode's first show in West Germany, in Hamburg.

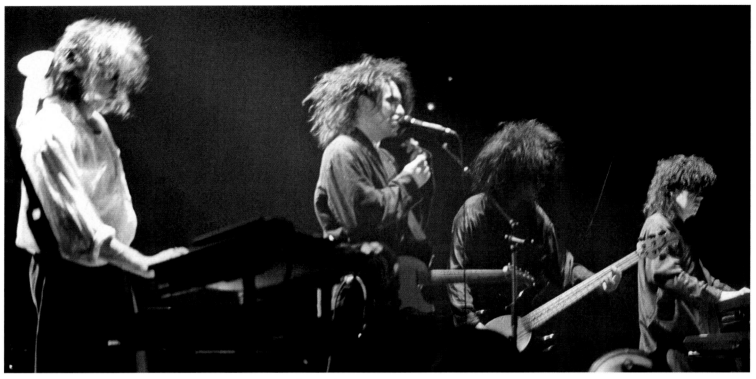

The Cure live in West Germany, 1985.

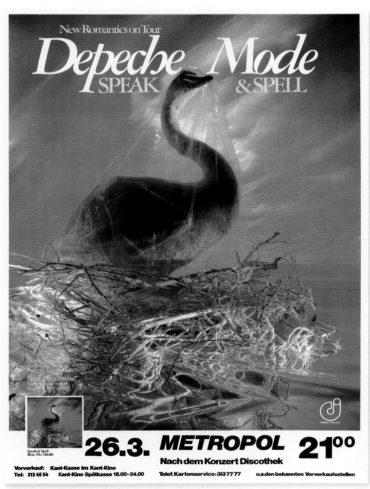

New Romantics on Tour—Depeche Mode live in West Germany, 1982.

tions. So we had to leave it off. I messed up the "New Romantics on Tour" slogan on the tour poster. The band and Dan teased me about it for a long time, singing "*We're the kings, we're the kings . . . of the New Romantic scene*" backstage.

You were working with other new bands from England as well at the time, the Cure for instance . . .

Jahnke: Yes, although we weren't their first promoters in West Germany. Initially, Alfred Hilsberg of Rough Trade Germany was looking after the band here in Hamburg. I still remember the conversation with the Cure's manager. He was there in our office and said that he loved Alfred Hilsberg but the man was completely disorganized, and he couldn't ask the band to deal with that anymore. And then he asked if I would be interested in putting on shows for the Cure. I said, "Yes, of course," and after that we organized tours for the Cure in Germany.

We put on one legendary show with the Cure in June 1985 at the Stadtpark in Hamburg. Some concerts you never forget about your entire life—that was one of them. The opening act started at three p.m. and played until three thirty. The Cure were supposed to play at four, but the band just didn't come onstage.

People were getting really pissed, and then I realized why: around four thirty, a pitch-black rain front came in, and right at the moment that it started to rain, the band came onstage and started to play. The Cure fans were all dressed in black— they had come with their hair teased up and in makeup . . . and it was raining. Nobody had a rain jacket or anything. Everyone's hair drooped, and makeup was running down by the barrel.

Depeche Mode put out an album and went on tour every year between 1981–1984, growing more successful each time. What was it like preparing for tours like that?

Jahnke: It was Gaby's job to take care of the organization for the Depeche Mode tours, including talking with Dan Silver and his people. They weren't tours that you organized on a moment's notice—the negotiations and work started at least half a year before.

Meyer: We would receive the info about when the band wanted to be on tour again, and a time frame for West Germany from the label or Dan Silver—for example, "Before they'll be in Sweden, after that in Italy," etc. . . . Then we would call up concert halls in different cities and ask whether they were available within that time frame. Then came all the tinkering and jostling; they always wanted to keep costs as low as possible with the routing.

Preparing took anywhere from three to six months. Venue capacities were the most important thing. You have to realize that in the eighties there weren't as many large concert venues as there are now. In Hamburg, the biggest concert venue was the Sporthalle, with a capacity of 7,000.

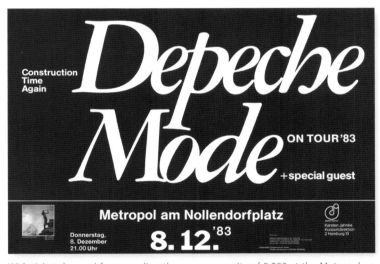

With ticket demand far exceeding the venue capacity of 2,000 at the Metropol on Nollendorfplatz, the show was moved on short notice to the Deutschlandhalle, which could hold up to 10,000.

The first time Depeche Mode played Berlin's Deutschlandhalle was on December 8, 1983. I was at the mixing desk and was just amazed at how large the hall was. The audience was totally losing it. At that point they already had railings in front of the stage to keep the crowds back, and were working with extra security.

During sound check, Dave looked up and spotted a large old slogan above the lighting rack: *People, animals, spectacles.* The phrase was left over from the late 1930s, when the Deutschlandhalle regularly hosted a circus. Dave asked what it meant and I told him. "We don't want that," he replied, and asked whether it could be taken down. It wasn't possible, it was built in. A discussion followed backstage; Dave didn't want to perform beneath the logo. Fortunately, it occurred to me that during the show it would

be pitch black up there and nobody would see it. And with that, it was problem solved.

How did it work with concert posters?

Jahnke: We either got templates from England or the German record company, and then had additional posters printed with simple text.

Meyer: We always had both—our own text posters and then the official tour posters. We had a good connection to Dan Silver and Daniel Miller, so we were able to explain that the lettering for the tour posters had to be larger in West Germany—in the bigger cities, there were so many different posters up that you had to make your own easier to recognize.

Jahnke: You could talk with them about those things, explain it to them, and then it would happen that way. The thing that bothers me about some managers today is that they have no clue about the particularities of the German market, and just go ahead with their own ideas.

Meyer: The record company also promoted the shows. They would work with our department as well as the venue organizers, who had their own people for promotion.

Jahnke: We've always worked with local partners in each city. We do the same thing today.

Were there things that had to be cleared up on short notice while the band was on tour?

Meyer: There was obviously still a lot left to do then too. There was the whole technical setup to prepare for—we sent anything we already had to the technical director in England, who would then tell us what else they needed, along with the stage dimensions for the setup, and so on and so forth. That also went to the West German tour technician. A tour technician and a tour manager who did the books was always there from our end.

Jahnke: At the time, we were still printing the tickets ourselves and distributing them to different presales offices.

Depeche Mode had a major breakthrough in 1984 with the singles "People Are People" and "Master and Servant." Was that noticeable on tour?

Meyer: From 1984 on, we really encountered a sort of mass hysteria at Depeche Mode shows. The halls were packed with teens who were beside themselves. Jäki Eldorado, our tour manager at the time—

Jahnke: Who was also Germany's first punk rocker, by the way . . .

Meyer: With his presence and cool head, he managed to get thousands of audience members to take a step back from the stage before the band came on, so that the fans in the first row wouldn't get crushed. There still weren't any barriers in the hall at the time, and there were these rows of young girls up front fainting because things had gotten so crowded. Jäki is up there onstage, knees trembling, and made the announcement over the mic, and you could actually see it like a wave moving backward.

At that point, the guys in Depeche Mode were an endless cause for debate among the youth. It came from this kind of compartmentalized thinking: it was punks against bikers, pop people against punks, skinheads against punks, on and on. Before the show in Kiel on December 8, 1984, the police got word that a number of bikers were planning to mix in with the crowds out in front of the Ostseehalle. They got spooked and immediately started talking about "imminent danger."

They had set up these cameras out in the foyer of the hall without consulting us. I found out about an hour before the show was set to start, and told our tour manager, Harald Bullerjahn, to please get the police to take them down—what exactly did they want to film? It wasn't the concertgoers who were the problem. And if they had been, cameras only would have made sense out in front of the building.

Harald also brought the information over to—I think it was J.D. Fanger—and Depeche Mode found out. They immediately threatened not to perform if the cameras stayed. Then we told the police that, which put them in a really nasty mood.

Jahnke: There was one overzealous police captain who wanted entry into the backstage with a hundred other officers, and barked at me, "Clear the way or we'll do it ourselves!" To which all I replied was that I would call the venue manager.

Meyer: After both we and the manager informed him that we had a right to the backstage area, things calmed down again.

Jahnke: Eventually the whole thing resolved itself. Luckily, the band didn't find out about that as well.

Meyer: And just days after that, the Stadthalle in Offenbach saved us at the last minute.

Jahnke: That's right—at the Böblingen show in 1984, a US soldier in the audience had stupidly lit off a smoke grenade during the encore, just like that, without thinking about it, and several people had been injured. The next day, the Alte Oper in Frankfurt called off the upcoming show due to security concerns.

Meyer: We called around and managed to move the concert to Offenbach on short notice, which was nearby. I can still remember the Stadthalle calling Karsten and telling him, "We're not scared of large animals. We'll do it." So we got a shuttle-bus system together and had 4,000 concertgoers driven from Frankfurt

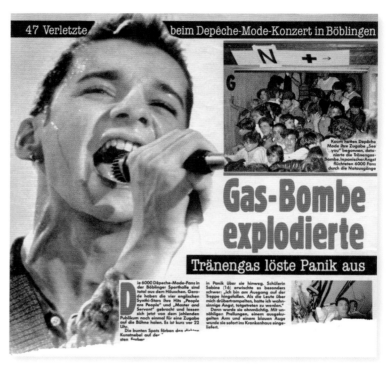

The incident at Böblingen on December 12, 1984, provided a welcome headline for *Bravo* magazine, though the article exaggerated what had occurred.

to the Stadthalle in Offenbach and back again. We arranged everything in half a day. And that was without a cell phone!

Jahnke: That's why it was so sad when we weren't able to work with the band after 1988. We didn't lose them because we hadn't done our work right and someone could level accusations. After the *Music for the Masses* tour, Dan Silver lost Depeche Mode to Steve Hedges's agency, and we were let go as well, unfortunately. Marek Lieberberg from Frankfurt took over for the band in West Germany.

Meyer: We were also a little offended somehow, because we really had spent so much time and effort on the band. Especially in 1982 on the second tour—things weren't exactly working out yet, and we had sunk some money into the band.

Jahnke: It's worse when you build a band up and then they ditch you the moment you finally start to make some money. We spent two years working on Depeche Mode in West Germany, but after that we quickly started earning money with them.

So it isn't uncommon in the concert business to work with bands that you initially lose money on, in the hopes that the next tours will work out better?

Jahnke: The first two Depeche Mode tours didn't bring in anything, financially speaking, but the band wasn't that expensive yet either, and our losses were limited. Even after the tours, everyone thought at that time that something would still come of Depeche Mode. There are also artists where you can quickly tell that noth-

ing will happen. But everyone had a positive feeling about Depeche Mode.

Meyer: We debated it at the office too: what did we see in the band, what was the record company saying, what did the press think? As far as the press went, there was *Szene* magazine from Hamburg, which didn't see a single Depeche Mode show that it liked. And even though they were on the covers of teen and music magazines from the mideighties on, the band remained down-to-earth. We weren't with them to see the wild days of the early nineties—we still had the nice boys from Basildon.

Your agency was responsible for a lot of bands in the 1980s. How important was Depeche Mode for you?

Jahnke: Depeche Mode was one of our most important bands at the time. When you had colleagues calling and telling you that the next time they really wanted to do Depeche Mode, you knew how important they were. All in all, we worked on a lot of good tours with them.

Meyer: I have one other good story from the life of a tour organizer. In 1984, the band had an Emulator II onstage, which at that time was a brand-new sampler with keys that had a lot of things running through it for the live show. Around noon on the day of the Münster show, the sampler broke—the band said, "We can't perform." To which we replied, "If the thing is *that* important, how is it that you don't have another one with you?"

Everybody was glued to the phones, the whole agency shut down. I was standing there with three phones, Karsten just the one. Daniel Miller was with the band, and wanted to try getting the thing fixed. At first we called the manufacturer E-mu Systems in the US—it was very early morning with the time difference—and tried to fix the Emulator with a direct connection between America and Münster. But it didn't work, and time was running short.

Miller then suggested that if we could dig up a second machine, he would program it. So we asked the contact at E-mu Systems whether someone else had an Emulator in Germany. "There must be a second guy. Hold on," he replied. He called around, then called back and told us there would be one at Conny Plank's studio near Cologne.

We called Conny up immediately and he told us that he had just lent his Emulator II to a studio musician in Bremen. We got his address and phone number, but he was already in Bremen and on the way home from his studio, Emulator in tow. He lived in some village outside town, and there were no cell phones at the time. So we told his wife over the phone that when her husband got home, he should call Hamburg right away. It kept getting later and later. When we got him on the line, we asked him to jump on the highway right away and drive to Münster.

He had some kind of junk car, though, so we told him to get a faster one. He raced to Münster in a Porsche. Outside the city, he even got a police escort so that he could make it through to the venue on time without any trouble. Münster isn't Hamburg, by which I mean a lot of concertgoers had come from out of town, and had buses to catch back home after the show. The crew had been telling jokes to the crowd from stage in the meantime. The concert finally started after about an hour delay. In the end, fifteen people were involved, doing everything they could so the concert would happen.

Jahnke: That's another example of positive stress. Because if it hadn't worked out . . .

Meyer: But it was the unfettered ambition of everyone involved to somehow still make it happen. Everyone wanted to save the show.

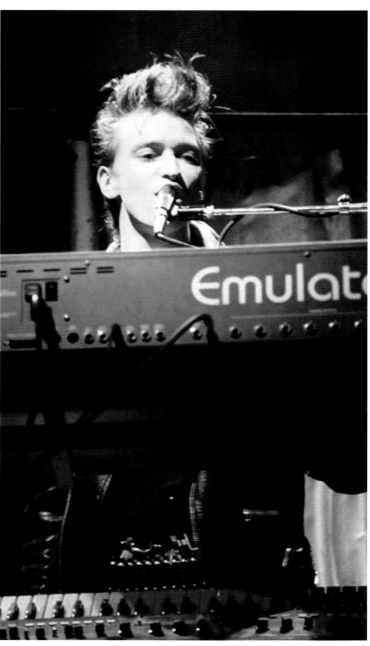

Alan Wilder behind his Emulator II on tour, 1984.

Gesellschaft für
Industrie-Elektronik
Verfahrens- und
Regelungstechnik mbH

1. Etage

hansa
tonstudios

RIEDEL
Industrie Elektronik GmbH

intro
data

CVS
Couvert Versand Service GmbH

5. Etage

Martin Gore at Hansa Studios in West Berlin, January 1986.

Black Celebration

By November 1985 Depeche Mode had started work on their next album, with the gray London weather perfectly matching the mood of the music. Nearly all of Martin's songs were gloomy; even label chief Daniel Miller was concerned that they wouldn't reach the charts. Still, he, the band, and Gareth Jones kept at work despite the doubts.

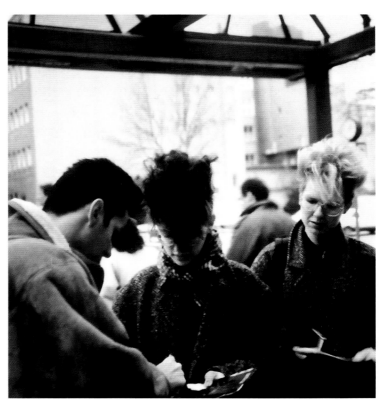

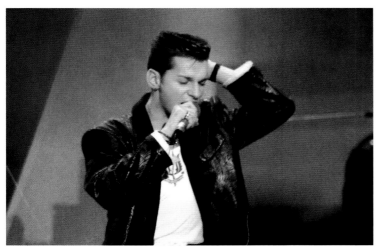

Depeche Mode may have been back in the studio in November 1985, but they were only too happy to pause their work for a slot on *Peter's Pop-Show,* one of the most important music programs in West Germany throughout the 1980s. There was also a gold record from Intercord for the compilation *The Singles 81–85.*

January 1986: While working on the new material at Hansa Studios, Depeche Mode stayed at the InterContinental Hotel. Word naturally spread like wildfire among fans, and autograph hunters could often be seen outside the studio and hotel.

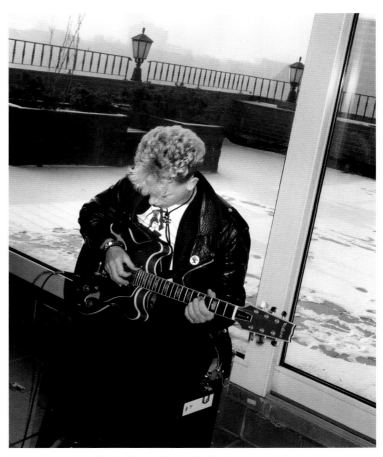

Artist pass for *Peter's Pop-Show,* November 9, 1985.

Martin Gore at Hansa Studios, January 1986.

West Germany the track cruised to number 4. By now it had become clear as day where Depeche Mode's most loyal fan base lay.

More TV appearances followed in March, most of them in West Germany, England, and Italy. In the meantime, Martin had packed his bags in West Berlin and joined the other band members in London and it was there, the album still unreleased, that rehearsals for the upcoming tour began at Nomis Studios.

Finally, on March 17, 1986, *Black Celebration* came out in stores. Depeche Mode had never struck such a somber tone, not just on the cover. Yet initial concerns about the record proved unfounded; the album spoke directly to many teenagers, and fans the world over were taken with it.

Legendary producer Gareth Jones at Hansa Studios, 1986.

In early 1986, the band returned once more to Hansa Studios in West Berlin, concentrating mostly on mixing the songs and filming a video for the album's first single, shot along the Berlin Wall.

"Stripped," a heavy-hearted track, arrived in record stores on February 10, 1986. Four days later, still in the middle of recording the new album in West Berlin, the band took a small charter plane to premiere the song at the Sanremo Music Festival in Italy.

In the UK, the new single only made it into the top 20, while in

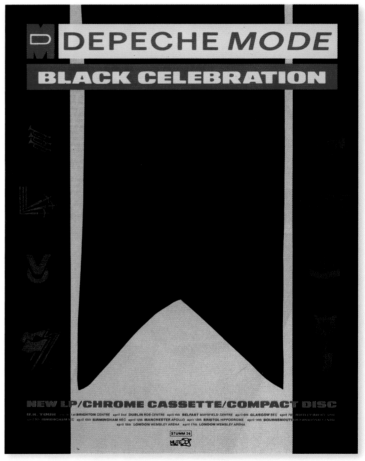

Advertisement for the UK album release, including UK tour dates.

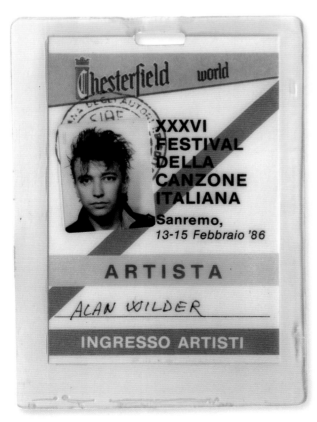

Alan Wilder's artist pass for the Sanremo Music Festival, February 14, 1986.

At a time when the music charts were inundated by flashier and flashier bubblegum pop à la Modern Talking, Bad Boys Blue, and Samantha Fox, Depeche Mode had delivered an album far outside the mainstream. Followers of the band immediately rewarded the decision: *Black Celebration* reached number 3 on the album charts in the UK, and number 2 in West Germany.

Leading up to the tour, Depeche Mode made a number of TV appearances, including several in Germany. On March 7, they gave two consecutive performances of "Stripped" in Cologne for *Peter Illmann Treff* and the *WWF Club*. On March 17, they returned to Sanremo, then on March 21 they performed two new songs, "A Question of Time" and "Black Celebration" live for the English TV show *The Tube*.

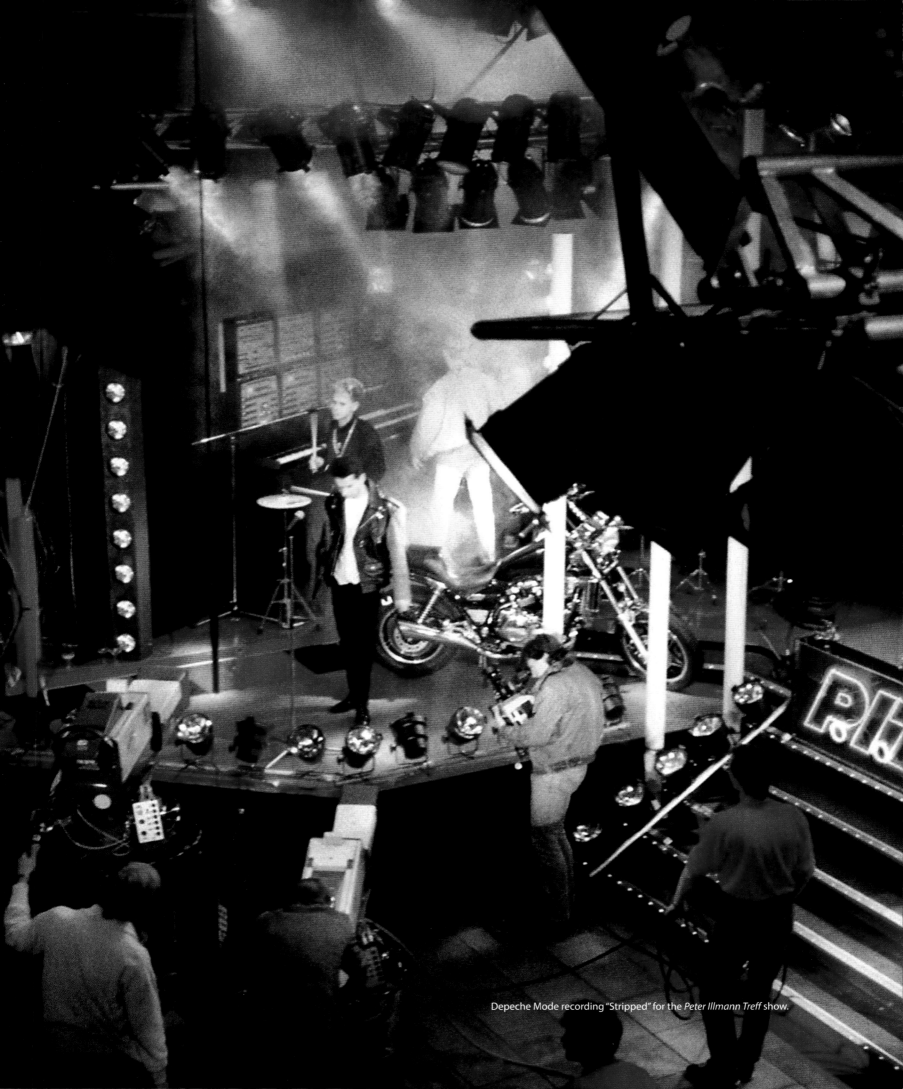

Depeche Mode recording "Stripped" for the *Peter Illmann Treff* show.

Let's Have a Black Celebration

The *Black Celebration* tour opened on March 29, 1986, with a concert at Oxford's Apollo Theatre.

Days later, "A Question of Lust" was filmed lived at the April 2 show in Dublin, sequences from which were later used in the music video for the single.

The UK leg of the tour had Depeche Mode playing in larger

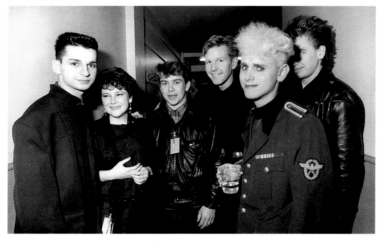

Before the tour opened in Oxford, the winners of a competition organized by tour sponsor Harp Beat had a chance to meet the band. On previous tours, similar meetups had come down to the band's mood or pure luck; now meetings were organized.

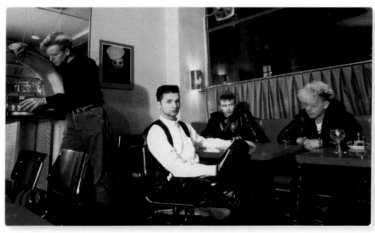

venues than before. If to date the band had mostly played in stately, older music theaters with capacities of around 2,000 people, now they were in halls with capacities of up to 10,000.

On April 9 and 10, the band played two consecutive nights in Birmingham. A journalist from West Germany's *ME Sounds* magazine was among the crowd, though he was unable to share its enthusiasm: "The arc of suspense in the live presentation in any event showed serious fluctuation, becoming completely tiresome when Martin Gore caught hold of the techno-blues and trudged up to the edge of the stage, mic in hand." Nonetheless, "Six thousand kids were all enthusiastically celebrating Dave, Andy, and Co."

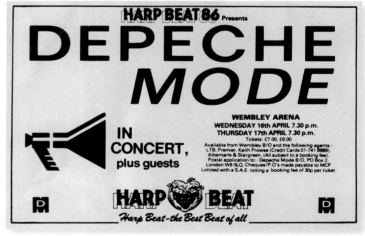

Concert ad for London's Wembley Arena on April 16 and 17. Located next door to Wembley Stadium, the indoor arena had already played host to stars like David Bowie, the Rolling Stones, and Pink Floyd.

On April 16 and 17, Depeche Mode played London's Wembley Arena for the first time in front of 8,000 people.

British magazine *Smash Hits* gave a downright enthusiastic review of the London show: "Five years ago Depeche Mode were one of the worst live groups ever imagined . . . Depeche Mode have developed into . . . well, simply brilliant performers."

The *Black Celebration* tour was also the first time Dave was able to make use of a radio microphone, giving him much greater freedom of movement about the stage. While Martin, Andy, and Alan

A band photo given away for free at shows by the UK tour sponsor.

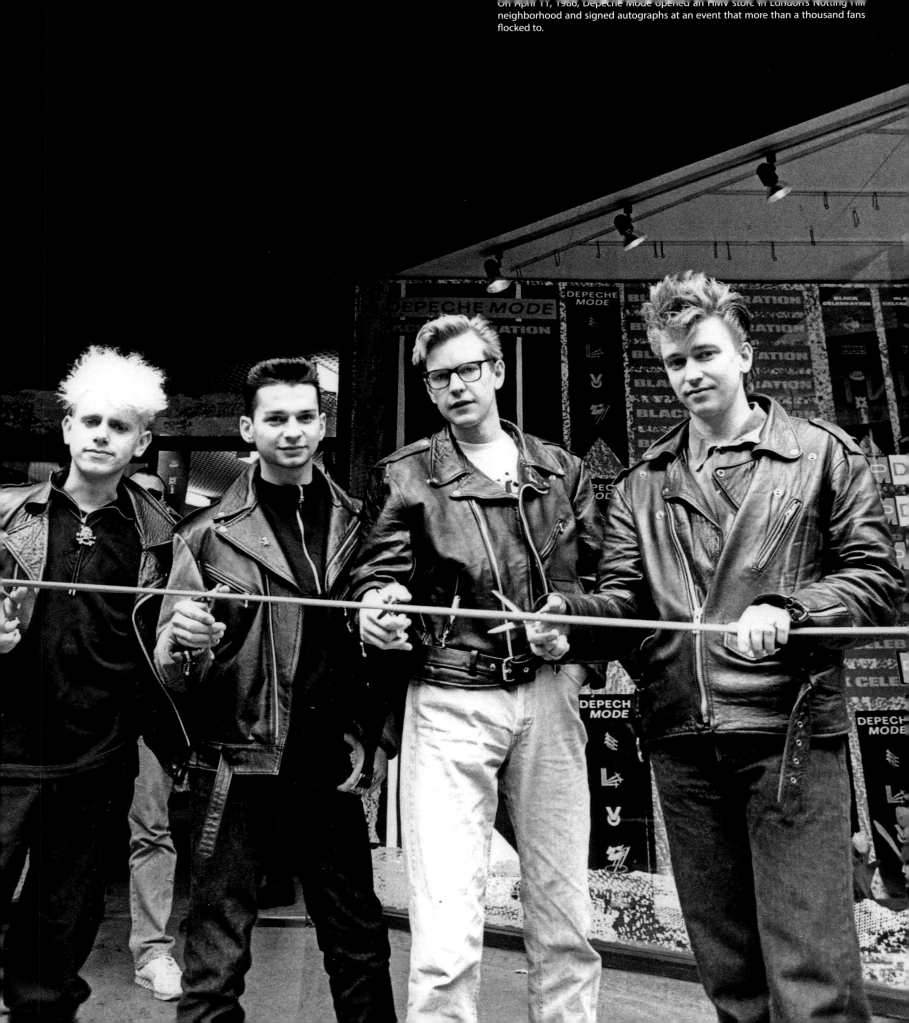

Beneath the black flag: tour pin from the *Black Celebration tour*, 1986.

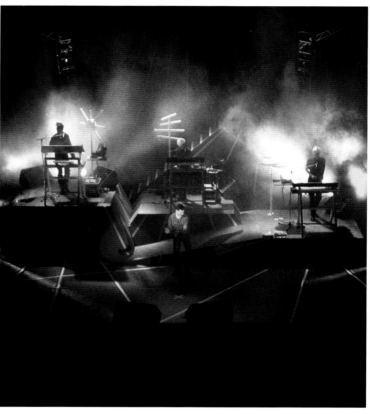

remained behind their keyboards on tall pedestals as before, Dave had the front area of the stage to himself for dancing. In addition to the keyboard pedestals, the stage featured specially designed metal structures that could be triggered to create sound effects using drumsticks.

The tour set list had twenty songs, including three from Vince Clarke's time with the band and "It's Called a Heart," a surprise today considering how much the band disparaged the song in later years. The centerpiece of the live performance was the light show, again designed by Jane Spiers.

The futuristic stage design from 1984's *Some Great Reward* tour continued to evolve on the *Black Celebration* tour. Jane Spiers's light design was especially effective, setting the perfect ambience and entrancing fans.

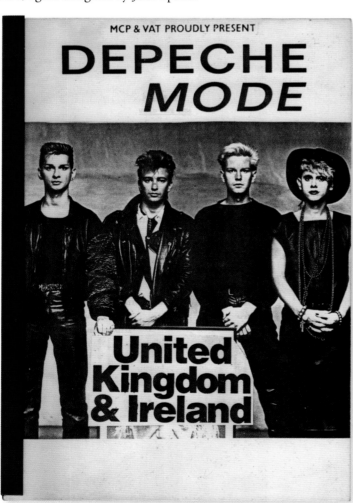

Crew itinerary, March 29–April 17, 1986.

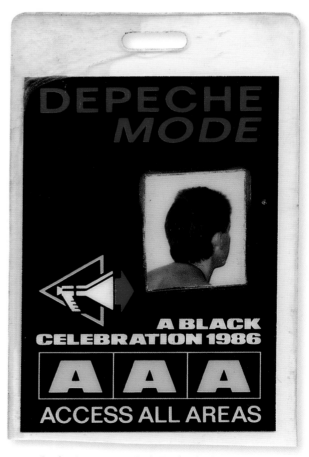

Production manager Andy Franks's backstage pass.

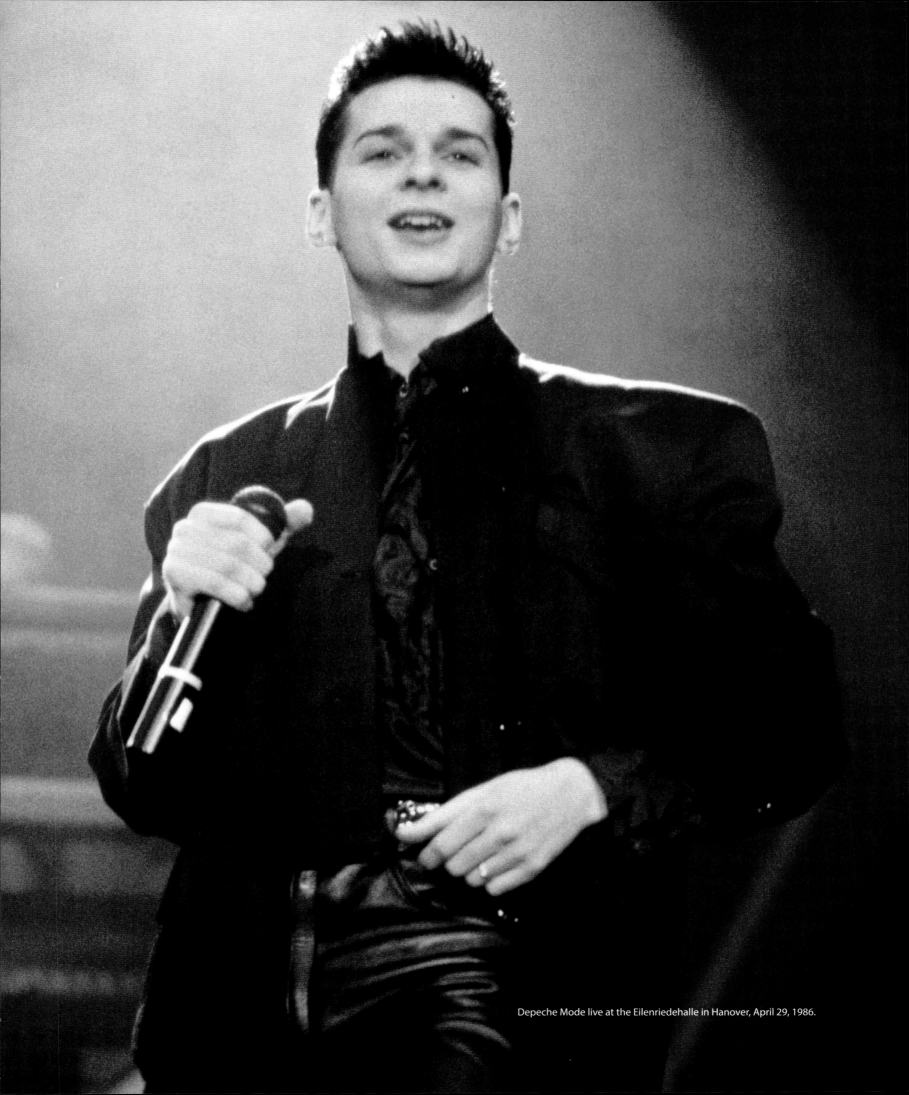

Depeche Mode live at the Eilenriedehalle in Hanover, April 29, 1986.

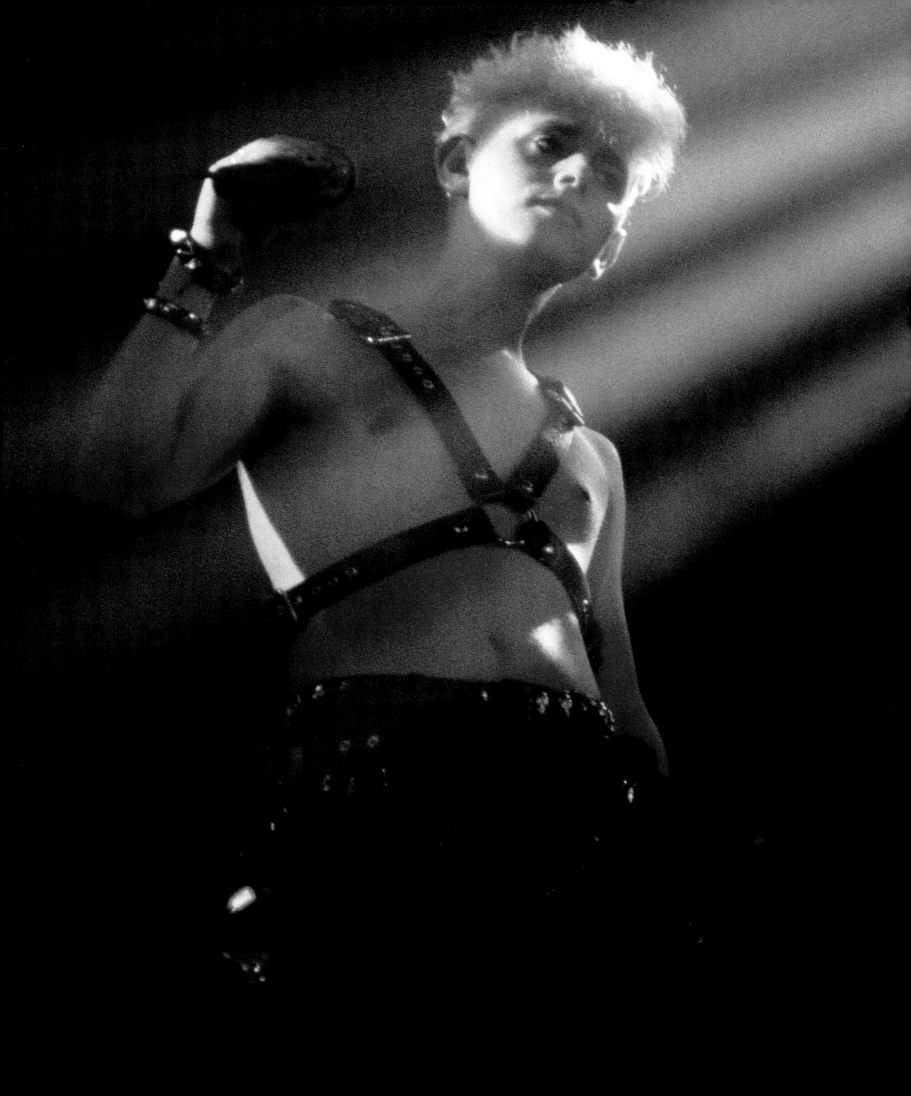

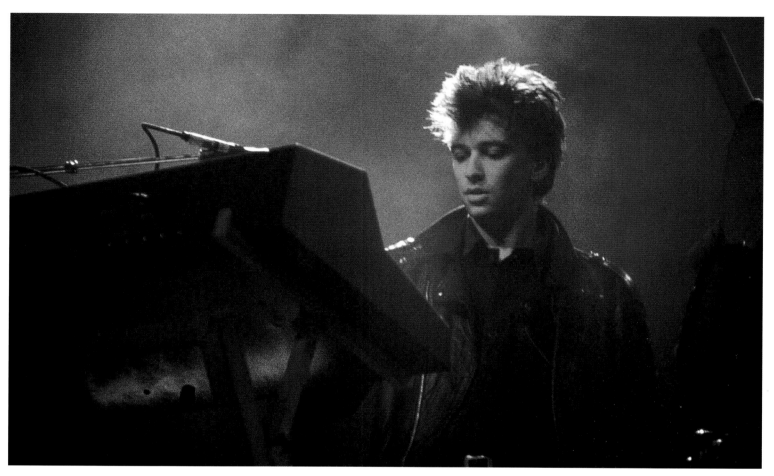

The band played thirteen shows on the UK and Ireland legs of the tour, during which time "A Question of Lust" came out on April 14, 1986, the first Depeche Mode single featuring Martin on lead vocals rather than Dave.

After a one-week pause, the tour picked back up on April 24 in the Norwegian capital, Oslo. In Scandinavia, too, the band's audience continued to grow; more than 5,000 came in Gothenburg, Sweden, and over 9,000 in Stockholm.

DEPECHE MODE · *A MATTER OF TASTE* (COPENHAGEN 1986) · 2LP BOOTLEG

One of the most popular bootlegs from 1986's *Black Celebration* tour was recorded in Copenhagen on April 28, 1986, later appearing with the title *A Matter of Taste*. As with other bootlegs, different versions came out on various formats, including colored vinyl.

The band played a total of fourteen shows in West Germany. An interview from their April 29 show at the Eilenriedehalle in Hanover between the doctor on call at the venue and a radio journalist for Norddeutscher Rundfunk illustrated the hysteria surrounding the band: "We're heading for a new record. We've already recorded thirty-five cases of near fainting, and that's even though the concert hasn't begun." That evening, the Red Cross was called in to attend to a hundred young concertgoers.

An unusual kind of sporting event took place a day before the

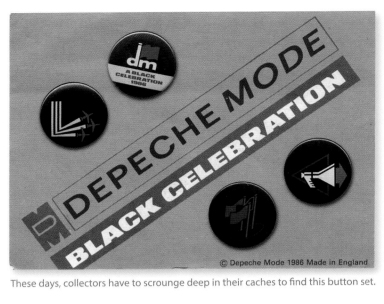

These days, collectors have to scrounge deep in their caches to find this button set.

band's May 2 show at Hans Martin Schleyer Hall in Stuttgart, as a way of breaking up the intermittent monotony of life on the road: a game of soccer between Intercord, the Stuttgart label that licensed the band's music in West Germany, and a number of the tour crew. Hans Derer, media head for Intercord, later recalled with a wink that "the band was so into football that I think they recruited their touring crew based on how well they could play."

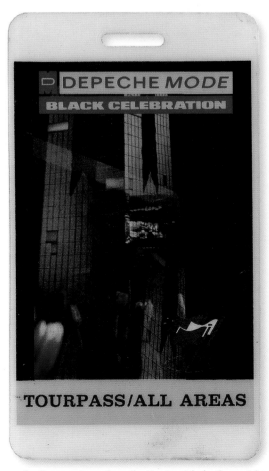

Backstage pass for German shows from the Karsten Jahnke Concert Agency, 1986.

Crew itinerary for April 28–May 25, 1986.

On May 18, 1986, following two shows in Brussels and one in Rotterdam, Depeche Mode played West Berlin's Waldbühne, performing against the impressive backdrop to nearly 20,000 fans.

The show stuck with the band for another reason as well. Alan recalled for the *Depeche Mode Information Service* that "Berlin was particularly interesting as we played the Waldbühne Stadium, which is an open-air venue built by Adolf Hitler before the Second World War. It was where he held his propaganda rallies. The feeling backstage was weird, we felt we could actually feel the 'vibes' from forty years ago." The first European leg of the tour finished on May 25, 1986, with a show in Rüsselsheim, Germany.

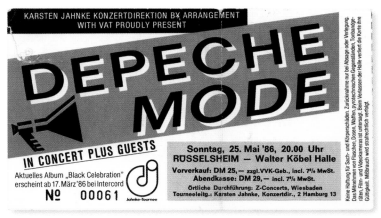

Ticket for the last concert on the European tour, in Rüsselsheim, May 25, 1986.

Alan with fans in Lyon, May 8, 1986.

On the eve of their Zurich show on May 4, the band received a gold record for *Black Celebration*. Three shows in France followed—two sold-out nights on May 6 and 7 at the Palais Omnisports de Paris-Bercy (today's Accor Arena) and a third at the Palais des Sports in Lyon.

Backstage pass for the *Black Celebration* tour, 1986.

Black Celebration in North America

One week after the end of their European tour, Depeche Mode began a one-and-a-half-month leg through North America on June 1, 1986, at the Wang Center in Boston. The band played twenty-eight shows across the US and Canada, including three sold-out performances at New York's Radio City Music Hall.

Ticket from the kickoff concert in Boston, June 1, 1986.

Many of the concerts took place under perfect weather in beautiful amphitheaters like Red Rocks in Denver and the Irvine Meadows Amphitheatre in Laguna Hills, California. Martin especially took a liking to California's mild climate.

Of the band's show at the Austin City Coliseum on June 28, one local newspaper wrote, "The crowd came with a sole

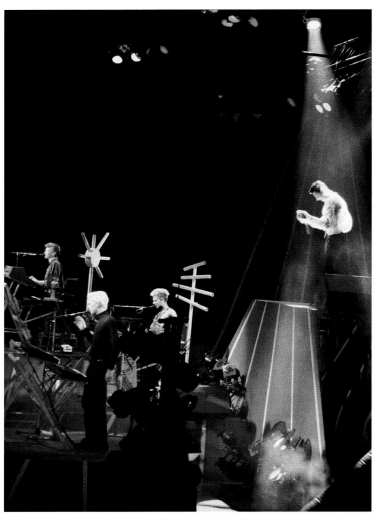

Depeche Mode live at Radio City Music Hall in New York, June 8, 1986.

purpose—to dance. The band came to play and make them dance. In fact, if the crowd had its way, the dancing would not have stopped."

Fletch recalled, "At the end of the European tour we were physically drained. Despite this, we only had a few days' rest before the daunting prospect of the American tour. We had toured the US the previous year and had an unexpectedly enjoyable and successful time. This year, though, was our biggest to date and we were visiting places where no electronic band had ever been . . . We expected to do well on the East and West coasts, but in middle America we were prepared for the worst. In the end, though, the whole tour was a huge success. Despite minimal support from radio stations, people turned up to the concerts in thousands . . . The only minor disaster we had was in Washington, DC, where the electricity was cut off, luckily on the last beat of the last encore, 'More Than a Party.' It was an amusing sight to see the security staff holding up lights and torches so the crew could pack away the equipment."

The last date of the North American tour came on July 15 in Irvine, California. Live clips from the show, filmed by Anton Corbijn, appeared later in the music video for "A Question of Time." Aside from a single photo for *NME* in 1981, it was the first time

Crew itinerary for June 1–July 15, 1986.

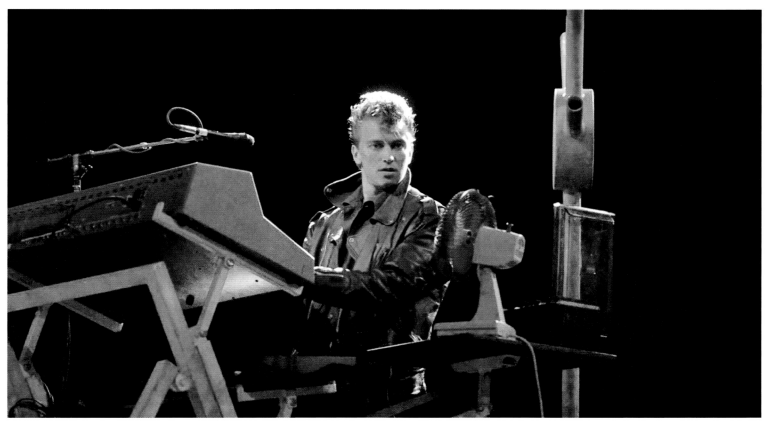

Alan onstage at the Irvine Meadows Amphitheatre, July 15, 1986.

"A Question of Time."

The award presented to Alan Wilder for two sold-out nights at the Irvine Meadows Amphitheatre.

the Dutch photographer and the band had worked together. It wouldn't be the last.

The band's rapid growth in popularity in the US came as a true surprise, and a pleasant one at that. Alan remembered: "We went on a tour that just seemed to take off, particularly in America. It seemed to be where we stepped up a gear and went from playing smallish club venues through to quite big arenas. So things moved very rapidly from that point onwards."

Arena Tour '86

Instead of returning home after the North American tour, Depeche Mode initially flew to Japan for three shows, playing on July 21 in Osaka, and Nagoya the following day. On July 23, 1986, Martin's twenty-fifth birthday and the day before playing at Tokyo's NHK Hall, Depeche Mode performed "A Question of Lust" on the Japanese TV show *Yoru No Hit Studio Deluxe.*

After Japan, the band opted to play a handful of open-air summer concerts in Europe. Arena Tour '86, as it was called, began on August 4, 1986, taking the band to Italy for two concerts, followed by four in France. The shows took place during the holiday season for both countries, and were scheduled in popular vacation spots.

The third single from *Black Celebration*, "A Question of Time," came out on August 11, 1986. An open-air show was planned that

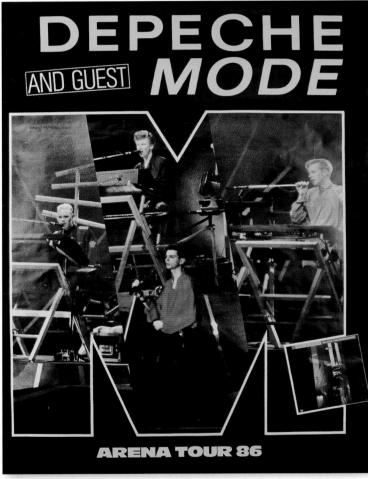

Poster for the Arena Tour '86.

same day for Royan in France, but had to be canceled on short notice due to torrential rain.

The band celebrated the end of its Arena Tour '86 on August 16 in Copenhagen, performing alongside two other English bands, New Order and Talk Talk.

In spite of the darker sound of the music, the band enjoyed itself on tour, relying in particular on a live crew that had grown to

Andy in high spirits, surrounded by fans after the final show on the *Black Celebration* tour on August 16, 1986, in Copenhagen.

forty people and become an integral part of the band. Among them was an American named Jonathan Kessler, who initially worked as a bookkeeper before coming on as the band's manager in the midnineties.

Dave had his own special memories from the *Black Celebration* tour: "The crew tend to play tricks on us a lot. At one of the last gigs, they covered the riser with all these porno pictures to try and put me off. They succeeded."

Between late-March and mid-August 1986, Depeche Mode played a total of seventy-five concerts around the world. Back from tour, they took things somewhat easier the rest of the year, although work continued, especially promoting "A Question of Time." They also continued to make TV appearances, going on shows like *Top of the Pops* and *Peter's Pop-Show*, which had become nearly compulsory.

In spite of all the sold-out concerts in North America, Depeche Mode didn't fully succeed in breaking through in the US in 1986, nor was every single from the album released there. The band's American label, Sire, for example, didn't view "Stripped" as hit material, and went instead with "But Not Tonight," the B-Side to "Stripped," in late October.

Martin, Andy, Alan, and Dave didn't think much of the idea, and had left the country once again with the impression that their US label didn't completely understand them as a band.

Be that as it may, the label largely chose "But Not Tonight" because it had been selected for the soundtrack to the teen film *Modern Girls.* Doing so, the thinking went, would help the band gain greater recognition among their target audience. As it turned out, neither the film nor the single were particularly popular with US audiences, so as of 1986, Depeche Mode remained a partially hidden gem. At least for the time being . . .

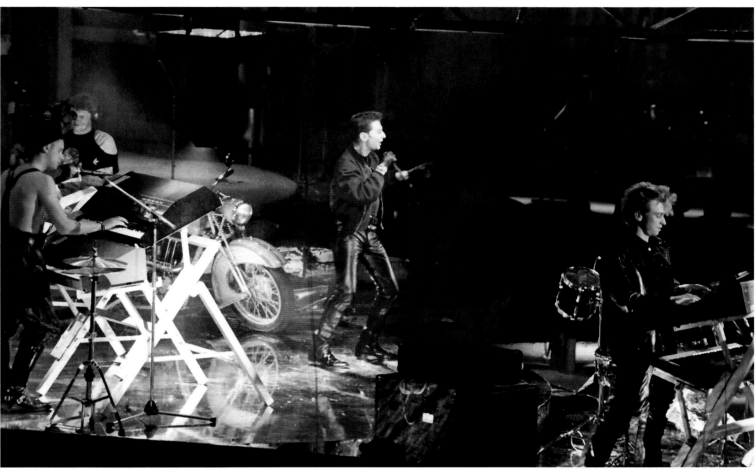

Depeche Mode on *Peter's Pop-Show*, November 22, 1986.

Backstage pass from August 16, 1986, in Copenhagen.

Artist pass for *Peter's Pop-Show*.

Interview with Dan Silver

How did you get the job as a booking agent in the music industry?

Music was always a major influence in my life. I knew instinctively from an early age that it held a power to communicate and to change things. From my very earliest days, listening to the radio was a huge window to my world. I listened to the top 30 album chart show every week, and from age eleven I had my first record player. I still remember the huge disappointment in 1963 that Christmas when my uncle had given me an album by Freddie and the Dreamers instead of the Beatles album I had asked him for. He told me that to him, "all the groups sound the same." But even at such an early age, I knew that was completely wrong!

A huge influence on me was the first album by the Velvet Underground. Age fifteen in 1967 when it was released, I used to play this album repeatedly, holding the record player loudspeaker so close to my chest so that the vibrations would literally pass through my body. Later in my music career, I was to act as agent and manager for John Cale, which I always considered to be an honor.

I listened to a huge spectrum of music. At home, my father would play jazz and classical music all the time. I listened to the "alternative" radio stations that played more adventurous music, such as Radio Luxembourg, and when pirate radio stations began, I graduated to listening to Radio Caroline and others. One very significant pirate station was Radio Geronimo, who opened my ears and mind to many of the American groups that I really rated—the Doors, Steve Miller Band, Joe Walsh, bands like Quicksilver Messenger Service, Love, Little Feat, J.J. Cale, Allman Brothers, Spirit, Janis Joplin, and the like. Along with the US bands I mention above, I took chances and listened to more obscure music and acts such as Can, Amon Duul II Nektar, and so on. And more obvious acts too, like Led Zeppelin, King Crimson, Simon and Garfunkel, John Martyn, Jethro Tull, Pink Floyd, Traffic, Cream. And obviously the Beatles and Stones and the other bands of that era.

It was completely obvious to me as a teenager that music was my major interest. I played in live bands—first bass guitar and then lead guitar—and I wrote some songs too. But I considered myself as having more potential than just "being a musician," and decided that I wanted to look for more of an executive role in the industry. I used to go to as many concerts as I could possibly afford to, plus of course to the many free concerts that were available in the late sixties and seventies. I grew up to the soundtrack of Pink Floyd, adopting them as my band on the release of their awesome first album, *Piper at the Gates of Dawn*, in 1967. This record was so completely different to everything I had ever heard before.

I saw Pink Floyd repeatedly from their earliest years going forward. Sometimes my own band would play at the same venue as them—but never on the same program. As well as seeing many of my heroes play concerts in London, I would travel to see bands. In 1968, at age sixteen, I hitched to the first ever Isle of Wight Festival, where I saw heroes Jefferson Airplane amongst many others. On the same day, after seeing the Stones play their famous concert at London's Hyde Park in 1969 (just after Brian Jones's death), I walked through Hyde Park to the Royal Albert Hall and that evening saw Chuck Berry and the Who. I don't think there could ever be a better day to enjoy as a teenager. I have seen many of the greatest acts live, ranging from Pink Floyd to MC5 to the Ramones to Springsteen and Santana, David Bowie, and many other legends.

I was also at the first ever Glastonbury Festival in 1970, again traveling on my own, hitching rides. It was known then as the Pilton Arts and Music Festival. It was a small affair, no more than 1,500 people, but it was amazing seeing the bands—T. Rex and Donovan, Country Joe, and many others—and being with like-minded people. Music commanded my heart with its strong alternative message and its counterculture agenda. I was at the Who show in Leeds when they recorded *Live at Leeds*. I saw Jimi Hendrix play live only once, at the Isle of Wight Festival in 1970. This was weeks before his untimely death, and actually a big disappointment. Jimi no longer had the Experience as his band, but the rather ragged Band of Gypsys performing newer songs and none of my favorites.

I grabbed the possibilities that music opened up with both hands and wanted to make sure that it would be a significant and deep part of me.

Music was like my constant companion—it could soothe or stimulate, and move me in ways that I can't really put into words. I recognized and embraced its power.

I soon worked out that one of the few ways into the music industry was to go to university to become the entertainments officer of the student union and promote the live entertainment. So that was my career plan. I went to the University of East Anglia in Norwich in 1972 and worked on the entertainments committee in my first year, sitting in on the committee that decided the music we would book.

In the summer of 1973, I went to the US for the first time. I saw the Eagles in Central Park, New York, in 1973, as well as the Doors, John McLaughlin, and Mahavishnu Orchestra, and Sly and the Family Stone. I went to Watkins Glen Festival and saw the Allman Brothers, Doobie Brothers, and Grateful Dead. Music stayed my priority.

And that autumn, 1973, I was elected as the supremo, the entertainments officer. I had a good and enthusiastic team around me and a high profile, as I played frequently in live bands on campus, and so this was a perfect fit for me. I booked a wide and diverse program, which varied from the commercial to the interesting—Spencer Davis Group, 10cc—and also in part indulged my personal taste with acts like John Martyn and Country Joe McDonald, most famous for his anti–Vietnam War song, Gentle Giant, Procol Harum, and also the Robin Trower Band. Another highlight for me was booking Captain Beefheart, who I simply worshipped for his amazing album *Clear Spot*. It is definitely one of my best ever ten albums.

I had done well commercially with the bands I had booked, and

we realized that we would make an end-of-year profit with this final concert with the Captain. But soon after I had booked them, I found out that the Captain had fired the Magic Band, and was touring with a completely different lineup. Then I heard the new album released on Virgin, which was a million miles away from *Clear Spot*. Instead of a masterpiece, it was a relatively disappointing "love" album. I renegotiated the fee downwards to bitter resistance from the agent, but still paid enough to keep the show. I discounted the fee because I thought that was commercially correct. But also because I was never going to hear live Mr. Zoot Horn Rollo hitting that magic note and letting it float.

After my year of booking the bands at university, I was offered a job at a booking agency in London and worked there in the summer of 1974. But it was not the best environment for me. I did not rate the bands I was booking very highly, and I didn't really see it as a good prospect. After working there for three months over the summer university holiday, I left the job and went back to Norwich that autumn to complete the final year of my degree. I graduated in 1975, when unemployment was high, and then I had to do some jobs that I hated and were in severe conflict with my values and what I wanted from my life.

When finally in 1977 I got a second job offer as a booking agent, I went for it. I worked in a small agency in the amazing period when punk and new wave had just started. Every kind of music was described as punk or new wave, including Blondie and Talking Heads, right through to the Damned, Elvis Costello, and the Stranglers, to Tom Robinson. One of the first tours I was a part of was the debut tour by Stiff Records. Dave Robinson at Stiff was a genius innovator; he put all the bands on his label on the same tour, so the lineup was both eclectic and spectacular. Established rockers like Dave Edmunds and Nick Lowe shared the stage with Ian Dury and the Blockheads, a very fresh and exciting Elvis Costello and the Attractions, the Damned, Wreckless Eric, and 999. The marketing was both wild and effective too. The tour T-shirt read: *If it ain't Stiff, it ain't worth a fuck.*

This tour showed me the immediacy and impact of good planning. Overnight the tour was successful and many extra shows were added. All the musicians from the bands would get up onstage for the end of the show and sing what became the tour anthem, "Sex & Drugs & Rock & Roll."

This time around I had no doubts, I was exactly where I wanted to be: at the center of music as it happened and made its impact on the world.

How did you meet Daniel Miller and the then-unknown Depeche Mode, and why did you decide to work with them?

I had first met Daniel as a teenager through a mutual friend. We both lived in north London and shared a social circle. We both watched the influential TV show *Rowan and Martin's Laugh-In* at the Hanison's open house in Hampstead. Daniel was a year older than me and he went to a different school, King Alfred's. I didn't really get to know him very well. This would be around 1967.

Much later we were to meet professionally in 1981. I had al-

Daniel Miller: founder of Mute Records, the man who discovered Depeche Mode, and a constant ally to the band.

ready established myself as a happening agent when I was asked for a meeting by Depeche Mode, who of course were on his label, Mute. The acts I looked after were mostly quite left field—bands like the Gang of Four, Big Country, Hazel O'Connor who I toured very successfully around the hit "punk" movie *Breaking Glass*, Spear of Destiny, and the Au Pairs—who were a formidable and very early feminist group. I acted as agent and then manager as well for John Cale from the Velvet Underground. I had found and established Joe Jackson. And I looked after some more conventional bands such as the Inmates, who were a blues band. I had worked previously in the grassroots agency Albion that had invented the pub-rock circuit and introduced me to punk and the Stiff label legend. I also looked after a band called the Tourists which featured a rather young Annie Lennox and Dave Stewart. I had broad tastes and wasn't scared to offer something new in the marketplace, but Depeche Mode was quite a challenge.

I hadn't yet formed my own agency. I was then working within an agency called TBA International. I never became a director of that company, but within that office I established my own list of artists and clients as an income stream.

Around April 1981, Depeche Mode was looking for an agent, very likely advised by Daniel. I was "interviewed" by Martin and Andy. I think they were both a little nervous when they visited me at my offices. I explained how I liked to work closely with the artist and to understand what they wanted to achieve, that it was my job through creative and strategic planning to develop their live careers. I don't know what they made of the diverse range of acts I looked after, but I think they were interested by the sort of personal commitment I said I made to the artists I represented. I promised them that they would not play any "shitholes"—as inferior gigs then and now are still known.

After that first meeting with Martin and Andy, Daniel invited me to see the band play at the Pits, a basement-bar gig in central London, on April 30, 1981. Their set was short, as it featured only the songs on the first album. When they played "Dreaming of Me," I told Daniel it was a hit. He later told me they had mimed the song

to the cassette of the recording he had made—it certainly stood out in the set. It was very early days for them, but the band looked moody and interesting. Dave's voice came across well, and the songs were pumping with rhythm and interesting. I saw good potential.

How difficult or how easy was it in 1981 to get a young and unknown band like Depeche Mode concerts in the UK?

Pushing a "New Romantic" band on the established UK circuit was difficult. They were not an obvious contender for success. But because I had already developed the two-shows-in-one-day format for new wave/punk, of a matinee for under-eighteens and an evening show for everyone else, I already held the key that would open up venues to allow their younger fans to see the band.

Nor were Depeche Mode seen as very "credible," as they were very much considered to be a "pop" group. But that did not put me off, I enjoyed the novelty of the sound and a fresher, newer attitude.

Music is very tribe-like—you understand that the bands have that kind of an influence when most of the audience dress exactly like them, and this is what I saw.

We quickly reached an agreement that I would act as agent for Depeche Mode. By August of 1981, I had them playing their first national shows around the UK, Brighton, Manchester, Leeds, and Edinburgh, for starters. They were planned at vibey clubs and generated a lot of excitement. Knowing they had a young audience, they were set up as two shows a day, a matinee (afternoon)

show for under-eighteens and an evening show for the older audience. I made sure the shows were accessible; ticket prices were as low as I could set them. As I look back today, I am amazed to see ticket prices of only £1.25 for the matinee show and £2 for the evening shows.

By September that year, I organized for them to play a benefit concert for Amnesty International, at the Venue in London, a 1,200-capacity building. I arranged an afternoon performance for the benefit and a second evening show as a "benefit" for Depeche themselves, in which the band were paid what was at the time a fortune to them. I can remember much later hearing Depeche Mode talking about this show on a tour bus. About how they had come up to London by train from Basildon with their new synthesizers still in the original cardboard boxes. How even though it was supposed to be a benefit, they had earned such a large amount of cash to take home at the end of the day.

In late September, I arranged a first set of shows in Europe to introduce them to those markets and the Mute Records licensees. They played their first club shows in Hamburg, Amsterdam, Brussels, and Paris. The venues and fees were small, but this was a hugely important first step—for the band and just as much for the record label too. Daniel Miller reminded me recently that he acted as both the tour manager and sound engineer for these shows, and agreed just how important these first steps were for everyone.

My working philosophy for international planning was simple and effective. If you set up a live show in any country and then tell the licensee the band is coming to their country, then they are

Depeche Mode live on April 30, 1981, at the Pits, a basement bar that also hosted the first meeting between Dave, Martin, Fletch, Vince, and Dan Silver.

obliged to do something. The live show acted as a prompt, and dovetailed very nicely with interviews and TV show appearances that the licensees then set up around the shows. The live show was a lever I used with some skill and authority to drive progress in Europe with promoters and licensees. The demand for tickets in itself demonstrated that something significant was going on.

I held big ambitions for Depeche Mode and I worked them relentlessly. Wherever the band had success, I followed it through by adding extra shows or playing the same market again quite quickly. Low ticket prices were very important in expanding their following. Even when in later years I moved their shows up from concert venues to arenas, I made sure the ticket price stayed as low as possible. It helped a lot that they were seen as being in the vanguard of the New Romantic movement. They worked with a radio plugger, Neil Ferris, who often had them on TV shows with the singles being played on Radio 1. In the first year, I took them on around June; by the end of the year in 1981, I had booked twenty-eight shows for them, including by the autumn a sixteen-date national tour with two sold-out nights at the Lyceum in London, a 2,200-standing-capacity venue. The audience was crazy for the band, I can still remember that night, seeing the balcony of the Lyceum bouncing up and down with the audience dancing to the beats and thinking to myself, *I hope there isn't going to be a structural failure.*

Within six months of me taking them on, this UK success was a huge and significant achievement.

What was the best possible advertisement for any concert?

A friend showing you his own ticket for the show and asking if you are going too. Well before the world knew anything about online marketing and went on the Internet, people's own personal networks are what counted the most. Wherever possible, I made sure that Depeche Mode tickets were well-printed "souvenir" tickets, as I understood the power of this peer-to-peer marketing.

After the first album release by Depeche Mode and its successful touring in the UK and most of Europe, there was a crisis meeting in the autumn of 1981 when Vince Clarke announced that he would be leaving the band. I remember that meeting at Mute with Daniel, the publicist Chris Carr, and plugger Neil Ferris, and the remaining three band members—Dave Gahan, Andy Fletcher, and Martin Gore. The question came up of course: "Who is going to write the songs now?" Slowly, all the eyes in the room turned around to look at Martin. One of the best songwriters of the past forty years was put into the hot seat. And since then, he has certainly made the grade.

After *A Broken Frame* was both written and recorded, they brought in Alan Wilder, in place of Vince. He was actually seen as quite a threat by the other band members because he was a proper keyboard player and could play keyboards with both hands—and at the same time.

This UK success was quickly followed up in 1982—a first show with Alan Wilder in the band and a debut show for Depeche Mode in America in New York at the Ritz in late January. I used this show to set up the label, Seymour Stein at Sire Records, and

to recruit as a US agent Wayne Forte, from the independent ITG Agency, who would report to me. This show in New York was followed in February by a fifteen-date tour of the UK which sold out, and consolidated the band's previous success in the UK. I switched the show in London from the Lyceum (2,200) to the Hammersmith Odeon (3,641 seats) and sold out two nights there. The live shows were showing just how popular the band was. All the concerts sold out in advance and audience reactions and reviews were amazing. This was all on the back of the first album's

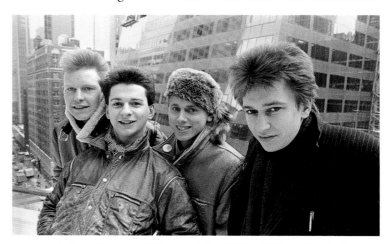

Andy, Dave, Martin, and "Vince Clarke's sub" (Alan Wilder) in New York.

release, so we sustained and grew their following throughout all this time.

Then in March I arranged a serious sweep through Europe: a live show in Stockholm (plus a key TV show too), three shows in Germany (Hamburg, Hanover, Berlin), plus shows in Holland, France, Luxembourg, and Belgium. For a "nice weekend" in April, I booked two shows in Jersey and Guernsey.

In May they played a first national tour of the US and Canada—only seven markets, but the key cities of New York, Philadelphia, Toronto, Chicago, Vancouver, San Francisco, and Los Angeles. *Speak & Spell*, the debut album, was a big success on radio with "Dreaming of Me," a hit in February, and "Just Can't Get Enough" in September 1982, which was a top 10 hit. It was verified as a gold-selling album in the UK (100,000) and Germany (250,000). Their success in the UK went from strength to strength. I worked the German market hard for them, with great feedback and ever-increasing numbers. Germany was still a divided country with the shadow of the war hanging over everything. When you arranged to play a show in Berlin, you had to drive through a restricted land corridor within East Germany, never stopping en route. And then "reenter" West Germany as you got to the western sector of the divided city. Berlin of course has a great mystique in music, fashion, and journalism, given Bowie's search for a great sound there, and lending his mystique and reputation to a great studio close to the Wall called Hansa.

A Broken Frame was released on September 27, 1982, just before the start of the UK tour in October. I geared up the UK album tour based on the previous success. The venues were bigger but the ticket price was still really low, which was an important

part of the success of the tour. They played twenty shows, including three dates in Ireland. I added second sold-out nights in Birmingham at the Odeon and in London too, again at the Hammersmith Odeon.

In Europe I was keen to push hard. TV and media reactions were strong, so for the new album release that autumn, in November and December they played seventeen shows in Europe—eleven of these were in Germany. All significantly larger than before, especially in Germany. Responding to ticket demand, they ending up playing a triumphant three consecutive nights at the Musikhalle in Hamburg, ending the tour just before Christmas.

Depeche Mode's recorded output started to reflect the dynamics of playing at bigger venues too, with a heavier and darker sound which then found a bigger audience.

1983's *Construction Time Again* album showed an evolving and harder sound. The live show reflected this; there was quite a bit of metal-bashing going on. A twenty-three-date UK tour in September and October ended with three sold-out nights at London's Hammersmith Odeon. Actually, Depeche Mode were very sick after the first night in London—three of them had a severe stomach infection and were throwing up. After the show had concluded, I made a late-night dash to the all-night pharmacy in London and managed to negotiate buying multiple bottles of strong medication, which I dispensed to them that same night in their hotel. It helped a lot: the sold-out shows on nights two and three took place successfully. It was so fortunate that I never had to contact the insurance loss adjuster to talk about rescheduling those sold-out shows.

Can you tell us more about your work with Depeche Mode in the early 1980s, at the time of the albums *Speak & Spell, A Broken Frame,* and *Construction Time Again*? At what point in an album's production were you brought in for tour planning, and what were the steps involved in booking a tour back then?

The live story was always an important focus for everyone on the Depeche Mode team. The success of the live show was revealed very early to be a major lever for every aspect of their career. I had the key role of coordinating the marketing team around every tour, from planning its scope and targets, agreeing on single and album release dates, the marketing and TV opportunities around the tour, and so on.

Well before any album was scheduled for release, the marketing team of myself as agent, Chris Carr as publicist, Neil Ferris as radio and TV plugger, and of course Daniel Miller as the record label head, met to plan the tour in detail, its timing and scope, and so on. The planning meeting was always attended by Depeche members too, so it was a very open and direct process of communication and decision-making.

I would take in a tour plan for approval. The venues would already be held in the diaries, deals would be negotiated and held in place. These deals outlined all aspects of the arrangements for the shows, the costs allocated for marketing, production, rental, and all other costs, as well as guaranteed fees to the artist. The meeting would approve my tour proposal and then break down the indi-

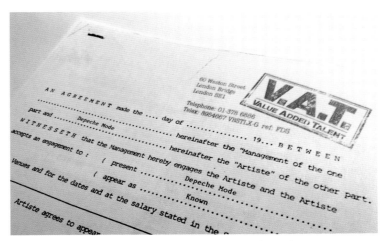

An early V.A.T. show contract for Depeche Mode.

vidual tasks and discuss and agree on timing for promotion. I would provide the team with regular and reliable feedback about sales, twice each week, and this would then influence the campaign. With no Internet and only print (music-news press and magazines, as well as national press) or sometimes using local radio station campaigns, we would drive the shows to a sold-out success. Even in early days, when I had spread the risk and used a number of different promoters within the UK, I negotiated individual contributions for a UK-wide marketing budget and marketed it as a national tour. This innovation in marketing was later widely adopted within the UK industry.

The tours were always carefully timed around the record-release schedule. Daniel and I would make sure that at least one single was released before the date of the album release. My tours would start just after the official album release date. It made most sense to play their strongest market of the UK first, and to give the promotion of the album a bit more time in Europe, as print media there was mostly monthly and this was appropriate to the way that market worked. I always made sure that the tours were booked to make the band available in the UK for *Top of the Pops*, the all-important TV chart show which was prerecorded in London on a Wednesday in those days. We would announce the tours only a few months in advance, with the aim to sell them out. This target was often met, and extra dates were then added to a successful tour.

Other planning meetings for dates outside of the UK involved the international department. Mute was then still a small label, and much of this day-to-day licensing work was undertaken by the publishing company Sonet, who acted as publisher with the writers Vince and Martin. Rod Buckle, the MD at Sonet, effectively introduced and administrated the licensing deals for Mute in Europe. Instead of me taking in a delivered tour for approval, the meetings would be used for strategy and planning and to discuss and agree what the plan should be and how best to implement it. We would sit down to discuss and review the different markets, and consider the update on the sales and promotional activities in each country, and talk about each country's potential. I had already gotten feedback from each of the national promoters to include their suggestions and expertise about what they judged as achievable.

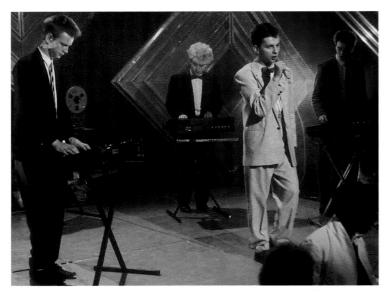

From the beginning, each new single brought Depeche Mode onto *Top of the Pops*. Their last appearance was in 2005.

Once the targets had been agreed, I would start the detailed process of discussion with promoters in each country as to how best achieve the next step for touring Depeche Mode. Being able to talk about their success in the UK was important in getting promoters' attention at first.

I would talk about the next record release and promotional plan and suggest a number of shows in specific cities. The promoters would then check availabilities and suggest venues, which I then ran production checks on. Often, I would talk to the promoters in detail well in advance of the international meeting, to get some input from them about what was best advised. Once the venues were selected, I would then review the outline deal—the costs and income projections—so that an outline contract agreement could be made. As soon as the deal guarantees proved adequate to fund the tour, I would start the process of putting together an international travel schedule, putting the bigger shows on weekends to optimize success, making sure the travel and logistics needed were achievable, and making sure that both the budget and itinerary were approved by Depeche Mode. I had a lot of direct contact and discussion with the group, reporting directly to them about ticket sales and adding extra nights. In later years, some of this detail was conducted and relayed to them via their tour and production managers. But overall approval and significant feedback always came directly to me from the band members.

There was a lot of two-way communication throughout, as the possibilities were explored and refined, then implemented and put together. Step by step, the tour booked by me was approved by both Mute as the label and by the artist too. I had a very close working relationship with the group and the label. Mute was by now an influential and very successful independent label, and I was very happy to contribute to and share in its success, and to be so involved with such an interesting and credible label. At the same time, I was also still looking after Vince Clarke in Yazoo, then again later as Erasure, also on Mute. And I represented Fad Gadget too.

In the early years, Depeche Mode became popular not only in Great Britain but also in West Germany, where they had many concerts, starting in 1982. How did the work with Karsten Jahnke and Gaby Meyer go?

I had worked other bands previously in West Germany with Karsten Jahnke, and I really liked the way he worked and appreciated his philosophy. We would spend at least as much time talking about artwork and marketing as about the financial deals.

Karsten was an extremely experienced promoter. Amongst his many skills was to choose and encourage keen and young people to work alongside him. One such person was Gaby Meyer, who had a strong work ethic and a marvelous sense of humor. She was very good at explaining the subtle intricacies of the West German market, and before very long she became both a friend as well as a colleague. Her ability to interpret and translate my ideas about the marketing of the band into the West German market was effective, and the resulting success became legendary. Again, we would spend as much time on practical details as anything else. She would describe each venue to me in detail before I made any commitment on behalf of the group.

West Germany was the most important territory financially, but I made sure that the rest of Europe came along for the same ride—I booked shows in Sweden with EMA, in Denmark with DKB, in Holland with Mojo, and in Belgium with Herman Schueremans. Each was the top international promoter in its country. All this predates the Live Nation conglomerate that most of them have since bought into. In France it was less obvious early on about any success or who might be the suitable promoter, and I was more open to bids and offers. But in most of the European countries, the promoter I chose from the beginning was chosen to be a long-term partner. The input from these experienced professionals helped me greatly and guided me in making the best decisions.

What we got right as much as anything else was the rhythm and timing of tour dates. As soon as the band's shows started to sell out, we began working on the follow-up shows. By working the market consistently and hard and with growing success at radio too, we soon marketed the band into playing the bigger indoor venues in West Germany and elsewhere. Wherever a city sold well and if there was enough demand, if it was possible to add a second or even third night, we would do so.

As well as their own tours, some key shows in West Germany made a difference. I booked them to play live at the Frankfurt Music Fair in February 1983, which in itself was highly unusual and was a big signal to the West German music industry. They played open-air festivals such as Schüttorf with Rod Stewart in May 1983, which allowed them to expand their audience base and to cross over from being a New Romantic pop band to having the aura of a rock band. One quite funny story from Schüttorf was when someone from Rod Stewart's entourage visited the Depeche Mode dressing room to request the loan of a hair dryer for Rod Stewart—it was raining that day. On being told that no one had a hair dryer, the messenger looked at us with hard eyes and said,

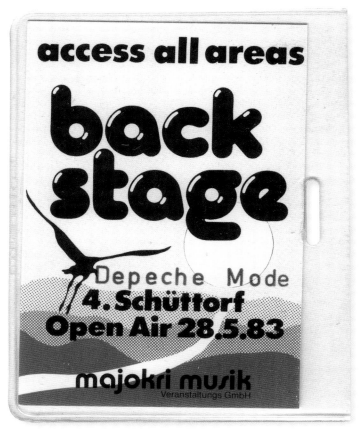

Backstage pass for the fourth Schüttorf Open Air festival on May 28, 1983.

"But you *should* have." Obviously, this was seen as a reasonable requirement for any New Romantic band.

In 1984 they played another big open-air event to 60,000 near Frankfurt, with Elton John as headliner. Elton was a real gent, he came over himself to the dressing room to say hallo. This was much appreciated by Depeche; I remember that Martin in particular was in awe of him. Playing at these crossover events to a new and wider audience was a good move, as the band by now had a very strong and impressive live show.

A mixture of good timing, great live shows, strong media interest, and airplay were all critical elements of their success in West Germany and everywhere else in the world. From their earliest days, the original tribe of followers they attracted were huge influencers with peers in increasing their popularity.

Your company V.A.T. had a strong independent reputation from the beginning, which fit perfectly with Depeche Mode and Mute Records. How was V.A.T. able to break into the market with its work in the 1980s?

It is my privilege to work in an industry where you can make things happen, and sometimes very quickly too. Before I established Value Added Talent in 1983, I had worked in the bigger agencies and I really did not enjoy or value that experience as a working environment. In fact, I was told by the agency where I was working just before going independent that I held far too many principles to ever be a successful agent, and I was asked

to leave, and they suggested that I find something else to do.

I took this as the highest possible praise of my ideals, and adopted the ultimate motivation that *I will show you, you bastards.*

At first, I went around to other agencies to see if there was a suitable opening. I remember that one told me that they only "grow their own agents" and suggested that Depeche Mode were well past their peak. At another agency, I was closely questioned about my roster, and every single band of note I looked after was phoned immediately after I left the building as they tried to steal them. It was very fortunate that I had established strong working relationships with my acts, and I quickly realized that the only way I could move forward in a way that was acceptable to me was to establish my own company. I traveled in Europe that summer of 1983, returning in early September to establish Value Added Talent.

I remember that Fletch told me his idea for a name for my agency too—he wanted me to call it Hawaii 5-0, after the TV series, and with the tag line "Book'em Danno"—which was very funny but not chosen. Instead, I went with Value Added Talent, which was a play on Value Added Tax.

This choice of name was also a statement of intent, that my mission was to add value. And this philosophy proved very successful through the eighties and indeed has served me and my clients well for the rest of my music career.

I decided when I set up Value Added Talent that it was to be centered around only one agent, who would retain complete control over everything the bands did, and that was to be me. I ex-

Backstage pass from the SWF3 Open Air festival on June 2, 1984, in Ludwigshafen.

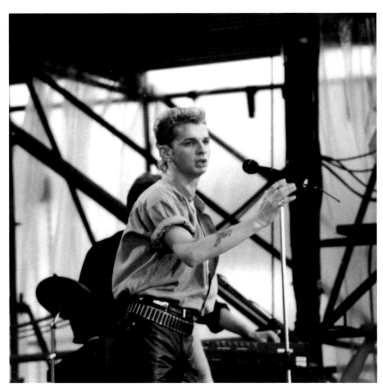

Depeche Mode live at the SWF3 Open Air festival at the Südweststadion in Ludwigshafen.

conjunction with the tour manager. The planning strategy and marketing of Depeche Mode live was very significant in their growing popularity, and I was of course the key person. Their first tour manager was John Botting, who I had worked with from the Gang of Four days. Later on it was to be J.D. Fanger and Andy Franks, who I had originally met as sound engineer and PA crew, respectively, with Gang of Four and Pigbag.

My primary role was to determine the tour—which markets, venues, promoters, and so on should be chosen when planning live shows—and then to supervise all details from the going-on-sale sequence until the actual conclusion of and final accounting for the live shows. I also took responsibility and financial control of all the payments, making prompt payment to the band and crew and suppliers as shows were played and deposit funds were released from being held to contract. Very often I could negotiate the release of the advances I held into the hands of the artist. Provided I could demonstrate that I had the correct legal indemnity and the cancellation insurance in place, this was generally agreed to by the various promoters. I had overall responsibility to make sure the tours were financially possible—there was no underwrite available from the record label. And, of course, the vital role that made sure that the band were playing the right venues at the right time. This was the key to the success, as was being able to respond quickly to signals of demand in the various markets.

panded the scope of my work. It was a combination of careful planning and detailed implementation. The role of the agent is to conduct a detailed liaison with the many different promoters to filter and explore and arrive at what might be possible, then refine this through to selection of the best markets and promoters and venues, making agreements with them as to costs and ticket prices, and getting the approval of the artist to the proposed schedule of venues and the income.

I took very active control to administrate and oversee all the practical details of the shows—when to go on sale, supervising the marketing spend, approving artwork, working on sponsorship from print and media such as radio stations and others. I expanded the workload to be much more than just making deals and booking gigs. In this way, I established my concept of adding value.

My focus was on the going-on-sale process and pulling levers that generated such good promotion that the shows succeeded straightaway at the box office

Depeche Mode was only one of ten acts I looked after in the eighties. I also looked after Vince Clarke's new band Yazoo, Spear of Destiny, Sade, John Cale from Velvet Underground (who I also managed), Fad Gadget, the Inmates, Gang of Four, Comsat Angels, as well as some smaller acts. The considerable workload was only made possible by having an excellent PA, at that time Julie Madden. I have been very lucky to enjoy such good support and loyal help over my many years working in live music.

You must keep in mind that Depeche Mode didn't have a manager, so there was a lot of extra workload and challenges that needed to be met. I effectively did logistics and budget control in

Depeche Mode had very enthusiastic fans from the beginning. How did you experience them?

By the early eighties, I was well versed in the punk and new wave scene and I wanted to find something new. New Romantic and fashion covered a lot of bases. I quickly recognized that Depeche Mode had a tribe of their own, the same conclusion arrived at many years later by D.A. Pennebaker in his documentary about their US tour, *101*. To be a fan of the band was like having a religion for the biggest fans. They dressed exactly like the band. I recognized many of the fans over the years; it was always good to get into the crowd and see the show through their eyes. I would always conceal the all-access pass I had, and enjoy becoming a part of the audience whenever possible.

And the fans were so many and so enthusiastic. I got used to crowds being at the backstage entrance when the band arrived and left, and to being mobbed when the fans found out which hotel the band were staying in. This started in the UK and quickly became a pattern across Europe. Eventually Depeche were to employ a dedicated security guard, who would look out for them at all times. Especially when they would go to a club after a show.

I tried to understand the fans as much as possible, mingling with them whenever possible as another member of the audience. It was so crazy when I took my own video camera to the *101* show, I had to stop filming. The fans would just freak out so enthusiastically when the camera was on them.

Depeche Mode fans were different in different countries. I remember early shows in Japan, when the band were playing a low stage and there was only a red rope across the front of the stage. I

questioned the promoter on this, asking him for better security, but he told me that Japanese audiences weren't like that. He was perfectly correct too—even when screaming for more, no one ever stepped over the line.

Another time, arriving in Hong Kong with Depeche Mode, I went through to arrivals before the band—it seemed really quiet, and I met up with our local promoter, David Wong. He was someone I had only ever spoken to on the phone, and when we finally met, he appeared to be only about sixteen years old. I waved the band through to then discover fans emerging from nowhere—I have no idea who flagged their arrival. I remember at the time that Dave was quite upset, saying that the fans shouldn't have seen him pushing his own suitcase.

Andy beside a fan at Cologne's InterContinental Hotel, May 1985; as the band's success grew, so did the personality cult around its members. Hotels in Europe were often besieged with fans.

The band and tour crew quickly became a sworn gang in the 1980s. How did the band and crew get along so well?

There was a strong unity of purpose in the team around the band. The crew were all good professionals and the team was based on long-term relationships. For example, Jane Spiers was the lighting designer for all the tours I carried out, as were core crew members J.D. Fanger on sound, Andy Franks on monitors, and Daryl Bamonte as stage tech and backline.

The dialogue with and support from me to the crew was unstinting. I was always ready to make a good job go even better, and I worked very hard. Any kind of impediment or obstacle to the success of the Depeche Mode tour and live show would become my business. I had good professional relationships with everyone. And I would join the tour frequently, so people got used to me

being around. I used to joke that I had an excellent relationship with the drummer in the band—this, of course, used to be a four-track reel-to-reel tape machine that fed the percussion into the live show. When buying a round of drinks on tour, I would order for myself a vodka and tonic—a VAT—although I actually preferred gin. This was partly poking fun at my marketing role.

The collective endeavor fostered a good fellowship. Everyone could see the band was successful, and everyone enjoyed that success. When you tour together, eat and sleep, travel, celebrate, and get tired, with other people doing the same job but being in a different place every day, then that becomes a family for the duration of the tour. You get to see people every which way too.

One of my fondest memories of Depeche Mode is of sitting on a tour bus in West Germany and watching *Spinal Tap* with them. Dave took this movie very seriously and learned and internalized a lot of the dialogue. On arrival at a new venue's dressing room, he would start up with the "wrong kind of bread in the sandwiches" sketch. Word for word. Watching this movie with the band doubled its hilariousness and its impact—that film really is so true to life on the road and the perils of being in a band.

Around most bands and in my long experience, I observe there is always a throng of people who tell the band members how great they are at all times, and always agree with exactly what the band say.

Sometimes I disagreed with what the band thought, and had to explain why something they thought was a good idea was actually quite a bad idea.

I saw my most important role of communicator as being the bands' ambassador to their fans. But with an equal duty of care to relay the fans' point of view to the band, and being the fans' ambassador too. Most of the time I managed to maintain a healthy balance. Many decisions within the band were actually quite heated arguments, especially, as I recall, between Dave and Fletch. Martin was often the only voice of reasonableness in the room, on the coach or wherever the meeting might be. But in general, I was always happy with the outcome, being prepared to hold out for my recommendations to be agreed, even if this took some time.

In 1984, Depeche Mode scored an international hit with their song "People Are People." How did that affect the tours?

This album and single woke up interest in Europe a lot. The UK tour was even more extensive, stretching to a second night at the Birmingham Odeon and a four-night run at London's Hammersmith Odeon. Ticket prices stayed low.

The music was tougher and worked on a bigger scale too. It was in Europe that the biggest upsizing of venues started, as we moved shows into the bigger indoor arena venues in West Germany—for example, the Sporthalle in Hamburg, Deutschlandhalle in West Berlin, and the Philips Halle in Düsseldorf. Of twenty-five dates on the European tour, West Germany staged fifteen of them, and at far bigger venues too.

This success in 1984 set them up very well. The following year in 1985, they played a fifteen-date tour of the US including their first ever sold-out "shed" show at Irvine Meadows in California, to

an audience of 15,000. And from there they flew on to Japan, where they played four nights.

In July 1985, they played at the biggest festival in Europe—two nights over a weekend in two locations—Torhout and Werchter. The lineup was the Ramones, R.E.M., Style Council, Lloyd Cole, Paul Young, U2, Joe Cocker, and . . . Depeche Mode.

There is always an intrinsic pressure on any artist to deliver live. As the scale of the venues and budgets increase, this can result in a spectacular staging of the music. The professionals always want to go further and better, especially when the financial success can fund bigger budgets and other excesses. When both the elements of production and the success of the music are in focus with each other, then truly great productions and fine performances can become high art.

I would say that by 1984, the dynamics of the live show delivered by Depeche Mode were truly impressive. I would rate their live show up against any of the other great live acts I have seen over my many years in music with great pride. I saw Depeche play live frequently; I would see them at least twice each week, often traveling on tour with them for several days at a time.

In August 1985, Depeche Mode played for the first time behind the Iron Curtain: Budapest and Warsaw. Hungarian-born Laszlo Hegedus, who had the appropriate contacts, was also involved in the organization. How did these concerts come about? What was different about these concerts than in Western Europe?

This showed us all the enormous gulf between Western and Eastern Europe . . . The shows in Eastern Europe were played for the joy of it rather than for any commercial reason. There were no record sales to support and very little income available by way of hard currency, but I was interested in the band playing in these markets, as was Daniel. We knew that most records were not sold but instead copied onto cassette tape. In 1985, we got the band to agree to play these few shows. I think both the band and crew members were just as curious as I was. These markets were very much an unknown quantity. We just set out to play the best shows possible in those circumstances.

Western Europe was already quite a complicated market to tour in. Each country had its own currency and work permit needs. Equipment was allowed to be imported to tour as a temporary import, but only when the re-export was guaranteed by an international carnet, a bonded document guaranteed by each country's Chamber of Commerce or national equivalent. This could mean time delays when crossing at borders and was often a brake on tour logistics.

Eastern Europe was played by a completely different set of rules. Because the budgets were so small and the distances so large, we could only agree to play the shows based on using locally supplied sound and lighting for production. The key crew and backline kit flew in and out of each country with the band, just like the band's very first live shows in Europe.

I became aware of a promoter who worked in these difficult

Ad (top) and a backstage pass for the Belgian rock festivals in Torhout and Werchter on July 6 and 7, 1985.

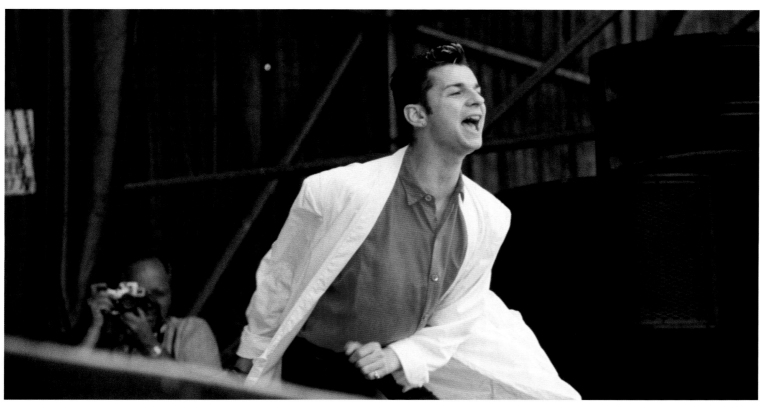

Depeche Mode live at the Rock Werchter Festival in Belgium, July 7, 1985.

territories. Almost no Western bands had played in countries like Poland, Hungary, East Germany, and so on. Laszlo Hegedus explained to me just how difficult it was to be paid in hard currency, but local currency was available in large quantities. It was interesting but not at all commercial. But everyone wanted the opportunity to play in these markets. We put together a small crew to work with locally supplied sound and lights instead of trucking in at great expense (and impossible logistics) the usual specifications.

The shows in Budapest and Warsaw in 1985 were financially supported by me booking Depeche on a festival show in Athens on the same leg. Their popularity was below the radar and was impressive. They played to 30,000 people across the shows in Budapest at the Volán Stadium.

The lineup in Athens was the Stranglers, Culture Club, and then Depeche Mode. It turned out to be a very lively event. It was at the old Olympic Stadium in Athens (100,000 capacity) and attended at first by only about 12,000 people or so. The Stranglers played first, and then Culture Club. Some of the audience didn't enjoy Culture Club at all—I saw cans being thrown at the stage. And above the sound from the PA, I could hear angry crowd noises. There was a huge crowd of young people who wanted to get entry to the show and they weren't going to pay. A host of projectiles were being thrown into the backstage area, which was close to the entrance to the stadium. I remember at this point getting the band and crew into the back of a trailer of an unloaded truck as the projectiles were thrown, to stay safe.

And then suddenly, and within ten minutes, the pressure of the crowd on the door overwhelmed it. Almost instantaneously, the size of the crowd increased from about 12,000 to 60,000 or so. I

was really happy about this—no one got hurt and Depeche played to five times the number of people.

I was not at the shows in Budapest but I did fly out to Warsaw, as did Daniel. Laszlo recently reminded me about how different these markets were. Instead of record sales, most streets had an "exchange" club where for a very low fee you could buy a cassette copy of recent releases. Laszlo tells me he set the shows up by importing and distributing some albums, and interest in Depeche quickly rose to the top of the tape-copying market. The fee was very low and the quality was at best mediocre with local production. But the audience was vast, and so grateful and receptive. I had got used to the enthusiasm of fans in Western Europe, and it pleased me no end that there was a similar reaction and enthusiasm for the band in the East.

It took awhile for the kids in France to get the Depeche Mode fever, but from 1984 on they were very enthusiastic. Whereas the band had played to 500 people in Paris in 1982, by 1984 there were 15,000. How did this huge leap come about, and what was it like working with the French partners?

I cannot begin to explain how exciting it was touring with Depeche Mode. They were a hot group, making a new scene, and they had a strong following, many of whom would imitate the black clothes and dressing style of the band. Their popularity went off the scale very quickly.

In 1984, I had a club show on sale in Paris at a 1,200-capacity venue. The rest of the European tour was booked into much bigger venues, averaging around 6,000-capacity. On the first day of

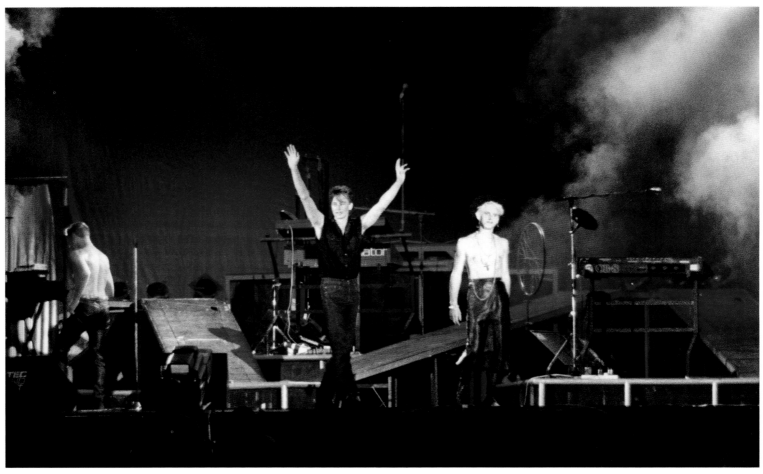

Depeche Mode live at the Rock in Athens '85 festival, July 26, 1985.

Andy Franks's backstage pass for the show in Athens.

going on sale, Paris had sold out. The promoter was at the time a relative newcomer to promoting international bands, although later on Salomon Hazot was to become one of the big French promoters. He phoned me and asked if he could move the show to a bigger venue. After much discussion and after agreeing to a significantly higher fee, I got the band's permission to upgrade the show to a 2,500-capacity venue, Casino de Paris, and set a new goal to sell twice as many tickets than we had first imagined. It went on sale the next day, and within only two hours it had sold out the extra 1,300 tickets. Once again, and very quickly, I had the promoter on the phone asking to move the show up again.

"But where to?" I asked "Palais Omnisports de Paris-Bercy," came back his answer. But this was a controversial and huge upgrade, as the venue had a 14,000 capacity! A lot of discussion followed. I asked Salomon to explain why the band was selling so well, and he could not explain it at all. "I just don't know why," he said, again and again. "I can't explain."

Anyway, once again he and I renegotiated the fee. The bigger building meant the band had to upgrade the PA they were supplying considerably, but a deal was made on the basis of 10,000 sales, which I thought adequately reflected strong confidence from the promoter. It seems that Depeche Mode was suddenly having a moment of great popularity.

The day of the show arrived. The band had to perform on TV in the afternoon of the show at Bercy, and then had a police escort

from the TV studio to the venue to make sure they arrived in time, which impressed them to no end. The show was completely sold out and a huge success. It opened up the prospect of multiple nights in Paris in its biggest indoor venue, and so this was a very significant step.

But no one could explain why the band had just become that popular. All the promoter, Salomon Hazot, could tell me when I asked him to explain was, "I just don't know . . ."

Depeche Mode in France that autumn caught up with the demand in the rest of Europe.

A year later, in 1985, Depeche Mode were booked into a festival called Rockscene in Brittany. I had dealt satisfactorily with the festival organisers in previous years. But this time, the deposit hadn't been lodged, which was always a very bad sign.

Upon my arrival at the hotel, I got into immediate contact with the promoter and said unless I was holding the full fee of £20,000 sterling, the band would not perform. Until I had received at least 50 percent, I added, they wouldn't even bother to set up the backline.

A stream of messengers began to arrive at the hotel, with large bundles of cash they presented me with. Some came from the door ticket sales, some from the caterers, and so on. It took a lot of counting. This was well before we all had mobile phones to take pictures, but I remember Dave coming into my hotel room where two of us were busy counting the money. He was dressed in a white vest, blue jeans, and wearing shades. He looked so funny standing there with huge piles of banknotes in each hand, with even more notes tucked into his belt. How I wish I had a camera to record that moment.

Eventually I held the full amount of the fee, so we then traveled to the festival site to check things out. On arrival, I saw Kosmo, who I knew from the London scene to be the Clash's tour manager. As usual, the Clash's ego said they wanted to play later than Depeche. But then I got on the phone to the Clash's agent in London, Ian Flooks, who I knew reasonably well. (He was the agent who two years earlier had told me that Depeche were past their

The Palais Omnisports de Paris-Bercy is a modern multipurpose arena in Paris. The futuristic pyramidal construction was completed in February 1984. Depeche Mode played their first concert at Bercy on December 17, 1984, with many more to follow over the coming years.

peak.) I told him about the uncertain local arrangements, especially about the dodgy stage security and that the forecast was for rain. In fact, as the conversation was coming to an end, I said to him, "Oh, and it is just starting to rain . . ."

I put Kosmo back on the phone to Ian. The Clash played before Depeche Mode.

Backstage pass from the Rock Scene '85 festival in Brest, July 13, 1985.

The audience numbers were decent, especially considering that at very short notice the event had also been given stern competition from Band Aid and its worldwide TV broadcast jointly from London and New York.

The next day, I had to sit and wait with the money in my hotel room for twenty-four hours due to the bank holiday of Bastille Day. I also knew that I had to get exchange control clearance to send the money via bank to London. If I tried to take the money through customs as cash, it would be liable to seizure. And it would be difficult to change French francs into sterling in London too. I made sure that the promoter and I were the first in the queue as the bank opened its doors. I was able to show the signed contract to the bank and get agreement that the funds could be handled through the exchange-controlled banking system. After a lot of counting in the bank's safety deposit room in the rear, and being smoked out by a French banker smoking endless Gauloises cigarettes as he counted the money, the amount was agreed.

The French market has always had its own rhyme and reason. It didn't show much interest in Depeche for the first few years V.A.T. toured them internationally, and then it suddenly exploded overnight. To this day, no one can explain this. But the best thing about France is that once you become established there, you then enjoy a loyal following for many years.

Even in the US, audience numbers didn't increase until 1986 with the *Black Celebration* tour. What kinds of efforts were necessary to establish Depeche Mode in the American market?

I worked Depeche Mode in the US by appointing Wayne Forte to

book the shows and conducting all of the detailed liaisons and logistics with him and the band and tour managers. Wayne was one of the few agents in the US who rated UK acts highly. He was very experienced and looked after David Bowie amongst many others. He always shared with me his intelligent and informed approach to touring and planning.

Whilst he and I provided the exposure of the band to the audience in the US, and showed the success of live shows as such an effective lever for media, I believe that it was the fans themselves who were responsible for Depeche having had such an impact. Very early on, Depeche was picked up on a playlist by KROQ, a very influential radio station in Los Angeles. When they got onto

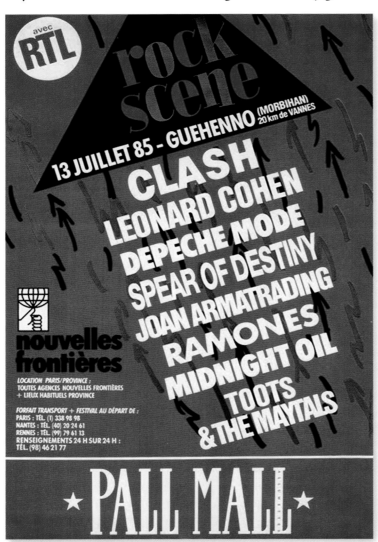

Poster for the Rock Scene '85 festival.

the KROQ playlist, this meant that automatically fifty other important radio stations also played the song. I credit the fans themselves for having some influence on the stations—many of them were phoning the radio stations and asking them to play Depeche Mode.

The live shows were definitely the spark for the success in the US. It took several years for record sales to catch up with ticket sales. It was rare for any UK-based agent to oversee and supervise

a band's tour in the US, but I took on this role very early on in the story of their development. And it was a huge workload with antisocial hours too, for a very modest payment, because the US agent I shared this work with needed to be paid in full. With careful coordination, I made sure that the time in between ending a tour in Europe and starting in the US was the minimum possible (plus one extra day as a safety in case of a customs clearance delay). This made for good cost control and helped to deliver a profit. And, of course, I wanted to optimize their success in the American and Canadian markets. Instead of any tension between international markets, which can happen when two different agents are involved and competing for the band's time, I was able to integrate dates in the US and Canada into a coordinated plan with smooth execution of a worldwide tour.

Events went amazingly well in the US. Progressive touring and the success of airplay on radio built up Depeche Mode's reputation. It was a very special day in 1987 when Depeche played a sold-out Madison Square Garden in New York. For a first and only time, I flew out to New York on the day of the show on the Concorde, accompanied by Daniel Miller. David Frost was in his usual seat, number one, and Daniel and I sat a few seats farther back.

I should have enjoyed this flight, but because I had mislaid my passport the previous night in London, I had had very little sleep and was really tired. Daniel and I sat together and chatted for the entire flight. I did enjoy the rapid entry and customs clearance afforded by flying on the Concorde. Within ten minutes of our arrival into JFK, we had cleared immigration and customs with our bags and were in the back of a limousine on the way to Manhattan.

Daniel and I had a meeting that morning with the band at the hotel—more of a review and celebration of success than about anything else. The show that night at Madison Square Garden was electric, the audience was so enthusiastic—another major step taken on the way to being a huge act in the US.

Madison Square Garden had sold out well in advance, but we weren't able to secure the second night there. I think it was basketball that had booked the night after. Instead, we added a second show in the New York area at the Jones Beach Theater. Jones Beach, although less historic than Madison Square Garden, was the same size venue, and it sold out too—the band were hot and on a roll.

The band became increasingly successful in the US. The success of their live performances and the scale of their tours finally impacted record sales. Nothing had changed with the strategy. As soon as we could see strong reaction and success, then more shows were committed to in the US and Canada. It really opened up when they started to sell out open-air arenas, or "sheds" as they are known. Given the support at radio from KROQ, Irvine Meadows in California was an early indicator of the success that could be achieved—Depeche had sold this out as early as March 1985. Gradually, the many other markets in America started to catch up. The music was far more successful on radio and for sales, and the live show did even better than before in every market, growing in capacity and mostly selling out in advance.

It was the fans' own peer group that led the way. And you could

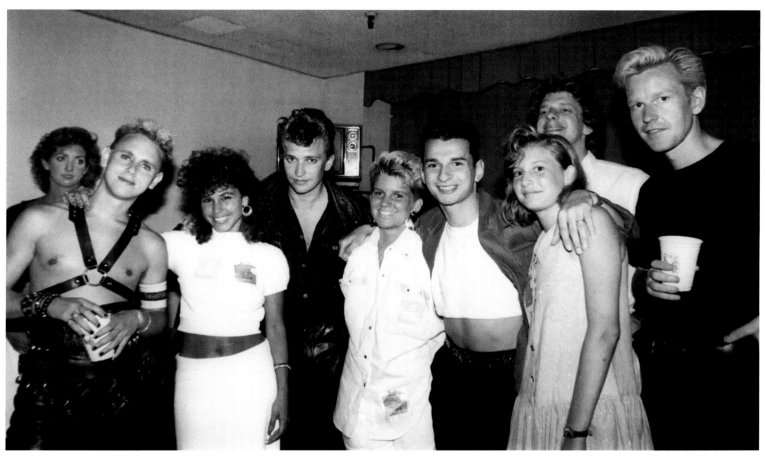

Depeche Mode backstage at the Forum in LA with winners of a radio contest organized by KROQ, July 13, 1986.

measure the impact of the live show by seeing just how many people wearing Depeche Mode tour T-shirts were walking around on the streets of the city they had just played, on the next day. I understood that their appeal was widening considerably in 1983 when a middle-aged man in a suit approached Dave Gahan at the LA airport asking for his autograph, telling him just how good the concert had been the night before.

With the *Music for the Masses* tour in 1987 and 1988, Depeche Mode was able to build on their international success. To what extent did your work with them also increase?

Depeche Mode was always my top priority in terms of attention to every matter. As the scale of the productions and budgets increased, so did the challenges and the complexity of managing every detail. Effectively I had a series of line managers to inform, and support for accounting and payments, tour production logistics problem-solving, and the full process of promoting and delivering a sold-out tour.

My workload and efforts for Depeche increased all the time as their success grew. From 1984 onwards, their cash flow and payment schedules needed their own separate diary to administrate.

In March 1988, Depeche Mode played behind the Iron Curtain for the second time: in East Berlin, Budapest, and Prague.

Was the organization easier than the first time? Did you notice anything different about the enthusiasm of the fans in the East?

Depeche Mode were a much more established band when they revisited Eastern Europe in 1988. There was a lot more demand for them in 1988, but the fee in hard currency was still very low.

The costs were subsidized by better fees in the West. As well as the show in East Berlin, they were in Budapest for two nights, where they sold 25,000 tickets, and an additional night in Prague, around 7,000 capacity. The tour then ended by reentering Western Europe in Vienna, Austria. A solid end-of-tour party there celebrated the success of part two in Europe, again their biggest and most successful tour of both the UK and Europe.

In 1988, they played shows in Eastern Europe for a second time, and in East Germany for the first time. I flew into West Berlin the day before the show in East Berlin to meet up with Laszlo. After he collected me from the airport, we went to a flat in West Berlin where we started to load up his VW. I helped him carry industrial-sized tins of food and sacks of vegetables into his vehicle, and we then drove to Checkpoint Charlie at the border. I had always read about East Berlin in the context of spies; it was really a big deal to be inspected at the border by guards with rifles and dogs and mirrors underneath the car as I gained entry. Just what I expected, and actually just what I wanted to see. I was admitted as

an official guest of the East German government and met with the local promoter. I found this visit to be fascinating.

We were put up in the official "Communist Party" hotel right by the Wall on Unter den Linden, where government officials would stay. It is where Kurfürstendamm would have extended into the East. In the West, Kurfürstendamm is huge and upmarket, it is West Berlin's premium expensive shopping street, but in the East, Unter den Linden was a bleak and desolate place.

The hotel was fascinating. It had all the benefits and pedigree of a five-star hotel—fine mahogany doors, sweeping white marble floors and large rooms, staff in uniforms, and so on.

But placed in the bathroom were the most rudimentary soap and shampoo sachets—not branded or scented or even designed at all. Just ugly and functional.

That evening we went to the hotel restaurant and had some drinks. Champagne was available and flowed freely. Then we asked for the menu and nothing happened for a very long time. Eventually some sliced bread and goose fat was put on the table.

Yes, that was the dinner—no menu, no choice, no pretense—just survival food!

The next day I was entertained by the East German official promoter with an interpreter. He wanted to show me the eastern side of Berlin and we visited some shops which had been recently renovated and which were obviously a source of local pride. One of these was a tobacconist. The lack of goods was very obvious; there was almost nothing on display on the shelves.

That evening the show took place. The production was very basic—I remember the lighting was "flown" on a scaffolding pole with two scaffold towers built on either side to support the weight. The sound was very basic too. But the venue was packed with at least 6,000 kids, and a large contingent of Communist Party officials were to be found backstage. Dressed in suits, they looked completely out of place, but to me this was all a part of the culture shock.

I had no control over the ticketing arrangements for the shows in the East. I was told that tickets would be low-cost and sold on the open market, but it turned out that the DDR had instead mostly allocated them to "good effort" young Communists, so not what you would think of as Depeche Mode's usual audience. From what I now understand, there was a very strong black market for those tickets and someone must have made a lot of money out of Depeche Mode playing in East Berlin. It certainly wasn't the group themselves, but we all enjoyed doing something so different.

The next morning it was snowing when the limo arrived to take me back to West Berlin. There was almost no traffic, everything was quiet and wrapped in cotton-white snow. I returned via Checkpoint Charlie.

A little over a year later, in autumn 1989, I was back in Berlin at an Erasure show as the Wall was finally coming down. Attendance at the show was below our expectation, as there were so many East Germans on the streets of West Berlin that the West Berliners were staying at home. I went down to Brandenburg Gate to investigate, and showing them my video camera as proof that I

was press—I wasn't, of course—I climbed up the media platform that allowed me to view East Berlin. I saw soldiers and people milling about. The position at that time was that East Germans were allowed into the West, but there was no two-way traffic at all—the West still could not enter the East. Then I went down to the Wall, and filmed myself as I borrowed a hammer and chipped away a piece from it—this is authenticated by real-time footage. I am sure that music and youth had a hand in this huge historical fall of the Wall, and the change from central-control authoritarian government toward more freedom in the DDR. And I believe, too, that music and Depeche Mode had some influence on these events.

After the show in East Berlin, Depeche went on to Budapest and played two nights to 30,000 fans, where by now they were a well-established act. And as well they played a first show in Poland, in Warsaw, at a 7,000-capacity sports hall. Again, due to the low hard-currency budgets and long distances, these shows were played with local production, sound, and lights. There was less to prove the second time, and a lot more to enjoy from the fans. I was at the show in Warsaw too, and I was very pleased to have achieved these shows in Eastern Europe. It felt like I was expanding their following with some very sincere new fans, and in underserviced markets too, where they were so hungry for this music.

And after this big success, the tour headed back to the US and Canada to follow up their autumn 1987 success by playing the outdoor summer circuit in May and June 1988.

The concert in Pasadena in the summer of 1988 in front of 70,000 people was the biggest and most important concert for Depeche Mode at that time. How did you feel about the concert and that time with the band? And after the Tour for the Masses, you and Karsten Jahnke did not work with Depeche Mode anymore. What happened?

The tour in the US in 1988 followed the success of November and December's tour of 1987. The audience numbers were much higher and this allowed the possibility of adding a big final show in California at the end of the US tour.

Pasadena is a bittersweet memory for me, as it was my final show as an agent for Depeche Mode. And at Pasadena, there was a major mood change within the band and entourage. Only four weeks earlier, I had seen everyone on the tour in the US—things had been as usual. I spent a long weekend with them seeing two shows in Texas.

The sound check at Pasadena was the strangest I had ever seen from Depeche. Martin was messing around on a guitar, not playing any keyboard at all. Dave was blowing on a harmonica and acting out, as if he was Bob Dylan. I didn't hear any familiar songs at all during the sound check, but after all, this was the final and 101st date on a hugely successful world tour, so perhaps this wasn't necessary.

I remember one of the crew explaining to me that they had more PA rigged than the Grateful Dead for this show. And that for the first time ever since I starting looking after the band, I was

Dave Gahan, Daryl Bamonte, and Martin Gore at sound check at the Rose Bowl in Pasadena, the night before the 101st concert of the *Music for the Masses* tour, 1987–88.

denied entry to the band's inner sanctum of the dressing room. I don't know whose idea this was, but I didn't appreciate it at all. This leg of the tour in America had changed things in ways I was not comfortable with. Suddenly, it felt like I didn't know the band anymore—a very strange feeling indeed.

Of course, the tour and this show were a massive achievement. It was a fitting culmination to a successful world tour. However, it was after this show that Depeche Mode finally decided they would stop touring with V.A.T. They had too many people whispering in their ears that they could do a better job, which actually meant they were offering to do an equivalent job, but cheaper.

Around such a happening band, most of these professionals were concerned with consolidating their own position. Some may have felt they looked better themselves if they held up other people as responsible for problems arising. This is what I discovered in the debriefing talks after Pasadena. Key people I had supported for so many years suddenly withdrew all loyalty . . .

No matter how large your dedication or effort there is always going to be someone, somewhere, in a club at some devil's hour, telling the artist they can do a better job. Whilst I was frequently on the road with them to see exactly what was going on, this opportunity to poach and the highly visible and successful tour extended over two years.

The exploitative model within the live industry is that of predatory behavior. Bigger sharks devour smaller fry. In the global scheme of the industry, and as an independent player in the live music industry, I didn't actually qualify as a shark, even a small one. Nor did I ever want to play by those rules.

Despite my best efforts, the decision to leave V.A.T. was made. I felt obliged to turn down my invitation to the premier of the

101 documentary in London. When I got my invitation, I wrote back to the band and to Daniel, telling them that everyone involved with Depeche Mode would have to get used to Dan Silver not being around. And this included Dan Silver.

In retrospect, I can celebrate that for so many years I maintained and expanded my role as agent, and achieved the huge success for Depeche Mode worldwide in touring. For seven long and successful years, I held the approval of Martin, Dave, Fletch, and Alan, and of Daniel too, to represent Depeche Mode, and I achieved so much with and for them. I must also give thanks to Vince Clarke, who carried on his post–Depeche Mode touring success with V.A.T. when we toured Yazoo, then later again with Erasure. Their success helped to reduce the pain I felt about losing Depeche Mode. It was very fortunate for my business that Erasure was having a lot of chart success following a careful development plan, where his live shows had once again driven credibility as a live act, which had promoted chart success.

This decision by Depeche Mode was a huge personal setback and disappointment to me. It really hurt. I had invested so much time and energy in making the band successful everywhere, and the loss was keenly felt . . .

In some strange way, it may even have turned out to be for the best for me personally, because Dave was setting out on a rather dark phase of his life. I kept in touch for a while afterward with a few key crew members and learned that Depeche Mode on tour was no longer such a happy family. I had achieved an extraordinary worldwide success with touring Depeche Mode. It was a time when our ambitions and dreams were well-matched.

It is impossible to take that away.

Music for the Masses

After recording at least part of their last three records in West Berlin, Dave, Martin, Alan, and Andy were keen for the band's sound to continue to evolve with their sixth studio album. Daniel Miller, who had his hands full at Mute, was also up for the change. The band chose David Bascombe as its new producer. Two years before, Bascombe had worked on an outstanding Tears for Fears album. Depeche Mode moved on from Hansa Studios, beginning work on the new record at Paris's Studio Guillaume Tell instead in February 1987.

Initially, all minds were focused on the next single. Several weeks before its official release, the band debuted its new song, "Strangelove," on the West German TV show *Extratour*.

Two days later, the band filmed a music video for the song, again under the direction of Anton Corbijn. The band and Corbijn had kept up a lively connection since the video for "A Ques-

David Bascombe and Martin at London's Konk Studios.

Performing "Strangelove" on the program *Extratour*, April 2, 1987.

tion of Time," and Dave, Martin, Andy, and Alan had all taken note of the strides the Dutch photographer had made in his visual style.

"Strangelove" came out on April 27, 1987; in the UK, the single "only" reached the top 20, even as it peaked at number 2 in West Germany. The track lagged far behind in the US at number 76.

In May, the band began the obligatory promotional circuit for the single, making guest appearances on multiple TV shows, including one on an important stage at the Montreux Rock Festival in Switzerland.

In the meantime, the band continued work on the new record, spending early May to mid-June at London's Konk Studios before moving to Denmark's Puk Studios for mixing, where they also filmed a video for the second single off the record. On June 20, 1987, the band took a break from recording for a rare kind of playback performance of "Shake the Disease" and "Strangelove" at the S.O.S. Racisme open-air festival in Paris, which was also broadcast on French television.

Despite the explicit politics of their song lyrics in their 1983 and 1984 releases, Depeche Mode had avoided getting involved in benefit concerts and political events as a band. This made the de-

cision to play this particular festival and support its aims all the more surprising. S.O.S. Racisme was a French NGO founded in 1984 to counteract discrimination against immigrants. Soon after, trade unions in West Germany founded an offshoot campaign entitled Don't Go After My Buddy!

On August 24, 1987, the second single from the new record, "Never Let Me Down Again," came out, again reaching number 2 on the West German charts.

Pass for the show in Montreux, Switzerland.

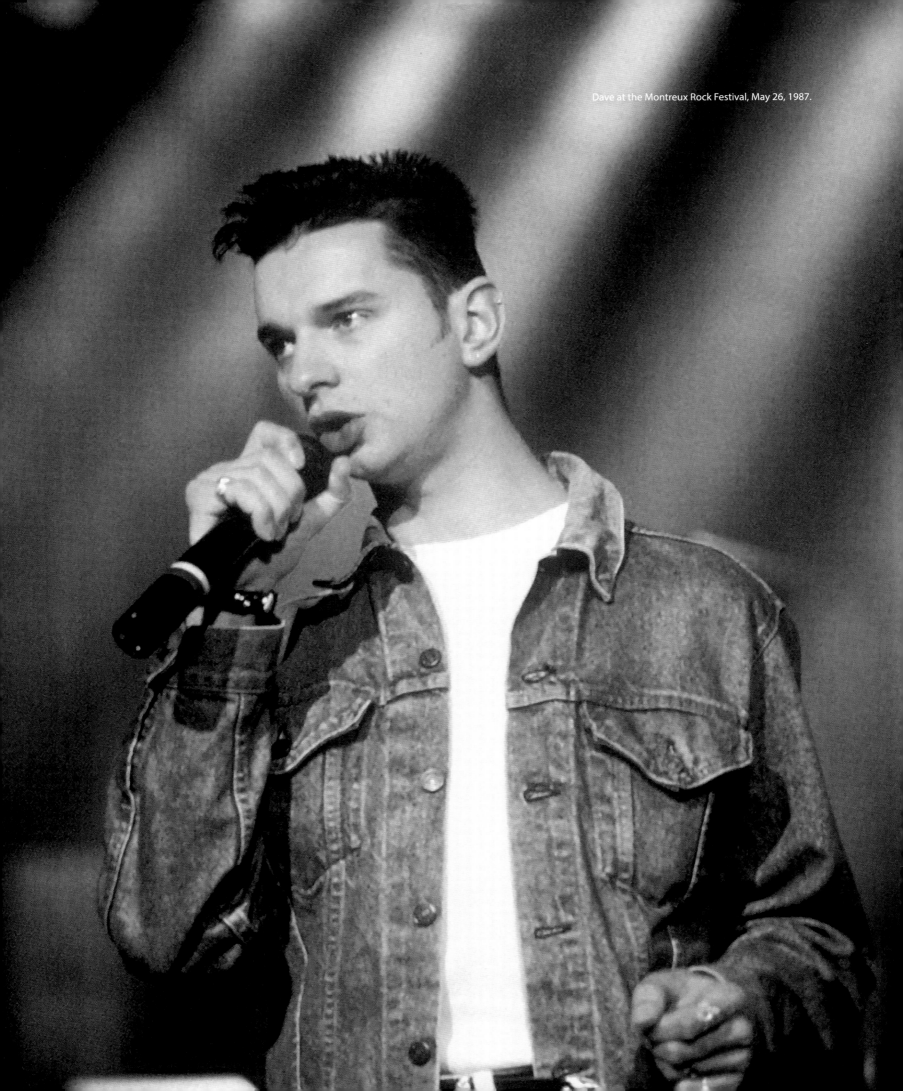

Dave at the Montreux Rock Festival, May 26, 1987.

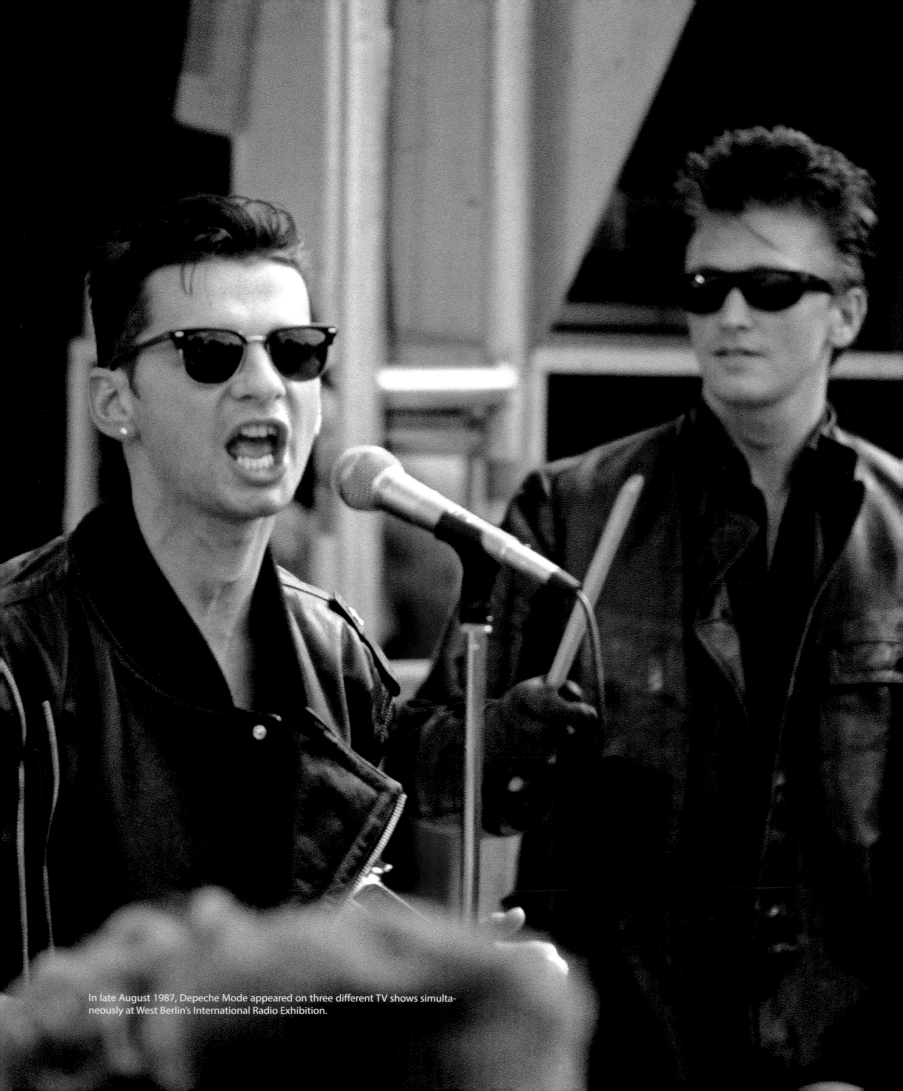

In late August 1987, Depeche Mode appeared on three different TV shows simultaneously at West Berlin's International Radio Exhibition.

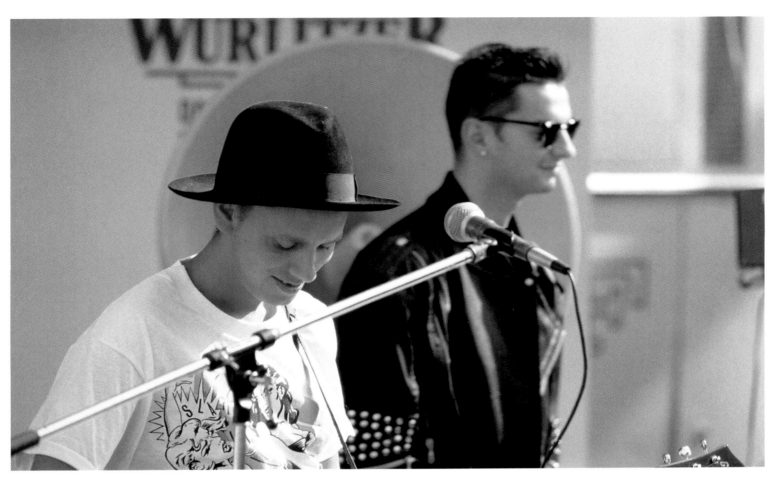

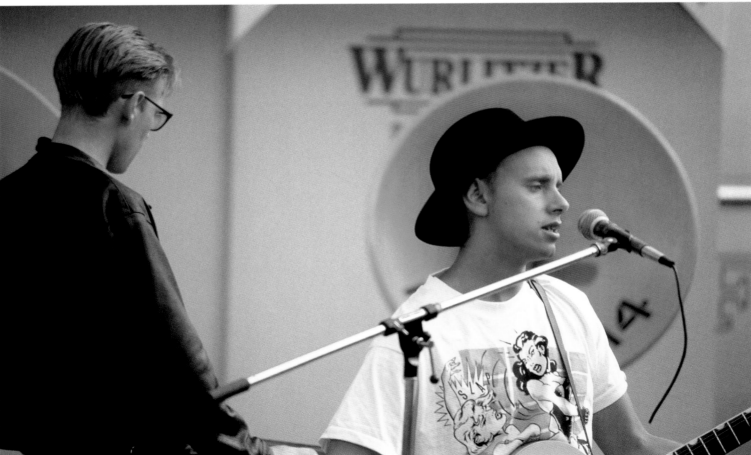

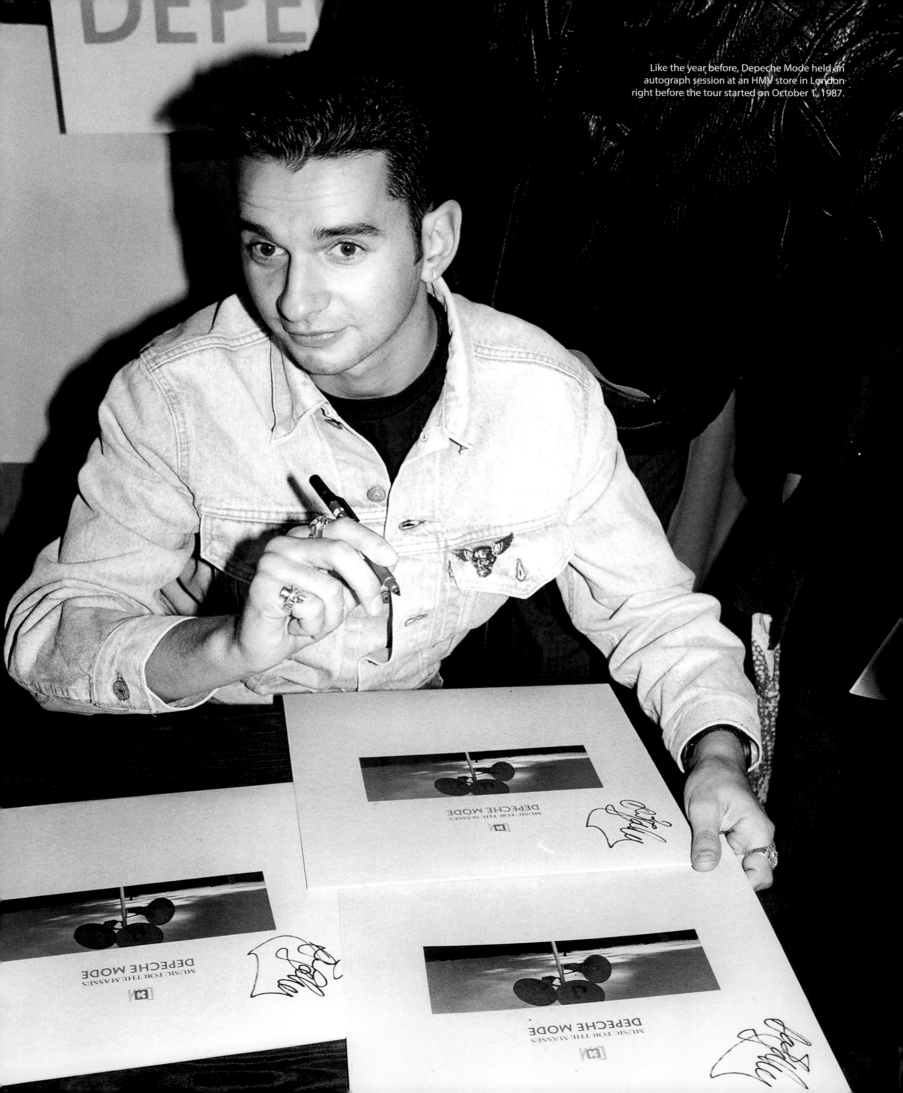

Tour for the Masses

On September 28, 1987, the new, eagerly awaited Depeche Mode album, *Music for the Masses*, was out in stores, where it took off: number 2 in West Germany, number 10 in the UK, and a respectable 35 in the US. A perfect setup for the upcoming tour.

In October 1987, the band started practicing for what would be their largest and longest tour to date, again using London's Nomi Studios. Depeche Mode didn't yet know exactly how many dates it would play, though the tour ultimately extended through June of the following year. On October 14, Dave also became a father, the first member of the band to have children. The upcoming tour threatened to be all the more strenuous for him, but there was little time for reflection.

The band opened its *Music for the Masses* tour on October 22 in Madrid, followed the day after by Barcelona.

After a day off, the band traveled to Munich to play at the Olympiahalle, which was only two-thirds sold out, to their surprise. Opening the show was Belgium's Front 242, a pioneering act that founded the electronic body music movement.

Backstage pass for the *Music for the Masses* tour, 1987–88.

Flyer for the two kickoff concerts in Spain, 1987.

Booklet for the European portion of the *Music for the Masses* tour.

ME Sounds reported enthusiastically from Munich that "the thing that sets Depeche Mode apart is the sheer depth of their hit roster. One top 10 melody after another drilled into the crowd, always with a destructive underlying minor note followed by a sunrise refrain."

The flags incorporated into the stage design on the *Music for the Masses* tour echoed propaganda rallies under totalitarian regimes.

Ad for three shows in Paris, November 16–18, 1987.

Four concerts in Italy were next on the tour schedule; on a day off, the band took time to film video clips with Anton Corbijn for their next single.

By early November, the band was back in West Germany for seven shows, with ticket sales running far better than they had in Munich.

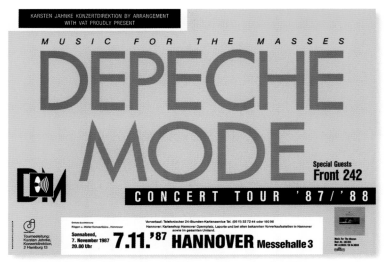

Poster for the Hanover show on November 7, 1987.

In the middle of the month, they played three consecutive dates in the Bercy neighborhood in Paris, each with 15,000 attendees. Next to London and Hamburg, Paris had developed into one of the band's strongholds in West Europe.

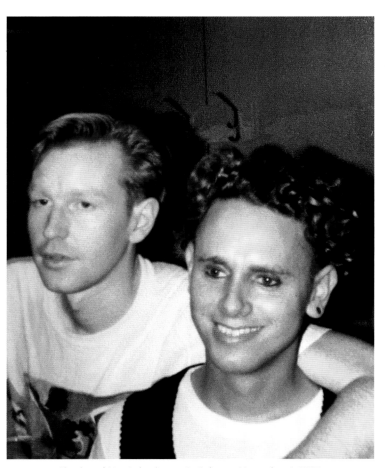

Fletch and Martin backstage in Cologne, November 6, 1987.

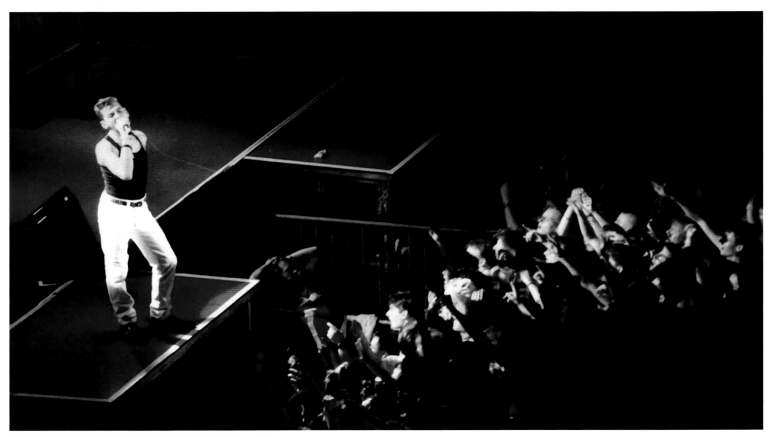

Depeche Mode live at the Festhalle in Frankfurt, November 3, 1987.

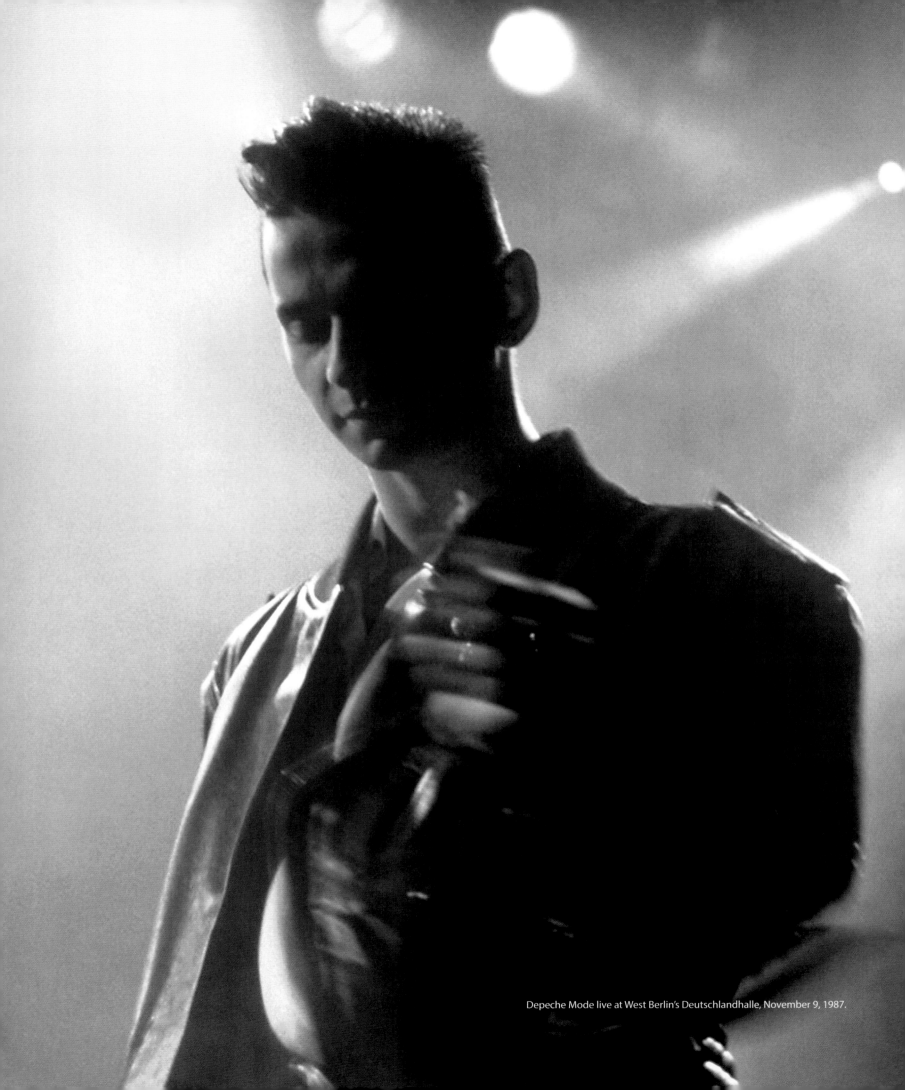

Depeche Mode live at West Berlin's Deutschlandhalle, November 9, 1987.

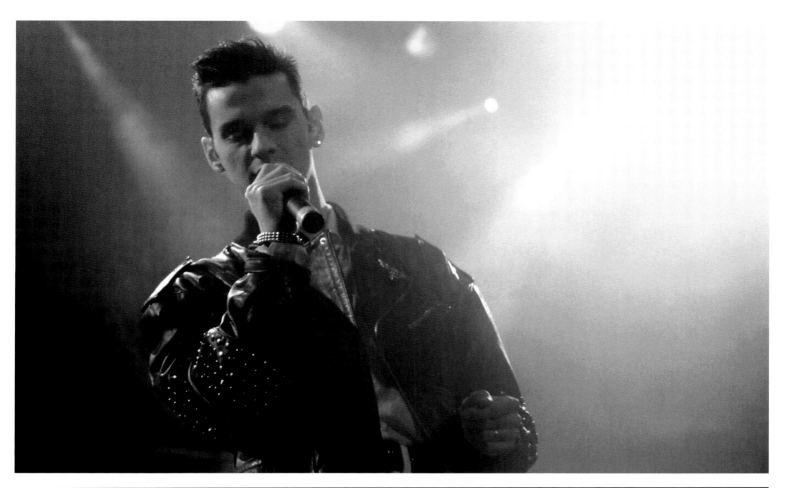

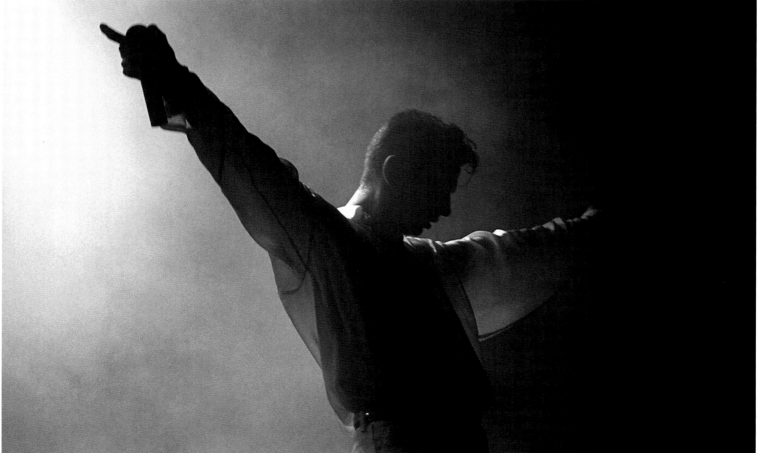

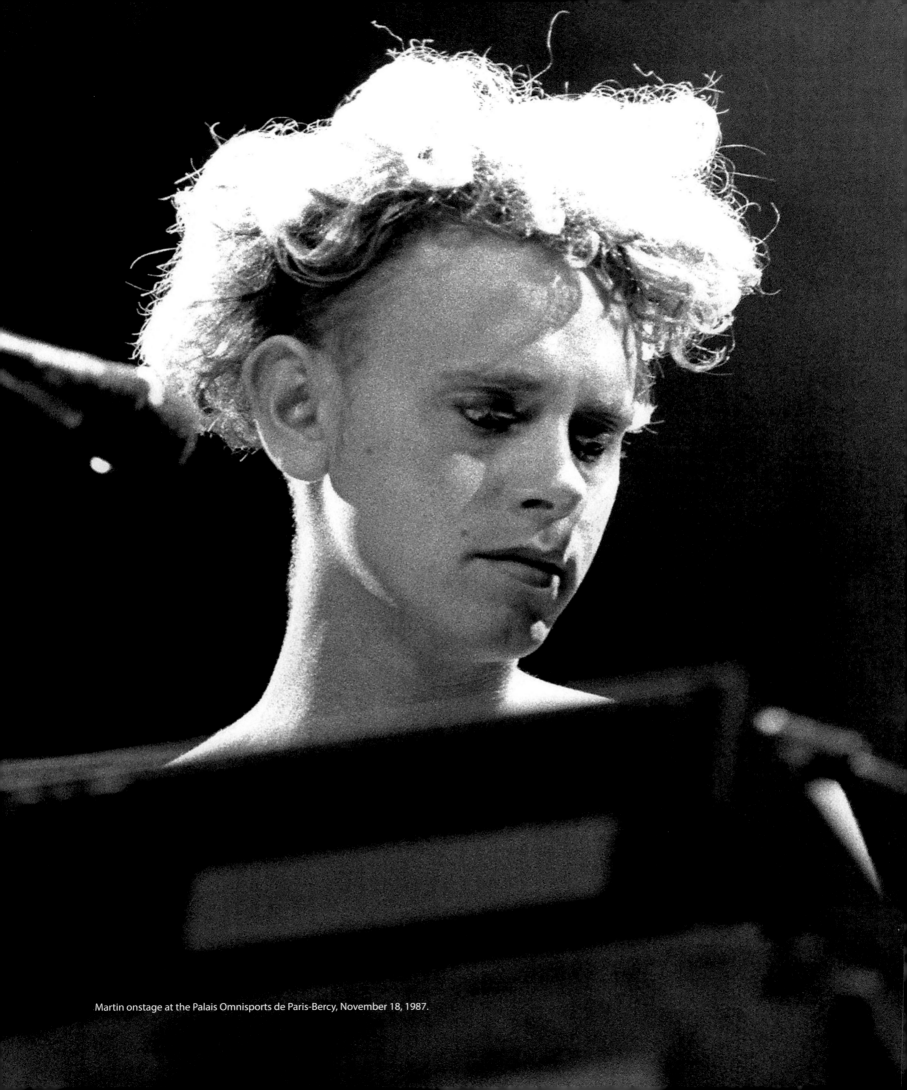

Martin onstage at the Palais Omnisports de Paris-Bercy, November 18, 1987.

On November 22, the band returned to another place that had come to feel like home, appearing for the third consecutive year on the annual *Peter's Pop-Show* in Dortmund, broadcast later on December 5.

Artist pass for *Peter's Pop-Show*, November 22, 1987.

Early December found Depeche Mode on a flight to North America, where they played eleven shows, once again in larger venues than their previous US tour. In Inglewood alone, the band played to a total of 27,000 people over two consecutive nights at the Forum. According to *Billboard* magazine, they brought in $460,000 over the course of the two nights; tickets for both shows sold out within just thirty minutes.

On December 5, 1987, Depeche Mode made its first appearance on the US version of *Top of the Pops,* at Hollywood Center Studios on LA's legendary Sunset Boulevard.

Ticket to the filming of *Top of the Pops* on December 5, 1987.

The New York show on December 18 similarly sold out within six hours. The reporter from the *New York Times,* however, was hardly able to share in the crowd's enthusiasm:

But onstage Friday night at a sold-out Madison Square Garden, Depeche Mode in the flesh was unintentionally comical. Most of the band's music is canned, replayed in concert by the same computer programs that deliver it in the studio—so Mr. Gore, An-

Music for the Masses backstage pass, 1988.

drew Fletcher, and Alan Wilder stood on pedestals with keyboard setups, danced to the beat or mouthed lyrics, and occasionally laid a finger on a key. Now and then, Mr. Gore picked up a guitar or a melodica to make a nonelectronic sound, but generally the band members seemed underemployed. Meanwhile, Mr. Gahan disported himself like someone who had been watching MTV for years on end, the better to absorb every narcissistic rock-singer shtick. Shouting "New York!" and "Hey!" during instrumental passages, swinging his microphone stand, grinning a show-business smile, waving to the crowd, delivering exaggerated pelvic thrusts, he moved like a shopworn version of Rod Stewart.

Concert reviews of this sort, which were far from seldom, reveal yet again what a polarizing phenomenon the band was, and continues to be. People either get what the band is trying to do and love it, or simply fail to see what all the hype is about and respond accordingly.

After New York, Depeche Mode returned to London for a well-deserved Christmas holiday. Just before the New Year, "Behind the Wheel," the third single off *Music for the Masses,* appeared. Here, too, the track did best in West Germany, coming in at number 6.

The tour picked back up on January 9, 1988, in Newport, England. Eleven shows throughout the UK followed, including two sold-out performances at Wembley Arena in London.

After performing for an average of 10,000 people per show in the US, the UK leg of the tour—with the exception of London—felt nearly familial. Most venue capacities were around 2,000, making it clear that the band still had room to expand its following at home.

Backstage in Oslo, February 15, 1988.

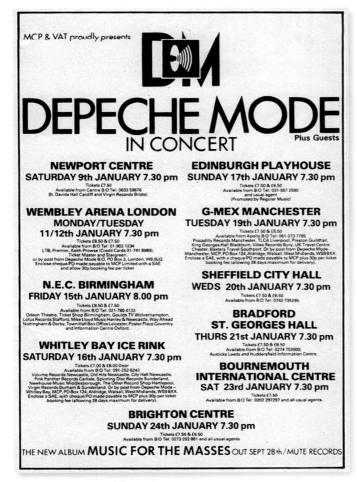

Ad for UK shows in January 1988.

The singer for Hard Corps, the opening act for the UK shows, caused some stir among press and show organizers alike when—already scantily clad to begin with—she bared her breasts during her band's set. For some organizers, this was a little too punk rock; on January 24 in Brighton, she had to confirm in writing at the express wish of the local promoter that she wouldn't undress on-stage, under threat of damages.

The European tour picked back up on February 6 in West Germany with two sold-out shows at Hamburg's Sporthalle, followed by a triumphant return to Scandinavia for five concerts. A show planned for February 22 in Rotterdam was unexpectedly canceled due to disagreements with the local promoter. As Andy later explained to the official Depeche Mode fan club magazine *Bong*, "The promoter wasn't confident that we could sell the tickets."

The Depeche Mode phenomenon . . . what was there left to prove?

Guest pass for the shows in Scandinavia, 1988.

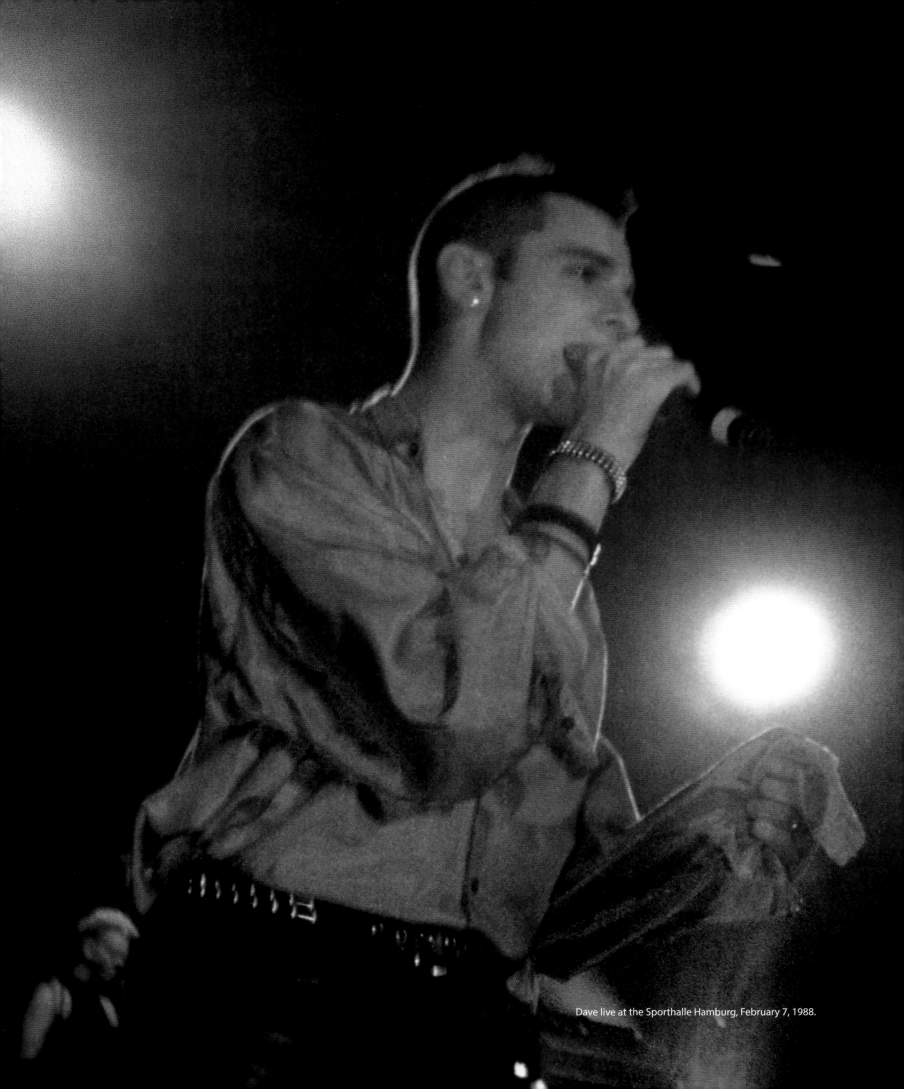

Dave live at the Sporthalle Hamburg, February 7, 1988.

Behind the Wall, Volume 2

In late February, the band began its first extensive tour of France—this time excluding Paris—playing nine dates in larger sports halls. After a March 5 gig in Strasbourg, they headed back behind the Iron Curtain for three unforgettable stops in Eastern Europe on its Tour for the Masses. Once again it was Hungarian promoter Laszlo Hegedus's untiring patience, especially in Czechoslovakia, that succeeded in wrangling legal permits from the authorities.

Dave at the Werner Seelenbinder Halle in East Berlin, March 7, 1988.

Arriving in East Berlin on March 6, Depeche Mode played the Werner Seelenbinder Halle the following night to 6,000 riled-up fans. The performance had been kept secret until shortly before by the East German organizers, nor was there any presale, making it the first concert on a Depeche Mode tour for which you couldn't officially purchase tickets. The organizers' rationale for the policy was that the venue capacity wouldn't be able to match ticket demand; at the time, Depeche Mode was second to none in popularity among East German youth. The result was a black market that sprang up outside the hall, with astronomical sums being paid. The exceptional circumstances surrounding the show weren't lost on the band either: "The main impression, though, was of the thousands of fans queuing outside the gig as we pulled up alongside in the coach," Alan later recounted. "We were told that most of them did not have tickets and that the concert was already oversold by many thousands. We knew that most would not get inside, but they were so enthusiastic anyway. It seemed like they were just happy to see us."

After a day's rest, the band played on March 9 and 10 in Budapest, followed by their first visit to Prague. For countless fans—particularly those in Prague and East Berlin—the band's performances were a long-standing dream come true; before, they hadn't had any realistic options for seeing Depeche Mode live. Two days later, the band was back on the other side of the Iron Curtain in Vienna.

Poster sales at the Werner Seelenbinder Halle in an era when the concept of merchandise was virtually nonexistent.

Depeche Mode arriving at the Nagoya train station in Japan, April 19, 1988.

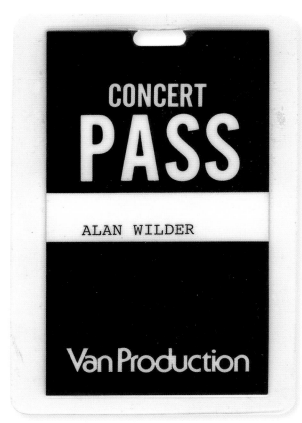

Alan's pass for the shows in Japan, 1988.

Concerts Overseas

With more performances already planned overseas, the band must scarcely have had time to realize just how special their stops behind the Iron Curtain had been. First on the docket stood four shows in Japan in mid-April, then a return to North America.

Fletch with a fan on April 21, 1988, in Tokyo.

Again, things were happening on a still larger scale. At a press conference on April 26 in Pasadena, California, the band announced a gigantic open-air show for June 18 at the Rose Bowl Stadium, with room for 70,000 fans. As the announcement went out over MTV, everybody was asking themselves the same question: would a British synthesizer group that was hardly ever heard on the radio really be able to fill an entire stadium?

The legendary Rose Bowl in Pasadena, California.

The band and label felt sure about it; after all, they had just sold 700,000 copies of *Music for the Masses*. Before that concert, however, Dave, Martin, Alan, and Andy headed off on a twenty-seven-date tour across the US. Where concert attendance was concerned, no other country had lost its mind over Depeche Mode like the US. The band even had its own plane during the run of dates, decorated unmistakably with a large Depeche Mode logo on the nose cone. The four members of the band and the thirty-person crew comprised a truly tight unit, often hanging out together after the shows. *Bong*, the official fan magazine, reported about the evening of June 1 in New York: "They ended up in a club called the Tunnel where a group of young Italian men decided to have a 'chat' with the girls. Things got slightly out of hand, and there was a bit of a rumpus out in the street. Luckily, no one was hurt, and according to Fletch, 'It was a bit like *West Side Story*, really.'"

The US portion of the *Music for the Masses* tour boasted a number of superlatives, not just in terms of the audience size. As *Bong* described elsewhere, "Phoenix, Arizona, holds two DM tour records . . . for being both the coldest and hottest date on the same tour! The first time Depeche Mode played there, on December 8, '87, it was freezing! The next time, June 15, '88, the temperature was 110 degrees. This led to two keyboards actually 'frying' in the heat! Just like the Scouts, the DM road crew have the motto 'be prepared' and carry spare keyboards 'just in case.' The concert went well and none of the crowd seemed any the wiser!"

The Concert Film

Since 1982, Depeche Mode had made various attempts to film their concerts, as a way of capturing the special feeling of their live show. Yet every film had left the band unconvinced, including *The World We Live in and Live in Hamburg* from 1984. This time in the US, the band and their label decided to make a new go of it, inviting filmmaker D.A. Pennebaker to one of the two shows in Portland. The label had asked Pennebaker if he would consider making a concert film about Depeche Mode, though the director didn't even know who the band was. "We were a little uncertain about the whole project, because they really wanted a big film," Pennebaker later recalled in an interview with the *AV Club*. "So I went to one of their concerts in Oregon, and I was really knocked out by their audience. It came over me that their audience only went to Depeche Mode concerts. They didn't go to any other concerts, so it wasn't like a shared audience or anything. So I was kind of intrigued that they had this strange audience that was kind of like a druid ceremony, you know, all making mystic signs and whatnot. So we got kind of intrigued by [Depeche Mode] and the possibility of making a film with them, and by the end we had gotten to like them a lot."

D.A. Pennebaker and his wife, US documentarian Chris Hegedus; the two began collaborating in 1976 and worked together on many projects, including a concert film about Depeche Mode and its fans during the *Music for the Masses* tour.

The band's "unique audience" drew notice in other cities as well; as one local paper wrote about the band's Philadelphia show on May 27, "A few years back, there was a sunny British pop group called Haircut 100. Last night at the Spectrum looked more like Haircut 10,000 as the throng of distinctly coiffured youths grooved to the melancholy beat of Depeche Mode, another British pop group with a decidedly cloudy outlook on life."

Speaking not long after that with the BBC about their crowds, Dave Gahan said, "We built up a real audience. It's not a fabricated audience . . . It's an audience of people that become a part of Depeche Mode as well. There is an incredible warmth, an incredible feeling between band and the audience . . . It's very emotional."

Booklet for the US leg of the *Music for the Masses* tour, 1988.

Show #101

On June 18, Tour for the Masses finally culminated in an open-air concert in Pasadena for close to 70,000 fans. There had never been so many people at a Depeche Mode concert before. The band sound-checked the day before, leaving the crew to sort out a multitude of technical issues.

As was common for shows in the US at the time, the Rose Bowl Stadium was completely seated. The radio station KROQ spent hours broadcasting about the "concert event of the summer" and talking up the few remaining tickets available through Ticketmaster. With three opening acts starting at noon—Thomas Dolby, Wire, and OMD (Orchestral Maneuvers in the Dark)—the concert took on a festival atmosphere.

It wasn't just the band itself that was deeply moved by the tremendous success of the show; as Daniel Miller recalled: "First of

Ticket from the Rose Bowl concert in Pasadena, June 18, 1988.

all, the sheer scale of it, 70,000 people . . . I'd never been to any concert before with 70,000 people. Secondly, it wasn't just 70,000 people watching the concert, it was 70,000 people *participating* in the concert, really responding. Everybody there was a fan, it wasn't, 'Let's go and have a look at this, see what it's like,' there were 70,000 Depeche Mode fans there."

The entire team was especially taken with a moment during "Never Let Me Down Again" when Dave waved his arms back and forth, and 70,000 fans motioned back, a minute-long interplay between stage and audience. "That was a truly exceptional moment," Martin remembered. "You could see the people from the first row to the last, how they were imitating him. It looked like a wheat field, it was just unbelievable." Andy also thought that the band was "more nervous about the recording and filming of the show than the actual number of people at the Rose Bowl."

Billboard magazine listed the show at the top of its weekly list for concerts with the most attendees. Depeche Mode had become

Tour manager Andy Franks's backstage pass from the legendary Rose Bowl concert.

inescapable in the US. Tour for the Masses was overshadowing everything the band had done to date. They had played one hundred and one concerts in front of some 900,000 people. In the resulting film, *101*, the exhaustion among the band—especially Dave—is visible by the last concert, as is a sense of perplexity. After such a huge success, such a high point, what else was left for a formerly small act out of Basildon?

Yet there was no time for brooding. In August, the band headed into London's Swanyard Studios with the young wiz Alan Moulder to mix their first live album, which had been recorded in Pasadena.

Following on the spectacular results of their US tour, Depeche Mode's US label Sire released a remix of "Strangelove" at the end of August. The video for "Strangelove '88" came about under the direction of Martyn Atkins, and was filmed at London's Senate House, the administrative seat for the University of London.

On September 7, 1988, the band was already back in LA, this time for the MTV Video Music Awards at the Universal Amphitheatre, where they did a special performance of "Strangelove."

Anton Corbijn had taken a particular liking to one the cities

Martin, Fletch, and Daryl Bamonte filming the video for "Strangelove '88."

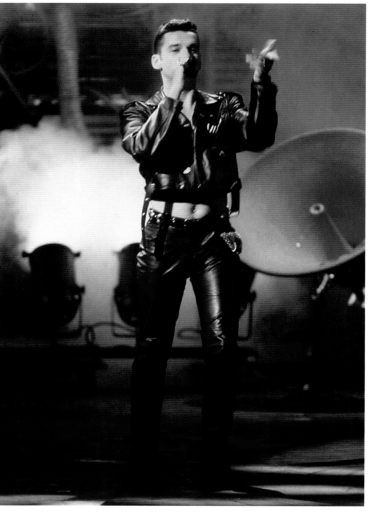

Dave at the MTV Video Music Awards.

that the band first visited that year, and at the end of September they flew to Prague to shoot photos for *Strangers,* his coffee-table book about the band.

On February 13, 1989, the single "Everything Counts Live" was released as a taste of what was to come on the live album, eventually titled *101*. The film premiere for *101* came soon after, on February 22 at London's Dominion Theatre, with the band present.

Despite all the huge moments and their rapid growth in popularity, Depeche Mode still found time for smaller events that proved no less fun. In February 1989, Mute Records put on a small going-away party for one of its most important employees, Gerry McKenna. Alongside Nick Cave and Erasure, Andy Fletcher and Martin Gore played as the "Duo Diablo," which included a rendition of Chuck Berry's "Thirty Days."

On March 13, *101* came out as a double live album. The band spent the next few days in a handful of Western European cities giving interviews, with promotional dates following that April in North America. By this point, nobody was really expecting that Depeche Mode could top its own success—yet the next album was already on the horizon . . .

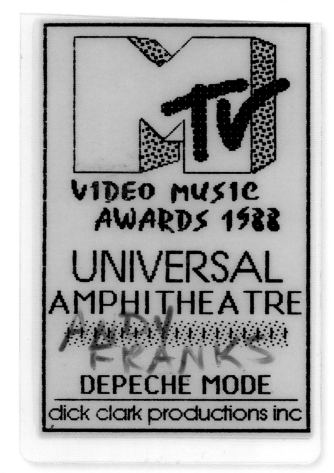

Tour manager Andy Franks's backstage pass for the MTV Video Music Awards.

UK ad announcing the release of Depeche Mode's first live album, 1989.

Interview with Laszlo Hegedus

In 1985, you organized the first Depeche Mode shows behind the Iron Curtain, in Budapest and Warsaw. How did that come about?

I lived in West Berlin then as an immigrant from Hungary, and I followed the music scene because I was a promoter and I was bringing English and American artists to Eastern Europe. It was a very complicated job. I started my company in 1982 in West Berlin—it was registered in the UK because most of the Eastern European governments were not recognizing West Berlin as a legitimate place.

In 1982, we started touring with medium-sized and smaller international artists, and by 1985 our business had developed to a level where we had rather good contacts with various Communist governments and their cultural offices. They more or less trusted our opinions on which artists we should bring to these countries. Some of them were very popular. The guys in the Polish government appreciated music. In Hungary, however, they didn't have a clue about music—they would not listen to it really, they were just government bureaucrats.

The Iron Curtain was bullshit—it was badly organized like everything else in Eastern Europe at that time, which means that if you knew the right places to cross into the Iron Curtain and *how* to cross, the little presents you should give, it was quite easy to get through. Crossing the border from West Berlin to East Berlin, we tried to avoid places like Checkpoint Charlie at Friedrichstrasse because sadistic people were employed there to harass young people, especially other Eastern Europeans. They hated that Hungarians could cross the border to West Berlin—we had relative freedom with Hungarian musicians and artists.

I contacted Dan Silver, their agent at the V.A.T. agency. I negotiated the first tours with him, he was very helpful, and I learned a lot from him, while he learned about Eastern Europe through me. Later I met their producer, Daniel Miller. I contacted him to discuss the tour marketing. I visited the band in the studio, where they were working with Daniel. So we kind of got to know each other and I became a familiar face for them: "the guy doing the Eastern European shows."

The first show was in July 1985 in Hungary. In Budapest we couldn't secure the sports arena or a bigger football stadium, so we had to go to the outskirts of the city, to a small football club. The director of the football club was a friend, so we rented the Volán Stadium, which no one outside of Hungary had ever heard about before Depeche Mode went there. Volán was not a very popular football club. They had some fans, probably a couple of thousand every weekend. But the stadium was quite big, with a capacity of 17,000, and we sold all the tickets quite quickly and built the stage to the specifications of Depeche Mode's technical crew. It went pretty well, they were happy with it. There were horrible dressing rooms, and there was nothing luxurious about it; it was quite modest. But no one from the band or crew complained, they understood—they were happy to be in Budapest.

The second show we did was a few days later in Warsaw, Poland. It was in a horrible ice hockey hall. Warsaw had some really bad venues—there were much better venues in other cities in Poland—but the government was insisting the show happen in Warsaw because they wanted to keep close control over it. They were suspicious about the political intentions of Depeche Mode because they didn't know or didn't understand the band's way of thinking. But that was no problem—until a huge crowd of at least three or four times the venue's capacity showed up. There were thousands of kids on the streets without any hope of hearing the band. But Depeche Mode came out of their bus and signed thousands of autographs. They got emotional about Poland—they felt that these poor fans needed better treatment.

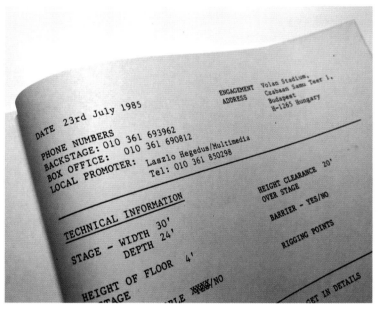

A copy of the crew itinerary for the show at the Volán Stadium in Budapest, 1985.

Were there other cities besides Budapest and Warsaw that the band wanted to perform in?

Yes, they wanted to perform *everywhere*, but the authorities were very suspicious at first. I mean, Depeche Mode was a different kind of band, not like a standard rock band. A few years earlier, the authorities had been complaining that other groups wore their hair too long or that they wore earrings and other symbols of being "gay"—and that was their problem: the moral influence on young socialist people. But Depeche Mode was a different kind of band, a new generation with a new musical approach.

I remember I was discussing Depeche Mode with some people involved in the Czech youth culture in Prague. There was a secret policeman or something, and this guy was a cultural decision-maker, and he said: "No, no, no Depeche Mode! Under no circumstances! Depeche Mode is a negative influence on our youth!"

It was different in East Germany because they understood Depeche Mode, they understood the music and the concept, they watched Western television and listened to Western radio stations. The East Berlin bureaucrats were really up to date. They wanted to

be part of the first tour, but they were slow and couldn't get the official permits in time—that's why they weren't involved in 1985.

Later, in 1988, Depeche Mode played in East Berlin. I had to make a secret promise to the East German authorities that the band wouldn't do things like make political statements. I knew the guys by then, and I knew that they didn't give a shit about politics. But of course, the whole thing *was* political, all these bands like Depeche Mode . . .

Depeche Mode and crew on July 30, 1985, at Torwar Hall in Warsaw.

In 1988, the band played four shows in the East. How early did you start with the preparations?

It doesn't work like that—there was no time line for when we had to start the preparations. I was constantly pushing the Czechs and East Germans to do something, not only with Depeche Mode, but also four or five other artists I was working with at that time. Getting the official permits and approval from the authorities was not at all easy, because they were scared of everything. It's not that they had some big ideological problem with the music; they didn't really understand the music or the lyrics. They were simply complicated bureaucratic administrations. It took them a very long time to understand that an artist wouldn't cause any direct harm to the socialist system, and we needed to get additional permits from government ministries, the Young Communists, the unions, and everyone else, in order to make a final decision.

In Prague, for example, they finally decided to let Depeche Mode play; there was a committee meeting with something like eighteen people involved, each representing one of the various offices—that was a very big deal. And at the same meeting, the other topic was U2. They were refused because "U-2" was a type of American spy airplane that had been shot down in the Soviet Union in the 1960s, and they didn't want to create publicity for a spy plane. So they said: "Not U2, but Depeche Mode is okay, let's do it."

The East Berlin show was confirmed in the fall of 1987 but the East Berliners wanted to keep it a secret. How did those prepa-

rations go with the East German officials? Who were you dealing with there?

In East Berlin, there was a government office near Checkpoint Charlie called the Künstleragentur. They were the official contact for foreign agents and foreign managers for all kinds of activities in East Germany. Sometimes they took us to meetings with people from other mysterious agencies, I guess they were Stasi and the FDJ—but it was never really clarified who was who. And in these meetings, they wanted us to guarantee what the band was and wasn't going to do.

In 1987, Depeche Mode were probably the biggest stars in East Germany—they could sell out any stadium. If I put 100,000 tickets on the market, 100,000 tickets would be sold out in two days. They were really, really big. And the East Germans knew that. So every businessman would want to go to the biggest stadium to see a big show, but the government officials were too scared of that. They kept the show secret because they wanted to limit the hysteria around the tickets. Finally, they found this sports arena with a very limited capacity.

The end of the story is: the show was brilliant, the band was really good, and the enthusiasm was incredible. The police closed the streets around the venue so that there were no big crowds like in Poland three years earlier. The thought was that maybe we could stay there for a week and play a sold-out show every night. So the band really felt bad that they couldn't play in a bigger venue, but there was no bigger venue available because the Stasi was worried about their ability to control all the kids.

Did you see any differences between the fans in the different cities?

I think the East German fans were much more knowledgeable about the lyrics and songs because they watched West German television and listened to West German radio all the time. In Prague and Budapest, they loved the music but they couldn't understand the lyrics.

Depeche Mode didn't make any money playing in the East, so why did they still do all of these shows?

I think they were trying to establish a different way of thinking and a different culture than other pop bands. Daniel Miller, the spiritual leader of that time, was a very special person and an original thinker. Maybe I'm wrong, but I believe he's the one who planted the idea of thinking about more than just the commercial side of things, thinking about the big picture, about fans who couldn't buy tickets or records but were still hungry for the culture and for what Depeche Mode meant as a lifestyle symbol for a new generation. I think Daniel was very influential, because the band members were young at that time and they were eager to learn. They were very open, very nice people—they stood apart from the usual rock bands who were visiting Eastern Europe.

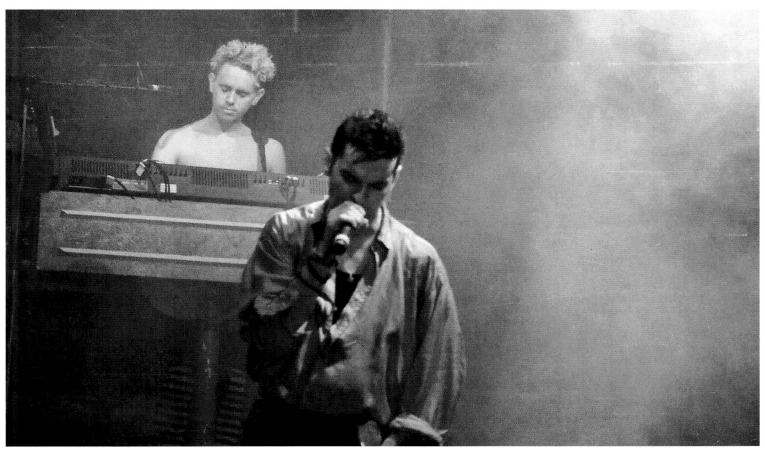

Depeche Mode live at the Sportovní Hala in Prague, March 11, 1988.

On edge at the press conference for the Depeche Mode concert on March 7, 1988, in East Berlin; at right is Laszlo Hegedus.

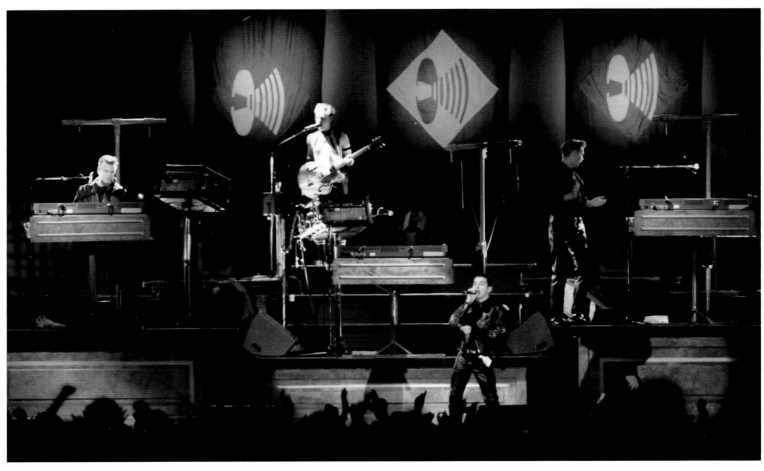

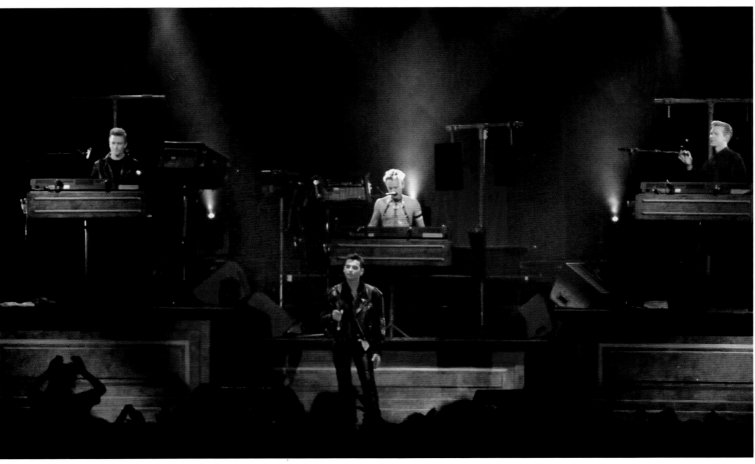

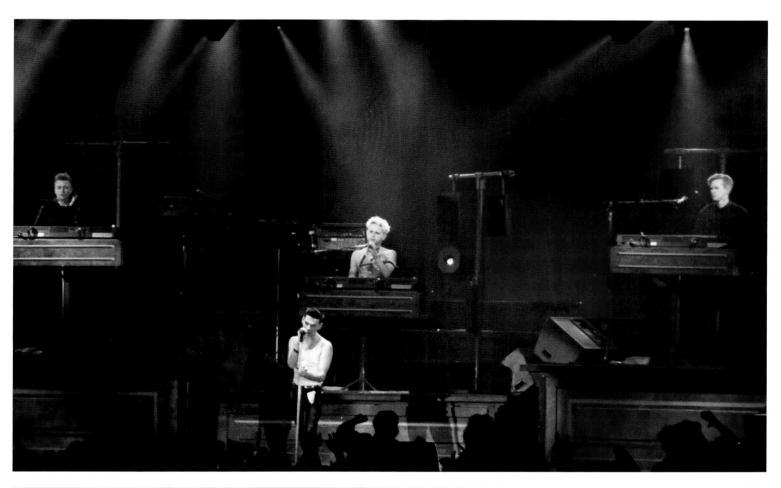

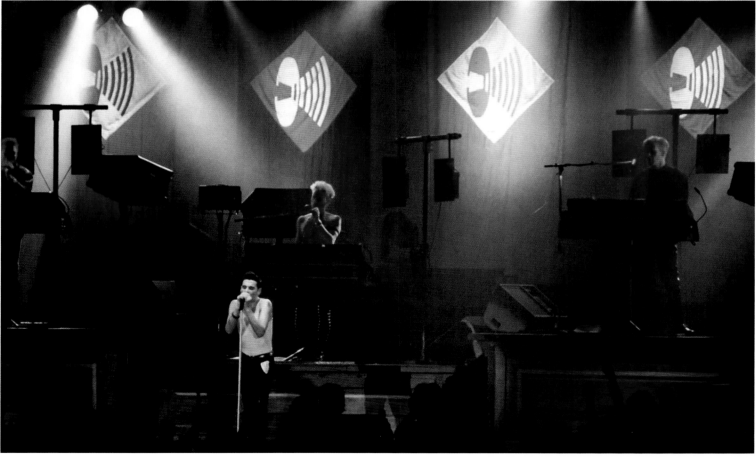

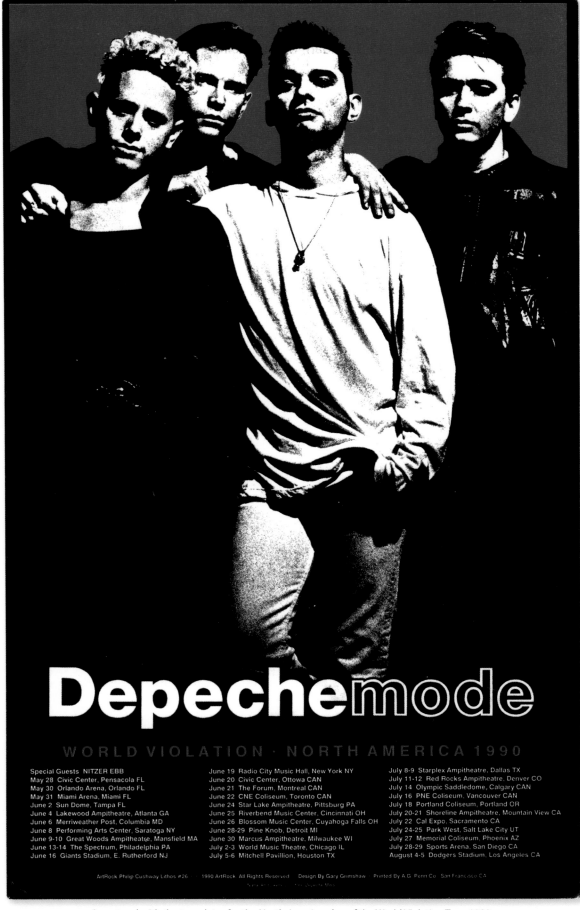

Depechemode

WORLD VIOLATION · NORTH AMERICA 1990

Special Guests NITZER EBB

May 28 Civic Center, Pensacola FL	June 19 Radio City Music Hall, New York NY	July 8-9 Starplex Ampitheatre, Dallas TX
May 30 Orlando Arena, Orlando FL	June 20 Civic Center, Ottowa CAN	July 11-12 Red Rocks Ampitheatre, Denver CO
May 31 Miami Arena, Miami FL	June 21 The Forum, Montreal CAN	July 14 Olympic Saddledome, Calgary CAN
June 2 Sun Dome, Tampa FL	June 22 CNE Coliseum, Toronto CAN	July 16 PNE Coliseum, Vancouver CAN
June 4 Lakewood Ampitheatre, Atlanta GA	June 24 Star Lake Ampitheatre, Pittsburg PA	July 18 Portland Coliseum, Portland OR
June 6 Merriweather Post, Columbia MD	June 25 Riverbend Music Center, Cincinnati OH	July 20-21 Shoreline Ampitheatre, Mountain View CA
June 8 Performing Arts Center, Saratoga NY	June 26 Blossom Music Center, Cuyahoga Falls OH	July 22 Cal Expo, Sacramento CA
June 9-10 Great Woods Ampitheatce, Mansfield MA	June 28-29 Pine Knob, Detroit MI	July 24-25 Park West, Salt Lake City UT
June 13-14 The Spectrum, Philadelphia PA	June 30 Marcus Ampitheatre, Milwaukee WI	July 27 Memorial Coliseum, Phoenix AZ
June 16 Giants Stadium, E. Rutherford NJ	July 2-3 World Music Theatre, Chicago IL	July 28-29 Sports Arena, San Diego CA
	July 5-6 Mitchell Pavillion, Houston TX	August 4-5 Dodgers Stadium, Los Angeles CA

ArtRock Philip Cushway Lithos #26 1990 ArtRock All Rights Reserved Design By Gary Grimshaw Printed By A.G. Penn Co San Francisco CA

A postcard with the tour dates for the North American leg of the World Violation Tour, 1990.

World Violation Tour

With sales from their live record *101* still running full steam ahead through May 1989, Depeche Mode was back in the studio at work on their next album. The band had so far managed to build on its success with each record; now, after the runaway triumph of *Music for the Masses* and a celebrated concert in Pasadena in front of 70,000 fans, what could the band hope for next?

Martin was, as always, very nervous about the band's first meeting to discuss the new record—what would Dave, Fletch, Alan, and Daniel Miller think of the new songs? "It's a very nerve-racking experience," Martin told MTV. "We usually meet at our office, and it's not just the rest of the band. It's usually Daniel from the record company and our producer. And we all sit down in a room, and I have to get my demos out and, usually with very shaky hands, put them into the cassette machine."

Martin's fears proved unfounded: the songs were great. This time the band chose Mark Ellis, better known as Flood, as its producer. Flood was already working with other bands on Mute's roster. After seven weeks with Ellis at Logic Studio in Milan, the band moved back into Puk Studios in Denmark that summer to finish the recordings.

At the end of August, Depeche Mode released its first single from the album, a taste of what was still to come. With strong blues and rock inflections, "Personal Jesus" ranks as one of the band's most exceptional tracks, and showed at the time that they were far from exhausting their creative potential.

Fans responded to the new direction, even if the single never rose higher than number 25 on the US charts. Over the follow-

ing weeks it became the best-selling 12" single in the history of Sire and Warner Bros.—and that included Madonna.

In tandem with their obligations to promote the new single, the band continued work on the new album. At the end of September, they moved to London's Church Studio (owned by Dave Stewart of the Eurythmics until 2004) for several weeks of mixing.

On November 18, the band appeared on *Peter's Pop-Show*, later broadcast on ZDF on December 2 and 31, 1989. They performed "Personal Jesus" and their next single, "Enjoy the Silence," although the latter wouldn't come out until February 1990.

Throughout this period, profound political changes were afoot in Eastern Europe, culminating with the fall of the Berlin Wall on November 9, 1989. Even though the band didn't make

Depeche Mode at *Peter's Pop-Show* on November 18, 1989.

any official statement about the events, it was clear to everyone that countless music fans from the GDR, Poland, Czechoslovakia, Russia, and other Eastern European countries would no longer be separated from their idols by a wall or curtain. Particularly for Depeche Mode fans, 1990 had an auspicious beginning. After promoting "Enjoy the Silence" on a number of TV shows in Europe, the band returned to the US in March to drum up publicity for the next record.

Violator came out worldwide in March 1990, marking yet another milestone in the band's history. Their sound had never been more hip, mature, or well-conceived.

Depeche Mode filming the video for "Personal Jesus" in June 1989 in the Tabernas Desert, a popular filming destination for spaghetti westerns in Andalusia, Spain.

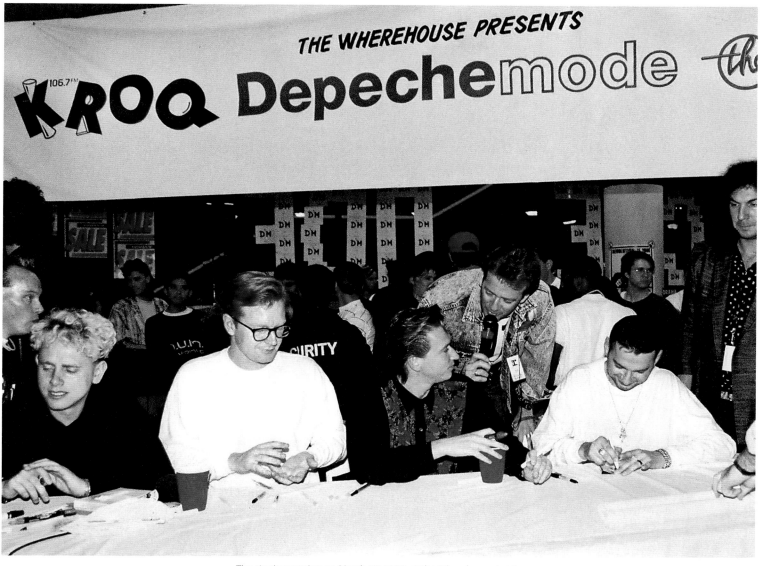

The signing session on March 20, 1990, at the Wherehouse in LA.

The Wherehouse, Los Angeles

Any lingering doubts about whether Depeche Mode would get their US breakthrough with the new album were put to rest on March 20, 1990. That afternoon, the four band members were scheduled for a record signing at the Wherehouse, a record shop in LA. Fans showed up by the thousands, filling the streets around the store and jamming traffic, while riot police attempted to bring the situation under control.

The band itself was whisked away from the unexpected rush just minutes after arriving on the scene; nobody could have signed 15,000 autographs in a single afternoon. TV stations were startled by the phenomenon, with some reporting on "riots," even though none actually took place. Andy spoke up for Depeche Mode fans a short while after, explaining to the *Los Angeles Times*, "Our fans don't get out of hand. They get excited and overeager sometimes, but they're mature and under control. They're intelligent, enthusiastic young people—not the wild, rowdy sort you find at metal concerts."

For many media outlets in the US, it was the first time they had ever heard the name Depeche Mode. Andy went on to explain how the band could nonetheless have so many fans in the US: "We are underexposed on radio and on TV. You don't see a lot of us on MTV either. This helps build up our concert audience because it's the only place people can see us. Not like some of these big artists like Paula Abdul, who you see on TV every other min-

A ticket from the first night at Dodger Stadium.

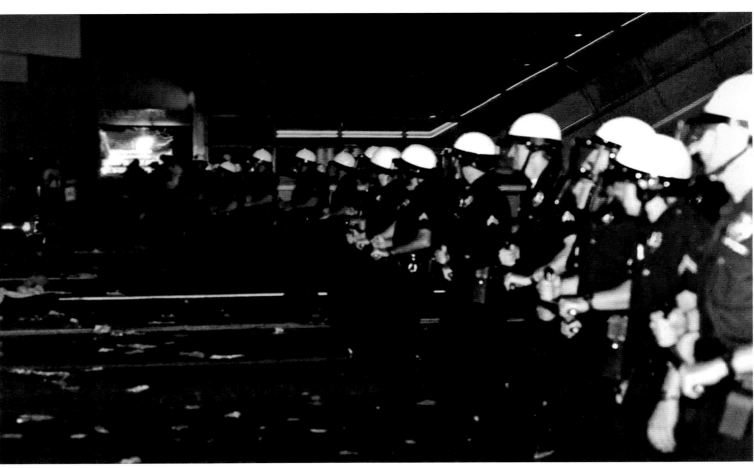

Alan Wilder live, 1990.

ute. They're overexposed. That may help on one album, but it hurts in the long run." The following day, record sales for both *Violator* and "Enjoy the Silence" went through the roof, and the upcoming tour quickly sold out.

With a full-length record and single in the top 10 on the US charts, Depeche Mode was riding high. Worldwide, *Violator* sold more than seven million copies over the next few months. Amid all the bustle and chaos surrounding their record signing in LA, the band simply continued on its promotional tour; on March 22, after a press conference and a series of interviews, the band played an exclusive show in Mexico City for broadcast the following day.

The tour opened on May 28, 1990, at the Pensacola Civic Center in Florida.

World Violation Tour

In early May, before the band's long-awaited World Violation Tour was set to begin, they released "Policy of Truth," the third single from the record. Filmed on the streets of New York by Anton Corbijn, the music video exuded an irrepressible coolness. The band was unstoppable. Meanwhile, they continued to rehearse in London for the upcoming tour.

The tour opened on May 28 in Pensacola, Florida, followed by forty-two shows across North America. In a number of cities, including Philadelphia and Dallas, Depeche Mode played two consecutive sold-out nights.

"No longer a band in the fringes, to be heard only at clubs, Depeche Mode has clinched its position in the mainstream spotlight. Since the band's appropriately titled 1987 album *Music for the Masses*, Depeche Mode has indeed garnered a mass appeal," wrote the *Tampa Bay Times* after the concert in Tampa on June 2, 1990.

The technical aspects of the live show had also been further refined in advance of the tour; Alan, Martin, and Andy each had two keyboards now, though the second only served as a backup. The band went with a similar tape setup for the drum tracks; on tour they started bringing two TASCAM MR-16 tape machines—one of them as a backup. "When you are playing a concert to over 50,000 people, you can't stop the show just because a tape won't play," tour technician Jonathan Roberts explained to *Bong* magazine. "The computer keeps both machines perfectly synchronized, so that if the main machine stops or breaks for any reason, then it

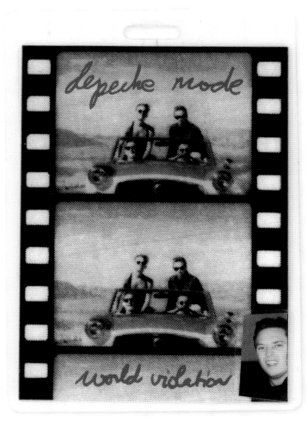

Backstage pass for the US tour, 1990.

Alan Wilder's backstage pass.

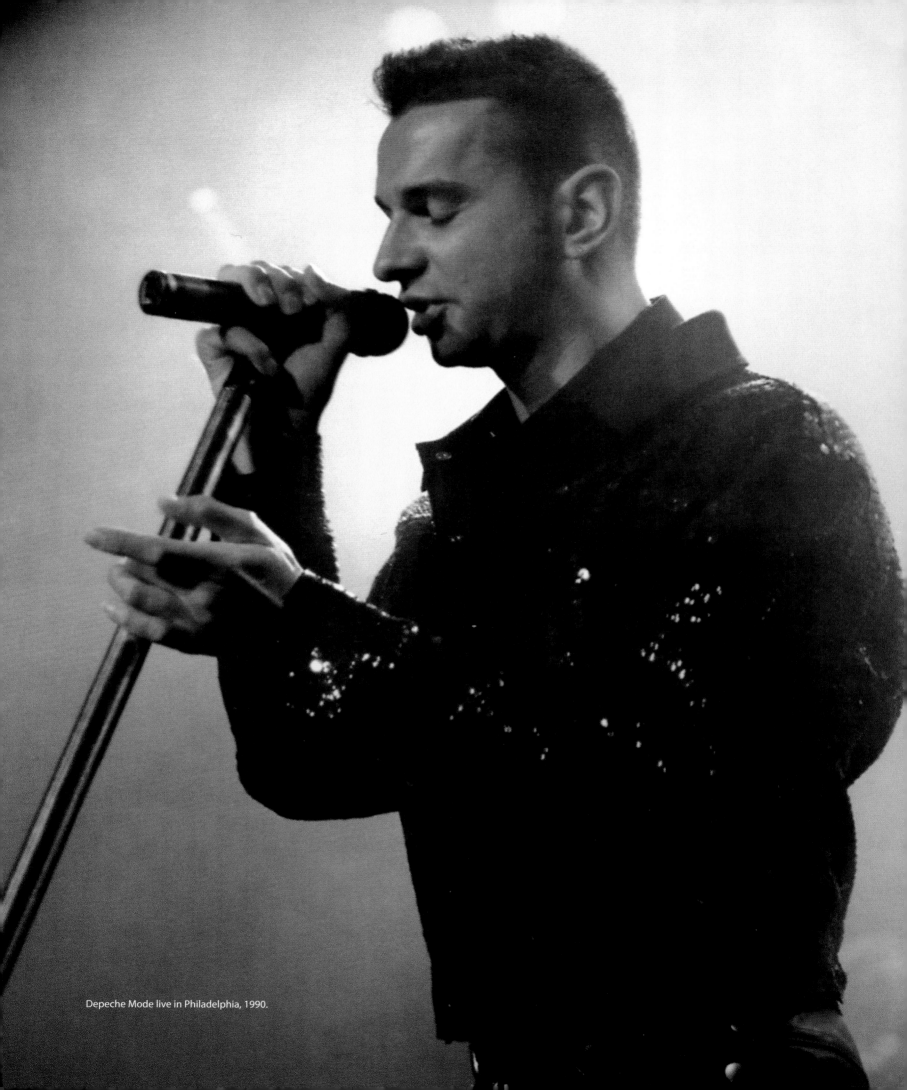

Depeche Mode live in Philadelphia, 1990.

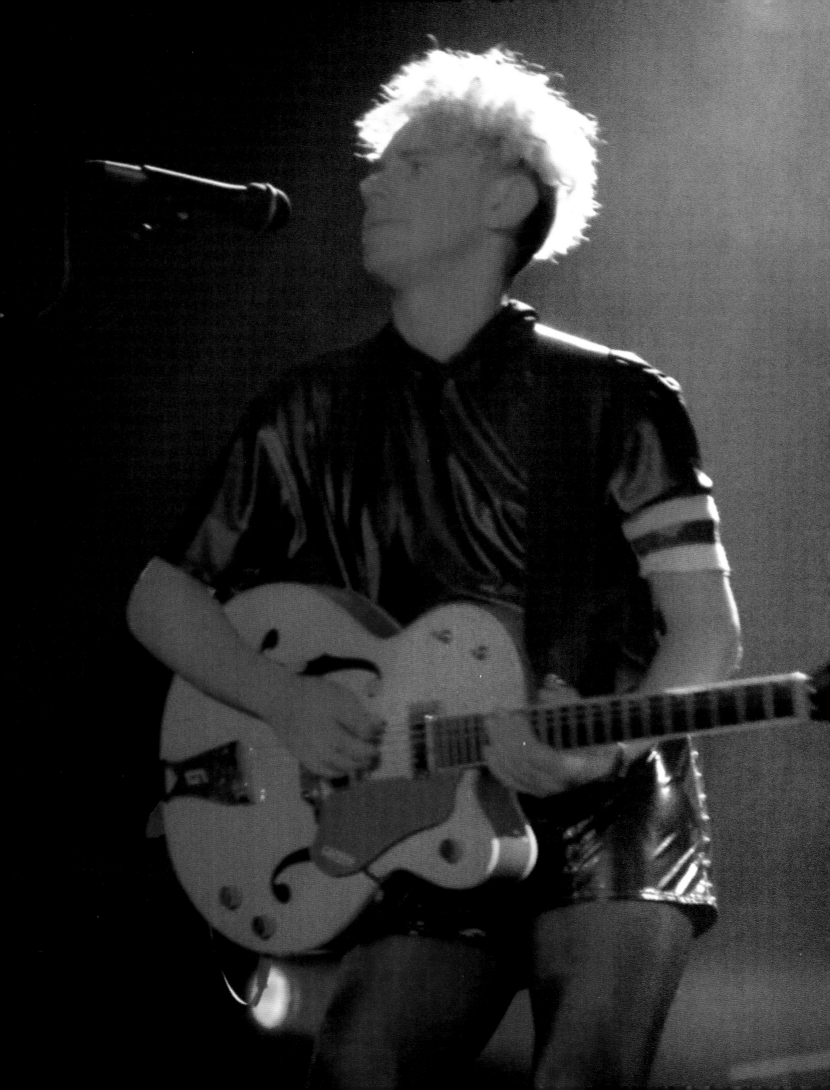

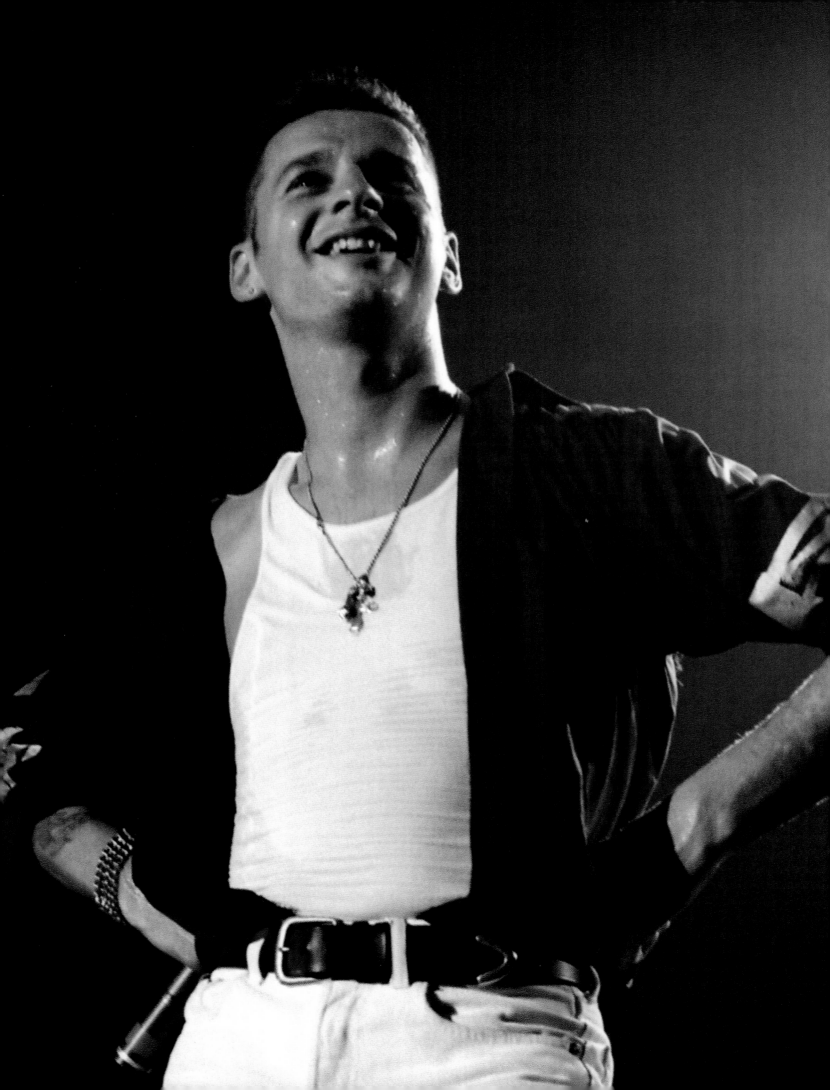

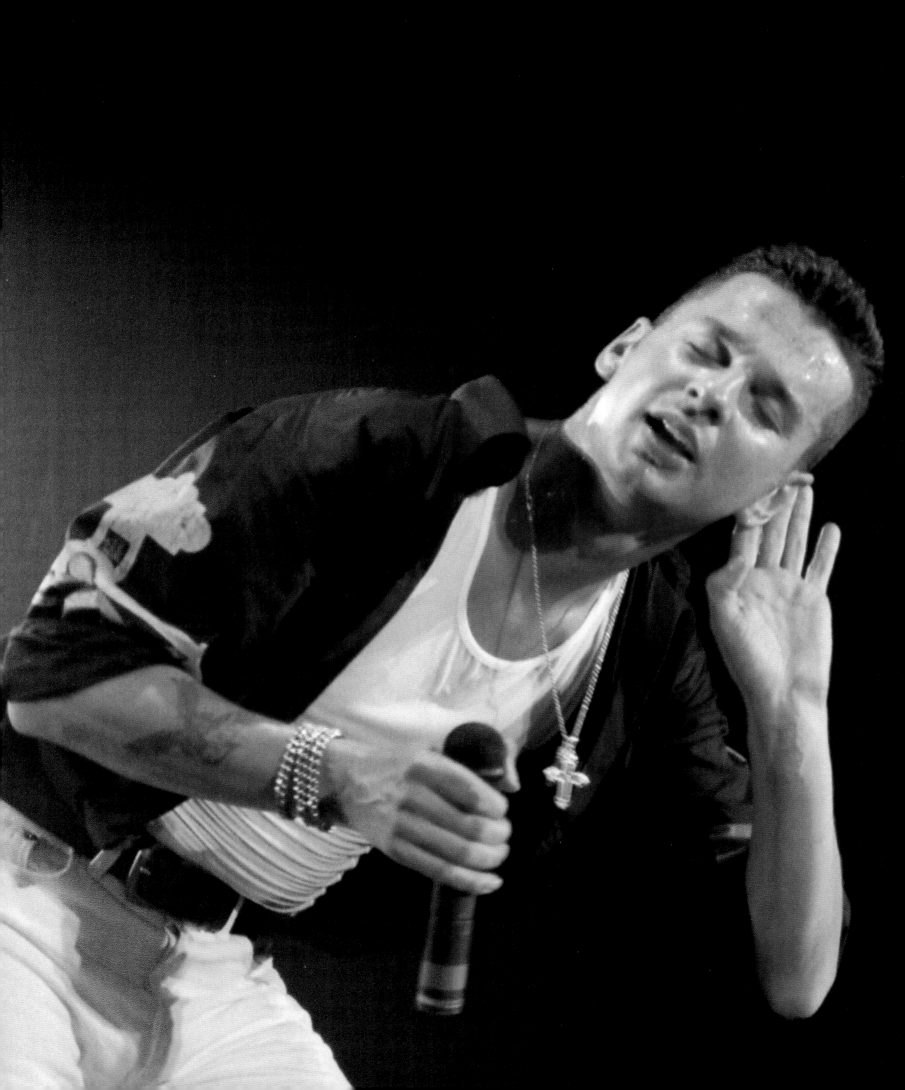

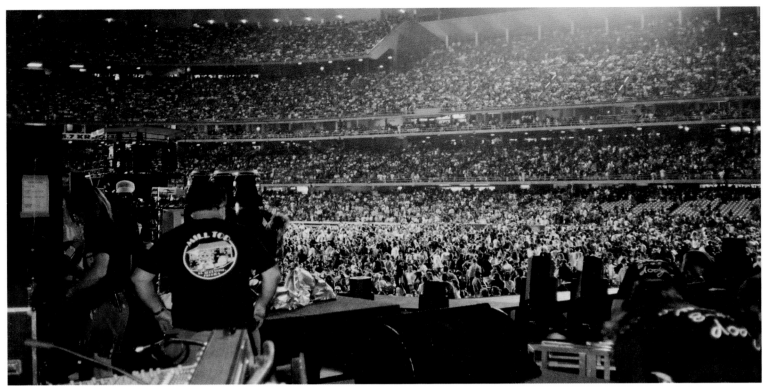

Sold out in a matter of hours: LA's Dodger Stadium on August 4 and 5.

An interview with Japanese media in Kanazawa, September 8, 1990.

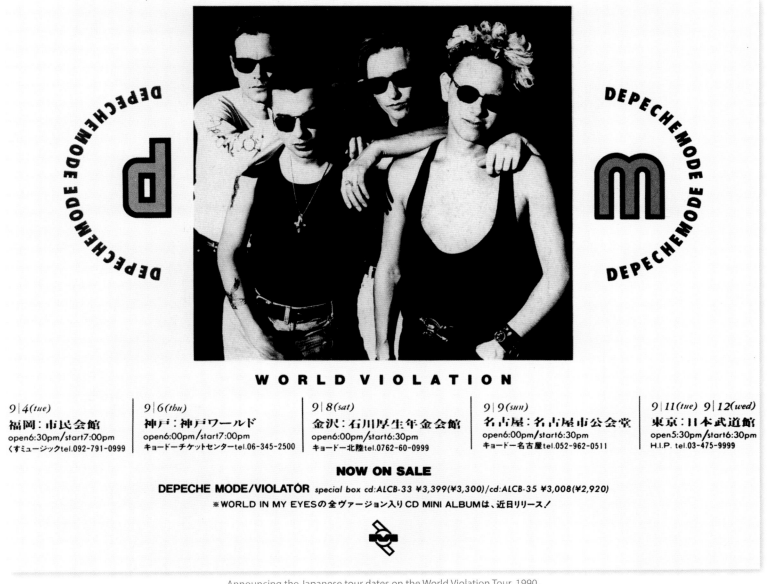

Announcing the Japanese tour dates on the World Violation Tour, 1990.

can swap automatically to the other and the show can continue without so much as a hiccup."

At Giants Stadium in New Jersey on June 16, 1990, Flood, the producer of *Violator,* ran into some old acquaintances. Speaking with the music magazine *Sonicstate,* he recalled: "Anton Corbijn came in, and he said, 'I've got a couple of friends for you, they wanna come in and see you.' And in walk these two scruffbags with hoods over, and it's Adam and Bono [from U2]. They said: 'Look, after what you have been doing with Depeche, would you like to come work with us, doing *Achtung Baby* in Berlin?' So I said yes."

Tickets for the band's LA show on August 4 at Dodger Stadium, with a capacity of around 50,000, sold out within an hour; the additional show booked for the following day sold out nearly as quickly.

Both of the band's Houston shows in early July similarly sold out within an hour; the mayor even issued the band a certificate, declaring them "Depeche Mode Days."

According to the *Daily News Adviser*, Depeche Mode's two shows in San Francisco on July 20 and 21 netted them a cool $780,000. At the end of the month, they played three consecutive sold-out shows in San Diego.

With the US portion of the World Violation Tour over by early August, the band flew to Australia to play its first shows down under. Unfortunately, at their Sydney show on August 31, two songs had to be struck from the set list when Dave developed a problem with his voice; the following day's show in Melbourne was canceled for the same reason. Yet Dave was quickly on the mend, and three days later the band was able to continue the tour with six shows in Japan.

On September 17, yet another single off *Violator* appeared in stores: "World in my Eyes." The video for the song features live clips from the US tour. It was the first time Depeche Mode had released four singles off one record.

エレクトロ・ポップ・バンドの中核!!

DEPECHE

デペッシュ・モード

WORLD MODE
VIOLATION

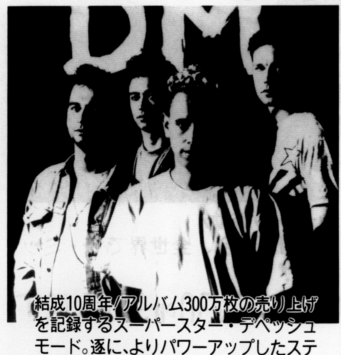

結成10周年!アルバム300万枚の売り上げ
を記録するスーパースター・デペッシュ
モード。逐に、よりパワーアップしたステ
ージを持って来日決定!!

9/6 (木)

7:00 P.M. START
(6:00 P.M. OPEN)

神戸ワールド
記念ホール

S¥5,150 (税含)
A¥4,635 (税含)

7/8 日 午前10時 発売開始!

発売所
チケット・セゾン ☎06-308-9999
チケットぴあ ☎06-363-9999

お問合せ:キョードーチケットセンター☎06-345-2500〔大阪市北区梅田2-5-6〕

Flyer for the concert in Kobe.

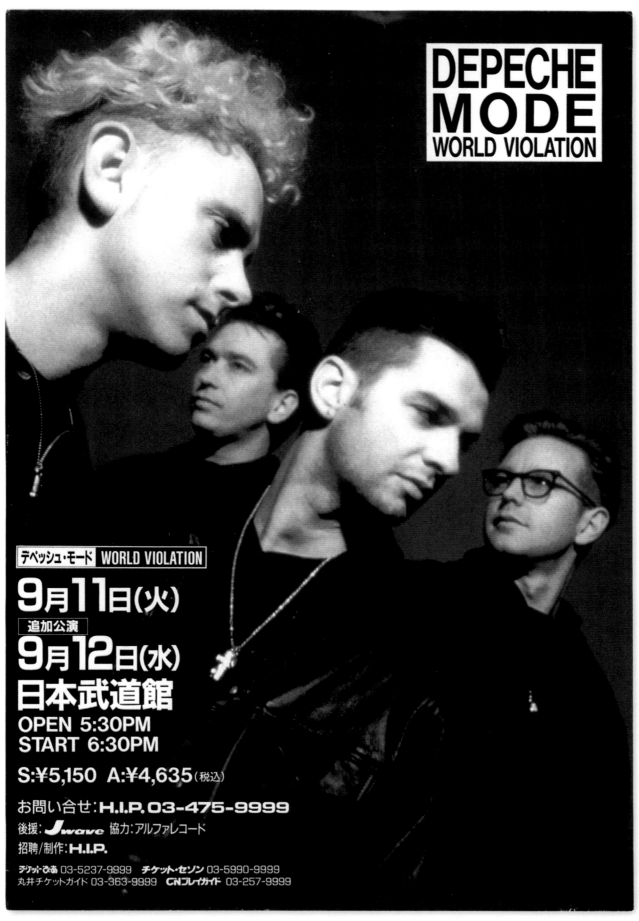

Flyer announcing both shows in Tokyo.

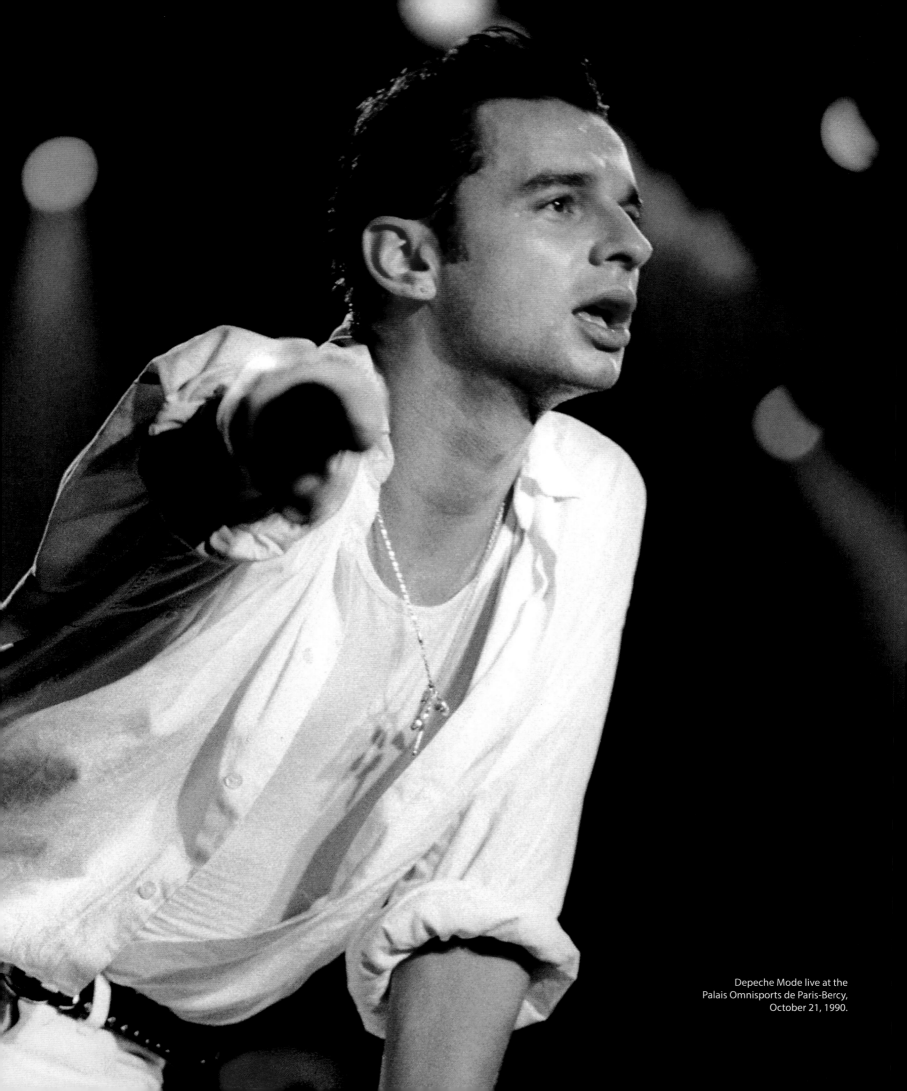

Depeche Mode live at the
Palais Omnisports de Paris-Bercy,
October 21, 1990.

World Violation in Europe

On September 28, 1990, the long wait was finally over for Depeche Mode fans in Europe. The band opened a string of thirty-two shows across the continent in Brussels; the press outdid itself in singing their praises. They were now perceived as real stars, not just another popular band from some indie label.

Martin in Brussels on September 28, 1990.

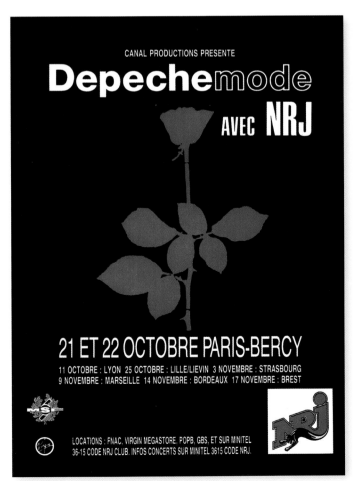

Ad for shows in France.

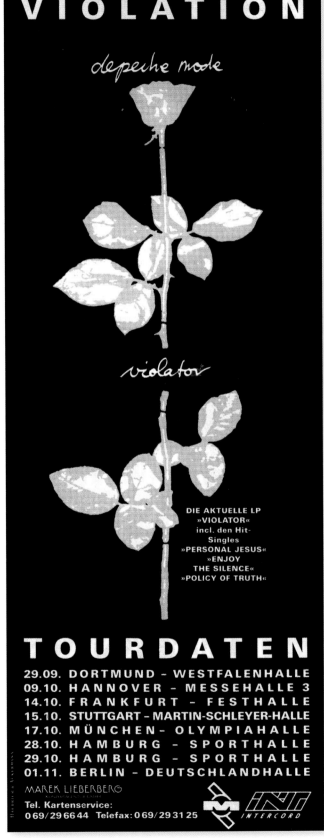

Ad for the German tour dates on the World Violation Tour, 1990.

Deutschlandhalle in a reunited Berlin on October 31, 1990; the numerous Eastern European vehicles in the parking lot indicate where many of the fans came from.

Fletch outside the Maritim Hotel in Berlin after the show at the Deutschlandhalle.

ish wit: "The gig in Frankfurt was particularly good, especially as tennis 'goddess' Steffi Graf showed up and danced, out of time, on the side of the stage."

Even with all the technical updates, on September 15 in Stuttgart, part of the PA failed right at the beginning of "Shake the Disease." Undeterred, thousands of fans continued to clap out the beat themselves, singing along with Dave through the end of the song. For everyone in attendance, it was an unforgettable moment.

The venues in Europe were frequently the same as they had been on the last tour, highlighting once again how Depeche Mode had been developing a far larger audience in the US.

They played nine shows in France, performing in Lyon to 23,000 people, and to 16,000 on both October 21 and 23 in Paris. Back home in the UK, the band played just six concerts in two cities, three each in London and Birmingham, winding up the tour on November 27, 1990.

Despite the resounding success of *Violator*, touring for the record had been shorter than for *Music for the Masses*, with eighty-eight shows over five months, half of them in North America. Even so, the band was more than ready for some time off.

Beginning on October 3, the band played eleven shows across reunified Germany. Crowds of fans from East Germany and the rest of Eastern Europe streamed into West German cities to finally see their idols live, without an Iron Curtain to prevent them. On October 31 and November 1, the band played two memorable shows at the Deutschlandhalle in a unified Berlin, where fans from East and West alike piled in together.

Speaking to *Bong* magazine, Daryl Bamonte reported on other guests at the band's shows in Germany with impeccably dry Brit-

MCP presents

Depeche mode
WORLD VIOLATION

Plus Special Guests

electribe 101

SOLD OUT

WEMBLEY ARENA
MONDAY/TUESDAY 19th/20th NOVEMBER FRIDAY 23rd NOVEMBER 7.30 pm

NEC ARENA BIRMINGHAM
THURSDAY 22nd NOVEMBER MONDAY/TUESDAY 26th/27th NOVEMBER 7.30 pm

This time the poster wasn't advertising ticket sales, but sold-out shows in London and Birmingham.

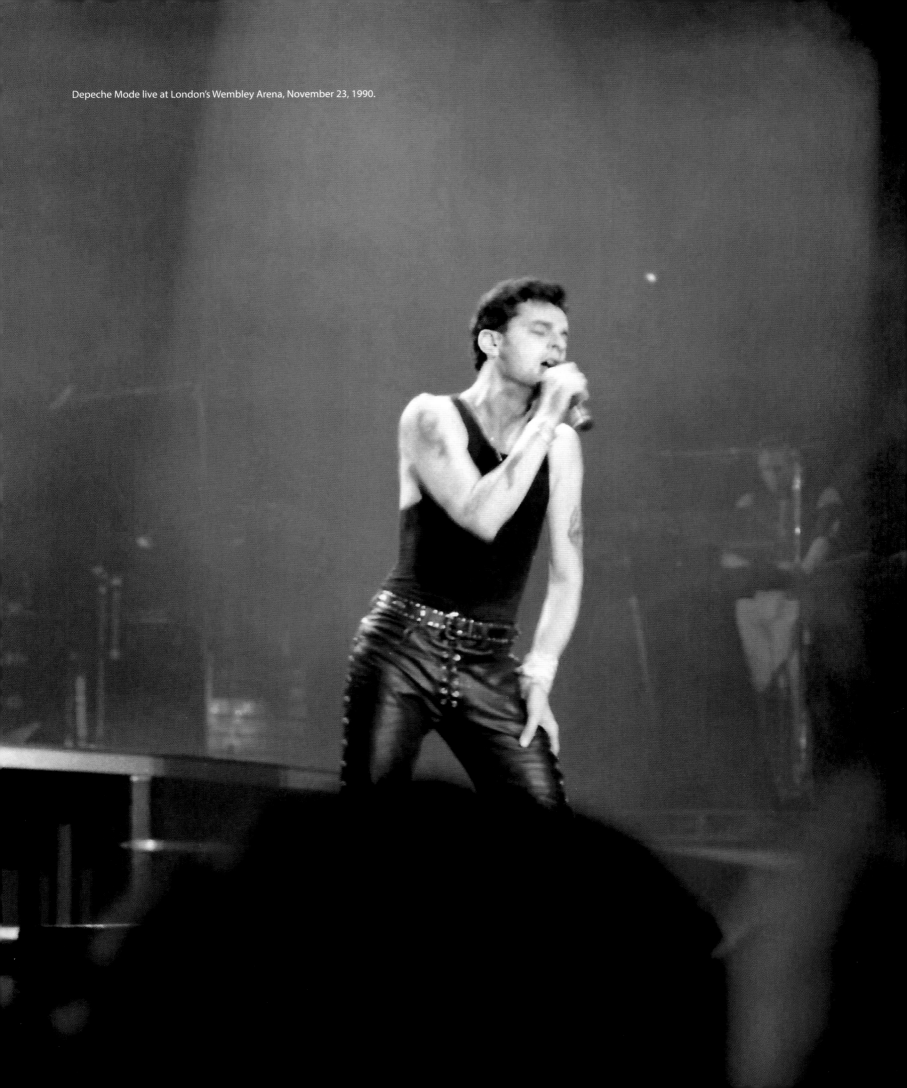

Depeche Mode live at London's Wembley Arena, November 23, 1990.

Interview with Peter Illmann

Peter Illmann was born in Dortmund in 1959. As the host of the shows *Formel Eins*, *P.I.T.–Peter Illmann Treff*, and *Peter's Pop-Show*, he became the most prominent advocate for pop music throughout the 1980s on German-language television.

How did you end up hosting *Formel Eins*, and what role did it play in the world of music broadcasting on West German television?

I was actually quite a latecomer to pop music. I never found my way into music that was popular in the seventies, because I wasn't a tremendous fan of rock. So my interest in pop really first developed in the eighties. At the time, the music I tended to like came from England—new wave and New Romantic. I liked it and found it interesting, more so than what was coming out of the US.

I got my start as a host on Bavarian state radio in 1980. I wound up on *Formel Eins* through a casting call. I went to an audition along with other applicants at a TV studio in Munich; later on they called me and, much to my surprise, gave me the job. The full scope of it, the kind of consequences it would have, obviously wasn't yet clear to me at the time, because nobody knew what the program had planned, whether people would want to watch music videos and whether there were even enough videos to watch— it was all still unknown. That made it all the more gratifying when the show came practically out of nowhere in 1983 and wound up on top. There was hardly any programming for that kind of music at the time—*Thommy's Pop Show* was only once a year, for example.

How were artists selected for the show?

Formel Eins was primarily focused on the West German charts. That meant any newcomers or artists who were already in the top 10 had to be played, including cheesy crooners, followed directly by Billy Idol. But that's how it was supposed to be on our end anyway, because it reflected the charts. We would also introduce new acts every week, and look around at other hit lists in England, the US, and sometimes Japan and Australia. A couple of lesser-known songs made it on air that way. Someone different picked out the new act each week: me, the editor, or the producer. I remember that our director, Michael Bentele, would also make these wild suggestions, very avant-garde—not that that was bad for the show's image. I suggested "People from Ibiza" by Sandy Marton once in 1984, which was really quite a middling Italian pop song. But I liked it because I had heard it on vacation in Spain.

As soon as we played a song on the show, it would appear on the West German charts—that's how simple it seemed. I wasn't aware of it at the time as a young host, but *Formel Eins* was in a real position of power, because nearly all of the new artists that we introduced on the show subsequently wound up on the charts. As long as it wasn't truly awful or too out there, people would buy it.

Peter Illman ushered in a new era of TV in West Germany on April 5, 1983, with the show *Formel Eins*. In 1985, he switched over to ZDF to host the shows *P.I.T.–Peter Illmann Treff* and *Peter's Pop-Show*.

How would you prepare for the show?

None of the editors told me ahead of time what I was supposed to say or not say, they trusted me completely. I would show up at the TV studio and work out some of what I was going to say just five minutes before we recorded. Sometimes it was cool and other times it was dumb—that also happened, obviously. It wasn't like I was thinking that this was actually a super important show people would still be talking about thirty years later. To me, it felt more like being a radio host. As it was, *Formel Eins* wanted to break up the standard TV routine of a glittering staircase and blinking lights. That explains the backdrop of a junkyard, which was the exact opposite.

What was it like working with the record labels?

They were all lined up, obviously, hoping to get their artists on the program. It was a different era; when the Media Control hit list came out, we had to figure out from one day to the next whether we already had a video by the artists, or wanted to have them on

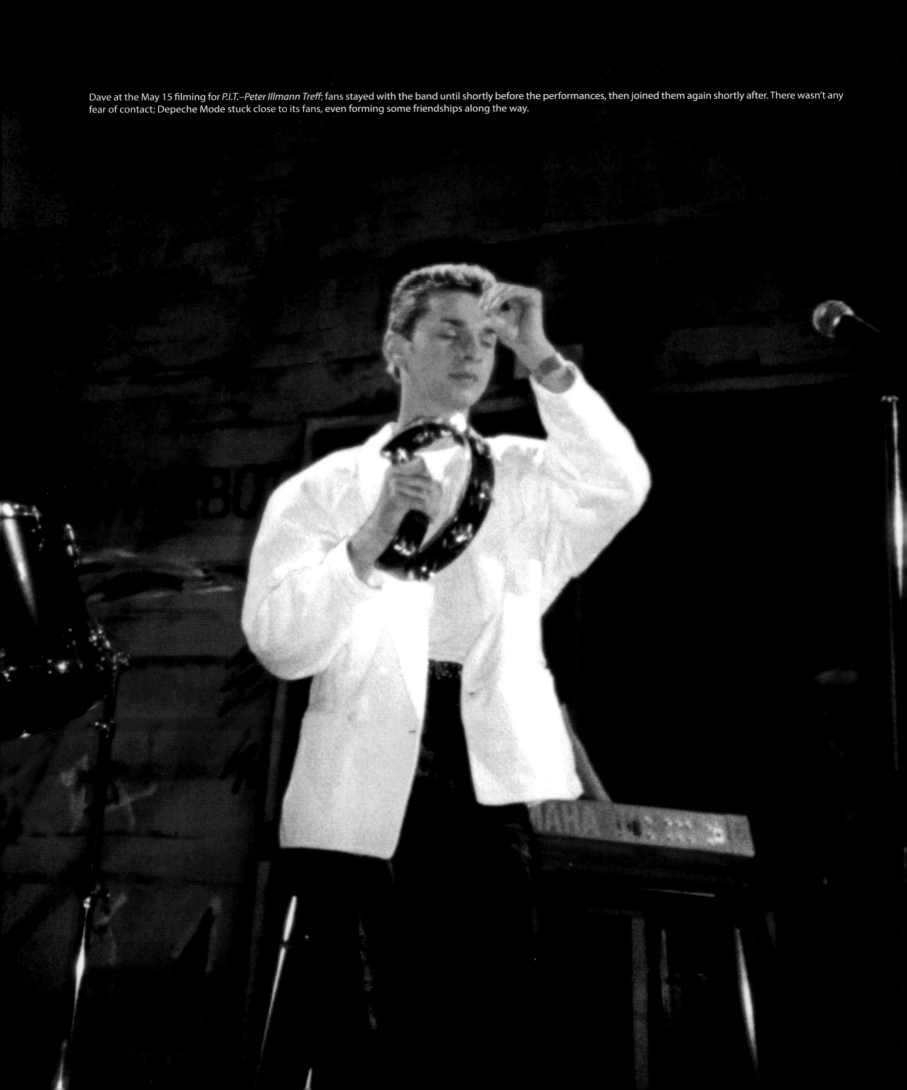

Dave at the May 15 filming for *P.I.T.–Peter Illmann Treff*; fans stayed with the band until shortly before the performances, then joined them again shortly after. There wasn't any fear of contact; Depeche Mode stuck close to its fans, even forming some friendships along the way.

the show. If the group was number 1 on the West German charts, we obviously wanted them on, like with Depeche Mode when they reached the top in 1984 with "People Are People." Every band that reached number 1 got a piece off an old Isetta as a prize—I gave Depeche Mode a fender, for example.

Depeche Mode was already on my radar by that time, I liked them a lot. But I was dealing with so many bands, as I was later on *Peter's Pop-Show*, that I wasn't able to focus on them, and today I've lost some perspective on who was on the program. Today, people come up to me and say, "You met Madonna!" But I can barely remember it.

Dave and Hans Derer, head of media at Intercord, proudly holding up the fender of a BMW Isetta as a prize for "People Are People" taking the number 1 slot in Germany.

Were you aware that East German youth were also watching *Formel Eins*?

I was getting crazy amounts of letters at the time, some of which obviously came from the GDR. Those were especially touching somehow—the show meant a lot more to them than it did to most West Germans. The latter also wrote, of course, sometimes griping about something I had said, or if they didn't like my outfit.

The letters from the GDR came across as much more expressive by contrast; they wrote about how much they liked the program, and that they would really like to visit the studio. Many of them would have given a lot just to stand in the studio, to feel the atmosphere and see the artists. I didn't really realize it at the time.

The reason I think Depeche Mode was so well received in West and East Germany in the eighties was because their music had a kind of longing in it. Maybe that reflects the "German soul" somewhat. That certain sense of melancholy was really important, and is why the band was so successful back then.

You switched over to ZDF after just a year at *Formel Eins*, and hosted the monthly show *P.I.T.–Peter Illmann Treff* from 1985 to 1990.

At *P.I.T.* I was also involved on the editorial side. I met regularly

with editor Holm Dressler to work out who we might invite on. We were the first show to bring Whitney Houston on German TV, for example. Then, after 1985, there was the annual *Peter's Pop-Show* on ZDF, which I took over from Thomas Gottschalk. From the mideighties on, *Peter's Pop-Show* developed into the most important pop music show on West German TV.

Many other European countries carried the show, including Eastern Bloc countries. Did you have any idea at the time how important the show was?

We had got word that the show was quite popular. The organization for *Peter's Pop-Show* was overseen in large part by the concert promoter Marcel Abraham, because the whole thing revolved around which of the top stars had time to be in Dortmund during the two days we produced the show. Especially in the first years, we managed to get only truly international stars on the show—Janet Jackson, for instance. Marcel Abraham was in a league of his own on that front, because he had the necessary contacts. I was constantly surprised by all the people he got to come.

A pink Studebaker Starlight was a symbol for *Formel Eins.*

As the host, I myself wasn't all that important for the show. The most important part was the music and the artists. That also made the editorial work related to hosting *Peter's Pop-Show* manageable.

What did you make of Depeche Mode's career at the time?

The band appeared on *Peter's Pop-Show* every year, because every year they had new hits. They occupied a different kind of place than all the one-hit wonders. Even Duran Duran didn't last as long. You could see that they were more than just another teen band, although they were treated that way for a long time in the public eye. And even though their music changed quite drastically over the years, their fans always followed.

I never had many private interactions with the bands myself. That was easiest to do when we were recording *Peter's Pop-Show* in Dortmund, because there were all these world-famous people living together for two days in one hotel, and the bar became a meet-

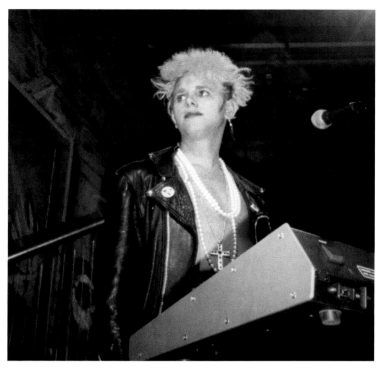

Martin recording on P.I.T.–Peter Illmann Treff on May 15, 1985; the band performed "Shake the Disease."

Depeche Mode playing *Peter's Pop-Show,* November 21, 1986.

ing point. The hotel in Dortmund was actually quite modest, but the bar was obviously bursting at the seams. Screaming fans were standing around outside the hotel and weren't allowed in—it was a state of emergency. I remember you could always find Depeche Mode at the bar. "We're all out of vodka again," you would hear people say, "because Depeche Mode drank it all." I rarely went to the bar, I was just too shy. The whole chaotic scene of artists and their fans—I preferred staying in my room, something I regret a little today.

Peter's Pop-Show was a dynamic mix of artists onstage and lots of young people in the audience. Was it noticeable when the crowd dug a particular act, or was it just a party the whole time?

Most of the audience had come to see specific bands, which made it tough for some. Modern Talking was booed so badly in 1986, for example, that they had to bring the sound from the venue down over broadcast, so that you couldn't hear it on TV. So there were large differences in how the audience treated the bands. But most of them were received positively.

You could see very quickly that Depeche Mode was a favorite among teens. Especially at night, with the fans standing outside the window of the hotel bar—there were so many other stars running around, and the fans only ever wanted to see Depeche Mode.

To this day, the thing that makes Depeche Mode's music stand out for me is that it doesn't sound dated. There's music from the eighties that when you listen to it today, you think: *It was cool at the time, but it's no good today.* When you listen to Depeche Mode's earlier work today, it may still sound like the eighties, but it doesn't sound "old," it sounds cool.

What changed in the early nineties?

In the early nineties, it became increasingly difficult for *Peter's Pop-Show* to get all the top stars to commit to two days. Sometimes it would involve up to thirty artists and bands per show. Aside from that, more and more managers started meddling in the lead-up to the show so that their artists would go on at specific times, because the audience share was particularly good then. That often led to arguments, because not everybody could perform at the same time. And once we stopped getting the larger acts, the show didn't make any sense anymore either, and it was canceled in 1993. With music videos growing more and more popular, stars didn't have to rely on those sort of shows anymore. Finally, MTV and later VIVA in Germany also pulled the rug out from under shows like *Formel Eins* and *Peter's Pop-Show.* Today, it might be possible to think about it again.

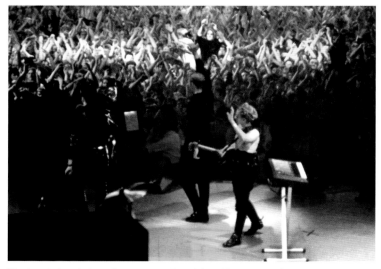

The band after their performance on *Peter's Pop-Show,* November 22, 1987.

Depeche Mode was right at home on the show, making appearances in 1985, 1986, 1987, and 1989. They only appeared twice on *P. I. T. –Peter Illmann Treff* by comparison, in 1984 and 1986. The final broadcast with Peter Illmann ran in 1992. The program, which was renamed the *ZDF Pop Show* along the way, was ultimately discontinued at the end of 1993.

Devotional Tour

There were no official dates announced for Depeche Mode for an entire year following the end of the World Violation Tour, a first since the band had started. Alan alone stayed active, working with Flood on the next Nitzer Ebb record and releasing his third Recoil album in April 1992; otherwise, he, Martin, and Andy enjoyed the London nightlife and looked after their families, while Dave, who had since divorced his wife Joanne, moved to the pulsing scene in LA.

In February 1992, the four met to begin work on the next album, in a villa near Madrid that had been rebuilt as a studio. But things were different. Andy recalled the reunion with Dave: "We didn't see him after the Violation Tour for about a year or so. When we came to Spain at the beginning of recording *Songs of Faith and Devotion*, he had long hair, saying we should become a grunge band, and disappearing into his bedroom for about four days at a time. So it was a real change." It wasn't only Dave's looks that had changed, though the topic of a possible drug problem never surfaced. Getting started in the studio proved difficult, with Alan suffering silently, and only two songs were completed. Dave had married his friend Teresa "T.C." Conroy in the meantime in Las Vegas, with an Elvis impersonator presiding.

Depeche Mode picked back up from August and September at the Château du Pape, a recording studio in the Eimsbüttel neighborhood in Hamburg. Final mixing happened in London.

Word got out quickly among Depeche Mode fans that Martin, Dave, Fletch, and Alan were staying in Hamburg, and *Bravo* was suddenly reporting on the band again. Yet with headlines like "Dave Totally Different" and "Fans Deeply Worried about Dave," it became clear that journalists were less concerned with new sounds from the band and mostly focused on Dave's change in appearance. In January 1993, Andy married his longtime girlfriend Graínne Mullan.

Dave with a fan outside Hamburg's Château du Pape studio.

On February 15, the band released a new single, "I Feel You," a heavy rock number that was similar in some respects to 1989's "Personal Jesus," yet at the same time totally different. The song glided into the top 10 in both Germany and the UK.

Unlike with their earlier releases, the band made only one TV appearance for their new single, in early April for Spanish broadcast. MTV's increasingly global reach made it unnecessary to perform on different stations across Europe for promotion. Much more important was making it onto heavy rotation on special-interest programs. The band's new music video and press photos offered the public a glimpse of Dave's new look, spreading confusion among many fans. Even so, Depeche Mode was back!

The band's eighth studio album, *Songs of Faith and Devotion*, came out on March 22, 1993. Drawing heavily on rock and blues, the album went on to have a sterling career despite the clear differences from the band's pop-synth sounds of the 1980s. Compared to *Violator*, the songs were more forceful, and the album contained more drama. Martin, however, presented a unique perspective in an interview with MTV: "The only difference I notice between the last album and the previous ones is that I think it's a little bit more positive."

Record sales in particular would show just how big the band had become; the album landed at number 1 on the charts in Germany, the UK, and the US. About one month after its release, a second single came out, "Walking in my Shoes." Alan, meanwhile, was back in the studio, working with sound assistant Steve Lyon to prepare the playbacks for tour.

Alan, Flood, and Martin at Hamburg's Marriott Hotel.

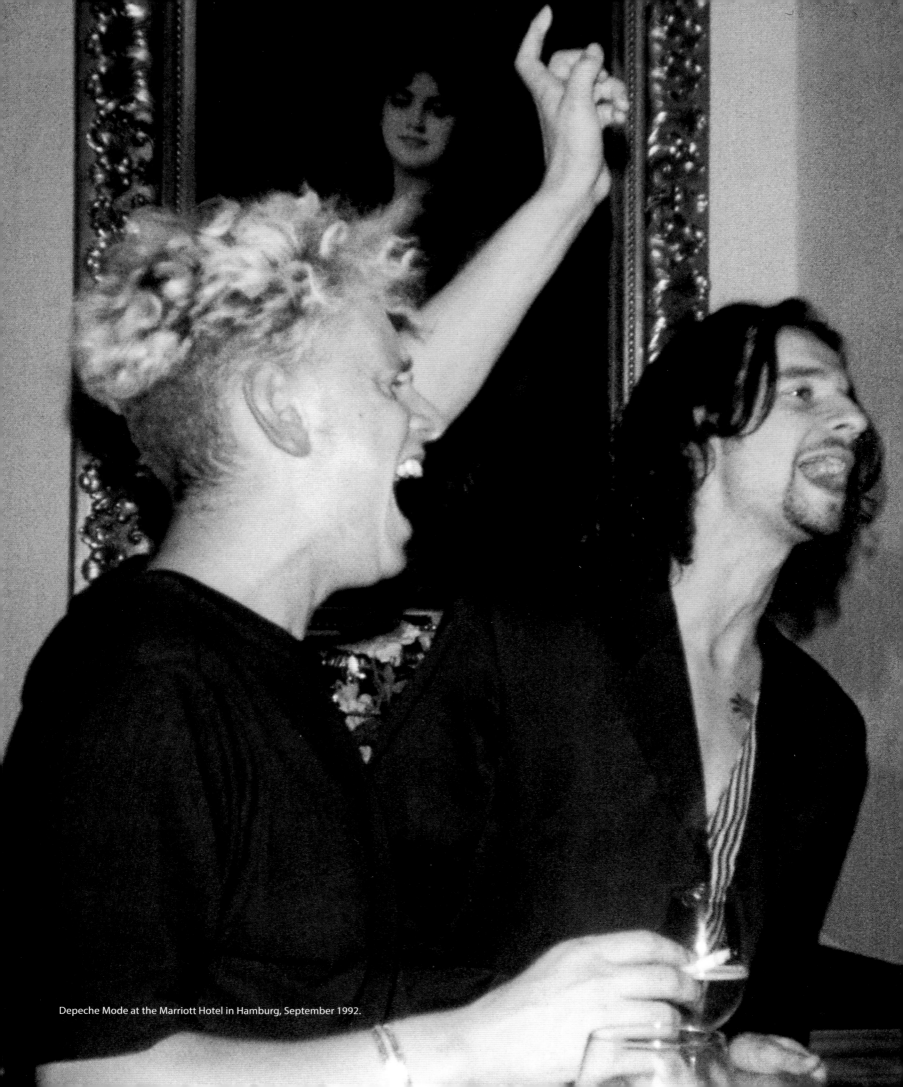

Depeche Mode at the Marriott Hotel in Hamburg, September 1992.

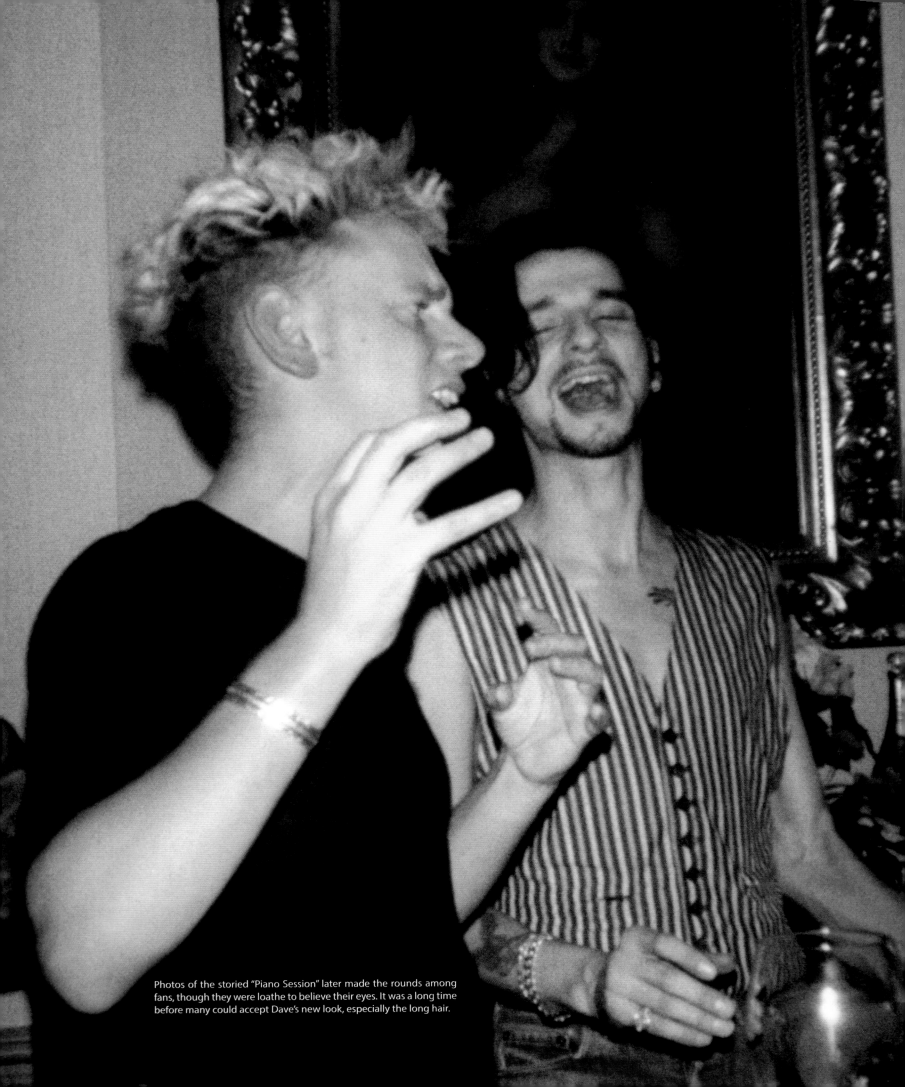

Photos of the storied "Piano Session" later made the rounds among fans, though they were loathe to believe their eyes. It was a long time before many could accept Dave's new look, especially the long hair.

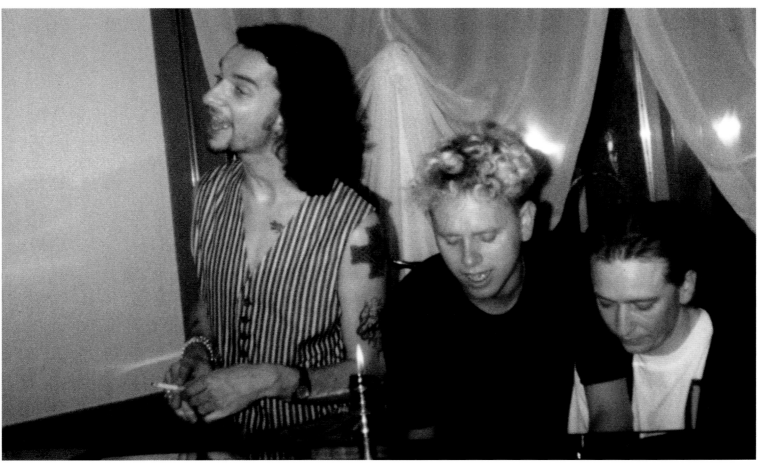

Depeche Mode with guests at the record release party for *Songs of Faith and Devotion* at London's Ministry of Sound, March 12, 1993; the event was streamed via satellite to other major cities where release parties were being held. Fans had a chance to ask the band questions.

All-access pass for the record release party in London, March 12, 1993.

Devotional Tour in Europe

With Anton Corbijn directing the stage design, the result was markedly different from earlier tours, with two continuous platforms stretching across the stage and videos projected onto multiple surfaces.

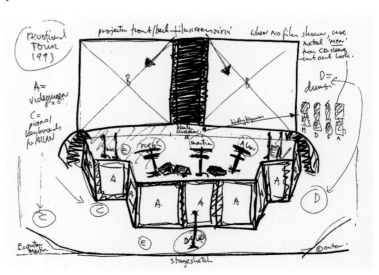

A sketch by Anton Corbijn from his first time designing the stage.

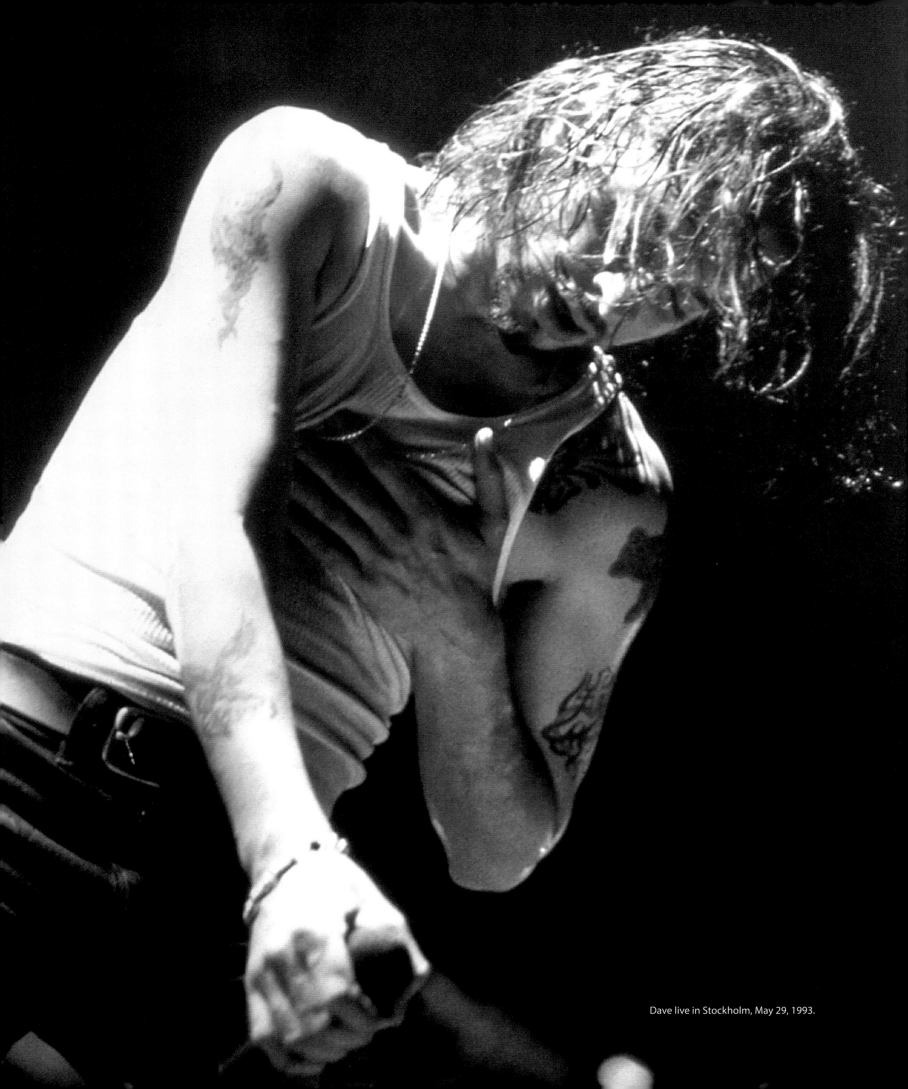

Dave live in Stockholm, May 29, 1993.

The band also made use of a drum kit for the first time; Alan took on the role for a number of songs, practicing for months ahead of time. In-ear monitors—small headphones that gave each individual band member a much clearer and better defined monitor mix—were another new addition to the stage setup. Two backup singers, Samantha Smith and Hildia Campbell, also accompanied the band onstage for part of the show. Last but certainly not least, Dave's beard and long hair left no doubt that the band had put the 1980s behind it.

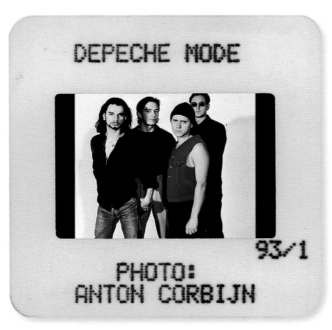

Change of costume: from pop sensations to rock stars; a promotional slide with a picture taken by Anton Corbijn for the Devotional Tour, 1993.

The initial leg of the European tour stretched over forty-one dates, from May 19, 1993, in Lille, to the end of July, with eleven of them in Germany.

It was a gigantic undertaking; the crew had swelled to seventy people, more than ever before. In keeping with the name of the tour, the roadies had T-shirts made with *Devotee* printed on the back, obviously with a certain ironic undertone.

To avoid the concert set list growing too monotonous over such a long tour, the band created eight playback tapes with different sequences of songs, marked red, green, yellow, and blue. The tapes allowed for four different set lists, with another set of combinations possible for the second half of the show. The tapes could be switched out while Martin sang a solo number.

Yet even with such a large production team and careful preparation, not everything went according to plan. To everyone's surprise, after the May 28 show in Gothenburg, Sweden, the opening band from the UK that had been booked for the European leg, Spiritualized, threw in the towel and quit the tour. A new opening act had to be found for the very next night. Daryl Bamonte wrote about it in his tour diary: "We went to the hotel disco after the show to think about a new support band. The resident band were playing, a dodgy Swedish ska band. Kessler asked them to support

Dave in a crowd of fans at the Forest National in Brussels.

us in Stockholm the next night. The drummer came around first, and agreed on behalf of his band."

A journalist from the UK's *Select* magazine came away from the Hanover show on May 31 deeply impressed by the band's German fan base: "Germany's really the Mode's spiritual home. In the UK, *Songs of Faith and Devotion* has sold 150,000 copies—an awful lot for an album preoccupied with themes of submission, lust, and a desperate belief in humankind. Out there it's 650,000 in six weeks, and still counting."

Notably, the band only played one show in the UK on that leg of the European tour, on July 31, 1993, at London's Crystal Palace to a crowd of nearly 36,000. It would prove a memorable evening for fans, with the popular Sisters of Mercy opening and a string quartet accompanying Martin on "Judas."

Fan clubs organized a long line of buses to the Crystal Palace from Germany; a handful of German tour companies also organized bus travel to the London show. The concert was filmed by BBC and later broadcast.

As a part of its "Up'n Away" sales campaign, Lufthansa offered discounted concert tickets, flights, and a meet-and-greet with the band for its July 17 show in Barcelona. Many German fans took up the offer for a quick getaway to Spain. The mood in Barcelona could hardly have been more upbeat; that night, the city earned its reputation as a mecca for Depeche Mode.

DEPECHE MODE • *ENJOY THE RUMOURS* (LONDON 1993) • CD BOOTLEG

Enjoy the Rumours is a high-quality live BBC recording.

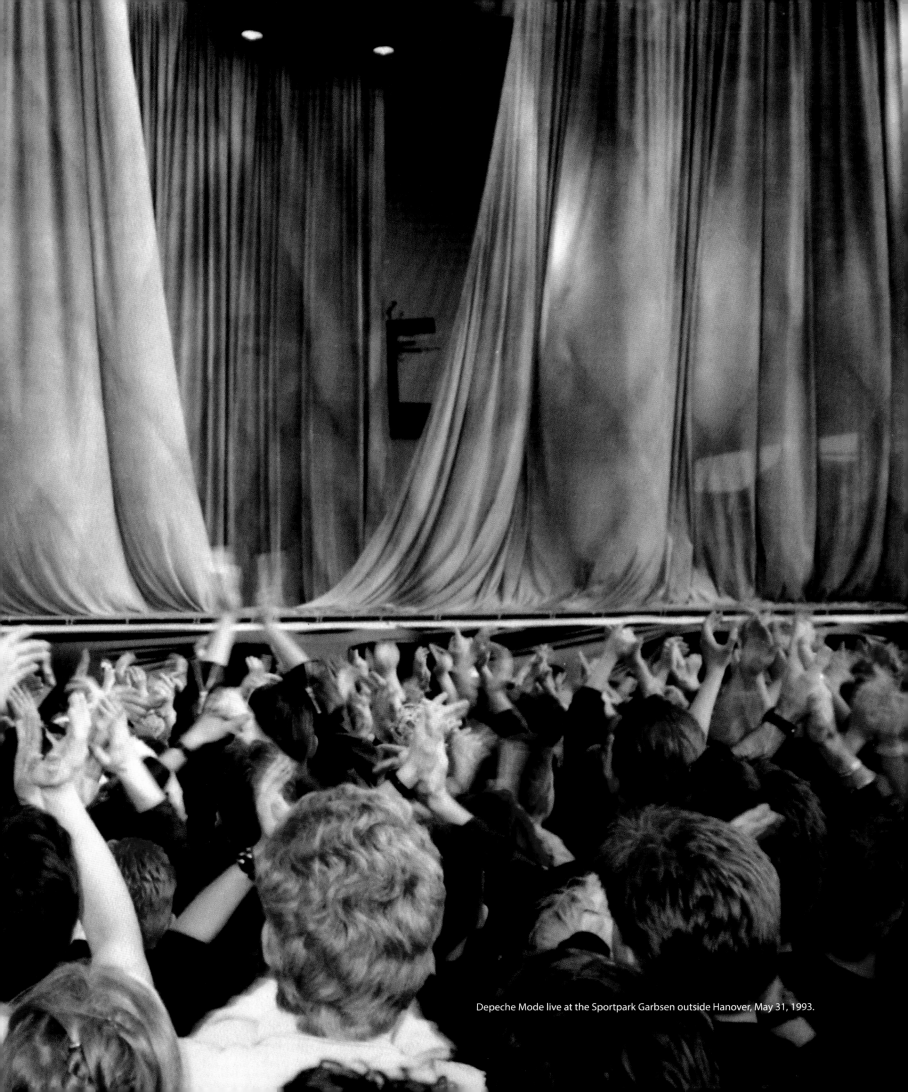
Depeche Mode live at the Sportpark Garbsen outside Hanover, May 31, 1993.

The stage at the Festwiese Leipzig; the band's first show there was an open-air concert to around 25,000 people.

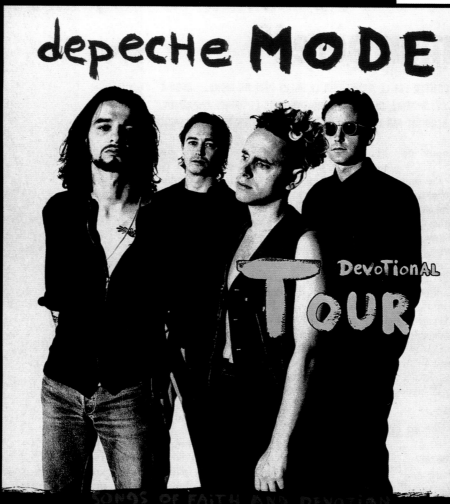

 PRESENTE

AVEC

29 & 30 JUIN 93 PARIS-BERCY

10 JUIN 93 NANCY
26 JUIN 93 LYON
3 JUILLET 93 BREST

5 JUILLET 93 BORDEAUX
6 JUILLET 93 BEZIERS
7 JUILLET 93 TOULON

LOCATIONS : POINTS DE VENTE HABITUELS
ET SUR MINITEL 3615 CODE NRJ CLUB

POUR CONNAITRE LA FREQUENCE NRJ DE VOTRE VILLE, TAPEZ 3615 CODE NRJ, RUBRIQUE STA.

Advertisement for shows in France, 1993.

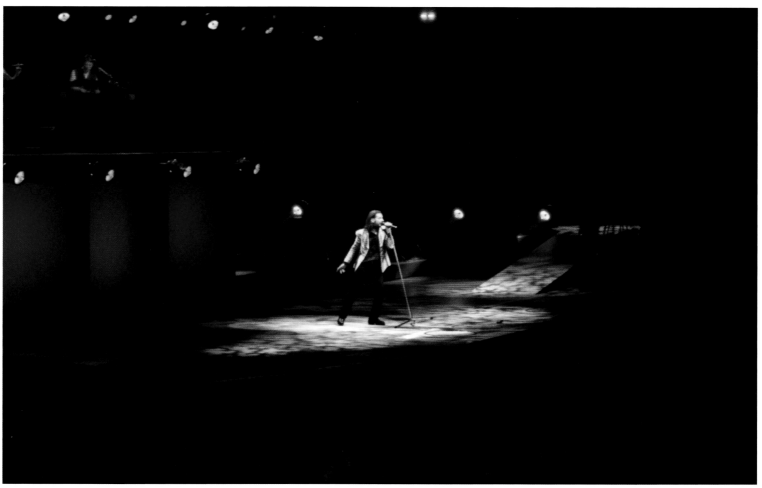

Depeche Mode live at the Palau Sant Jordi in Barcelona, July 17, 1993.

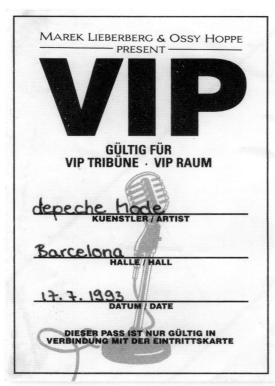

VIP pass for the Barcelona concert.

Excited German fans in Barcelona.

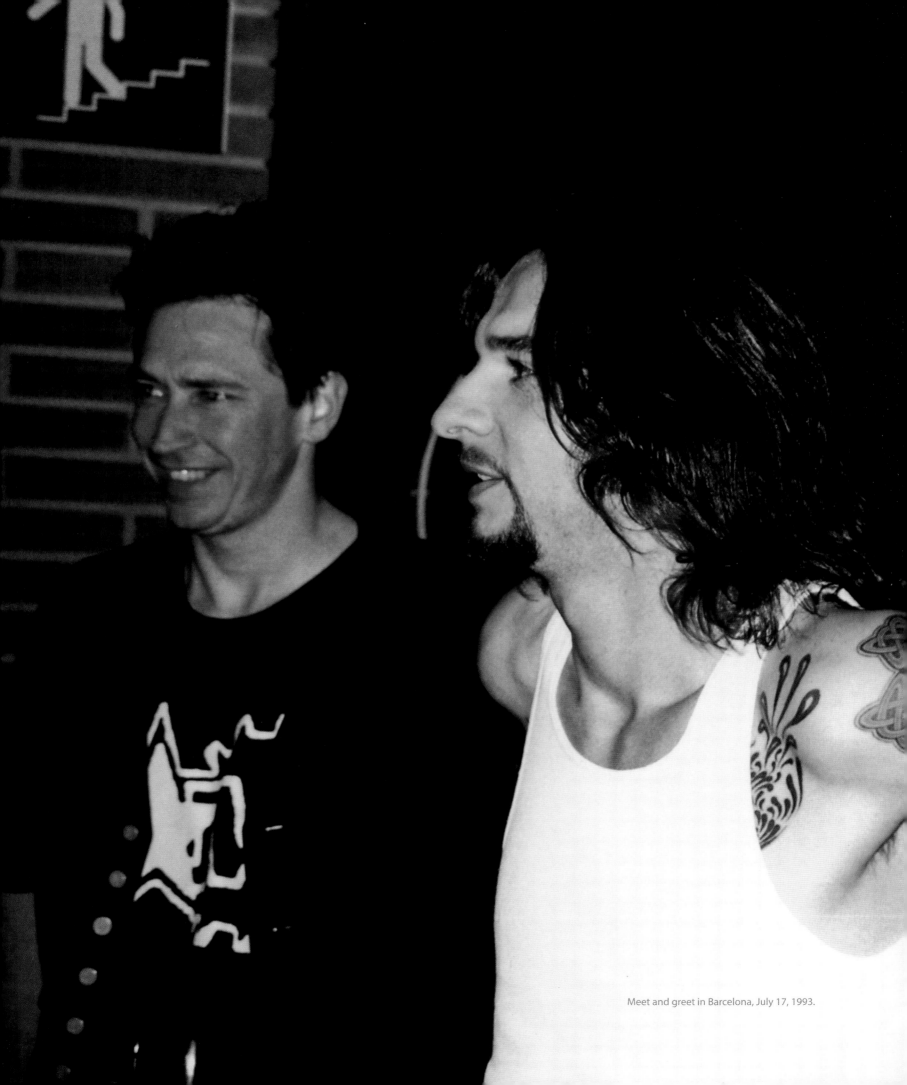

Meet and greet in Barcelona, July 17, 1993.

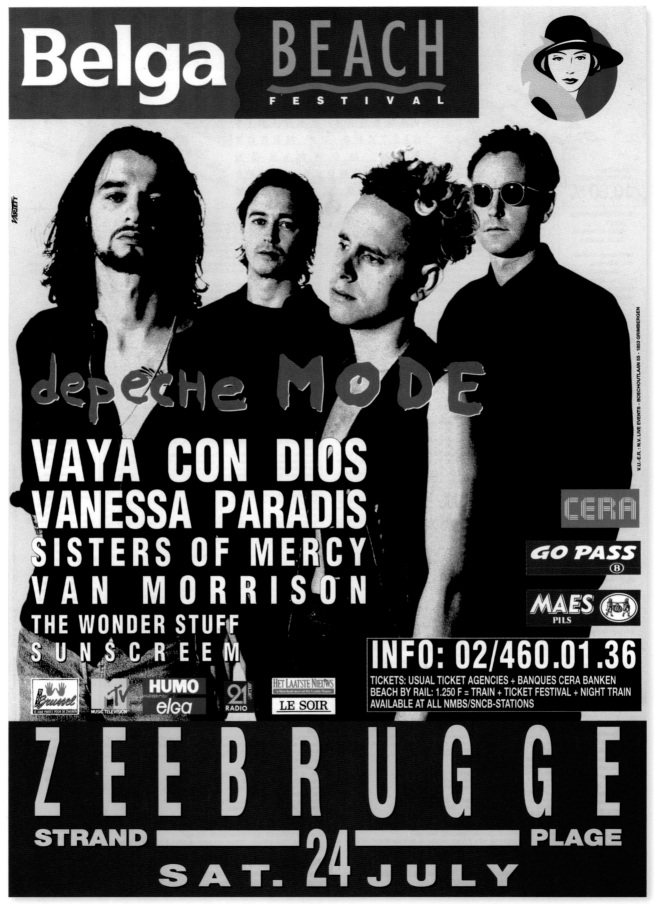

Ad for the Belga Beach Festival in Zeebrugge, Belgium, July 24, 1993.

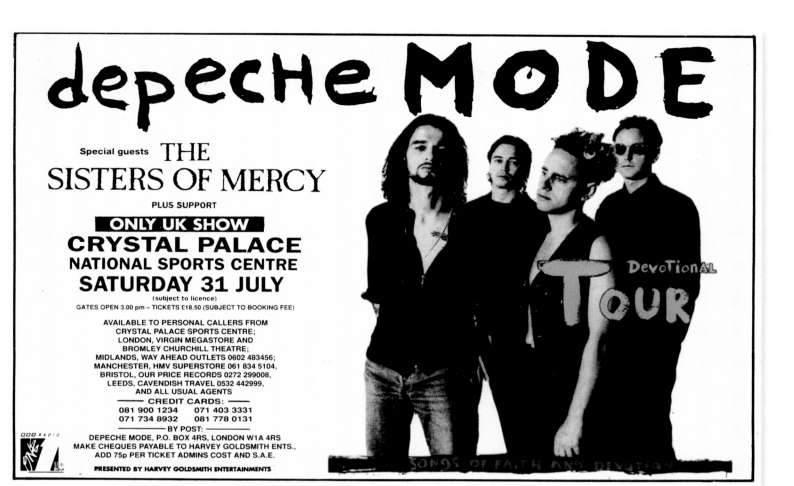

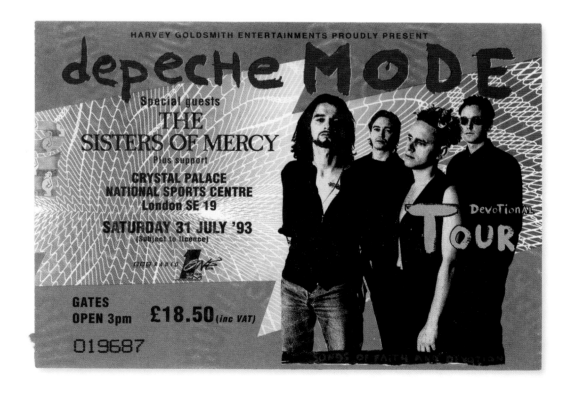

Ad and ticket for the unforgettable show on July 31, 1993, at London's Crystal Palace.

Devotional in North America

Following a month-long break, the band opened the North American leg of their tour in early September in Quebec. At forty-nine shows, this portion of the tour had as many stops as the 1983–84 *Construction Time Again* tour had worldwide.

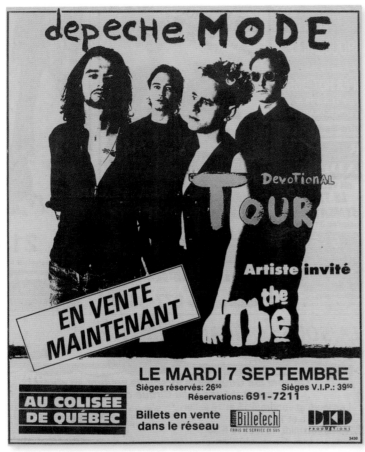

Ad for a show in Quebec, Canada, September 7, 1993.

In the meantime, the next single off the record, "Condemnation," came out September 13. The video for the track was filmed in Hungary around the band's show in Budapest.

After a show in East Rutherford, New Jersey, on September 21, the *New York Times* wrote, "The audience was on its feet, often dancing; the English band's lead singer, David Gahan, was twitching his hips like Mick Jagger, shaking his shoulder-length hair like Bono of U2, whirling his microphone stand and throwing his hands in the air to cue shouts and sing-alongs."

Unsurprisingly, the concerts on September 23 and 24 at Madison Square Garden both sold out; over the two nights, the band brought in nearly $770,000, according to an October 24 piece in the *Reporter*.

Even for a seventy-odd person crew, the Devotional Tour presented a massive logistical and technical challenge: an additional two hundred local assistants were needed per show, and it took nine trucks to move the tour equipment from city to city, plus four nightliners for the crew.

The band and its immediate circle traveled in a privately char-

tered plane. Daryl Bamonte explained the task that lay before lead crew members to *Bong*: "Depeche Mode do not have a manager, therefore we have a group of people on this tour called 'The Committee,' who have meetings to discuss various points of the tour. The Committee comprises Kessler (the manager, if you ask me), J.D., Franksy, tour manager Ivan Kushlik, tour accountant Derek Rauchenberger, and myself."

Those in immediate proximity to Dave knew about his drug addiction, and there had already been serious conversations between the band and him on the European tour. Ultimately, though, as long as the concerts could still go on, they let him have his way.

Still, complications were bound to arise. Near the end of the October 8 performance in New Orleans, Dave had a heart attack onstage and had to be taken to the hospital. Martin sang the encore in his place. Just two days later, though, Dave was back onstage in Houston, and the tour continued.

In the US, Depeche Mode again played two consecutive nights in multiple cities, and in late November they played five nights running at the Forum in LA, a city that had without question become one of the band's home bases. A total of three US shows had to be canceled or postponed on short notice due to Dave's health. After two shows in Mexico City in early December, they headed back to Great Britain for more.

The tour was accompanied by a series of new releases. On November 23, Depeche Mode followed *The World We Live in and Live in Hamburg* and the concert film *101* with *Devotional*, another live film released on videocassette. In creating it, Anton Corbijn had used clips from shows in Barcelona, Liévin, and Frankfurt on the European tour.

A new LP, *Songs of Faith and Devotion Live*, featuring recordings from Copenhagen, Liévin, and New Orleans, with a song sequence following the studio album, also came out on December 6, 1993.

The mood on tour was anything but positive. Daniel Miller recalled that "Dave was obviously heavily on drugs at the time,

Devotional Tour booklet, 1993.

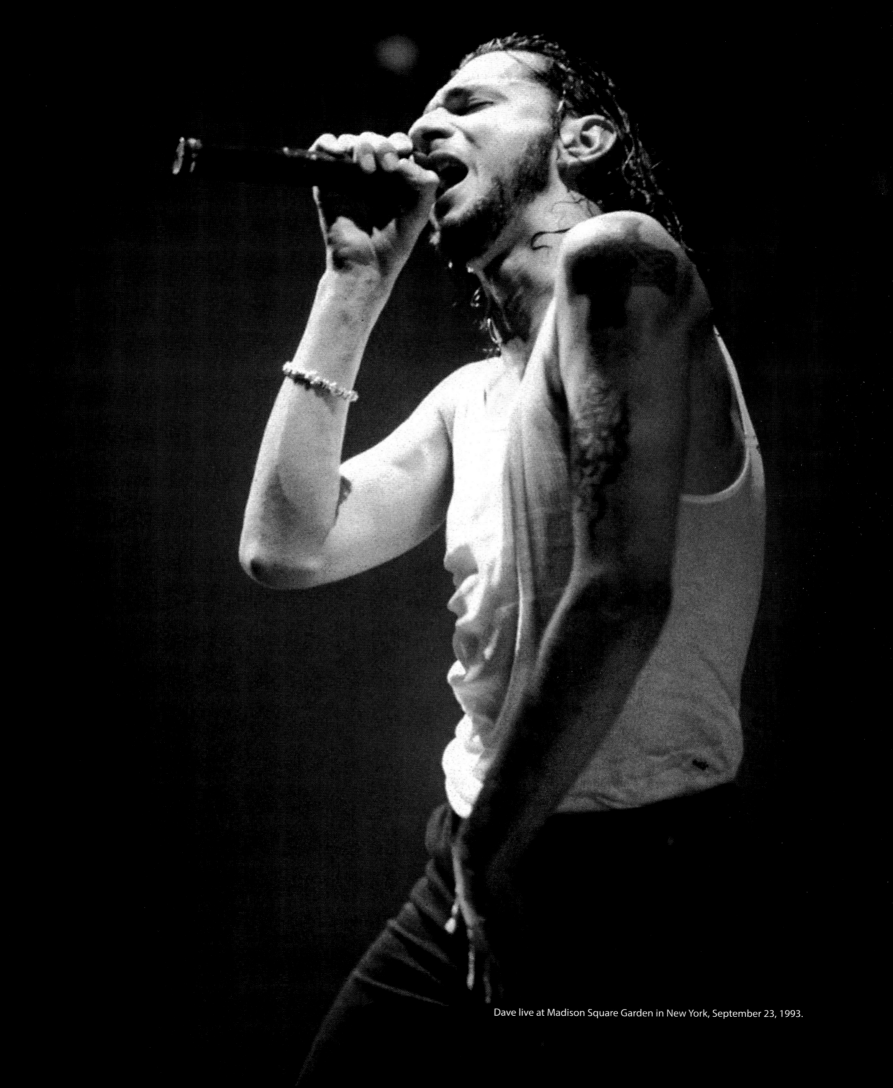

Dave live at Madison Square Garden in New York, September 23, 1993.

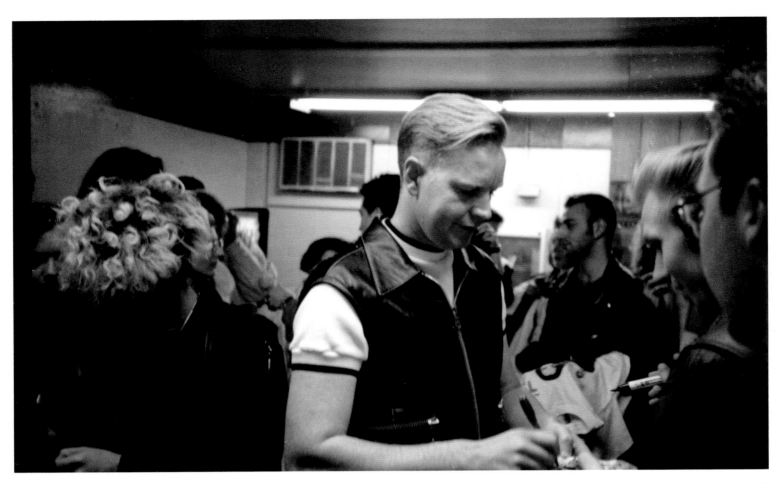

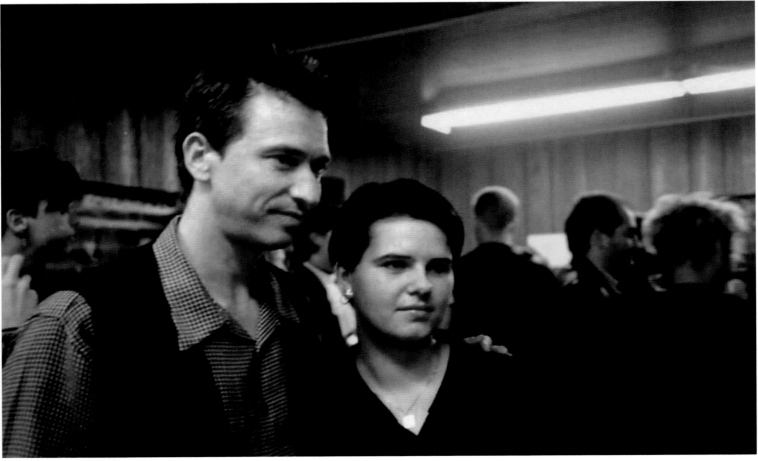

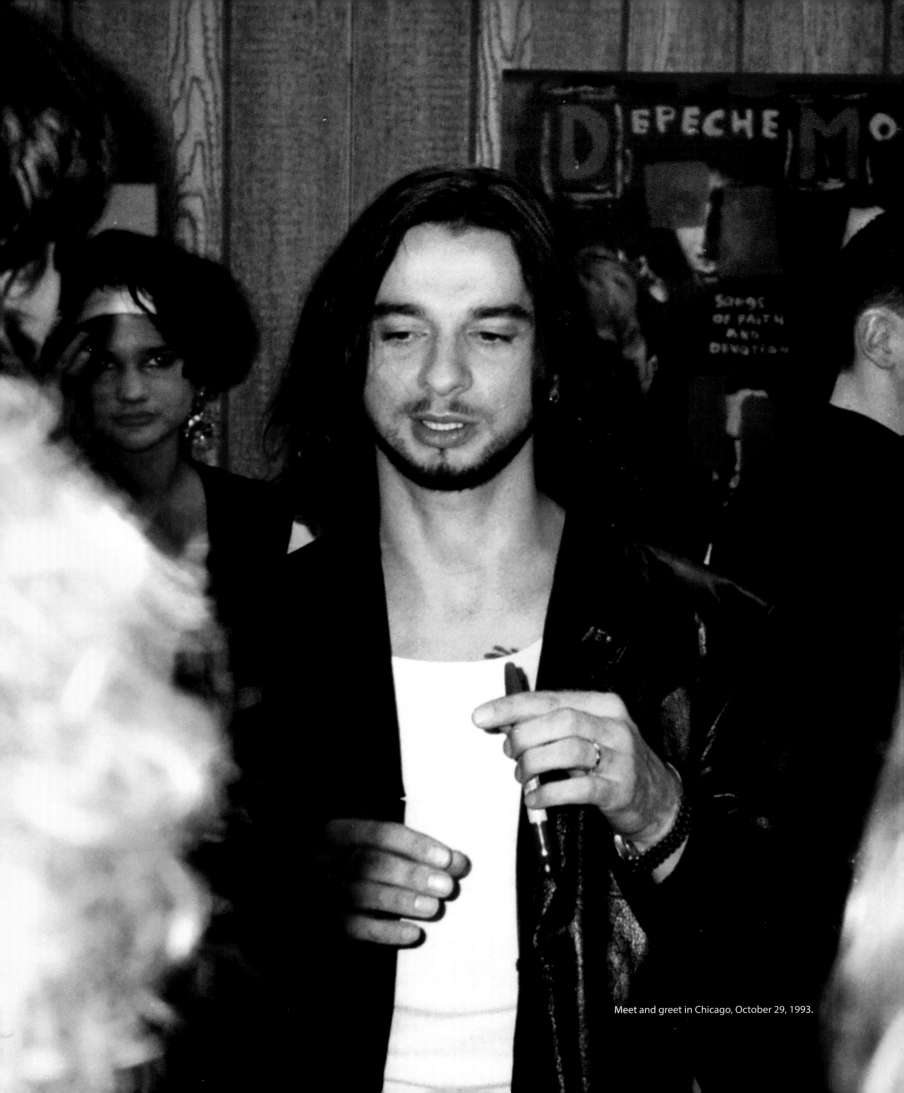

Meet and greet in Chicago, October 29, 1993.

throughout that tour. The band weren't talking to each other. You'd have Martin and Fletch going to the gig in one car, Alan would go to the gig in another car, and Dave would go in another car. Dave didn't really speak to the other members of the band. The only times he saw the other members of the band was when they were onstage. The moment he got offstage, he went into his dressing room . . . It was a very, very unhappy situation. Fletch was finding it very difficult, he was having personal problems—they were *all* having a lot of problems."

Despite the tensions, there were still after-parties every night. Andy later told *NME*, "The intensity of the partying had gone to a new stage. It had just been steadily getting worse and worse and worse and worse, until on that tour in particular it was just one huge party. Every night."

On December 2 and 3, Depeche Mode played in Mexico City, followed by another five shows in Great Britain and Ireland. The last took place on December 20 at London's Wembley Arena. The mood was once again festive, with Martin accompanied by a string quartet, as at the Crystal Palace that summer. And with that, the tour might have come to a close . . .

Songs of Faith and Devotion Live was the band's second live album.

German ad for *Songs of Faith and Devotion Live* and *Devotional*.

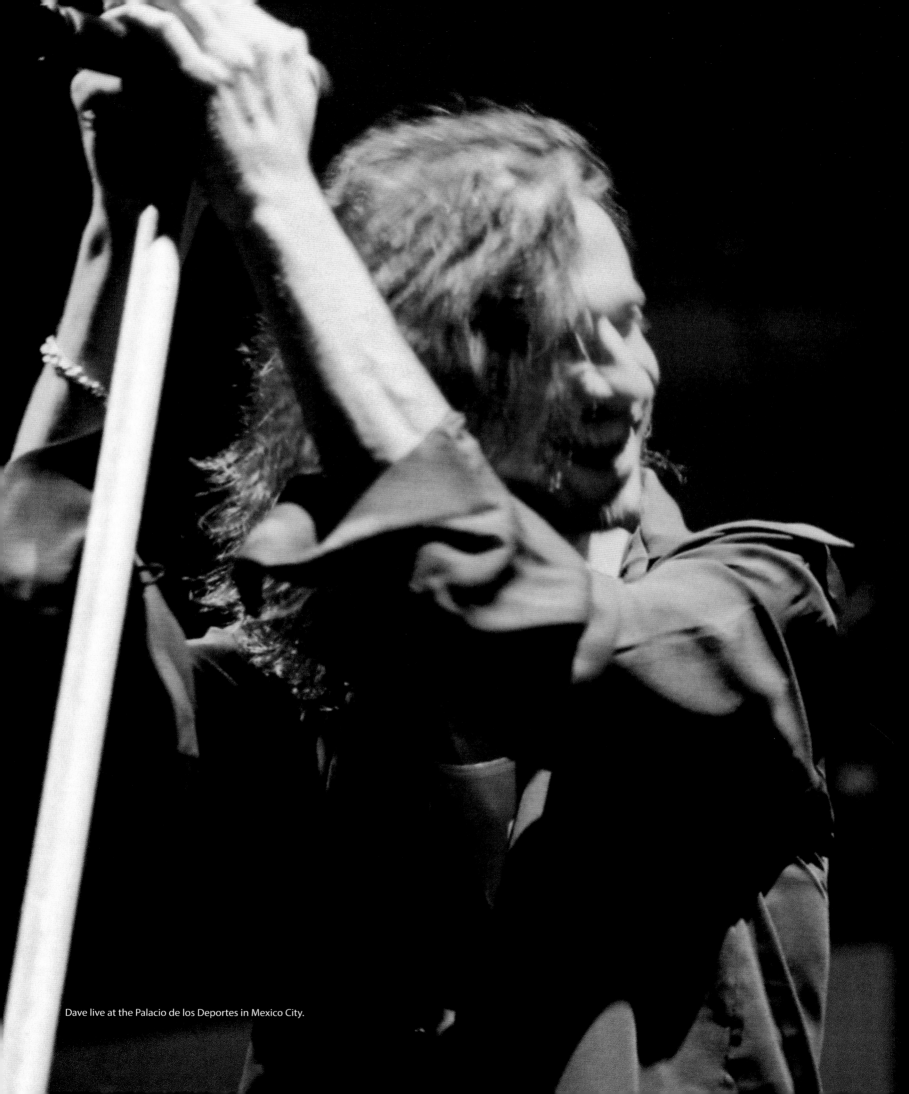

Dave live at the Palacio de los Deportes in Mexico City.

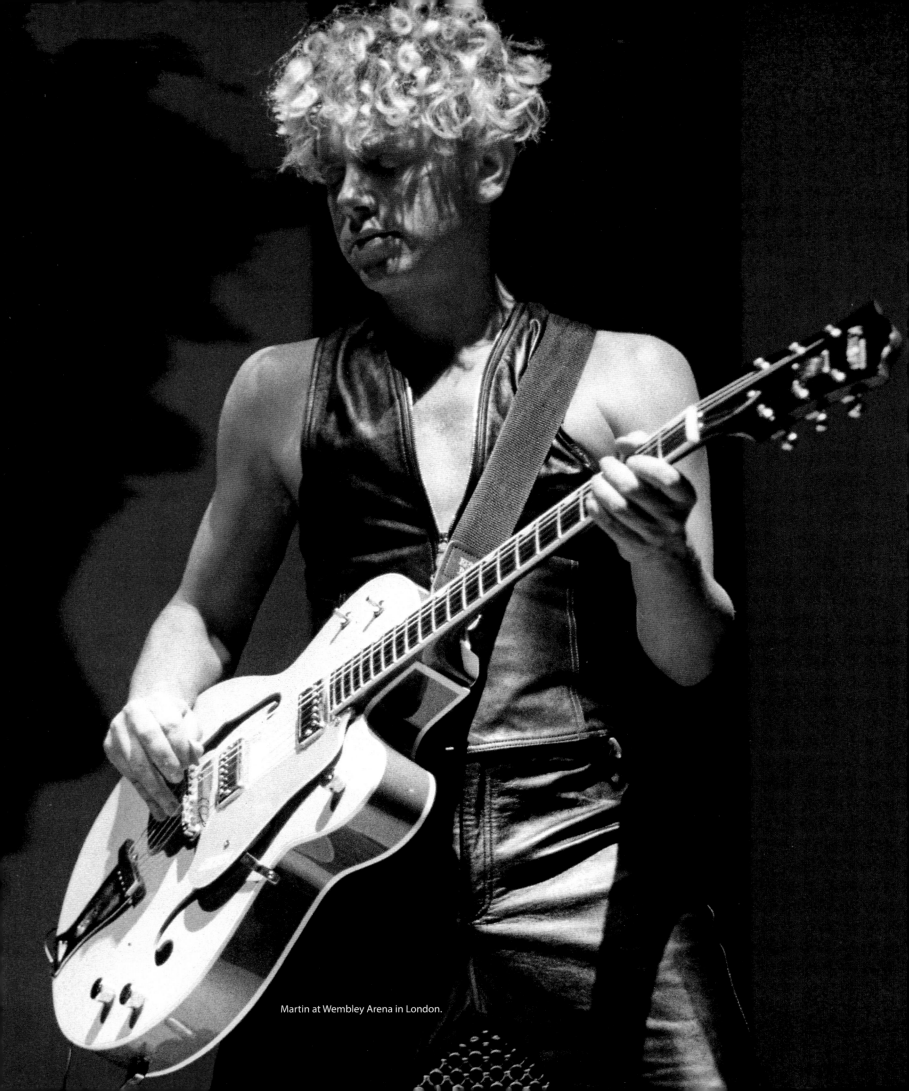

Martin at Wembley Arena in London.

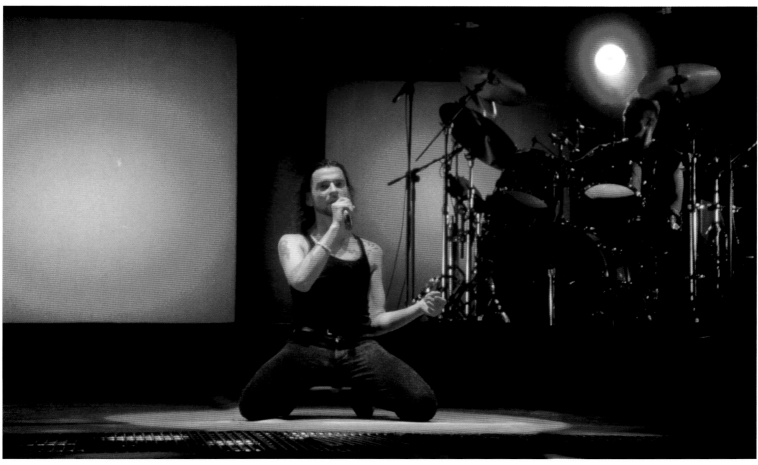

Depeche Mode live at London's Wembley Arena on December 20, 1993.

Ad for shows in the UK, December 1993.

Like at the Crystal Palace, Martin was accompanied by a string quartet at the Wembley Arena.

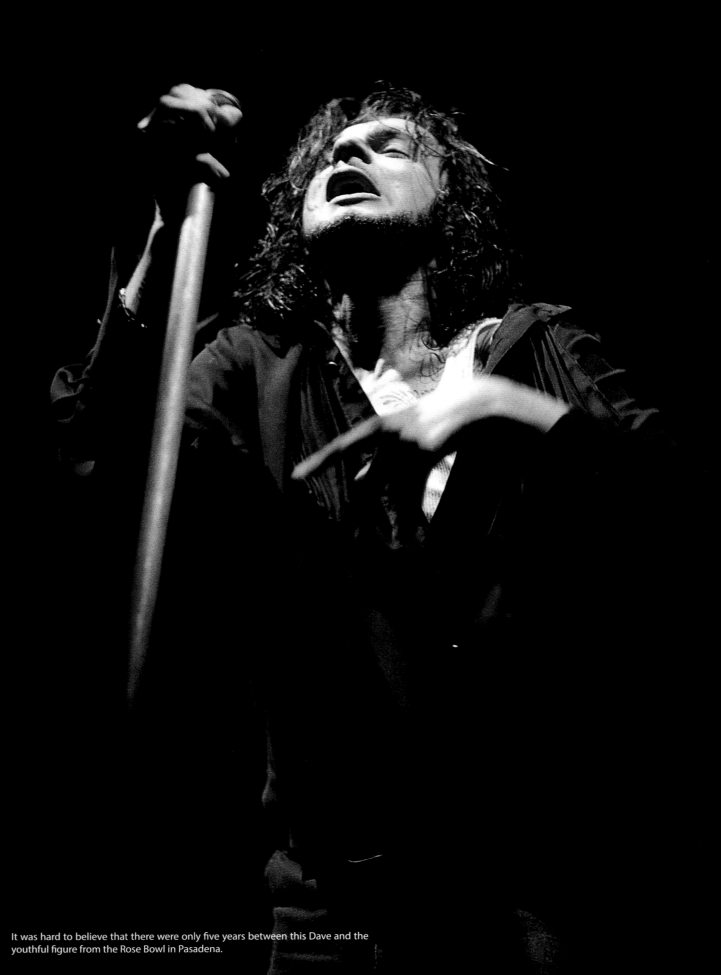

It was hard to believe that there were only five years between this Dave and the youthful figure from the Rose Bowl in Pasadena.

Exotic Tour, 1994

Fueled by ongoing success and worldwide demand, the band decided to extend the tour into 1994, even though Daniel Miller tried to dissuade them. Alan later explained their reasoning: "I think if one is truthful, it was financial. There weren't many other reasons that I could think of why we'd want to do it, except that we did play a few territories that we wouldn't normally have gone to, like South America. But I think, if you weigh everything up, the sensible decision would have been, 'We don't need to do this, let's just stop.'" At that point, however, nobody was thinking like that.

Just after Christmas, Alan Wilder and Steve Lyon returned to the studio to prepare the tapes for the next section of the tour, spending several weeks in Milan at Logic, where they had worked on *Violator*. Alan later recalled a new arrangement for "I Want You Now" with unmistakable bitterness: "The only people present were myself, Steve Lyon, and Daryl Bamonte. This is also where the techno 'Rush' introduction and various other bits and pieces were done. The remaining members of the band didn't hear 'I

Martin with fans in Hong Kong.

A meet and greet in Singapore, March 1, 1994.

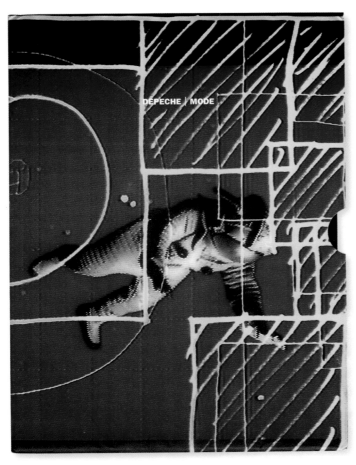

Booklet from the US summer tour in 1994.

forty concerts still planned in the Americas, the topic of whether to cancel the tour or continue playing with a replacement for Andy had already surfaced among the band in the Philippines.

The solution was both surprising and obvious: instead of calling it off entirely or having a new musician flown in, the band made the snap decision to ask crew member and longtime friend Daryl Bamonte if he would play keys in Andy's place for the rest of the Exotic Tour. Daryl didn't hesitate.

When asked in an interview how the choice had fallen on him of all people, Bamonte replied drily, "Because I'm part of the gang." Alan and Daryl immediately began practicing in Daryl's hotel room during a short break after the two shows in Honolulu. Alan later explained, "While everyone else was sunning themselves on the beach and enjoying a well-earned rest, Daryl and I spent a week cooped up in a hotel room in Hawaii where I taught him the entire set. He subsequently played it perfectly for the rest of the tour—pretty good, eh, considering he'd hardly ever played a keyboard before in his life."

The tour also brought Depeche Mode to South America for the first time, with Daryl's stage debut coming on April 4, the first of two shows in Brazil. As he was heading out to the venue from his hotel room in São Paulo, keyboard under arm, an elderly woman approached him in the lobby and said, "I hope you're much better than the band we had down here last night." Daryl didn't know

VIP pass for the US summer tour in 1994.

Want You Now' or any of the other music until it was played on-stage." On January 10, 1994, "In Your Room," the fourth single off *Songs of Faith and Devotion*, was released.

The band met back up in South Africa on February 2, 1994, to start rehearsals for the Exotic Tour. They had never played South Africa before, and now they had multiple shows lined up. Stage design was significantly stripped down in comparison to recent shows, with only a single level and smaller platforms for each individual musician, making transportation decidedly easier. During several songs, new edits of videos that had already been produced for the Devotional Tour by Anton Corbijn were projected onto a large screen.

Five shows in Johannesburg starting on February 9 followed, then two in Cape Town, one in Durban, and an additional two in Johannesburg. Two shows were also planned for Durban originally, but the first was canceled when Alan suddenly fell ill.

Other exhilarating destinations came after, in keeping with the name of the tour. On March 1, 1994, Depeche Mode flew to Singapore for a show, before traveling to Australia for five dates. After that came a show in Hong Kong, plus two in the Philippines.

While some crew members assumed Dave would be the one who wouldn't make it through the tour on account of his drug use, in the end someone else had to pull the emergency break. After two shows in Honolulu on March 25 and 26, Fletch yielded to a long-standing bout of depression and flew home. With another

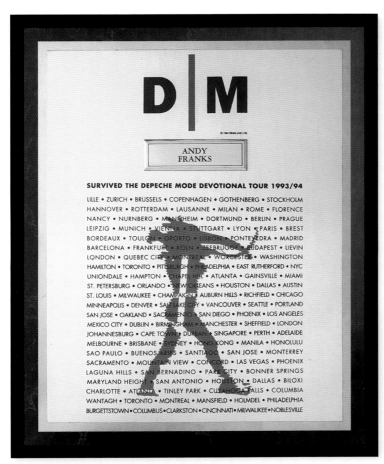

An award presented to the band and crew members in honor of their surviving the Devotional Tour in 1993–94.

the-tour prank as has become tradition amongst the rock and roll touring fraternity. We also experienced tour managers–turned–backing vocalists in drag (Andy Franks, etc.). Other favorites included talcum powder on the drum skins, Mrs. Mop coming on with a broom to sweep the stage during Dave's finest moment, and exposed arses at the side of the stage . . . Ooh, how we laughed."

Between the two tours for *Songs of Faith and Devotion*, Depeche Mode had played 157 shows, more than ever before or after. Some two million fans had seen the band live, and five million had purchased the album.

After the last show the band parted ways, with only Dave surfacing briefly in public on August 27, 1994—the day of Martin's wedding to his girlfriend, Suzanne Boisvert, in Great Britain—to play with Primal Scream at the Reading Festival outside London. During the song "Loaded," Dave came onstage and played harmonica. It would be his last public stage appearance for years.

Alan at the last after-party on the Devotional Tour. It would also be his final show with the band.

what the woman was talking about, until it dawned on him that she thought he was a member of the hotel band.

Argentina was next on the docket. The newspaper *El Atlantico* reported on the Buenos Aires show: "The audience was composed of true devotees of the band. This is not a common thing with other bands. For instance, during the last INXS concert in Buenos Aires, you could see Guns N' Roses or Metallica T-shirts in the audience. This time it wasn't the same. Everybody had only one name on their caps, T-shirts, and banners: *Depeche Mode*!"

The band also performed in Santiago, Chile, where a soccer riot near to the venue meant the band had to drive past burning barricades on their way to the gig. Then a date planned for April 12 in Bogotá, Colombia, was canceled on short notice. After one-offs in Costa Rica and Mexico, it was back again to North America. Depeche Mode played thirty-one shows across the US and two in Canada. One of the New York shows in mid-June had the Cure's Robert Smith and Perry Bamonte in the crowd; Perry had wanted to see his brother Daryl play live.

On July 8, what had been a nerve-racking tour for everyone involved finally came to an end with a show in Indianapolis. It would be the last time that Alan stood onstage with Depeche Mode, although nobody knew this at the time, not even Alan himself. He had his own memories of the last show: "Jez Webb—the guitar tech—emerged, to my surprise, from the shell of the piano during 'Somebody,' I think. This is a typical last-date-of-

Ultra Launch Parties

The Devotional Tour in 1993, and the 1994 Exotic Tour after it, had left the band and its crew completely exhausted. It had been too much, and at some point spiraled out of control, especially the after-parties, with all the drugs and drinking binges. Yet while Martin, Andy, and Alan had their families to go back to in Europe, Dave and his second wife, Teresa "T.C." Conroy, returned to Los Angeles to pursue the wild life of rock stars to the fullest.

Nearly a year had passed since Depeche Mode's last show when Alan announced he was leaving the band in spring 1995. "I think my decision to leave the band came during the making of that album [*Songs of Faith and Devotion*]. I can remember one or two occasions during the recording that stick vividly in my mind, particularly those first sessions where I thought, *This is not enjoyable, this is the last time I want to be in this situation.*"

Initially, Alan only shared the decision with the other members of the band and Daniel Miller. As Andy recalled, "We just had a meeting—Martin, me, and Alan—and he just announced it. I personally think he felt that there wasn't going to be another Depeche Mode album, and he'd get his bit in first, and of course considering the state Dave was in at the time, at any point we could have a phone call saying he was dead." Alan couldn't get Dave on the phone in LA, so he sent him a fax. On June 1, 1995—Alan Wilder's birthday—Mute sent out a press release announcing his departure from Depeche Mode.

Dave, meanwhile, continued on in his chosen home, seemingly unaffected by the development. Rumors about his physical condition continued making the rounds. Daniel Miller came back from visiting Dave in LA with words of comfort for the German licensing label Intercord, saying that Depeche Mode's front man "hasn't been better in years."

Just how wrong Miller was in his assessment became clear when news reports about a possible suicide attempt broke internationally on August 18. After a serious fight with his wife, Dave had cut himself with a razor in the bathroom of his villa, and was brought to Cedars-Sinai Medical Center after an emergency call. Days before, Dave had ended up in the headlines when he attacked an art dealer friend, striking his head so hard that the man required medical treatment. The cause for the outburst was supposedly the art dealer joking that he had slept with Dave's wife. Soon after, Dave entered therapy.

With Alan's departure and Dave's ongoing drug addiction, Depeche Mode found itself at a serious crossroads in 1995.

It was at Miller's eventual suggestion that the remaining band members met at London's Eastcote Studios at the end of the year to work on a couple of new songs written by Martin—initially without the pressure of producing an entire record all at once.

Tim Simenon—who had already worked with Depeche Mode, as well as Björk, Sinéad O'Connor, U2, and David Bowie—was brought on as producer. Simenon turned to a host of others in the studio for help, including keyboardist Dave Clayton and programmer Kerry Hopwood.

While Dave's continuing drug habit was well known among the band, it was only when they went to do vocal takes at a studio in New York in spring 1996 that the full extent of the issue became clear: his voice was failing. The band decided their singer should begin by taking a break and consulting with a vocal coach.

Back in LA, things nearly reached the point of no return at the Sunset Marquis Hotel. On May 28, 1996, Dave collapsed after overdosing, resuscitated at the last second.

When he came to in the hospital, he was locked to the bed with handcuffs as the police read him his rights and placed him under temporary arrest. After his release from the clinic, he was let out on bail and returned to therapy for four weeks. By now the DA's office had also filed charges.

Legal proceedings began on July 9, 1996, at the Beverly Hills Municipal Court. "The court let me do therapy," Dave explained. "I spent about a year living in a detox clinic with other drug addicts and alcoholics. I had to do regular urine tests. If they had found an illegal substance even once, I would have had to go to prison in LA for two years. I was really afraid of that. It became clear to me for the first time in my life that I wasn't immortal."

The Sunset Marquis Hotel in West Hollywood is infamous for catering to the excesses of stars from the entertainment industry.

Then the longed-for miracle actually occurred—Dave managed to quickly accomplish what few addicts are able to: within a remarkably short window of time, he had turned his life around and was clean, divorcing his second wife of four years in the process.

"The best thing that happened to Dave was his arrest," Daniel later recounted to *Bong*. "They forced him to go into rehab and

INTERNE MITTEILUNG

An:	████████████████████
Von:	████████████
Betreff:	Ausstieg Alan Wilders bei Depeche Mode / Erasure
Kopien an:	
Datum:	18.5.95

Aufgrund der Mitteilung Mutes, daß Alan Wilder Depeche Mode verlassen hat, ████████ mit Daniel Miller telefoniert, um (nochmals) zu versuchen, Klarheit über die Zukunft der Band zu bekommen.

Laut Daniel bedeutet der Ausstieg keinesfalls das Ende von Depeche Mode, sondern ein Beginn eigenständigen Arbeitens von Alan. Ein Projekt sei bereits halbfertig und Mute in Verhandlungen mit Alan.

Vielmehr hat Martin Gore bereits fünf Stücke so weit fertig, daß sie fertig aufgenommen und produziert werden könnten. An weiteren Songs wird gearbeitet.

Dave Gahan hat eine ärztliche Behandlung beendet, so daß er bald wieder einsatzfähig sei. Daniel hat ihn in L. A. getroffen und ist der Meinung, daß es Dave so gut ginge wie seit Jahren nicht mehr.

Andy Fletcher hat durch Konzentration auf völlig 'artfremde' Dinge ebenfalls eine persönliche Krise überwunden und klinkt sich daher wieder verstärkt ein.

Wann tatsächlich ein neues Depeche Mode-Album aufgenommen werden wird, steht allerdings noch in den Sternen.

Diese Infos decken sich in etwa mit Aussagen Martins und Fletchs Herrn ████████ gegenüber bei einem rein zufälligen Treffen.

Der VÖ-Termin für das "Greatest Hits"-Album steht nachwievor nicht fest, wird aller Wahrscheinlichkeit nach nicht vor März 96 und nicht im Januar oder Februar 96 sein. Überraschungen möglich...

Weiter informierte mich Daniel über die Arbeiten am Erasure-Album. Es laufe alles termingerecht und die Produzenten Thomas Fehlmann und Gareth Jones verliehen dem Sound weitere Attraktivität.

Mit Francois Kervorkian (Album-Mixer u. a. zweier Depeche Mode-Alben, des letzten Kraftwerk-Albums sowie Remixer von Michael Jackson, U2 etc.) wurde ein End-Mixer von Weltrang verpflichtet.

By mid-May, Daniel Miller was writing to colleagues at the Intercord label in Germany about the band's current state.

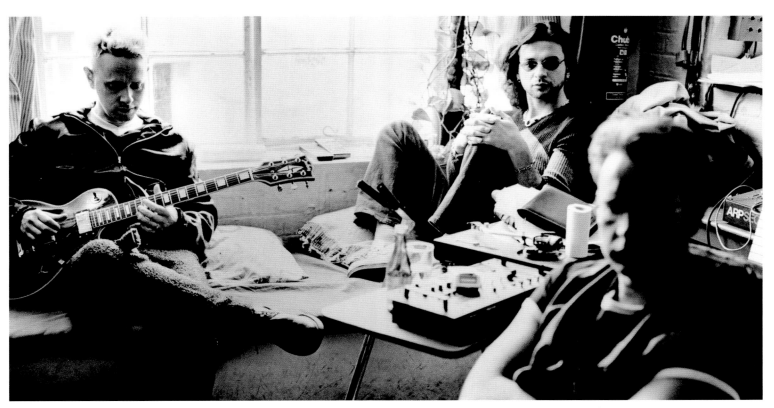

Depeche Mode in October 1996 at Eastcote Studios in London. This picture was sent out to the press as promotion for the new record.

told him if he didn't come out clean, he'd be chucked out of America. I think his love for America and his desire to be able to work there and live there—plus he suddenly realized the impact everything was having on the band—I think helped him though that."

On January 30, 1997, the band made a memorable appearance on *Top of the Pops* with their new single, "Barrel of a Gun." For their first public date in nearly three years, the band brought special reinforcements to the stage, with current producer Tim Simenon behind one of the keyboards and none other than photographer Anton Corbijn on the drum kit. In a subsequent interview with the newspaper *Der Tagesspiegel*, Corbijn recalled, "Depeche Mode thought I was a good drummer, because one time in the studio I had sat down at a drum set when I was bored. Even though the performance on *Top of the Pops* was playback, I still had to hit the drums in the right spot. So I took drum lessons and bought a drum kit for £1,500. After the performance, I received a fee of £400 from the BBC. So in the end I paid £1,100 to have some fun." Anton later told the UK's *Guardian* that going on *Top of the Pops* with Depeche Mode had been "one of the happiest moments" in his professional life. Just fourteen days later, the same lineup was back on the show for a repeat performance. Their first single in three years, "Barrel of a Gun" reached number 3 on the German charts and a surprising number 4 in the UK.

On April 4, Depeche Mode performed its single, "It's No Good," on the UK's *TFI Friday Show*. The person behind the drums was as yet unknown to fans, Austrian drummer Christian Eigner, who the band had met in the US.

The cover of *Bong* magazine, the official fan club publication: "Look here, everybody's fine."

Release Parties in Place of Touring

Depeche Mode had decided not to tour with the new album, first and foremost out of concern for Dave. Even so, the band wanted to present the songs live, at least at a handful of select events.

On April 10, the band threw a release party for the new album *Ultra* at London's Adrenalin Village, their first time playing new songs onstage since spring 1993. The set list included six songs with Christian Eigner on drums and Dave Clayton on keys, after Clayton had helped record the tracks in the studio.

On April 14, 1997, *Ultra* finally hit stores, landing in the US a day later. Sales quickly left little doubt as to how strongly fans were anticipating the record, and how faithful they had remained to the group. *Ultra* took the top spot on the charts in Germany and the UK, and went to number 5 in the US.

Even though by 1997 MTV and other music channels like Germany's VIVA were far and away the most important media outlets for promoting new releases, both the band and label decided Depeche Mode would make a number of more traditional television appearances, performing "It's No Good" and "Barrel of a Gun" on Canal+ in Paris on April 21, and "It's No Good" four days later for a show in Stockholm.

Anton Corbijn's girlfriend Nassim Khalifa, Martin Gore, and J.D. Fanger backstage at *Top of the Pops* on January 30, 1997.

The band was scheduled for a performance on May 7 on Germany's *RTL Samstag Nacht* show. Rumors quickly spread, and starting around noon, a small group of fans began gathering in the foyer of Cologne's MMC Studios in the hopes of scoring a glimpse of the band, or even a ticket for that evening's sold-out show. When a label employee showed up around two thirty asking how many of them were waiting to see Depeche Mode, only a few guessed at what was going on—they were being invited to come in and see the band practice.

Ushered in, the fans now stood barely twenty feet from the band, who were in a good mood and all joking around, with only Andy seeming somewhat out of sorts. After the first run-through of "It's No Good," one of the fans mustered up all his courage to ask the band for an autograph, and suddenly the dams broke loose: everyone swarmed their idols, who were only too happy, if

Ultra. Party. 10th April 1997

Adrenalin Village
Queenstown Road
Battersea
SW8 4NP

10th April 1997

8:00pm onwards (arrive early!)

Admits 1

MUTE

Only a handful of tickets were available for the London show, though fans also had a chance to win tickets through the band's official fan club magazine, *Bong*. The live recordings of "Barrel of a Gun," "Useless," and "It's No Good" were later released on the singles "Home" and "Useless."

with a certain stoic calm, to fulfill requests for autographs and pictures. After ten minutes or so, the spontaneous autograph session came to an end and rehearsal continued.

Recording began at nine p.m. sharp, with the band launching into "Barrel of a Gun" to a storm of cheers, and eventually finishing with "It's No Good." The performance was broadcast later that evening on TV.

On May 13, 1997, Depeche Mode made Internet history at the House of Blues in West Hollywood, giving the first interview to be streamed in real time to the *Kevin and Bean* morning show on KROQ. The interview also marked the inauguration of the band's official website, and broke records for the number of people tuning in to a live music broadcast on the Internet.

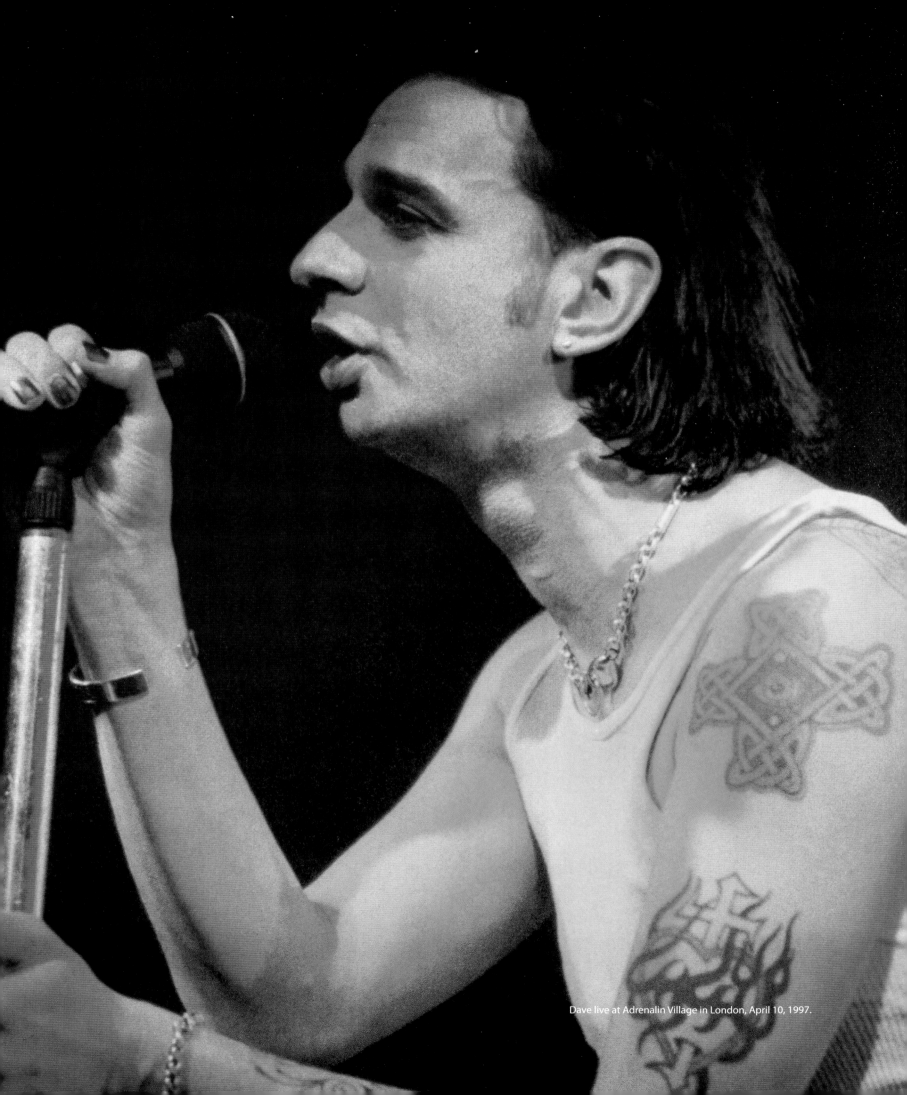

Dave live at Adrenalin Village in London, April 10, 1997.

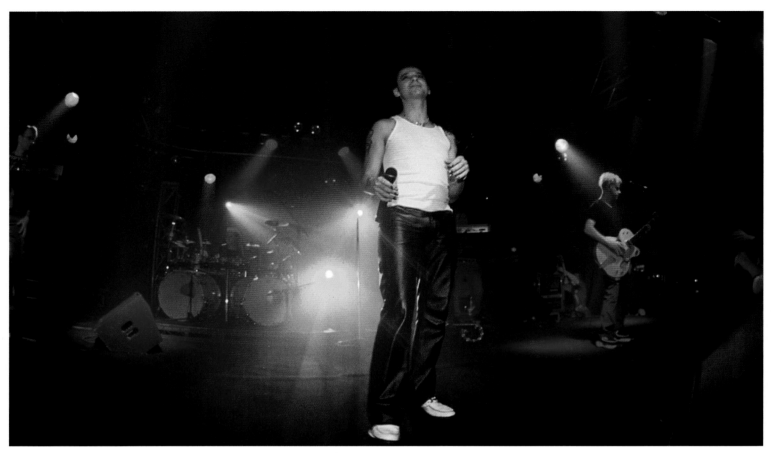

Depeche Mode live at Adrenalin Village, April 10, 1997.

Backstage passes for the show on April 10, 1997, at Adrenalin Village in London.

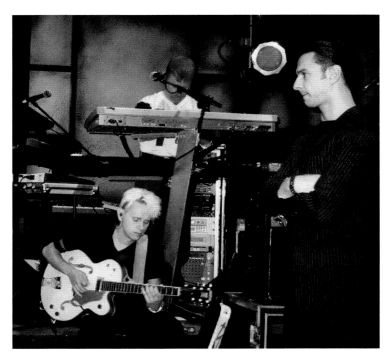

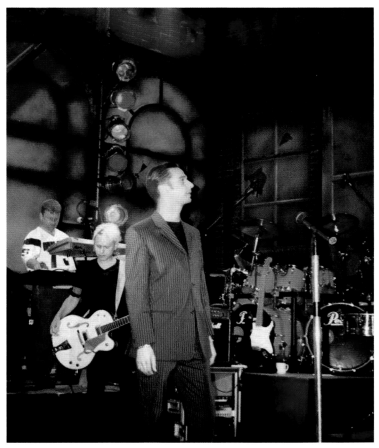

On May 15, the band rehearsed for a show at the Shrine Expo Hall, after which they drove to neighboring Burbank to perform "It's No Good" on *The Tonight Show with Jay Leno*, the band's first live performance on American TV.

Depeche Mode played the second of its *Ultra* launch parties in LA on May 16, keeping the same set list as before. "We've done a similar thing in London for the record, like a record release party. There's gonna be quite a lot of fans there that have won tickets through various radio stations, also a lot of friends and guests," Dave explained in a TV interview before the LA show. "I think, for me personally, it sounds good enough to walk out and sing and feel really nervous and excited at the same time. And to not use something to prop myself up with, and just have to go out and 'be drawn to the light,' as Mick Jagger would say."

The record's third single, "Home," was released on June 16, 1997, the second single in the group's history to be sung by Martin alone. While he almost never spoke about the meaning behind his lyrics, it quickly became clear to most that "Home" could only be about Dave.

Shortly after the *RTL Samstag Nacht* program aired, *Hot Wire*, a popular fan magazine run by Andy Drabek from Zwickau, ran a special *Ultra* edition with fan reports from Cologne. Fanzines like *Hot Wire* are still an important source of information about the band today.

This time, the band also used an entirely new medium to promote the record: the Internet. On May 13, 1997, depechemode.com went online.

Tickets weren't available for sale via the normal avenues; either you had the right connections or you got lucky through one of the giveaways.

On August 31, Dave and Andy made a surprise appearance at the IFA Berlin, the city's international radio exhibition, in order to receive gold awards for 400,000 sales of *Ultra*. Martin was away, still filming parts for the video to the band's new single. Even if their brief appearance wasn't announced in the press—only the venerable *New Life* magazine mentioned the band's visit, in a piece the size of a postage stamp—hundreds of fans still showed up at the event, greeting the band with chants.

Accompanying Dave and Andy onstage were Herbert Kollisch and Anne Haffmans from Intercord, Jonathan Kessler, and the man who had discovered the band and practically served as a father figure, Daniel Miller. Dave appeared healthy, relaxed, and happy as he received his award, making it hardly conceivable

that just months before he had tried to take his own life, and that his heart had stopped beating for two minutes from a drug overdose.

The fourth single off the record, "Useless," came out in mid-October. The video for the song made it clear that Dave had found his way back to his former style. Even if the band didn't have an exact plan for what would come next, one thing was clear to everyone: Depeche Mode wasn't finished yet.

Martin in Los Angeles, May 15, 1997; photo taken by J.D. Fanger. Photos and videos from sound check went up on the official website.

Backstage pass to the show at the Shrine Expo Hall in LA.

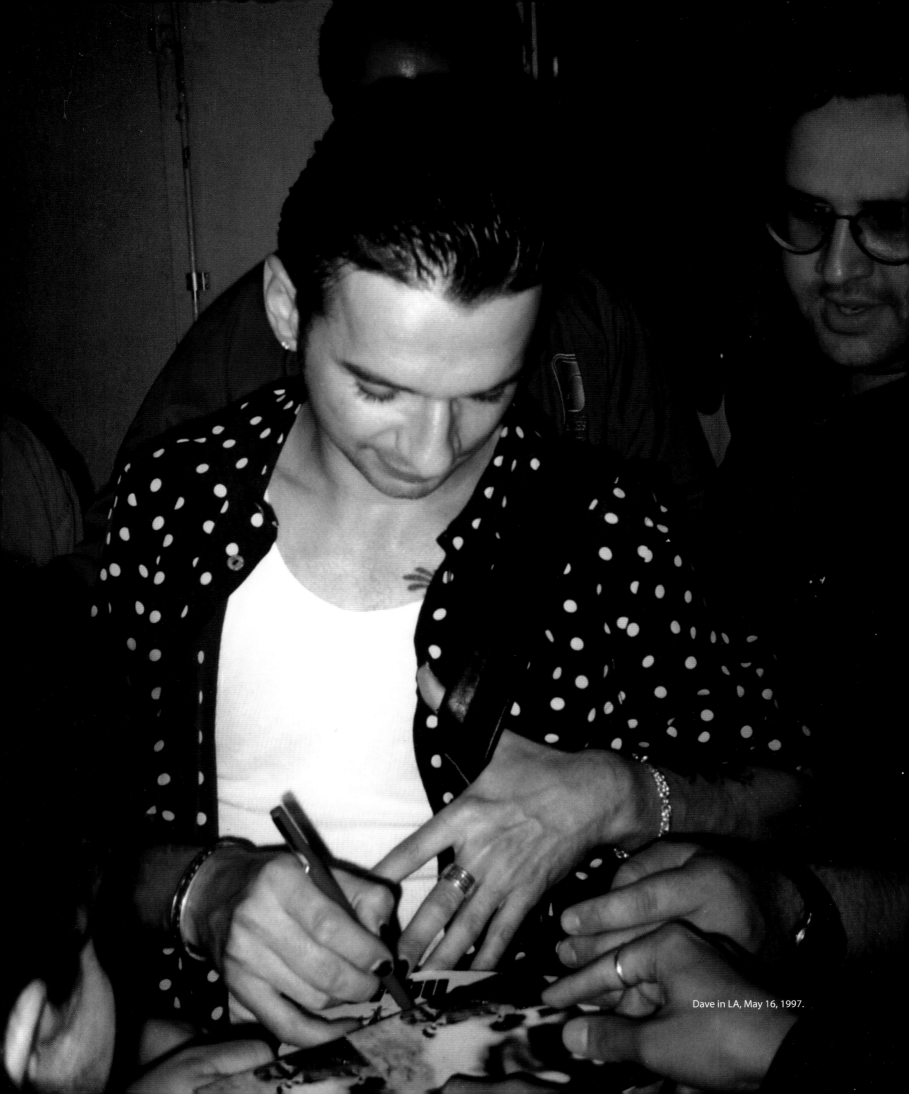

Dave in LA, May 16, 1997.

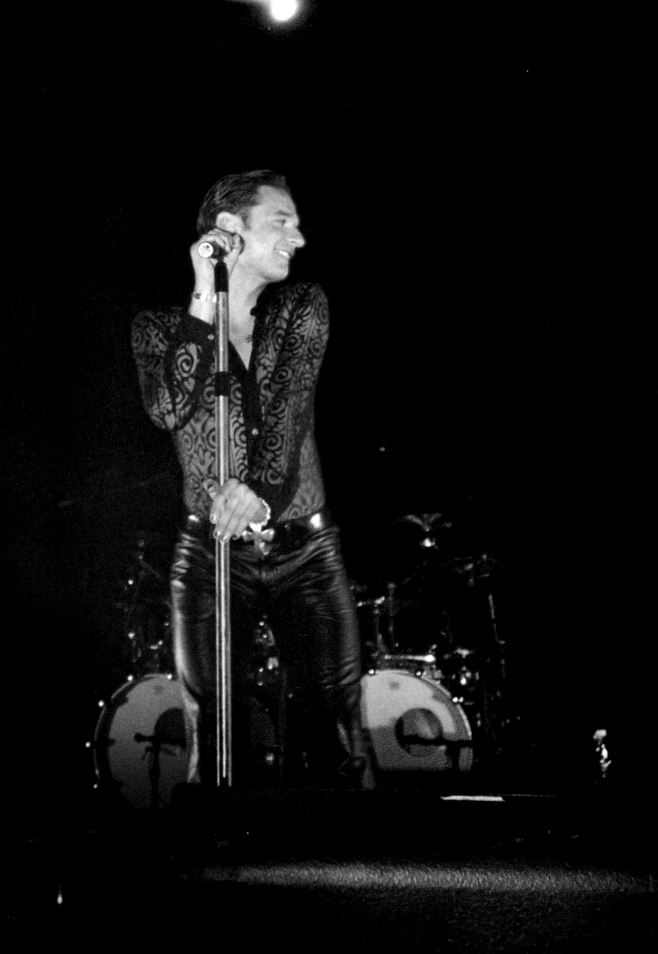

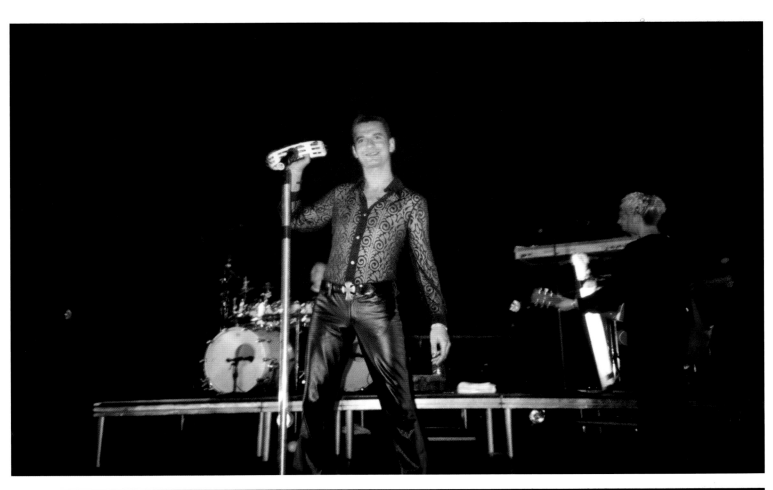

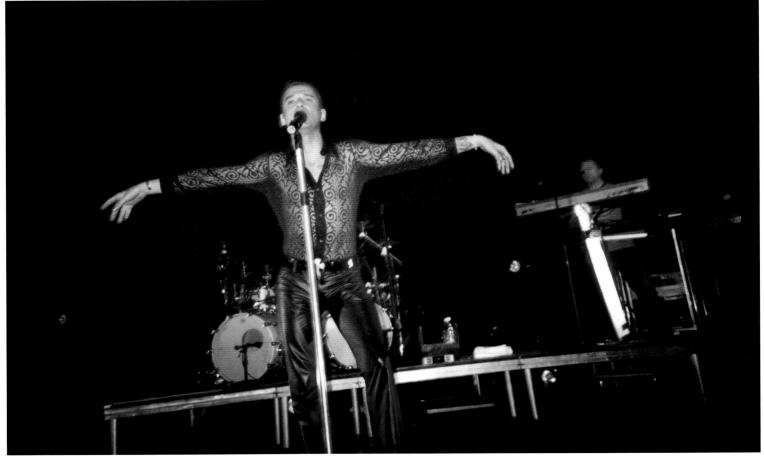

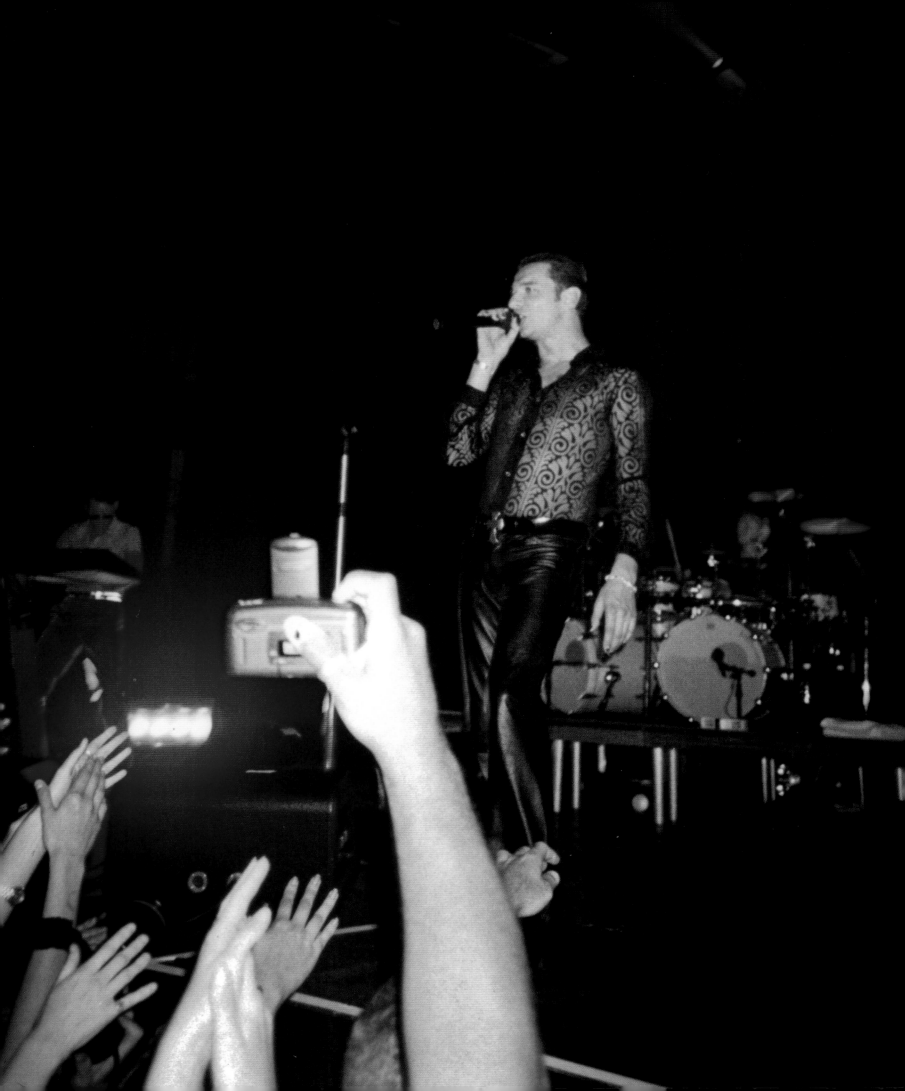

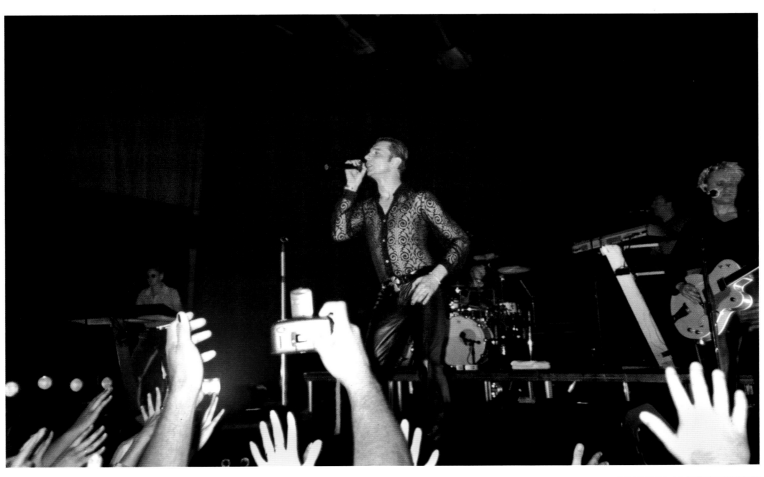

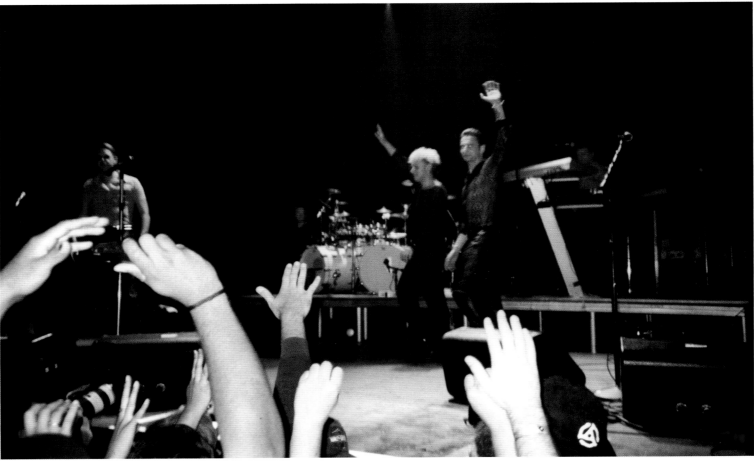

On August 31, Depeche Mode received an award alongside representatives from Mute and Intercord for 400,000 units sold of the band's new record, *Ultra*.

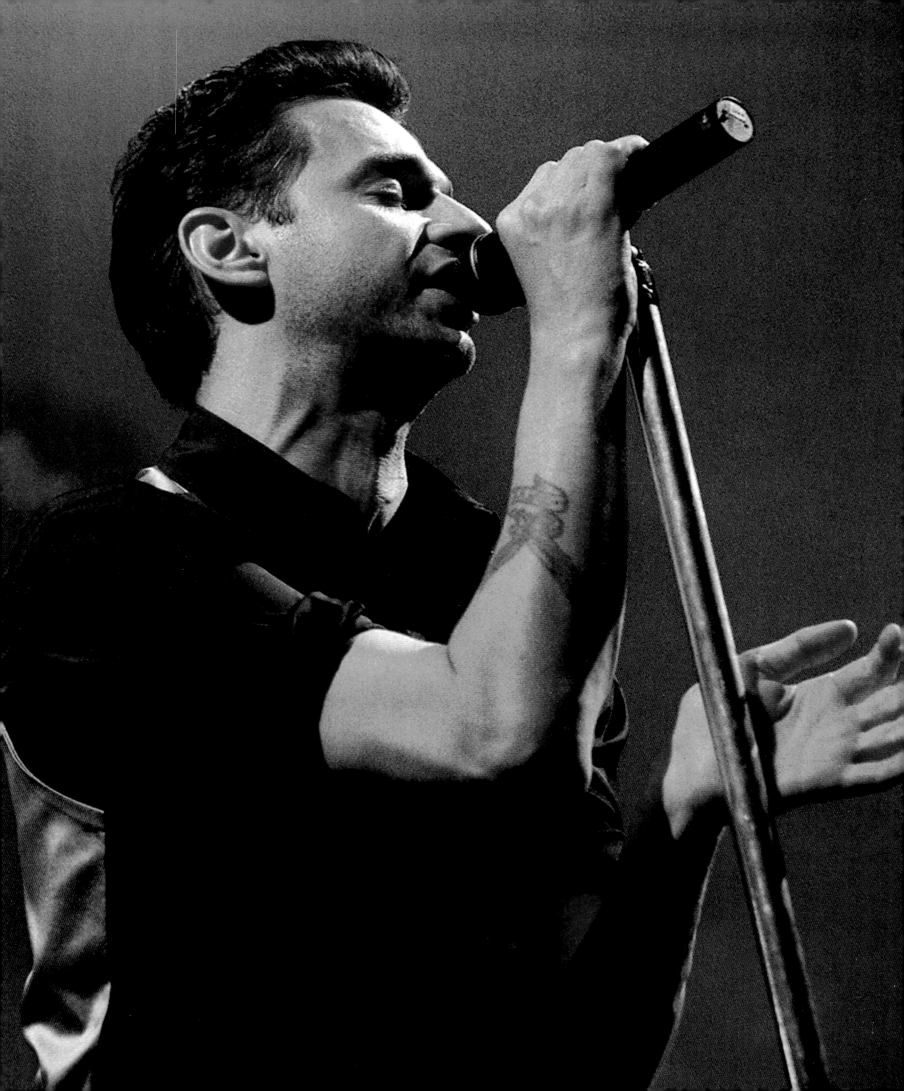

The Singles 86>98 Tour

When they met up with producer Tim Simenon in spring of 1998 at London's Eastcote Studios and the legendary Abbey Road Studios to record two new songs, Depeche Mode hadn't been on tour for nearly four years.

One of the recordings was done specifically for a singles compilation, set to appear later that fall, which had originally been planned for 1995 as a "Greatest Hits" record.

The press conference at Cologne's Hyatt Hotel, April 20, 1998.

Depeche Mode arriving in Cologne the day before their press conference.

To mark the event, Depeche Mode staged a press conference at the Hyatt Hotel in Cologne to announce—much to fans' delight—a fall tour for the upcoming compilation, *The Singles 86>98*.

As Andy explained, "When we finished the last tour, four years ago, we thought maybe it would be the last Depeche Mode tour, but we have just been in the studio for three months recording new material and this upcoming tour—which we are all very happy about—we think is going to be one of the best Depeche Mode tours."

The band also revealed that this tour would be significantly shorter than the previous one, lasting only four months. Dave explained the band's reasoning: "After Alan departed, we had to have a rethink about how we were going to work, and we had to find people to fulfill the role that Alan played. It took quite awhile, probably about six months during the recording of *Ultra*, before we really settled in and became okay with each other."

"We want to be back," Andy declared, before adding that the band "are going to use a drummer for the first time, full-time on-stage. He is really good and he worked with us already on the *Ultra* parties and TV shows."

Late that summer, the band met at 3 Mills Studios in London to rehearse for the tour with the drummer Andy mentioned, Christian Eigner. UK keyboardist Peter Gordeno and two new backup singers, Jordan Bailey and Janet Cook, further filled out the band's live show.

The tour opened in Eastern Europe on September 2, 1998, in Tartu, Estonia, a city the band had never played before. Estonia

was followed by a show in Riga, Latvia, then on September 5 by the band's first visit to Russia, first Moscow then St. Petersburg two days later.

The shows presented many Eastern European fans with an opportunity they had been waiting ages for, as the band's following had been growing steadily throughout the region since the 1980s. Even though the Iron Curtain had come down nine years before, borders were still enforced and in some cases visas were required.

With the Internet still in its early days, getting tickets required a lot of logistical effort on the part of fans who wanted to follow the band from show to show, especially in former Eastern Bloc

Press kit prepared by the Marek Lieberberg Concert Agency.

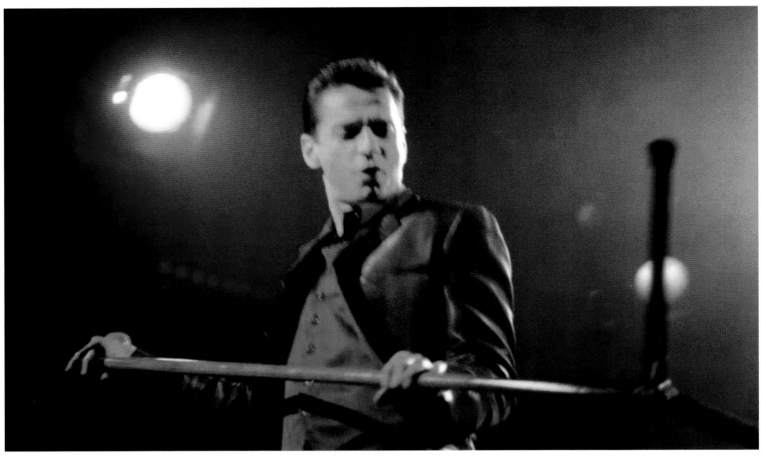

Dave Gahan at the start of the tour in Tartu, Estonia, September 2, 1998.

countries. Lodging and travel connections weren't always easy to organize, either. Even so, more and more "Devotees," as they had come to be called, took all these challenges upon themselves for a chance to see their favorite group play live as many times as possible.

The start of the tour was marked by a new single, "Only When I Lose Myself," the second one not to be taken off a full studio album, following 1985's "It's Called a Heart." Brian Griffin, who had designed the band's album covers in the early eighties, directed the video for the song. And just like before, a Depeche Mode single was an event for the charts: in Germany the song reached number 2, in the UK number 17. The band's many loyal fans in other European countries made themselves heard as well; "Only When I Lose Myself" went to number 1 on the charts in Hungary and Spain.

Following four concerts in Scandinavia, the band returned to Prague on September 15, 1998, to the very same sports hall they had played ten years before, then on the Eastern side of a still-divided Europe. Scores of fans from neighboring Poland traveled to Prague to finally see Depeche Mode live again.

Two shows at the Waldbühne in Berlin followed shortly after, their first visit to Germany in five years. Andy spoke about the experience with Denver's *Westword* magazine: "To go back onstage and really perform, like we're doing right at the moment, is a real joy . . . I was watching during our show in Berlin, and Dave was singing fantastically, the audience was going crazy, and I was just

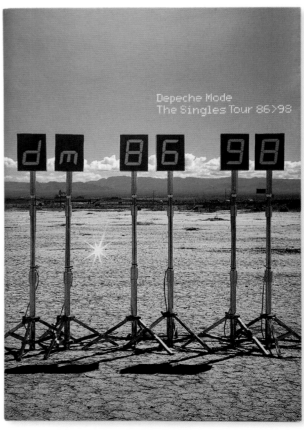

Booklet for the *Singles 86>98* tour.

The band at a Berlin press conference on September 18, 1999, in advance of the release of *The Singles 86>98*.

Berlin's Waldbühne, September 18, 1998.

staring at it all—and I ended up forgetting what I was playing. It was spectacular, and the crowd response was unreal. It's just been great fun."

The European leg of the tour numbered thirty-two dates in total, ten of which were in Germany, including a first-time stop in Erfurt.

All-access pass for the European shows on the tour for *The Singles 86>98*.

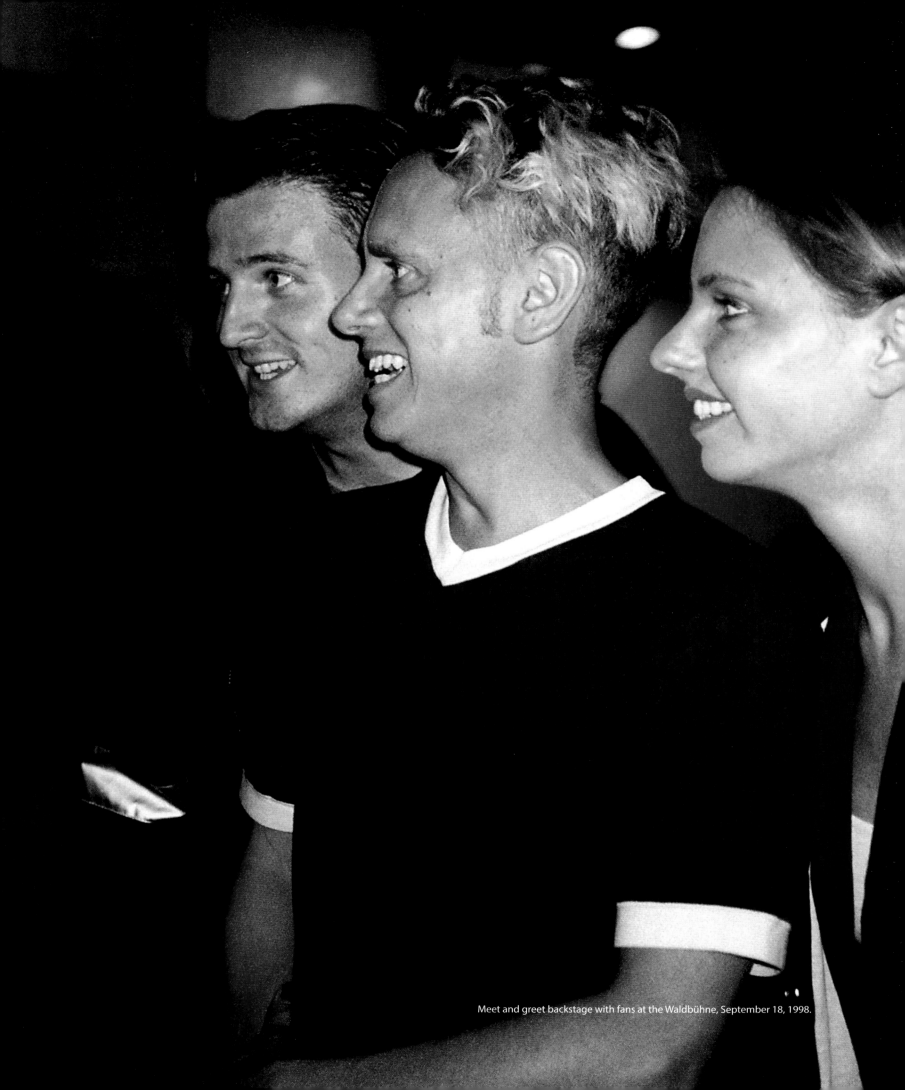

Meet and greet backstage with fans at the Waldbühne, September 18, 1998.

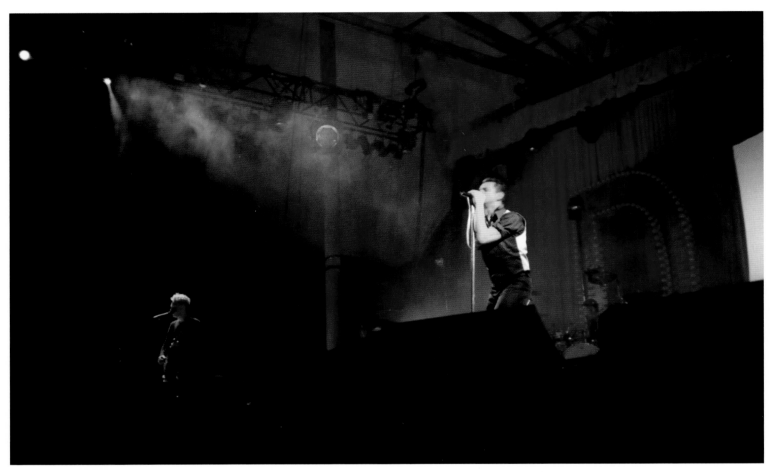

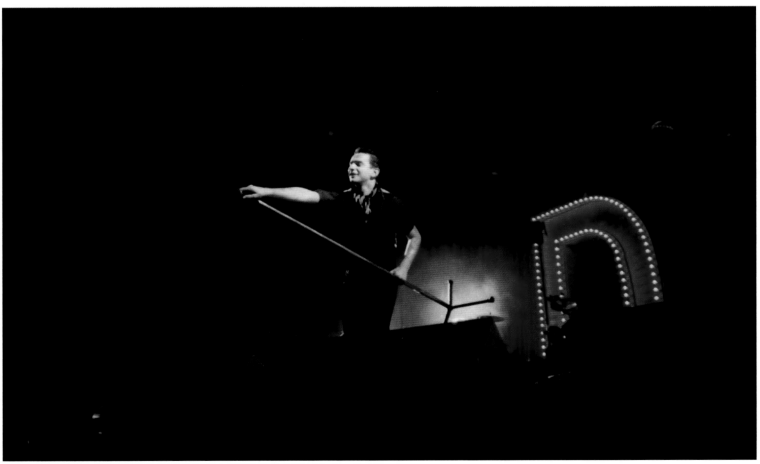

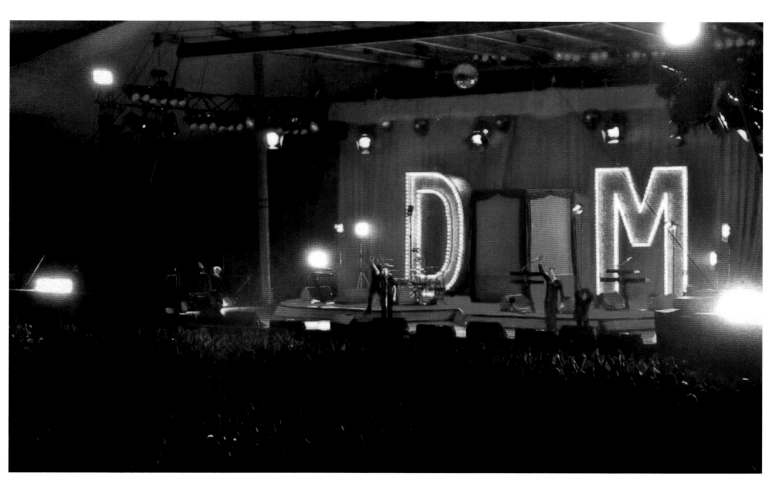

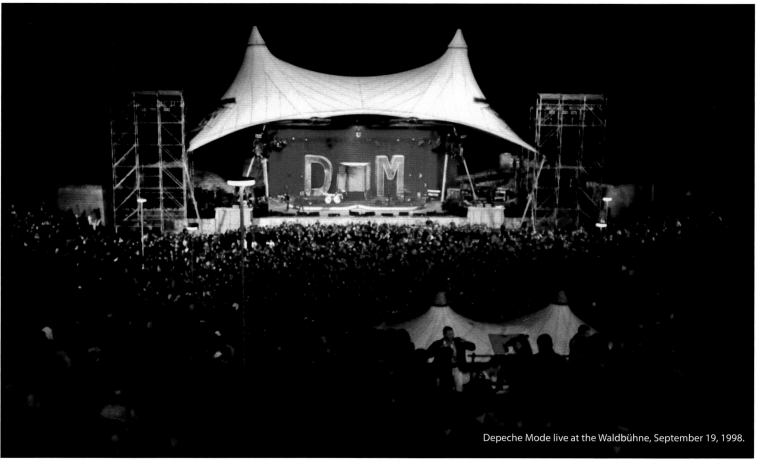

Depeche Mode live at the Waldbühne, September 19, 1998.

Ad by the Marek Lieberberg Concert Agency.

Depeche Mode performing in Stuttgart, September 23, 1998.

A performance on October 5, 1998, in Cologne was filmed by MTV, with part of it broadcast as a forty-seven-minute special. The video made clear that the band's strong desire to perform had returned in full force, especially for Dave.

On October 13, Depeche Mode played Munich's Olympia-halle: "My God, how this band is venerated!" wrote a reporter for *Musikexpress* magazine. "The billowing sea of arms has reached all the way up to the upper lip of the dish of the Olympiahalle for nearly two songs now . . . In sullen Munich, this sort of enthusiasm is generally reserved for UFO landings, papal visits, and maybe the Rolling Stones."

In the UK, the band made just three stops, in their old strongholds of London, Manchester, and Birmingham.

In the meantime, the compilation record *The Singles 86>98* had come out, landing at number 1 on the German charts and number 5 in Great Britain.

VIP pass for the European shows on the tour for *The Singles 86>98*.

Life as a Tour Crew Member

Stage design for the *Singles* tour was quite reserved by comparison to the Devotional Tour: the backdrop was dominated only with the large letters *D* and *M*, decorated with string lights.

The crew was also smaller, totaling around forty people. The stage equipment required five trucks for transport, plus one extra for merchandise. The crew traveled from city to city in two night-liner buses; the band itself traveled by private jet. Production manager Lee Charteris described a typical work day in his tour diary: "We start load-in at seven or eight a.m. so I am up before then, and basically I oversee the building of the show, so I am in the venue all day. I set up an office much like anyone else's from my touring road cases—that's where Andy Franks (tour manager), Jonathan Kessler, and I all work. It's basically a lot of phone calls mixed in with a bit of table football. It is a long day that usually finishes at two or three a.m. on a show day and it's all about patience, diplomacy, and sometimes a little counseling when tempers are fraught."

One long-standing crew member and friend of the band's since the early days, Daryl Bamonte, had stopped working with them. After more than fourteen dedicated years with Depeche Mode, he had switched over to another seminal UK indie band for whom his brother Perry was playing guitar: the Cure.

Depeche Mode in London, September 30, 1998.

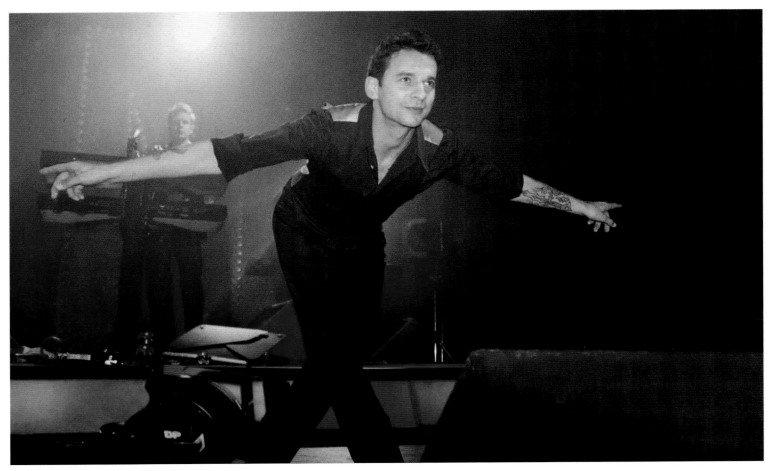

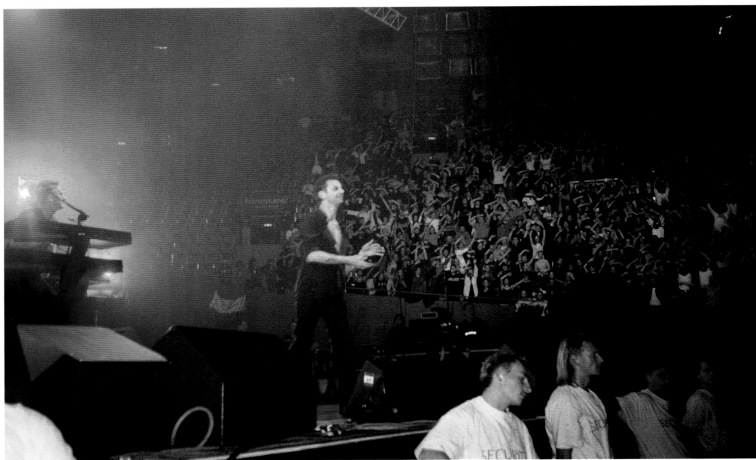

Depeche Mode at Munich's Olympiahalle on October 13, 1998
(on the left) and Frankfurt's Festhalle on October 11, 1998.

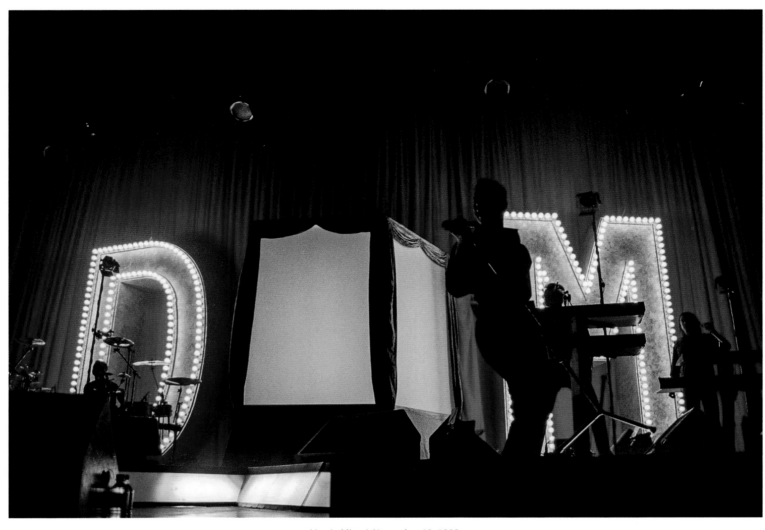

Live in Miami, November 13, 1998.

The US Leg

The tour picked back up on October 27, 1998, with thirty-one shows in the US and two in Canada. Reporting on the band's first US performance in four years, the *Boston Globe* wrote, "Depeche Mode live has always seemed somewhat at odds with Depeche Mode in the studio. The two sounds and styles are closer now. They've kept the sense of grace and beauty, while turning up the energy and buoyancy a notch."

Two sold-out nights at New York's Madison Square Garden on October 28 and 29 brought a good 27,000 fans through the doors, and netted the band $1.1 million, according to *Billboard*. The *Daily News* wrote, "The one-time kings of teen depression have stuck around long enough to see their fans brighten their wardrobe, grow up, get jobs, come out of the closet—in short, pass though whatever stages they needed to greet yesterday's mope anthems as today's pop nostalgia."

On November 2, Depeche Mode went on the *Late Show with David Letterman* to play "In Your Room" live. Invitations to national TV shows were a strong signal that the band had come into its own, and was perceived as having done so. The days of being a teen pop band were ancient history.

A button set from the tour for *The Singles 86>98*.

All-access pass for the North American leg of the tour for *The Singles 86>98*.

VIP pass for the North American leg of the tour for *The Singles 86>98*.

On December 12, Depeche Mode was invited to a special kind of event at radio station KROQ, which had been instrumental in helping the band break through in the US in the eighties. The station asked the band to play its Almost Acoustic Christmas festival, which had been taking place annually since 1989. Depeche Mode played an eleven-song set as the headlining act, including memorable acoustic renditions of "Sister of Night," "A Question of Lust," and "Enjoy the Silence." The encore of "Never Let Me Down Again" featured surprise guest Billy Corgan of the Smashing Pumpkins singing with Dave and playing guitar. The Smashing Pumpkins had previously covered the song on a Depeche Mode tribute album called *For the Masses*.

After just four months, the *Singles 86>98* tour ended on December 22 in Anaheim, California, for a total of sixty-six concerts at which more than 800,000 people had come to see Depeche Mode—and their rediscovered joy in performing.

DEPECHE MODE · *KROQ ACOUSTIC CHRISTMAS 1998 +* · CD BOOTLEG

The words "BRAT Productions" and catalog number "LCDMUTEL5" printed on the cover were intended to give the impression of this being an official release. Yet BRAT, the webmaster for the band's official website, had nothing to do with the bootleg.

***FOR THE MASSES* (TRIBUTE TO DEPECHE MODE) · CD (USA)**

Countless tribute albums dedicated to Depeche Mode have been released in recent decades—though not all of them for entirely altruistic motives. One very special tribute came in the summer of 1998, when a group of well-known stars came together to put their own spin on the band's work, on the sampler *For the Masses*. Acts included the Cure, the Smashing Pumpkins, the Deftones, Veruca Salt, Monster Magnet, and Rammstein from Germany. The album landed on the US charts and reached the top 20 in Germany, making it the most successful of all the Depeche Mode tribute albums.

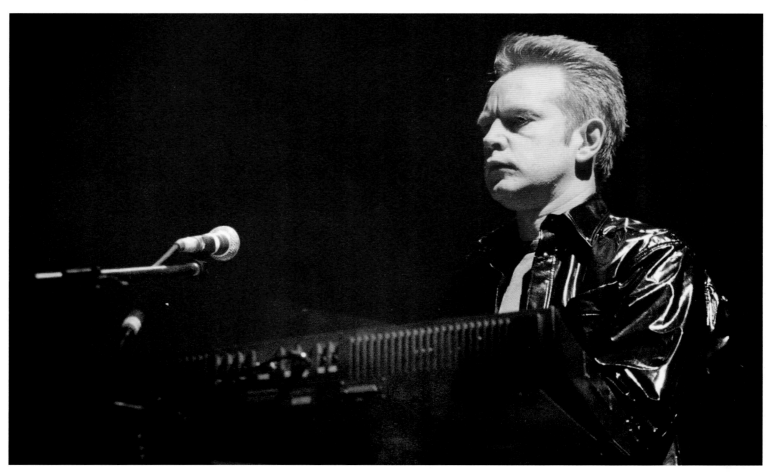

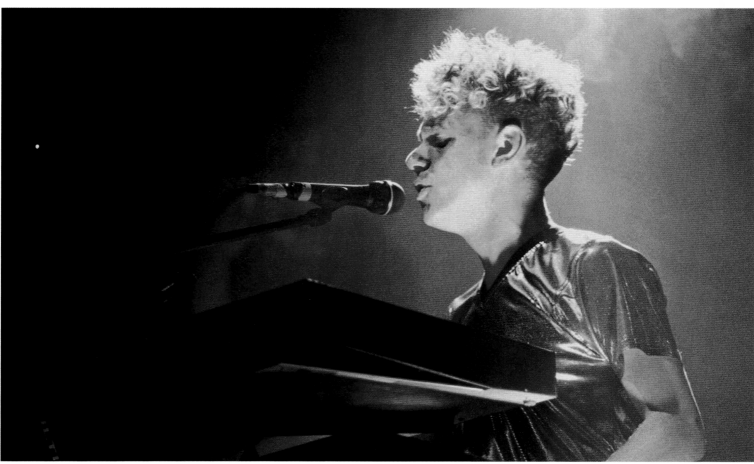

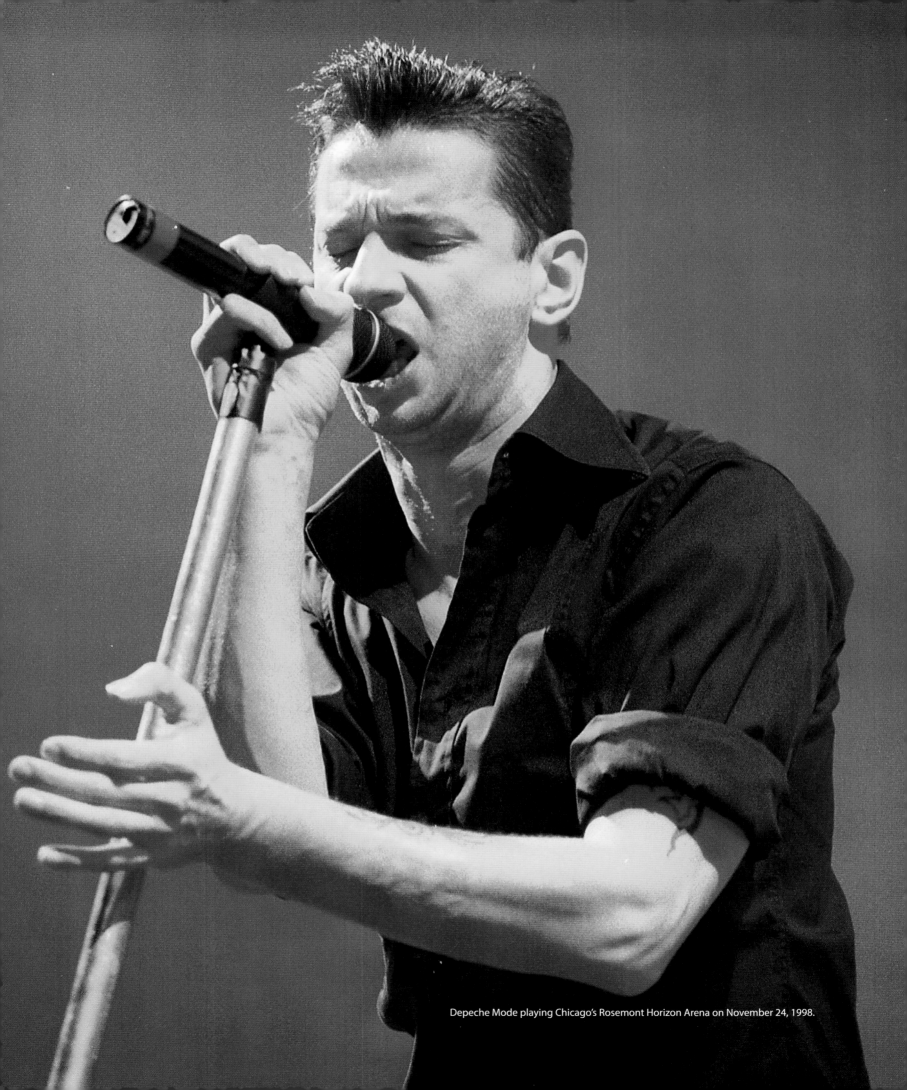

Depeche Mode playing Chicago's Rosemont Horizon Arena on November 24, 1998.

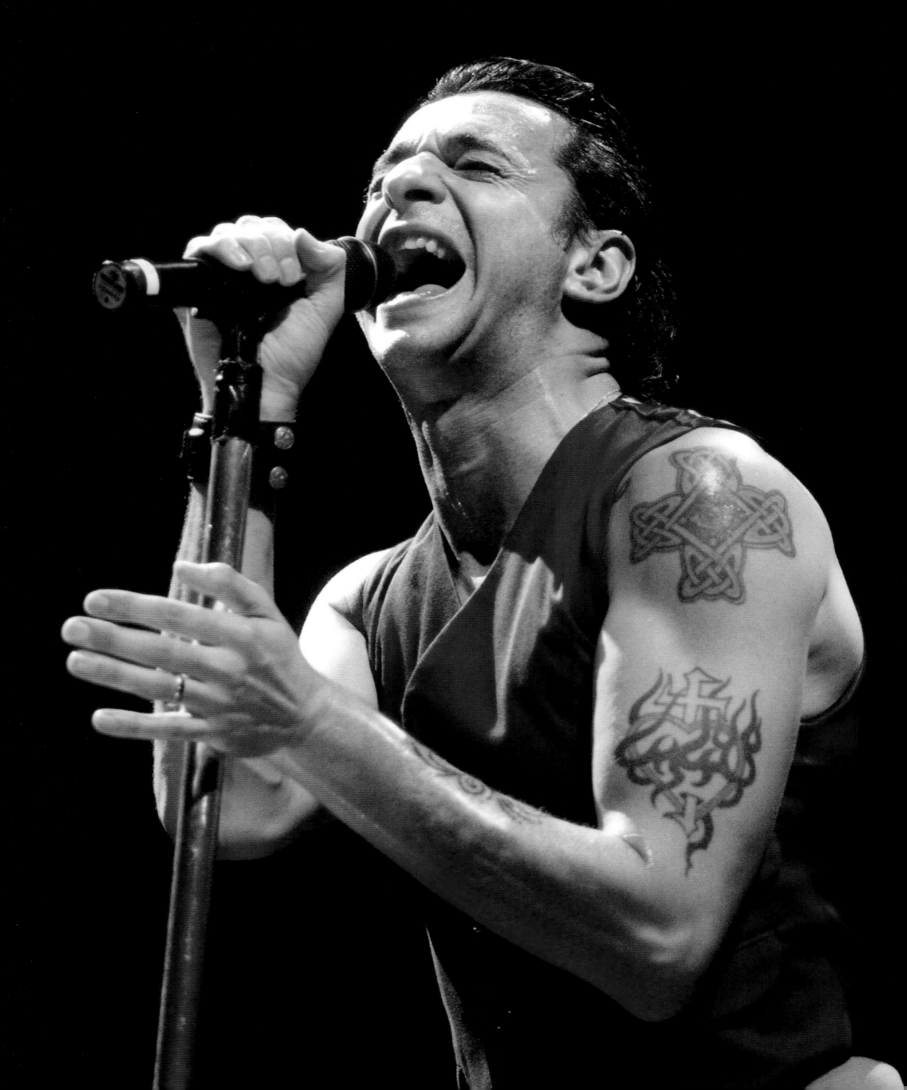

Exciter

The turn of the millennium found the band savoring a moment of peace in their personal lives: Dave had left his problems behind in LA and moved to New York, where he married for a third time and had another child. Martin was living with his family in Santa Barbara, California, while Andy remained in London with his wife and two children.

"After the last tour, I wasn't sure what was going to happen," Dave later said of the period immediately following the *Singles 86>98* tour. "I really enjoyed doing the older songs, and I simply embraced them. I felt like if this was going to be the end, then it was okay. So recording the new album has been quite a surprise really, to be honest."

After a one-year hiatus, the band met in late 1999 with Daniel Miller and their manager, Jonathan Kessler, to discuss a new Depeche Mode record. This time around, Martin had found it difficult to start the songwriting process, but managed to make progress with the help of his musician friend Paul Freegard and their old companion Gareth Jones.

Preproduction began in early 2000 at Sound Design Studio in Santa Barbara, and in May the band moved to London. Recording eventually continued in New York, with tour drummer Christian Eigner invited into the studio for the first time.

A memorable event came to pass on June 22 at 429 Harrow Road in London: Depeche Mode renewed their record contract. For twenty years now, the band had remained loyal to Daniel Miller and Mute, while the label still did everything in its power to support the band. Nowhere else was the band's artistic approach better understood, nowhere else did a deeper bond of trust exist.

Mixing for the new record began in November at Electric Lady Studios in New York, concluding in London in January 2001.

On March 13, 2001, Depeche Mode announced its new album, *Exciter*, at a press conference in Hamburg, along with tour plans for the coming September.

While the band's tenth studio album wasn't due in stores for another two months, by the time of the press conference the entire album was already making the rounds on the Internet, avail-

Dave with a fan upon his arrival to Hamburg, March 13, 2001.

able on the new mp3 file-sharing services. "Of course we're somewhat disappointed that our new songs are already up on Napster," Fletch admitted at the press conference. "Napster fills a hole, sure, but people also miss out on something. Before we enjoyed the anticipation of a new album from our favorite bands, then the release date was like Christmas."

"We started planning for this tour back about June 2000," manager Jonathan Kessler later recalled in an interview about how the tour came together. "We nailed down where we were going to go specifically, and the size and the type of venues we wanted to play. And then we started to look very much at the art side of it. How do we want to present the tour and how do we

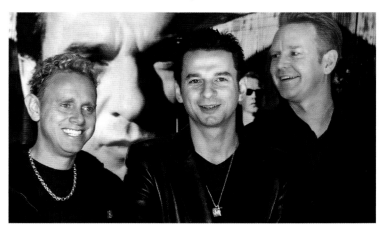
The Hamburg press conference in March 2001 took place at Valentino's, a legendary nightclub and one-time popular meeting spot for the city's jet-setters.

want to present ourselves? We think about what kind of show and songs we want to do, which is a lengthy process."

On March 21, 2001, Depeche Mode performed two new songs on *Top of the Pops* in London: "Dream On" and "I Feel Loved." It had been nearly twenty years since their performance of "New Life" on the show helped the band get its start in the music business.

In late March, the group endured marathon interview days in London, Paris, and Rome regarding the new tour and album.

Depeche Mode at Mute, 429 Harrow Road, on June 22, 2000.

Press release for the new album and upcoming tour.

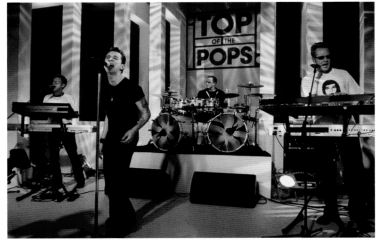

Depeche Mode recording at *Top of the Pops* in London, 2001.

The first single release, "Dream On," came out on April 23. The song quickly went to number 1 on the charts in Germany, a first since "People Are People" in 1984. The song also topped the charts in Italy, Spain, and Denmark, and reached number 6 in the UK.

All the waiting finally reached its end on May 14: *Exciter* was out in stores. It may have been the first Depeche Mode record in four years, but fans' enthusiasm was unabated.

In contrast to its predecessor, *Exciter* was a "typical" Depeche Mode record. The songs Martin had written were minimalist yet impactful, drawing on electronic music in stripped-down arrangements. The album also worked with an experimental style known as "glitch" that became popular around the turn of the millennium. Overall, *Exciter* came out nearly sounding like a concept album, similar to *Black Celebration* from 1986.

German magazine *Laut* even drew comparisons between producer Mark Bell and Gareth Jones: "Things look good for the future of Depeche Mode. *Exciter* is a step forward. If this is going to be the start of a new decade for Depeche Mode, Mark Bell might be the new Gareth Jones."

Unsurprisingly, the album jumped to number 1 on the German record charts, also making it into the top 10 in both the US and the UK.

Exciter Tour in North America

As usual, the source for the graphics, photographs, layout for the full record and its singles, and eventually the stage design for the *Exciter* tour was Anton Corbijn: "I have just made the stage design and worked on it with Lee Chateris, who was the production manager last time. We just talked about the possibilities of the ideas I had and how practical it would be. I'll probably present it to the band in a couple of days in Los Angeles . . . If they like it, we go from there, and if they don't, I will have to come up with something else . . . First, I want to design the stage, and then the filming part will come."

Preproduction for the tour began with initial rehearsals in May 2001 in London, then later in Santa Barbara, California. As on the last tour, drummer Christian Eigner and keyboardist Peter Gordeno accompanied Martin, Dave, and Andy live, alongside backup singers Jordan Bailey and Georgia Lewis.

Anton Corbijn's stage design sketches for 2001's *Exciter* tour.

On June 4, 2001, the band played a warm-up show to around six hundred fans at the Roxy in LA, to try out the songs in front of a live audience before the tour officially began. Tickets were available exclusively through giveaways on KROQ.

Martin's guitars at Sound Design Studio in Santa Barbara, June 1, 2001.

Pass for the warm-up show at the Roxy in LA.

Several days before the tour was set to open in Quebec on June 11, 2001, the crew was already at work erecting the stage. The production team was slightly larger than it had been for the *Singles 86>98* tour, involving around fifty people this time, with an additional sixty needed locally as stagehands, runners, and for catering. A cargo plane had been used to transport the equipment from Europe to North America, and it took six trucks to move it from city to city.

Christian Eigner and Peter Gordeno had now become a steady part of the Depeche Mode touring family; Martin commented about Gordeno that he "has got to be the wittiest one of all. He can definitely make you smile if you are having a bad day and make some smart comment to cheer you up."

Up through mid-August, Depeche Mode played forty dates across the US and Canada. On June 26, the night before the first of their two New York shows, the band was invited onto the *Late Show with David Letterman to* perform "Dream On."

The extra days off Depeche Mode planned for the *Exciter* tour, about ten each month, stretched the North American leg out to two months. While this decision raised touring costs, it also offered more time to recuperate, which in turn meant better performances.

After so many years, there were also well-worn preshow rituals to attend to: "One thing we love to do is to play table football," Fletch explained. "We have one in our 'pub' backstage and we always play before the show." For his part, Dave prepared in his dressing room with thirty to forty minutes of vocal warm-ups.

A KROQ sticker for the shows in California starting in August 2001.

Right before their Philadelphia show on June 30, the band did an interview with MTV. Later that night, Dave brought the MTV cameraman out onto stage in between songs to congratulate the channel on its twentieth birthday in front of a cheering crowd; the band knew well enough what MTV had done for it over the years. Another single off the record, "I Feel Loved," came out during the North American portion of the tour on July 30.

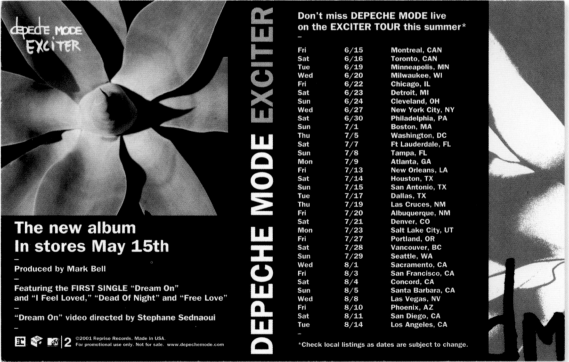

Promotional postcards from Sire Records for the shows in North America.

Advertisement for "Dream On," the new single from *Exciter*, and the upcoming US tour.

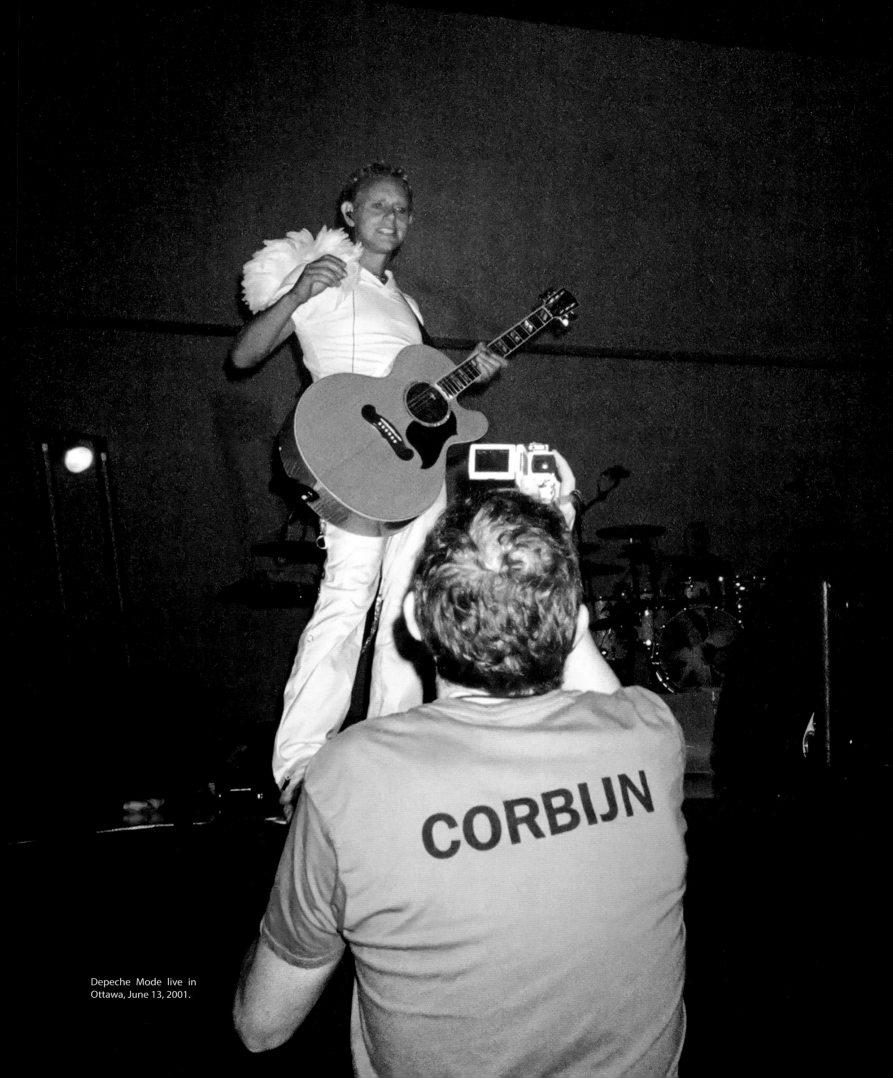

Depeche Mode live in
Ottawa, June 13, 2001.

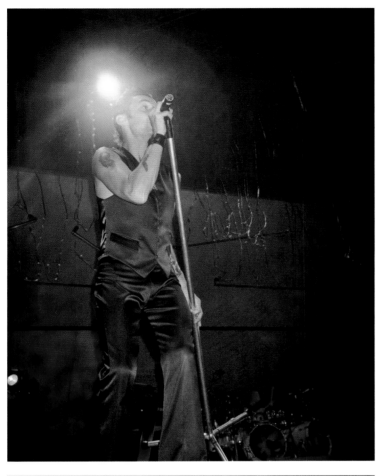

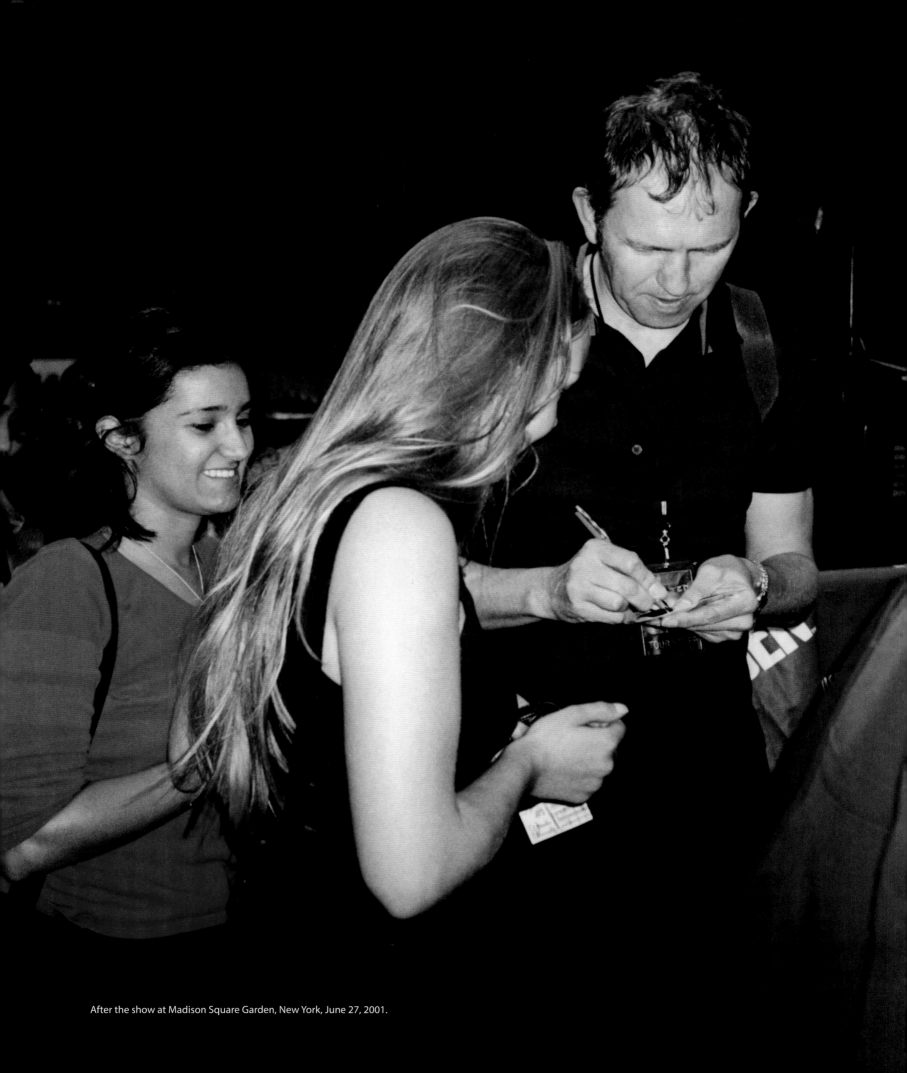

After the show at Madison Square Garden, New York, June 27, 2001.

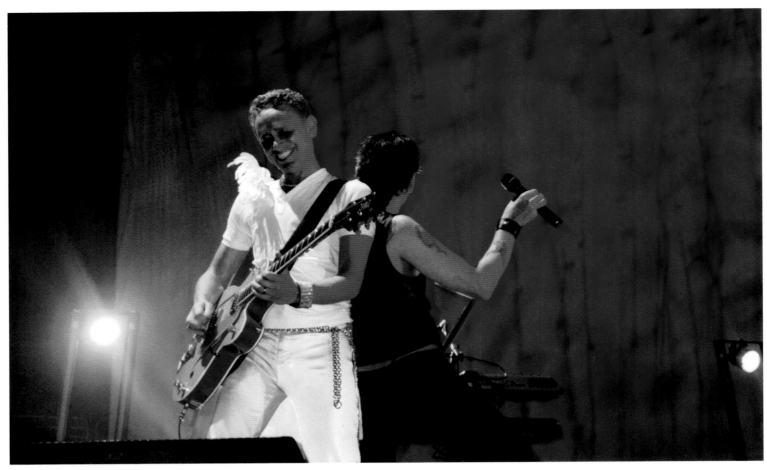

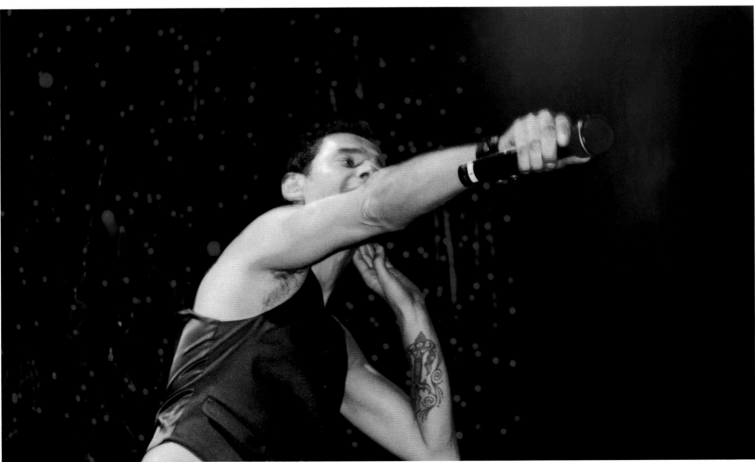

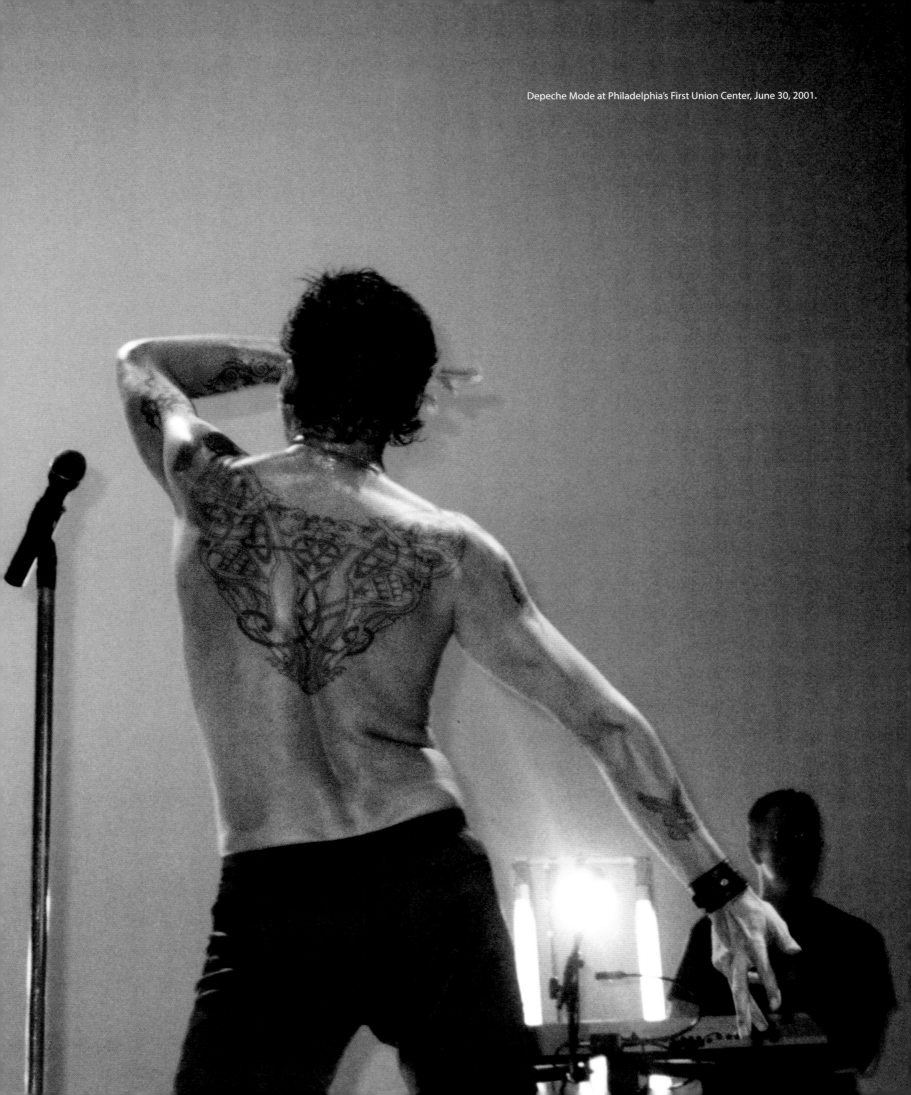

Depeche Mode at Philadelphia's First Union Center, June 30, 2001.

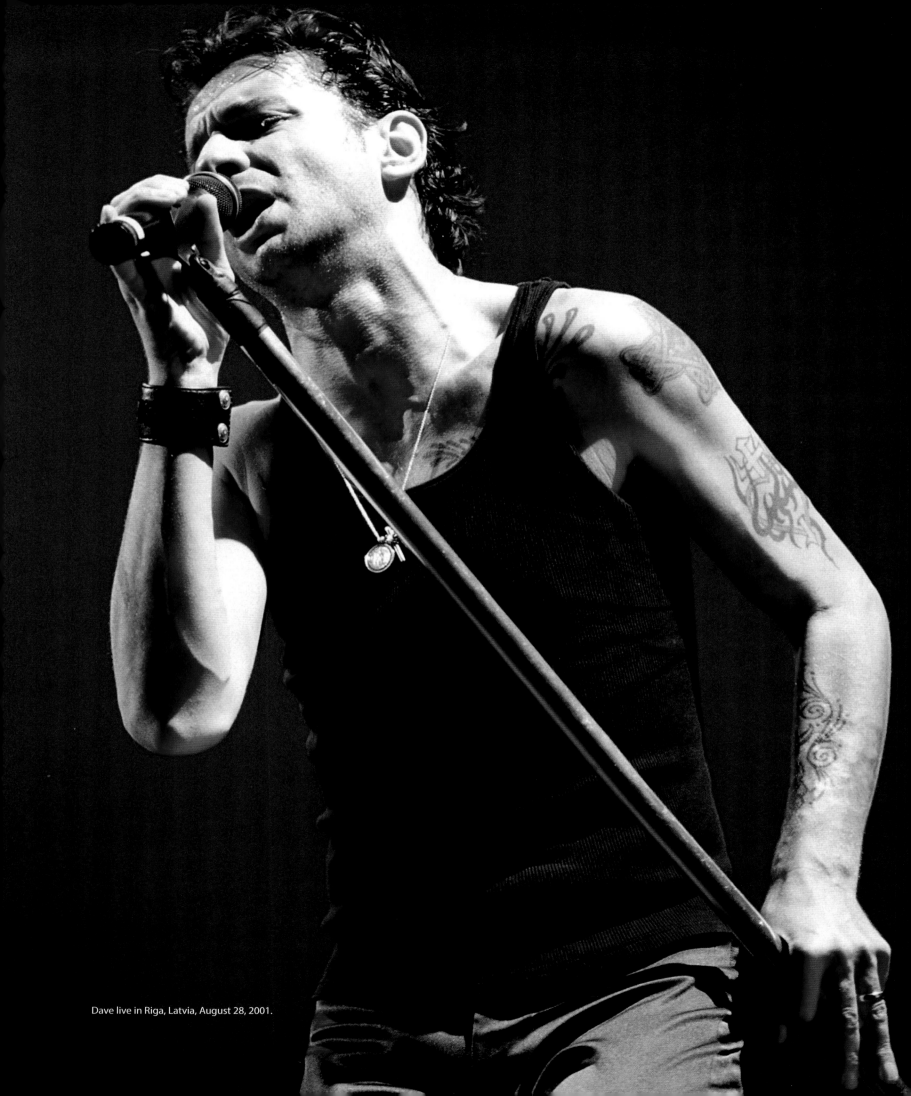

Dave live in Riga, Latvia, August 28, 2001.

Exciter Tour in Europe

A solid week after the band's last US show in California on August 19, the forty-three-date European leg of the *Exciter* tour kicked off on August 28 in Estonia's capital, Tallinn. Moving from show to show in a privately chartered plane that could seat up to a hundred passengers, the band followed Estonia with shows in Latvia and Lithuania.

On September 2, Depeche Mode returned to Warsaw, sixteen years after its first visit. The concert left a particularly deep impression on the evening's opening band, Technique. Ten years since the Iron Curtain had disappeared, Warsaw remained an Eastern European metropolis dominated by construction from the seventies, somewhere in between falling apart and taking off. Sarah Blackwood of Technique recounted her impressions to Sweden's *Release Music Magazine*: "When we supported Depeche in Warsaw, you can really see why electronic music is so popular there. It fits the landscape, you know. When you go through Warsaw you can't play rock, you have to play something electronic."

Two days later, Depeche Mode was back in Prague, with two dates at Berlin's Waldbühne following directly after. The band played twelve concerts in Germany, compared with just four in the UK.

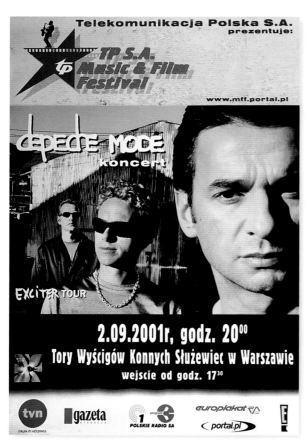

Poster for the concert in Warsaw, September 2, 2001.

The afternoon of their Vienna show on September 11, the band learned of the horrific series of terrorist attacks in the US. Martin later recalled his sense of helplessness: "After watching all the images on TV, we were trying to decide, 'What do we do? Do we go

Depeche Mode live in Warsaw.

onstage? Do we play tonight?' It all seemed a little bit futile to go on and sing and dance. Dave called home to his wife, they live in New York, not too far from where the World Trade Center was. And she said, 'Of course you should go on. Your music brings joy to the world. You should carry on.' And I thought that was a great answer." The band moved forward with the tour.

On October 9 and 10, Depeche Mode played two sold-out nights at the Bercy Arena, its Parisian home away from home since 1984. Anton Corbijn filmed both shows for a later live DVD. Asked ahead of time about the crowds at Depeche Mode concerts, Martin responded, "They're still, especially in Europe, very heavily dressed in black. There's still a real cult thing going on. Even the mothers coming with their children are dressed in black. That's a real European phenomenon. In America, the audience looks like anyone else's audience, but here, it's such a cult thing."

Supporting the band on this part of the tour was an act that was especially dear to Martin, Andy, and Dave: Frank Tovey, better known as Fad Gadget. A good twenty years had passed since a young Depeche Mode, right at the start of their career, opened for Fad Gadget in London. There had been little news from the exceptional artist for a long time, but when the band discovered that he was playing shows again, it didn't take long for them to invite him to join them.

Even after all the years and countless shows, there were still blank spots on the map for the band. October 30 found the band in Istanbul, Turkey, for the first time, and a few days later in Zagreb, Croatia.

On November 5, 2001, the day the single "Freelove" came out, the *Exciter* tour wrapped up with a show in Mannheim. Fans had prepared something special in advance of the show, holding up hundreds of signs saying *Thank You* during the encore and releasing air balloons. Martin recalled the by now common practice of pranks among the crew: "Jez Web, our guitar tech, played a very funny joke at the last show in Mannheim. While we were performing 'Personal Jesus,' he came out with a giant-sized mobile phone and pretended to be making a call—it was hysterical."

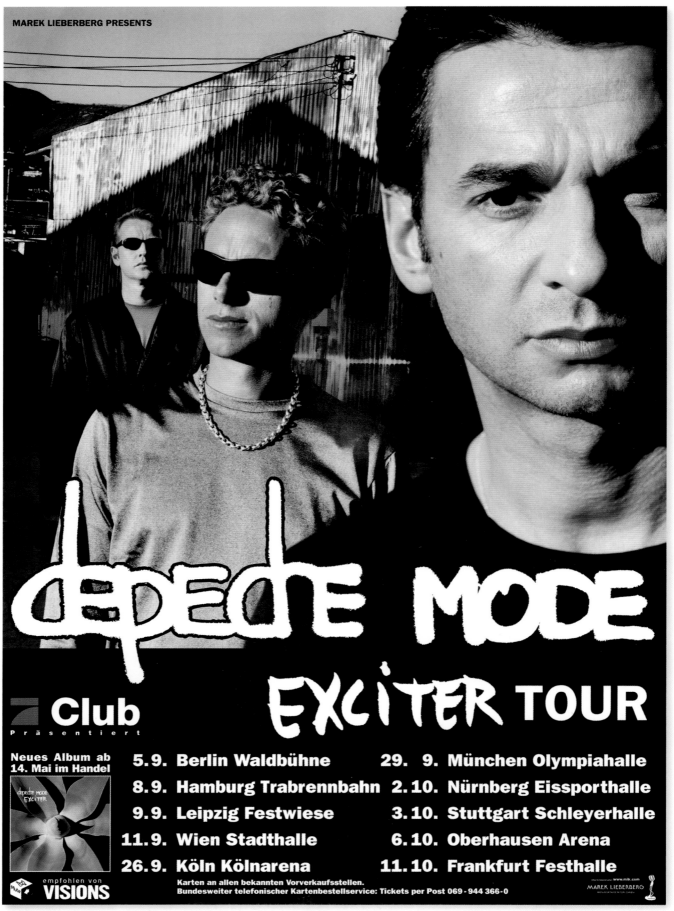

Poster announcing the *Exciter* tour dates in Germany, 2001.

This was the first really large Depeche Mode tour in seven years; doubts had arisen beforehand as to whether the band would be able to meet its own goals. Looking back, Jonathan Kessler could happily say that the "tour has been extremely, extremely successful. I think beyond our wildest dreams. America was extremely successful. And Europe, I think, was probably even more successful, beyond my even wildest and craziest expectations and hopes."

Within the space of seven months, Depeche Mode had played more than eighty shows to 1.2 million people. But the band wasn't quite done with Germany after its last show in Mannheim. Three days later, on November 8, they attended the MTV Europe Music Awards in Stuttgart, where they played their hit "Never Let Me Down Again." On February 11, 2002, "Goodnight Lovers" was released as the fourth single off the album, with the concert DVD *One Night in Paris* completing the cycle of releases three months later.

The final show on the *Exciter* tour on November 5 in Mannheim.

Booklet for the *Exciter* tour, 2001.

by keyboardist Peter Gordeno and Depeche Mode's live programmer Andrew Phillpott. Beginning that June, Dave also toured extensively on his solo record, *Paper Monsters,* playing a total of seventy-five shows across Europe and the US. In addition to their own songs, Dave and Martin both included a number of classic Depeche Mode tunes on their set lists.

Andy had developed a real liking for DJing, and continued touring through Europe into 2004. In the meantime, Martin had started composing new songs for Depeche Mode.

Exciter and the touring around it were a tremendous success for Depeche Mode, showing the band a viable path forward. They didn't have to rush anything. *Exciter* had revealed that fans would stay loyal no matter how long the band might break for, and would follow them down whatever new musical path opened.

Solo Projects

Following on the tour's success, Dave's ambitions to finally develop his own songwriting grew and he began working on a first solo record in 2002. Martin continued work on his own project, *Counterfeit*, and DJ'd occasionally, while Andy toured the international circuit as a DJ.

By 2003 the solo efforts were ready, and were released on Mute Records. That April, Martin did a short tour of eight cities in Europe and the US for his new record, *Counterfeit 2*, accompanied

Pin from the *Exciter* tour, 2001.

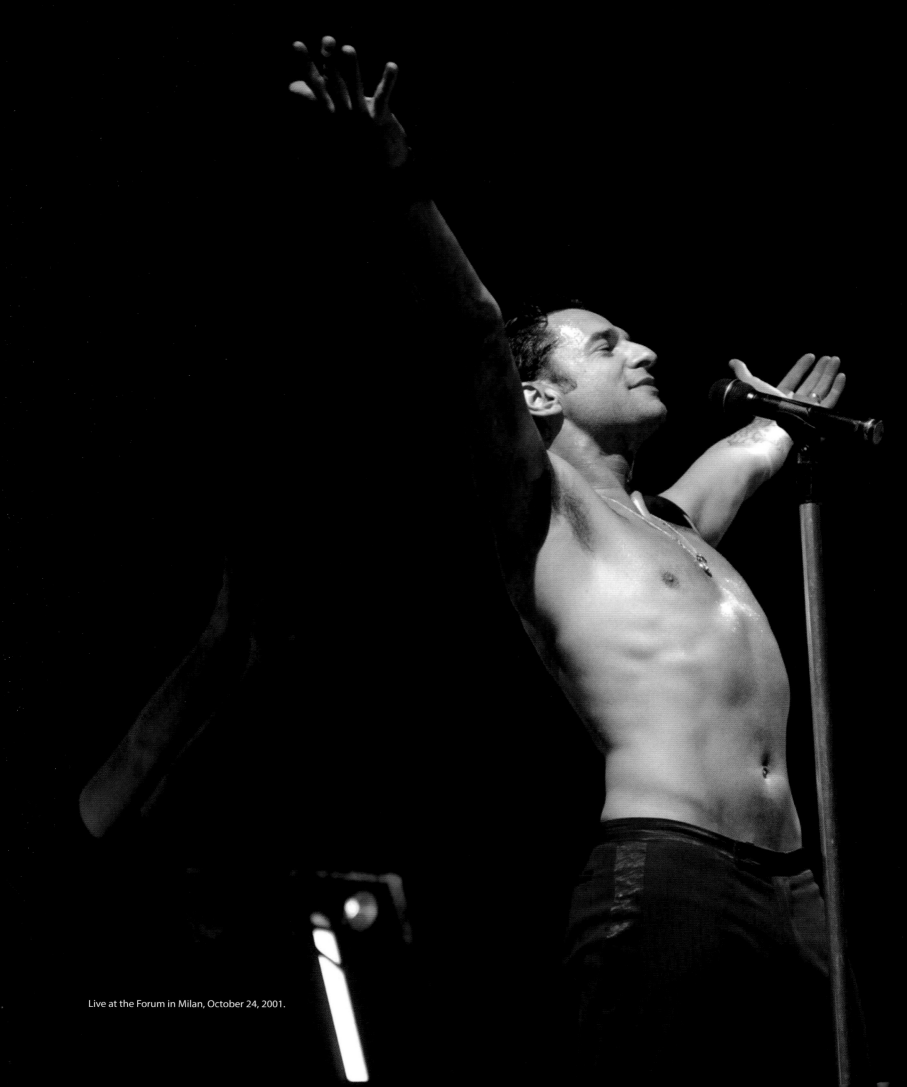

Live at the Forum in Milan, October 24, 2001.

Interview with Markus Kavka

Aside from shows like *Formel Eins* and *Peter's Pop-Show*, there weren't many options for Germans to see pop bands on TV in the 1980s. What was your experience of watching these programs as a young person at the time, especially with regard to Depeche Mode?

At the time I devoured any and every music show there was on TV. Even stuff like *Bananas*, which was really a comedy show with one or two musical acts per episode. The *WWF Club* with Jürgen von der Lippe always had musical guests on as well, and *Formel Eins* was an absolute must for me. Then there were music-only shows, like *Rockpalast*. I watched everything, even if I didn't know who was going to be on ahead of time.

Around 1981–82, long before *Formel Eins* took off, there was one show on Bavarian state television's third channel that had music videos. So I had already seen the Depeche Mode video for "Just Can't Get Enough" there. Then in 1984 I saw the video for "People Are People" on *Formel Eins*, when the band was making its commercial breakthrough and started appearing regularly in *Bravo*.

For a lot of listeners, Depeche Mode was first and foremost a chart band around the time of "People Are People." Those listening to the hit parade at the time would also listen to Depeche Mode in passing, even if they didn't know the first thing about the band's style or attitude.

For me, things were the opposite way around; nearly everything on the music shows was sort of collateral damage for me, and the only thing I would remember afterward was a live appearance or video by Depeche Mode.

There were several other UK bands that I liked: Soft Cell, Duran Duran, Thompson Twins, Tears for Fears. But I really only got excited when Depeche Mode was playing. It took a fairly long time before we had a video recorder at my parents' house. But once it was there, I recorded one video after another of Depeche Mode.

The way young people consumed music changed in the 1990s, starting with MTV programs in English, then the German programs on VIVA in 1993. If teens had mostly listened to the radio in the 1980s, now they were watching music television. What was your experience of the newfound power of music programming, and how did you wind up as a host yourself?

I had hosted radio shows as a student in Erlangen in the early nineties and freelanced for music magazines. I first came into contact with music television around the turn of the new year in 1993, when an English company was looking to produce a heavy metal show for the private channel ITV. I was cast for the show; they filmed a pilot episode with me that they also broadcast. But the project didn't go any further than that.

Then in April 1994, I took a job as editor of *Metal Hammer*, which was collaborating with VIVA on its heavy metal show. When they started looking for a new host, I sent them the video tape with the pilot episode, then I had an audition and got the job. My first show on music television aired in August 1995.

I started to be able to watch MTV regularly from my apartment around early 1994. Up to that point I had mostly watched the channel in hotels, when I was on the road. I was a big fan of Ray Cokes and shows like *Most Wanted* and *Alternative Nation, 120 Minutes*, shows with more alternative formats. At the time, I didn't even dream that I would later end up on MTV myself.

Working in music television came about naturally for me. I didn't go to the casting because I was a sweet little boy who wanted to be a teen heartthrob on TV, I went because of my previous experience as an editor on a show. My path ran through content, more as an editor-host and less of a classic VJ. I never read scripts off a teleprompter either, but spoke freely about whatever occurred to me. An entirely new era in the music business was being ushered in at the time. It had started before in the 1980s with MTV in the US, when the record labels figured out that making it on MTV's video rotation meant an instant hit.

Artists first became stars on MTV—MTV *created* stars. Good examples are Madonna's career, or Michael Jackson's, whose videos went a long way to establishing their core brand, or corporate identity. In other eras they wouldn't have become global stars as quickly as they did.

A video like Michael Jackson's "Thriller" was the starting signal for music videos becoming their own art form. Initially, videos had been promotional tools more than anything; the band stood around in the studio while they were filmed. But more and more often directors were hired, especially in the nineties, whose own artistic development began with music videos—directors that later went on to make great feature-length films.

To my mind, the peak era of music videos was from the mid-to-late nineties, as far as the artistic ambitions and budget were concerned. That's when the record companies had the most money, mostly through CD sales, and the most significant music videos were created. When music television was getting its start, it was a kind of changing of the guard. Artists were supposed to throw a hit single up the radio charts too, obviously. Dave from Depeche Mode later told me about the time around when *Ultra* was coming out. When they got to the question of which song should be the first single, Dave wanted "It's No Good," because he thought it was good for radio. But the band ultimately decided to go with "Barrel of a Gun," which wasn't a radio song but had a strong video.

Depeche Mode videos worked well because they had started collaborating with Anton Corbijn at an early point. He didn't just create the band's look in his videos but a whole new corporate identity, which played no small role in their success. The band wouldn't have been on TV as often as they were if they hadn't had Anton as their in-house art director.

After a long break, Depeche Mode put out a record in 1993 that had a musical shift, but also a significant shift in image. That was particularly clear in the case of Dave. The band visibly left the 1980s behind it. As a music journalist, how did you perceive Depeche Mode in that period, amid all the grunge and techno?

Markus Kavka in the mid-eighties; one photo of him taken at a Depeche Mode show in Munich in 1987 even made it into *Bravo*.

At first I went through a spell of being bothered, because I was mostly into guitar music at the time. I still listened to Depeche Mode, but the bands that left the deepest mark on me were Nirvana, Soundgarden, and other grunge bands, though there were also the Pixies, Sonic Youth, and others. Blues and gospel influences were easy to detect on *Songs of Faith and Devotion*. I needed a moment to accept that Depeche Mode were taking up elements that I had already heard in other bands' music in recent years. It took a little while to reconcile the image I had of them up to that point with their new musical influences.

I must have listened to the album ten times through, and each time it got a little closer for me, until the band that I had loved for so long and their music became one thing again. It was a total awakening, and it's not for nothing that this album in particular is one of my favorite Depeche Mode records.

By 1993, Depeche Mode had become a stadium band, in terms of their live act. They had played large venues throughout the eighties as well, shows in front of 10,000 fans, or at the Rose Bowl in Pasadena—but they were still young guys standing behind their keyboards; not much else was happening. It wasn't until the De-

votional Tour in 1993 that it turned into a big-ass rock show. That suited me quite well, because the bands I was listening to at the time had the same setup. And I liked them being a little more rock live than they were on the album.

I spoke with Dave at a later point about the 1990s and the changes in that period, in an interview when his record *Paper Monsters* came out. He told me about the moment he got the material from Martin for *Songs of Faith and Devotion*. How he had felt that it didn't have anything to do with him, and he couldn't find his way into the songs. For the first time in the band's history, he said to himself, *It's not that I have to adapt to these songs, but rather me taking these songs and making them my own*. And then he really did go and sing those songs with tremendous passion, live even more so.

The tour for *Songs of Faith and Devotion* was the band's most successful to date, with the music videos for it running on MTV and VIVA. How important do you think music television was in driving their career forward?

At this point Anton Corbijn has to be mentioned directly. By "Enjoy the Silence" at the latest, I was eagerly awaiting each new

Depeche Mode music video to see what he and the band would do this time. In my mind's eye, I have an image of every Depeche Mode clip, something I don't for any other video I've seen—that was Anton with his own exceptional visual language. For me, it was also the key as to why the band still had a presence on music television in the 1990s. Before I was there, I remember that the heads at MTV in Great Britain didn't find the band all that interesting anymore because its members were older than the newer groups on the charts. By that time, Depeche Mode already had the status of a cult band, not a band for the charts.

It came as a big surprise to them when Depeche Mode had a top 10 hit with "Dream On" in 2001 in Great Britain. But from a commercial point of view, the band wasn't fit for heavy rotation on MTV or VIVA. Depeche Mode were a bit too old for VIVA, they only showed up on low rotation, in the evenings or nighttime broadcasts, or on special programs. They weren't played all that much on MTV in the UK, either.

They would still have an interview for each new album, but I definitely saw more Depeche Mode on MTV in Germany than I did in Great Britain.

Depeche Mode strongly embraced the era's new electronic sound on 1997's *Ultra*. How did those in charge of music television see the band in that period?

There was a tremendous rap wave at the time, there was a lot of R&B and Euro-dance on. Depeche Mode didn't really seem to fit anymore. But they had a good lobby, because the people making the decisions—music heads and lead editors—were all more or less the same ages as the band was. That didn't mean, however, that every new Depeche Mode clip automatically made it on to the top rotation, or that they did substantive reporting on the band. It was more documentaries that were shown about the band, shows like *MTV Masters* or *MTV Essentials* that could draw from the entire history of the group.

MTV's target audience at the time was fourteen to nineteen years old, twenty-five at the oldest. And by the late nineties, Depeche Mode was a band that was aimed mostly at people over twenty-five, and which people between their midtwenties and mid-to-late thirties listened to.

With *Exciter*, the band put out a concept album in 2001 influenced by minimalism on the one hand, while on the other they were filling large stadiums once again after the *Singles* tour, and seemed to be back in the game . . .

Depeche Mode also had a little comeback on music television with *Exciter*. In 2001, right after I had joined MTV, the MTV Europe Music Awards took place in Frankfurt, where Depeche Mode played "Never Let Me Down Again." Their performance was amazing, they played an extended version of the song. That's also where I had my first interview with the band. I was beside myself at first that Depeche Mode had been nominated for the MTV Europe Music Awards. But my doubts grew when I took a

Depeche Mode at the MTV Europe Music Awards in 2001; their performance of "Never Let Me Down Again" at the Festhalle in Frankfurt was a crowning triumph.

closer look, because the band didn't show up in important categories like "Best Band" or "Best Video," but a new category, "Web Award." And they hadn't even won that, Limp Bizkit's website had. Nominating Depeche Mode for such an unimportant category when they were also performing live felt mildly insulting to me. The band commented on its nomination for the Web Award with a great deal of irony, by the way, during my interview with them. But a lot more people were paying more attention to Depeche Mode than they had in recent years, and there were more strong videos for *Exciter*. "Dream On" was running on heavy rotation at that point, and I think MTV helped in that way to make the song a number 1 hit in Germany.

People in charge also saw that the band might be older than other artists, but was still cool.

By *Violator* in 1990 at the latest, it had become clear to Depeche Mode that electro-pop had played itself out. That's why they had to open themselves up to new musical influences in the 1990s. Martin had discovered blues and gospel, but was also listening to new electronic music, which they tried out at the level of

singles remixes. Depeche Mode had recognized that it was important to bring the band forward into the new millennium. Who knows if the band would still be around today if they had just kept on doing what they had before. But they've stayed relevant up to today, because Martin always kept his finger on the pulse.

In the 2000s, the music industry entered a severe crisis with the Internet and the often illegal spread of music through online file-sharing sites like Napster. Music television in its traditional form also became superfluous, or didn't manage to adapt. Throughout this period, Depeche Mode made themselves somewhat scarce, putting out only one album every four years. At the same time, more people attended the shows with every tour. The music industry may have been experiencing a crisis, but Depeche Mode was taking off again.

It really is a phenomenon. A couple of bands from the same era followed a similar path and live off their ability to sell out stadiums—U2, for example. With Depeche Mode and their tours, the live show functions totally independently from the new records. The records provide an occasion for the band to go back on tour. But in the meantime, there are people who will now go to a Depeche Mode show without having listened to the new record.

What's astounding about the shows is that they aren't retro. Depeche Mode aren't conjuring up some form of nostalgia, the shows have a real relevance to the here and now. The high-tech setup, which grows more sophisticated with each passing tour, is a perfect match for the new songs. And you never get the impression that you've seen it all before—that they're doing the same thing. I can't entirely get past a tendency to prefer the old songs, but I think it's cool that the shows aren't some kind of golden-oldies event. And it's cool that such a large section of the fan base has stuck with the band into the present day.

You're a music journalist, but you're also a fan of the band. Can you talk a bit more about how it feels to interview your idols?

My first interview with Depeche Mode was one of the moments in my life that sticks out. I had already been working for a while as a music journalist, and met most of my biggest idols. I was in a total state when it was confirmed that I would meet Depeche Mode in 2001 at the MTV Europe Music Awards in Frankfurt and interview them. That was about fourteen days before the awards, and I immediately started to think about questions. The week before was bad, really bad, I could hardly sleep. I would wake up at night and tweak the questions, I did that the whole night through. The end result being that during the interview, I only asked the first question off the list, which I had changed umpteen times, and then the band and I simply fell into a relaxed chat. All the agitation in the lead-up . . .

I couldn't recognize myself, because up to then I had done all my interviews without a sheet on my lap. Now, with Depeche Mode, I thought, nothing could be allowed to go wrong. But the band's relaxed manner meant that I didn't have to stick to the sheet. I think I managed not to come across as a fanboy, but as well prepared, with some idea about the band. That sort of foundation of knowledge lets you enter into a conversation in an entirely different way, because you're familiar with the story. I was much more agitated leading up to the interview than the occasion called for, but that obviously had to do with me being a fan.

It was a lovely experience to discover that the band was exactly the way I had pictured each of their personalities. Not a trace of arrogance, nothing jaded or bored in their appearance. The band didn't know who I was ahead of time. *Here comes some idiot from MTV*, they must have been thinking, *looking for an interview at an award show where we've only been nominated for a Web Award.*

I had an awful interview with Martin at the Rock am Ring open-air in 2006, though. Depeche Mode were headlining, and MTV was broadcasting all the headliners live from the main stage. But the band had never had a show broadcast truly live up to that point, they had always approved the live takes before they were broadcast. Now they were supposed to play live and be broadcast live, without delay. Management, the record company, and the event organizers knew that the band wouldn't agree. So someone came up with the "marvelous" idea of really telling them only on the day of the performance itself, when they couldn't back out anymore. When Martin found out backstage, he said, "If it's broadcast live, we're not playing." There was a heated discussion, and at some point their live keyboardist Peter Gordeno said, "Guys, it's just music. Nobody gets hurt. Let's go out and play." To which Martin replied, "You've got a point."

All that was going on behind the scenes, though I was kept up to date. And then after the show I was supposed to interview Martin. I was hosting Rock am Ring at the time with Nora Tschirner. She was down in front of the stage in the trenches with the fans, and I was up in the press box, where all the bands came up for interviews. Everyone except Depeche Mode. That meant I had to go down into the backstage area, which was difficult logistically because the press box was on the third floor. To get backstage, I had to run down two flights and fight my way through a sea of fans waiting in front of the stage with help from a security guard.

Thirty seconds before we went live on air, I was sitting across from Martin. I was completely out of breath, and knew all about the discussion as to whether they would play or not, and whether MTV would carry it live or not. I was so tense, I could just feel a number of fuses blowing in my head. That never happened to me before or after—suddenly, I couldn't speak proper English anymore, even though I had been in American Studies and spent a semester abroad in the US. I had my questions at the ready, and it wasn't our first meeting, but the questions just didn't come to me. I spent the whole time talking about surface-level festival details.

Martin did everything he could not to leave me in the lurch while I asked one bad question after another in bad English. That was an excruciating moment in my career as a music journalist. Despite all that, I was happy Depeche Mode played Rock am Ring, and that I was there with MTV.

By the time we signed off, I was so riled up inside I had tears in my eyes.

ANGEL

00:03:05:12 00:03:

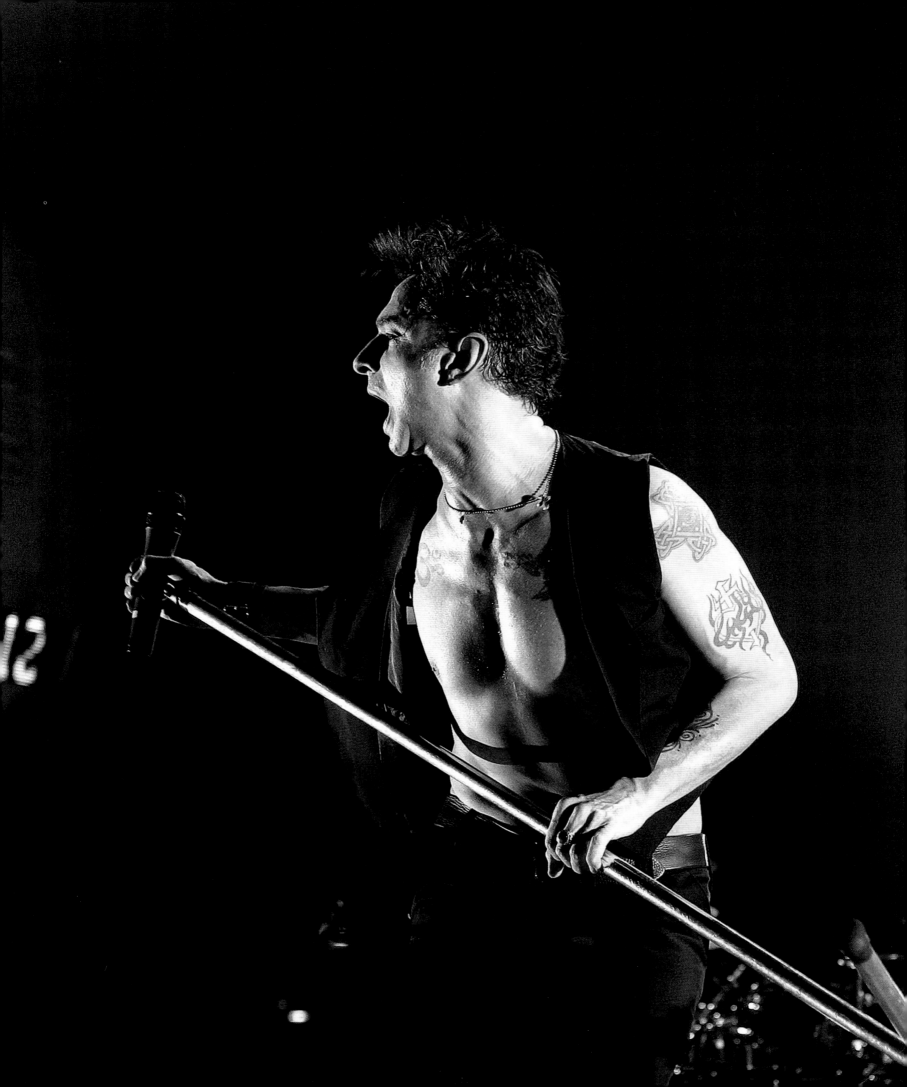

Touring the Angel

"I wanted to move the sound on from the last album," new producer Ben Hillier explained. "The last album was very digital sounding. I wanted to incorporate a lot more of the analog sounds from Depeche Mode's past and bring in more obvious use of guitar and that sort of stuff."

In January 2005, Martin, Andy, and Dave met Ben Hillier in a studio in Santa Barbara to record the next Depeche Mode album. In interviews leading up to the sessions, Dave had announced that he didn't want to just sing Martin's songs going forward, he also wanted to contribute his own compositions. And changes really did come to pass: from the demos that Dave had developed ahead of time with Christian Eigner and Andrew Phillpott, three made it onto the new album. After multiple sessions in the US, production finished up in London that July.

The band's enthusiasm about the upcoming album was palpable; they were in high spirits at a press conference on June 16, 2005, in Düsseldorf, along with concert promoter Marek Lieberberg, to announce a new record and tour to select fans and journalists. Fans would still have to bide their time for the first single to come out, however. Finally, on September 3, Depeche Mode went on the British television program *CD:UK* in London to perform "Precious." The single itself appeared in stores a month later—as well as on the new online music platforms—and quickly reached the top 5 in Germany and the UK.

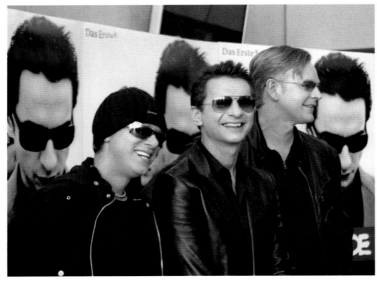

On June 16, 2005, Depeche Mode and Marek Lieberberg staged a press conference at Düsseldorf's LTU Arena.

A few days after their London performance, the band traveled to Cologne with live drummer Christian Eigner to perform "Precious" and another song off the new album for *Top of the Pops*.

The single was one of the few Depeche Mode tracks whose meaning Martin spoke about in personal terms: "'Precious,' in particular, for me, is a song about my children, because I'm in the middle of a divorce at the moment. It's about what they must be going through."

Ticket to attend the filming of *Top of the Pops* on September 8 in Cologne.

Playing the Angel

Depeche Mode's new record, *Playing the Angel*, appeared on October 17, immediately making its way to the top of the German charts. The following day, the band was in New York to rehearse for the upcoming tour, where ten days later they played a warm-up gig to a sold-out crowd of five hundred at the Bowery Ballroom. Peter Gordeno and Christian Eigner again played in the live ensemble, although the band decided to do without backup singers this time around. In another contrast to recent tours, the band opted for more elaborate staging, again under the direction of Anton Corbijn. The design gave the keyboard stands a UFO look and featured massive projections, with a large metal ball hovering above it all from the stage ceiling.

In addition to preproduced visuals running on the screens in the background, photographs taken during the live show were also displayed, making the projections more dynamic and changing from night to night. All of this meant the crew had gone back up to seventy people, among them programmer Kerry Hopwood, who had worked on the *Ultra* production crew in 1997.

Futuristic stage design for Touring the Angel, 2005–06.

In October, the band was in New York for a signing session at Tower Records.

Pass for the warm-up show at the Bowery Ballroom in New York.

Rehearsals wrapped up in Jacksonville, Florida, in late October, with the tour set to start on November 2. A hurricane had other plans for the band, however, and the first date had to be called off on short notice due to security concerns. The tour got going instead the following day in Tampa. The band's first show on the US leg included a special kind of premiere for Dave: "Suffer Well," one of the songs he had written for the new album, was included for the first time on the band's live set list.

The band toured into December, playing twenty-five shows throughout the US and Canada, with the Raveonettes opening for most of the tour. At the Raveonettes's final show on December 1 in Toronto, Martin came onstage and accompanied them, singing their song "The Heaven."

The North American finale for Touring the Angel came on December 11, at California's Universal City, the same place the tour before last had ended. The band played an hour-long acoustic set for KROQ's Almost Acoustic Christmas. None other than Coldplay was the supporting act. Other bands performing that weekend included the White Stripes and Death Cab for Cutie. Depeche Mode's new single, "A Pain that I'm Used To," came out the next day.

Depeche Mode live at the KROQ Almost Acoustic Christmas festival, December 11, 2005.

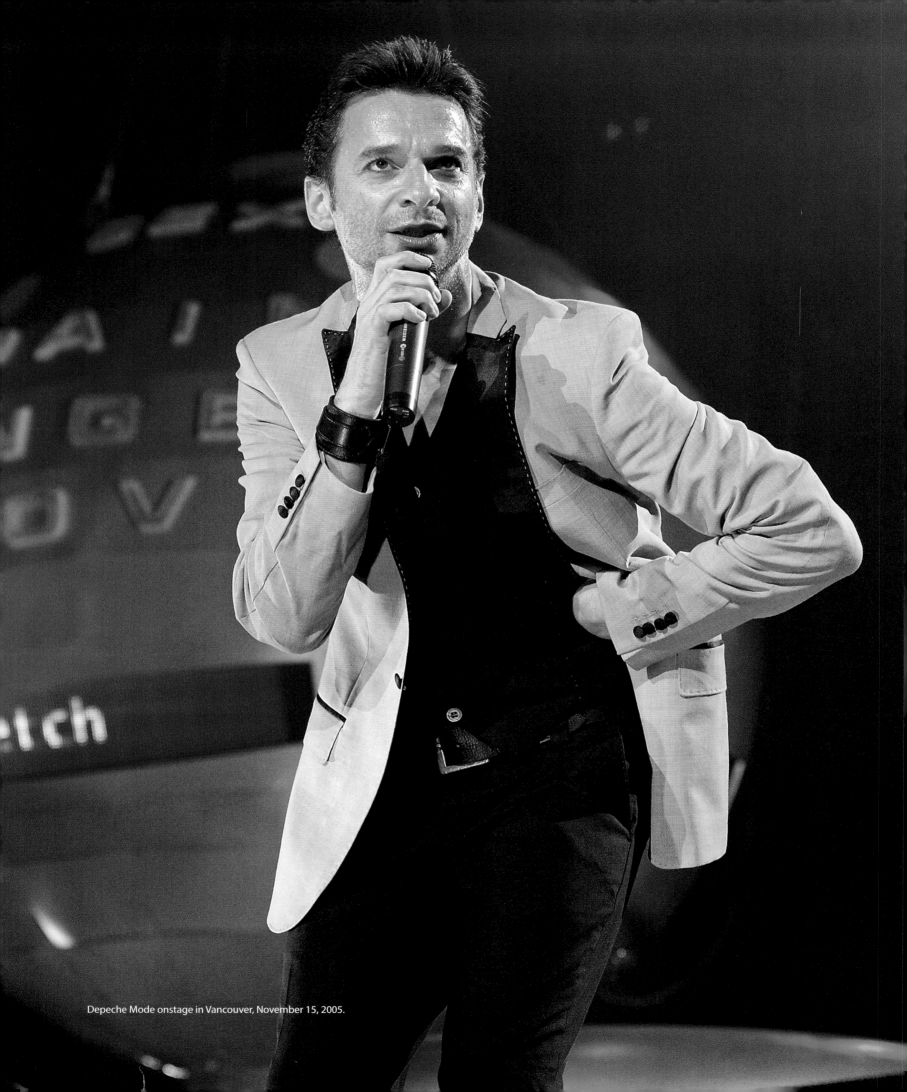

Depeche Mode onstage in Vancouver, November 15, 2005.

Everything Counts in Larger Amounts

In early December 2005, *Billboard* listed the ticket proceeds per concert for different artists playing across the US. Depeche Mode landed in the top twenty, earning around $500,000 per show at the start of their fall tour, with average attendance hovering at 7,500. First place was reserved for a fellow Brit, Paul McCartney, who earned close to $3.4 million. McCartney played two evenings in Anaheim in California in front of over 28,000 total guests. Still, over the course of the tour, Depeche Mode had been able to significantly increase ticket proceeds: playing on November 18 in San Jose, California, to over 13,000 people, they made more than $900,000, according to the January 7, 2006, edition of *Billboard*.

On November 21 and 22, 2005, Depeche Mode played LA to just under 29,000 people, earning some $2 million off tickets. Ten days later, Paul McCartney would play the same place for nearly the same number of attendees, and earned more than double.

The band's earnings had grown steadily since the touring for *Music for the Masses*. Yet the large sums had to be reconciled with all the expenses that each show incurred. Aside from preproduction costs, lodging and transport for the band, crew, and equipment, there were other expenses as well: location rental and technical expenses, on-site staff, security, insurance, etc. Plus, tour organizers, concert promoters, and any number of other actors also wanted their own share of the pie, and then there were taxes to consider. All of this made the total earnings per evening relative, even if the band was also profiting on merchandise sales.

Touring Europe

After a month-long pause, the European leg of the tour opened on January 13, 2006, at Dresden's Messehalle.

Reporting on the band's Berlin show, *Musikexpress* wrote, "The image of the evening came during the hymn of the century, 'Enjoy the Silence': Gahan introduced Gore, bowing before him and then imitating an angel beating its wings with his long, gangly arms. You simply don't know what to do with such an overdose of emotion. What a contrast to the Devotional Tour, when a strung-out Gahan had to pull off the show alone up front, as his bandmates went through the motions at a great distance, not just spatially. And now these two have come together, and want to let everyone know it. It's images like these that defined the evening."

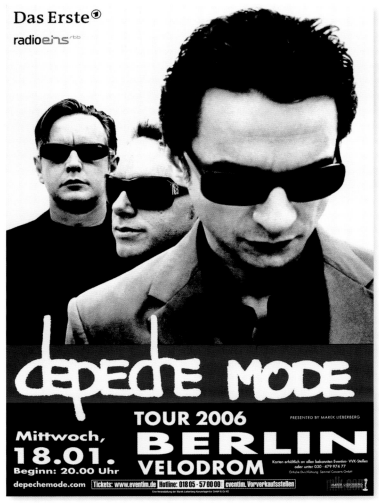

Poster for a show at Berlin's Velodrom on January 18, 2006; today, the Velodrom stands on the site of the Werner Seelenbinder Halle, the location of Depeche Mode's first concert in East Germany in 1988, before it was torn down in 1992.

Soon after, Martin, Andy, and Dave made a special TV appearance, performing "Precious" on January 28 in Salzburg for the ZDF program *Wetten, dass..?* Appearing on the most popular talk program in German television at the time showed that the band had begun to reach multiple generations of fans.

The two shows in Milan on February 18 and 19, 2006, were

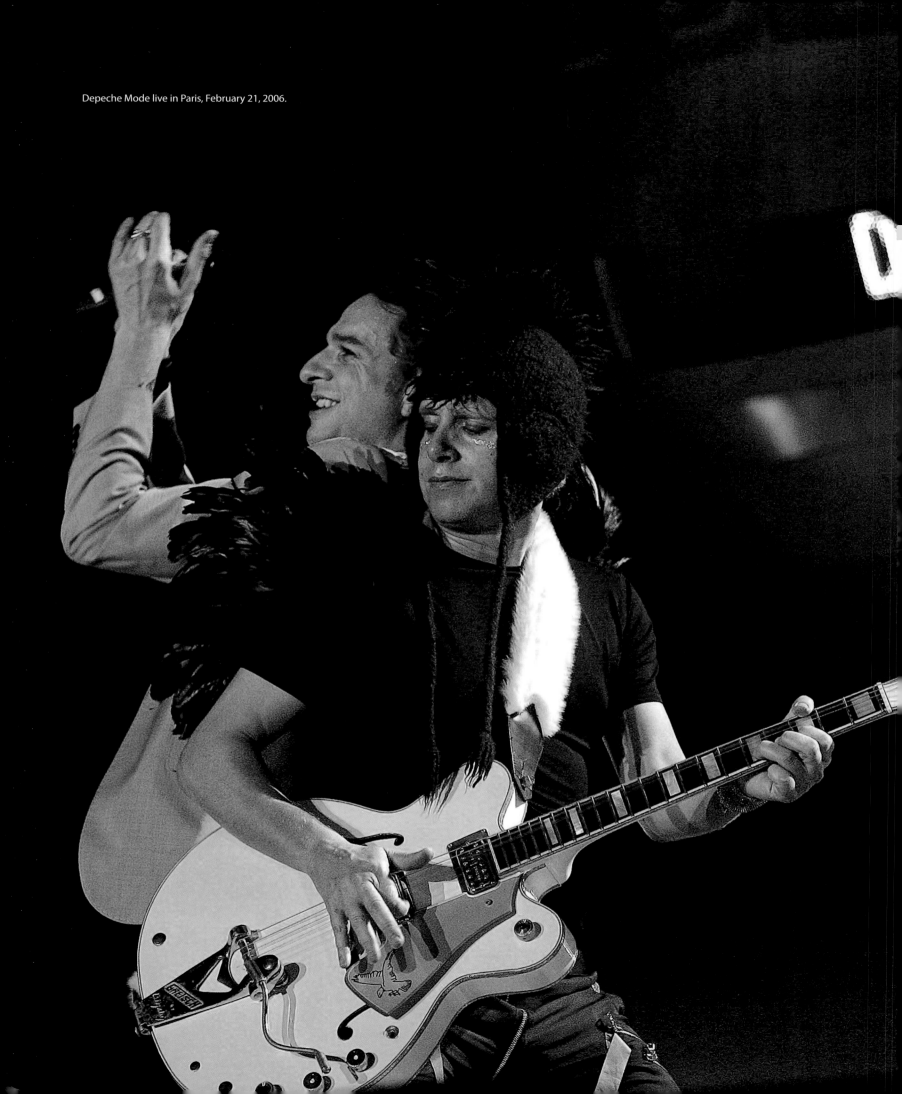

Depeche Mode live in Paris, February 21, 2006.

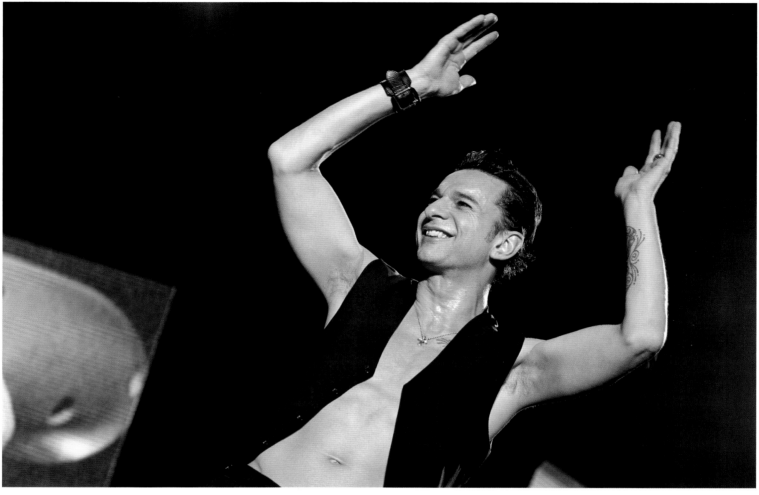

Dave onstage in Katowice, March 14, 2006.

filmed live under the direction of Blue Leach, who had already helped with preparing the stage show. The recordings were intended for a live DVD. One moment that really stood out came in the encore, "Goodnight Lovers," with Dave and Martin standing together on one of the stage runways, singing amid a sea of fans.

By April, the band had played fifty-two concerts across Europe. Ticket sales in Germany had gone so well in the months leading up to the tour that multiple additional concerts were booked. Many of the shows sold out.

On March 27, "Suffer Well" came out—the first Depeche Mode single written by Dave. As with their previous tour, the band's final four European club concerts were in Great Britain: Manchester, Birmingham, and two shows in London.

North America, Round Two

Following their European concert-hall tour, Depeche Mode met back up in late April for a second round of touring throughout the US, Mexico, and Canada, this time playing outdoor concerts. They tweaked the live set, shortening it slightly to include eighteen to twenty songs instead of twenty-two, as before.

The tour through North America featured a new additional ser-

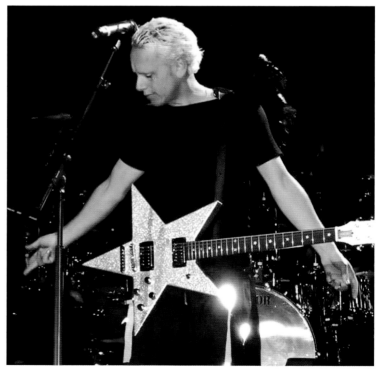

Martin live at the Starlight Theatre in Kansas City, May 10, 2006.

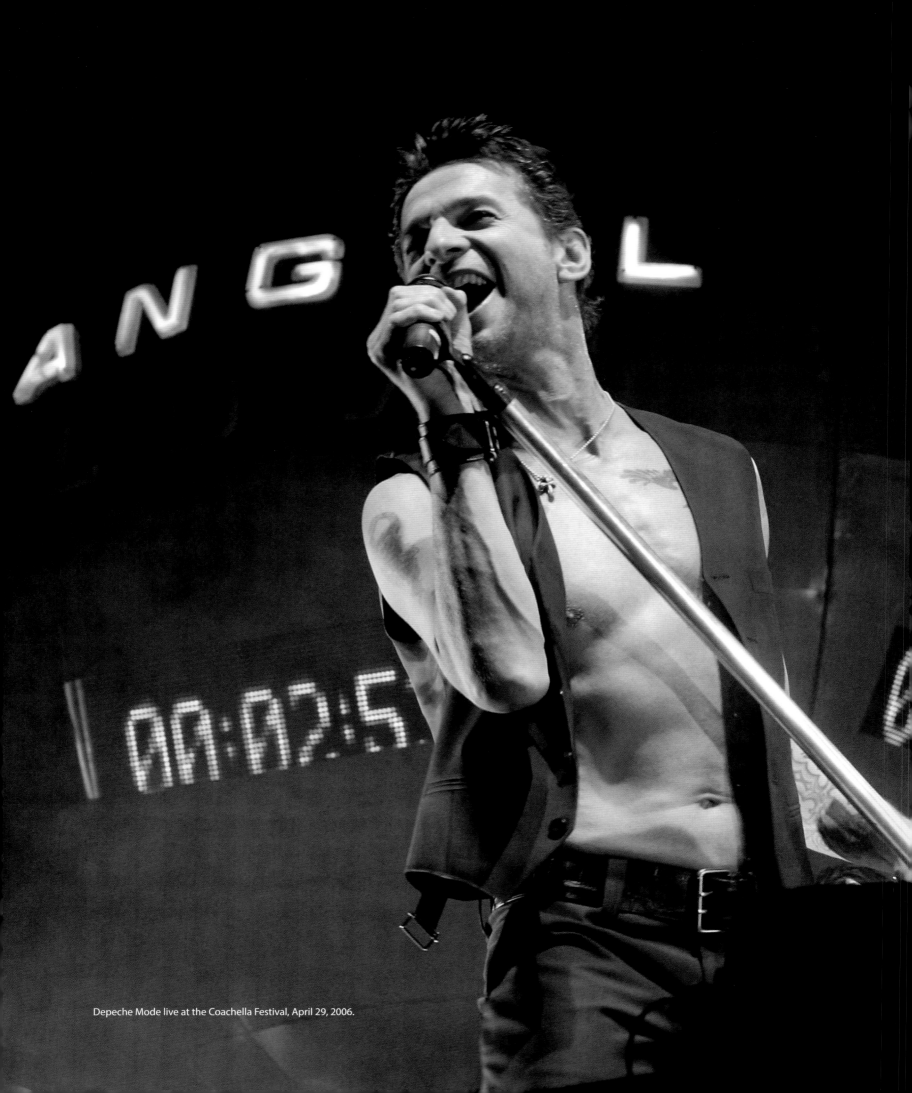

Depeche Mode live at the Coachella Festival, April 29, 2006.

vice for fans of live recordings that had also been on offer in Europe. For decades, live Depeche Mode bootlegs of varying quality had been circulating on the black market. In 2004, this led Mute Records to create a new company, Live Here Now, that specialized in making professional concert recordings. On the *Playing the Angel* tour, this resulted in forty-three live recordings, which could be preordered at the shows using vouchers, with the CD arriving later by mail.

Sadly, not all of the planned shows were able to take place. At a surprisingly cold outdoor concert on May 10, 2006, in Kansas City, Dave suddenly lost his voice halfway through the show. Martin sang the rest of the songs for the set, which ultimately had to be cut short. The show planned the following evening in Chicago was canceled for the same reason, though the tour picked back up after May 13.

Back to Europe

After thirteen shows in total, the band returned to Europe in late May for another set of concerts—this time outdoors or at festivals—that lasted into August. The band played in Germany, appearing for the first time at Rock im Park and Rock am Ring. The latter set was carried live on MTV. A day later, on June 5, the single "John the Revelator" came out.

Unlike their initial touring for the record, the band decided to only play two consecutive nights for the open-air concerts, so as to have more days off between shows. The sheer number of performances had been too demanding of the musicians, who were over forty by now. Dave explained the new working procedure: "We were able to make the scheduling slightly different, so that we could really enjoy the performances more. It seems like when we do two performances and there's a day off, then there is one performance and a couple of days off, we all enjoy it a lot more."

This leg of the tour included stop-offs in Eastern Europe and three sold-out shows at Berlin's Waldbühne. On July 20, the band played a nearly 2,000-year-old Roman arena in Nîmes, France. Other spectacular sites followed—ten days later an open-air show was planned directly on the Bosphorus in Istanbul.

The tour finally culminated on August 1 in Athens. Initially, the band had planned to finish with an outdoor concert in Tel Aviv on August 3, but a war was raging in the north of Israel against Lebanon-based Hezbollah, with rockets flying daily. Andy Fletcher explained the band's decision in 2013 to the newspaper *Haaretz*: "We, the band, didn't want to cancel, but Hezbollah was firing all those rockets and we were to play in front of 50,000 people. So we thought, *Is this a sensible thing to do?* In the end, it was our crew who voted against it. And we couldn't force seventy people to do something they considered dangerous."

Over the ten months of touring for the new record, Depeche Mode played 125 shows, many of which sold out. 2.5 million people had come to see them, more than twice as many as the previous *Exciter* tour. The tremendous growth left the band searching for answers. "It's very strange," Andy reflected, "because we're more popular now on a live scale than we were at our sales peak

Flyer for the Recording the Angel campaign run by Live Here Now.

with *Violator*. We seem to be getting more and more popular, which is a bit odd. The less records we release, the more popular we get live."

On September 25, the DVD *Touring the Angel: Live in Milan* came out, followed shortly thereafter by the fourth single off the album, "Martyr." Then, on November 2, one long wait for the band finally came to an end: at the MTV Europe Music Awards in Copenhagen, Depeche Mode won the category "Best Band." A visibly happy Andy Fletcher was there to receive the prize.

Fourteen days later, Depeche Mode released a new compilation, ironically entitled *The Best of Depeche Mode Volume 1*. Yet things were far from over.

Tour of the Universe

After the wild success of Touring the Angel, the band members decided to pull back for the moment and once again pursue individual interests.

Andy went on a number of short tours as a DJ through Europe, South America, and Israel. Dave spent June recording his second solo album for later release that fall, though this time he didn't tour. Martin already had new Depeche Mode songs at the ready.

The band met back up in May 2008 and started working on the new album in a series of studios, again with producer Ben Hillier. Dave came to the table with several more songs, developed with Christian Eigner and Andrew Phillpott.

Fletch, Dave, and Martin recording in Santa Barbara.

On October 6, 2008, with the new record as yet unfinished, Depeche Mode staged a press conference at Berlin's Olympiastadion with various media outlets and select fans to announce a new world tour for the forthcoming album, *Sounds of the Universe*. The band ultimately worked through mid-December on the record.

On February 21, 2009, Depeche Mode performed their new

The October 6 press conference at Berlin's Olympiastadion.

single, "Wrong," at the Echo Music Awards in Berlin, to an overwhelmingly enthusiastic reception from fans. The other stars present that evening, U2 among them, felt like an afterthought. "Wrong" came out six weeks later, landing at number 2 on the charts in Germany.

"Wrong" celebrated its worldwide premiere at the Echo Music Awards on February 21, 2009.

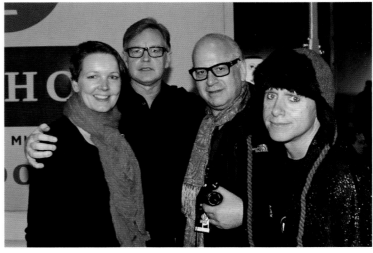

All in the Mute family: Anne Haffmans, Andy Fletcher, Daniel Miller, and Martin Gore.

By that time, the band was already rehearsing at New York's SIR Studios for their upcoming Tour of the Universe. Christian Eigner explained how he approached new material: "I usually start to listen to the drum patterns on the album and then change it if I have to, just to make it work in bigger places. And then I'm usually doing that for, let's say, three or four shows, and then I tweak it."

On April 20, 2009, the wait was finally over: *Sounds of the Universe* was officially released. The album went to number 1 in twenty-one countries, Germany included.

Just three days later in Los Angeles, the band appeared on *Jimmy Kimmel Live!*, where they played a seven-song set right on Hollywood Boulevard.

Tour of the Universe in Europe

What had by now become the obligatory ritual of a warm-up concert took place on May 6 in front of 5,000 fans in Luxembourg. Fans at the Rockhal in Esch-sur-Alzette went particularly wild over "Strangelove" from *Music for the Masses* and 1984's "Master and Servant."

Flyer for the first show of the tour in Luxembourg.

Ticket for the show in Tel Aviv.

anticipation, Dave suddenly fell ill and had to be rushed off to the hospital. The concert had to be canceled, and Dave immediately flew back to New York for further medical care, leaving the tour suspended.

The tour officially began four days later on May 10 in Tel Aviv, although things got off to an inauspicious start. The day before the band's first long-awaited appearance in Israel, Andy's father died unexpectedly in England, leaving him to decide whether he would be able to play under the conditions or have to cancel. The band had already been forced to cancel a show in Israel four years before due to Hezbollah attacks, and Andy decided that they couldn't let fans down again—he stayed on tour.

Two days later the band was in Athens, where the bad luck followed them: with the opening act finished and the crowd full of

The news arrived shortly before nine p.m.: the concert in Athens had unfortunately been called off.

Depeche Mode live at the Ramat Gan Stadium in Tel Aviv on May 10, 2009.

Hope springs eternal: after the canceled shows, the tour picked back up on June 8 at Leipzig's Zentralstadion.

Fletch with fans in Leipzig.

In New York, Dave finally received the news that he had a bladder tumor. For a long time it remained unclear how long he would have to stay off tour, and which shows, if any, would still be able to take place. Recalling the unnerving time, Martin said, "With the death of Andy's dad and then that happening to Dave, it felt just like we were doomed."

A total of fifteen concerts had to be called off before Depeche Mode were back onstage together, for an outdoor show in Leipzig on June 8, 2009.

Two days later, Depeche Mode played Berlin's Olympiastadion for the first time before 70,000 fans. Among the crowd were members of A-ha and Nitzer Ebb.

Nitzer Ebb had been friends with the band for an especially long time. The night before, they had played at Convention of the Universe, a show organized by fans at Postbahnhof in Berlin that was attended by Martin, Daniel Miller, and a small crew of Depeche Mode's touring entourage. Nitzer Ebb's singer, Douglas, later recalled a particularly touching moment from the June 10 concert in Berlin: "Dave Gahan dedicated 'Never Let Me Down Again' to Bon Harris and Douglas McCarthy. I am, admittedly, a sentimental fool, but I truly wept. With that one gesture, those few words, and that song, Dave summed up over two decades of love, happiness, heartbreak, and sorrow."

Before every tour, the band found itself confronting the same question: which songs to play live? Especially after having released

Depeche Mode performed at the Olympiastadion in Berlin on June 10, 2009. The night before, the Convention of the Universe—a large fan event with over a thousand guests—took place at the Postbahnhof, with Nitzer Ebb playing a comeback show of sorts to a sold-out audience. The evening brought a special reunion; despite the stress of touring, Martin, Peter Gordeno, Christian Eigner, Daniel Miller, and Anne Haffmans didn't want to pass up the chance to see Nitzer Ebb playing live. In October, Depeche Mode announced that Nitzer Ebb would support them on tour.

so many albums, choosing had become more and more complicated. Martin explained the band's procedure: "The most difficult thing is choosing a set list. And that really is the three main members of the band sitting down and making lists of songs that they want to do, and then if all three of us pick a song, we know it's obviously in the list; if two of us pick a song, it's more than likely in the list; and then it's a little bit of arguing after that about what the final set list should be."

For Tour of the Universe, Martin and Peter Gordeno would often decide quite spontaneously about new songs for the set list. As Peter recalled, "When we first started rehearsing, we had two or three different versions of a single song, so we worked up an acoustic version of "Home" and "A Question of Lust" and a couple of other things. And then we started varying it quite a lot more, and then it got to the point where we would just be like on the plane on the way to a gig and just going: 'Do you know that song? Let's try that tonight.' So I've got my headphones on and I'm learning it in the plane. Run through it once in the dressing room and then just go on and do it."

Building the stage in Leipzig.

For the stadium tour, a crew of thirty worked for a solid three days on the basic setup. Only after they were done would the large trucks arrive, ten in total, after which it took the crew about five hours to put together the PA system and light and video installations. Breaking down the setup, by contrast, took three hours.

A small controversy came at the start of the tour about a Corbijn video for "Strangelove" set to be projected on the large stage screen, in which a woman suggestively sucks the toes of another. After the first shows, the band fell into conversation about whether the sequence was too "over the top." In the end, the band decided along with Anton to tone it down using crossfades, though without substantively changing it. "The bigger reason for trimming the naughty wasn't the 'porn factor' but the ego—I mean, 'show factor,'" Andy later explained to the *Las Vegas Review Journal* with a wink of the eye. "To be honest, the main reason for the compromise is that during 'Strangelove,' which is the song being played, people were watching the screen and not watching us!"

The following single off the record, "Peace," came out on June

15. At the July 9 show in Bilbao in the Basque Country, Dave had another mishap: "I jumped across the stage and suddenly it felt like somebody had thrown a rock at my leg. I couldn't put my foot down anymore. Chris, our drummer, gave me a questioning look when I was only able to hop around on one foot. I pointed to my calf and said, 'I can't set my foot down!' There were only three songs left and we managed to finish the show. The stage had a hard cement floor, and it turned out that my entire calf muscle was torn."

The incident meant that the following two shows in Porto and Seville had to be called off. Of the twenty-seven outdoor shows originally planned in Europe, only nineteen happened, five in Germany. For this tour as well, Live Here Now made and sent out professional recordings of nearly fifty shows.

Tour of the Universe in America

Two weeks after their last European concert, the band picked back up in Toronto on July 24. Dave had healed from his muscle injury in the meantime, and was ready for the band's North American leg.

With two sold-out shows at New York's Madison Square Garden, the band earned just under $2.5 million dollars playing before 26,000 fans on August 3 and 4, according to *Billboard* magazine. By comparison, U2 played two sold-out shows a few days later at Wembley Stadium in London to 160,000 people, and made the equivalent of $20 million.

Bad luck struck again following the band's Seattle show on August 10. Dave's severely overtaxed voice forced him to take a break, on doctor's orders. Two concerts had to be canceled before Depeche Mode could return to the stage on August 16 in Los Angeles. The North American tour finished on September 5.

After a solid three-week pause, the band returned to Central and South America for the first time in four years; this leg also

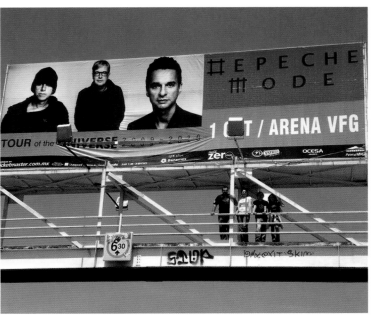
Depeche Mode fans in Guadalajara, Mexico.

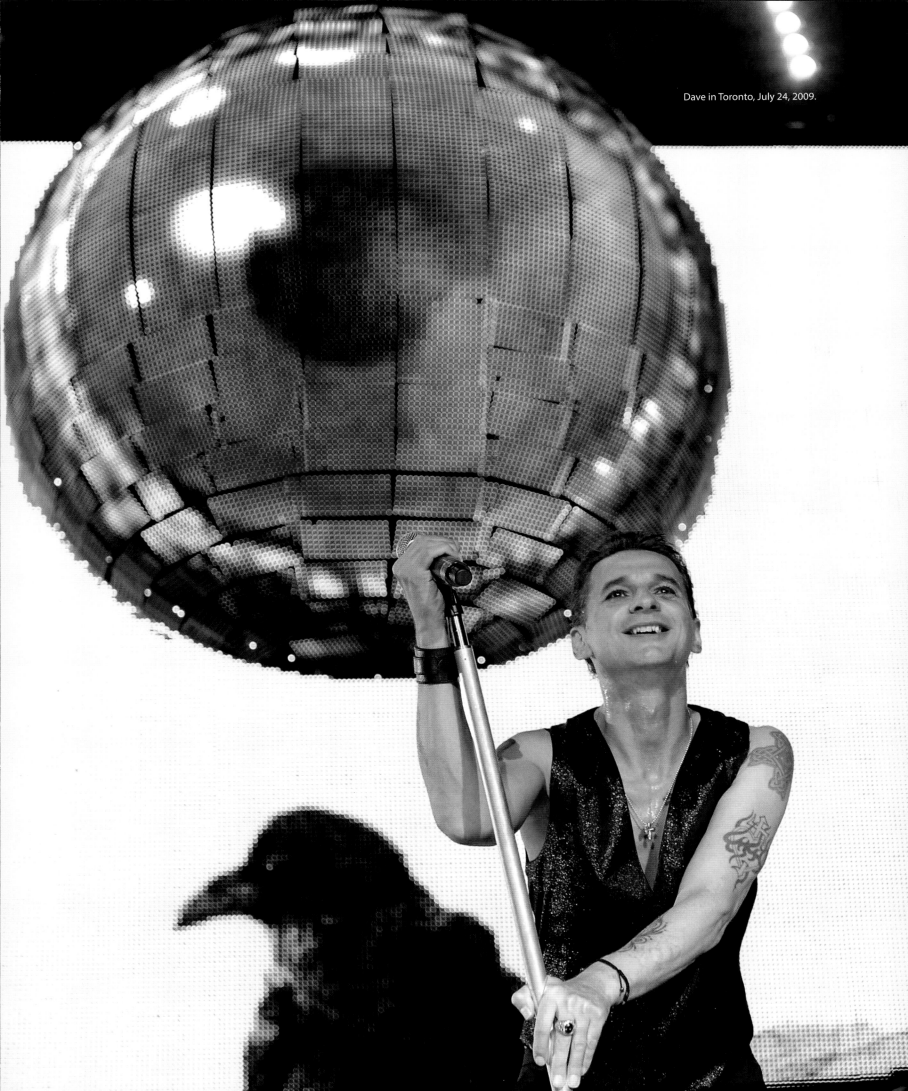

Dave in Toronto, July 24, 2009.

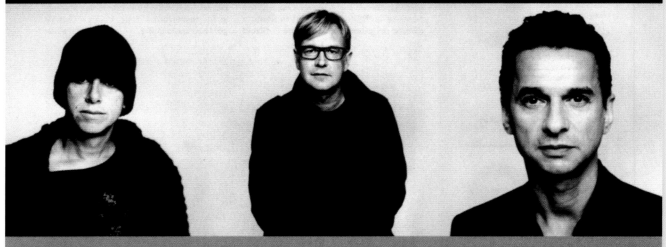

Ad for the North American tour dates.

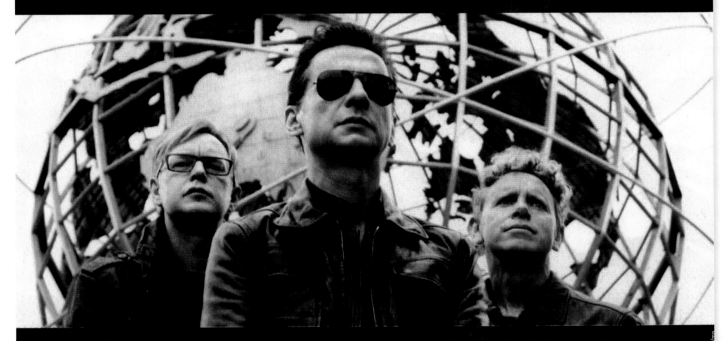

Ad for the French tour dates.

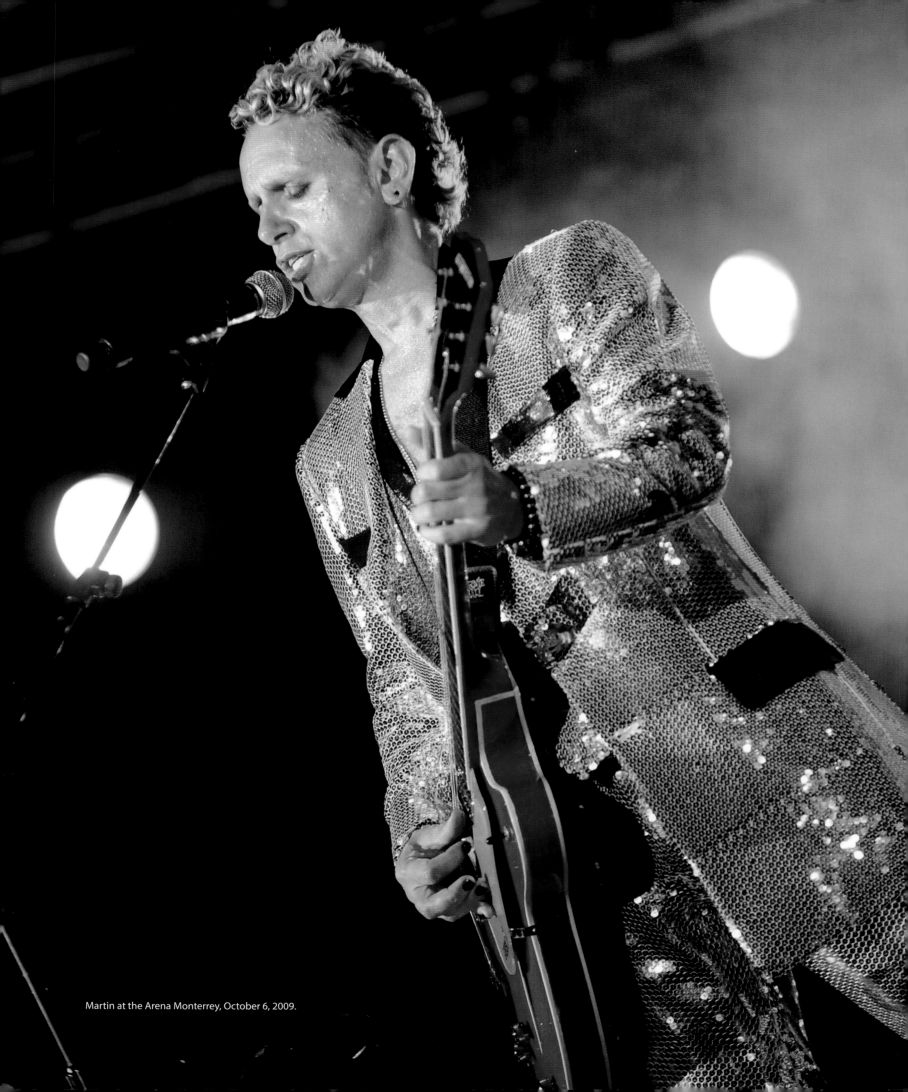

Martin at the Arena Monterrey, October 6, 2009.

included four concerts in Mexico. In Mexico City alone, the band played to 90,000 people over two nights.

The shows in Mexico were followed by a festival in Costa Rica and one show each in Bolivia, Peru, Chile, and Argentina. Two shows had originally been planned in Brazil, but couldn't go forward for technical reasons.

Concert Halls in Europe

The band didn't allow itself much time to rest after the shows in South America, returning to Europe instead to begin a concert hall tour on October 31 in Oberhausen, Germany.

Through February 2007, Depeche Mode played fifty shows across Europe, ten of which were in Germany. Even with all the ups and downs the band had experienced on tour to date, the joy they took in performing continued unabated. They used a free day in Germany on November 5 to play Batschkapp, a small and legendary club in Frankfurt.

The band's two shows in Barcelona on November 20 and 21 were filmed live for a subsequent DVD entitled *Tour of the Universe*.

The third single off *Sounds of the Universe*, "Fragile Tension," came out in early December, followed shortly after by a series of shows in Great Britain. Depeche Mode hadn't played Glasgow in Scotland since the *Black Celebration* tour. Otherwise the band stuck to their strongholds of Birmingham, Manchester, and of course London.

Following a break over Christmas, the band played Berlin on January 9, 2010, followed by their first visit to the Ukrainian capital, Kyiv, on February 8.

One of the most memorable and moving performances in the band's career came on February 17 at London's Royal Albert Hall, at a benefit concert staged for the Teenager Cancer Trust. Martin invited a "very special guest" onto the stage for the encore, and suddenly Alan Wilder was sitting behind the piano, playing

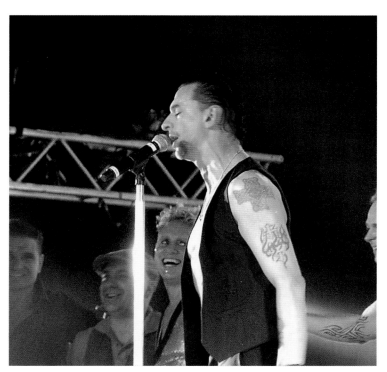

The final show of the tour, at Düsseldorf's Esprit Arena.

"Somebody" with Martin. The crowd went absolutely wild, making the floors shake.

In late February, the band played the final two shows of the tour in Düsseldorf. At the second show, a crowd of fans held up signs reading, *DM Come Back*, a play on the track "Come Back" off the current record.

Depeche Mode soon received yet another award: on March 4, at the Echo Music Awards, the band took the prize for "Best International Rock/Pop Group," with Andy and Martin present to receive it.

Finished at last, Tour of the Universe had truly demanded everything of the band. Depeche Mode had persevered through the challenges, giving everything they had to their fans. It also meant they could enjoy their free time in 2011 all the more.

Andy went back out on the road touring as a DJ. After understandably making himself scare at first, Dave let himself be talked into a special event that spring: on May 6, he performed with a live band in Los Angeles for Music Cares. The eight-song set included a stirring rendition of Joy Division's "Love Will Tear Us Apart," and Martin joined him on guitar for the set finale of "Personal Jesus."

The strong friendships that continued to exist within Depeche Mode even after a thirty-year career as a band were on full display at a joint fiftieth birthday celebration for Martin and Andy, held on July 9 at London's Under the Bridge Club in Chelsea. Guests included Dave, Peter Gordeno, a crowd of other longtime music associates like studio technician Gareth Jones, tour crew member Daryl Bamonte, and Anton Corbijn. Deb Danahay, who had looked after the *Depeche Mode Information Service* from the band's first days in Basildon, also stopped by. Depeche Mode really was one big family.

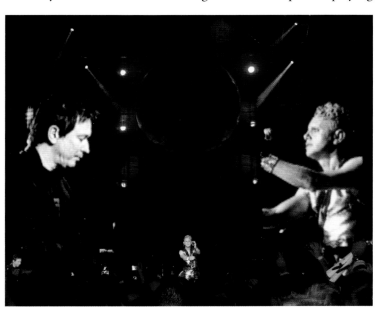

A performance that inspired hopes of Alan's return . . .

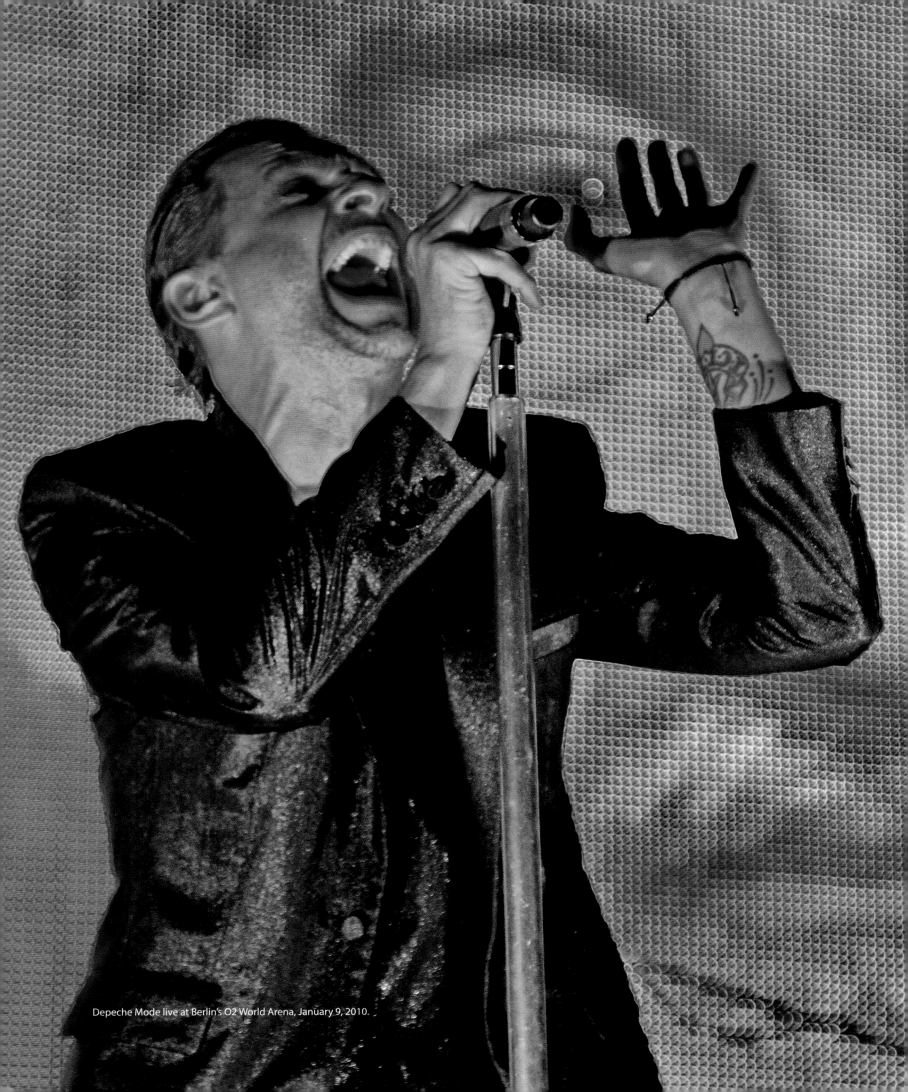

Depeche Mode live at Berlin's O2 World Arena, January 9, 2010.

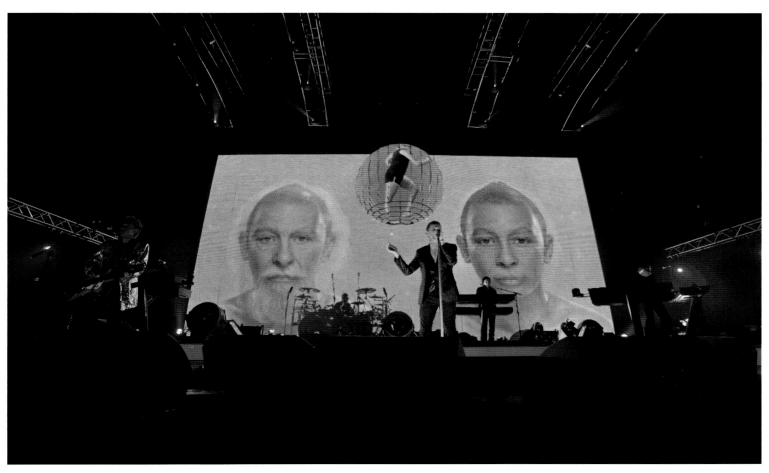

Interview with Nitzer Ebb

How did you start working with Mute Records? I think it was around 1987?

Douglas McCarthy: We signed in 1986, then released the album in '87, so '86.

Bon Harris: Yeah. And it was kind of like, when we first started releasing records, we were self-releasing and then Mute kind of expanded and Daniel had some kind of like sublabels that he was funding, and initially, one of our singles was kind of coreleased on one of the sublabels and through that we began to meet Daniel more and more, and he listened. We were making the *That Total Age* album at the time, and Daniel kept track of the progress and eventually decided he wanted to sign us to Mute itself rather than the sublabel.

When did you first meet Depeche Mode?

McCarthy: After we signed, actually. Dan had signed . . . Well, like Bon said, he had all these sublabels. So officially, the signing I think was through Mute, but like Bon said it was three sublabels. So, the label we were signed to was Transglobal, which was kind of like more of a dance label that had S-Express and Renegade Soundwave and us, and then there was Product Ink, which had . . . eh, Jesus Christ . . . Sonic Youth and other kinds of like quite arty kind of rock bands, you know, alternative rock bands. Then there was Blast First, which was much more kind of like straight ahead, you know, it had Big Black . . . Head of David was on that. So then, to celebrate the signing and expansion that Bon was mentioning of the label into these other sublabels, Mute put on a special show in the now nonexistent Broadway in Hammersmith, which is a club that was there since I think the forties or fifties,

Nitzer Ebb as its original lineup: David Gooday, Bon Harris, and Douglas McCarthy.

actually, and is now a train station, of course. And the lineup was Head of David, Nitzer Ebb, and Big Black. And that was probably the first time I met any—Martin was there, I think, Fletch was there—that's the first time we met any members of Depeche Mode. And then, as the album, our first album, was progressing, *That Total Age*, we had a release date coming up. We got pushed back a little bit, actually, it was supposed to be released in '86 but they pushed it back to '87 and that happened to be coinciding with the release in '88 of *Music for the Masses*. So Dan, he actually thought it was kind of a fun band, Depeche, and wanted us to open for them. And we thought it was a terrible idea, because we were young and slightly . . . Well, it was a combination of being very strong-headed about the music industry and we deeply distrusted it, and also we were slightly naïve about the music industry. So we refused to do the tour, but Daniel persuaded us to do it. And then, you know, lo and behold, we saw the first show and were like: "Ah. Now we understand." [Laughter] That's what you're supposed to be doing if you're in a band and entertaining people. So we became very good friends from . . . Pretty much from the *Music for the Masses* tour, we started our friendship.

Depeche Mode's concerts in Great Britain and Germany were attended by many teenagers during the eighties. And they had posters in youth magazines and all that stuff. How did you perceive them?

Harris: Well, it was . . . Initially, there was a club near us, in sort of like the early days, the Blitz Club, and Depeche was kind of part of that scene. So that's like when we were first aware of them in terms of their records and everything. It was quiet, sort of underground, and new. And then they obviously went through quite a pop phase. So at that point, I think we thought it was cool, like a band from an underground scene that sort of got some recognition. They weren't unique—Soft Cell and a bunch of other bands were actually making an impression on them and popular culture.

In 1984, Nitzer Ebb released their first single, "Isn't It Funny How Your Body Works," on their own label, Power of Voice Communications.

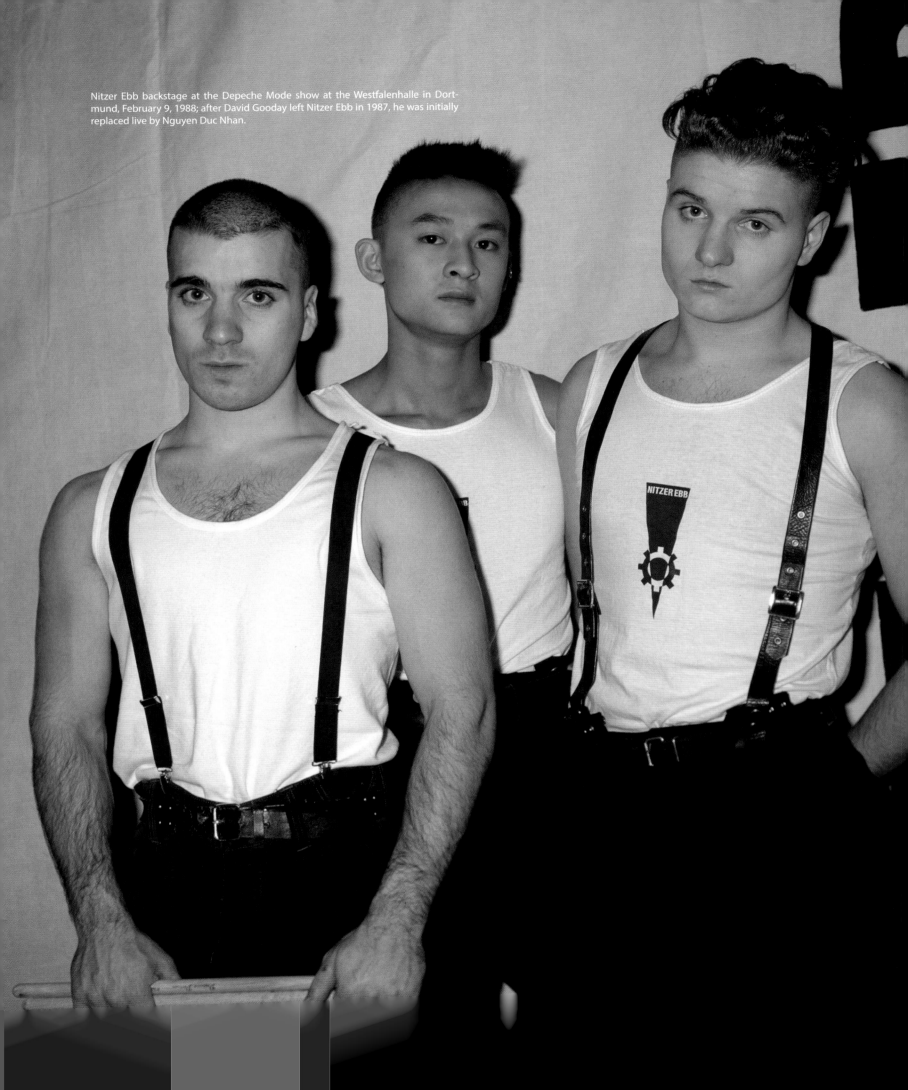

Nitzer Ebb backstage at the Depeche Mode show at the Westfalenhalle in Dortmund, February 9, 1988; after David Gooday left Nitzer Ebb in 1987, he was initially replaced live by Nguyen Duc Nhan.

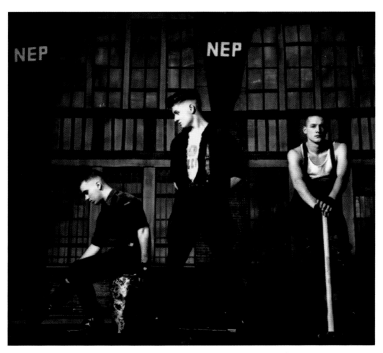

A familiar aesthetic: just as Depeche Mode did on the cover of 1983's *Construction Time Again*, Nitzer Ebb was photographed with a mallet.

But then we sort of lost track of them a little as we went into more and more alternative music and they got more and more mainstream. So they were less relevant to us until our paths converged again on the *Music for the Masses* tour, or with Mute, really.

McCarthy: Which, ironically, that was that path that I think . . . you know, *Black Celebration*, great album, but I think the power for them coming back and moving away from any kind of "popdom" was *Music for the Masses*, and then it was compounded by *Violator*. They were so good at their art at that point—songwriting for pop music, but also invoking something darker. It was a really interesting time for us to be associated with them.

Harris: Yeah. So we were always very aware of them, let's put it that way. Whether we were that attached to them at certain points, it was less relevant at some points, but we were always super aware of what they were doing. Local lads and all that.

McCarthy: Definitely a lot of familiarity in that background, pretty much working-class kids that, you know, weren't THAT stupid [laughter] and liked fashion and music. And films.

You were supposed to support the US tour in 1988 but then you weren't permitted to travel there?

McCarthy: Yes, that is true. The official reason that US Immigration gave was that we lacked musical merit.

Harris: Yeah, fair enough. Basically, they cited that we weren't legitimate artists or musicians.

McCarthy: Yes, the way the thing was, we were actually already signed to Geffen Records, we were signed to a label in LA, like an American label, like a *massive* American label. But, whatever. Things were a lot more difficult then, and we have become a lot more difficult now.

Your sound differs a lot from Depeche Mode, especially live. How did the audience react to you?

Harris: Well, it's actually quite surprising. If we go back to the *Music for the Masses* tour, we were doing our songs on *That Total Age*, which are quite harsh, actually, very punk rock in this sort of stadium environment. But I think the even more shocking thing about it is how warmly we were received by a lot of their audience. Maybe it was Mute, maybe it was the Essex connection, I don't know what it was, but it wasn't such a battle for us. I mean, initially it was a small section of their audience, but the amount of people that still come up to us today and say: "The reason I got turned on to either Nitzer Ebb or more alternative music is because I was at a Depeche Mode concert and you opened for them." A lot of people have said to me personally: "I've never heard music that was kind of like *that* minimal and forceful." Maybe they'll get into techno or house or something slightly less pop-oriented. So we were always very quickly accepted by their fan base as part of their story. Doing subsequent tours, *Violator* especially, that kind of just grew more and more, and also working with Alan in the studio, the associations grew. But even early on, they accepted us quite quickly.

How did your collaboration with the producer Flood come about?

McCarthy: It was Daniel. Basically, as Bon said, we had our own label. And initially, our label was called Power of Voice Communication and we had already started the process of making an al-

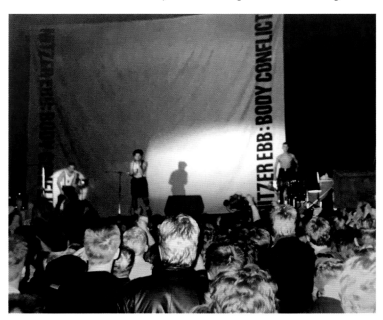

Nitzer Ebb opening for Depeche Mode in Stockholm, February 12, 1988.

bum. We'd released three 12"s, a four-track EP called *Isn't It Funny How Your Body Works*, a 12" single called "Warsaw Ghetto," and then "Let Your Body Learn" as a 12" single. It was at the point of "Let Your Body Learn" that Daniel contacted us to say that he wanted us to be involved in this label. But we had already got quite far down the road with the album at that point, which became *That Total Age*. And then, after we signed to Mute and had done the tour with Depeche, we definitely had embedded ourselves into the Mute family, as you pointed out earlier, and we parted company with the people we had been working with at the label, and it was essentially just me and Bon. And we were still very young and inexperienced, we'd only made one album and these various 12"s.

With money we got from the Mute signing, we bought as much equipment as we could. We certainly didn't spend anything on us, we just bought as much equipment as we could. Then we went about the process of trying to learn it and write with it. So we'd done a series of demos, which were well-received by Daniel Miller, and then there was the process of looking for a producer. [We had] never really thought about producers as such. We knew they existed, obviously, but we weren't putting the pieces together, like,

Nitzer Ebb artist pass for the US portion of the World Violation Tour, 1990.

Promotional display for the US leg of the World Violation Tour.

"Oh, this person worked with this band, this band, and this band, that makes sense, we should work with them." We never learned to think that way. So Dan suggested Flood, and the one thing we did know about Flood was that he worked with Erasure and Nick Cave, and that was about it.

So we had a meeting with Flood—he had already listened to the demos, and he had great ideas. We had a meeting in Daniel's office at Mute Records and we were just kind of blown away by his assuredness and knowledge. And then, as we started to work with

him, we realized that—I'm not even kidding—like 70 percent or more of the bands we had been influenced by, he had worked with, like as an engineer or a producer. It was a very good move from Dan to introduce us, and it went from there.

Your next big support tour for Depeche Mode was in 1990, with more than forty shows. That must've been hard work, was it not?

McCarthy: Yes. Well, after we'd done the *Music for the Masses* tour, which actually, you know, to be completely fair to Depeche Mode: back then, they worked a lot harder than they need to work on their more recent tours. They don't need to anymore, because they're doing huge stadiums, whereas back then they were trying to break through in America and were definitely hungry for everything. They weren't at the top of their game in terms of sales, but they were at the top of their game in terms of absolute performance. So we learned a lot from them, but you just knuckle down and get on the road and that's it. When you're on the road, you play, and if you're not playing, it's costing you money, so you keep playing. So we'd already . . . in between doing *Music for the Masses* and the *Violator* tour, we'd done the *Believe* tour, and it was the *Showtime* tour that we went on with them, but we'd already started doing shows for *Showtime* in Europe.

Advertisement for the release of *Showtime* and the tour with Depeche Mode.

Depeche Mode and Nitzer Ebb backstage in Philadelphia, June 13, 1990.

Harris: Yeah, we'd already done the European shows.

McCarthy: So we'd already gotten used to the idea that if you . . . you know, we were doing, say . . . There were certain points during both of those, the *Believe* tour and subsequent tours after, but *Believe* and *Showtime*, when we would do ten or twelve shows back-to-back, have a day off and a travel day, do another ten or twelve shows back-to-back, and just keep going.

Harris: Our schedule itself was pretty brutal, you know, when we did our own tours, so when we got to Depeche and [Europe], not only did we have hotels [laughter], but then we got off in order to get the production for the next show, you know, it'd be like one day on and one day off, or sometimes two days, but only when it was back-to-back in the same city. So in terms of the actual work schedule, it was a lot easier. The problem is, especially if you're there like three nights, the party schedule [laughter]. That actually made it the hard work.

McCarthy: The hardest thing about the *Violator* tour was the party schedule. The music schedule was easy [laughter].

Nitzer Ebb live at the Universal Amphitheatre in Southern California, August 1, 1990; in 1989, Julian Beeston joined the band on drums, though he never appeared in official promo photos. Nitzer Ebb remained Bon Harris and Douglas McCarthy.

Martin Gore wearing a Nitzer Ebb shirt in Munich, October 17, 1990.

Is there a big family backstage with Nitzer, Depeche Mode, and all the workers, or is it mostly routine?

McCarthy: On that tour, yes.

Harris: You know, Depeche was still at a stage that they could go to a club with their own personal security—they could go to a club without insurance implications. They were much freer back then.

McCarthy: Thing is, this was pre–social media, so it was a lot easier. There were still some treacherous things that happened for all of us. For bands, each band member, or crew. You were on the road, you were away from everything, and yeah, sometimes . . . I think it was on the *Violator* tour when Mart got a mug shot of him somewhere in Texas [laughter]. And it was just funny, nothing was that . . . crazy.

Harris: But the thing is, their crew was really tight, they had all been together for a long time. They were sort of legendary people, or an institution among their crew. We'd been with them enough,

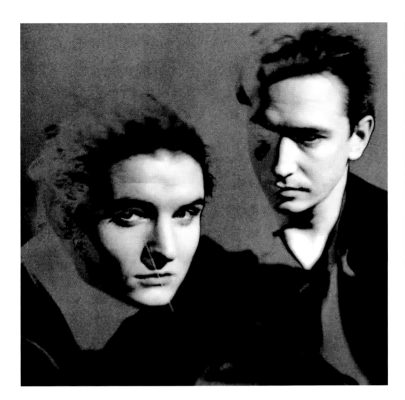

Joining the World Violation Tour also resulted in artistic collaborations for Nitzer Ebb; Alan Wilder mixed the song "Come Alive" from the Nitzer Ebb EP *As Is*, released in June 1991, and he and Flood produced the album *Ebbhead* that followed in September. Douglas can be heard as a guest singer on "Faith Healer" on the Recoil album *Bloodline*, released in 1992. The single was well received by Depeche Mode and Nitzer Ebb fans alike and proved an absolute classic on the dance floor. The video for the single, in which Douglas McCarthy can be seen alongside Alan Wilder, was broadcast around the world on MTV.

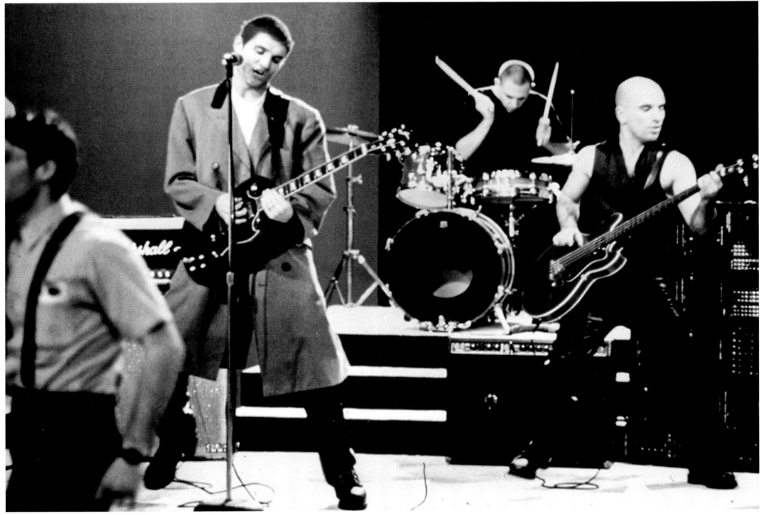

Nitzer Ebb in 1994; much like Depeche Mode with *Songs of Faith and Devotion*, Nitzer Ebb's music changed drastically in the mid-nineties. In 1995, the band released a guitar-heavy album, *Big Hit*, with new drummer Jason Payne. The record and tour both flopped and Nitzer Ebb disbanded without a sound, offering no official explanation. Even so, Douglas and Bon stayed musically active in the years that followed.

so it really was like if all the band was going out tonight, 'We're going to this club, come on down,' we'd all go together: bands, crew, same van or bus. It was like a bunch of friends going out, really nice, bonkers, and fun. It was good. You know, they weren't really that important that they had to be so isolated. You'd go in a club and you'd go to a little area in the corner with a velvet rope around it, but that was about it. And even then, on some of those nights, all of us would go on the dance floor and just have a laugh. It was really fun. But tiring [laughter].

In 2009, you played live in Berlin at the Postbahnhof as a part of the Convention of the Universe. Daniel Miller and Martin Gore were at the show and invited you afterward to be the support act for the next Depeche Mode tour in 2010. Do you remember that?

McCarthy: I remember Daniel and Martin came to the Postbahnhof. The thing is, we've already been talking about the days of the 1990 *Violator* tour. But after that, quite quickly things became such big business that nothing was left to chance. From their end, anyway. So I think we had probably already discussed that we were going to be the opener, and I think that would've been for *Industrial Complex*?

Harris: Yeah.

Was it different than the 1990s?

McCarthy: Audience-wise it was better, probably, than it ever was. The nineties stage wasn't very good. It was . . . it's a massive machine. Depeche Mode is a huge machine, it really is. I mean, the logistics, the finances involved in it, it takes a year or more to plan ahead. So you're very aware that you're walking into a systemic operation. And you don't necessarily have to be a part of it. So if you don't fit, you're not gonna fit. No one is making allowances for anyone. Not that we ever needed that, but it's like the train is rolling and if you can get on it and stay on it, that's fine, but no one really gives a fuck if you fall off.

Harris: Yeah. And another thing is, they just got bigger and bigger and bigger. So there's that, and then also everyone has their own personal history and their own personal drama, so as this thing is growing, there is this desire to eradicate—for obvious reasons—any form of thing that could be volatile or could disrupt it, because there's just so much invested in it. Kind of like we're saying,

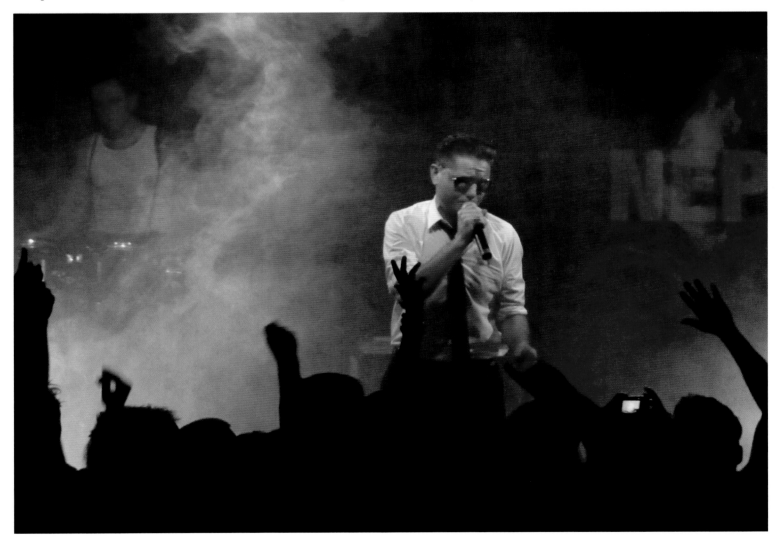

Nitzer Ebb live at the Convention of the Universe on June 9, 2009, at Berlin's Postbahnhof, the evening before Depeche Mode played Berlin's Olympiastadion.

when you look back at *Violator*: it was still massive, but it kind of surprises me sometimes when I think back at how relaxed it was. I remember a couple of times, us getting into punk rock dances and then Mart would jump in and wouldn't land it—

McCarthy & Harris: I remember one time when Mart was under about fifteen of us or like stage diving [laughter]. But now—just no.

McCarthy: But having said that, on a personality level they haven't changed, it's just the system around it. Given the opportunity, Mart would still be at the bottom of ten people on a dance floor in San Francisco.

Harris: So yeah, as all things got massive, then it's also part of the industry that has become much more like, you know, an industry, with investors and all.

McCarthy: And even for us, on a way, way lower level, you know, it's a job that we do and we have to take it seriously. It's a job where you can have a drink at work—I mean, there's plenty of people who have a drink at work. But we are not . . . we're not doing what we used to do, to just go, "YEAH!" and fucking go for it. We're fiftysomething years old, you know.

Harris: And you consider these guys—constant security, everything has become much more of an industry.

McCarthy: And honestly, I'm all for it completely, but the laxness previously of like having fans backstage, female fans backstage. You know, it's not a question of us wanting that to happen anymore or not wanting it to happen anymore. It's just, with the reality of the world now, that's not gonna fly. You're opening yourself up to a fucking world of pain with any number of people who just can do an online thing. It's all just part and parcel.

Harris: Society and the industry have changed, so their organization has changed appropriately with it.

McCarthy: It's a very tight business, a very tight organization. And you know, it's the same with us with Peddy. Peddy doesn't take any shit from anyone, and we rely on that. To get us . . . through.

Some people wonder how Depeche Mode can still be so popular today. Do you have any theories?

McCarthy: Very good songs and amazing shows.

Harris: You know, they've outlasted a lot of people that were considered giants, and they just kept going. They always held their own and it always seemed a little unfair how they got treated sometimes. They'd sell out massive stadiums, and yet in the music press, or some popular consciousness, there are some rock bands

who are actually smaller than them but somehow more revered. They've outlasted everyone because their songs are fucking brilliant and when they do a tour—it's still magic! They are such good performers. I don't know how many times we've seen it from the side of the stage, but the hair on the back of your neck still stands up . . .

McCarthy: The last tour we were on with them was with Black Line, which is our other outfit based in LA. And there are certain songs, you know, quite quickly you know the set list and you'd just be sitting and you'd go and listen to a song . . . and like Bon said, it's an emotional reaction, like . . . I'm not lying, at certain times you'd feel tears a little bit.

Harris: There are songs they have written that obviously touch a lot of people on a very personal level, and because they are, at the heart of all this crazy-big machine, such genuine people. And when they get on a stage, they are real and they give it everything and you can't help but feel it. It's just amazing. They're awesome.

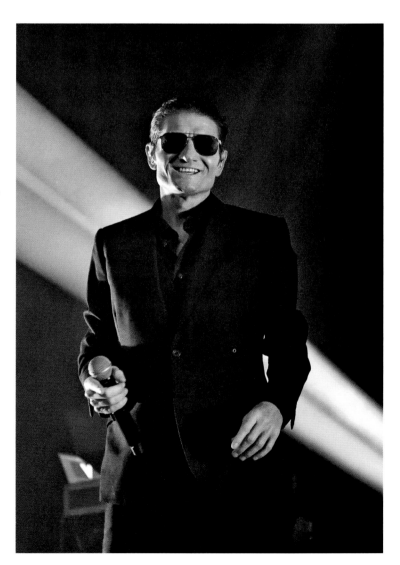

The comeback kid: Douglas McCarthy onstage with Nitzer Ebb, 2023.

INTERVIEW WITH PEDDY SADIGHI

After a long break, in 2006 Nitzer Ebb started out on a successful comeback. One of the actors responsible was Pedram "Peddy" Sadighi from Hamburg, a huge fan of Depeche Mode and Nitzer Ebb.

You founded your booking and management agency neuwerk Music in 2005. Just one year later, you organized Nitzer Ebb's *Body of Work* tour. How did that come about?

I first found out about about the Fixmer/McCarthy project in the fall of 2004. After that, a friend and longtime partner helped to arrange a meeting with Terence Fixmer in Berlin. So in 2005, after I started neuwerk I mean, we took over booking for Fixmer/McCarthy. That obviously meant Nitzer Ebb was a constant topic of conversation. At some point, I had an idea for a large one-off show, and asked Douglas to talk to Bon and see whether there was any interest. There was, so we started talking about the next steps.

Did you believe Nitzer Ebb would stage a successful comeback, or were you skeptical?

I was 100 percent convinced. I could feel how my own love of the band was alive and well, and knew that others like me would think the same.

Was there a lot of interest on the part of local promoters?

There was immense interest. To my surprise, I also discovered that Nitzer Ebb had a tremendous presence in the global techno scene, something which I didn't really have any idea about up to that point. A lot of well-known DJs and acts had grown up with Depeche Mode, Kraftwerk, D.A.F., Front 242, and Nitzer Ebb themselves. For them, those bands were practically living legends, like they were for us too, fans from the early days.

London, Yokohama, Melbourne, San Francisco. The *Body of Work* tour in 2006 was truly international, it didn't limit itself to Europe. Were you at all the concerts, or did you work with partner agencies?

I actually was at all the shows and organized them myself—even the South American dates. For the US and South America, I worked with local agencies and partners. It doesn't usually make any sense to organize these sort of tours outside Europe, because of all the differences in how they are handled. But up to now it's worked out very well.

What was it like for you to suddenly come face-to-face with all these bands you loved, and become a part of the Mute family in some sense?

Daniel Myer from Architect, manager Peddy Sadighi, and Paul Kendall during Recoil's *Selected* tour in the US, 2010.

It was unreal. I can still clearly remember the two shows at the Sporthalle Hamburg in 1988 on the *Music for the Masses* tour. Depeche Mode with Nitzer Ebb as the support. At that time, those were MY bands. I'd skip school whenever a new record was out and be outside the record store by nine a.m. so I could instantly get my hands on the album. In working with Alan Wilder, Nitzer Ebb, and the shows with Depeche Mode, I came full circle, personally speaking. I never would have dared to dream that as a fifteen-year-old. It's one of the best things about my work.

After that came the *Selected* tour in 2010 with Alan Wilder, the first time he took Recoil on tour internationally. How nervous were you as a Depeche Mode fan to suddenly be working with one of your "stars"?

I was obviously quite curious and worked up. But Alan had put me at ease within minutes. It was a great first conversation, he was totally relaxed and cool. We were swapping ideas for the Recoil tour in no time at all, then switched seamlessly to the organization. The tour with Alan Wilder and Paul Kendall was one of the coolest tours I've had the chance to be a part of.

When you're working with giants in the music scene, do you ultimately stay a fan of your clients, or does it become more of a professional relationship?

The working relationship obviously stays professional. That's how it should be too—ultimately, I'm earning money with my work, and have to deliver. As soon as the show starts, however, the fan in

you takes over. It's a special feeling to be part of something that before you were only able to observe from the outside. Then there are the friendships that develop over the years, which I wouldn't want to miss out on. We're all in touch with each other, and we're not talking about music or tours but totally normal questions, how people are doing, etc.

Out of all the concerts, which moments stand out to you as personal highlights?

The first shows with Nitzer Ebb in 2006, the shows with Alan Wilder throughout the whole Recoil tour, especially in Anaheim with Martin Gore as a special guest, or with Dave Gahan in NYC. The split shows with Nitzer Ebb and Recoil during the Short Circuit Festival put on by Mute in 2011 at London's Roundhouse . . . And, of course, all the shows with Nitzer Ebb, Douglas McCarthy, and Black Line supporting Depeche Mode in recent years.

Douglas McCarthy and Recoil live at the Short Circuit Festival in London, 2011.

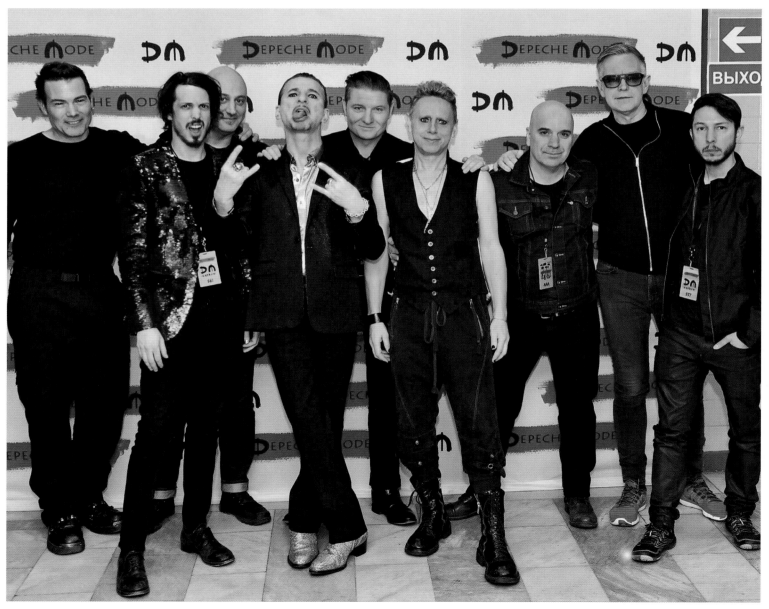

Peddy Sadighi with Depeche Mode and Black Line in Eastern Europe during the Global Spirit Tour, 2018.

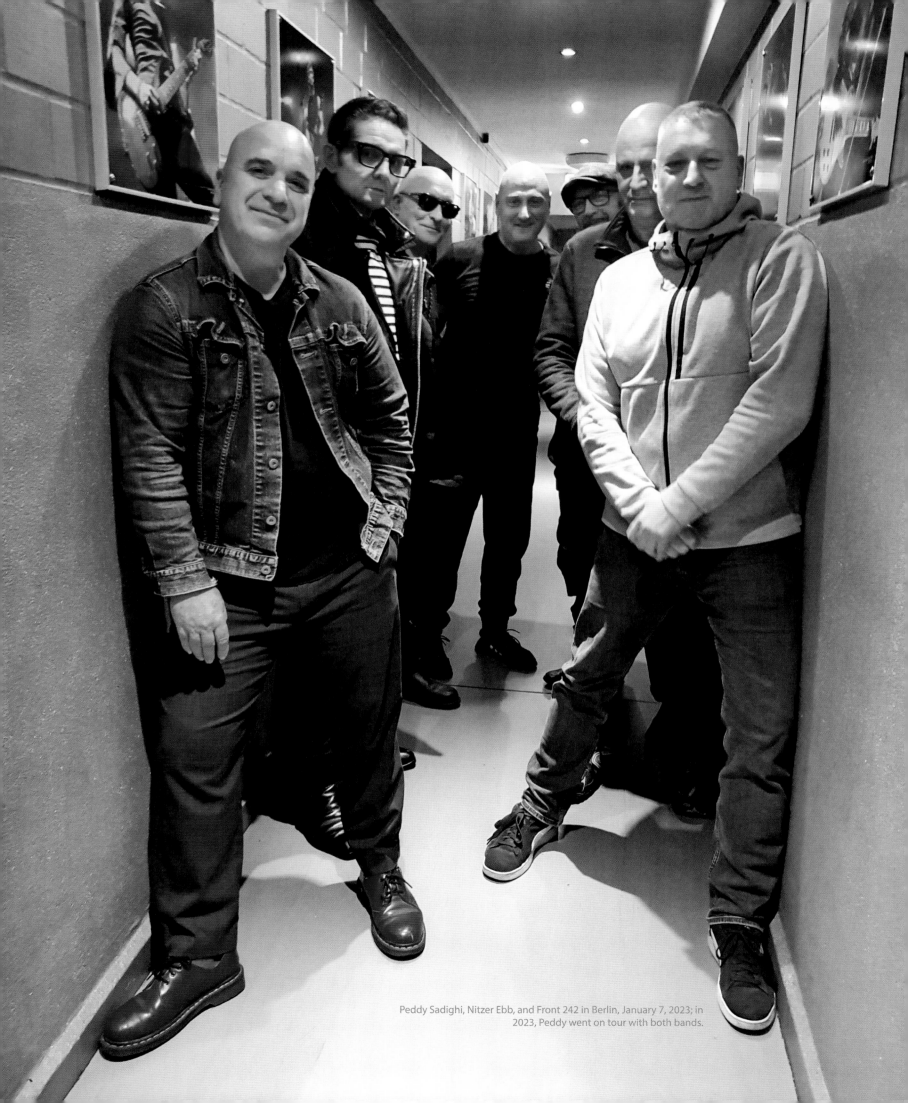

Peddy Sadighi, Nitzer Ebb, and Front 242 in Berlin, January 7, 2023; in 2023, Peddy went on tour with both bands.

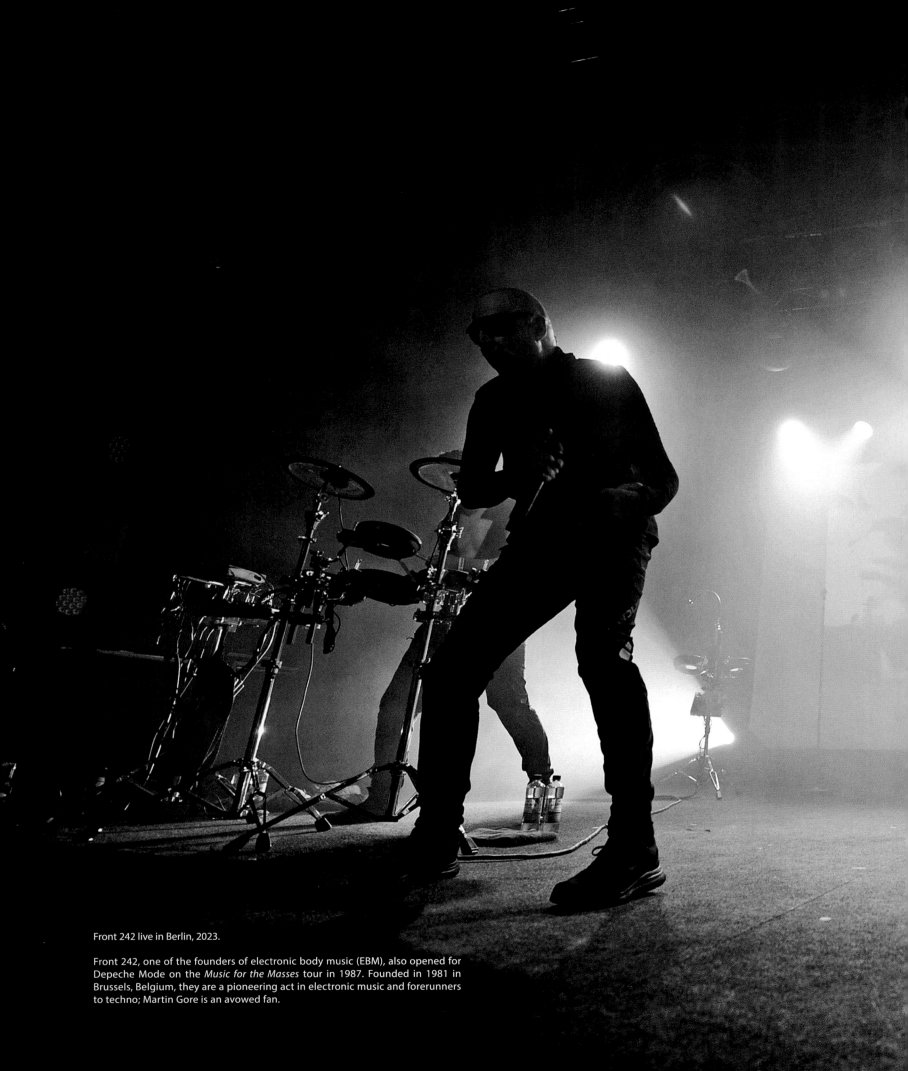

Front 242 live in Berlin, 2023.

Front 242, one of the founders of electronic body music (EBM), also opened for Depeche Mode on the *Music for the Masses* tour in 1987. Founded in 1981 in Brussels, Belgium, they are a pioneering act in electronic music and forerunners to techno; Martin Gore is an avowed fan.

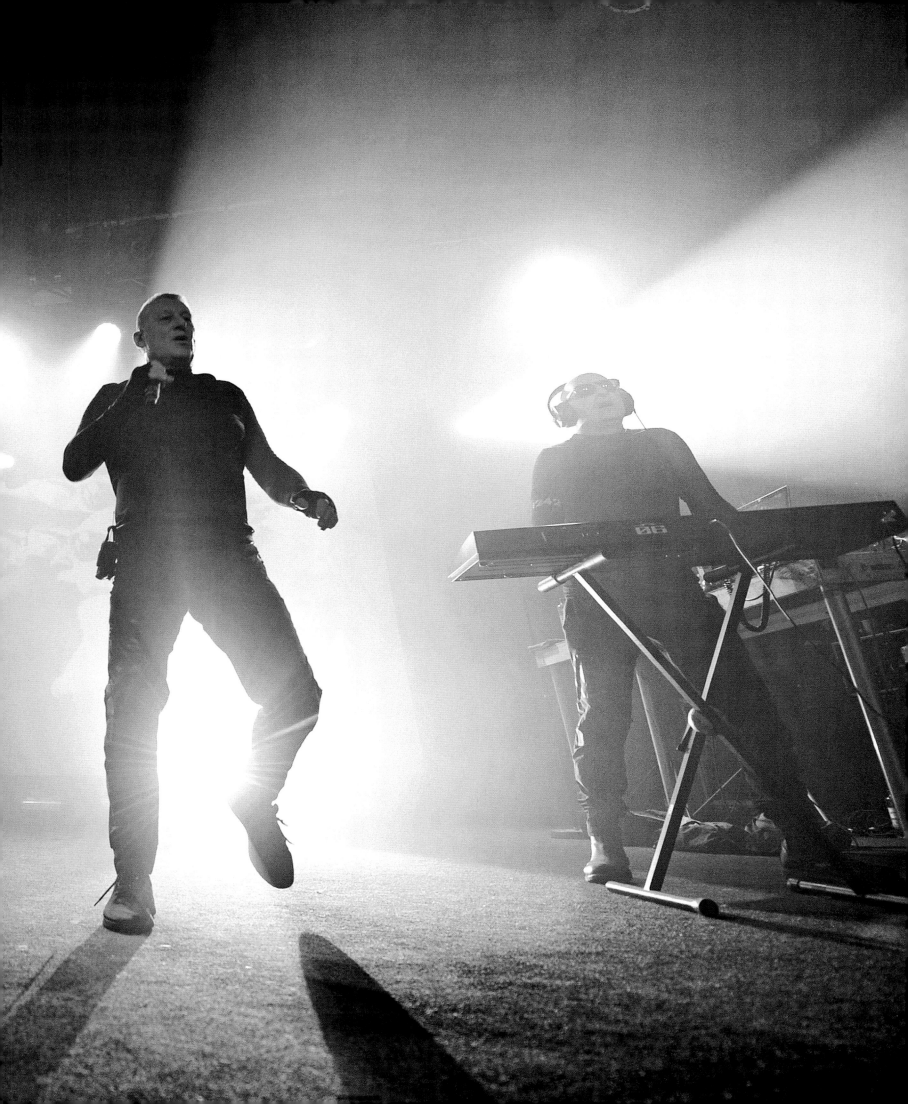

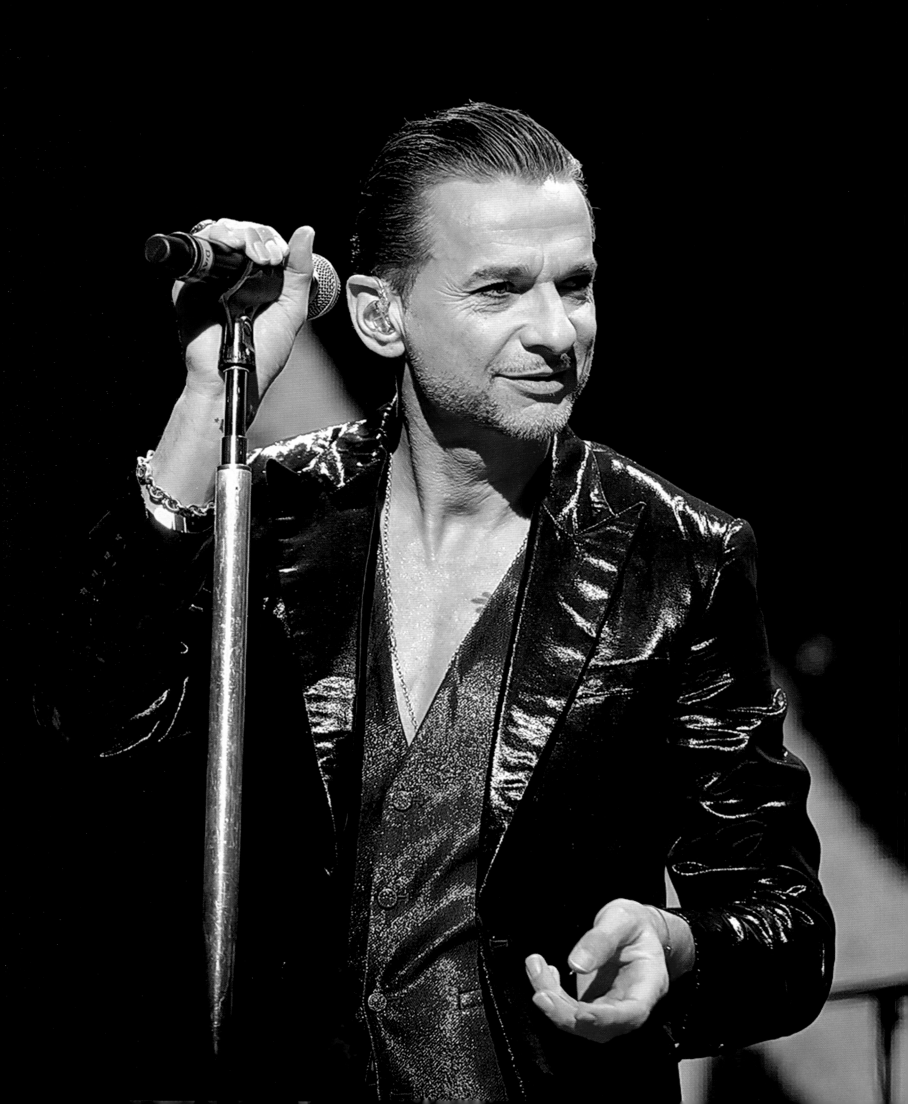

Delta Machine

Since 2001, Depeche Mode had kept up a four-year rhythm: one year working on a new album, a year on tour, two years off, then back into the studio. In January 2012 it was time: the band met with Daniel Miller and Jonathan Kessler in Santa Barbara to listen to Martin's and Dave's new demos, and discuss the next Depeche Mode record.

Depeche Mode worked on the album through that year, shuttling between Santa Barbara and New York over multiple sessions with producer Ben Hillier. Final mixing took place in December in London alongside Daniel Miller and Flood. That same year, Dave recorded vocal tracks for the band Soulsavers, for release the following May.

A Changing Musical Landscape

In the fall, the gears of the Depeche Mode machine began to churn, starting with a listening party on October 23 in Paris for select business partners of the band. The press conference the following day, however, differed somewhat from those of years past. The band invited fans and media outlets as usual, but simply announced a world tour for the coming year called Depeche Mode 2013, along with the first concert dates. Only after being questioned about it did they confirm there would be a new album. The reason for the hesitation was the unfinished negotiations as to which label Depeche Mode would release their new album on.

Press conference in Paris, October 23, 2012.

The decision to announce a world tour and begin presales without a concrete plan for an album was a clear sign of how the music industry had changed over the decades, especially with the Internet. If through the late 1990s tours had largely served to bring greater attention to studio albums and drive sales, live performance was now the most important source of income—and not only for Depeche Mode.

The main reason was the worldwide decline in album sales due to music's availability on the Internet, even if a loyal fan base meant Depeche Mode was still selling many more physical copies of their records than other artists.

The plan worked. Even without a concrete announcement about a new record, tickets for the band's first concerts in Germany were as good as gone. The ties binding fans to the band seemed to observe their own laws.

Just before Christmas, word got out that after thirty years, Depeche Mode would part ways with Mute Records to sign with the US label Columbia Records, a division of Sony Music. The band's long-standing mentor and friend Daniel Miller would continue working on the band's behalf, however, and the Mute logo would still appear on future releases.

In early February 2013, as the band began rehearsals in New York for the upcoming tour alongside Christian Eigner and Peter Gordeno, the first advance single, "Heaven," came out. A string of smaller promo gigs followed; on March 11, the five performed nine songs on the *Late Show with David Letterman*. The band played another nine-song mini-concert in Austin on March 15, in a small club only able to fit six hundred thrilled fans.

On March 21, the band was in Berlin for the Echo Music Awards, where they performed "Heaven," before playing it again shortly after in Vienna for the show *Wetten, dass..?*

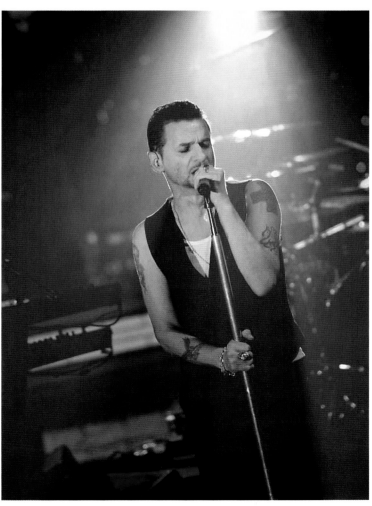

Live on the *Late Show with David Letterman*, March 11.

Depeche Mode played Austria's capital again on March 24, an exclusive ten-song set to 1,500 fans in the museum quarter. The show was streamed live on the Internet by Telekom's music magazine, *Electronic Beats*. The next day there followed a shorter five-song promotional gig to a live audience for the TV station Canal+ in Paris.

Delta Machine, the new Depeche Mode album, came out on March 25. As one might have guessed from the name, the record held a combination of blues and electronic music. Unsurprisingly, the record cruised to number 1 on the charts in Germany, and high up into the top 10 in both the UK and US.

In mid-April, the band and backing musicians met back up in Los Angeles for a week of rehearsals for the upcoming tour. The week concluded with a five-song set played live on Hollywood Boulevard for *Jimmy Kimmel Live!* on April 24, 2013.

Two days later, on April 26, the band teamed up with radio station KROQ for a small club show at the Troubadour in Los Angeles. They played ten songs to a crowd of 350 people—there wasn't room for anyone else. The concert featured the first ever live performance of 1986's "But Not Tonight," which had been released in place of "Stripped" as a single in the US.

Announcement for the show in Vienna on March 24.

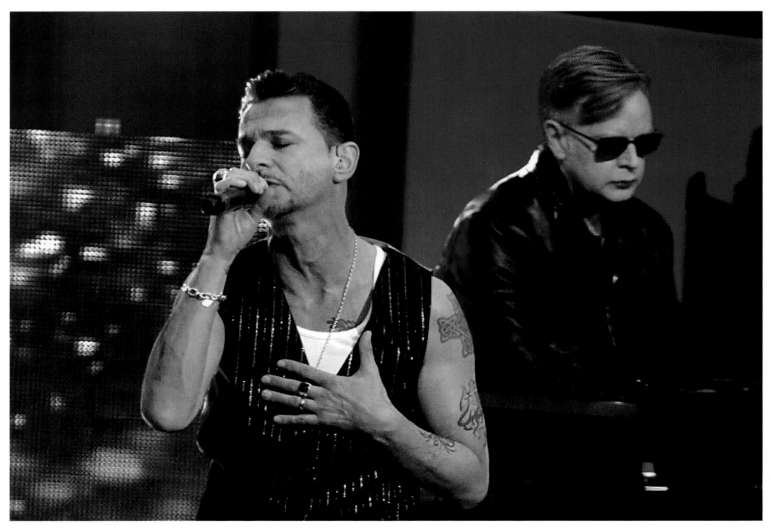

Depeche Mode on *Jimmy Kimmel Live!*

An announcement for the Echo Music Awards on March 21, 2013, in Berlin.

electronic
beats

Vienna's MuseumsQuartier decked out in the colors of *Delta Machine*, March 24, 2013

Garderobe · WC

Depeche Mode live at Vienna's
MuseumsQuartier.

Depeche Mode kicked off the tour in Nice, France, on May 4.

European Touring

Back in Europe in early May, the band rehearsed in Nice for the tour, with visuals already prepared by Anton Corbijn. The rehearsals were the first time the band saw the videos—they were pleased. Corbijn spoke more about his work with the band in an interview: "There's no written contract between us. If they want to work with others, they can. But they trust me, I always give them my best. I don't want them to work with me just out of habit. I want to prove it to them again every time that they were right to trust me."

The tour kicked off in Nice on May 4. For the first time, the show had Peter Gordeno on bass guitar in addition to keys. Two days later, the band played to close to 20,000 people in Tel Aviv. They continued on to southeastern Europe, with Belgrade on the itinerary for the first time. In the meantime, the single "Soothe My Soul" came out.

Two days after their May 15 show in Bucharest, a show was planned for Istanbul. The crew was already on-site, but the trucks carrying the stage equipment were held up at the Bulgarian-Turkish border and weren't able to make it on time. The show had to be canceled on short notice.

In another change to the tour schedule this time around, the band inserted a day off in between shows, with only a few excep-

Forced layover in Istanbul on May 17.

tions. Everyone in the band was over fifty now, and especially for Dave, who was giving everything he was able to physically, the pauses were necessary to be in top form for each performance while also still managing to have fun.

This decision brought a number of advantages for transportation logistics and stage setup as well, even if tour costs were somewhat higher than before.

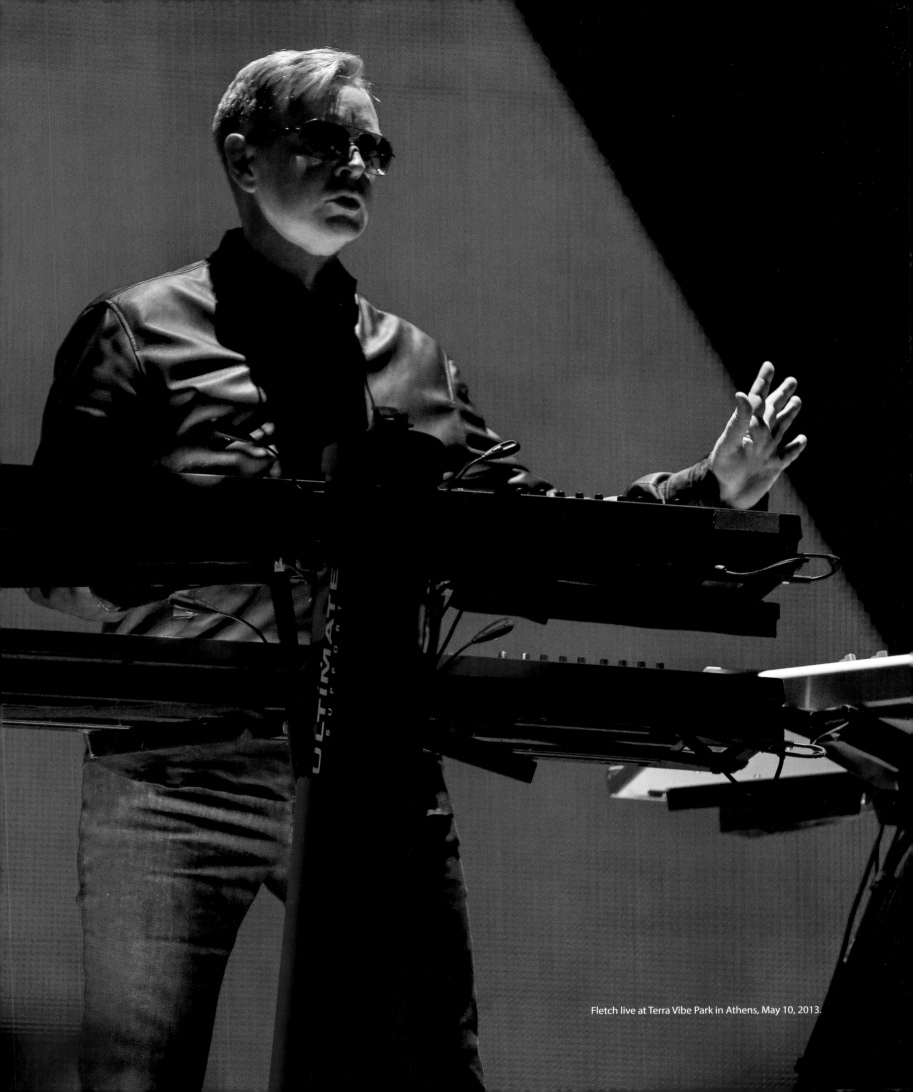

Fletch live at Terra Vibe Park in Athens, May 10, 2013.

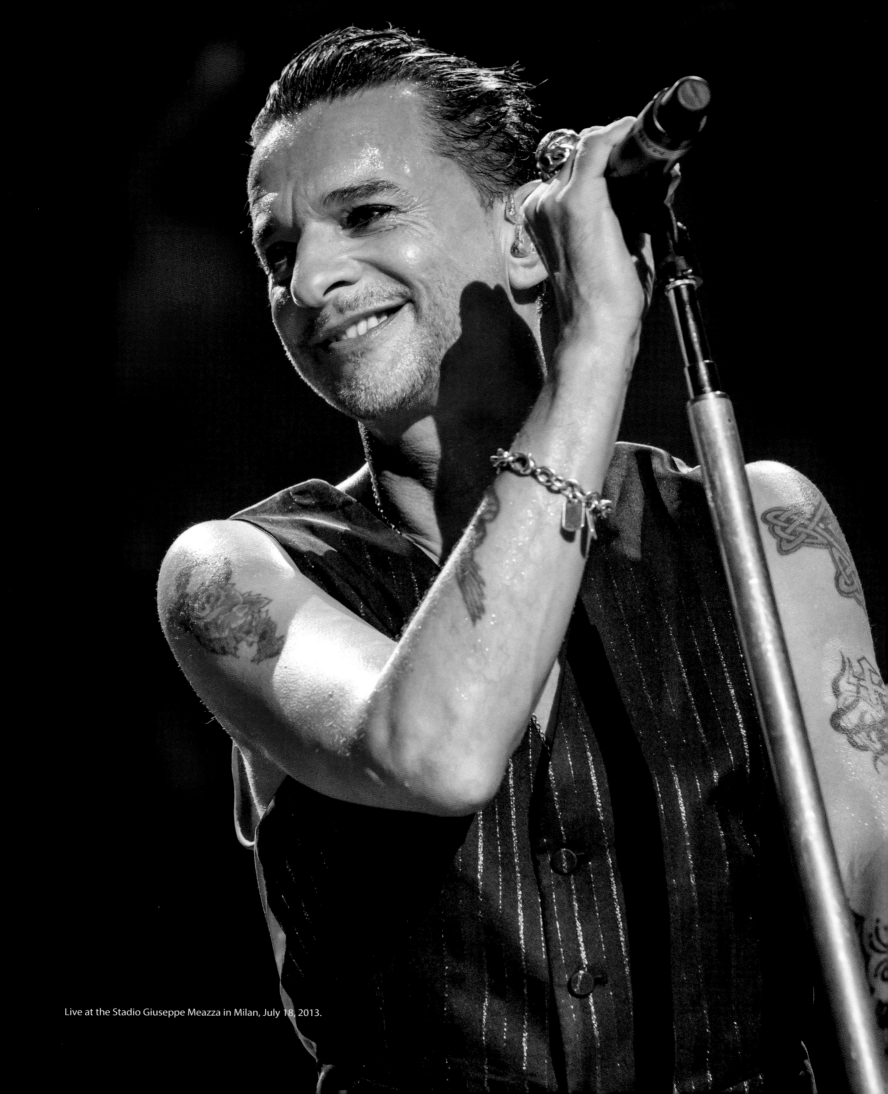

Live at the Stadio Giuseppe Meazza in Milan, July 18, 2013.

The band receiving an award for *Delta Machine* from colleagues at Sony Italy in advance of headlining the Rock Werchter Festival in Belgium on July 7, 2013.

Martin with fans in Locarno, Switzerland.

At the band's June 1 show in Munich's Olympiastadion, and again on June 9 in Berlin, Anton Corbijn filmed a number of sequences for the music video for the band's next single, "Should Be Higher." The clip premiered August 22 on Vevo, an online video and entertainment outlet run at that time by Sony and Universal, among other major labels.

In July, Depeche Mode played four festivals in Europe, including the Moon and Stars Festival in Switzerland, in the middle of picturesque Locarno.

Ruminating on the Rock Werchter Festival in Belgium, Martin later noted, "It's different to playing your own shows. I like some festivals, but overall I'd like to play to our own crowds. It's always a bit more of a challenge playing to a festival crowd, but it really depends on where you are. We played one in Werchter in Belgium where . . . I don't know if we just happened to play on the last night and everyone had been there for three or four days and everyone was a zombie. It was 80,000 people, but they just didn't seem to react like normal crowds do."

The band wrapped up its European stadium tour on July 29 after thirty-seven concerts.

North American Tour

After a solid three weeks' rest, the band continued from August to October with twenty-four shows across North America, including seven in California alone.

Before the band's September 26, 2013, show in Mountain View, California, at the Shoreline Amphitheatre, Live 105 Radio asked Martin about his favorite song to perform. He replied, "I think just because of the crowd participation—it just amazes me every single night—"Never Let Me Down Again," when everybody starts waving, flailing their arms around. It's just amazing to look and see that happening every night."

The band's October 11 performance at the Austin City Limits festival was streamed live on the Internet. Shortly thereafter, the third single off the album, "Should Be Higher," came out.

After a short break at the end of the North American tour, the band flew to a new destination for an unusual sort of show: on November 3, they played an outdoor concert in Abu Dhabi, United Arab Emirates, as part of a Formula One racing event. It wasn't only locals who were there to see it; some fans traveled all the way from Germany not to miss a show at such an unusual venue.

Backstage pass for family members of the band.

European Tour, Round Two

"When I do watch myself and when I am performing, I enjoy becoming that guy up there," Dave reflected to Anton Corbijn about his development as a front man. "It's a lot of fun for me to present this guy, to act out a part. There's a lot of acting going on up there."

Beginning in Belfast on November 7, 2013, the band was back on the road in Europe. Both shows on November 25 and 27 at Berlin's O2 Arena were filmed by Corbijn, for later release on DVD. The evening in between the two shows had a special live session, with Martin and Peter Gordeno playing a number of songs at the Bel Ami Club, a former brothel. The songs were later released as bonus material for the DVD *Alive in Berlin,* which Corbijn produced.

European fans of the band had in the meantime made a running gag of bringing large inflatable bananas with them to the shows, after Fletch had been observed eating a banana between songs. At the band's Dresden show on February 12, 2014, a a fan handed Gahan a banana during "Just Can't Get Enough"; the singer got the reference and brought the banana over to Fletch.

World politics again interrupted the band's tour on February 26, when a concert planned for Kyiv, Ukraine, had to be canceled on short notice after a series of violent clashes there and in other parts of the country made the show too risky for everyone involved.

By the time the band finished on March 7 in Moscow, they had played forty-four concert halls all across Europe. Touring around *Delta Machine* lasted nearly a year, with 106 concerts that drew some 2.4 million people in total.

It wasn't long after the tour that Dave and Martin were back at work on solo projects that couldn't have been more different. In January 2015, Dave was in the studio, helping with the second Soulsavers album. He was able to make an impression on some critics, including a *Rolling Stone* journalist who wrote, "Does anyone else out there still get goose bumps when someone from Depeche Mode goes solo? No? Then Dave Gahan will make sure you do again."

On April 27, Martin released a record of his own, *MG,* that was composed entirely of experimental instrumental tracks. "A dark, cinematic, and tension-filled work that opens fresh doors onto new sonic spaces using old tools without any experimental shyness," wrote *Sound and Recording* magazine.

On October 19, Dave Gahan & Soulsavers presented their new album, *Angels & Ghosts,* live in Los Angeles, with Martin Gore and Nitzer Ebb among the crowd.

Andy Fletcher was also active as a DJ through the end of the year.

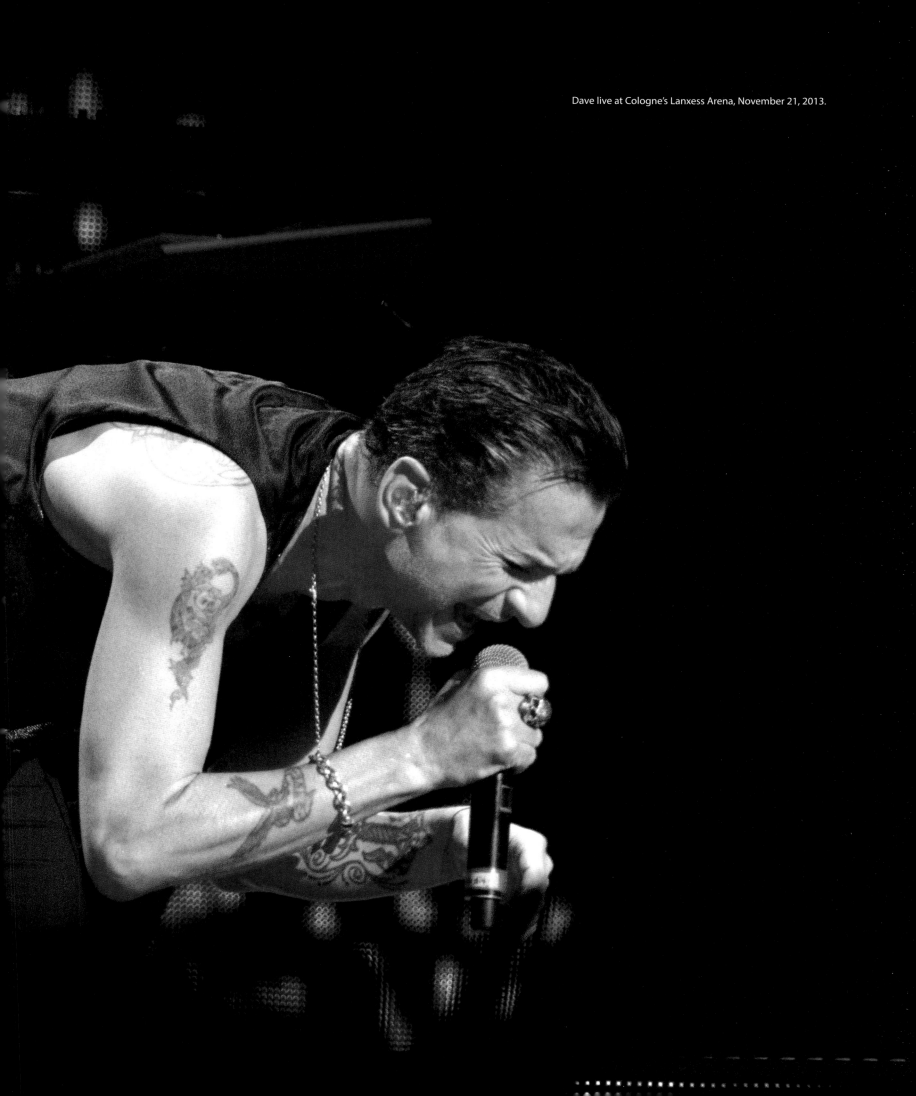

Dave live at Cologne's Lanxess Arena, November 21, 2013.

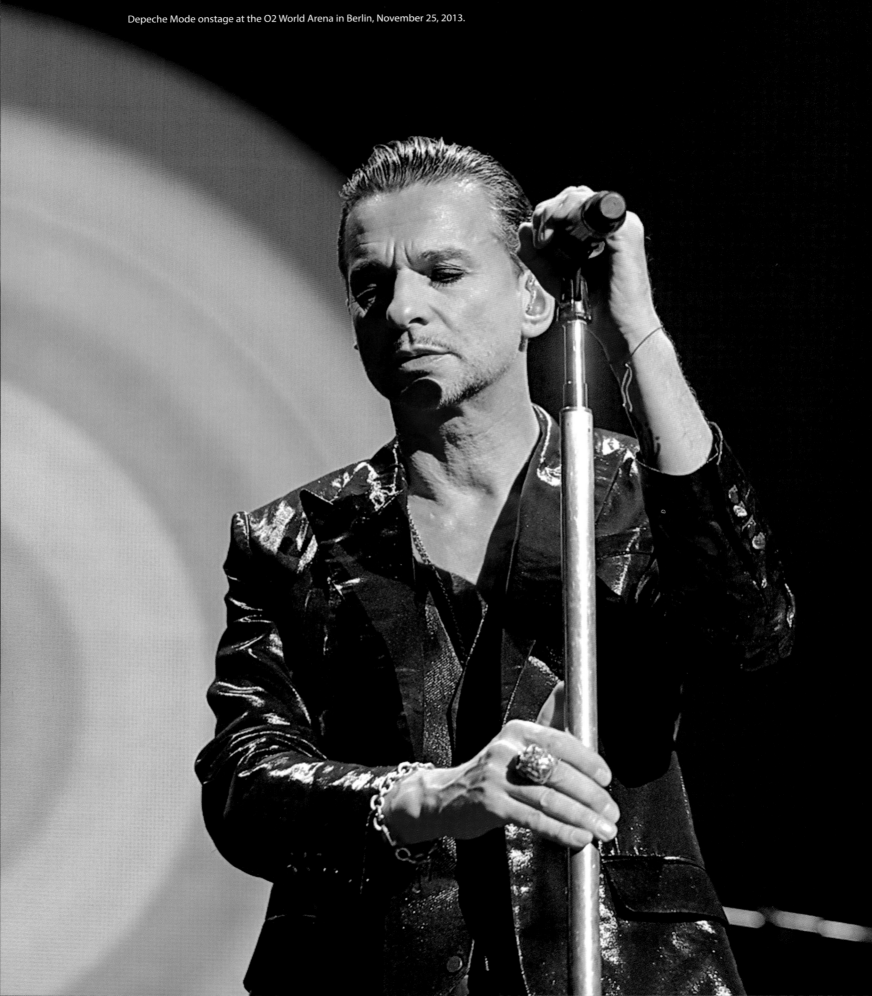

Depeche Mode onstage at the O2 World Arena in Berlin, November 25, 2013.

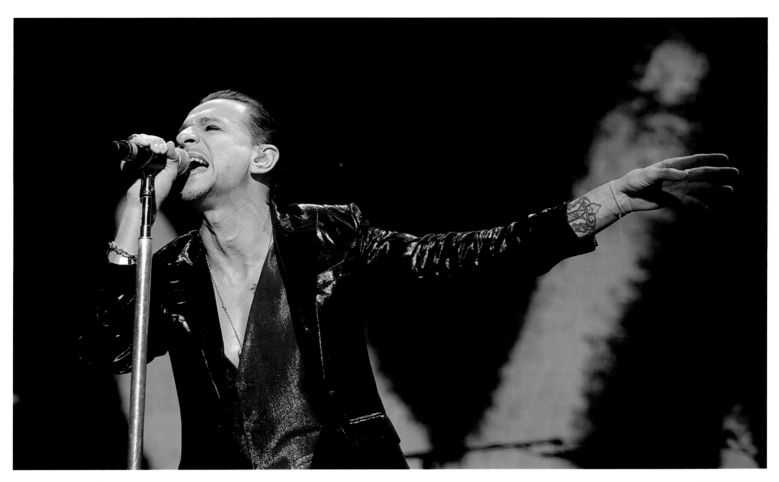

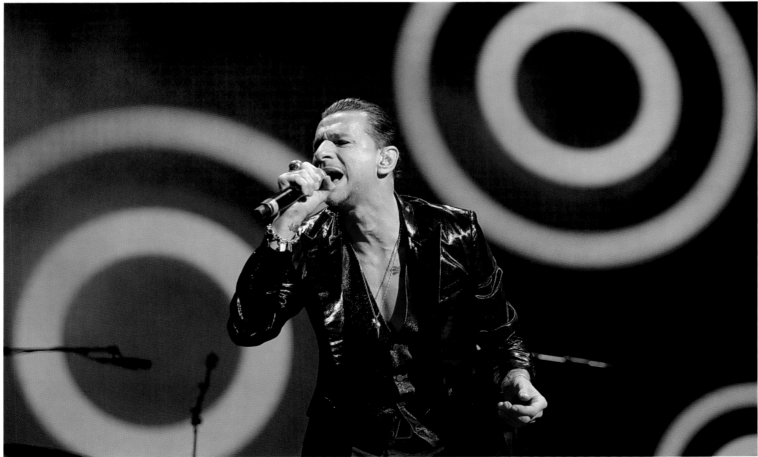

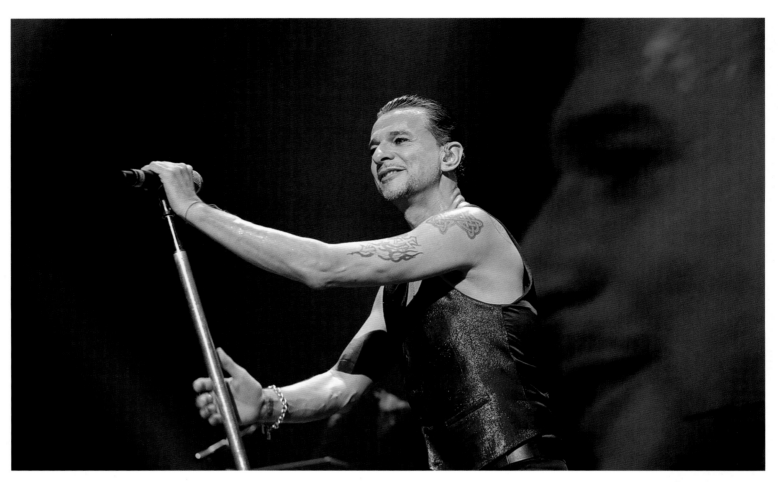

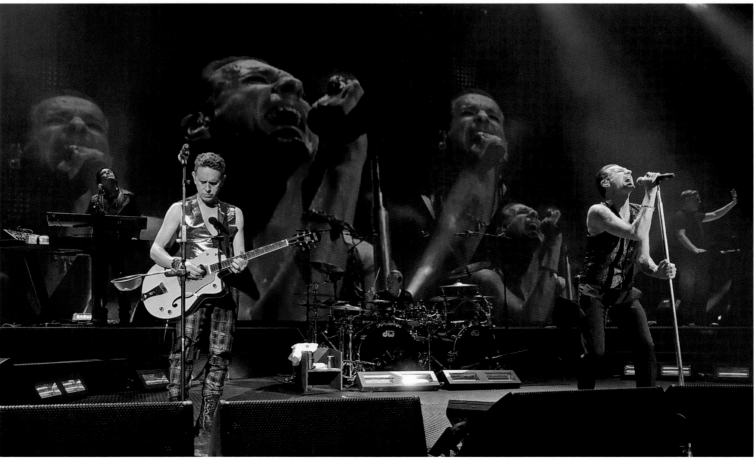

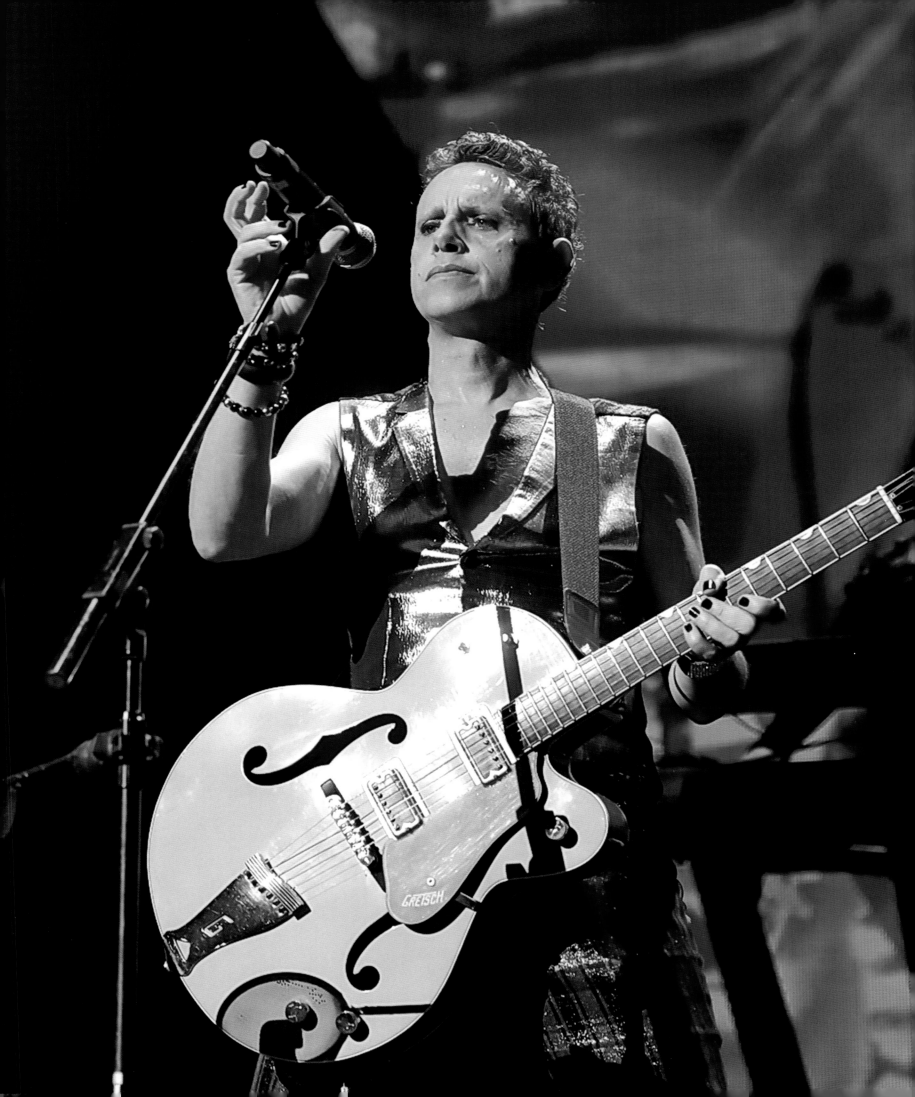

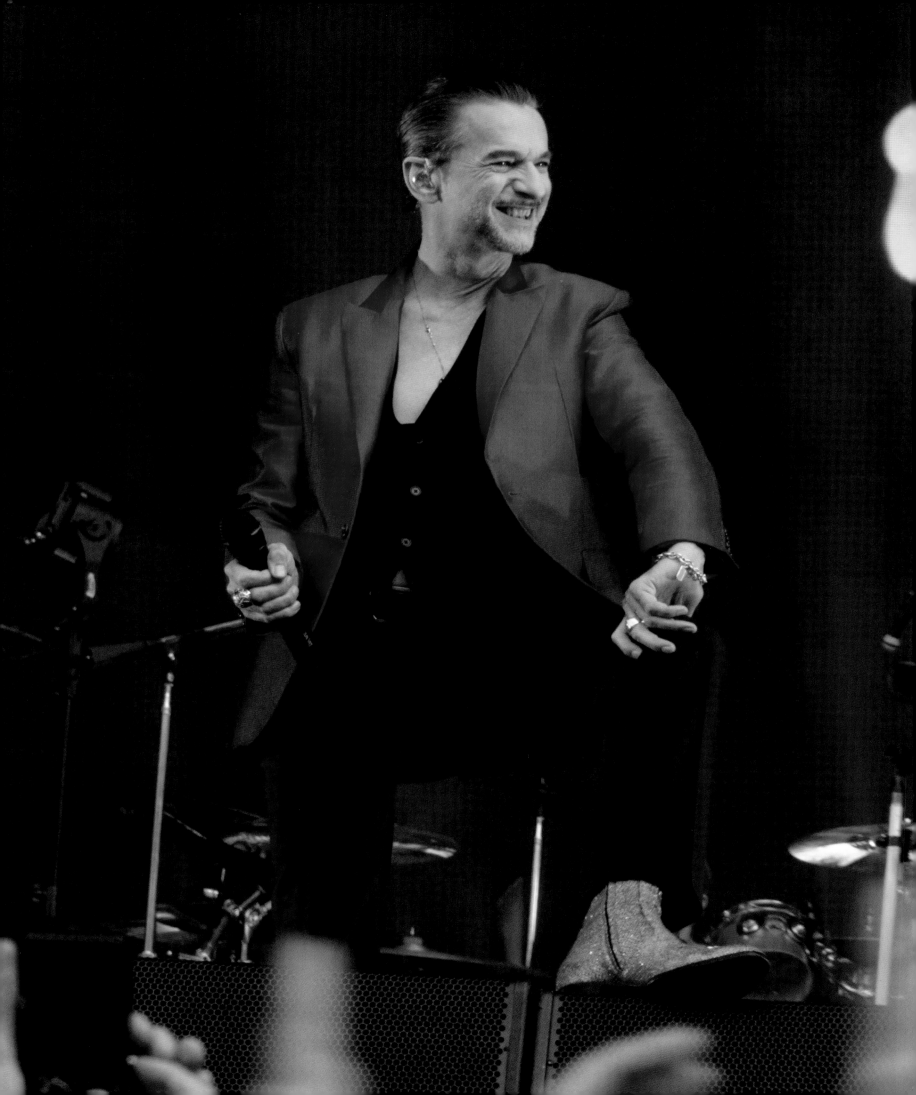

Global Spirit Tour

"The *Spirit* album is an exciting project for me especially," Peter Gordeno recalled, "because it was the first time I got involved in the writing on the record, which I did with Christian Eigner and with Dave Gahan. A lot of the stuff me and Christian did was together in his place in Vienna. Dave was in New York writing lyrics."

In mid-April 2016, Depeche Mode began recording its fourteenth studio album in Santa Barbara, this time choosing England's James Ford as producer. Working alongside Christian Eigner and Peter Gordeno, Martin and Dave had twenty songs written. Fans caught wind of the recording sessions early on and set the rumor mill churning, though no official statement came from Depeche Mode yet.

On October 11, with recording still unfinished, the band gave what by now had become a routine press conference, this time in Milan, to announce a new album and tour. In the Q&A that followed, fans and journalists peppered the band again about the chances of a possible reunion with Vince Clarke and Alan Wilder. Dave's answer was fairly clear: "We've been lucky; for the last almost twenty years now, we've had Peter Gordeno and Christian Eigner playing with us . . . You can put the light on them, I think they're down there somewhere, there are a couple journalists that look suspiciously like Peter Gordeno and Christian Eigner—oh yeah, they are. So that question's kind of redundant really, but we're very lucky to have them play with us for so long."

Tickets for the upcoming European tour went on presale a cou-

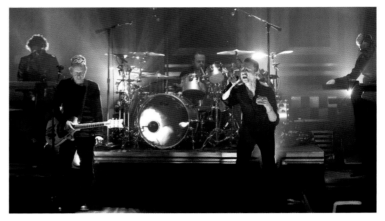

The band's first performance for their new album, *Spirit*, came on *The Tonight Show Starring Jimmy Fallon* in New York on March 1, 2017.

their effect on the band. As Martin explained in an interview, "When I started to write, I came to the realization that I had to reflect what was happening in the world. And I knew that this record would be fairly different from many other Depeche Mode records."

The band met up with its two live musicians in early February, at New York's Avatar Studios, to begin rehearsing for the upcoming tour. On March 3, they performed their new single live on *The Tonight Show Starring Jimmy Fallon*. Three days later, they played a small afternoon concert for thirty select fans at Avatar Studios, followed by a second set for journalists that evening.

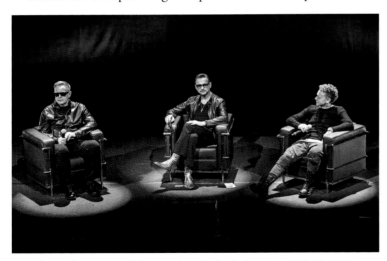

Depeche Mode announced the tour dates for its forthcoming Global Spirit Tour on October 11, 2016, from Milan's venerable Teatro dell'Arte. The press conference was streamed live over the Internet, and fans were able to ask the band questions.

ple of days later; in just a few weeks' time, more than 450,000 had been sold in Switzerland and Germany alone, all without a single soul knowing the new songs. Excitement about the new album rose to a fever pitch when the new single, "Where's the Revolution," came out on February 3, 2017; the song lyrics were political in a way that they hadn't been since "People Are People" was released.

The Brexit vote and the election of Donald Trump had had

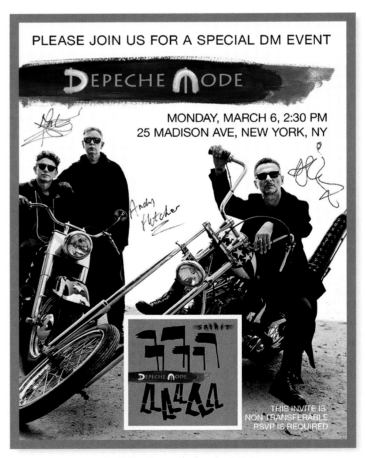

Invitation to see the band rehearse.

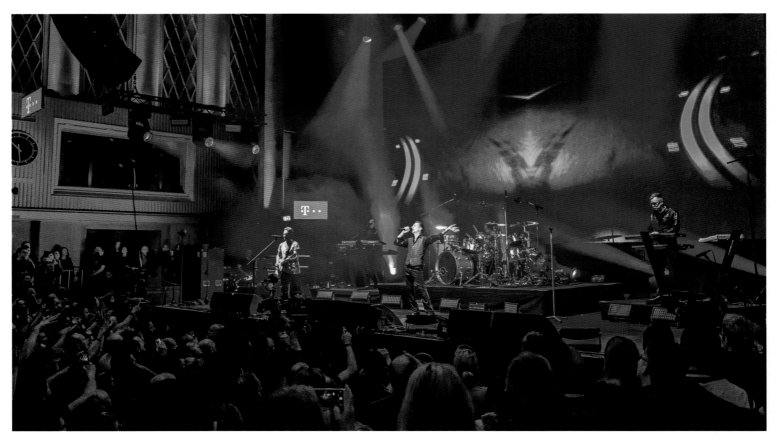

On March 17, 2017, Depeche Mode played a celebrated show at the old radio station on Nalepastrassee in Berlin; through 1990, East German radio had been headquartered at the site.

Warm-Up Shows

As on earlier tours, Depeche Mode opened with a series of smaller promo gigs in Europe and the US before beginning the actual tour.

On March 17, the day *Spirit* was released, Telekom organized a special concert in Berlin for the band's first appearance in Germany in three years. Broadcast over the Internet in a 360-degree live stream, the band played a Telekom Street Gig to 1,000 fans selected by lottery in the large broadcasting studio of the former radio station on Nalepastrassee. "It was all lit up for TV as well to be streamed, so there was way more light onstage than what there normally is," Dave recounted to *Der Spiegel*. "So I was sort of looking for some shadow and there was none, I realized after a while. There was nowhere to hide."

Another exclusive gig for a hand-selected audience followed on March 21 in Paris for a French TV station. Fletch recalled another mini-concert five days later in Glasgow at the BBC 6 Music Festival in *Skinny* magazine: "There was a funny thing before we went on, when all of us realized that we didn't know the set list. We all panicked; are we doing 'Enjoy the Silence' or not?' It was just one of those things, but there was a big rush where the crew had to reprint all the set lists until we finally got one."

Another exclusive set before a crowd of just two hundred followed on March 23 at a convention in Basel, Switzerland, part of a charity event with Swiss watchmaker Hublot.

Back in the US on April 21, Columbia Records invited forty fans to a rehearsal for the Global Spirit Tour at LA's SIR Studios. The set list included a cover of the song that had brought Dave to Depeche Mode all the way back in 1980, David Bowie's "Heroes." Bowie had died in 2016, and Dave explained what the exceptional artist meant to him in an interview with *Forbes*: "We were recently rehearsing actually, and we opened the rehearsal room to a few people, here at SIR in Hollywood. We covered a Bowie song, and I almost lost it. It was 'Heroes.' We just did it, and went into it, and it was really very moving and I felt all kinds of stuff. I grew up listening to Bowie, so he's probably the one artist that I've continually listened to from when I was twelve years old. By the time I was sixteen, suddenly he was making me not feel like an odd person. I related so much to everything that he was musically, and his identity too."

On April 27, the band played a "Special Thank You Show" to a handful of fans chosen by lottery at a small club in Los Angeles that barely held a hundred people. Musician Mark Lanegan (Queens of the Stone Age, Soulsavers) later told *mxdwn* magazine: "Dude, they're like the most badass club band too. I'd never seen them play on a small stage. I wondered, *How's that going to be*? You're so used to seeing them play these huge 20,000-seat arenas. Dude, it was so fucking badass. It all comes down to Dave, because he's an amazing front man. It doesn't matter whether he's playing an arena or in front of a hundred people, he's the fucking shit."

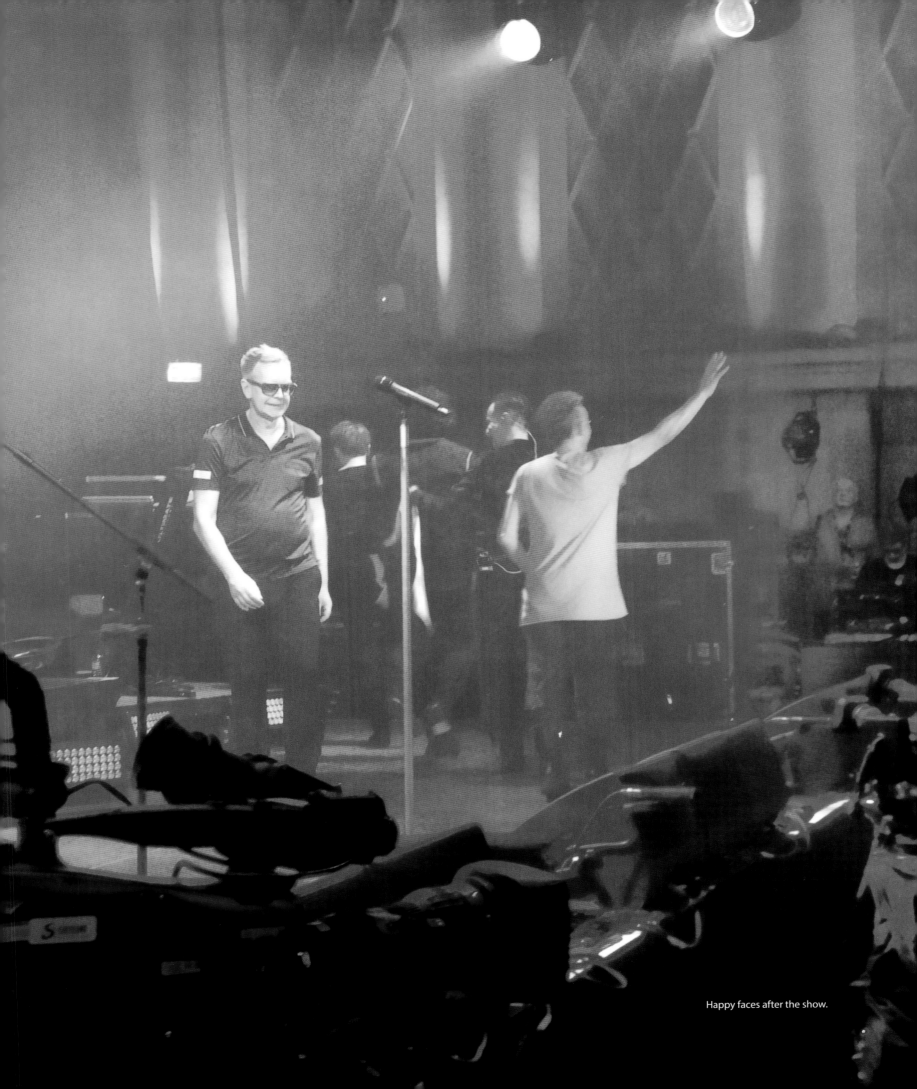

Happy faces after the show.

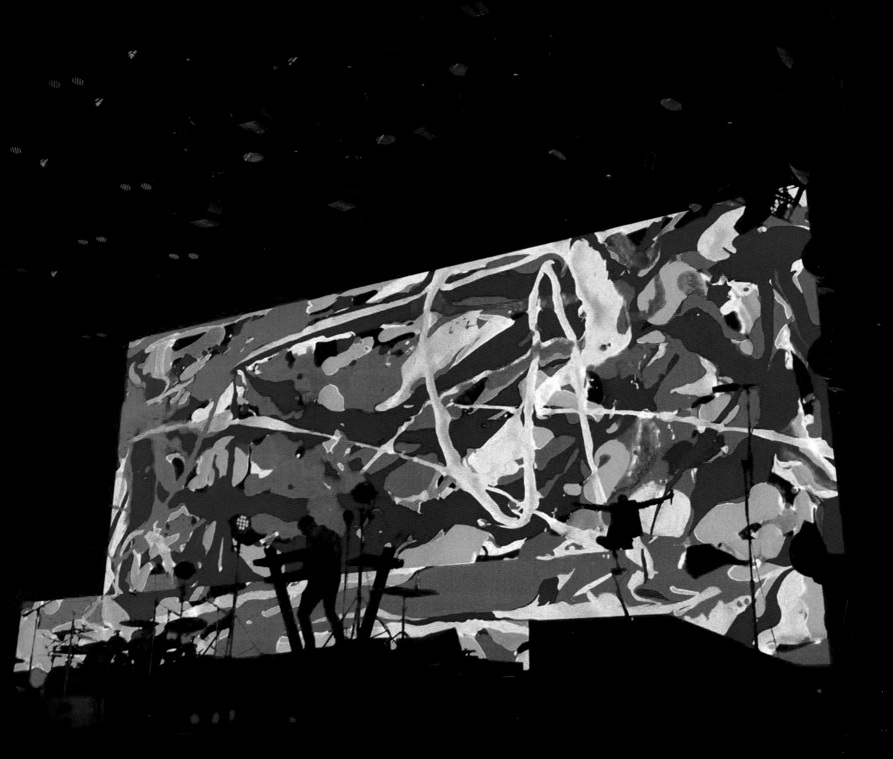

The Global Spirit Tour opened on May 5, 2017, at the Friends Arena in Stockholm.

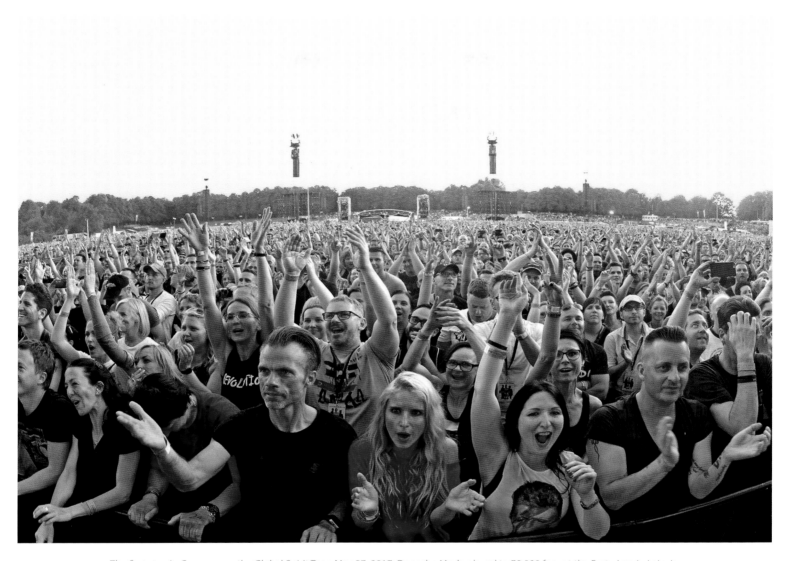

The first stop in Germany on the Global Spirit Tour, May 27, 2017. Depeche Mode played to 70,000 fans at the Festwiese in Leipzig.

Global Spirit Tour, Round One

The Global Spirit Tour launched at the Friends Arena in Stockholm on May 5, 2017, in front of more than 36,000 people.

Starting on July 23, the band played thirty-three shows across Europe. Eight were in Germany, which was also home to the largest shows. The biggest was in Leipzig on May 27, with 70,000 people in attendance.

The June 3 show in London had 65,000 people, with a number of longtime associates among them, including Anton Corbijn, Daniel Miller, Andy Franks, Daryl Bamonte, and photographer Brian Griffin.

After a month-long break, the tour picked back up on August 23 in North America. The venues were somewhat smaller in comparison to the European stadiums, holding anywhere from 4,000 to 18,000 people. As on the previous tour, weather thwarted the band's Florida plans; a show scheduled for September 13 in Tampa had to be called off with the approach of Hurricane Irma. The band and promoters considered organizing a last-minute performance at a safer spot in the vicinity, but there wasn't enough time to erect the stage.

Los Angeles once again proved itself to be the band's US home; over four consecutive nights in mid-October, Depeche Mode played to a total of 65,000 people at the Hollywood Bowl. As *Billboard* reported, "Depeche Mode played four shows at its Hollywood Bowl engagement for the Global Spirit Tour: October 12, 14, 16, and 18. According to Andrew Hewitt and Bill Silva Presents, the show's promoter, the four-night run is the most shows any act has played in a single engagement since the promoter began working with the Hollywood Bowl in 1991. An impromptu sing-along broke out at the conclusion of 'Home,' which was sung by the band's Martin Gore while Gahan was offstage. At the end of the song, after the lights went down, the crowd kept on singing—prompting Gahan, who had returned to the stage, to say, 'We got some singers tonight.' He grabbed his mic and thrust it into the crowd, encouraging them to keep it up. Then the band joined in to accompany the fans. 'Here's to the Hollywood Bowl!' For nearly two minutes, the fans kept on going, eventually ending with Gore exclaiming, 'Wow!' and Gahan adding, 'You really were the best!'"

Overall, Depeche Mode played thirty shows across the US and Canada, ending on October 27.

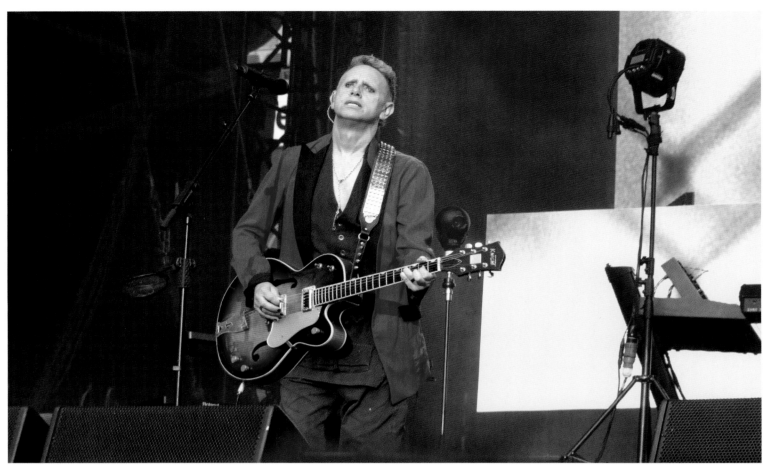

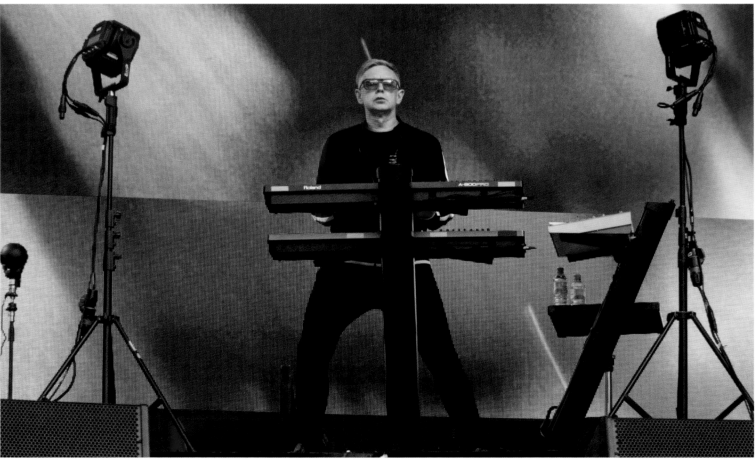

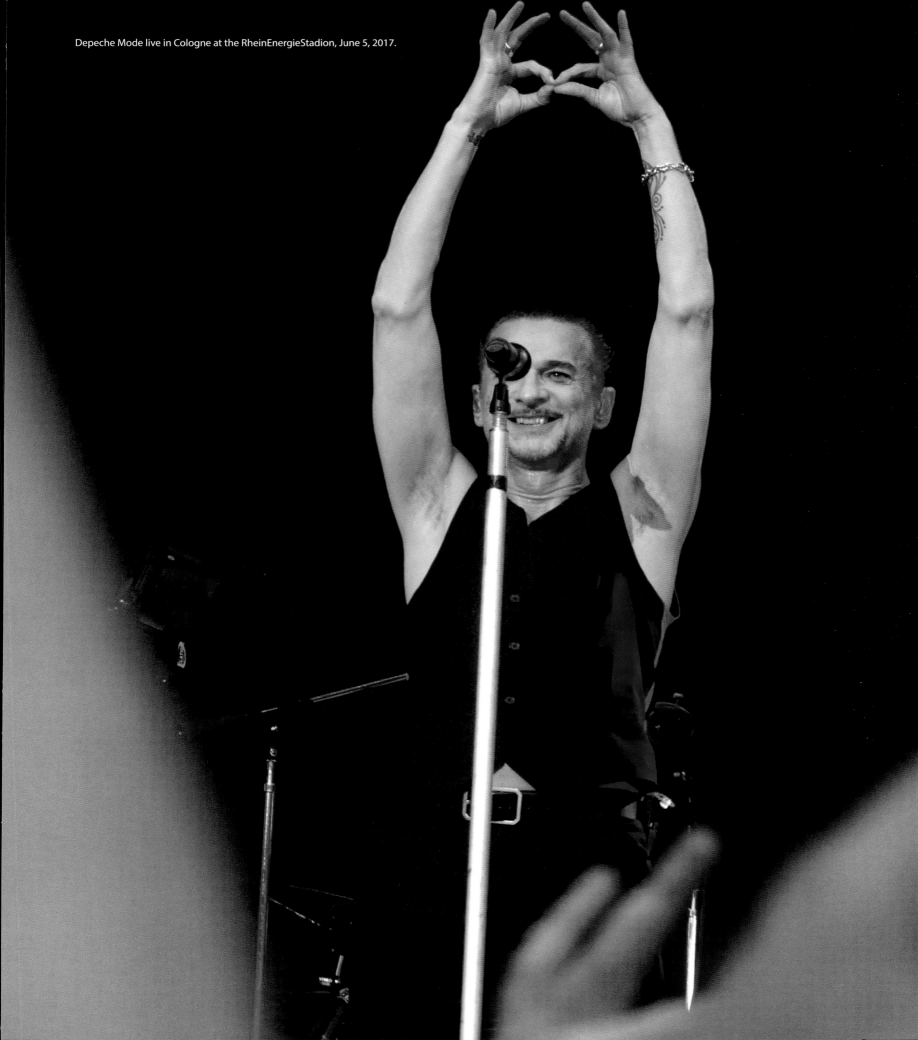

Depeche Mode live in Cologne at the RheinEnergieStadion, June 5, 2017.

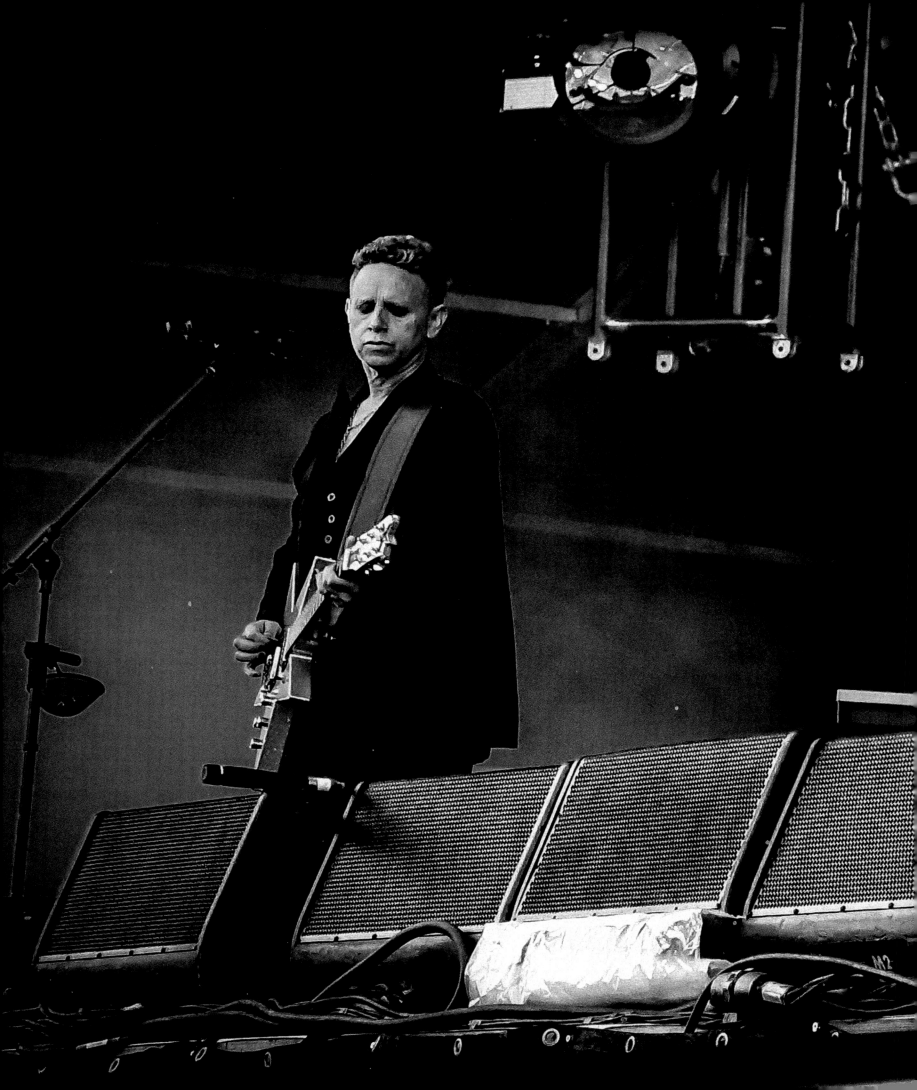

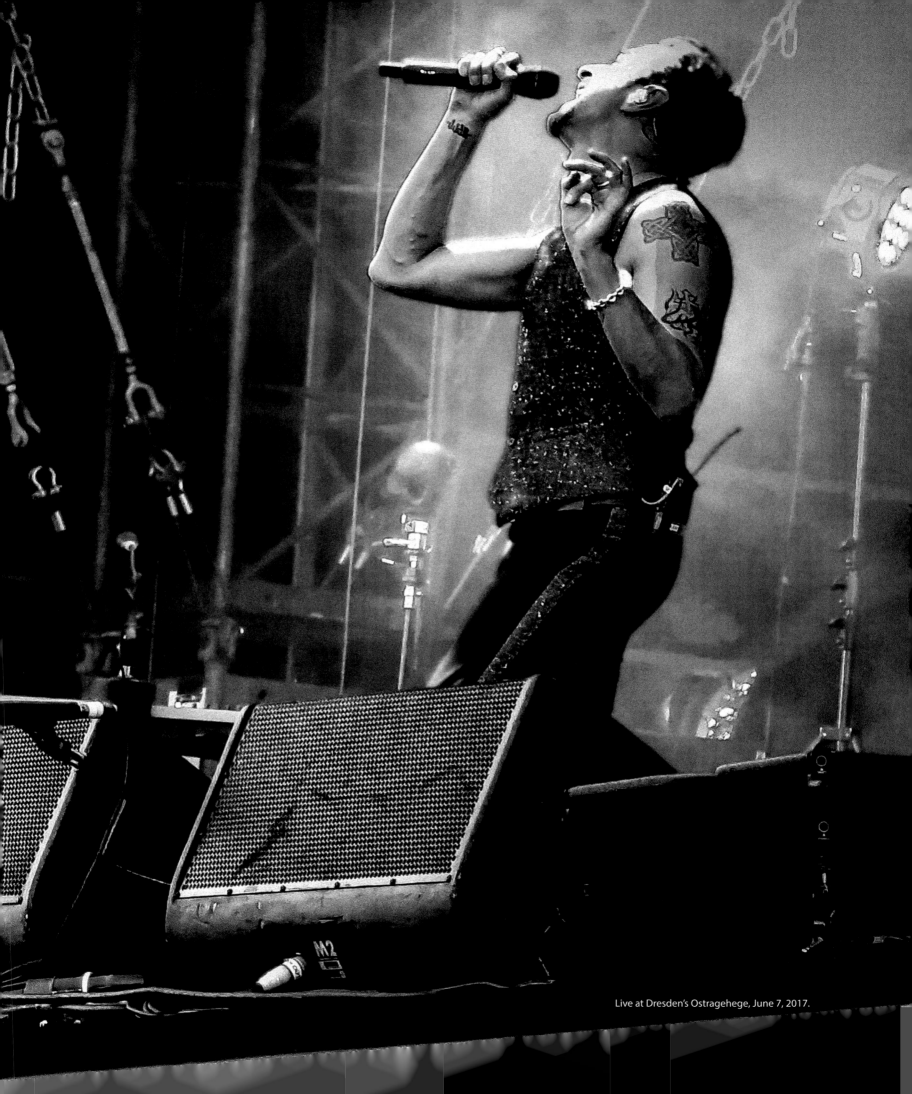

Live at Dresden's Ostragehege, June 7, 2017.

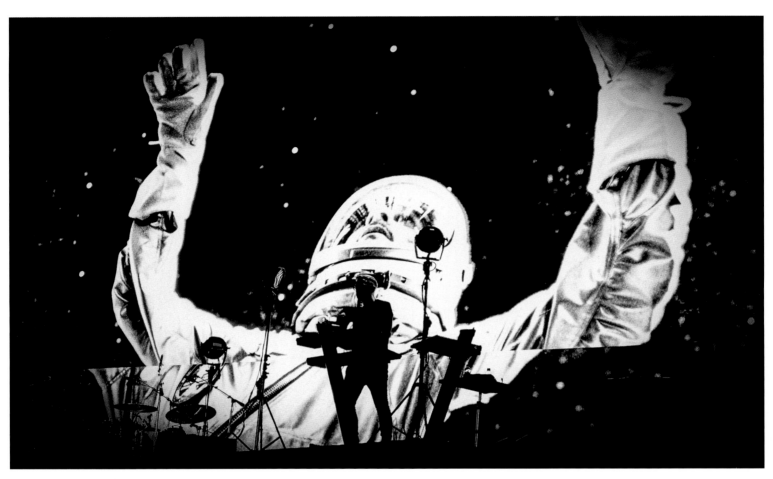

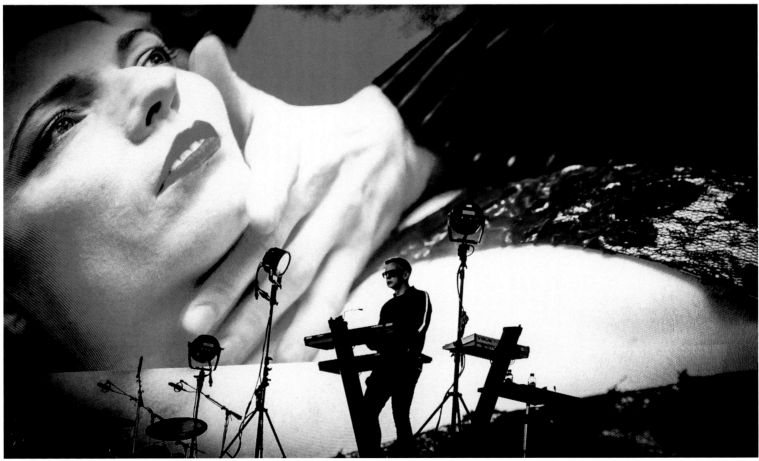

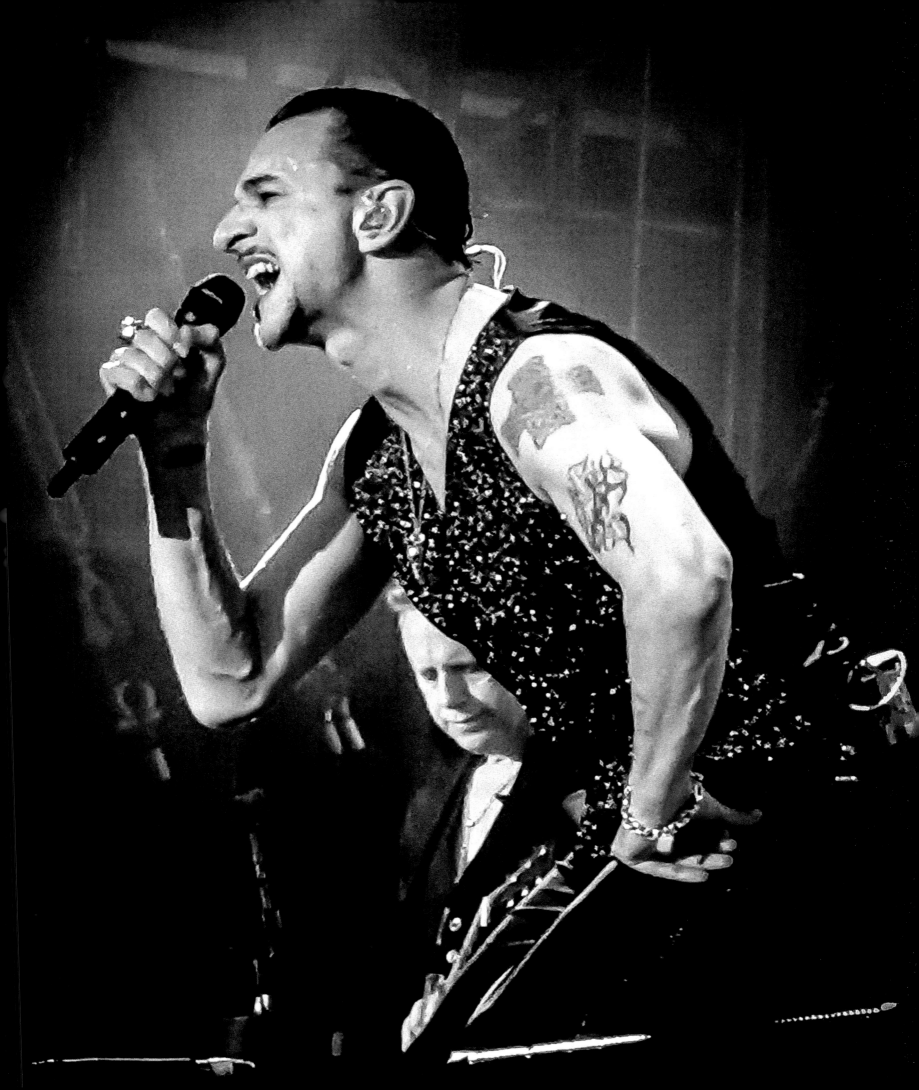

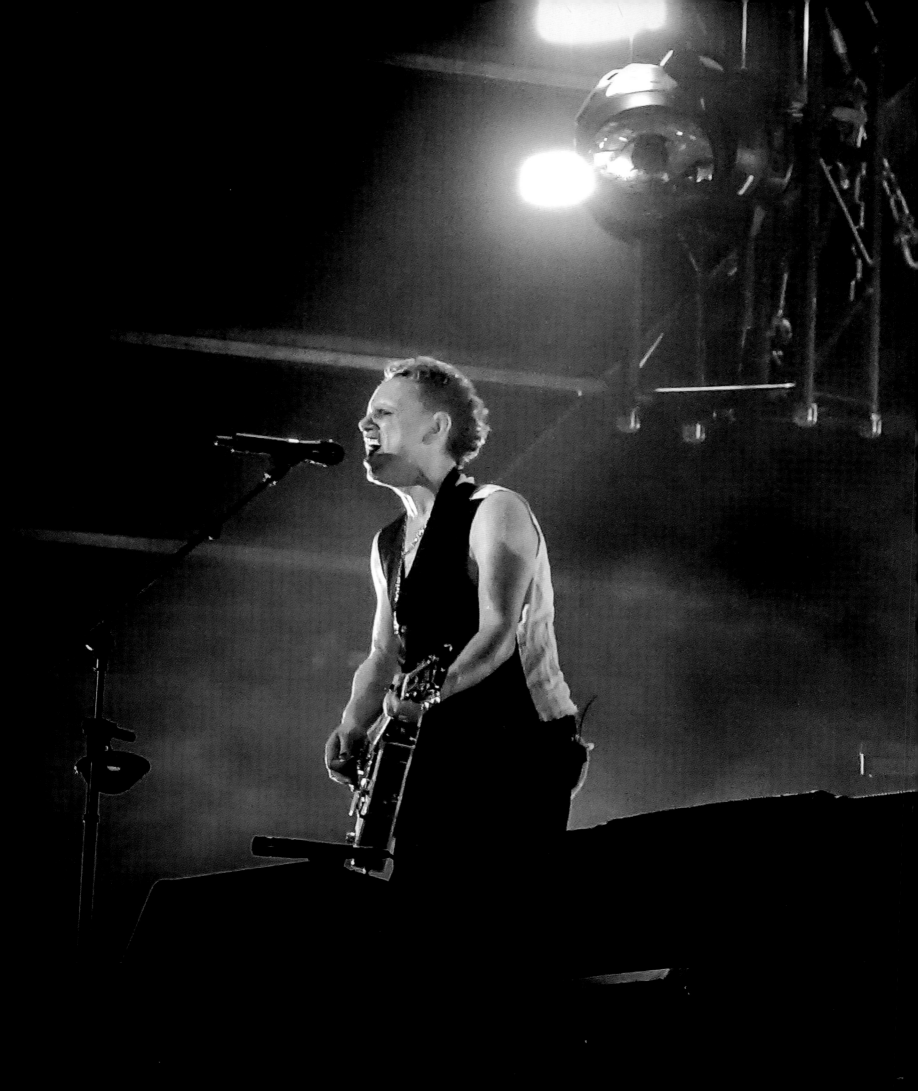

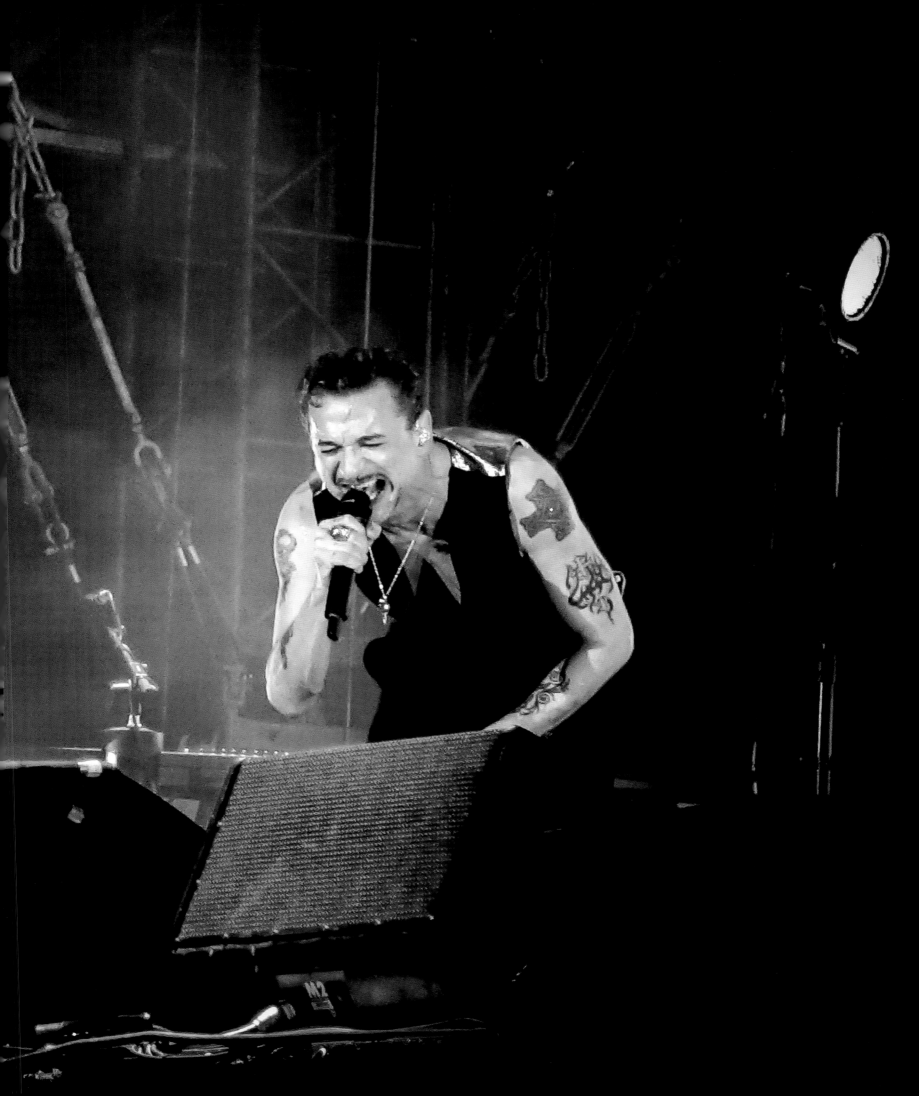

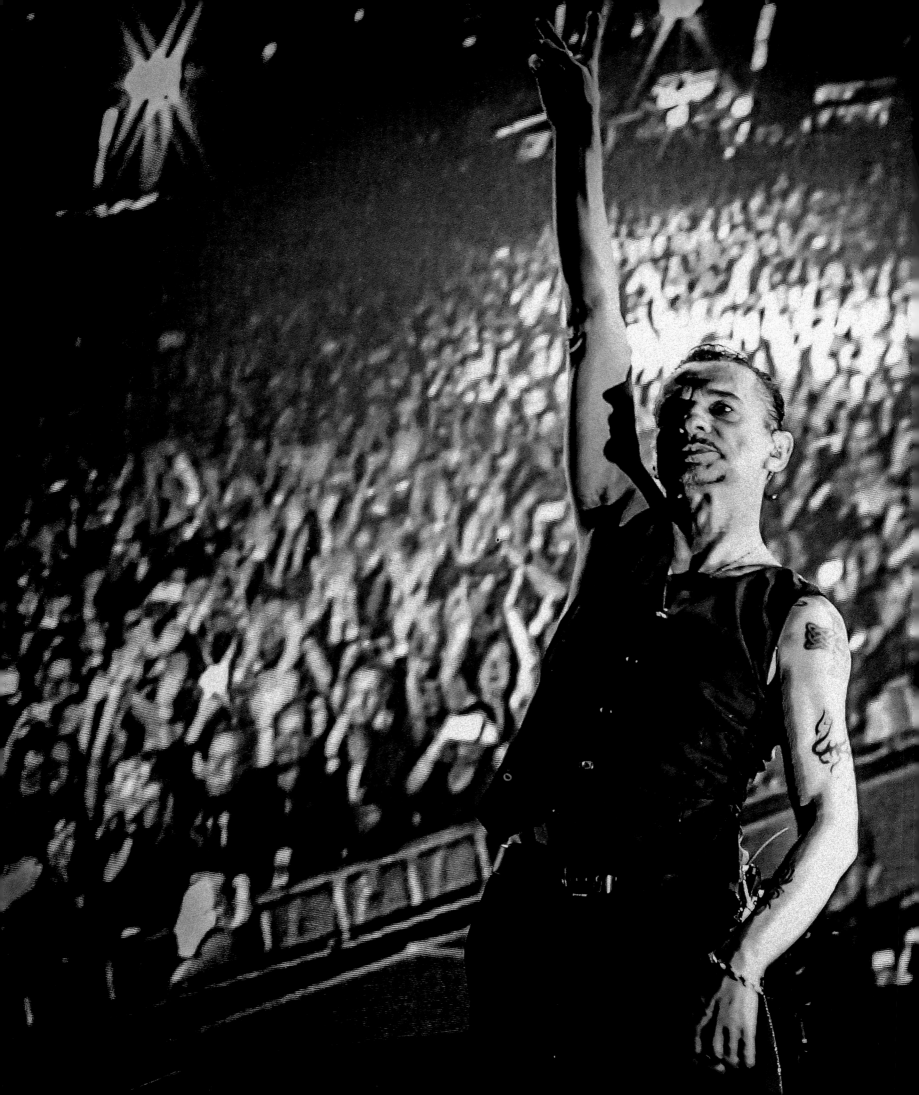

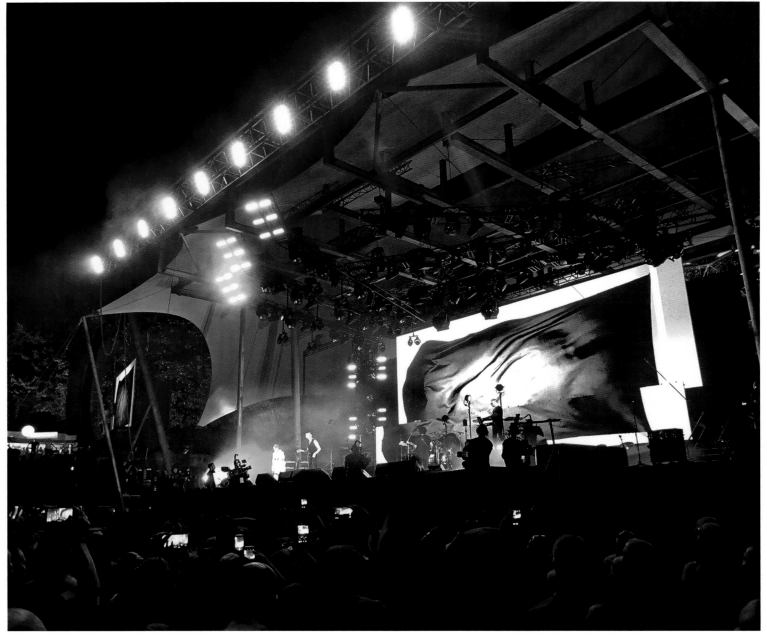

One indisputable highlight of the Global Spirit Tour was the band's cover of David Bowie's smash hit "Heroes"; the song was included in the set in Berlin, where Bowie had lived for several years and recorded multiple records at Hansa Studios.

Global Spirit Tour, Round Two

By mid-November, the band was back in Europe for a concert hall tour that would stretch through February 2018. Nearly all the shows sold out, averaging around 12,000 in attendance. In February 2018, the band visited Kraków, Łódź, and Gdańsk in Poland for the first time.

The following March, Depeche Mode opened its Central and South American leg of the tour with two outdoor shows in Mexico City, where the enthusiasm of the crowd left a lasting impression on the band. It seemed as though over the years, more and more Mexicans had fallen head over heels for Dave, Martin, and Andy.

There was no stopping Depeche Mode in South America ei-

ther; government officials in Buenos Aires, Argentina, even dubbed the musicians honorary guests of the city.

Starting in May, the band played another nine shows across North America. In late June and July, they also headlined a number of European festivals, including the Isle of Wight Festival in the south of England, Hungary's Volt Festival, and Lollapalooza in Paris, although with a much shorter set list of fifteen songs instead of the regular twenty-two.

The Global Spirit Tour ended in Berlin with two shows at the Waldbühne on July 23 and 25, 2018. Anton Corbijn filmed both for *Spirits in the Forest,* a concert film that premiered in select theaters on November 21, 2019.

Yet *Spirits in the Forest* was more than your average concert film, sensitively depicting the stories of six Depeche Mode fans

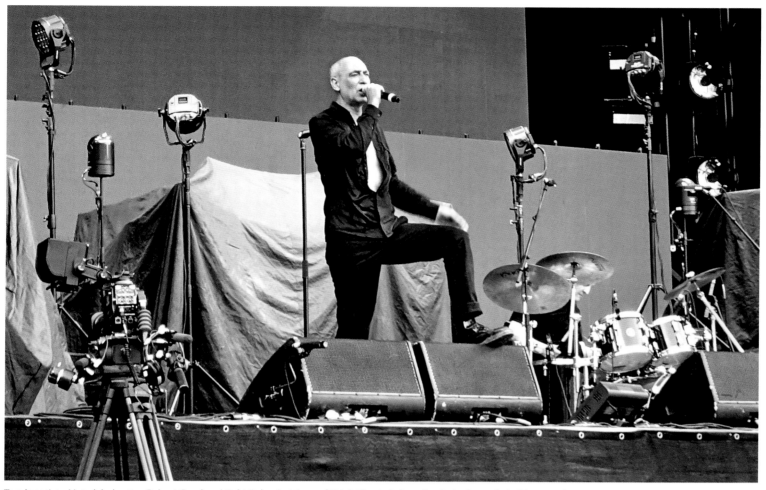

Two longtime Mute labelmates, Robert Goerl and Gabi Delgado-López of D.A.F. (Deutsch Amerikanische Freundschaft), came along as support for the final shows in Berlin. D.A.F. ranks with Kraftwerk and Can as among the most influential artists in the electronic music world. For their last song, D.A.F. played their hit "Als wär's das letzte Mal" (translated as "Like It Was the Last Time"), which for many fans, sadly, turned out to be true: in March 2020, legendary D.A.F. front man Gabi Delgado-López died unexpectedly.

from around the world and showing how the band's music brought people together across time zones, difficult circumstances, language barriers, and age gaps. The film came out on May 1, 2020, as a limited box set and on Blu-ray, as well as a double CD, and was celebrated by *Forbes* as "the new gold standard in concert films."

On the Global Spirit Tour, Depeche Mode had played more than 130 concerts in front of around three million people over the course of fifteen months. It was the band's third-longest tour to date, after the Devotional and Exotic tours of 1993–94. And it had taken its toll on the band.

Dave explained to *New Musical Express* in January 2020: "For the first six months after you've been out there for over a year, it's always a weird transition. This time more than ever, I just thought, *I don't know if I want to make music anymore*. Not because I don't like music, but because I was so drained. Still, music is one of the only things that makes any sense to me in life." Asked whether the band would record again, Dave replied, "I can't honestly answer that question. Depeche have made so many records together, and after a tour Martin and I are like, 'See you then!' There will more than likely will be another record, but we really don't make plans beyond what we've just done . . . We'll see."

Ad for the worldwide premiere of the film *Spirits in the Forest*.

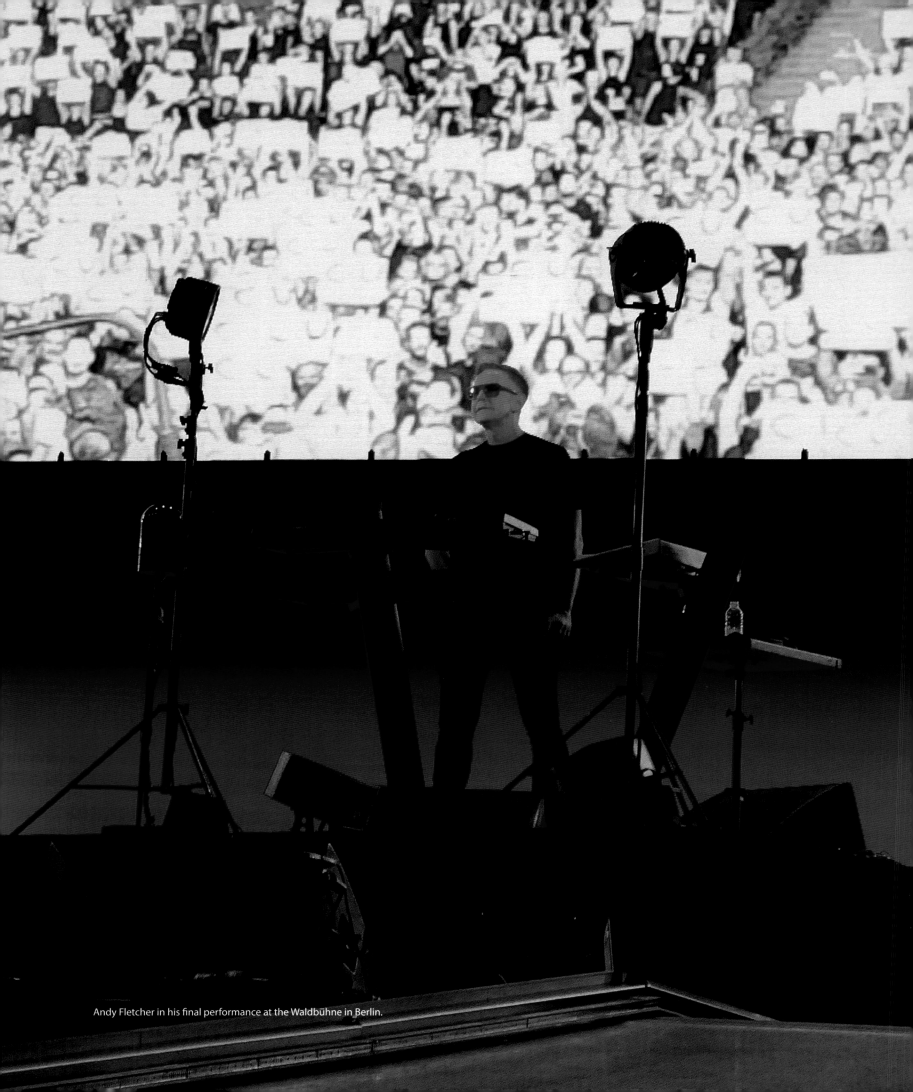

Andy Fletcher in his final performance at the Waldbühne in Berlin.

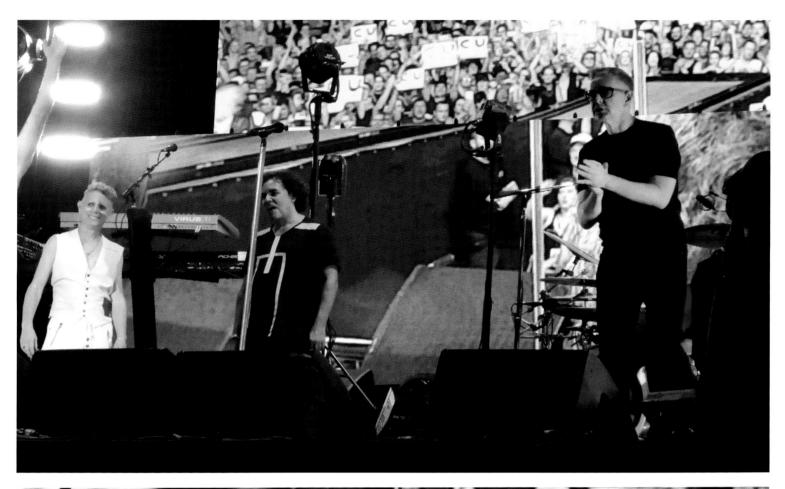

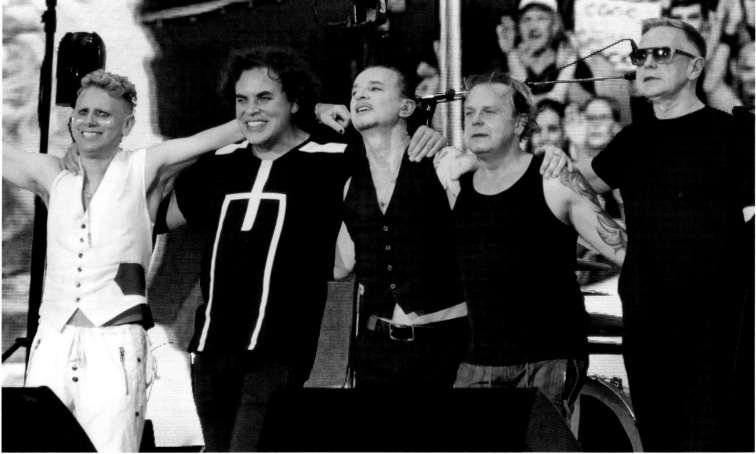

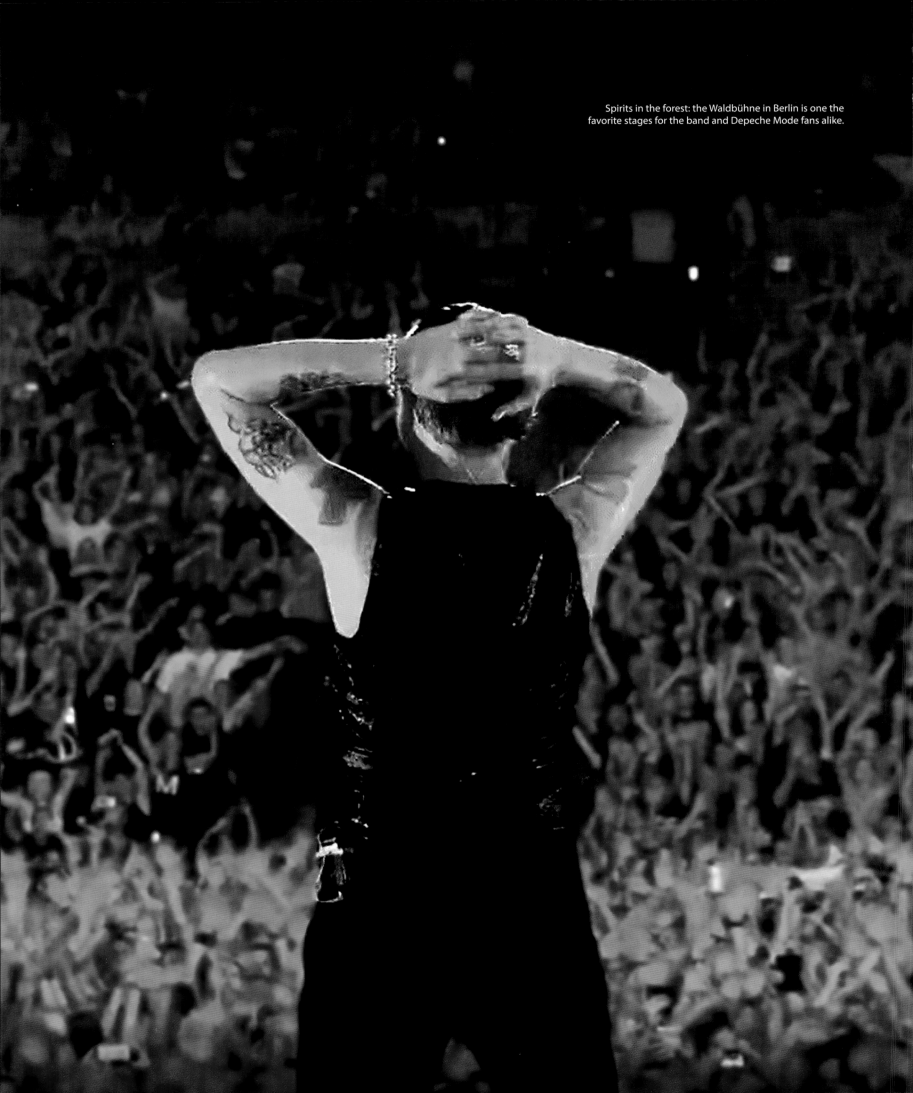

Spirits in the forest: the Waldbühne in Berlin is one the favorite stages for the band and Depeche Mode fans alike.

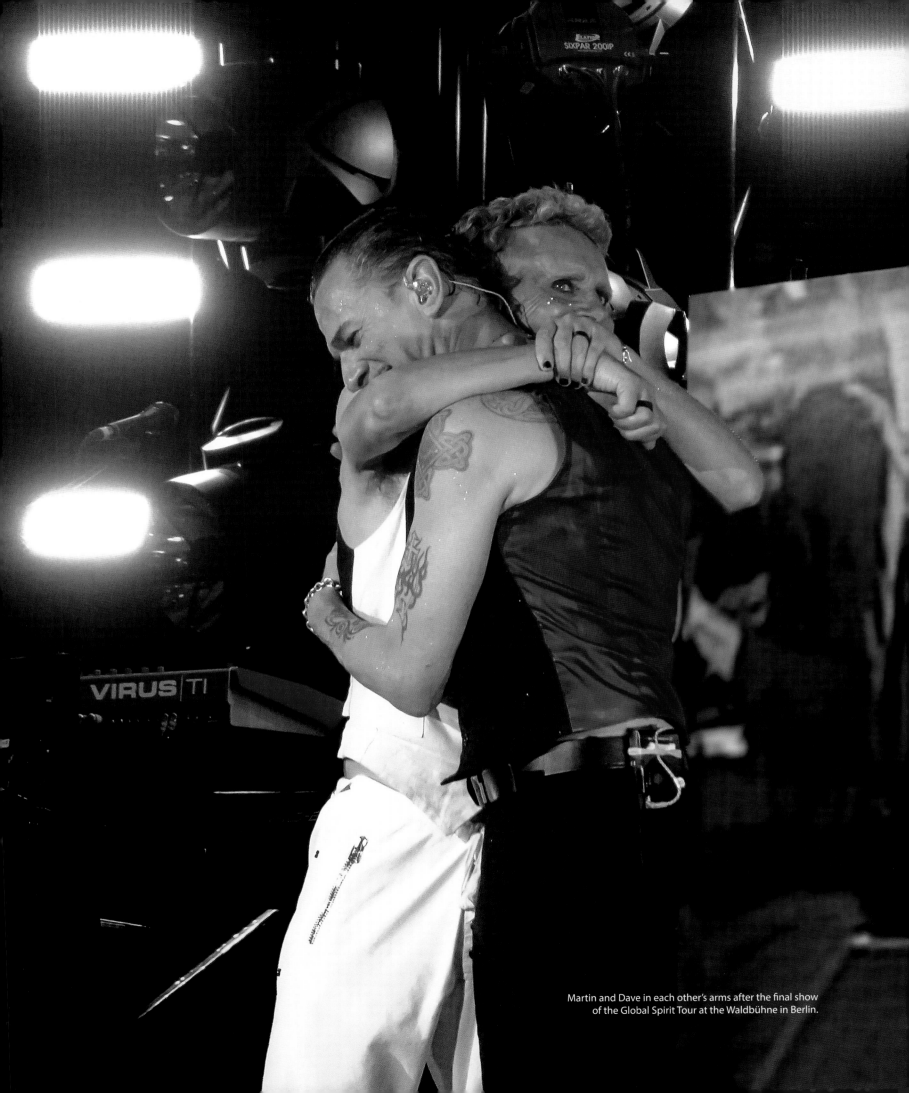

Martin and Dave in each other's arms after the final show
of the Global Spirit Tour at the Waldbühne in Berlin.

2020 INDUCTEES

DEPECHE MODE

THE DOOBIE BROTHERS

WHITNEY HOUSTON

NINE INCH NAILS

THE NOTORIOUS B.I.G.

T. REX

APPEARANCES BY

LUKE BRYAN
SEAN "DIDDY" COMBS
MILEY CYRUS
DAVE GROHL
DON HENLEY
JENNIFER HUDSON
ALICIA KEYS
ADAM LEVINE
CHRIS MARTIN
LIN-MANUEL MIRANDA
BRAD PAISLEY
BRUCE SPRINGSTEEN
ST. VINCENT
RINGO STARR
GWEN STEFANI
CHARLIZE THERON
AND MORE

AHMET ERTEGUN AWARD

JON LANDAU **IRVING AZOFF**

HBO ORIGINAL

THE ROCK & ROLL
HALL OF FAME
2020 INDUCTIONS

SPECIAL EVENT
STREAMING NOV 7 | **HBO**max

Memento Mori

Going by the usual four-year rhythm, a new Depeche Mode album would have been due in 2021. Yet things were different this time around. The global COVID-19 pandemic had made it impossible to tour in front of millions of fans for the moment. This left the band members with unexpected time to be with their families, while all fans could do was hope that the musicians kept active through the lockdowns.

June 2020 saw some initial speculation, when Peter Gordeno made mention of new plans during a video chat with the UPC music school in Lima, Peru: "At the moment writing for the next Depeche record is my main concern. I've been starting to do that, Christian and I work together on music and send it out to Dave in New York and he likes to get down on the lyric side. Christian's got a great studio in Vienna where he lives, I just go over there for a couple of weeks and we literally just jam." Yet no further information about a new Depeche Mode album was forthcoming.

Still, the band was drawing notice in a different arena; as popular as they had been over more than forty years, public recognition of their unparalleled career had never quite matched their commercial success. This made it all the more joyous to learn in

Screenshot from the award ceremony.

of course to Vince Clarke and of course to Alan Wilder, who are part of the DM family and DM history and of course of the success of this band." During the presentation, Dave wondered what would have become of him if he hadn't joined the band, to which Andy replied without missing a beat, "You'd have been still stealing cars, Dave." All three appeared wonderfully relaxed, kidding around and thanking each other.

Announcement of Depeche Mode's induction into the Rock & Roll Hall of Fame, 2020.

2020 that the band would be inducted into the Rock & Roll Hall of Fame, which had been honoring and organizing exhibitions on music industry stars since 1986.

The museum website described Depeche Mode as follows: "Known for their dark, industrial love songs for the modern era, Depeche Mode earned a massive following by pushing sonic and lyrical boundaries with new synthesizer technology and captivating live performances."

The pandemic meant the band wasn't able to receive the award in the usual context of a live performance. Instead, a cheery Dave, Martin, and Andy made a video appearance on November 7, 2020, each tuning in separately from their homes.

With Andy happily holding the trophy in front of the webcam and lamenting that they couldn't play a concert, Dave and Martin spontaneously broke into the opening riff of "Personal Jesus," before erupting in laughter. Dave began his own acceptance speech by mentioning earlier colleagues, extending "a big congratulations

A shot of the Depeche Mode exhibition at the Rock & Roll Hall of Fame, 2020; inductees are selected by a committee of music historians.

Anton Corbijn, Andy, Martin, and Dave signing the limited-edition book *Depeche Mode by Anton Corbijn (81–18)*.

Andy, Dave, and Martin also thanked Daniel Miller, the team at Mute Records, Anton Corbijn, Jonathan Kessler, Peter Gordeno, Christian Eigner, the road crew, tour managers, Rob Stringer at Sony Music, the fans who had stuck with them through so many years, and their families.

Although the three didn't take the opportunity to announce a new record, the images left fans assured that the founding members of Depeche Mode still got along, and that it would only be a matter of time before they were back in the studio and then on the road.

In fall 2020, Anton Corbijn and art book publisher Taschen put out *Depeche Mode by Anton Corbijn (81–18)*, an extremely limited volume signed by Martin, Dave, and Fletch. The book featured a number of unreleased photographs from Corbijn's archives, including both official and more private portraits of the band, as well as spontaneous, unstaged shots and breathtaking live images from the tours dating back to 1988. The book also contains sketches and drafts of stage designs and album covers with handwritten comments from Corbijn, placing the reader directly in the middle of his working process, and a lengthy interview with the Dutch master. For the publisher, Taschen, the book sold out faster than nearly any other title they'd published.

Another significant award followed the next year, this time for Daniel Miller, a pioneer in electronic music and the man who discovered Depeche Mode. On November 21, 2021, Miller received the Icon Award at the A&R Awards in London for his life's work as an A&R manager. The award celebrates individuals in the UK "whose professional feats will influence generations to come."

Among those accompanying Daniel to the festivities was Fletch, who didn't miss the opportunity to pose with the prize winner in front of a photo wall. Speaking about Miller to *Music Business Worldwide*, Vince Clarke reflected, "First and foremost, Daniel is a music fan. This is why, I think, he connects so well with the artists on the label. He'll sign a band not for their earning potential but rather because he likes their music. This is what sets Mute apart from most other record companies."

2021 brought no news from the band; the only performances came from Dave: a handful of December shows in London, Paris, and Berlin for the new Soulsavers album.

Still, Martin hadn't been idle; he recorded a number of demos during the pandemic, as he discussed later with *SPIN* magazine. "We had so much time on our hands to write, which is always a good thing, so we ended up with a lot of songs to choose from." The influence of the pandemic was also clear in the number of new songs that revolved around the theme of death. This led to the album being titled *Memento Mori*, a common Latin phrase that means, *Remember that you have to die*.

But the songs weren't only about transience and death; the lyrics also reflected current political events. As Martin later reported to German radio broadcaster radioeins, "'My Cosmos Is Mine' was the last song I wrote for the album; I think for me, after the pandemic, the Russians invading Ukraine was too much to deal with it. For me, the song is about saying I realize I have no control over what happens in the world but at least I have control over what happens in my mind."

Even after what had been an exhausting last tour in 2017–18, the strength of the new demos convinced Dave to record a new Depeche Mode album and take it on tour. He had his own songs to contribute, and Fletch was overjoyed that Depeche Mode would continue.

Yet after years apart, and just six weeks before the band was finally set to meet again in the studio in July 2022, terrible news arrived.

Daniel Miller and Fletch at the A&R Awards in London, November 21, 2021.

We are shocked and filled with overwhelming sadness with the untimely passing of our dear friend, family member, and bandmate Andy "Fletch" Fletcher.

Fletch had a true heart of gold and was always there when you needed support, a lively conversation, a good laugh, or a cold pint.

Our hearts are with his family, and we ask that you keep them in your thoughts and respect their privacy in this difficult time.

Depeche Mode, May 26, 2022

Andy Fletcher Dies

No Depeche Mode fan will ever forget May 26, 2022. That evening, the band posted startling news to its official social media accounts: "We are shocked and filled with overwhelming sadness with the untimely passing of our dear friend, family member, and bandmate Andy 'Fletch' Fletcher. Fletch had a true heart of gold and was always there when you needed support, a lively conversation, a good laugh, or a cold pint. Our hearts are with his family, and we ask that you keep them in your thoughts and respect their privacy in this difficult time."

It wasn't just the fans who were taken by surprise; Andy had been the only band member, after all, who hadn't distinguished himself with drug- or alcohol-induced escapades. Everyone, in fact, had thought he would outlive the rest of the band. Depeche Mode later announced the cause of death as an aortic dissection, a tear in his central aorta. At just sixty, Andy Fletcher had died far too young.

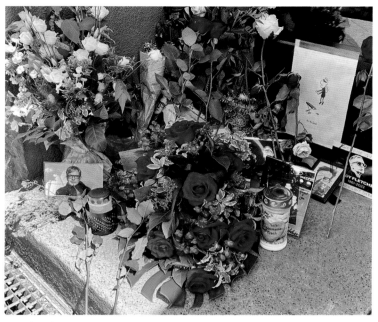

A final farewell to Fletch from Depeche Mode fans at Hansa Studios in Berlin.

"Fletch was always the one questioning the success of the band and asking how it could be better," Daniel Miller wrote in a personal statement about Fletcher's death on Mute's website. "He wasn't pessimistic, he just wouldn't let the band and Mute rest on their laurels, and his persistence in always striving for more was a big part of Depeche Mode's success. As a label, we unexpectedly spent more time with Fletch during the pandemic than we had in many years, and Fletch was always interested in what else was going on at Mute . . . When venues started up again, he began coming to more Mute shows."

Dave subsequently spoke to the *Guardian* about meeting Daniel Miller at Fletch's burial in London in mid-June: "He walked in with his wife, and Martin and I stood up and kind of fell into him, and he put his arms around us and all of us were just . . . I was sobbing. It was just the three of us. I can't explain it, but that's when I totally lost it."

Over the years, Fletch hadn't taken a significant role in the songwriting or the studio recordings, and his musical contributions to the live shows had been equally limited. Yet he was an irreplaceable part of the band, because he mediated between Dave and Martin, because he held the band together, simply because he was a part of it. Because they had been friends, from the very beginning. It was one of the unique appealing aspects that had defined Depeche Mode since it started: It wasn't about quantifiable creative input. Depeche Mode came out of postpunk. And if you belonged, you belonged. This meant that throughout the band's career, Andy earned the same income as the other band members. As much as they may have all pursued individual paths, Depeche Mode had always been a gang.

It's understandable that Dave would have thought, in his grief, that this might be the end of Depeche Mode. Yet when Martin asked him in a phone call, "We're moving on, right?" Dave answered, "Yeah," without a moment's hesitation.

With the first studio session planned for mid-July, Martin deliberated on whether to put it off at first, after everything that had just happened. "We decided it was probably best for us to focus on the album, on the music, something we know, something to take our minds off Andy's death," he recalled to the *Guardian*. So they started recording, and as large as the hole was that Andy left behind, his death also brought Martin and Dave closer together than ever before: "We have to make decisions as the two of us, so we talk things out, we talk a lot more on the phone, even FaceTime sometimes. That's something we just never did before."

Memento Mori

Recording began in July, this time at Martin's home studio in Santa Barbara. James Ford again served as producer, alongside the Italian Marta Salogni, who had worked previously with Björk, Goldfrapp, Bloc Party, and Soulsavers, and was primarily responsible for the recording and engineering side. The Depeche Mode machine was back up and running.

With recording still in the works, the band invited media outlets and fans to a press conference on the afternoon of October 4, 2022, at the Berliner Ensemble, where they also played a snippet from a new track, "Ghosts Again." The song had a melancholic, danceable sound, and it quickly became clear that it would likely be the next single.

The press conference opened with a conversation between Martin, Dave, and US music journalist Barbara Charone, with Martin discussing the album title *Memento Mori*: "It sounds very morbid, but I think you can look at it very positively as well: live each day to the max." Dave talked about missing Andy's comments in the studio during recording. Asked about the upcoming concerts and their missing band mate, he replied, "He will be there in spirit anyway, I'm sure." One audience member asked whether Depeche Mode would ever play an unplugged show, which got a wink from Dave: "We can't really unplug, 'cause we're an electronic band."

Marta Salogni finished mixing *Memento Mori* at the end of 2022 in London. As tour preparations gradually got underway and more and more dates were announced, many of the shows quickly sold out.

Martin, Dave, and US music journalist Barbara Charone.

"Ghosts Again"

The new single, "Ghosts Again," came out on February 9, 2023, undoubtedly the most melancholy yet poppiest Depeche Mode track since 2005's "Precious." Even though Martin had cowritten the song long before Andy's death with Richard Butler, the singer and songwriter for the Psychedelic Furs, the lyrics now held a deeply moving personal resonance.

The band headed to Europe for a handful of dates to promote the single, new album, and upcoming tour. On February 11, they returned to the Sanremo Music Festival in Italy after thirty-three years, where they performed "Ghosts Again" and "Personal Jesus." Throughout the eighties, Depeche Mode had been a regular guest at the festival.

The promotional dates featured Christian Eigner on drums and

Depeche Mode with Cliff Masterson, conductor of the BBC Concert Orchestra.

Depeche Mode live at the Sanremo Music Festival, February 11, 2023.

Peter Gordeno on keys as usual, though it was quite unfamiliar to miss Fletch onstage.

Two days later, the band performed its new single on TV in Paris for the show *Quotidien*, followed on February 14 by a four-song set on the popular program *Taratata*, though it wasn't broadcast on French television until late March.

On February 16, the band played a session at London's Maida Vale Studios for BBC Radio 2. They performed new arrangements of "Walking in My Shoes" and "Ghosts Again," and a cover of "Sundown" by Scott Walker, accompanied by the BBC Concert Orchestra, a first in Depeche Mode history. The string arrangements gave the songs a new and highly charged feeling. The session was eventually broadcast on April 6 over the radio, with two songs also featured on the BBC's YouTube channel.

By early February, all kinds of rumors were swirling across social media that Depeche Mode might be coming to Germany for

a concert. Without any truly solid information, excitement continued to build until the press made it official on February 10: Depeche Mode would perform on February 19 in Munich, and Sony, along with radio station Bayern 1, would invite four hundred fans!

The venue was kept a secret at first out of fears of uncontrollable crowds. Tickets for the event also didn't go public, and were only available by lottery through individual radio stations. At Munich's Alte Kongresshalle, neither "Wagging Tongue" nor "My Favourite Stranger" from the new album got off on the right foot when the band tried to perform them, and had to be started over again. With a wink, Dave promised that on tour things would run more smoothly.

Guest pass for the show in Munich.

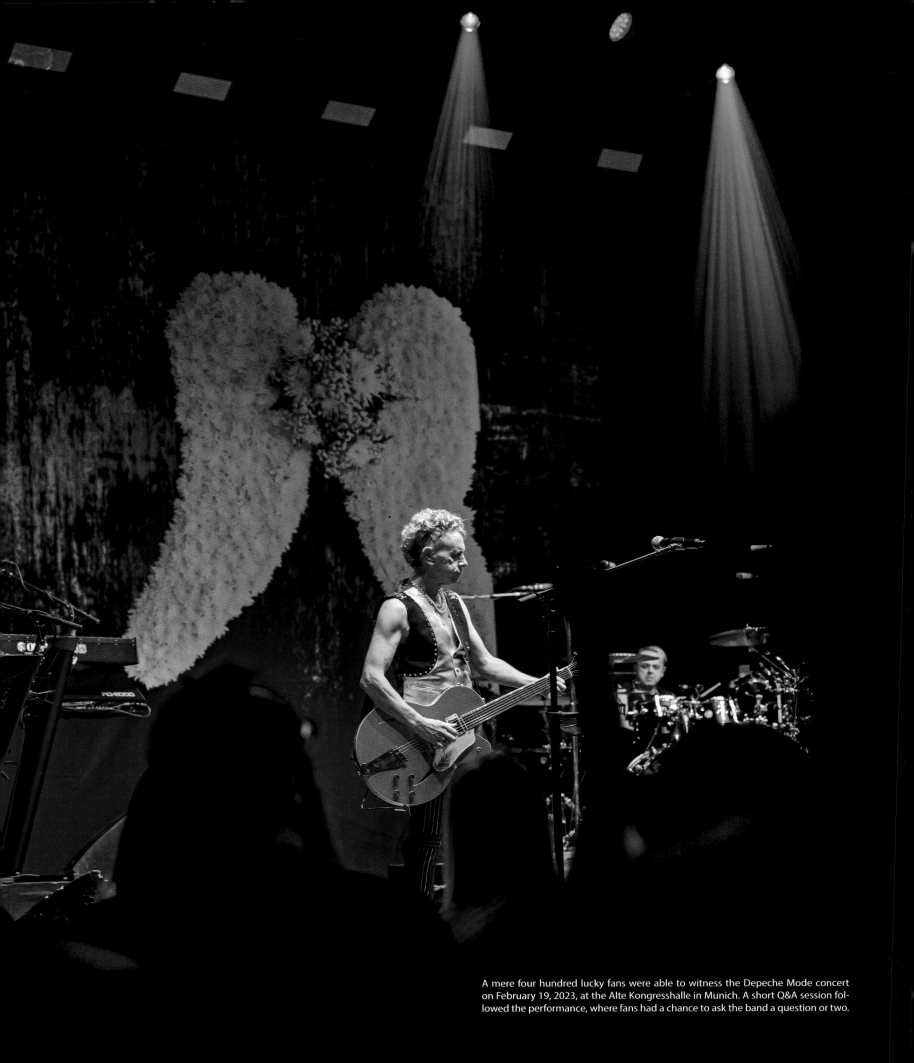

A mere four hundred lucky fans were able to witness the Depeche Mode concert on February 19, 2023, at the Alte Kongresshalle in Munich. A short Q&A session followed the performance, where fans had a chance to ask the band a question or two.

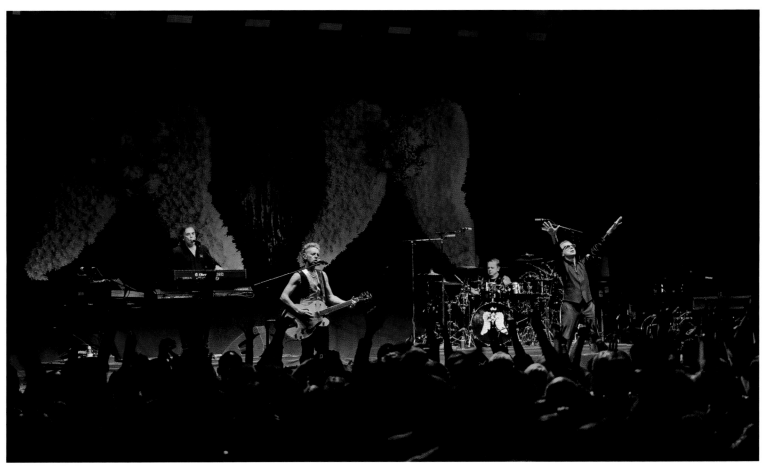

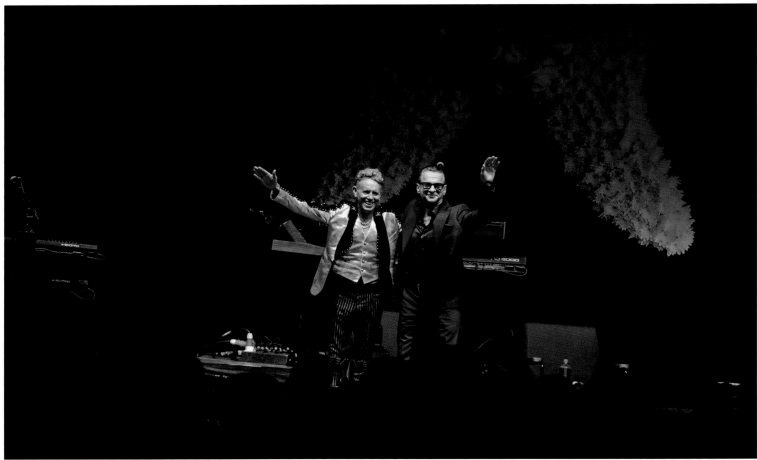

Depeche Mode—Pop-Up Bus Tour

In March, for the release of the new Depeche Mode album and to promote the upcoming concerts in Germany, the band and Columbia Records sent a vintage double-decker bus through the country. The vehicle, decorated in the style of *Memento Mori*, made a total of eight stops in larger German cities, at times drawing massive crowds and long lines. The bus carried exclusive merchandise as well as different versions of the new record. Fans patiently withstood hours-long waits to finally get their hands on the coveted wares, some of which were limited editions.

Some fans also got the chance to take special souvenir shots in the *Memento Mori* photo booth, with the album cover projected behind them. Those who uploaded photos to the website www.dm-mm-2023.de were automatically entered into a lottery, with the hope of landing a personal meeting with Dave and Martin, as well as tickets to the Leipzig show.

Parallel to the pop-up bus tour, record release parties were organized in Hamburg, Berlin, and Dresden.

Following their promotional dates in Europe, Depeche Mode returned to the US for a guest performance of "Ghosts Again" and "Personal Jesus" on CBS's *Late Show with Stephen Colbert.* A "secret rehearsal show" at SIR Studios in Los Angeles followed the next day, an eight-song set for which local radio stations gave away a small number of tickets. Depeche Mode finished rehearsing at Oakland Arena two days before the start of the tour. After that, it was flight cases packed and the team headed to Sacramento for the first official Depeche Mode show since 2018.

Some of the winners of a meet and greet with Martin and Dave in Leipzig on May 26, 2023.

In March 2023, the Depeche Mode "pop-up bus" toured a number of German cities, bringing crowds and long lines with it, as on March 26, 2023, at Kurt-Masur-Platz in Leipzig (below).

Memento Mori Tour, 2023

With 1.5 million tickets sold in February of 2023, even before the first show, concert promoter Live Nation booked an additional twenty-nine shows in North America for that fall. The official start of the tour fell the same day the album came out, March 23. As in the past, and unlike most other bands, when Depeche Mode went on tour, only a few concertgoers knew the songs off the new record ahead of time.

Though six years had passed since their last record, *Memento Mori* immediately leaped to number 1 on the album charts in Germany. Fans' love for the band was the same as always.

A crowd of fans traveled from Germany to Sacramento for the start of the tour. This time, Anton Corbijn's stage design consisted of a single huge *M* set center stage, in reference to the album title, and three screens. Peter Gordeno played bass guitar on the opening number, "My Cosmos Is Mine," an uncommon sight at a Depeche Mode concert but one that made the song even more dynamic. For the first time, drummer Christian Eigner was no longer positioned center stage in the back, but on the right, in Fletcher's former spot. This gave Dave more room, something he put to full use in his performance. One absolute highlight of the evening was Andy's favorite song, "World in My Eyes," during which his picture—a portrait taken by Anton Corbijn from 1990—appeared on-screen. Dave sang "Sister of Night" for the first time, a tune that he had sung on the album *Ultra* from 1996 but only Martin had sung live to date. An intimate version of "Waiting for the Night" was another highlight, with Martin and Dave singing together at the edge of the stage for the encore. In another first, Christian Eigner switched off the drums and played keys during the song.

The set list had twenty-three songs in total, ranging all the way from "Just Can't Get Enough" to songs off the current album.

Even with thousands attending every show, Dave didn't miss a single detail. In between songs at their March 30 show in Las Vegas, he spotted a young girl on the side of the stage holding a sign up that it was her first Depeche Mode show, and her thirteenth birthday to boot. Sure enough, the singer led the crowd in "Happy Birthday," with thousands singing along, and Peter Gordeno brought her a guitar pick as a present.

Meanwhile, it had become something of a small tradition for friends of the band to be invited to their shows at New York's Madison Square Garden. On April 14, Richard Butler was in attendance; he had cowritten four songs for the album with Martin. The opening act was also something to celebrate: Dave's daughter playing with her own band, Stella Rose & the Dead Language.

Depeche Mode played a total of ten shows on the first leg of the tour in North America. After a four-week pause, they headed off to Europe in mid-May for a longer stadium tour.

They picked back up on May 16 and May 18 with two shows in Amsterdam. Through August they played thirty-six dates across twenty-one countries. Seven were in Germany—more than any other European country, as had been the case for decades.

The third leg of the tour began in late September with two concerts in Mexico City, which had become one of the band's strongholds. The tour then continued through the US and Canada up until mid-December, finishing with four shows in Los Angeles. As of this writing, the tour will continue into 2024; it's not just fans in South America and Asia who are waiting!

With their new album *Memento Mori* and the touring for it so far, Martin and Dave have demonstrated that throughout all the adversity, Depeche Mode is still a force to be reckoned with. It's a privilege for fans to be able to accompany the band along the way.

The first show in Germany on the *Memento Mori* tour was in Leipzig, on May 26. It was a special stop in a number of respects; thirty years before, on June 19, 1993, Depeche Mode had played their first show after the Berlin Wall fell at the same venue in Leipzig, at a time when Alan Wilder was still in the band. May 26

The apple doesn't fall too far from the tree: Stella Rose Gahan.

also marked a year to the day since Andy Fletcher had unexpectedly passed away. For the 70,000 fans gathered, this made seeing Fletch's picture all the more emotional when it was projected during "World in My Eyes," many watching with tears in their eyes. The song that followed, "Wrong," almost felt like it was directed against the universe itself.

Following the first encore of "Waiting for the Night," Dave had a few moving words about what made that date special: "We just want to acknowledge that tonight is one year since we lost our friend Andrew Fletcher. And we know that he would love this and would love to have been here with you all tonight. So let's all just remember him in our hearts, please. Thank you."

The upbeat "Just Can't Get Enough" that followed may not have seemed appropriate to everyone in the audience, but over the last tours the main hook had been played by Fletch, "the best one-finger keyboardist in the world," as he ironically dubbed himself. It was an incredible night on the *Memento Mori* tour, one which won't be soon forgotten.

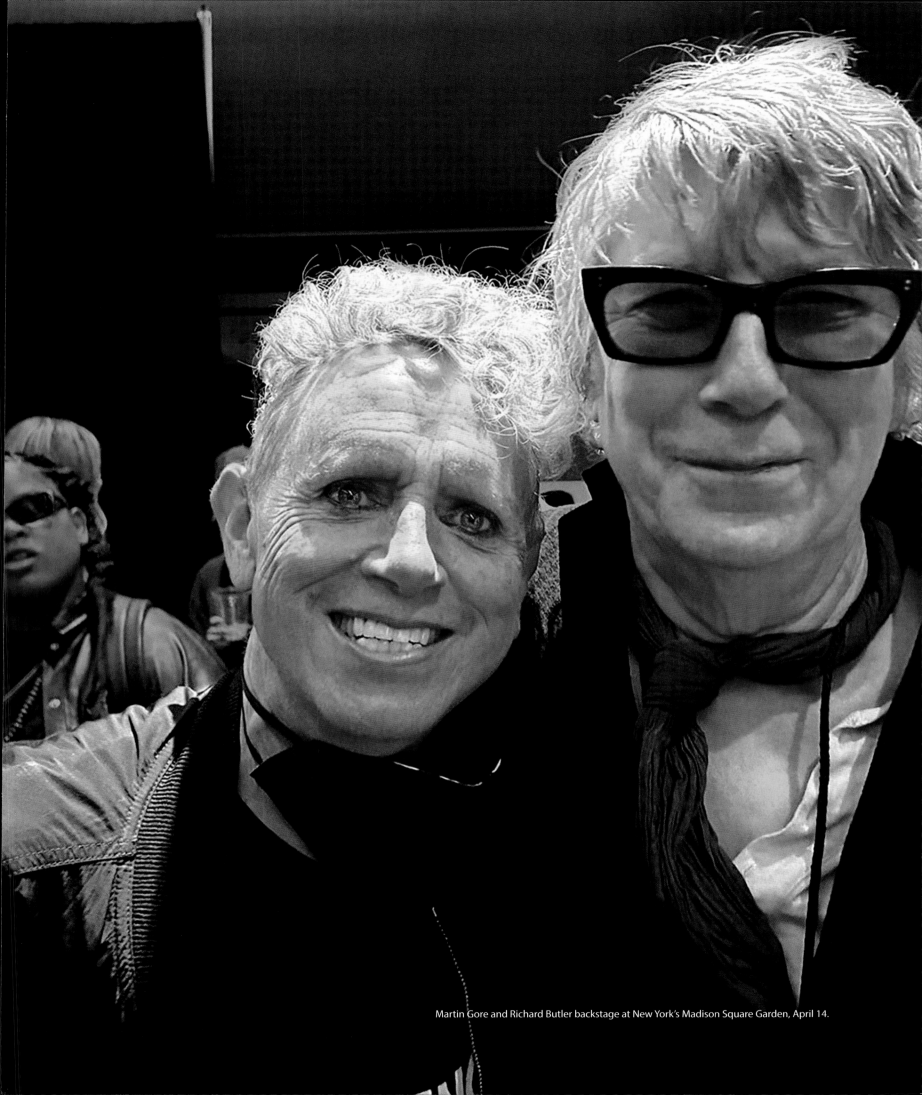

Martin Gore and Richard Butler backstage at New York's Madison Square Garden, April 14.

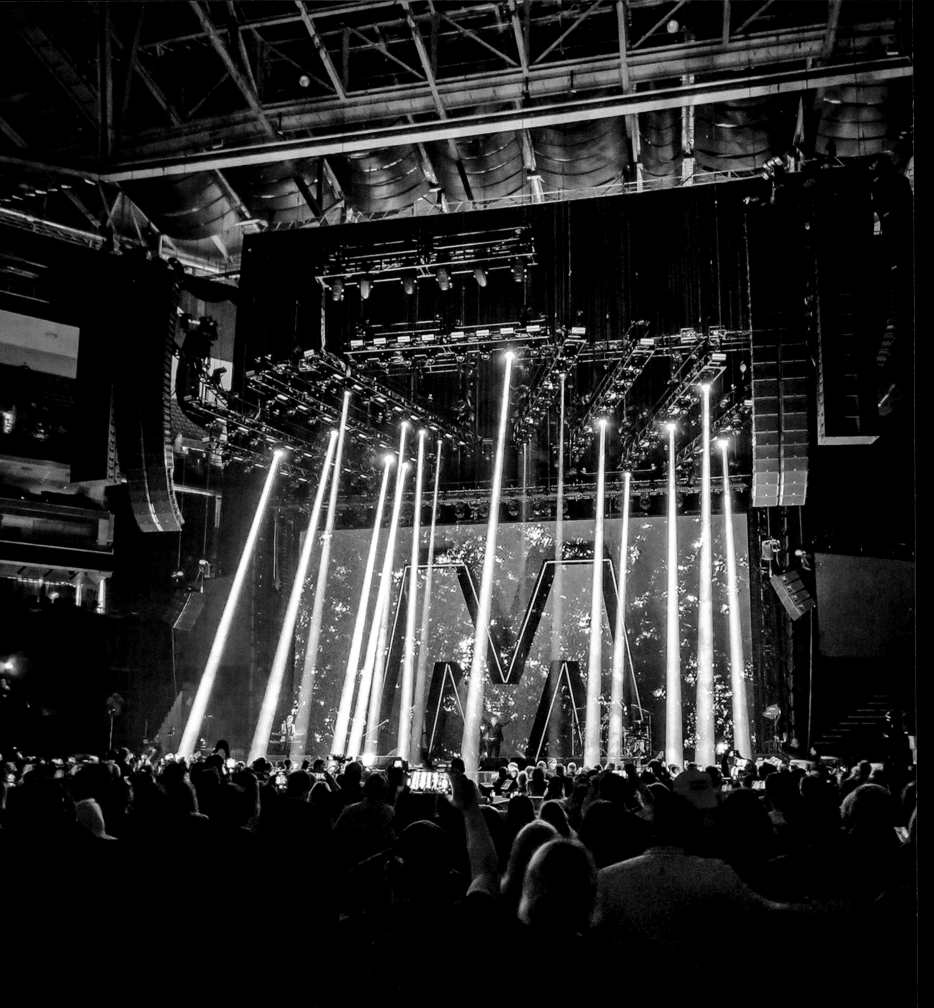

The tour's opening show in Sacramento.

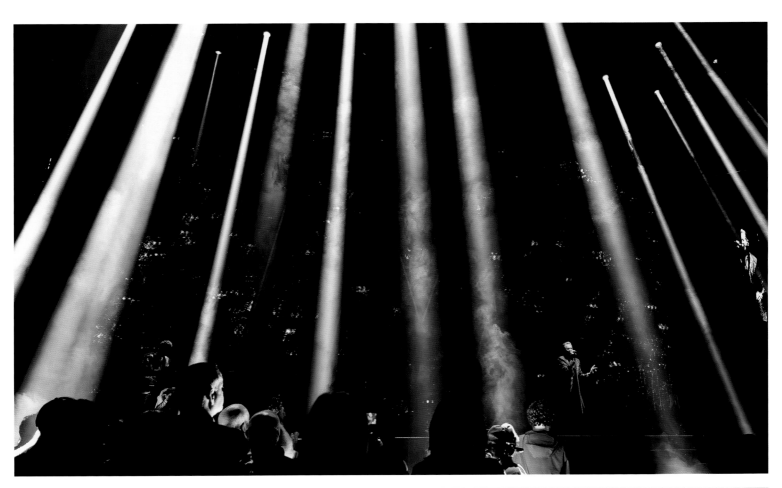

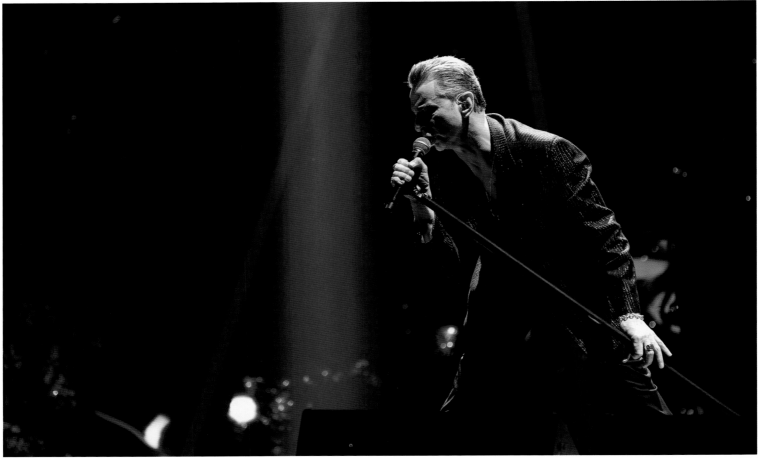

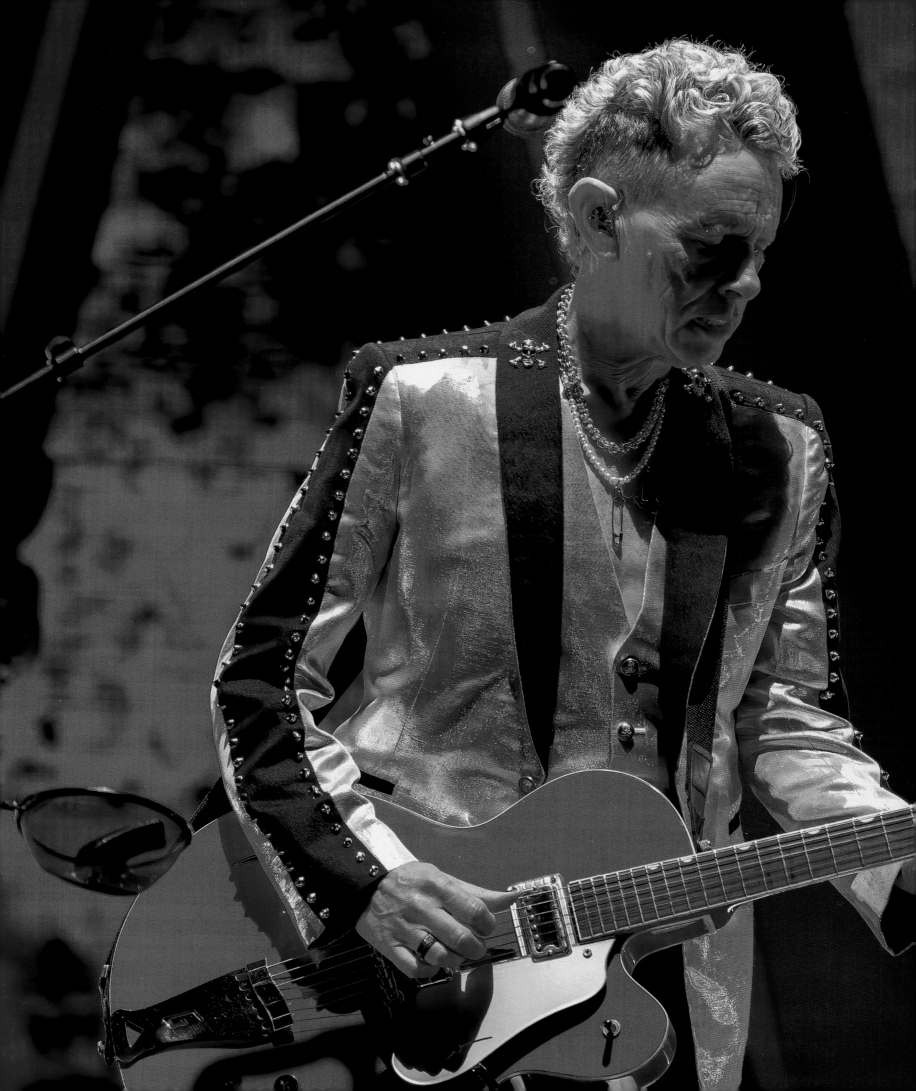

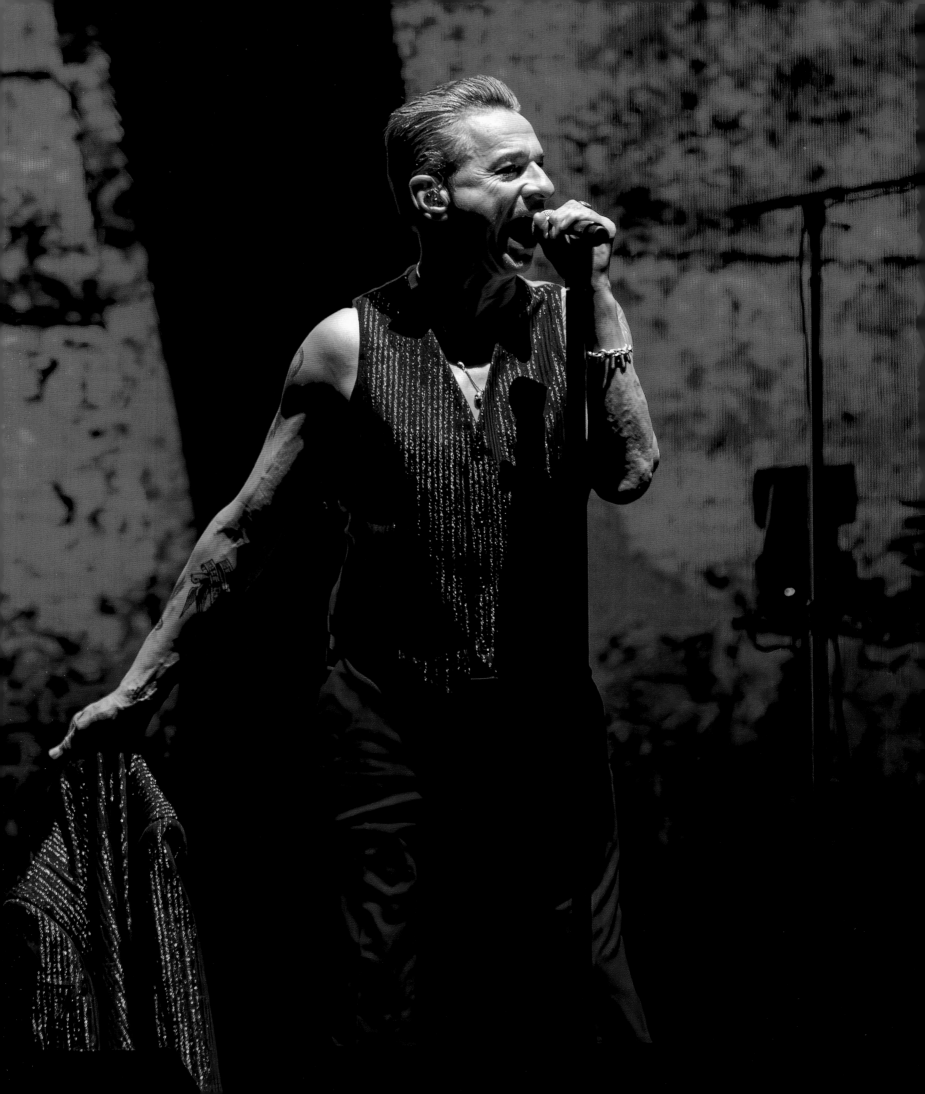

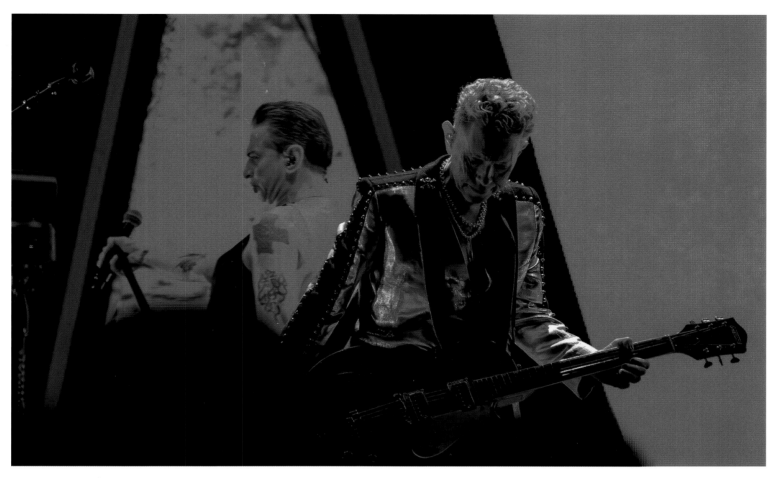

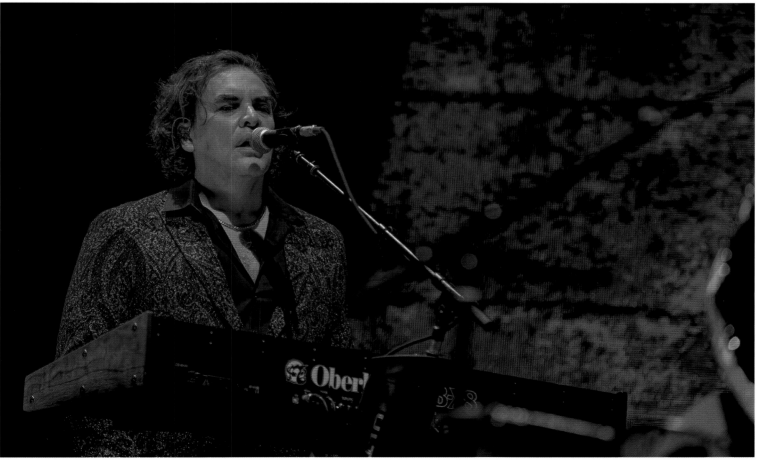

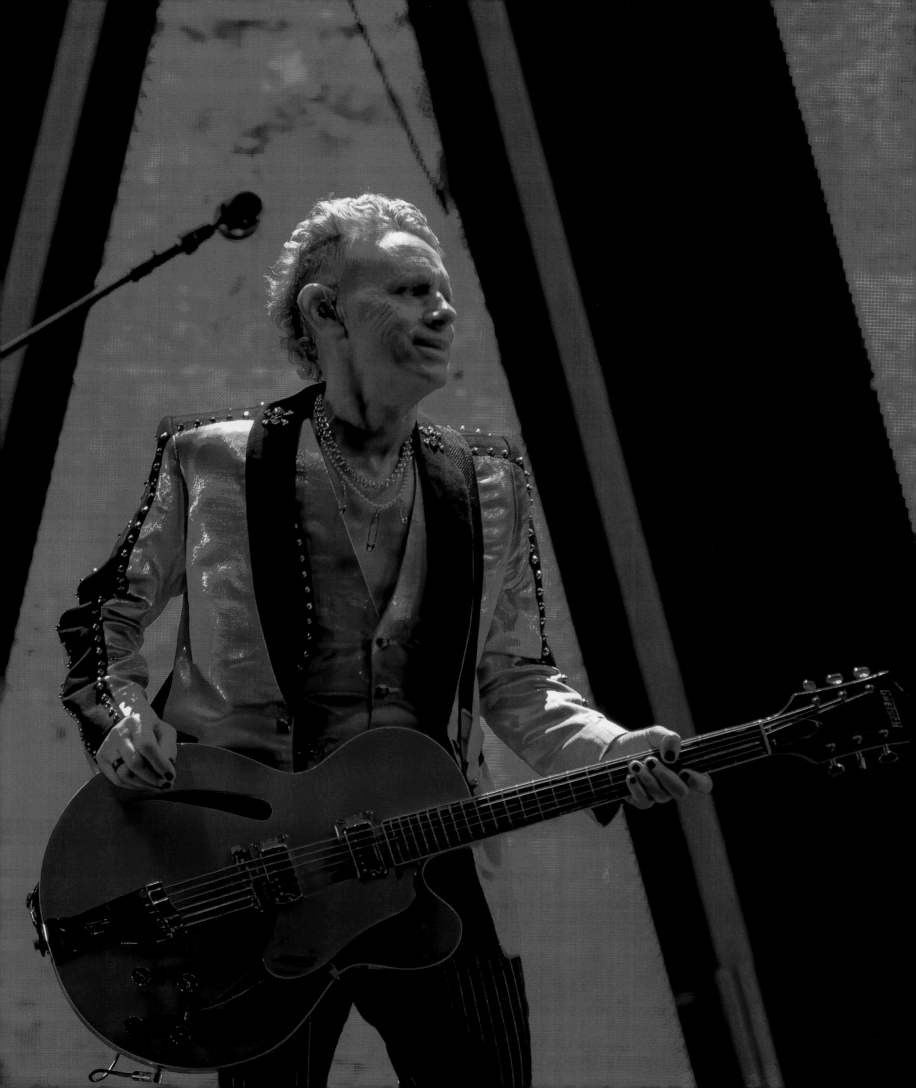

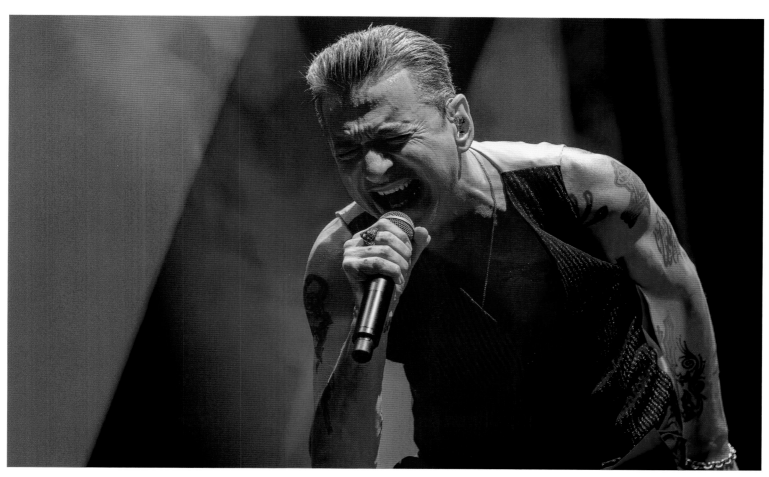

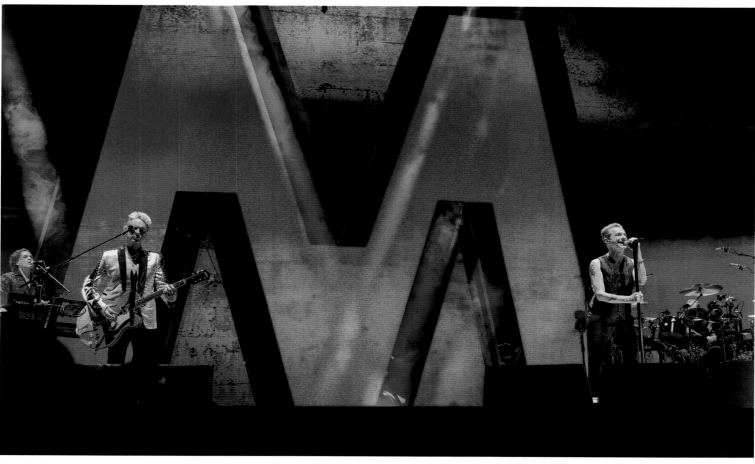

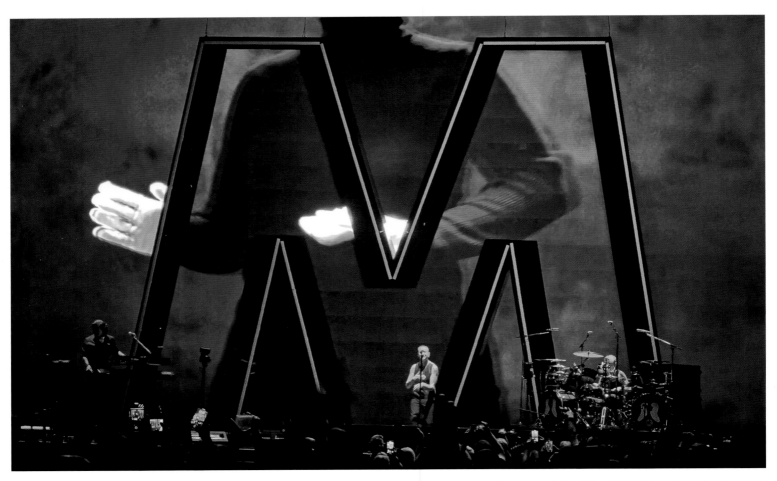

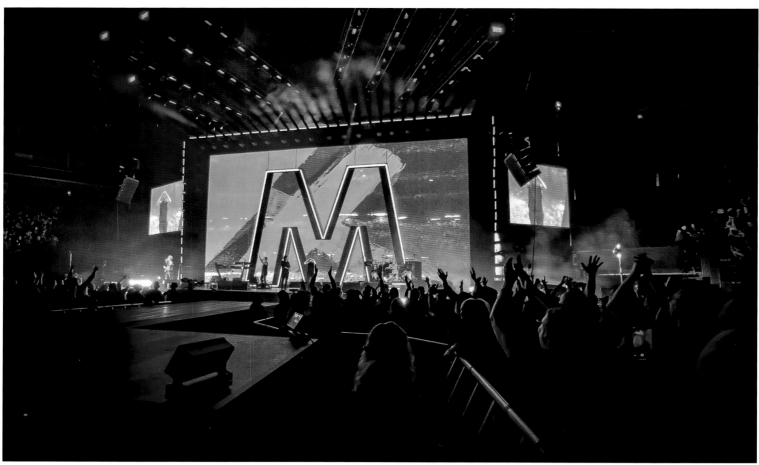

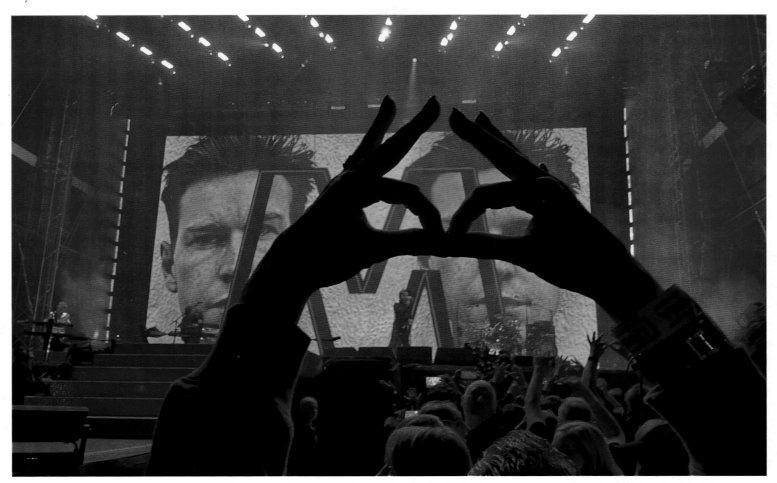

The show in Leipzig on May 26, 2023, took place exactly one year to the day after Fletch's death, a highly emotional event for both the band and their fans.

This pass is part of an early entry package for holders of "front-of-stage" (FOS) tickets. The limited packages were distributed on-site and included a game involving a card and dice. Fans with these packages were also allowed to enter the venues early, thus assuring them of getting some of the best seats in the house.

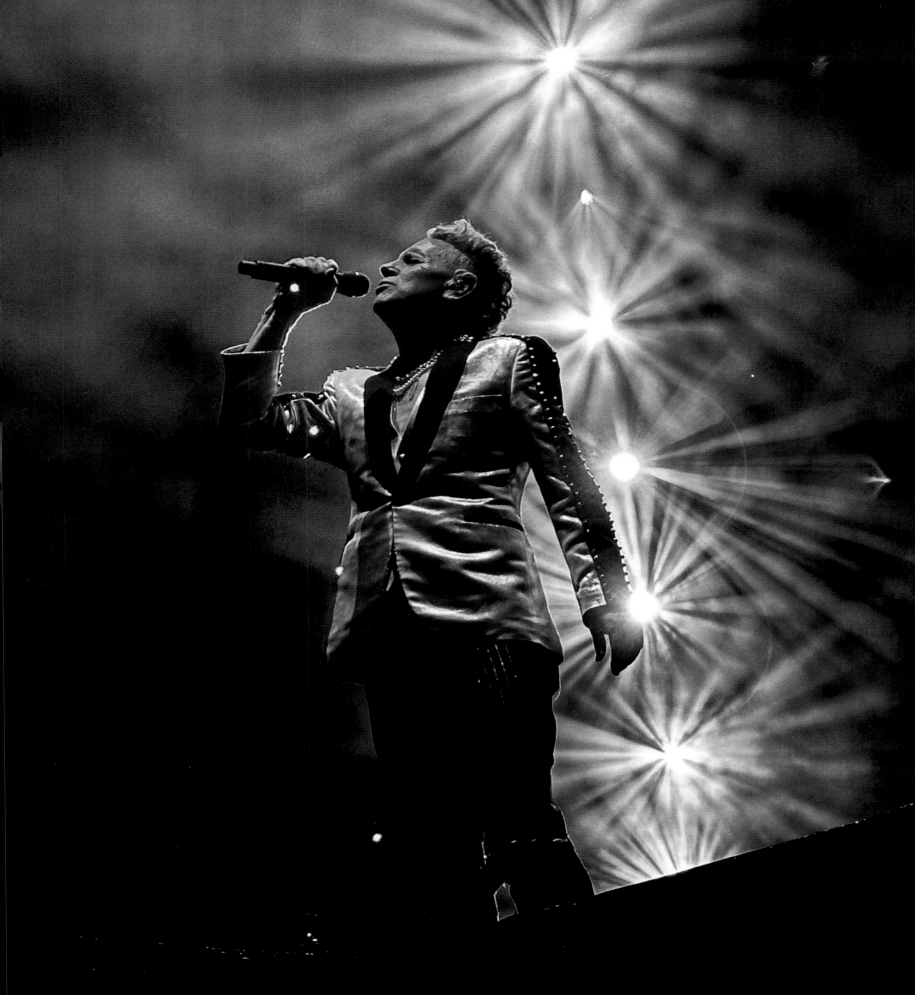

The concert at the Festwiese in Leipzig was a flood of emotions.

Tour Dates, 1980–2024

EARLY TOURING, 1980–81

06/14/1980—Basildon, St. Nicholas School
06/21/1980—Southend-on-Sea, Top Alex

07/02/1980—Southend-on-Sea, Top Alex

08/16/1980—Rayleigh, Croc's
08/30/1980—Rayleigh, Croc's

09/20/1980—Rayleigh, Croc's
09/24/1980—London, Bridge House

10/11/1980—Rayleigh, Croc's
10/16/1980—London, Bridge House
10/23/1980—London, Bridge House
10/25/1980—Rayleigh, Croc's
10/29/1980—London, Ronnie Scott's
10/30/1980—London, Bridge House

11/08/1980—Rayleigh, Croc's
11/11/1980—London, Bridge House
11/14/1980—Southend-on-Sea, Technical College
11/29/1980—Rayleigh, Croc's

12/01/1980—London, Bridge House
12/10/1980—London, Bridge House
12/18/1980—London, the Venue
12/19/1980—London, Music Machine
12/28/1980—London, Bridge House

01/03/1981—Rayleigh, Croc's
01/06/1981—London, Bridge House
01/11/1981—London, Hope & Anchor
01/19/1981—London, Bridge House
01/23/1981—Southend-on-Sea, Rascals
01/23/1981—London, Hope & Anchor

02/01/1981—London, Moonlight Club
02/02/1981—Leeds, Warehouse
02/03/1981—Sheffield, Limit Club
02/09/1981—London, Bridge House
02/12/1981—London, Moonlight Club
02/14/1981—London, the Rainbow
02/16/1981—London, Cabaret Futura
02/26/1981—London, Lyceum Ballroom

03/16/1981—London, Bridge House
03/24/1981—London, Moonlight Club
03/29/1981—London, Lyceum Ballroom
03/30/1981—Dartford, Flicks

04/02/1981—Southend-on-Sea, Technical College
04/04/1981—London, Thames Boat Trip
04/06/1981—London, Bridge House
04/11/1981—Rayleigh, Croc's
04/12/1981—London, Bridge House
04/16/1981—Leeds, Amnesia
04/21/1981—London, the Embassy Club
04/23/1981—Birmingham, Cedar Ballroom
04/26/1981—London, Lyceum Ballroom
04/28/1981—Basildon, Sweeneys
04/30/1981—London, the Pits

05/01/1981—London, South Bank Poly
05/03/1981—Basildon, Raquel's
05/09/1981—Cardiff, Nero's
05/12/1981—London, the Venue
05/25/1981—Dartford, Flicks

06/01/1981—London, Bridge House
06/02/1981—London, Hammersmith Palais
06/09/1981—Chadwell Heath, Regency Suite
06/11/1981—London, BBC Radio 1 Studio
06/27/1981—Rayleigh, Croc's

07/23/1981—London, the Venue
07/25/1981—Den Haag, Zuiderpark
07/29/1981—London, Bridge House
07/30/1981—Slough, Alexandra's Bar

08/02/1981—Brighton, Jenkinsons

08/05/1981—Manchester, Rafters
08/06/1981—Leeds, Warehouse
08/07/1981—Edinburgh, Nite Club
08/26/1981—London, ICA

09/19/1981—London, the Venue
09/25/1981—Hamburg, Markthalle
09/26/1981—Amsterdam, Paradiso
09/28/1981—Brussels, Disco Rojo
09/29/1981—Paris, Les Bains Douches

10/16/1981—Richmond, Christ's School
10/19/1981—Bristol, Lawrence Weston School

SPEAK & SPELL TOUR, 1981

10/31/1981—Newcastle, University

11/02/1981—Edinburgh, Coasters
11/03/1981—Manchester, Fagins
11/04/1981—Birmingham, Locarno
11/05/1981—Nottingham, Rock City
11/06/1981—Liverpool, University
11/07/1981—Sheffield, Sheffield City Polytechnic
11/09/1981—Bristol, Locarno
11/10/1981—Basildon, Raquel's
11/11/1981—Brighton, Top Rank Suite
11/12/1981—Poole, Arts Centre
11/14/1981—Leicester, Leicester University
11/15/1981—London, Lyceum Ballroom
11/16/1981—London, Lyceum Ballroom

12/03/1981—Chichester, Chichester Festival Theatre

"SEE YOU" TOUR, 1982

01/20/1982—Rayleigh, Croc's
01/22/1982—New York, the Ritz
01/23/1982—New York, the Ritz

02/10/1982—London, Paris Theatre BBC Studios
02/12/1982—Cardiff, Top Rank
02/13/1982—London, Hammersmith Odeon
02/14/1982—Portsmouth, Guildhall
02/15/1982—Bath, the Pavilion
02/16/1982—Exeter, University
02/18/1982—Hanley, Victoria Hall
02/19/1982—Leeds, Leeds Metropolitan University
02/20/1982—Newcastle, Newcastle City Hall
02/21/1982—Glasgow, Tiffany's
02/22/1982—Hull, Tower Cinema
02/24/1982—Norwich, Norwich U.E.A.
02/25/1982—Canterbury, University of Kent
02/26/1982—Oxford, Polytechnic
02/27/1982—London, Bridge House
02/28/1982—London, Hammersmith Odeon

03/05/1982—Madrid, Rock-Ola
03/06/1982—Madrid, Rock-Ola
03/20/1982—Stockholm, the Ritz
03/24/1982—Hamburg, Trinity
03/25/1982—Hanover, Ballroom Blitz
03/26/1982—Berlin, Metropol
03/28/1982—Rotterdam, De Lantaren
03/30/1982—Oberkorn, Rainbow Club

04/02/1982—Paris, Le Palace
04/03/1982—Brussels, Volksbelang
04/10/1982—St. Helier, Fort Regent
04/12/1982—Guernsey, Beau Sejour

05/07/1982—New York, the Ritz
05/08/1982—Philadelphia, East Side Club
05/09/1982—Toronto, Concert Hall
05/10/1982—Chicago, Stages
05/12/1982—Vancouver, Commodore Ballroom
05/14/1982—San Francisco, Kabuki Night Club
05/15/1982—Pasadena, Perkins Palace
05/16/1982—Los Angeles, the Roxy

A BROKEN FRAME TOUR, 1982–83

10/04/1982—Chippenham, Golddiggers
10/06/1982—Dublin, National Stadium
10/07/1982—Cork, Cork City Hall
10/08/1982—Galway, Leisureland
10/10/1982—Southampton, Gaumont Empire
10/11/1982—Leicester, De Montfort Hall
10/12/1982—Brighton, the Dome
10/13/1982—Westcliff-on-Sea, Cliffs Pavilion
10/15/1982—Bristol, Colston Hall
10/16/1982—Birmingham, Odeon Theatre
10/17/1982—Birmingham, Odeon Theatre
10/19/1982—Glasgow, Tiffany's
10/20/1982—Edinburgh, Playhouse
10/21/1982—Newcastle, Newcastle City Hall
10/22/1982—Liverpool, Liverpool Empire Theatre
10/24/1982—London, Hammersmith Odeon
10/25/1982—London, Hammersmith Odeon
10/27/1982—Manchester, Manchester Apollo
10/28/1982—Sheffield, Sheffield City Hall
10/29/1982—St. Austell, Cornwall Coliseum

11/24/1982—Stockholm, Casablanca
11/25/1982—Stockholm, Draken
11/26/1982—Copenhagen, Saltlagret
11/28/1982—Bochum, Zeche
11/29/1982—Cologne, Stadthalle
11/30/1982—Hamburg, Musikhalle

12/02/1982—Hanover, Ballroom Blitz
12/03/1982—Berlin, Metropol
12/04/1982—Goslar, Odeon
12/05/1982—Munich, Alabamahalle
12/07/1982—Stuttgart, Oz
12/09/1982—Saarbrücken, Universität
12/10/1982—Minden, Studio M
12/12/1982—Brussels, Le Mirano
12/14/1982—Utrecht, Muziekcentrum

02/07/1983—Frankfurt, Messehalle

03/24/1983—New York, the Ritz
03/25/1983—Toronto, Music Hall
03/26/1983—Chicago, Aragon Ballroom
03/28/1983—Vancouver, Commodore Ballroom
03/29/1983—San Francisco, Kabuki Night Club
03/30/1983—Los Angeles, Beverly Theatre

04/02/1983—Tokyo, Tsubaki House
04/03/1983—Tokyo, New Latin Quarter
04/06/1983—Hong Kong, A.C. Hall
04/09/1983—Bangkok, Napalai Convention Hall
04/10/1983—Bangkok, Napalai Convention Hall

05/28/1983—Schüttorf, Vechtewiese, 4th Schüttorf Open-Air

CONSTRUCTION TIME AGAIN TOUR, 1983–84

09/07/1983—Hitchin, the Regal Theatre
09/09/1983—Dublin, SFX City Theatre
09/10/1983—Belfast, Ulster Hall
09/12/1983—Bristol, Colston Hall
09/13/1983—Brighton, the Dome
09/14/1983—Southampton, Gaumont Empire
09/15/1983—Coventry, Apollo
09/16/1983—Sheffield, Sheffield City Hall
09/18/1983—Aberdeen, Capitol Theatre
09/19/1983—Edinburgh, Edinburgh Playhouse
09/20/1983—Glasgow, Tiffany's
09/21/1983—Newcastle, Newcastle City Hall
09/23/1983—Liverpool, Liverpool Empire Theatre
09/24/1983—Manchester, Manchester Apollo
09/25/1983—Nottingham, Royal Concert Hall
09/26/1983—Hanley, Victoria Hall
09/28/1983—Birmingham, Odeon Theatre
09/30/1983—Cardiff, St. David's Hall

10/01/1983—Oxford, Apollo Theatre
10/03/1983—Portsmouth, Portsmouth Guildhall
10/06/1983—London, Hammersmith Odeon
10/07/1983—London, Hammersmith Odeon
10/08/1983—London, Hammersmith Odeon

12/01/1983—Stockholm, Draken

12/02/1983—Copenhagen, Saga
12/03/1983—Lund, Akademiska Föreningen
12/05/1983—Antwerp, Hof Ter Lo
12/06/1983—Amsterdam, Paradiso
12/08/1983—Berlin, Deutschlandhalle
12/10/1983—Mannheim, Rosengarten Musensaal
12/11/1983—Saarbrücken, Universität
12/12/1983—Sindelfingen, Ausstellungshalle
12/13/1983—Neu-Isenburg, Hugenottenhalle
12/15/1983—Cologne, Sartory Saal
12/16/1983—Düsseldorf, Philips Halle
12/17/1983—Borken, Stadthalle
12/19/1983—Münster, Münsterlandhalle
12/20/1983—Bremen, Stadthalle
12/21/1983—Hamburg, Musikhalle
12/22/1983—Hamburg, Musikhalle
12/23/1983—Hamburg, Musikhalle

02/03/1984—Birmingham, Odeon Theatre

03/05/1984—Bologna, Teatro Tenda
03/06/1984—Milan, Orfeo Music Hall
03/08/1984—Valencia, Pacha Club
03/09/1984—Barcelona, Studio 54
03/10/1984—Madrid, Universidad Politécnica

06/02/1984—Ludwigshafen, Südwest Stadion, SWF3 Open-Air '84

SOME GREAT REWARD TOUR, 1984–85

09/27/1984—St. Austell, Cornwell Coliseum
09/28/1984—Hanley, Victoria Hall
09/29/1984—Liverpool, Liverpool Empire Theatre

10/01/1984—Oxford, Apollo Theatre
10/02/1984—Nottingham, Royal Concert Hall
10/04/1984—Dublin, SFX City Theatre
10/05/1984—Dublin, SFX City Theatre
10/06/1984—Belfast, Ulster Hall
10/08/1984—Manchester, Manchester Apollo
10/09/1984—Gloucester, Leisure Centre
10/10/1984—Cardiff, St. David's Hall
10/12/1984—Birmingham, Odeon Theatre
10/13/1984—Birmingham, Odeon Theatre
10/14/1984—Blackburn, King George's Hall
10/16/1984—Glasgow, Barrowlands
10/17/1984—Aberdeen, Capitol Theatre
10/18/1984—Edinburgh, Edinburgh Playhouse
10/19/1984—Sheffield, Sheffield City Hall
10/20/1984—Newcastle, Newcastle City Hall
10/22/1984—Bristol, Colston Hall
10/23/1984—Brighton, the Dome
10/24/1984—Portsmouth, Portsmouth Guildhall
10/27/1984—Ipswich, Gaumont Theatre
10/29/1984—Leicester, De Montfort Hall
10/30/1984—Southhampton, Gaumont Empire

11/01/1984—London, Hammersmith Odeon
11/02/1984—London, Hammersmith Odeon
11/03/1984—London, Hammersmith Odeon
11/04/1984—London, Hammersmith Odeon
11/15/1984—Copenhagen, Folketeatret
11/16/1984—Stockholm, Eriksdalshallen
11/17/1984—Lund, Olympen
11/18/1984—Oslo, Skedsmohallen
11/20/1984—Essen, Grugahalle
11/21/1984—Ludwigshafen, Friedrich Ebert Halle
11/22/1984—Siegen, Siegerlandhalle
11/23/1984—Freiburg, Stadthalle
11/26/1984—Florence, Teatro Tenda
11/27/1984—Bologna, Teatro Tenda
11/28/1984—Milan, Teatro Tenda
11/30/1984—Basel, St. Jakobshalle

12/01/1984—Munich, Deutsches Museum
12/03/1984—Berlin, Deutschlandhalle
12/04/1984—Hanover, Eilenriedehalle
12/05/1984—Münster, Münsterlandhalle
12/07/1984—Oldenburg, Weser Ems Halle
12/08/1984—Kiel, Ostseehalle
12/09/1984—Hamburg, Alsterdorfer Sporthalle
12/11/1984—Böblingen, Sporthalle
12/12/1984—Offenbach, Stadthalle

12/13/1984—Düsseldorf, Philips Halle
12/14/1984—Hamburg, Alsterdorfer Sporthalle
12/15/1984—Amsterdam, Carre Theatre
12/16/1984—Rotterdam, De Doelen
12/17/1984—Paris, Palais Omnisport de Paris-Bercy
12/18/1984—Deinze, Zaal Brielport

03/14/1985—Washington, DC, Warner Theatre
03/15/1985—New York, Beacon Theatre
03/16/1985—Boston, Orpheum Theatre
03/18/1985—Montreal, Le Spectrum
03/19/1985—Toronto, Massey Hall
03/20/1985—Detroit, Royal Oak Theatre
03/22/1985—Chicago, Aragon Ballroom
03/23/1985—Rock Island, Augustana College
03/24/1985—Carbondale, Shyrock Auditorium
03/26/1985—Houston, Cullen Auditorium
03/27/1985—Dallas, Bronco Bowl
03/30/1985—Los Angeles, Hollywood Palladium
03/31/1985—Laguna Hills, Meadows Amphitheater

04/01/1985—San Diego, Sports Arena
04/03/1985—Oakland, Kaiser Convention Center
04/07/1985—Tokyo, Koseinenkin Hall
04/08/1985—Tokyo, Nakano Sun Plaza
04/09/1985—Osaka, Koseinenkin Hall
04/12/1985—Tokyo, Nakano Sun Plaza

07/06/1985—Torhout, Torhout Festival
07/07/1985—Werchter, Werchter Festival
07/09/1985—Nice, Theatre de Verdure
07/11/1985—Lyon, Halle Tony Garnier
07/13/1985—Brest, Rockscene Festival
07/23/1985—Budapest, Volán Stadium
07/26/1985—Athens, Panathinaiko Stadium
07/30/1985—Warsaw, Torwar Hall

BLACK CELEBRATION TOUR, 1986

03/29/1986—Oxford, Apollo Theatre
03/31/1986—Brighton, Conference Centre

04/02/1986—Dublin, RDS Stadium
04/04/1986—Belfast, Maysfield Centre
04/06/1986—Glasgow, Scottish Event Center
04/07/1986—Whitley Bay, Ice Rink
04/09/1986—Birmingham, NEC
04/10/1986—Birmingham, NEC
04/12/1986—Manchester, Apollo
04/13/1986—Bristol, Hippodrome
04/14/1986—Bournemouth, International Centre
04/16/1986—London, Wembley Arena
04/17/1986—London, Wembley Arena
04/24/1986—Oslo, Skedsmohallen
04/25/1986—Gothenburg, Sweden
04/26/1986—Stockholm, Ice Stadium
04/28/1986—Copenhagen, Valby-Hallen
04/29/1986—Hanover, Eilenriedehalle
04/30/1986—Aachen, Eurogress

05/02/1986—Stuttgart, Hanns Martin Schleyer Halle
05/03/1986—Munich, Rudi Sedlmayer Halle
05/04/1986—Zürich, Hallenstadion
05/06/1986—Paris, Palais Omnisport de Paris-Bercy
05/07/1986—Paris, Palais Omnisport de Paris-Bercy
05/08/1986—Lyon, Palais des Sports de Gerland
05/10/1986—Brussels, Forest National
05/11/1986—Düsseldorf, Philips Halle
05/13/1986—Ludwigshafen, Friedrich Ebert Halle
05/14/1986—Saarbrücken, Saarlandhalle
05/16/1986—Hamburg, Alsterdorfer Sporthalle
05/17/1986—Hamburg, Alsterdorfer Sporthalle
05/18/1986—Berlin, Waldbühne
05/20/1986—Münster, Münsterlandhalle
05/21/1986—Bremen, Stadthalle
05/22/1986—Dortmund, Westfalenhalle
05/24/1986—Rotterdam, Ahoi
05/25/1986—Rüsselsheim, Walter Köbel Halle

06/01/1986—Boston, Wang Center
06/03/1986—Philadelphia, Tower Theatre
06/04/1986—Philadelphia, Tower Theatre
06/06/1986—New York, Radio Music Hall

06/07/1986—New York, Radio Music Hall
06/08/1986—New York, Radio Music Hall
06/10/1986—Cleveland, Blossom Music Festival
06/12/1986—Rochester, Finger Lakes Performing Arts Center
06/13/1986—Wantagh, Jones Beach Theater
06/14/1986—Columbia, Merriweather Post Pavilion
06/17/1986—Montreal, Verdun Auditorium
06/18/1986—Toronto, Kingswood Music Theatre
06/20/1986—Toronto, Kingswood Music Theatre
06/21/1986—Clarkston, Pine Knob Music Theatre
06/22/1986—Chicago, Poplar Creek Music Theatre
06/24/1986—Saint Paul, Civic Center
06/26/1986—Fort Young, Will Rogers Memorial Center
06/28/1986—Austin, City Coliseum
06/29/1986—Houston, Southern Star Amphitheater

07/01/1986—Denver, Red Rocks Amphitheater
07/03/1986—Salt Lake City, Park West Amphitheater
07/05/1986—Berkeley, Greek Theatre
07/06/1986—Mountain View, Shoreline Amphitheatre
07/08/1986—Vancouver, Labatt's Expo Theatre
07/11/1986—San Diego, San Diego Sports Arena
07/13/1986—Los Angeles, the Forum
07/14/1986—Irvine Meadows Amphitheatre
07/15/1986—Irvine Meadows Amphitheatre
07/21/1986—Osaka, Festival Hall
07/22/1986—Nagoya, Koseinenkin Hall
07/23/1986—Tokyo, NHK Hall

08/04/1986—Fréjus, Les Arenes
08/05/1986—Pietro Ligure, Stadio Comunale
08/06/1986—Rimini, Stadio Comunale
08/08/1986—Nîmes, Arenes de Nîmes
08/09/1986—Annecy, Stade de Annecy-le-Vieux
08/12/1986—Bayonne, Les Arenes
08/16/1986—Copenhagen, Valby Idrætspark

MUSIC FOR THE MASSES TOUR, 1987–88

10/22/1987—Madrid, Pabellón de la Ciudad Deportiva
10/23/1987—Barcelona, Palau Blaugrana
10/25/1987—Munich, Olympiahalle
10/26/1987—Bologna, Palasport
10/27/1987—Rome, PalaEUR
10/29/1987—Turin, PalaRuffini
10/30/1987—Milan, Pala Trussardi

11/02/1987—Stuttgart, Hanns Martin Schleyer Halle
11/03/1987—Frankfurt, Festhalle
11/04/1987—Essen, Grugahalle
11/06/1987—Cologne, Sporthalle
11/07/1987—Hanover, Messehalle
11/09/1987—Berlin, Deutschlandhalle
11/11/1987—Ludwigshafen, Friedrich Ebert Halle
11/12/1987—Zürich, Hallenstadion
11/13/1987—Lausanne, Halle des Fetes
11/16/1987—Paris, Palais Omnisport de Paris-Bercy
11/17/1987—Paris, Palais Omnisport de Paris-Bercy
11/18/1987—Paris, Palais Omnisport de Paris-Bercy

12/01/1987—San Francisco, Cow Palace
12/04/1987—Los Angeles, the Forum
12/05/1987—Los Angeles, the Forum
12/07/1987—San Diego, San Diego Sports Arena
12/08/1987—Phoenix, Compton Terrace
12/10/1987—Dallas, Reunion Arena
12/12/1987—Chicago, the Pavilion
12/14/1987—Montreal, Maple Leaf Gardens
12/15/1987—Montreal, Montreal Forum
12/17/1987—Fairfax, Patriot Center
12/18/1987—New York, Madison Square Garden

01/09/1988—Newport, Newport Centre
01/11/1988—London, Wembley Arena
01/12/1988—London, Wembley Arena
01/15/1988—Birmingham, NEC
01/16/1988—Whitley Bay, Ice Rink
01/17/1988—Edinburgh, Playhouse
01/19/1988—Manchester, G-Mex
01/20/1988—Sheffield, Sheffield City Hall
01/21/1988—Bradford, St. George's Hall
01/23/1988—Bournemouth, International Centre
01/24/1988—Brighton, Centre

02/06/1988—Hamburg, Alsterdorfer Sporthalle
02/07/1988—Hamburg, Alsterdorfer Sporthalle
02/09/1988—Dortmund, Westfalenhalle
02/10/1988—Oldenburg, Weser Ems Halle
02/12/1988—Stockholm, Ice Stadium
02/13/1988—Gothenburg, Skandinavium
02/15/1988—Oslo, Drammenshallen
02/17/1988—Copenhagen, Valby-Hallen
02/18/1988—Copenhagen, Valby-Hallen
02/19/1988—Kiel, Ostseehalle
02/21/1988—Brussels, Forest National
02/23/1988—Lille, Espace Foire
02/25/1988—Brest, Parc du Penfeld
02/26/1988—Nantes, Palais de la Beaujoire
02/27/1988—Bordeaux, Patinoire de Mériadeck
02/29/1988—Toulouse, Palais des Sports

03/01/1988—Montpellier, Le Zenith
03/02/1988—Lyon, Palais des Sports
03/04/1988—Besançon, Palais des Sports
03/05/1988—Strasbourg, Rehenus Halle
03/07/1988—East Berlin, Werner Seelenbinder Halle
03/09/1988—Budapest, Sportcsarnok
03/10/1988—Budapest, Sportcsarnok
03/11/1988—Prague, Sportovní Hala
03/13/1988—Vienna, Stadthalle

04/18/1988—Osaka, Festival Hall
04/19/1988—Nagoya, Koseinenkin Hall
04/21/1988—Tokyo, NHK Hall
04/22/1988—Tokyo, NHK Hall
04/29/1988—Mountain View, Shoreline Amphitheatre
04/30/1988—Sacramento, California Exposition & State Fair

05/02/1988—Seattle, Center Coliseum
05/04/1988—Vancouver, Pacific Coliseum
05/05/1988—Portland, Portland Civic Auditorium
05/06/1988—Portland, Portland Civic Auditorium
05/08/1988—Salt Lake City, Salt Palace Convention Center
05/09/1988—Denver, McNichols Sports Arena
05/11/1988—Austin, Frank Erwin Center
05/13/1988—Arlington, Music Mill Amphitheater
05/14/1988—Houston, Southern Star Amphitheater
05/15/1988—New Orleans, Lakefront Arena
05/17/1988—Cedar Rapids, Five Season Center
05/18/1988—Minneapolis, Northrop Auditorium
05/20/1988—Chicago, Poplar Creek Music Theatre
05/21/1988—Clarkston, Pine Knob Music Theatre
05/22/1988—Cincinnati, Riverbend Music Center
05/24/1988—Nashville, Starwood Amphitheater
05/25/1988—Atlanta, Southern Star Amphitheater
05/27/1988—Philadelphia, Spectrum
05/28/1988—Columbia, Merriweather Post Pavilion
05/30/1988—Cleveland, Blossom Music Festival

06/01/1988—East Rutherford, Brendan Byrne Arena
06/03/1988—Wantagh, Jones Beach Theater
06/04/1988—Wantagh, Jones Beach Theater
06/07/1988—Mansfield, Great Woods Amphitheater
06/08/1988—Montreal, Montreal Forum
06/09/1988—Toronto, C.N.E. Grandstand
06/11/1988—Pittsburgh, Palumbo Center
06/15/1988—Phoenix, Compton Terrace
06/18/1988—Pasadena, Rose Bowl

WORLD VIOLATION TOUR, 1990

05/28/1990—Pensacola, Civic Center
05/30/1990—Orlando, Orlando Arena
05/31/1990—Miami, Miami Arena

06/02/1990—Tampa, the Sun Dome
06/04/1990—Atlanta, Lakewood Amphitheater
06/06/1990—Columbia, Merriweather Post Pavilion
06/08/1990—Saratoga, Performing Arts Center
06/09/1990—Mansfield, Great Woods Performing Arts Center
06/10/1990—Mansfield, Great Woods Performing Arts Center
06/13/1990—Philadelphia, the Spectrum
06/14/1990—Philadelphia, the Spectrum
06/16/1990—East Rutherford, Giants Stadium
06/18/1990—New York, Radio City Music Hall
06/21/1990—Montreal, Montreal Forum

06/22/1990—Toronto, C.N.E. Grandstand
06/24/1990—Pittsburgh, Starlake Amphitheater
06/25/1990—Cincinatti, Riverbend Music Center
06/26/1990—Cleveland, Blossom Music Center
06/28/1990—Clarkston, Pine Knob Music Center
06/29/1990—Clarkston, Pine Knob Music Center
06/30/1990—Milwaukee, Marcus Amphitheater

07/02/1990—Chicago, World Music Theatre
07/03/1990—Chicago, World Music Theatre
07/05/1990—Houston, Cynthia Woods Mitchell Pavilion
07/06/1990—Houston, Cynthia Woods Mitchell Pavilion
07/08/1990—Dallas, Starplex Amphitheater
07/09/1990—Dallas, Starplex Amphitheater
07/11/1990—Denver, Red Rocks Amphitheater
07/12/1990—Denver, Red Rocks Amphitheater
07/14/1990—Calgary, Olympic Saddledome
07/16/1990—Vancouver, Pacific Coliseum
07/18/1990—Portland, Memorial Coliseum
07/20/1990—Mountain View, Shoreline Amphitheatre
07/21/1990—Mountain View, Shoreline Amphitheatre
07/25/1990—Salt Lake City, Salt Palace
07/27/1990—Phoenix, Veterans Memorial Coliseum
07/28/1990—San Diego, Sports Arena
07/29/1990—San Diego, Sports Arena
07/31/1990—San Diego, Sports Arena

08/01/1990—Universal City, Universal Amphitheater
08/04/1990—Los Angeles, Dodger Stadium
08/05/1990—Los Angeles, Dodger Stadium
08/31/1990—Sydney, Horden Pavilion

09/04/1990—Fukuoka, Shimin Kaikan Hall
09/06/1990—Kobe, World Kinen Hall
09/08/1990—Kanazawa, Ishikawa Koseinenkin
09/09/1990—Nagoya, Nagoya-Shi Kokaido
09/11/1990—Tokyo, Nippon Budokan
09/12/1990—Tokio, Nippon Budokan
09/28/1990—Brussels, Forest National
09/29/1990—Dortmund, Westfalenhalle
09/30/1990—Dortmund, Westfalenhalle

10/02/1990—Copenhagen, Valby-Hallen
10/03/1990—Copenhagen, Valby-Hallen
10/05/1990—Gothenburg, Sweden
10/06/1990—Stockholm, Globe Arena
10/08/1990—Frankfurt, Festhalle
10/09/1990—Hanover, Messehalle
10/11/1990—Lyon, Halle Tony Garnier
10/12/1990—Zürich, Hallenstadion
10/14/1990—Frankfurt, Festhalle
10/15/1990—Stuttgart, Hanns Martin Schleyer Halle
10/17/1990—Munich, Olympiahalle
10/21/1990—Paris, Palais Omnisport de Paris-Bercy
10/22/1990—Paris, Palais Omnisport de Paris-Bercy
10/23/1990—Paris, Palais Omnisport de Paris-Bercy
10/25/1990—Liévin, Stade Couvert Regional
10/26/1990—Rotterdam, Ahoy
10/28/1990—Hamburg, Alsterdorfer Sporthalle
10/29/1990—Hamburg, Alsterdorfer Sporthalle
10/31/1990—Berlin, Deutschlandhalle

11/01/1990—Berlin, Deutschlandhalle
11/03/1990—Strasbourg, Rhenus Sport Hall
11/05/1990—Barcelona, Palau Sant Jordi
11/07/1990—Madrid, Palacio de los Deportes
11/09/1990—Marseille, Palais des Sports
11/11/1990—Milan, Palatrussardi
11/12/1990—Rome, PalaEUR
11/14/1990—Bordeaux, Patinoire de Mériadeck
11/15/1990—Bordeaux, Patinoire de Mériadeck
11/17/1990—Brest, Parc du Penfeld
11/19/1990—London, Wembley Arena
11/20/1990—London, Wembley Arena
11/22/1990—Birmingham, NEC
11/23/1990—London, Wembley Arena
11/26/1990—Birmingham, NEC
11/27/1990—Birmingham, NEC

***DEVOTIONAL* TOUR, 1993**

05/19/1993—Lille, Espace Foire
05/21/1993—Zürich, Hallenstadion

05/24/1993—Brussels, Forest National
05/25/1993—Brussels, Forest National
05/27/1993—Copenhagen, Forum
05/28/1993—Gothenburg, Sweden
05/29/1993—Stockholm, Globe
05/31/1993—Hanover, Sportpark Garbsen

06/01/1993—Rotterdam, Ahoy
06/03/1993—Lausanne, Patinoire de Mallay
06/04/1993—Milan, Forum di Assago
06/07/1993—Rome, PalaEUR
06/08/1993—Florence, Palasport
06/10/1993—Nancy, Esplanade du Zenith
06/11/1993—Nuremberg, Frankenhalle
06/12/1993—Mannheim, Maimarkthalle
06/14/1993—Dortmund, Westfalenhalle
06/15/1993—Dortmund, Westfalenhalle
06/16/1993—Berlin, Waldbühne
06/18/1993—Prague, Sparta Stadium
06/19/1993—Leipzig, Festwiese
06/21/1993—Munich, Olympiahalle
06/23/1993—Vienna, Stadthalle
06/25/1993—Stuttgart, Hanns Martin Schleyer Halle
06/26/1993—Lyon, Halle Tony Garnier
06/29/1993—Paris, Palais Omnisport de Paris-Bercy
06/30/1993—Paris, Palais Omnisport de Paris-Bercy

07/03/1993—Brest, Parc Penfeld
07/05/1993—Bordeaux, Patinoire de Mériadeck
07/07/1993—Toulon, Zenith Omega
07/10/1993—Porto, Estádio das Antas
07/11/1993—Lisbon, Alvalada Stadium
07/13/1993—Pontevedra, Estadio Pasaron
07/15/1993—Madrid, Las Ventas Bullring
07/17/1993—Barcelona, Palau Sant Jordi
07/21/1993—Frankfurt, Festhalle
07/22/1993—Cologne, Sporthalle
07/24/1993—Zeebrugge, Belga Beach Festival
07/27/1993—Budapest, MTK Stadium
07/29/1993—Liévin, Stade Couvert Regional
07/31/1993—London, Crystal Palace

09/07/1993—Quebec City, Colisée de Québec
09/08/1993—Montreal, Montreal Forum
09/10/1993—Worcester, Centrum
09/12/1993—Landover, Capital Centre
09/14/1993—Hamilton, Copps Coliseum
09/15/1993—Toronto, Sky Dome
09/17/1993—Pittsburgh, Civic Arena
09/18/1993—Philadelphia, Spectrum
09/21/1993—East Rutherford, Brendan Byrne Arena
09/23/1993—New York, Madison Square Garden
09/24/1993—New York, Madison Square Garden
09/25/1993—Nassau, Veterans Memorial Coliseum
09/27/1993—Hampton, Coliseum
09/28/1993—Chapel Hill, Dean Smith Coliseum
09/29/1993—Atlanta, Omni

10/01/1993—Gainsville, O'Connell Center
10/02/1993—Miami, Miami Arena
10/03/1993—St. Petersburg, Suncoast Dome
10/05/1993—Orlando, Orlando Arena
10/08/1993—New Orleans, Lakefront Arena
10/10/1993—Houston, the Summit
10/11/1993—Houston, the Summit
10/13/1993—Dallas, Reunion Arena
10/14/1993—Dallas, Reunion Arena
10/15/1993—Austin, Frank Erwin Center
10/17/1993—St. Louis, St. Louis Arena
10/19/1993—Milwaukee, Bradley Centre
10/20/1993—Champaign, Assembly Hall
10/22/1993—Auburn Hills, the Palace of Auburn Hills
10/23/1993—Auburn Hills, the Palace of Auburn Hills
10/26/1993—Richfield, Richfield Coliseum
10/28/1993—Rosemont, Rosemont Horizon Arena
10/29/1993—Rosemont, Rosemont Horizon Arena
10/30/1993—Minneapolis, Target Center

11/02/1993—Denver, McNichols Arena
11/04/1993—Salt Lake City, Delta Center
11/06/1993—Vancouver, Pacific Coliseum
11/07/1993—Seattle, Seattle Center Coliseum
11/08/1993—Portland, Memorial Coliseum
11/12/1993—San Jose, Arena

11/13/1993—Oakland, County Coliseum
11/14/1993—Sacramento, Arco Arena
11/16/1993—San Diego, Sports Arena
11/18/1993—Phoenix, Veterans Memorial Coliseum
11/20/1993—Los Angeles, the Forum
11/21/1993—Los Angeles, the Forum
11/23/1993—Los Angeles, the Forum
11/24/1993—Los Angeles, the Forum
11/26/1993—Los Angeles, the Forum

12/02/1993—Mexico City, Palacio de los Deportes
12/03/1993—Mexico City, Palacio de los Deportes
12/12/1993—Dublin, the Point
12/14/1993—Birmingham, NEC
12/17/1993—Manchester, G-Mex
12/18/1993—Sheffield, Arena
12/20/1993—London, Wembley Arena

EXOTIC TOUR, 1994

02/09/1994—Johannesburg, Standard Bank Arena
02/11/1994—Johannesburg, Standard Bank Arena
02/12/1994—Johannesburg, Standard Bank Arena
02/14/1994—Johannesburg, Standard Bank Arena
02/15/1994—Johannesburg, Standard Bank Arena
02/18/1994—Cape Town, Good Hope Centre
02/19/1994—Cape Town, Good Hope Centre
02/23/1994—Durban, Exhibition Centre
02/25/1994—Johannesburg, Standard Bank
02/26/1994—Johannesburg, Standard Bank

03/01/1994—Singapore, Indoor Stadium
03/05/1994—Perth, Entertainment Centre
03/07/1994—Adelaide, the Barton Centre
03/08/1994—Melbourne, Flinders Park Tennis Centre
03/10/1994—Brisbane, Festival Hall
03/12/1994—Sydney, Entertainment Centre
03/16/1994—Hong Kong, Hong Kong Stadium
03/18/1994—Manila, Folk Arts Theatre
03/19/1994—Manila, Folk Arts Theatre
03/25/1994—Honolulu, Blaisdell Arena
03/26/1994—Honolulu, Blaisdell Arena

04/04/1994—São Paulo, Olympia
04/05/1994—São Paulo, Olympia
04/08/1994—Buenos Aires, Sarsfield Stadium
04/10/1994—Santiago de Chile, Estadio Nacional
04/14/1994—San Jose, Gymnasio Nacional
04/16/1994—Monterrey, Auditorio Coca-Cola

US SUMMER TOUR, 1994

05/12/1994—Sacramento, Cal Expo Amphitheater
05/14/1994—Mountain View, Shoreline Amphitheatre
05/15/1994—Concord, Concord Pavilion
05/17/1994—Las Vegas, Theatre for the Performing Arts
05/18/1994—Phoenix, Cricket Wireless Pavilion
05/20/1994—Laguna Hills, Meadows Amphitheater
05/21/1994—San Bernardino, Glen Helen Pavilion
05/24/1994—Salt Lake City, Park West Amphitheater
05/28/1994—Kansas City, Sandstone Amphitheater
05/29/1994—St. Louis, Riverport Amphitheater
05/31/1994—San Antonio, HemisFair Arena

06/01/1994—Houston, Cynthia Woods Mitchell Pavilion
06/03/1994—Dallas, Starplex Amphitheater
06/05/1994—Biloxi, Mississippi Coast Coliseum
06/08/1994—Charlotte, the Palladium at Carowinds
06/09/1994—Atlanta, Lakewood Amphitheater
06/11/1994—Chicago, World Music Center
06/12/1994—Cleveland, Blossom Music Center
06/14/1994—Columbia, Merriweather Post Pavilion
06/16/1994—Wantagh, Jones Beach Theater
06/17/1994—Wantagh, Jones Beach Theater
06/20/1994—Toronto, Kingswood
06/21/1994—Montreal, Montreal Forum
06/23/1994—Boston, Great Wood P/A/C/
06/24/1994—Holmdell, Garden State Arts Center
06/28/1994—Philadelphia, the Spectrum
06/29/1994—Pittsburgh, Star Lake Amphitheater

07/01/1994—Columbus, Polaris Amphitheater
07/03/1994—Clarkston, Pine Knob Music Theatre

07/04/1994—Clarkston, Pine Knob Music Theatre
07/06/1994—Cincinnatti, Riverbend Music Center
07/07/1994—Milwaukee, Marcus Amphitheater
07/08/1994—Indianapolis, Deer Creek Music Center

ULTRA LAUNCH PARTIES, 1997

04/10/1997—London, Adrenalin Village

05/16/1997—Los Angeles, Shrine Exposition Hall

THE SINGLES 86>98 TOUR, 1998

09/02/1998—Tartu, Tähtvere Puhkepark
09/03/1998—Riga, Jurmala Tennis Halle
09/05/1998—Moscow, Olimpiski
09/07/1998—St. Petersburg, SKK Indoor Arena
09/09/1998—Helsinki, Hartwall Arena
09/11/1998—Copenhagen, Valby-Hallen
09/12/1998—Gothenburg, Sweden
09/13/1998—Stockholm, Globe Arena
09/15/1998—Prague, Sporthalle
09/16/1998—Vienna, Stadthalle
09/18/1998—Berlin, Waldbühne
09/19/1998—Berlin, Waldbühne
09/20/1998—Erfurt, Messehalle
09/22/1998—Brussels, Forest National
09/23/1998—Stuttgart, Hanns Martin Schleyer Halle
09/25/1998—Zürich, Hallenstadion
09/26/1998—Bologna, Palamalaguti
09/27/1998—Milan, Forum
09/29/1998—London, Wembley Arena
09/30/1998—London, Wembley Arena

10/02/1998—Manchester, Nynex
10/03/1998—Birmingham, NEC
10/05/1998—Cologne, Kölnarena
10/06/1998—Cologne, Kölnarena
10/07/1998—Paris, Palais Omnisport de Paris-Bercy
10/09/1998—Hanover, Messehalle
10/10/1998—Leipzig, Messehalle
10/11/1998—Frankfurt, Festhalle
10/13/1998—Munich, Olympiahalle
10/15/1998—Saragossa, Pabellon Principe Felipe
10/16/1998—Barcelona, Palau Sant Jordi
10/17/1998—San Sebastián, Velódromo de Anoeta
10/27/1998—Worcester, Centrum
10/28/1998—New York, Madison Square Garden
10/29/1998—New York, Madison Square Garden

11/01/1998—Philadelphia, First Union Spectrum
11/05/1998—Toronto, Skydome
11/06/1998—Montreal, Molson Centre
11/08/1998—Cleveland, Gund Arena
11/09/1998—Auburn Hills, the Palace of Auburn Hills
11/11/1998—Fairfax, Patriot Center
11/13/1998—Miami, Arena
11/14/1998—Orlando, Arena
11/15/1998—Tampa, Ice Palace
11/18/1998—Houston, Compaq Center
11/19/1998—Dallas, Reunion Arena
11/20/1998—San Antonio, Alamodome
11/22/1998—New Orleans, Lakefront Arena
11/24/1998—Rosemont, Rosemont Horizon Arena
11/25/1998—Rosemont, Rosemont Horizon Arena
11/29/1998—Denver, McNichols Arena

12/01/1998—Salt Lake City, Delta Center
12/02/1998—Boise, Idaho Center
12/04/1998—Vancouver, Pacific Coliseum
12/06/1998—Portland, Rosegarden
12/07/1998—Seattle, Key Arena
12/09/1998—Sacramento, Arco Arena
12/11/1998—Oakland, Oakland Coliseum
12/12/1998—Los Angeles, KROQ Almost Acoustic Christmas
12/14/1998—Phoenix, America West Arena
12/15/1998—San Diego, Cox Arena
12/18/1998—Los Angeles, Great Western Forum
12/19/1998—Los Angeles, Great Western Forum
12/20/1998—Anaheim, Arrowhead Pond
12/22/1998—Anaheim, Arrowhead Pond

EXCITER TOUR, 2001

06/04/2001—Los Angeles, Roxy
06/11/2001—Quebec City, Colisee Pepsi Arena
06/13/2001—Ottawa, Corel Centre
06/15/2001—Montreal, Molson Centre
06/16/2001—Toronto, Molson Amphitheater
06/19/2001—St. Paul, Xcel Energy Theatre
06/20/2001—Milwaukee, Marcus Amphitheater
06/22/2001—Chicago, World Music Theatre
06/23/2001—Clarkston, DTE Energy Music Theatre
06/24/2001—Cleveland, Blossom Music Center
06/27/2001—New York, Madison Square Garden
06/28/2001—New York, Madison Square Garden
06/30/2001—Philadelphia, First Union Center

07/01/2001—Mansfield, Tweeter Center For Performing Arts
07/03/2001—Wantagh, Jones Beach Theater
07/05/2001—Columbia, Merriweather Post Pavilion
07/07/2001—Fort Lauderdale, National Car Rental Center
07/08/2001—Tampa, Ice Palace
07/09/2001—Atlanta, Hifi Buys Center
07/13/2001—New Orleans, UNO Lakefront Arena
07/14/2001—Houston, Cynthia Woods Mitchell Pavilion
07/15/2001—San Antonio, South Texas Amphitheater
07/17/2001—Dallas, Smirnoff Music Center
07/19/2001—Las Cruces, Pan American Center
07/20/2001—Albuquerque, Journal Pavilion
07/21/2001—Denver, Fiddler's Green Amphitheater
07/23/2001—Salt Lake City, E Center
07/27/2001—Portland, Rose Garden Arena
07/28/2001—Vancouver, Pacific Coliseum
07/29/2001—Seattle, Gorge Amphitheater

08/01/2001—Sacramento, Sacramento Valley Amphitheater
08/03/2001—Concord, Chronicle Pavilion
08/04/2001—Mountain View, Shoreline Amphitheatre
08/05/2001—Santa Barbara, Santa Barbara Bowl
08/08/2001—Las Vegas, the Joint
08/10/2001—Phoenix, American West Arena
08/11/2001—Chula Vista, Coors Amphitheater
08/14/2001—Los Angeles, Staples Center Arena
08/15/2001—Los Angeles, Staples Center Arena
08/18/2001—Anaheim, Arrowhead Pond
08/19/2001—Anaheim, Arrowhead Pond
08/28/2001—Tallinn, Song Festival Grounds
08/29/2001—Riga, Skono Stadium
08/31/2001—Vilnius, Vingis Park

09/02/2001—Warsaw, Tor Słuzewiec
09/04/2001—Prague, Paegeas Arena
09/05/2001—Berlin, Waldbühne
09/06/2001—Berlin, Waldbühne
09/08/2001—Hamburg, Trabrennbahn
09/09/2001—Leipzig, Festwiese
09/11/2001—Vienna, Stadthalle
09/12/2001—Budapest, Kisstadion
09/16/2001—Moscow, Olimpiski
09/18/2001—St. Petersburg, SKK Arena
09/19/2001—Helsinki, Hartwall Arena
09/21/2001—Stockholm, Globe Arena
09/22/2001—Oslo, Spektrum
09/23/2001—Copenhagen, Parken Stadium
09/25/2001—Amneville, Galaxy
09/26/2001—Cologne, Kölnarena
09/27/2001—Cologne, Kölnarena
09/29/2001—Munich, Olympiahalle
09/30/2001—Munich, Olympiahalle

10/02/2001—Nuremberg, Eissporthalle
10/03/2001—Stuttgart, Hanns Martin Schleyer Halle
10/04/2001—Zürich, Hallenstadion
10/06/2001—Oberhausen, Arena
10/07/2001—Antwerp, Sport Palais
10/09/2001—Paris, Palais Omnisport de Paris-Bercy
10/10/2001—Paris, Palais Omnisport de Paris-Bercy
10/11/2001—Frankfurt, Festhalle
10/13/2001—Barcelona, Palau Sant Jordi
10/14/2001—Madrid, Palacio Vistalegre
10/17/2001—London, Wembley Arena
10/18/2001—London, Wembley Arena
10/20/2001—Manchester, MEN Arena
10/21/2001—Birmingham, NEC
10/23/2001—Lyon, Halle Tony Garnier

10/24/2001—Milan, Forum
10/25/2001—Bologna, Balamalaguti
10/28/2001—Athens, Basketball Arena
10/30/2001—Istanbul, Abdi Ipekci Arena

11/03/2001—Zagreb, Dom Sportova
11/05/2001—Mannheim, Maimarkthalle

TOURING THE ANGEL, 2005–06

10/28/2005—New York, Bowery Ballroom

11/03/2005—Tampa, St. Pete Times Forum
11/05/2005—Atlanta, Arena at Gwinnett Center
11/07/2005—Houston, Toyota Center
11/08/2005—Dallas, American Airlines Arena
11/09/2005—San Antonio, SBC Center
11/11/2005—Denver, Magness Arena
11/12/2005—Salt Lake City, E Center
11/15/2005—Vancouver, GM Place
11/16/2005—Seattle, Key Arena
11/18/2005—San Jose, HP Pavilion
11/19/2005—San Diego, Ipayone Center
11/21/2005—Los Angeles, Staples Center
11/22/2005—Los Angeles, Staples Center
11/23/2005—Anaheim, Arrowhead Pond
11/25/2005—Phoenix, Glendale Arena
11/26/2005—Las Vegas, the Joint
11/29/2005—Rosemont, Allstate Arena
11/30/2005—Auburn Hills, the Palace of Auburn Hills

12/01/2005—Toronto, Air Canada Centre
12/03/2005—Atlantic City, Borgata Event Center
12/04/2005—Montreal, Bell Centre
12/07/2005—New York, Madison Square Garden
12/08/2005—New York, Madison Square Garden
12/09/2005—Fairfax, Patriot Center
12/11/2005—Universal City, KROQ Almost Acoustic Christmas

01/13/2006—Dresden, Messehalle
01/15/2006—Hamburg, Color Line Arena
01/16/2006—Hamburg, Color Line Arena
01/18/2006—Berlin, Velodrom
01/20/2006—Düsseldorf, LTU Arena
01/21/2006—Düsseldorf, LTU Arena
01/23/2006—Prague, Sazka Arena
01/24/2006—Erfurt, Messehalle
01/26/2006—Frankfurt, Festhalle
01/29/2006—Antwerp, Sport Palais
01/31/2006—Geneva, Arena

02/01/2006—Marseille, Le Dome
02/03/2006—Toulouse, Zenith
02/04/2006—Lyon, Halle Tony Garnier
02/06/2006—Madrid, Palacio de Deportes
02/07/2006—Madrid, Palacio de Deportes
02/08/2006—Lisbon, Pavilhao Atlantico
02/10/2006—Barcelona, Palau Sant Jordi
02/11/2006—Barcelona, Palau Sant Jordi
02/14/2006—Munich, Olympiahalle
02/15/2006—Munich, Olympiahalle
02/16/2006—Vienna, Stadthalle
02/18/2006—Milan, Forum
02/19/2006—Milan, Forum
02/21/2006—Paris, Palais Omnisport de Paris-Bercy
02/22/2006—Paris, Palais Omnisport de Paris-Bercy
02/23/2006—Paris, Palais Omnisport de Paris-Bercy
02/25/2006—Copenhagen, Parken Stadium
02/26/2006—Gothenburg, Sweden
02/28/2006—Oslo, Spektrum

03/01/2006—Stockholm, Globe
03/03/2006—St. Petersburg, Russia SKK
03/04/2006—Moscow, Luzhniki Sport Palast
03/06/2006—Helsinki, Hartwall Arena
03/09/2006—Stuttgart, Hanns Martin Schleyer Halle
03/10/2006—Friedrichshafen, Messehalle
03/11/2006—Mannheim, SAP Arena
03/13/2006—Graz, Stadthalle
03/14/2006—Katowice, Spodek
03/16/2006—Tallinn, Saku Arena
03/17/2006—Riga, Arena Riga
03/18/2006—Vilnius, Siemens Arena

03/21/2006—Budapest, Papp Laszlo Arena
03/22/2006—Zagreb, Dom Sportova
03/24/2006—Amneville, Galaxie
03/25/2006—Douai, Gayant Expo
03/26/2006—Rotterdam, Ahoy
03/28/2006—Zürich, Hallenstadion
03/30/2006—Manchester, MEN Arena
03/31/2006—Birmingham, NEC

04/02/2006—London, Wembley Arena
04/03/2006—London, Wembley Arena
04/27/2006—Mountain View, Shoreline Amphitheatre
04/29/2006—Indio, Coachella Festival
04/30/2006—Las Vegas, Theater under the Stars

05/04/2006—Mexico City, Foro Sol
05/05/2006—Mexico City, Foro Sol
05/07/2006—Monterrey, Arena
05/10/2006—Kansas City, Starlight Theatre
05/13/2006—Wantagh, Jones Beach Theater
05/14/2006—Holmdel, PNC Bank Arts Center
05/17/2006—Montreal, Bell Centre
05/18/2006—Toronto, Air Canada Centre
05/20/2006—Atlantic City, Borgata
05/21/2006—Bristow, Nissan Pavilion

06/02/2006—Nuremberg, Rock im Park
06/04/2006—Nuremberg, Rock am Ring
06/05/2006—Bremen, Weserstadion
06/07/2006—Aarhus, Aarhus Stadion
06/09/2006—Warsaw, Legia Stadion
06/11/2006—Bratislava, Inter-Bratislava Stadium
06/12/2006—Budapest, Puskas Ferenc Stadium
06/14/2006—Ljubljana, Central Bezigrad Stadium
06/16/2006—Imola, Heineken Jamming Festival
06/17/2006—Interlaken, Airport / Greenfield Festival
06/21/2006—Sofia, Lokomotive Stadion
06/23/2006—Bucharest, National Stadium
06/25/2006—London, Hyde Park / Wireless Festival
06/26/2006—Dublin, the Point
06/28/2006—Berlin, Waldbühne
06/29/2006—Arras, Main Square Festival

07/01/2006—Belfort, Eurokeenes Festival
07/02/2006—Werchter, Rock Werchter Festival
07/06/2006—Kristiansand, Quart Festival
07/07/2006—Stockholm, Stockholm Stadium
07/10/2006—Locarno, Moon And Stars Festival
07/12/2006—Berlin, Waldbühne
07/13/2006—Berlin, Waldbühne
07/15/2006—Leipzig, Festwiese
07/17/2006—Rome, Curva Olympico
07/19/2006—Nyon, Paleo Festival
07/20/2006—Nîmes, Arena
07/22/2006—San Sebastian, Estadio Anoeta
07/23/2006—Benicassim, Festival Internacional de Benicassim
07/25/2006—Torrevieja, Antonio Soria Park
07/26/2006—Granada, Plaza de Toros
07/30/2006—Istanbul, Kuruçesme Bosporus Park

08/01/2006—Athens, Terra Vibe

TOUR OF THE UNIVERSE, 2009–10

05/06/2009—Esch Alzette, Rockhal
05/10/2009—Tel Aviv, Ramat Gan Stadium

06/08/2009—Leipzig, Zentralstadion
06/10/2009—Berlin, Olympiastadion
06/12/2009—Frankfurt, Commerzbank Arena
06/13/2009—Munich, Olympiastadion
06/16/2009—Rome, Stadio Olimpico
06/18/2009—Milan, Stadio San Siro
06/20/2009—Werchter, TW Classic Festival
06/22/2009—Bratislava, Inter Stadium
06/23/2009—Budapest, Puskas Ferenc Stadium
06/25/2009—Prague, Eden Slavia Stadium
06/27/2009—Paris, Stade Du France
06/28/2009—Nancy, Zenith de Nancy
06/30/2009—Copenhagen, Parken

07/01/2009—Hamburg, HSH Nord Arena
07/03/2009—Arvika, Arvika Festival

07/06/2009—Carcassonne, Esplanade Gambetta
07/08/2009—Valladolid, Estadio Jose Zarillo
07/09/2009—Bilbao, Bilbao BBK Live Festival
07/24/2009—Toronto, Molson Amphitheater
07/25/2009—Montreal, Bell Centre
07/28/2009—Bristow, Nissan Pavilion
07/31/2009—Mansfield, Comcast Centre

08/01/2009—Atlantic City, Borgata
08/03/2009—New York, Madison Square Garden
08/04/2009—New York, Madison Square Garden
08/07/2009—Chicago, Lollapalooza Festival
08/10/2009—Seattle, Key Arena
08/16/2009—Los Angeles, Hollywood Bowl
08/17/2009—Los Angeles, Hollywood Bowl
08/19/2009—Anaheim, Honda Center
08/20/2009—Santa Barbara, Santa Barbara County Bowl
08/22/2009—Las Vegas, Pearl Palms Concert Theater
08/23/2009—Phoenix, US Airways
08/25/2009—Salt Lake City, E Center
08/27/2009—Denver, Red Rocks
08/29/2009—Dallas, Superpages Center
08/30/2009—Houston, Woodlands Pavilion

09/01/2009—Atlanta, Lakewood Amphitheater
09/04/2009—Tampa, Ford Amphitheater
09/05/2009—Fort Lauderdale, Bankatlantic Center

10/01/2009—Guadalajara, Arena V/F/G/
10/03/2009—Mexico City, Foro Sol
10/04/2009—Mexico City, Foro Sol
10/06/2009—Monterrey, Arena
10/08/2009—Alajuela, Autodroma La Guacima
10/10/2009—Bogotá, Parque Simón Bolívar
10/12/2009—Lima, Explanada der Estadio Monumental
10/13/2009—Lima, Explanada der Estadio Monumental
10/15/2009—Santiago de Chile, Club Hipico
10/17/2009—Buenos Aires, Club Ciudad
10/31/2009—Oberhausen, KoPi Arena

11/01/2009—Bremen, AWD Dome
11/03/2009—Hanover, TUI Arena
11/07/2009—Mannheim, SAP Arena
11/08/2009—Stuttgart, Hanns Martin Schleyer Halle
11/10/2009—Geneva, Palexpo
11/12/2009—Valencia, Recinto Ferial
11/14/2009—Lisbon, Pavilhao Atlantico
11/16/2009—Madrid, Palacio de Deportes
11/17/2009—Madrid, Palacio de Deportes
11/20/2009—Barcelona, Palau Sant Jordi
11/21/2009—Barcelona, Palau Sant Jordi
11/23/2009—Lyon, Halle Tony Garnier
11/25/2009—Bologna, Palamalaguti
11/26/2009—Turin, Palaolimpico
11/28/2009—Erfurt, Messehalle
11/30/2009—Rotterdam, Ahoy

12/01/2009—Nuremberg, Arena
12/03/2009—Vienna, Stadthalle
12/04/2009—Graz, Stadthalle
12/06/2009—Zürich, Hallenstadion
12/07/2009—Zürich, Hallenstadion
12/10/2009—Dublin, the O2
12/12/2009—Glasgow, SECC
12/13/2009—Birmingham, LG Arena
12/15/2009—London, O2 Arena
12/16/2009—London, O2 Arena
12/18/2009—Manchester, MEN Arena

01/09/2010—Berlin, O2 World Arena
01/11/2010—Budapest, Sports Arena
01/14/2010—Prague, O2 Arena
01/17/2010—Liévin, Stade Couvert Regional
01/19/2010—Paris, Palais Omnisport de Paris-Bercy
01/20/2010—Paris, Palais Omnisport de Paris-Bercy
01/23/2010—Antwerp, Sport Palais
01/25/2010—Malmö, Malmö Arena
01/26/2010—Gothenburg, Sweden
01/29/2010—Bergen, Vestlandhallen
01/31/2010—Stockholm, Ericsson Globe

02/02/2010—Helsinki, Hartwall Arena
02/04/2010—St. Petersburg, SKK
02/06/2010—Moscow, Olimpisky

02/08/2010—Kyiv, Palace of Sports
02/10/2010—Łódź, Hala Arena
02/11/2010—Łódź, Hala Arena
02/14/2010—Zagreb, Tuborg Greenfest Arena
02/17/2010—London, Royal Albert Hall
02/20/2010—London, O2 Arena
02/22/2010—Horsens, Forum
02/23/2010—Horsens, Forum
02/26/2010—Düsseldorf, Esprit Arena
02/27/2010—Düsseldorf, Esprit Arena

DELTA MACHINE TOUR, 2013–14

05/04/2013—Nice, Palais Nikaia
05/07/2013—Tel Aviv, Hyarkon Park
05/10/2013—Athens, Terra Vibe Park
05/12/2013—Sofia, Georgi Asparuhov Stadium
05/15/2013—Bucharest, National Stadium
05/19/2013—Belgrad, Usce Park
05/21/2013—Budapest, Puskas Ferenc Stadium
05/23/2013—Zagreb, Hippodrom
05/25/2013—Bratislava, Inter Stadium
05/28/2013—London, O2 Arena
05/29/2013—London, O2 Arena

06/01/2013—Munich, Olympiastadion
06/03/2013—Stuttgart, Mercedes-Benz Arena
06/05/2013—Frankfurt, Commerzank Arena
06/07/2013—Bern, Stade de Suisse
06/09/2013—Berlin, Olympiastadion
06/11/2013—Leipzig, Red Bull Arena
06/13/2013—Copenhagen, Parken Stadium
06/15/2013—Paris, Stade de France
06/17/2013—Hamburg, Imtech Arena
06/22/2013—Moscow, Lokomotive Stadion
06/24/2013—St. Petersburg, SKK Arena
06/27/2013—Borlänge, Peace & Love Festival
06/29/2013—Kyiv, Olympia Stadium

07/03/2013—Düsseldorf, Esprit Arena
07/05/2013—Düsseldorf, Esprit Arena
07/07/2013—Werchter, Rock Werchter Festival
07/09/2013—Locarno, Piazza Grande
07/11/2013—Bilbao, BBK Festival
07/13/2013—Lisbon, Optimus Alive Fest
07/16/2013—Nîmes, Antic Arena
07/18/2013—Milan, Stadio San Siro
07/20/2013—Rome, Olympiastadion
07/23/2013—Prague, Eden Arena
07/25/2013—Warsaw, Nationalstadion
07/27/2013—Vilnius, Vingis Park
07/29/2013—Minsk, Arena

08/22/2013—Detroit, DTE Energy Music Theatre
08/24/2013—Tinley Park, First Midwest Bank Amphitheater
08/27/2013—St. Paul, Minnesota State Fair
08/30/2013—Atlantic City, Ovation Hall

09/01/2013—Toronto, Molson Canadian Amphitheater
09/03/2013—Montreal, Bell Centre
09/06/2013—Brooklyn, Barclays Center
09/08/2013—Wantagh, Nikon at Jones Beach Theater
09/10/2013—Bristow, Jiffy Lube Live
09/12/2013—Atlanta, Aaron's Amphitheater at Lakewood
09/14/2013—Tampa, Live Nation Amphitheater
09/15/2013—Fort Lauderdale, BB&T Center
09/18/2013—Houston, Cynthia Woods Mitchell Pavilion
09/20/2013—Dallas, Gexa Energy Pavilion
09/22/2013—Chula Vista, Sleep Train Amphitheater
09/24/2013—Santa Barbara, Santa Barbara Bowl
09/26/2013—Mountain View, Shoreline Amphitheatre
09/28/2013—Los Angeles, Staples Center
09/29/2013—Los Angeles, Staples Center

10/02/2013—Los Angeles, Staples Center
10/04/2013—Austin, Austin City Limits Music Festival
10/06/2013—Las Vegas, Pearl Concert Theater at Palms Casino Resort
10/08/2013—Phoenix, Desert Sky Pavilion
10/11/2013—Austin, Austin City Limits Music Festival

11/03/2013—Abu Dhabi, Yas Arena
11/07/2013—Belfast, Odyssey
11/09/2013—Dublin, the O2

11/11/2013—Glasgow, the Hydro
11/13/2013—Leeds, Leeds Arena
11/15/2013—Manchester, Manchester Arena
11/19/2013—London, O2 Arena
11/21/2013—Cologne, Lanxess Arena
11/23/2013—Hanover, TUI Arena
11/25/2013—Berlin, O2 World
11/27/2013—Berlin, O2 World
11/29/2013—Herning, Jyske Bank Boxen

12/01/2013—Erfurt, Messehalle
12/03/2013—Bremen, ÖVB-Arena
12/05/2013—Oberhausen, König-Pilsener-Arena
12/07/2013—Amsterdam, Ziggo Dome
12/09/2013—Malmö, Arena
12/11/2013—Gothenburg, Sweden
12/13/2013—Oslo, Telenor Arena
12/15/2013—Helsinki, Hartwall Arena

01/15/2014—Barcelona, Palau Sant Jordi
01/17/2014—Madrid, Palacio de Deportes
01/18/2014—Madrid, Palacio de Deportes
01/21/2014—Montpellier, Park & Suites Arena
01/23/2014—Lyon, Halle Tony Garnier
01/25/2014—Antwerp, Sportpaleis
01/27/2014—Birmingham, LG Arena
01/29/2014—Paris, Palais Omnisport de Paris-Bercy
01/31/2014—Paris, Palais Omnisport de Paris-Bercy

02/02/2014—Strasbourg, Zénith de Strasbourg
02/04/2014—Mannheim, SAP Arena
02/06/2014—Bratislava, Slovnaft Arena
08/02/2014—Vienna, Stadthalle
10/02/2014—Prague, O2 Arena
12/02/2014—Dresden, Messehalle
14/02/2014—Zürich, Hallenstadion
15/02/2014—Zürich, Hallenstadion
18/02/2014—Turin, PalaOlimpico
20/02/2014—Milan, Mediolanum Forum
22/02/2014—Bologna, Unipol Arena
24/02/2014—Łódź, Arena Łódź
28/02/2014—Minsk, Arena

02/03/2014—Riga, Arena
04/03/2014—St. Petersburg, SKK Indoor Arena
07/03/2014—Moscow, Olimpiski

GLOBAL SPIRIT TOUR, 2017–18

05/05/2017—Stockholm, Friends Arena
05/07/2017—Amsterdam, Ziggo Dome
05/09/2017—Antwerp, Sportpaleis
05/12/2017—Nice, Stade Charles-Ehrmann
05/14/2017—Ljubljana, Dvorana Stožice
05/17/2017—Athens, Terra Vibe Park
05/20/2017—Bratislava, Štadión Pasienky
05/22/2017—Budapest, Groupama Aréna
05/24/2017—Prague, Eden Aréna
05/27/2017—Leipzig, Festwiese
05/29/2017—Lille, Stade Pierre-Mauroy
05/31/2017—Copenhagen, Telia Parken

06/03/2017—London, London Stadium
06/05/2017—Cologne, RheinEnergieStadion
06/07/2017—Dresden, Ostragehege
06/09/2017—Munich, Olympiastadion
06/11/2017—Hanover, HDI Arena
06/12/2017—Hanover, HDI Arena Zusatzshow
06/18/2017—Zürich, Letzigrund Stadion
06/20/2017—Frankfurt, Commerzbank-Arena
06/22/2017—Berlin, Olympiastadion
06/25/2017—Rome, Stadio Olimpico
06/27/2017—Milan, Stadio San Siro
06/29/2017—Bologna, Stadio Rentao Dall'Ara

07/01/2017—Paris, Stade de France
07/04/2017—Gelsenkirchen, Veltins Arena
07/06/2017—Bilbao, BBK Live Festival
07/08/2017—Lisbon, NOS Alive Festival
07/13/2017—St. Petersburg, SKK Indoor Arena
07/15/2017—Moscow, Otkritie Arena
07/17/2017—Minsk, Minsk-Arena
07/19/2017—Kyiv, Olimpiyskiy National Sports Complex
07/21/2017—Warsaw, PGE Narodowy

07/23/2017—Cluj, Cluj Arena

08/23/2017—Salt Lake City, USANA Amphitheater
08/25/2017—Denver, Pepsi Center
08/27/2017—Detroit, DTE Energy Music Theatre
08/30/2017—Tinley Park, Hollywood Casino Amphitheatre

09/01/2017—Uncasville, Mohegan Sun Arena
09/03/2017—Toronto, Air Canada Centre
09/05/2017—Montreal, Bell Centre
09/07/2017—Washington, DC, Verizon Center
09/09/2017—New York, Madison Square Garden
09/11/2017—New York, Madison Square Garden
09/15/2017—Miami, American Airlines Arena
09/18/2017—Nashville, Ascend Amphitheater
09/20/2017—Austin, Austin360 Amphitheater
09/22/2017—Dallas, Starplex Pavilion
09/24/2017—Houston, Cynthia Woods Mitchell Pavilion
09/27/2017—Phoenix, AK-Chin Pavilion
09/30/2017—Las Vegas, T-Mobile Arena

10/02/2017—Santa Barbara, Santa Barbara County Bowl
10/06/2017—San Diego, Mattress Firm Amphitheater
10/08/2017—San Jose, SAP Center
10/10/2017—Oakland, Oracle Arena
10/12/2017—Los Angeles, Hollywood Bowl
10/14/2017—Los Angeles, Hollywood Bowl
10/16/2017—Los Angeles, Hollywood Bowl
10/18/2017—Los Angeles, Hollywood Bowl
10/21/2017—Seattle, Key Arena
10/23/2017—Portland, Moda Center
10/25/2017—Vancouver, Rogers Arena
10/27/2017—Edmonton, Rogers Place

11/15/2017—Dublin, 3Arena
11/17/2017—Manchester, Manchester Arena
11/19/2017—Birmingham, Arena Birmingham
11/22/2017—London, O2 Arena
11/24/2017—Frankfurt, Festhalle
11/26/2017—Antwerp, Sportpaleis
11/28/2017—Stuttgart, Hanns Martin Schleyer Halle
11/30/2017—Mannheim, SAP Arena

12/03/2017—Paris, Accorhotels Arena
12/05/2017—Paris, Accorhotels Arena
12/07/2017—Barcelona, Palau Sant Jordi
12/09/2017—Turin, Pala Alpitour
12/11/2017—Turin, Pala Alpitour
12/13/2017—Bologna, Unipol Arena
12/16/2017—Madrid, WiZink Centre

01/09/2018—Copenhagen, Royal Arena
01/11/2018—Hamburg, Barclay Card Arena
01/13/2018—Amsterdam, Ziggo Dome
01/15/2018—Cologne, Lanxess Arena
01/17/2018—Berlin, Mercedes-Benz Arena
01/19/2018—Berlin, Mercedes-Benz Arena
01/21/2018—Nuremberg, Arena Nürnberger Versicherung
01/24/2018—Bordeaux, Bordeaux Metropol Arena
01/27/2018—Milan, Mediolanum Forum
01/29/2018—Milan, Mediolanum Forum
01/31/2018—Prague, O2 Arena

02/02/2018—Budapest, BSA
02/04/2018—Vienna, Stadthalle
02/07/2018—Kraków, Tauron Arena
02/09/2018—Łódź, Atlas Arena
02/11/2018—Gdańsk, Ergo Arena
02/13/2018—Minsk, Minsk Arena
02/16/2018—St Petersburg, SKK Arena
02/18/2018—Helsinki, Hartwall Arena
02/20/2018—Riga, Arena Riga
02/22/2018—Vilnius, Siemens Arena
02/25/2018—Moscow, Olimpiyski

03/11/2018—Mexico City, Foro Sol
03/13/2018—Mexico City, Foro Sol
03/16/2018—Bogotá, Simon Bolivar Park
03/18/2018—Lima, Estadio Nacional
03/21/2018—Santiago de Chile, Estadio Nacional
03/24/2018—Buenos Aires, Estadio Unico de la Plata
03/27/2018—São Paulo, Allianz Parque

05/22/2018—Anaheim, Honda Center

05/24/2018—Sacramento, Golden 1 Center
05/27/2018—San Antonio, AT&T Center
05/29/2018—Tulsa, BoK Center

06/01/2018—Chicago, United Center
06/03/2018—Philadelphia, Wells Fargo Center
06/06/2018—Brooklyn, Barclays Center
06/09/2018—Boston, TD Garden
06/11/2018—Toronto, Air Canada Centre
06/23/2018—Newport, Isle of Wight Festival
06/26/2018—Sopron, Volt Festival
06/28/2018—Odense, Tinderbox Festival
06/30/2018—St. Gallen, Open-Air St. Gallen Festival

07/02/2018—Barolo, Collisioni Festival
07/05/2018—Gdynia, Open'er Festival
07/07/2018—Arras, Main Square Festival
07/09/2018—Herouville, Beauregard Festival
07/12/2018—Aix-Les-Baines, Musilac Festival
07/14/2018—Madrid, Mad Cool Festival
07/17/2018—Nyon, Paleo Festival
07/19/2018—Carhaix Plouguer, Vieilles Charrues Festival
07/21/2018—Paris, Lollapalooza Paris
07/23/2018—Berlin, Waldbühne
07/25/2018—Berlin, Waldbühne

MEMENTO MORI TOUR, 2023–24

03/23/2023—Sacramento, Golden 1 Center
03/25/2023—San Jose, SAP Center at San Jose
03/28/2023—Los Angeles, Kia Forum
03/30/2023—Las Vegas, T-Mobile Arena

04/02/2023—San Antonio, AT&T Center
04/05/2023—Chicago, United Center
04/07/2023—Toronto, Scotiabank Arena
04/09/2023—Quebec City, Centre Videotron
04/12/2023—Montreal, Bell Centre
04/14/2023—New York, Madison Square Garden

05/16/2023—Amsterdam, Ziggo Dome
05/18/2023—Amsterdam, Ziggo Dome
05/20/2023—Antwerp, Sportpaleis Antwerpen
05/23/2023—Stockholm, Friends Arena
05/26/2023—Leipzig, Festwiese
05/28/2023—Bratislava, Národný Futbalový Stadión
05/31/2023—Lyon, Groupama Stadium

06/02/2023—Barcelona, Parc del Fòrum
06/04/2023—Düsseldorf, Merkur Spiel-Arena
06/06/2023—Düsseldorf, Merkur Spiel-Arena
06/09/2023—Madrid, Ciudad del Rock
06/11/2023—Bern, Stadion Wankdorf
06/14/2023—Dublin, Malahide Castle
06/17/2023—London, Twickenham Stadium
06/20/2023—Munich, Olympiastadion
06/22/2023—Lille, Stade Pierre Mauroy
06/24/2023—Paris, Stade de France
06/27/2023—Copenhagen, Parken
06/29/2023—Frankfurt, Deutsche Bank Park

07/01/2023—Frankfurt, Deutsche Bank Park
07/04/2023—Bordeaux, Stade Matmut-Atlantique
07/07/2023—Berlin, Olympiastadion
07/09/2023—Berlin, Olympiastadion
07/12/2023—Rome, Stadio Olimpico di Roma
07/14/2023—Milan, Stadio San Siro
07/16/2023—Bologna, Stadio Renato Dall'Ara
07/21/2023—Klagenfurt, Wörthersee Stadion
07/23/2023—Zagreb, Zagreb Arena
07/26/2023—Bucharest, Arena Nationala
07/28/2023—Budapest, Puskas Arena
07/30/2023—Prague, Letnany Airport

08/02/2023—Warsaw, PGE Narodowy
08/04/2023—Kraków, Tauron Arena Kraków
08/06/2023—Tallinn, Tallinna Lauluväljak
08/11/2023—Oslo, Telenor Arena

09/23/2023—Mexico City, Foro Sol
09/29/2023—Austin, Moody Center

10/01/2023—Dallas, American Airlines Center
10/04/2023—Houston, Toyota Center
10/07/2023—New Orleans, Smoothie King Center
10/10/2023—Orlando, Amway Center
10/12/2023—Miami, Miami-Dade Arena
10/15/2023—Atlanta, State Farm Arena
10/19/2023—Nashville, Bridgestone Arena
10/21/2023—Brooklyn, Barclays Center
10/23/2023—Washington, DC, Capital One Arena
10/25/2023—Philadelphia, Wells Fargo Center
10/28/2023—New York, Madison Square Garden
10/31/2023—Boston, TD Garden

11/03/2023—Montreal, Bell Centre
11/05/2023—Toronto, Scotiabank Arena
11/08/2023—Detroit, Little Caesars Arena
11/10/2023—Cleveland, Rocket Mortgage Fieldhouse
11/13/2023—Chicago, United Center
11/16/2023—Denver, Ball Arena
11/18/2023—Salt Lake City, Vivint Smart Homes Arena
11/21/2023—Edmonton, Rogers Place
11/24/2023—Vancouver, Rogers Arena
11/26/2023—Seattle, Climate Pledge Arena
11/28/2023—Portland, MODA Center

12/01/2023—Las Vegas, T-Mobile Arena
12/03/2023—San Franciso, Chase Center
12/06/2023—San Diego, Pechanga Arena
12/08/2023—San Diego, Pechanga Arena
12/10/2023—Los Angeles, Kia Forum
12/12/2023—Los Angeles, Kia Forum
12/15/2023—Los Angeles, Crypto.com Arena
12/17/2023—Los Angeles, Crypto.com Arena

01/22/2024—London, O2 Arena
01/24/2024—Birmingham, Utilita Arena
01/27/2024—London, O2 Arena
01/29/2024—Manchester, AO Arena
01/31/2024—Glasgow, OVO Hydro

02/03/2024—Dublin, 3Arena
02/06/2024—Antwerp, Sportpaleis Antwerpen
02/08/2024—Amsterdam, Ziggo Dome
02/10/2024—Copenhagen, Royal Arena
02/13/2024—Berlin, Mercedes-Benz Arena
02/15/2024—Berlin, Mercedes-Benz Arena
02/17/2024—Hamburg, Barclays Arena
02/20/2024—Berlin, Mercedes-Benz Arena
02/22/2024—Prague, O2 Arena
02/24/2024—Prague, O2 Arena
02/27/2024—Łódź, Atlas Arena
02/29/2024—Łódź, Atlas Arena

03/03/2024—Paris, Accor Arena
03/05/2024—Paris, Accor Arena
03/07/2024—Munich, Olympiahalle
03/12/2024—Madrid, WiZink Centre
03/14/2024—Madrid, WiZink Centre
03/16/2024—Barcelona, Palau Sant Jordi
03/19/2024—Lisbon, Altice Arena
03/21/2024—Bilbao, Bizkaia Arena—BEC
03/23/2024—Turin, Pala Alpitour
03/26/2024—Budapest, MVM Dome
03/28/2024—Milan, Mediolanum Forum
03/30/2024—Milan, Mediolanum Forum

04/03/2024—Cologne, Lanxess Arena
04/05/2024—Cologne, Lanxess Arena
04/08/2024—Cologne, Lanxess Arena

Sources

In the interest of better readability, footnotes weren't included in the text. Where sources aren't cited directly on the page, the following were used.

1980–1981 • THE BEGINNING / *SPEAK & SPELL* TOUR

www.electronicbeats.net/thomas-fehlmann-recalls-his-depeche-moment/
www.bbc.co.uk/blogs/nowplaying/2011/06/depeche-drums-a-furry-flop.shtml

1982–1983 • "SEE YOU" TOUR / *A BROKEN FRAME* TOUR

One Two Testing Magazine, 11/1982
www.youtube.com/watch?v=euX9RKeniRU
Record Mirror, 10/1982, p.13
Musikmagazin, 1982, p. 26.

1993–1994 • DEVOTIONAL TOUR / EXOTIC TOUR

www.shunt3.0.recoil.co.uk/qa_vault/dm_live_02.html

1997 • *ULTRA* LAUNCH PARTIES

www.youtube.com/watch?v=q4MfE77TS08

1998 • *THE SINGLES 86>98* TOUR

Billboard, 11/14/1998, p.14.

2001 • *EXCITER* TOUR

DVD: *One Night in Paris*, Disc 2
www.youtube.com/watch?v=I27PyhhqGV4

2005–2006 • TOURING THE ANGEL

DVD: *Touring the Angel*, Disc 2
Billboard, 12/03/2005, p.25.
Billboard, 12/17/2005, p.18.

2009–2010 • TOUR OF THE UNIVERSE

DVD: *Tour of the Universe*, Disc 2
www.electronicbeats.net/nitzer-ebbs-douglas-j-mccarthy-shares-his-depeche-moment/
www.cafe.se/dave-gahan/
Billboard, 08/29/2009, p.15.

2013–2014 • *DELTA MACHINE* TOUR

www.youtube.com/watch?v=k42dX7tzrGA
www.youtube.com/watch?v=YHPXYTM0Nuk
DVD: *Alive In Berlin*, Disc 2

2017–2018 • GLOBAL SPIRIT TOUR

www.youtube.com/watch?v=rk-lmacty7Q
www.youtube.com/watch?v=AcHcCaybcz4

2023–2024 • *MEMENTO MORI* TOUR

www.spin.com/2022/10/martin-gore-depeche-mode-interview/

EXCLUSIVE INTERVIEWS BY THE AUTHORS WITH

Douglas McCarthy & Bon Harris (Nitzer Ebb), Laszlo Hegedus, Peter Illmann, Karsten Jahnke, Markus Kavka, Gaby Meyer, Peddy Sadighi, Dan Silver.

WRITTEN SOURCES

Various issues from *Musikexpress, Sounds, Spex, Rolling Stone, New Life, Bong-Magazin, BMA-Sheets, NME, SPIN, Record Mirror, Bravo, Popcorn, PopRocky*. Books include Steve Malins, *Depeche Mode: Black Celebration* (2009); Simon Spence, *Depeche Mode Just Can't Get Enough* (2011); and two previous books by the authors of the present work: *Depeche Mode: Monument* (Akashic Books, 2017) and *Behind the Wall: Depeche Mode Fan Culture in the GDR* (2018).

ONLINE DATABASES

The Depeche Mode Facebook Group—Classic photos and videos
Depeche Mode Live Wiki

Image Credits

The photography featured in this book spans the entire length of Depeche Mode's unparalleled, forty-plus-year career. With such a long period of time covered, and despite their best efforts, the authors were not able to identify all copyright owners. Many of the photos were sold at record stores or exchanged without the photographer's name being given. This makes researching the images—even with the help of the Internet—a nearly impossible task. Many images came from the archives of Intercord and Mute Records, or from Dennis Burmeister's own collection. The exceptions are given below.

The authors would like to apologize in advance if any rights holders have been omitted. In the case of justifiable claims, please contact the publisher to receive proper credit in future editions.

FRONT MATTER

Title photo: Michael Hermann, p.6: Dirk Schwulera

1980–1981 • THE BEGINNING / SPEAK & SPELL TOUR

p.08–09: unknown, p.10 (1): Steve Burton, p.10 (2): Phil Burdett, p.11: Steve Burton, p.12 (1): Robert Marlow, p.12 (2): unknown, p.13 (1): Andy Drabek, p.13 (2): unknown, p.14 (1): unknown, p.14 (2): Dennis Burmeister, p.14 (3): unknown, p.15 (1) Steve Burton, p.15 (2): Dennis Burmeister, p.16 (1): Steve Burton, p.16 (2), (3), (4): Dennis Burmeister, p.17 (1), (2): Steve Burton, p.18: Jonathan Crabb, p.19 (1), (2): Jonathan Crab, p.19 (3): Dennis Burmeister, p.20 (1): BBC Archives, p.20 (2): Dennis Burmeister, p.21: Tim Williams, p.22 (1): Dennis Burmeister, p.22 (2): Intercord Archives/R. Drechsler, p.23: Intercord Archives/R. Drechsler, p.24: Dennis Burmeister, p.25: Dennis Burmeister, p.26–27: Dennis Burmeister, p.28–29: Fraser Gray/Alamy Stock Foto.

1982–1983 • "SEE YOU" TOUR / A BROKEN FRAME TOUR

p.30 (1): Tony Nutley, p.30 (2): Dennis Burmeister, p.30 (3): Alan Wilder Archives, p.31: Antoine Giacomoni/Alan Wilder Archives, p.32 (1): unknown, p.33 (1): unknown, p.33 (2): Dennis Burmeister, p.34 and 35: Dennis Burmeister, p.36 (1), (2): Dennis Burmeister, p.36 (3): Archives Ernesto Duarte Brito, p.36 (4): WDR Archives, p.37: Intercord Archives, p.38: unknown, p.39 (1), (2) unknown, p.40 (1), (2): Dennis Burmeister, p.41: Bravo, p.42–43: Erik Lüpke, p.44 (1): Luxemburger Wort Archives, p.44 (2): St. Helier Jersey Heritage Archives, p.45 (1), (2): Dennis Burmeister, p.45 (3): unknown, p.46 (1): unknown, p.46 (2): BBC Archives, p.46 (3): Dennis Burmeister, p.47: Dennis Burmeister, p.48 (1): Daniel Miller, p.48 (2): Dennis Burmeister, p.49 (1), (2): unknown, p.50 (1), (2), (3), (4): Dennis Burmeister, p.51: Intercord Archives, p.52 (1): Dennis Burmeister, p.52 (2): Nancy Clendaniel, p.53 (1): unknown, p.53 (2), (3): Dennis Burmeister, p.54: unknown, p.55: (1), (2) unknown, p.56: (1), (2), (3), (4): Dennis Burmeister, p.57 (1), (2), (3): Dennis Burmeister.

1983–1984 • CONSTRUCTION TIME AGAIN TOUR

p.58 (1): M. Joedicke, p.58 (2): Dennis Burmeister, p.59: Dennis Burmeister, p.60: Chi Ling Mai, p.61 (1): Leisa Evans, p.61 (2): unknown, p.62 (1): unknown, p.62 (2): Dennis Burmeister, p.63: Intercord Archives, p.64–65: unknown/FC New Life, p.66: unknown/FC New Life, p.67 (1), (2), (3): unknown/FC New Life, p.68 (1): unknown, p.68 (2), (3): Dennis Burmeister, p.69: unknown, p.70 (1): unknown, p.70 (2), (3): Dennis Burmeister, p.71: Dennis Burmeister, p.72 (1), (2): unknown, p.73: unknown, p.74: unknown, p.75 (1), (2): unknown, p.76: unknown, p.77 (1), (2): unknown, p.78 (1): unknown, p.78 (2), (3): Dennis Burmeister, p.79 (1): unknown, p.79 (2), (3), (4): Dennis Burmeister.

1984–1985 • SOME GREAT REWARD TOUR

p.80: unknown, p.81 (1): unknown, p.81 (2): Dennis Burmeister, p.82: unknown, p.83 (1), (2): unknown, p.84 (1): unknown, p.84 (2), (3): Dennis Burmeister, p.85: Alamy/BD5K92, p.86: Rob Robinson, p.87 (1), (2): Rob Robinson, p.88 (1), (2): Rob Robinson, p.89 (1), (2): Rob Robinson, p.90–91: Rob Robinson, p.92 (1), (2): Rob Robinson, p.93 (1), (2): unknown, p.94 (1): unknown, p.94 (2): Dennis Burmeister, p.95: unknown, p.96 (1): unknown, p.96 (2), (3), (4), (5), (6), (7), (8): Dennis Burmeister, p.97: unknown, p.98 (1), (2): Dennis Burmeister, p.98 (3): unknown, p.99 (1): Dennis Burmeister, p.99 (2): unknown, p.100: unknown, p.101 (1), (2): unknown, p.102 (1), (2): unknown, p.103: unknown, p.104 (1), (2), (3): Dennis Burmeister, p.105 (1): Dennis Burmeister, p.105 (2): John Frazier, p.105 (3): Dennis Burmeister, p.106 (1), (2): Dennis Burmeister, p.107: unknown, p.108 (1), (2): Dennis Burmeister, p.108 (3): unknown, p.108 (4): unknown, p.109: Wojciech Frelek.

INTERVIEW WITH KARSTEN JAHNKE AND GABY MEYER

p.110: WENN Rights Ltd./Alamy Stock Photo, p.111: Franklin Hollander, p.112: Gaby Meyer, p.113 (1): Intercord Archives/R. Drechsler, p.113 (2): Dennis Burmeister, p.114 (1): Dennis Burmeister, p.114 (2): unknown, p.115: Dennis Burmeister, p.116: Bravo, p.117: unknown.

1986 • BLACK CELEBRATION TOUR

p.118: unknown, p.119 (1): unknown, p.119 (2): Dennis Burmeister, p.119 (3): unknown, p.119 (4): unknown, p.120 (1): Sunshine Gray, p.120 (2), (3): Dennis Burmeister, p.121: Ludwig Rehberg,

p.122 (1): unknown, p.122 (2), (3), (4), (5): Dennis Burmeister, p.123: HMV Archives, p.124 (1), (2): Dennis Burmeister, p.124 (3): unknown, p.124 (4): Dennis Burmeister, p.125: Lukas von Saint-George, p.126: Lukas von Saint-George, p.127 (1), (2): Lukas von Saint-George, p.128 (1), (2), (3), (4), (5), (6), (7), (8): Dennis Burmeister, p.129 (1): Dennis Burmeister, p.129 (2): unknown, p.129 (3), (4): Dennis Burmeister, p.130 (1), (2): Dennis Burmeister, p.130 (3): Ebet Roberts, p.131 (1): Alan Wilder, p.131 (2): Screenshot, p.131 (3): Alan Wilder, p.132 (1): Dennis Burmeister, p.132 (2): Andras Lengyel, p.133 (1): unknown, p.133 (2), (3): Dennis Burmeister.

INTERVIEW WITH DAN SILVER

p.134: Dan Silver, p.136: Daniel Miller, p.137: Steve Cooks, p.138: Allan Tannenbaum, p.139: Dennis Burmeister, p.140: BBC Archives, p.141 (1), (2): Dennis Burmeister, p.142: unknown, p.143: unknown, p.144 (1), (2): Dennis Burmeister, p.145: Lukas von Saint-George, p.146 (1): Nicos Vasaras, p.146 (2): Dennis Burmeister, p.147 (1): unknown, p.147 (2): unknown, p.148: Dennis Burmeister, p.149: Edwin Gould/KROQ Promo, p.151: Mute Promo.

1987–1988 • MUSIC FOR THE MASSES TOUR

p.152 (1): unknown, p.152 (2): unknown, p.152 (3): Dennis Burmeister, p.153: Duncan Raban, p.154: Lukas von Saint-George, p.155 (1), (2): Lukas von Saint-George, p.156: HMV Archives, p.157 (1), (2), (3): Dennis Burmeister, p.158–159: unknown, p.160: Dennis Burmeister, p.161 (1): Dennis Burmeister, p.161 (2): Simon Cordey, p.161 (3): unknown, p.162: Petra Gall/Schwules Museum, p.163 (1), (2): Petra Gall/Schwules Museum, p.164: unknown, p.165 (1), (2), (3): Dennis Burmeister, p.166 (1): Dennis Burmeister, p.166 (2): Eva Losnedahl, p.166 (3): Dennis Burmeister, p.167: unknown, p.168 (1): Dennis Burmeister, p.168 (2): unknown, p.169 (1): unknown, p.169 (2): Dennis Burmeister, p.169 (3): unknown, p.170 (1): unknown, p.170 (2): Chris Hegedus, p.171 (1), (2), (3): Dennis Burmeister, p.172 (1): Daryl Bamonte, p.172 (2): Dennis Burmeister, p.172 (3): unknown, p.173: unknown.

INTERVIEW WITH LASZLO HEGEDUS

p.174: Gáti György, p.175: Dennis Burmeister, p.176: unknown, p. 177 (1): unknown, p.177 (2): Gabriele Senft (?), p.178 (1), (2): Detlef Laux (?), p.179 (1), (2): Detlef Laux (?).

1990 • WORLD VIOLATION TOUR

p.180: Dennis Burmeister, p.181 (1), (2): unknown, p.182: unknown, p.183 (1): unknown, p.183 (2): Dennis Burmeister, p.184 (1), (2): unknown, p.185 (1), (2): unknown, p.186: unknown, p.187 (1): Richard Blade, p.187 (2), (3): Dennis Burmeister, p.188: unknown, p.189: unknown, p.190: unknown, p.191: unknown, p.192 (1): unknown, p.192 (2): unknown, p.193: unknown, p.194: Dennis Burmeister, p.195: Dennis Burmeister, p.196: unknown, p.197 (1): Stephane Devillers, p.197 (2), (3): Dennis Burmeister, p.198 (1), (2): Norman Winter, p.198 (3): Dennis Burmeister, p.199: Michael Rose.

INTERVIEW WITH PETER ILLMANN

p.200: Harry Stahl, p.201: WDR Archives, p.202: unknown, p.203 (1), (2), (3): unknown, p.204 (1): Intercord Archives, p.204 (2): WDR Archives, p.205 (1), (2), (3): unknown.

1993–1994 • DEVOTIONAL TOUR / EXOTIC TOUR

p.206 (1): Michael Jenkel, p.206 (2): unknown, p.207: Michael Jenkel, p.208: Michael Jenkel, p.209 (1), (2): Michael Jenkel, p.210 (1): unknown, p.210 (2): Dennis Burmeister, p.210 (3): Anton Corbijn, p.211: Intercord Archives/Eija Väliranta, p.212 (1): Dennis Burmeister/Anton Corbijn Dia Slide, p.212 (2): unknown, p.212 (3): Dennis Burmeister, p.213: Norman Winter, p.214–215: Norman Winter, p.216: unknown, p.217 (1), (2), (3): Norman Winter, p.218 (1), (2): unknown, p.219: unknown, p.220: Dennis Burmeister, p.221 (1), (2): Dennis Burmeister, p.222 (1), (2): Dennis Burmeister, p.123: Intercord Archives/Joe Sia, p.224 (1), (2): unknown, p.225: unknown, p.226 (1), (2): Dennis Burmeister, p.227: unknown, p.228: Ian Dickson (?), p.229 (1): Michael Rose, p.229 (2): Dennis Burmeister, p.229 (3): unknown, p.230: unknown, p.231 (1): Wing Shya, p.231 (2): Alex Ortega, p.232 (1), (2): Dennis Burmeister, p.233 (1): Alan Wilder, p.233 (2): Stephane Devillers.

1997 • ULTRA LAUNCH PARTIES

p.234: Alan Wilder, p.235: Alamy/2DA9AJ6, p.236: Dennis Burmeister, p.237 (1): Anton Corbijn/Mute Promo, p.237 (2): Dennis Burmeister, p.238 (1): Mute429/Mute Promo, p.238 (2), (3): Dennis Burmeister, p.239: Intercord Archives (no information), p.240 (1): Intercord Archives (no information), p.240 (2), (3): Dennis Burmeister, p.242 (1): unknown, p.242 (2): J.D. Fanger, p.242 (3), (4): Dennis Burmeister, p.243: unknown, p.244: unknown, p.245 (1), (2): unknown, p.246: unknown, p.247 (1), (2): unknown, p. 248: unknown, p.249 (1), (2), (3): unknown.

1998 • THE SINGLES 86>98 TOUR

p.250: unknown, p.251 (1), (2): unknown, p.251 (3): Dennis Burmeister, p.252 (1): unknown, p.252 (2): Dennis Burmeister, p.253 (1): unknown, p.253 (2): unknown, p.253 (3): Dennis

Burmeister, p.254 (1): unknown, 254 (2): unknown, 255: unknown, p.256 (1), (2): unknown, p.257 (1), (2): unknown, p.258: Dennis Burmeister, p.259 (1), (2): unknown, p.259 (3): Dennis Burmeister, p.260 (1), (2): unknown, p.261: unknown, p.262 (1): unknown, p.262 (2): Dennis Burmeister, p.263 (1), (2), (3), (4): Dennis Burmeister, p.264 (1), (2): Andrew Labis, p.265: Andrew Labis.

2001 • *EXCITER* TOUR

p.266: Alamy/2H0THE3, p.267 (1): Mute Records, p.267 (2): Frank Meinke, p.267 (3): unknown, p.268 (1): Dennis Burmeister, p.268 (2): BBC Archives, p.268 (3): Anton Corbijn, p.269 (1): Paul Villegas, p.269 (2), (3): Dennis Burmeister, p.270 (1), (2): Dennis Burmeister, p.271: Dennis Burmeister, p.272: unknown, p.273 (1), (2), (3), (4): unknown, p.274: Anita Karl, p.275 (1), (2): Anita Karl, p.276 (1), (2): unknown, p.277: unknown, p.278: unknown, p.279 (1): Dennis Burmeister, p.279 (2): unknown, p.280: Dennis Burmeister, p.281 (1): Dennis Burmeister, p.281 (2): Tracy Gensch, p.281 (3): Dennis Burmeister, p.282: Alamy/2H0THET, p.283: Dennis Burmeister.

INTERVIEW WITH MARKUS KAVKA

p.284: Thomas Neukum, p.286: Markus Kavka, p.287: unknown, p.289: Thomas Neukum.

2005–2006 • TOURING THE ANGEL

p.290–291: Alamy/2E95TNM, p.292 (1): Wibke Kuemmel, p.292 (2): Dennis Burmeister, p.292 (3): unknown, p.293 (1), (2): Dennis Burmeister, p.293 (3): unknown, p.294: Alamy/W0B2M0, p.295 (1): unknown, p.295 (2): Dennis Burmeister, p.296-297: Alamy/2HBJR75, p.298: Alamy/2E95TMD, p.299 (1): Alamy/B4MNWD, p.299 (2): unknown, p.300: Alamy/DP1D17, p.301: Dennis Burmeister.

2009–2010 • TOUR OF THE UNIVERSE

p.302: unknown, p.303 (1) Ben Hillier, p.303 (2): unknown, p.303 (3): Axel Schmidt, p.303 (4): unknown, p.304 (1), (2) Dennis Burmeister, p.304 (3): unknown, p.305: unknown, p.306 (1): unknown, p.306 (2): Ana S., p.307: Norman Winter, p.308 (1), (2): unknown, p.309: Alamy/C3DF6B, p.310: Dennis Burmeister, p.311: Dennis Burmeister, p.312: Israel Martinez, p.313 (1): unknown, p.313 (2): McBiene, p.314-317: O2 World Berlin.

INTERVIEW WITH NITZER EBB

p.318: Nitzer Ebb/Mute Promo, p.319 (1), (2): Nitzer Ebb/Mute Promo, p.320: Lukas von Saint-George, p.321 (1): Nitzer Ebb/Mute Promo, p.321 (2): Fredrik Hammarlund, p.322 (1), p.322 (2): Dennis Burmeister, p.323: Dennis Burmeister, p.324 (1): unknown, p.324 (2): unknown, p.324 (3): Tobias Schulze, p.325 (1), (2), (3): Recoil/Mute Promo, p.326: Dennis Burmeister, p.327: Daniela Vorndran.

INTERVIEW WITH PEDDY SADIGHI

p.328: Nadia Morganistik, p.329: Peddy Sadighi, p.330 (1): unknown, p.330 (2): Peddy Sadhigi, p.331: Nadia Morganistik, p.332–333: Daniela Vorndran.

2013–2014 • *DELTA MACHINE* TOUR

p.334: Pedro Becerra, p.335 (1): unknown, p.335 (2): CBS, p.336 (1): Electronic Beats by Telekom, p.336 (2): unknown, p.337: ARD, p.338–345: Electronic Beats by Telekom, p.346 (1): unknown, p.346 (2): depechemode.com, p.347: Alamy/DAX8B5, p.349 (1): Sony Music Belgium, p.349 (2): Romy R., p.350: Dennis Burmeister, p.351: Lanxess Arena Cologne, p.352–355: O2 World Berlin.

2017–2018 • GLOBAL SPIRIT TOUR

p.356: Jürgen Keilwert, p.357 (1): unknown, p.357 (2): unknown, p.357 (3): Dennis Burmeister, p.358: Markus Nass, p.359: Norman Winter, p.360: Jesper Schmitt, p.361: LVZ–Leipziger Volkszeitung, p.362–363: Jürgen Keilwert, p.364–371: Uwe Silbermann, p.372: Erik Lübke, p.373 (1): Daniela Vorndran, p. 373 (2): Dennis Burmeister, p.374: Michaela Hall, p.375 (1), (2): Michaela Hall, p.376: Sony Music, p.377: Erik Lübke.

2023–2024 • *MEMENTO MORI* TOUR

p.378: Rock and Roll Hall of Fame/Promo, p.379 (1): Rock and Roll Hall of Fame/Promo, p.379 (2): YouTube-Screenshot, p.379 (3): Rock and Roll Hall of Fame/Promo, p.380: depechemode.com, p.381: Daniel Miller/Miller-Zillmer-Stiftung, p.383 (1): Depeche Mode/Mute Promo, p.383 (2): Carsten Drees, p.384 (1): Dennis Burmeister, p.384 (2): Andreas Budtke, p.385 (1): Screenshot, p.385 (2): Cliff Masterson, p.385 (3): Dennis Burmeister, p.386–387: Juliane Haerendel, p.388: Frank Swierza, p.389 (1): Columbia/Sony, p.389 (2): Sascha Lange, p.390: Matt Licari/Promo, p.391: Erika Anderson-Butler, p.392: Dirk Schwulera, p.393-399: Kirsten Bohlig, p.400–403: Dirk Schwulera, p.404 (1): MonaDMSpirit, p.404 (2): Dennis Burmeister, p.405: Tara Salt.

Thanks

We'd like to extend a heartfelt thanks to the following people for the interviews and support (in alphabetical order): Anne Haffmans, Bon Harris, Laszlo Hegedus, Peter Illmann, Karsten Jahnke, Markus Kavka, Douglas McCarthy, Gaby Meyer, Pedram Sadighi, Dan Silver, Catrice Toporski (for translating the Nitzer Ebb interview), and Alan Wilder.

A special thanks goes to our astoundingly patient editor, Anvar Čukoski, and all the staff at Blumenbar/Aufbau, Lilia from Howdy Partner Booking, Stefan Kopielski, Daniel Myer, and our families and friends.

Dennis would also like to thank Erik Lüpke, Markus Räbiger, Michael Jenckel, Norman Winter, Steve Burton, Deb Danahay, Daniela Vordran, Kirsten Bohlig, the administrators for the Depeche Mode Classic Photos and Videos Facebook group, Michael Rose, Andy McMinn, and Linda Meijer, as well as Antonia Kirchenwitz.

DENNIS BURMEISTER is a graphic designer, DJ, and promoter. Over the past thirty-five years, he has gathered together one of the largest Depeche Mode collections in the world. With several thousand items, it could fill a museum. He is the cocreator of *Depeche Mode: Monument* and *Depeche Mode: Live.*

SASCHA LANGE is an author and historian of youth culture. His book *DJ Westradio* was published in 2007 by Aufbau Taschenbuch Verlag. He is the cocreator of *Depeche Mode: Monument* and *Depeche Mode: Live.*